COLLINS
COMPLETE GUIDE TO
BRITISH
MUSHROOMS
& TOADSTOOLS

Paul Sterry and Barry Hughes

Collins

HarperCollinsPublishers Ltd.
77–85 Fulham Palace Road
London W6 8JB

www.harpercollins.co.uk

Collins is a registered trademark of
HarperCollinsPublishers Ltd.

First published in 2009

Text © 2009 Paul Sterry and Barry Hughes
Photographs © Paul Sterry and Barry Hughes

13 12 11 10 09

10 9 8 7 6 5 4 3 2 1

CONSERVATION OF FUNGI

Fungal habitats need to be protected, and indeed many of the best are. But at the personal level, every mycologist – be they a beginner or an old hand – needs to show responsibility and exercise a degree of caution while foraying, so that picking is kept to an absolute minimum. Regardless of whether or not it has an effect on the body of the fungus underground, the destruction of natural objects that you profess to be interested in, for anything other than identification purposes, is to be discouraged. So, respect the natural environment and, wherever possible, leave the mushrooms and toadstools you come across for others to enjoy.

A catalogue record for this book is available from the British Library.

ISBN 978 0 00 723224 6

Collins uses papers that are natural, renewable and recyclable products made from wood grown in sustainable forests. The manufacturing processes conform to the environmental regulations of the country of origin.

Acknowledgement
We would like to thank Geoffrey Kibby for his helpful comments on the text and pictures in this book.

Paul Sterry would like to thank Andrew Cleave, Andrew Merrick, Bill Helyar and the late Mick West for their help and encouragement, and for their unerring ability to find unusual fungi.

All photographs taken by the authors.

Edited and designed by D & N Publishing, Baydon, Wiltshire

Colour reproduction by Nature Photographers Ltd
Printed and bound in Italy by Arti Grafiche

CONTENTS

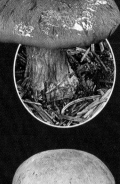

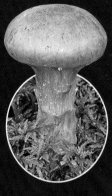

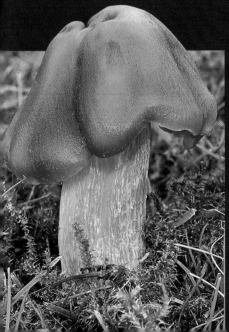

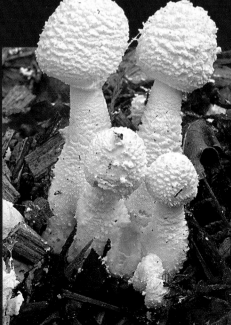

INTRODUCTION

Many people are aware of fungi for only a few weeks in autumn when colourful toadstools – fungal fruit bodies – adorn the countryside. But ask any keen mycologist (a person who studies fungi), and he or she will tell you that in reality fungal fruit bodies of all sorts can be found throughout the year. And as for the fungi themselves, the main bodies of which are found underground or concealed within a feeding substrate, they are ever present.

Fungi are much more than just colourful curiosities to be admired on the woodland floor or on a tree stump. In nature they are ubiquitous, and in environmental terms their importance cannot be overstated: amongst other things, they aid the growth of trees and are vital agents of decay and in the recycling of nutrients. Furthermore, they touch our lives in many profound and intimate ways – ways that many people are completely unaware of. From the yeasts that give us our daily bread, not to mention beer and wine, to the mould that grows on marmalade and provides penicillin and other drugs, fungi are everyday household companions. It is no exaggeration to say that, without fungi, life on earth as we know it could not exist.

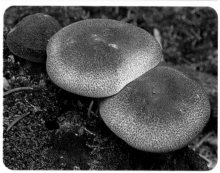

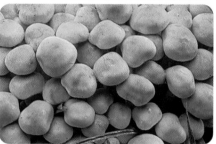

PLUMS AND CUSTARD *Tricholomopsis rutilans* (TOP), and Sulphur Tuft *Hypholoma fasciculare* (ABOVE), two colourful examples of fungal fruit bodies that appear in autumn.

Beer, wine, blue cheese and bread are just four examples of the unseen ways in which fungi enrich our lives.

THE REGION COVERED BY THIS BOOK

This book includes species of fungi found in the whole of mainland England, Wales, Scotland and Ireland, as well as on offshore islands including the Shetlands, Orkneys, Hebrides, Isle of Man, Isles of Scilly and Channel Islands.

THE CHOICE OF SPECIES

With several thousand larger species to choose from, and available space dictated and limited by the size and format of this book, the coverage has been restricted mainly to fungi that are encountered on a regular basis, and ones with sufficiently distinct features to allow a good chance of an accurate identification being made; a few bizarre and extraordinary unusual species have also been included for good measure. The choice of species was based partly on the authors' personal experiences, but for the main part was influenced by the pool of information gathered by decades of fieldwork by other dedicated mycologists.

HOW TO USE THIS BOOK

The main identification section of this book (the species descriptions) has been designed so that the text and main photographs for each species face each other on the left and right pages, respectively; special features, relevant to identification, have sometimes been added as insets in the text pages. The main photographs are labelled so that the identity of the fungus in question is clear. The text has been written to complement the information conveyed by the photographs. By and large, the order in which the species appear in the main section of the book roughly follows standard fungal classification. However, because many areas of fungal classification are in a state of flux, the order may differ slightly from that found in other guides, past, present or future. Towards the end of the book, atypical fungal groups and fungi associated with specialised habitats are presented in a more visual way, allowing the photographs to speak for themselves. A section on woodlands and tree identification is included, reflecting the importance of these habitats, and fungal associations with trees, in environmental terms and as aids to fungal identification. Finally, a gazetteer of important habitats for fungi, and their key associated species, rounds off the book.

SPECIES DESCRIPTIONS

At the start of each species description the most commonly used and current English name is given. The primary source of reference for this is *Recommended English Names for Fungi in the UK*, published under the umbrella of the Fungus Conservation Forum. The current scientific names and species status of the phylum Basidiomycota is taken from the Kew *Checklist of the British and Irish Basidiomycota*. The English name is followed by the scientific name of the fungus in question, which comprises the species' genus name first, followed by its specific name. In a few instances, reference is made, either in the species heading or the main body of the text, to a further subdivision – subspecies – where this is pertinent, or to variations from the norm (referred to as 'var.'). Because fungal classification is constantly changing, mention is sometimes made of previous given names; these are shown in brackets.

The text has been written in as concise a manner as possible. Each description begins with a summary of the fungus in question. To avoid potential ambiguities, subheadings break up the rest of each species description. Different subheadings are used for different fungal types. So, for example, subheadings used for *Boletus* species include 'Cap', 'Pores', 'Stipe', 'Habitat' and 'Status'; subheadings used for *Cortinarius* species include 'Cap', 'Gills', 'Stipe', 'Habitat' and 'Status'; and subheadings used for brackets include 'Fruit body', 'Upper surface', 'Underside', 'Habitat' and 'Status'.

PHOTOGRAPHS

Great care has gone into the selection of photographs for this book and in most cases the images have been taken specifically for the project. Preference was given to photographs that serve both to illustrate key identification features of a given species, and to emphasise its beauty. In many instances, smaller inset photographs illustrate features useful for identification that are not shown clearly by the main image. Although all species covered have been recorded in the UK, some of the photographs were taken in other parts of Europe.

EDIBILITY

Complete Guide to British Mushrooms and Toadstools is a field guide, not a guide to the edibility or otherwise of British fungi. However, because many fungus enthusiasts enjoy eating the occasional wild mushroom, reference is made to species that, by consensus, are considered to be worth eating. Cep *Boletus edulis*, Chanterelle *Cantharellus cibarius*, Field Mushroom *Agaricus campestris*, Morel *Morchella esculenta* and Horn of Plenty *Craterellus cornucopioides* are many connoisseurs's favourites. At the other extreme, a few species are deadly and these are also highlighted in the text.

The utmost caution must be observed before eating wild mushrooms. The appearance of many species varies considerably; never eat fungi unless you are 100 per cent certain of their identity. The best advice is 'if in doubt, don't eat'. Bear in mind too that individual people's tastes vary and a species that is delicious to one may seem unpleasant to others. Furthermore, edible wild fungi invariably deteriorate, in terms of palatability, with age and maturity and often acquire numerous fly larvae!

WHAT ARE FUNGI?

Until comparatively recently, fungi were thought of as plants, albeit rather unusual ones. Nowadays, however, they are recognised as entirely separate from either plants or animals. In classification terms they command their own kingdom, sometimes referred to as 'the fifth kingdom', although, confusingly, scientists now recognise the existence of seven kingdoms of living organisms! For simplicity's sake, taking five to be the overall number, the accompanying four kingdoms are: Prokaryota (bacteria); Protozoa (this includes the fungus-like Myxomycota, or slime moulds, which are included in this book on p. 334 as they were previously regarded as fungi and are still regularly recorded on many fungus forays); Plantae (the plants); and Animalia (the animals).

BASIC FUNGUS BIOLOGY

Although you might be forgiven for thinking that mushrooms and toadstools are all there is to a fungus, this is far from the truth. In most instances the main body of a fungus is hidden from view and consists of a mass of thin threads called *hyphae*, which permeate the particular species' growing medium, such as rotting wood, soil or leaf litter. The collective name for fungal hyphae that comprise the hidden body of the fungus is the *mycelium*, and sometimes this mass of white threads is inadvertently discovered if you break off a piece of bark on a decaying tree stump. Hyphae are responsible for feeding the fungus: they produce enzymes to aid the release of nutrients, which are then absorbed along with water from the growing medium.

Some fungi reproduce asexually, by simple division. Others have asexual and sexual stages. Sexual reproduction in fungi typically involves the fusion of hyphae from different fungal colonies. Toadstools, in their many different forms, are fungal fruit bodies and are composed of tightly packed hyphae; their role is to produce and disperse spores.

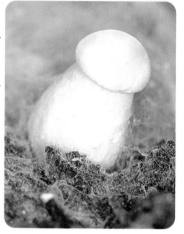

ABOVE: **Mycelium and embryonic fruit body of a *Boletus* species.**
BELOW: **Mycelium of a *Boletus* species.**

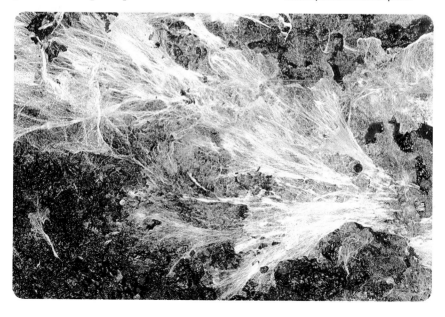

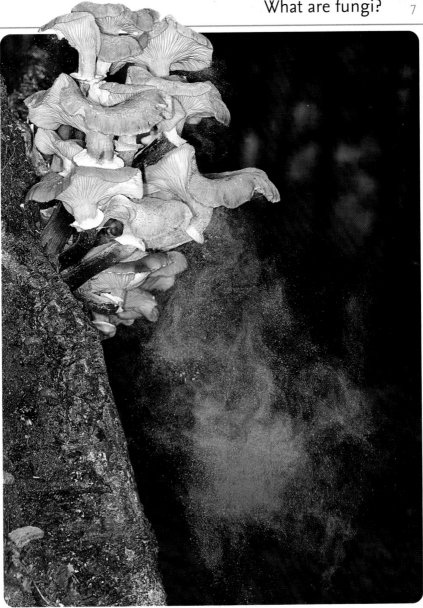

Computer-generated image illustrating the release and dispersal of spores, over a period of several hours, from a clump of HONEY FUNGUS *Armillaria mellea*.

UNIQUE FEATURES

Unlike plants, fungi do not manufacture their own food by photosynthesis, and cellulose (the main structural component in plants) is replaced in them by chitin (the tough component in an insect's exoskeleton). Unlike animals, fungi do not ingest food but instead digest their food externally and then absorb it.

CLASSIFICATION

In order to make sense of the natural world, scientists attempt to discern relationships between organisms. A hierarchy of divisions and subdivisions is created, with organisms placed in appropriate groups based on the similarities and differences between them. This is called classification, and in all areas of the natural world, including Fungi, the major subdivision of a kingdom is into groups called *phyla* (singular *phylum*). Each phylum contains subdivisions called *classes* and within these are groups called *orders*. Each order contains a number of *families*; these are further subdivided into different *genera* (singular *genus*), within which are contained different *species* (singular and plural). Among members of the same genus, the first word in each species' binomial scientific name is the same.

The following fungal phyla are covered by this book:

Phylum Basidiomycota

Characterised by producing sexual spores on external, projecting hyphae called 'basidia'; when mature, the spores are released and are borne by the wind. The phylum includes typical mushrooms and toadstools, as well as puffballs, earthstars, bracket fungi, hedgehog fungi, corals, jelly fungi, rusts and smuts; the precise way in which they are classified is beyond the scope of this book.

Phylum Ascomycota

Characterised by producing sexual spores inside club-shaped *asci* (singular *ascus*); when mature, the spores are shot out through the end of the ascus. The phylum includes cup fungi, morels, flask fungi, certain gall-forming fungi, yeasts and lichenised fungi.

BELOW: *Peziza michelii*, belonging to the phylum Ascomycota.

ABOVE: **SHEATHED WOODTUFT** *Kuehneromyces mutabilis*, a typical member of the phylum Basidiomycota.

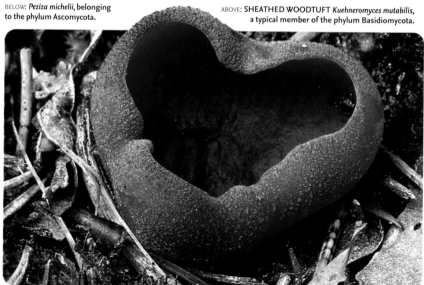

FUNGI AND ECOLOGY

Most naturalists recognise the significance of fungi in decay and the recycling of nutrients from dead organic matter back into the environment. And the number of species that live in dead wood, leaf litter and humus-rich soil is only too apparent when their toadstools appear in autumn. But the role of many species of fungi goes far beyond simply acting as agents of decay: many have a complex and entirely positive relationship with living plants, and trees in particular. In these partnerships, the fungus sheathes the tree roots, and its hyphae extend into the soil and penetrate the tree's root cells; this association is known as a mycorrhiza, which means 'fungus root'. The fungus derives almost all of its energy requirements from the photosynthetic reactions of the tree's leaves. In return, the tree obtains nitrogen and phosphorous, otherwise in short supply, via fungal action in the soil. Many of the toadstools that adorn the woodland floor in autumn are the fruiting bodies of these partnerships.

The relationship between a few fungal species and trees is less benign and parasitism is well documented, as are instances where fungi invade an already diseased or damaged tree, hastening its end. It is a short step from this strategy to that found in the Honey Fungus *Armillaria mellea*, and many of its relatives, which are capable of penetrating seemingly healthy trees, ultimately causing their demise. Elsewhere in the natural world, some fungi parasitise insects, and in a few cases they even attack their own. There seem to be no limits to the extraordinary ways in which fungi make a living.

RIGHT: **The mycorrhizal association between FLY AGARIC** *Amanita muscaria* **and SILVER BIRCH** *Betula pendula* **is one of the best known and widely quoted.**

BELOW: **HONEY FUNGUS** species growing on the stump of a tree whose death it may well have contributed to or caused.

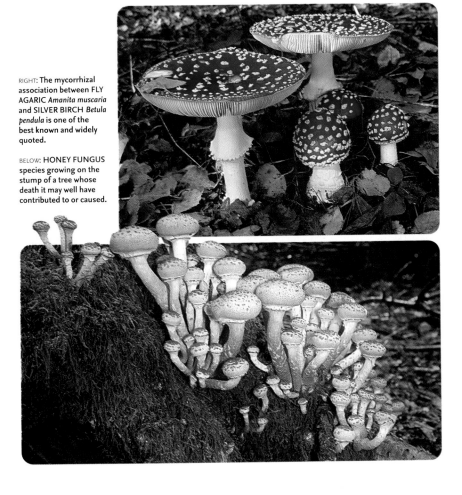

WEIRD AND WONDERFUL LIFESTYLES

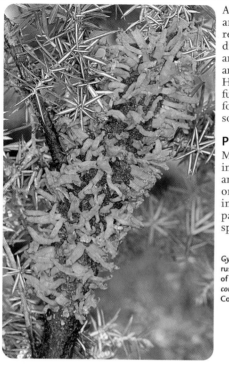

Almost all aspects of fungal natural history are fascinating and intriguing. If you have read the previous pages you will have discovered that many are agents of decay and recycling, while others have intimate and symbiotic relationships with tree roots. However, the lifestyles of a few species of fungi are truly bizarre; to whet your appetite for the subject, the following pages reveal some weird and wonderful examples.

PLANT PARASITES

Most species of flowering plant are affected in one way or another by fungal pathogens and parasites. In many instances, the effect on the plant host is the only sign of an infection. But in a few species, fungal parasites themselves put in a visible and spectacular appearance.

Gymnosporangium clavariiforme is a plant-parasitic rust. Its teliospore stage appears in spring as tufts of orange strands on the stems of Juniper *Juniperus communis*; the alternate-generation host is usually Common Hawthorn *Crataegus monogyna*.

ALDER TONGUE *Taphrina alni* is a gall-inducing fungus that produces flame-coloured tongue-like strands that flare from the cones of Common Alder *Alnus glutinosa* in autumn.

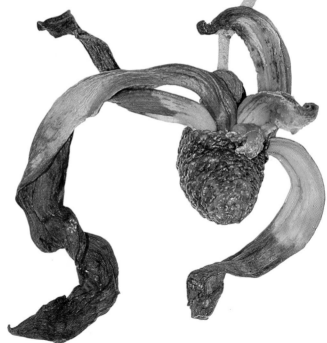

PARASITES OF OTHER FUNGI

A few species of fungi are actually parasitic on other fungi – unsurprising perhaps, given the potential nutritional value of many fruit bodies. Their discovery usually evokes considerable excitement among mycologists.

RIGHT: **THE SNAKETONGUE TRUFFLECLUB** *Cordyceps ophioglossoides* parasitises the subterranean FALSE TRUFFLE *Elaphomyces granulatus*; only the spore-producing heads appear above ground level.

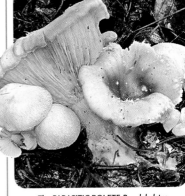

SQUAMANITA PARADOXA

Surely the most extraordinary example of parasitism in fungi is the Powdercap Strangler *Squamanita paradoxa* (p. 88). It affects a grassland fungus called Earthy Powdercap *Cystoderma amianthinum*: as formation of the latter's fruit body is in progress, *Squamanita* takes over, its own cap and upper stipe appearing in place of those of its host.

BELOW: The intriguing parasitic **PIGGYBACK ROSEGILL** *Volvariella surrecta* appears on the caps of the Clouded Funnel *Clitocybe nebularis*.

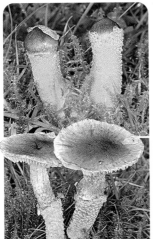

The initial stages of fruit-body formation where *Squamanita* is bursting through the upper stem of *Cystoderma*.

The mature fruit bodies of *Squamanita*, borne atop the stems of *Cystoderma*.

BELOW: The **PARASITIC BOLETE** *Pseudoboletus parasiticus* grows on the fruit bodies of the Common Earthball *Scleroderma citrinum*. Although this is usually cited as a parasitic relationship, some authorities now think a degree of symbiotic partnership may be involved.

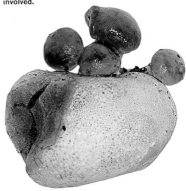

An uninfected cap of **EARTHY POWDERCAP** *Cystoderma amianthinum*.

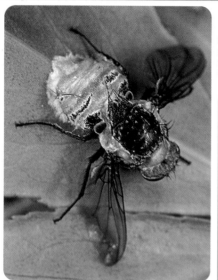

A fly infected with the conidial stage of *Entomophthora muscae*; prior to death, the fungus altered the fly's behaviour so that it climbed to an exposed position on a shrub, thereby ensuring good spore dispersal. By contrast, if the fly had been infected with the fungal life-cycle stage that produces resting spores, it would have crawled down to the ground before dying, allowing the spores to remain dormant in the soil.

HYGROSCOPIC RESPONSES

As with all living things, fungi are dependent upon water to varying degrees – for example, the amount of rainfall has a profound influence on the autumn appearance of many species' fruit bodies. Intriguingly, however, certain species of earthstar and their relatives also show strong physical hygroscopic responses to water that persist for several years after the fruit body first appeared. In these species, their 'rays' curl tightly around the spore sac when dry, compressing and protecting it while conditions for spore germination are not optimal. But within hours of being inundated by rain, the rays expand, the spore sac inflates, and spore release can take place.

PARASITES OF INSECTS

Several species of fungi are specialist parasites of insects. Some affect dormant stages in the life cycle, but a few infect active adult insects and in a few instances even modify their host's behaviour.

PARASITES OF MOTH LARVAE AND PUPAE

The larvae of many moth species burrow underground in order to pupate. Larger species are vulnerable to infection by the Scarlet Caterpillarclub *Cordyceps militaris* (p. 302).

LEFT: The fruit body of *Cordyceps militaris* as it appears *in situ*.

RIGHT: Excavated mature *Cordyceps* and the remains of its moth larva host.

The subterranean pupae of small moth species are sometimes infected and killed by *Paecilomyces farinosus* (p. 302).

ABOVE: The fruit bodies of *Paecilomyces* as they appear *in situ*.

RIGHT: Excavated mature *Paecilomyces* and the remains of its moth pupa host.

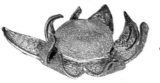
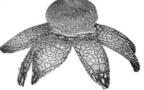

Hygroscopic response in the BAROMETER EARTHSTAR *Astraeus hygrometricus*.

SPORE DISPERSAL

Most typical fungi rely on the wind to disperse their spores once these fall from the gills or pores of the toadstool cap or bracket in question. A few species employ more active methods to improve their chances of spore dispersal, and some rely on animal agents to act on their behalf. With some inkcaps (pp. 218–21), the cap and gills liquify (deliquesce) to expose more spore-bearing tissue.

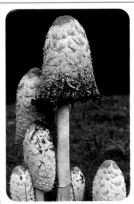

Coprinus comatus deliquescing.

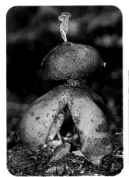

LEFT: As with other earthstars and puffballs, spore release in the ARCHED EARTHSTAR *Geastrum fornicatum* is achieved when the spore sac is impacted by raindrops, causing a puff of spores to be ejected.

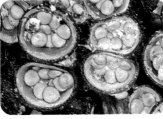

ABOVE RIGHT: The spores of the COMMON BIRD'S NEST *Crucibulum laeve* are contained within egg-like packets that sit in the fruit-body 'nest'. When impacted by raindrops, the 'eggs' are splashed out and dispersed.

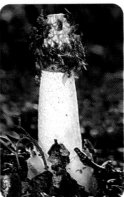

BELOW: Although the fruit body of the SHOOTING STAR or CANNONBALL FUNGUS *Sphaerobolus stellatus* is a mere 2–3mm across, the spore ball is ejected with such violent force that it can travel a distance of 5m or more.

RIGHT: The spores of the STINKHORN *Phallus impudicus* are contained within a slimy mass, borne at the tip of the fruit body. An unspeakable smell attracts flies, which consume the slime (and hence spores), dispersing them when they depart the scene.

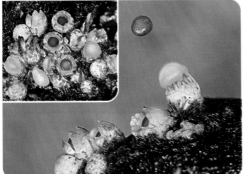

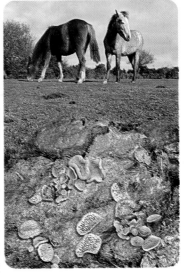

DUNG FUNGI

A number of fungal species are found exclusively on dung (p. 344). That produced by herbivores is the most interesting for mycologists, as herbivore digestion is relatively inefficient and their dung is an excellent growing medium in nutritional terms. The spores of most dung fungi tolerate passage through the gut of the animal in question; in the case of some species they will not germinate until this digestive process has happened.

The NAIL FUNGUS *Poronia punctata* is a classic New Forest species, found on the dung of ponies.

IDENTIFICATION OF FUNGI

The accurate identification of fungi is not always easy, and persistence and patience are often needed. Having an experienced mycologist as a mentor will help you to hone your skills, and local fungus groups, which hold regular forays, welcome beginners. Some of these groups are affiliated to the British Mycological Society (BMS) and others to the Association of British Fungus Groups (ABFG); visit their respective websites for details (p. 366).

APPROACHES TO IDENTIFICATION

For experienced mycologists, the process of identifying fungi involves initial observation and recording of the field characters ('macro characteristics'), followed by a detailed microscopic examination of the fruit body and its spores ('micro characteristics'). This later stage can be very time-consuming, requires considerable experience and a library of specialised literature, and is beyond the scope of this book.

Some experienced mycologists maintain that accurate fungal identification cannot be achieved using macro (field) characteristics alone. This is true to some extent, but with a little practice, careful observation of the field characteristics and a good field guide many species can be identified with a reasonable degree of certainty. The identification of fungi has parallels with the English legal system. Some species are so distinctive and unique they can be identified 'beyond reasonable doubt'. But with others, where there are possible alternatives, identification is sometimes based 'on the balance of probability'. It has to be accepted that many species cannot be identified without a microscopic examination. To these two traditional approaches to fungal identification, a third must now be added – DNA analysis. Although it is still in its infancy, this field has led to some major adjustments to the hitherto accepted order of things; further changes can be expected in the years to come.

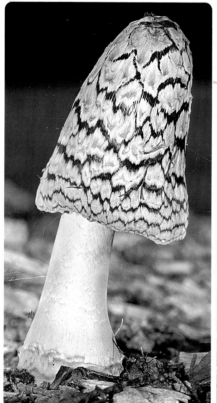

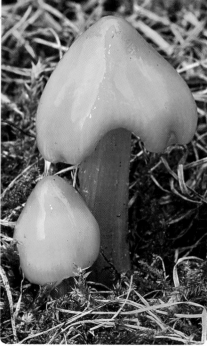

There is no doubt as to the identity of this MAGPIE INKCAP *Coprinopsis picacea* (LEFT) but, by contrast, attention to details such as texture, colour and degree of viscosity were needed to be sure that this waxcap (BELOW) was indeed the PERSISTENT WAXCAP *Hygrocybe persistens*.

TOOLS OF THE TRADE

When foraying for fungi, the following items of equipment are needed:

Trug

• **A container** for holding your specimens. A shallow basket or trug is ideal as it allows the fruit bodies to be kept apart and free from damage and contamination. Do not use plastic bags.

• **A small mirror** for looking at the undersurface of a fungal cap or bracket in order to assess the gills or pores. Using a mirror avoids the need, in most cases, to pick the fungus in question. In particular, it should be used to inspect the larger perennial brackets that may have taken several years to attain their present size.

• **A knife and/or small trowel** for digging up the occasional specimen when key field characteristics cannot be observed using a mirror, or where you want to take the specimen home for further examination. Make sure you dig up the whole fruit body, as the base of the stipe may yield valuable clues: it may or may not have rootlets (particularly important in the genus *Agaricus*); it may be pointed or rounded (useful with *Cortinarius* species); or it may have a volva (as in *Amanita* species) or a bulb (*Inocybe* species). Digging up the fruit body goes against the grain for those with a botany background. Research has shown that, unlike flowers, the collection of a fruit body does not damage the fungal organism as such, which is buried in the substrate; it does, however, deny or restrict the organism the opportunity to produce spores from that fruit body, albeit to a limited degree. So collecting should be kept to an absolute minimum. Some landowners will not permit the collection of fungi on their land and this regulation should be respected.

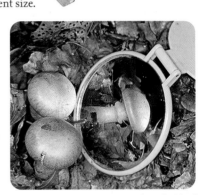

ABOVE: **Examining the underside of a *Cortinarius* fruit body using a mirror.**

LEFT: ***Boletus legaliae*, unearthed complete, allowing detailed examination of the base to take place.**

• **A 10× magnification hand lens.** This is vital because many species have characteristics that are not visible to the naked eye but can easily be seen under a hand lens. This particularly applies to the minute, bristle-like hairs (setae) found in some species.

• **A digital camera.** Modern, lightweight digital cameras have revolutionised photography over the past few years. Many have excellent close-up facilities and the images they produce can, on occasions, yield as much information as a hand lens. The vast majority of the images used in this book, and all the close-up images showing details, were taken with digital cameras.

Hand lens

IMPORTANT CHARACTERISTICS

The following are some of the characteristics that should be noted and, preferably, photographed:

> **!** Only fresh, mature specimens in good condition should be examined.

• **Size** Most fungi vary considerably in size, both during their period of growth and maturity, and between individuals of the same species. Like all living organisms fungi require water and nutrients to thrive, and a shortage or abundance of either will affect their size. The sizes given in the text are the typical maximum attained under normal conditions for any given species; they are guidelines only, and it is a mistake to place too much emphasis on this characteristic.

• **Shape** The shape of the fruit body, particularly the cap, should be noted (*see* p. 20 for cap shapes).

• **Texture** The surface of the cap is a fairly reliable and constant characteristic. It may be smooth or fibrous or granular or hairy or wrinkled. It should also be noted if any veil remnants are adhering to the cap or margin (*see* p. 20 for cap shapes).

• **Colour** This is one of the most visual field characteristics yet it can be very misleading. Many species have a wide range of shades of colour, sometimes with markedly different colour forms, and illustrations in field guides often depict only one colour. Some colours are very fugitive and readily wash out or fade. This particularly applies to some red species of *Russula*. Another problem is encountered with species that are hygrophanous, which means that there is a significant difference between their wet and dry states, to say nothing of the intermediate stages during the drying process.

Russula luteotacta fading. *Tubaria furfuracea* – dry (LEFT) and moist (RIGHT).

• **Flesh** The consistency of the flesh in both the cap and stipe can be important. It may be hard or soft, tough and fibrous, or brittle. Following an initial perusal, the fruit body should be cut longitudinally through the cap and stipe, and any colour changes in the flesh noted. Any change may be instant or take a little time to show. Colour changes are particularly important in determining some *Agaricus* and *Leccinum* species. Some *Mycena* and *Lactarius* exude a liquid when damaged, and the quantity and colour of this should be noted.

LEFT: The 'milk' colour of the SAFFRONDROP BONNET *Mycena crocata* is a diagnostic tool in identification.

RIGHT: Immediately after cutting, the flesh of *Boletus pulverulentus* turns a deep blue colour.

BELOW: Like other members of the genus, *Amanita franchetii* has a striking and conspicuous ring.

• **Stipe ring** The stipe should be checked to determine whether or not a ring is present (*see* p. 22 for examples of different types of ring). With some species the ring is very short-lived and may show only as a zone.

• **Taste** The taste of a fungus can yield some valuable information. Taste normally falls within the categories of hot, mild or bitter. Fungi should not be tasted by anyone who is inexperienced, and specimens from genera containing poisonous species should be avoided even by experienced mycologists. The method of tasting a fungus is to chew a very small piece of the cap flesh on the tip of the tongue for a minute or two and then spit it out. It is never swallowed.

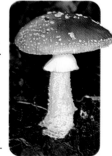

• **Smell** There is a wide variation in people's sense and concept of smell; it is highly subjective and a particularly difficult characteristic to communicate.

RIGHT: Emitting a strong smell of garlic, the aptly named GARLIC PARACHUTE *Marasmius alliaceus* is a species that can be located by smell, and identified with certainty using this feature.

Nevertheless, it is important, and the first thing many experienced mycologists do when examining a fungus is to smell it. With some species the smell is strong and unmistakable, but with others it is more ephemeral and these just have to be learnt by experience. Most accomplished mycologists would acknowledge that the greater their expertise in identification of fungi, the more important smell becomes in the process.

• **Gills** A careful examination of the gills of a fungus will yield some valuable information. Look at their attachment to the stipe, a fairly constant characteristic (*see* p. 21 for details). Gill edges should also be inspected, as they can be smooth or serrated and are sometimes sterile and uncoloured. With some genera, notably *Agaricus* and *Cortinarius*, the gills change colour

LEFT: Examining gill colour and spotting with the aid of a mirror.

as the fruit body develops and spores mature, and both young and mature specimens should be inspected. It is not necessary to remove a fruit body to inspect the underside as this can be achieved with a small mirror. This equally applies to the large bracket fungi.

• **Habitat** The majority of fungi have specific habitat requirements, such as grassland, deciduous woodland and so on (*see* pp. 354–65 for the most important fungal habitats), so where they are found should be noted. When a fungus is actually growing on wood, the identity of the tree should be established if possible, as some species are host-specific or have a very restricted range. Identity of dead wood, particularly if it is fallen and decayed, does present problems but observation of the surrounding standing trees will give a clue. Even a simple differentiation between deciduous and coniferous trees will often be helpful. Pages 350–3 will help in the identification of trees and their wood.

• **Chemicals** The identification of some species is aided by the use of certain chemicals. The chemical is applied to the tissue and the colour change noted. In the past this was a fairly routine and extensive practice, but it has now fallen into disfavour to some extent. This is partly due to doubts being cast over the value of some of these tests as identification aids, but also because many of the chemicals previously used have been removed from circulation because of health and safety concerns. Nevertheless, some chemicals are still useful – including iron salts, which are applied to the stipe of members of the *Russula* genus; and potassium hydroxide (KOH), which has a more general application. These and other chemicals can be obtained through the ABFG. Chemicals are not used randomly, but generally only with species that are suspected of being potential reactors.

• **Spores** Fungal spores probably provide more conclusive identification information than any other single feature. It is first important to establish their colour by making a spore print. To do this, remove the cap from the stem and place it gills-side-down on a piece of white paper; cover it with a glass or bowl to prevent it from drying out and leave it for several hours, preferably overnight. When the cover and cap are removed, a perfect spore print in the shape of the gills will normally be revealed. Spore prints are generally white, cream, pink or various shades of brown; by establishing the colour of the spores a large number of species can be eliminated. The first stage in fungal identification is assignation to the appropriate family; knowing the spore colour aids this process considerably.

A spore print is a mass of fallen spores that individually are far too small to be seen even with a hand lens.

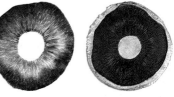

Spore print from a CULTIVATED MUSHROOM *Agaricus bisporus*, and the cap from which it was produced.

GLOSSARY

Acute Sharp.

Adnate Gills that are attached to the stipe along their entire depth (p. 21).

Adnexed Gills that narrow towards the region where they are attached to the stipe (p. 21).

Adpressed Pressed closely to the surface.

Anastomosing Gills running together irregularly to form a vein-like network.

Appendiculate Margin fringed with hanging veil remnants.

Ascomycete Popular term for a member of the phylum Ascomycota (p. 8); usually abbreviated to asco.

Basidiomycete Popular term for a member of the phylum Basidiomycota (p. 8).

Bulb Swollen base to the stipe.

Calcareous Soil containing calcium (chalk or limestone).

Campanulate Bell-shaped (p. 20).

Cap Expanded, umbrella-like structure borne at the apex of the stipe, below which spore-producing structures (gills, pores or spines) are borne.

Ciliate Delicate, often marginal, hairs.

Clavate Club-shaped.

Clustered Growing together from a single or fused base.

Concolorous Of the same colour.

Cortina Filamentous or fibrous partial veil.

Crenate Minutely serrated.

Cuticle Surface layer of tissue.

Decurrent Gill attachment that extends down the stipe (p. 21).

Decurrent tooth Gill attachment where the teeth extend down the stipe.

Denticulate Toothed.

Depressed Referring to a cap with a depressed centre.

Eccentric Off-centre.

Fibrillose Covered in delicate hairs (p. 20).

Fibrous Comprising dense fibres.

Fimbriate Fringed.

Floccose Fleecy.

Fugacious Transient or short-lived.

Gill Spore-producing structure found below the cap of typical mushrooms and toadstools.

Gleba Spore-bearing mass in puffballs and earthstars.

Gluten Sticky substance found on the cap surface of some mushrooms.

Granular Covered in granules.

Gregarious Several fruit bodies growing in close proximity.

Hygrophanous Different in colour and appearance when wet compared to dry.

Hygroscopic Changing shape in response to humidity.

Infundibuliform Funnel-shaped.

Inrolled Curled inwards.

Iron salts A chemical sometimes used to aid identification.

KOH Potassium hydroxide, a chemical sometimes used to aid identification.

Latex Milk-like substance exuded by certain fungi (*see* 'Milk').

Merulioid Folded into a shallow, maze-like pattern.

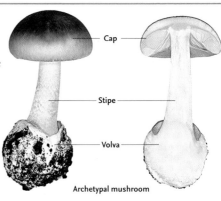

Cap — Stipe — Volva

Archetypal mushroom

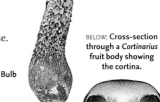

Bulb

BELOW: **Cross-section through a *Cortinarius* fruit body showing the cortina.**

Peeling cap cuticle of BIRCH BRITTLEGILL *Russula betularum.*

Milk Fluid exuded by certain fungi.
Mycorrhizal Symbiotic relationship between
the mycelium of certain fungi and plant roots.
Obtuse Blunt.
Parasite An organism that lives and gains its nutrition
from, and at the expense of, another organism.
Peristome Marginal edge of the opening of earthstars
and related fungi.
Polypore Name given to fungi (mainly
brackets) whose fruit bodies are pored on
their underside.
Pore Open-ended tube on the underside
of certain fungal groups through which
spores are released.
Potassium hydroxide *See*
'KOH'.
Pruinose Having a dusty
coating or 'bloom'.
Pubescent Having a
coating of downy hairs.
Pulvinate Cushion-
shaped.
Punctuate Pitted with dots.
Resupinate Entirely attached to the growing
substrate or by the upperside of the cap.
Reticulate Netted (p. 22).
Rhizoid Fine mycelial strand.
Rhizomorph Root-like, massed strand of
mycelia.
Rimose Radial cracking seen on the caps of
certain fungi.
Ring Remains of the universal veil that stay
attached to the stipe in certain fungi.
Scale Flat, fleshy flake seen on the caps of
certain fungi.
Sclerotium Pea-shaped mass of hyphae to
which a fruit body is connected.
Serrate Toothed.
Sessile Attached directly to the growing
substrate and lacking a stipe.
Seta (plural setae) Minute, bristle-like hairs.
Sinuate Gills attached to stipe by a short
decurrent tooth or notch.
Spines Spore-bearing structures seen in toothed fungi.
Spore Tiny, dispersive, reproductive unit of fungi.
Squamulose With small scales.
Stipe Stalk of a fungus.
Striate Marked with fine lines (p. 20).
Stroma Soft or crusty tissue in which fruit bodies are embedded.
Tomentose Coating of velvety hairs.
Umbo Central, raised swelling seen on the cap of certain fungi.
Universal veil Membrane that encloses the developing embryo
fruit body.
Ventricose Gill that is swollen in the middle of its length.
Viscid Slimy coating, seen particularly on the caps of certain
fungi.
Volva Sac-like basal remains of the universal veil, enclosing the
base of the stipe.

Milk

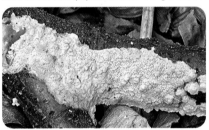

BIRCH POLYPORE *Piptoporus betulinus* showing underside.

Phlebia rufa, a typical resupinate fungus.

ABOVE: **Pores**

Formation of the ring from its veil origins in
the FRECKLED DAPPERLING *Lepiota aspera*.

Undersurface of
WOOD HEDGEHOG
Hydnum repandum.

FUNGAL FEATURES AND SHAPES

Throughout this book's species descriptions, reference is made to various fungal features and shapes that aid identification. Although these are seldom diagnostic on their own, each feature provides a clue that aids recognition. The following visual guide will help you become familiar with what these terms mean and hence speed up the process of identification.

CAP SHAPE

The following cap shapes are mentioned in the species identification text:

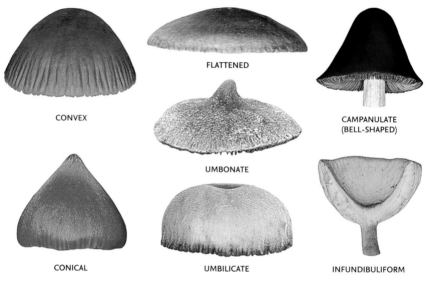

CONVEX

FLATTENED

UMBONATE

CAMPANULATE
(BELL-SHAPED)

CONICAL

UMBILICATE

INFUNDIBULIFORM

CAP TEXTURE

The following cap textures are mentioned in the species identification text:

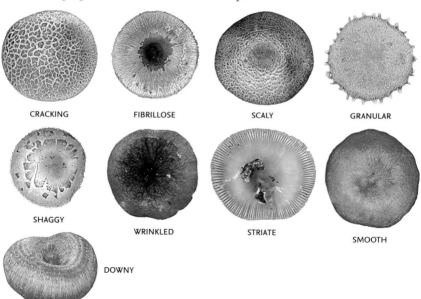

CRACKING

FIBRILLOSE

SCALY

GRANULAR

SHAGGY

WRINKLED

STRIATE

SMOOTH

DOWNY

GILL ATTACHMENT

The following forms of gill attachment are mentioned in the species identification text:

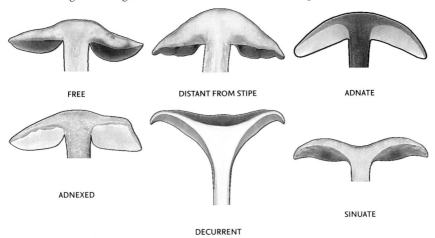

FREE

DISTANT FROM STIPE

ADNATE

ADNEXED

DECURRENT

SINUATE

GILL ARRANGEMENT

Arranged here as a fungal 'wheel', the following gill arrangements are mentioned in the species identification text:

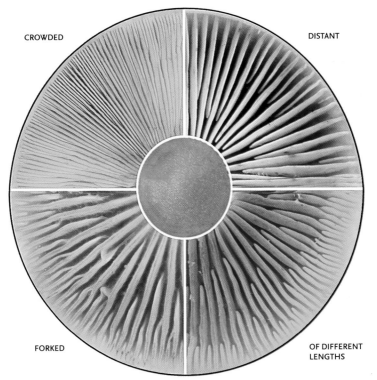

CROWDED

DISTANT

FORKED

OF DIFFERENT LENGTHS

STIPE SHAPE, TEXTURE AND FEATURES

The following stipe shapes and features are mentioned in the species identification text:

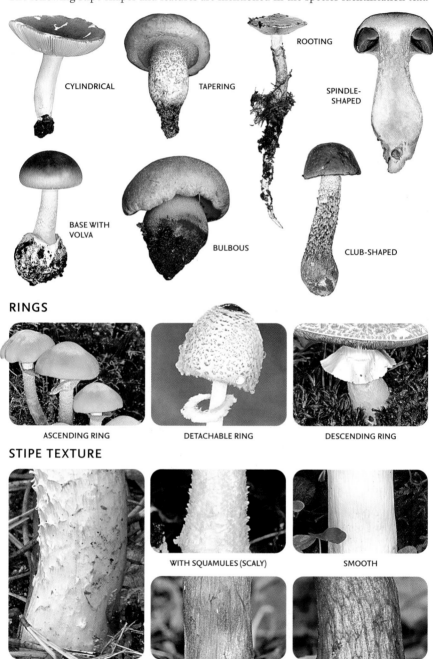

CYLINDRICAL

TAPERING

ROOTING

SPINDLE-SHAPED

BASE WITH VOLVA

BULBOUS

CLUB-SHAPED

RINGS

ASCENDING RING

DETACHABLE RING

DESCENDING RING

STIPE TEXTURE

WITH SQUAMULES (SCALY)

SMOOTH

SHAGGY

FIBRILLOSE

RETICULATE

MAIN FUNGAL GENERA AND GROUPS

The following guide provides a visual short cut to the most important and regularly encountered genera and groups of fungi found in the British Isles. They merit inclusion here either because of the diversity of species they embrace or the abundance of some of their representative species, or both.

BOLETUS, THE BOLETES (P. 30)

Mostly shades of brown. Caps bear tubes and pores on undersurface, not gills. Closely related genera include *Leccinum* and *Suillus*. Many change colour when the flesh and/or pores are cut or damaged. Spore print is usually olive-green or brown. Stipe is often stout and swollen, and sometimes covered by fine dots or net.

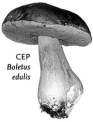

CEP
Boletus edulis

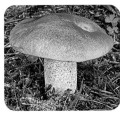

Suillus collinitus

LACTARIUS, THE MILKCAPS (P. 46)

Caps and gills exude latex when damaged. Latex properties aid identification: depending on the species, it may change colour on drying or exposure to air; taste mild, bitter or acrid. Cap margin is usually inrolled at first, often funnel-shaped in maturity. Spore print is usually whitish. Stipe often has a short-lived white bloom.

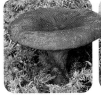

Lactarius fuliginosus

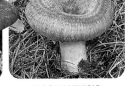

WOOLLY MILKCAP
Lactarius torminosus

RUSSULA, THE BRITTLEGILLS (P. 62)

Many species have brightly coloured caps that contrast with white or cream gills and stipe; colour often fades with age or is washed out by rain. Extent of peeling of cap cuticle aids identification of some species. Gills are usually brittle. Stipe usually has a chalk-like texture; iron salts may cause a pink or green colour reaction.

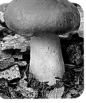

SCARLET BRITTLEGILL
Russula pseudointegra

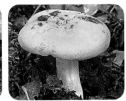

OCHRE BRITTLEGILL
Russula ochroleuca

MACROLEPIOTA, THE PARASOLS (P. 80)

RIGHT: **PARASOL**
Macrolepiota procera

Caps are brownish with radiating scales and a persistent centre; underlying paler flesh shows through. Gills are crowded and free; spore print is white. Stipe is usually cylindrical, tapering from a bulbous base. Most have a double ring that becomes detached and can slip up and down stipe.

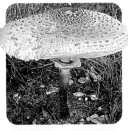

AMANITA (P. 90)

Includes very poisonous species. Mostly medium-sized and mushroom-shaped. Cap is colourful in some species. Found in two distinct forms. The typical *Amanita* is stout, and the presence of universal and partial veils results in a ring and, sometimes, ruptured remnants sticking to cap and stipe. The other form is more slender, with no ring and a striate edge to cap (this group was formerly in the genus *Amanitopsis*). Many have a volva at base of stipe. Gills are usually free or adnexed; spore print is white. Smell is sometimes distinctive; *Amanita* species should never be tasted.

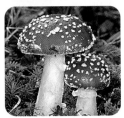

GREY SPOTTED
AMANITA *Amanita excelsa*

PANTHERCAP
Amanita pantherina

HYGROCYBE, THE WAXCAPS (P. 96)

Includes many colourful species. Cap
and stipe texture (dry, greasy or viscid) is
sometimes critical in identification. Spore
print is white. Most favour unimproved
grassland, particularly where grazed or cut.
The closely related genus *Hygrophorus* contains
species associated mainly with woodland.

GOLDEN
WAXCAP
*Hygrocybe
chlorophana*

FIBROUS WAXCAP
Hygrocybe intermedia.

ARMILLARIA, THE HONEY FUNGI (P. 106)

Robust, relatively tough fungi. Mostly
honey-coloured; cap is usually minutely scaly.
Gills are whitish, often with rusty spots; spore
print is whitish. Most species have a persistent ring.
Associated with dead or living wood; some species
are aggressive parasites. Sometimes solitary but
usually clustered and impressive.

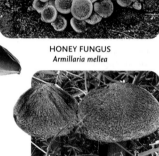

TRICHOLOMA, THE KNIGHTS (P. 108)

Thickset, fleshy fungi. Caps are often broadly
umbonate; colours include shades of white,
yellow, grey or brown. Cap surface is dry or
greasy, smooth or scaly; some have fine,
hair-like fibrils. Gills are often sinuate and
usually pale; spore print is white. Some,
particularly the white species, are hard *Tricholoma*
to identify; taste, smell, discoloration *ustaloides*
and habitat are useful features.

HONEY FUNGUS
Armillaria mellea

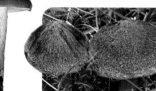

MELANOLEUCA, THE CAVALIERS
(P. 116)

Fairly distinctive genus but one whose members
are hard to identify with certainty in the field.
Medium to large fungi with broad caps that are
soon flattened and typically umbonate. In some species,
dark cap colour contrasts markedly with whitish gills.
Stipe often has dark fibres. Most grow in woodland.

GREY KNIGHT
Tricholoma terreum

CLITOCYBE, THE FUNNELS (P. 118)

Usually convex at first but funnel-shaped in
maturity. Colours are usually muted. Some are
hygrophanous. Gills are decurrent, often deeply
so; spore print is usually white or cream. Stipe is
often slender, sometimes curved, usually with fibrils.
Smell is often distinctive: usually either pleasant
(e.g. aniseed-like),
or unpleasant and
mealy.

COMMON
CAVALIER
*Melanoleuca
polioleuca*

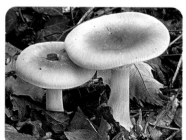

RIGHT:
CLOUDED FUNNEL
Clitocybe nebularis

FAR RIGHT:
ANISEED FUNNEL
Clitocybe odora

LACCARIA, THE DECEIVERS (p. 124)

Extremely variable fungi (often confusingly so) in terms of size, shape and colour. Cap is usually convex at first, becoming flattened and wrinkled in maturity. Gills are usually adnate or slightly decurrent. Spore print is pale. Stipe is tough, sometimes slightly compressed and twisted. Most are associated with woodland.

THE DECEIVER
Laccaria laccata

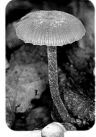

AMETHYST DECEIVER
Laccaria amethystina

COLLYBIA, THE TOUGHSHANKS (p. 126)

Stipes are tough and fibrous. Cap is hygrophanous in some species. Gills are often adnexed and white, maturing buff. Spore print is white or cream. Some species grow on decaying wood and in clusters.

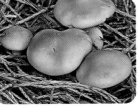

LEFT: SPINDLE SHANK
Collybia fusipes

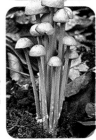

RIGHT: CLUSTERED TOUGHSHANK
Collybia confluens

MARASMIUS, THE PARACHUTES (p. 132)

Mostly small fungi whose rather delicate appearance belies their relatively tough nature. Cap is usually domed and sometimes furrowed towards margins. Gills are distant or rudimentary in some species. Spore print is white. Many species grow on decaying woodland debris, including twigs and leaves.

LEFT: GARLIC PARACHUTE
Marasmius alliaceus

RIGHT: PEARLY PARACHUTE
Marasmius wynnei

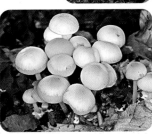

LEPISTA, THE BLEWITS (p. 136)

Robust fungi that superficially resemble members of the genus *Tricholoma*. Some species are edible. Caps are often domed at first, flattening with maturity; funnel-shaped in one species. Gills are usually crowded. Stipe is usually robust. Spore print is pinkish or white. Grow in woods and meadows.

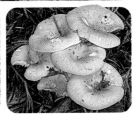

Lepista sordida

TAWNY FUNNEL
Lepista flaccida

MYCENA, THE BONNETS (p. 140)

Small fungi with conical or bell-shaped caps. Cap colours are variable but usually grey or brown; cap is usually striated or grooved when moist. Stipe is slender; may be tough, elastic or brittle. Gills are usually adnate or adnexed, with some decurrent; some have a coloured edge, visible through a hand lens. Spore print is white. Some exude 'milk' from broken stem (white or coloured).

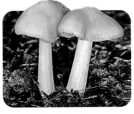

ABOVE: *Mycena rosea*

RIGHT: BURGUNDYDROP BONNET
Mycena haematopus

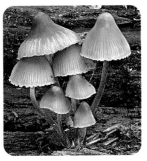

ENTOLOMA, THE PINKGILLS (p. 154)

Size, shape and hue are variable; the only consistent features are pinkish gills and polygonal pink mature spores. Colour is often sombre but young specimens of some have blue cap and/or stipe; colour fades with age. Fibrils on stipe sometimes run diagonally downward, giving a twisted appearance. Most are grassland species.

Entoloma chalybaeum

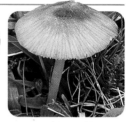

MOUSEPEE PINKGILL
Entoloma incanum

PLUTEUS, THE SHIELDS (p. 158)

Highly variable in size. Most species are shades of brown, but grey and yellow species are not uncommon. Cap is convex at first in many species, often flattening and umbonate in maturity. Gills are free; spore print is pink. Grow on wood or wood debris, standing or buried; often found on woodchip mulch.

RIGHT: **YELLOW SHIELD**
Pluteus chrysophaeus

LEFT:
VEINED SHIELD
Pluteus thomsonii

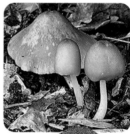

CORTINARIUS, THE WEBCAPS (p. 164)

Large genus; many are extremely hard to identify. Usually small to medium-sized. Appearance is variable, with several distinct groups. Some are hygrophanous, others slimy; some have bulbous bases. Most have universal and partial veils, the latter cobweb-like (cortina). Gill colour is variable, changing (along with cortina) as spores mature; spore print is brown.

LEFT: **SURPRISE WEBCAP**
Cortinarius semisanguineus

RIGHT:
VIOLET WEBCAP
Cortinarius violaceus

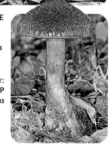

GYMNOPILUS, THE RUSTGILLS (p. 186)

Typically, small to medium-sized orange-brown fungi. Cap is usually convex at first, flattening with maturity. Gills are yellowish, becoming stained and spotted rust-brown as spores mature. Spore print is rust-coloured. Grow on decaying wood, including woodchip mulch. Some species form large and spectacular clumps.

BELOW LEFT: **COMMON RUSTGILL** *Gymnopilus penetrans*

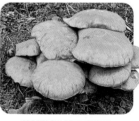

SPECTACULAR RUSTGILL
Gymnopilus junonius

HEBELOMA, THE POISONPIES (p. 190)

Variable group; most are poisonous. For simplicity's sake, many can be placed in one of two complexes: *H. crustuliniforme* (with a radish-like smell) and *H. sacchariolens* (with a sickly sweet smell). Some exude droplets from gills and stipe apex in damp weather. Spore print is tobacco-brown. Mostly associated with trees.

ROOTING POISONPIE
Hebeloma radicosum

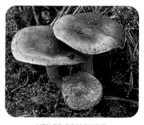

VEILED POISONPIE
Hebeloma mesophaeum

INOCYBE, THE FIBRECAPS (P. 192)
Complex genus. Microscopic examination is needed for accurate identification of many species. Most are small, with dull colours and campanulate caps. Some have a bulbous base; others have fine hairs on stipe (visible with a hand lens). Gills are usually adnate or adnexed and crowded; spore print is tobacco-brown.

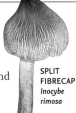

SPLIT FIBRECAP
Inocybe rimosa

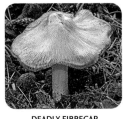

DEADLY FIBRECAP
Inocybe erubescens

HYPHOLOMA, THE TUFTS (P. 200)
Small, rather robust fungi, typically in shades of orange or yellow. Cap is convex at first, flattening with maturity. Gills are pale at first, darkening with maturity. Spore print is dark brown. Grow on dead and decaying wood, some species forming large and spectacular tufted clumps.

PHOLIOTA, THE SCALYCAPS (P. 202)
Generally fleshy, medium or large fungi, mostly in shades of yellow or orange-brown. Usually associated with wood and sometimes form impressive clumps. Most have a short-lived ring that leaves remnants on cap edge when young. Gills are generally adnate and crowded, with a rusty-brown spore print.

SULPHUR TUFT
Hypholoma fasciculare

CONIFER TUFT
Hypholoma capnoides

PANAEOLUS, THE MOTTLEGILLS (P. 206)
Distinctive small to medium-sized fungi. Cap is domed and egg- or bell-shaped. Stipe is typically slender, delicate-looking but tough. Gills are adnate and usually pale-edged and mottled. Spore print is dark brown to blackish. Associated with grassland, some species growing on dung.

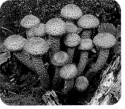

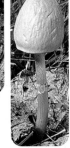

ABOVE: **SHAGGY SCALYCAP**
Pholiota squarrosa

RIGHT: **EGGHEAD MOTTLEGILL**
Panaeolus semiovatus

AGARICUS, THE MUSHROOMS (P. 208)
Includes many edible mushrooms. Mostly large and fleshy with a dry, smooth or scaly texture. Cap is button-like at first, flattening with age. White ring is present, persistent in some. Gills are usually crowded and free; pale at first, darkening with maturity. Spore print is dark brown. Some have a distinctive smell.

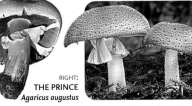

RIGHT:
YELLOW STAINER
Agaricus xanthodermus

RIGHT:
THE PRINCE
Agaricus augustus

PSATHYRELLA, THE BRITTLESTEMS (P. 214)
Rather delicate-looking fungi. Cap is usually bell-shaped or flattened; hygrophanous in some species. Stipe is slender and brittle. Gills are pale at first, darkening with maturity. Spore print is dark brown or blackish. Found in a wide variety of habitats, including lawns, grassland, woodland and dead wood. Some species form sizeable clumps.

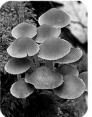

Psathyrella laevissima

PALE BRITTLESTEM
Psathyrella candolleana

COPRINOPSIS, THE INKCAPS (p. 218)

Fungi whose gills mature black. Some species liquefy or deliquesce to aid spore dispersal, while others are very fragile; many small species grow on dung. Genera *Coprinellus* and *Parasola* are related. Genus *Coprinus* (formerly the group's umbrella genus) is superficially similar but unrelated.

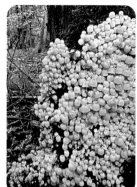

LEFT: **FAIRY INKCAP**
Coprinellus disseminatus

BELOW: **OYSTER MUSHROOM**
Pleurotus ostreatus

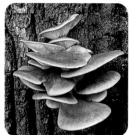

PLEUROTUS, THE OYSTERS (p. 222)

Fleshy fungi whose caps are sometimes leathery-looking. Some species are funnel-shaped, others superficially bracket-like. Note the presence of a tapering stipe, although this is often small and eccentric. Gills are decurrent. Spore print is pale. Grow on decaying and living wood. Some species grow in sizeable clusters or tiers.

POLYPORES (p. 230) AND BRACKETS (p. 252)

Come in a variety of shapes and sizes, including typical brackets and fungi with a cap and stem. Have decurrent tubes that open as pores on underside of cap. Spores can be white, brown or colourless. Familiar genera include *Polyporus, Ganoderma, Stereum* and *Trametes.*

WINTER POLYPORE
Polyporus brumale

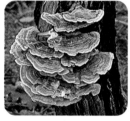

TURKEYTAIL
Trametes versicolor

CLAVARIA AND *RAMARIA,* THE CLUBS, CORALS AND SPINDLES (p. 234)

Come in diverse shapes and colours: from simple upright, unbranched clubs or spindles to coral-like clumps. An indistinct stem is present in many simpler forms. Some fork repeatedly, and have either pointed or blunt tips. Spores are produced on outer surface of fruit body. Spore print is white or pale yellow.

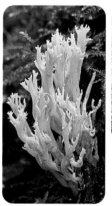

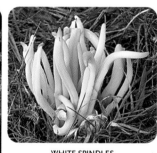

WHITE SPINDLES
Clavaria fragilis

GEASTRUM, THE EARTHSTARS (p. 270)

Bizarre fungi. Fruit bodies start life as onion-shaped 'eggs'. Outer skin splits and spreads into star-like rays and segments, revealing a puffball-like spore sac. Spores exit via a central pore when sac is impacted; margins are fibrous or pleated. Sac is stalked in some species; fruit body is hygroscopic in a few.

ABOVE: **UPRIGHT CORAL**
Ramaria stricta

RIGHT: **COLLARED EARTHSTAR**
Geastrum triplex

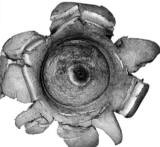

LYCOPERDON, THE PUFFBALLS (P. 274)

Spores mature as a ball-like mass inside rounded spore sac, and are liberated via apical pore when sac is impacted. Either solitary or clump-forming. In the related genera *Calvatia*, the fruit body disintegrates, exposing the spore mass; with *Bovista*, the outer skin disintegrates and the detached fruit body rolls around in the wind. Another associated genus is *Scleroderma*.

COMMON PUFFBALL
Lycoperdon perlatum

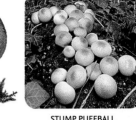

STUMP PUFFBALL
Lycoperdon pyriforme

HYDNUM, HYDNELLUM, PHELLODON AND OTHERS, THE TOOTHED FUNGI (P. 296)

The feature of this group is the underside of the fruit body, which is densely covered with spines or teeth on which the spores develop. Those in the genus *Hydnum* are mushroom shaped, fleshy and rather fragile with a tapering stipe. Most other toothed fungi are resupinate and grow on the ground in conifer debris, or sometimes the leaf litter of deciduous trees, where they often form large irregular patches.

TERRACOTTA HEDGEHOG
Hydnum rufescens

ABOVE: *Hydnellum aurantiacum*

HELVELLA, THE SADDLES (P. 310)

Variable fungi, some saucer- or saddle-shaped with a simple stem, others cup-shaped. The two most common species have an irregular and distorted head, and a hollow, ribbed and furrowed stem. Colours are typically subdued and sombre. Texture is usually rather brittle, with a smooth spore-bearing surface. Often associated with woodland paths.

WHITE SADDLE
Helvella crispa

MORCHELLA, THE MORELS (P. 318)

Distinctive, bizarre-looking fungi that are prized for their edibility. Fruit body comprises a head and stem. The head, which produces spores, is rounded to conical, and is deeply pitted and ridged, giving it a honeycomb appearance. Stipe is stout, pale and hollow. Associated with grassland and woodland. Fruits in spring.

LEFT: **COMMON MOREL** *Morchella esculenta*

ABOVE: **ELASTIC SADDLE** *Helvella elastica*

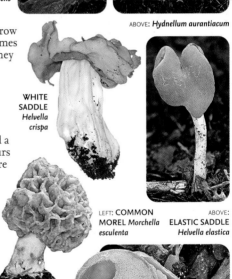

PEZIZA, THE CUPS (P. 320)

Generally disc- or cup-shaped, usually sessile but occasionally with a short, rudimentary stem. Grow on a wide range of substrates. Colour is usually a shade of brown, but some have a reddish or purple tint. Flesh is mostly thin and fragile. Taste and smell are not significant. Some exude clear or coloured juice when damaged, which is useful in identification.

BLISTERED CUP
Peziza vesiculosa

Members of the genus *Boletus* are imposing fungi, mostly in shades of brown. Boletes do not have gills; instead, the spore-bearing surfaces beneath the caps comprise, with one exception, sponge-like tissue consisting of long tubes ending in pores. Many change colour when the flesh and/or pores are cut or damaged; a finger pressed firmly against the pore surface will usually suffice. The spore print is generally a shade of olive-green or brown. The stipe is often very stout and swollen, and is sometimes covered by fine dots or a raised net that becomes sparser or less distinct towards the base. Members of the former genus *Xerocomus* have a more slender, less bulbous stipe. Boletes grow in grass or leaf litter among a wide range of tree species, and they appear from early summer to autumn. The family includes some excellent edible species, although a few are poisonous.

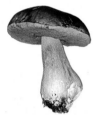

Cep or Penny Bun *Boletus edulis* (Top 100)

Variable bolete with several forms and associated similar species. One of the best edible mushrooms, much sought after for its culinary qualities. **CAP** To 25cm across; hemispherical, then flattened-convex; surface slightly greasy at first but then dull and wrinkled; various shades of pale or dark brown, with a whitish edge to margin and often covered in a pale bloom when young. **PORES** Small and rounded; white, maturing yellow to olive; little or no colour change to flesh or pores. **STIPE** To 15cm long; very stout and barrel- or club-shaped; white, streaked light brown with upper half covered in a white net that is absent or less distinct on lower part. **HABITAT** Deciduous and coniferous woodland. **STATUS** Widespread and common. **SIMILAR SPECIES** *B. aereus* is darker brown in colour, with a very matt cap, and is usually associated with oak.

Net on stipe

Pine Bolete *Boletus pinophilus* (= *B. pinicola*)

One of the *B. edulis* group, with a reddish-brown cap and strictly associated with conifers. **CAP** To 15cm across; hemispherical, then flattish convex; surface slightly greasy at first, but becoming dull and wrinkled with small bumps; dark reddish brown or chestnut. **PORES** Small and rounded; whitish, maturing yellowish or olive-brown; little or no discoloration to flesh or pores. **STIPE** To 10cm long; very stout and barrel- or club-shaped; paler and pinker than cap, and covered in a whitish net that becomes increasingly darker and sparser towards base. **HABITAT** Pines on acid soil. **STATUS** Common in Scotland, occasional elsewhere.

Summer Bolete *Boletus reticulatus* (= *B. aestivalis*)

One of the earliest boletes to fruit. Similar to Cep but with a less bulbous stipe and more extensive net. **CAP** To 20cm across; hemispherical, then convex or flatter; surface smooth and suede-like at first, but becoming increasingly cracked at centre; coffee-coloured to tobacco-brown. **PORES** Small and rounded; greyish white, maturing yellowish with an olive tint; little, if any, discoloration to flesh or pores. **STIPE** To 15cm long; spindle-shaped; pale brown, covered with a fine white net that extends down to base, discolouring brown with age. **HABITAT** Mixed deciduous woodland, usually with Beech or oak, or parkland with solitary trees. **STATUS** Widespread but occasional.

Oak Bolete *Boletus appendiculatus*

Bolete whose bright yellow pores and flesh bruise blue. **CAP** To 15cm across; hemispherical, then flattish convex, but often somewhat misshapen or grooved; surface slightly greasy, then finely felty and sometimes developing small cracks or fissures, particularly at centre; ochre, reddish brown or chestnut. **PORES** Small and rounded; lemon-yellow, becoming more olive. **STIPE** To 13cm long; stout and cylindrical but tapering upward, with a pointed, rooting base; yellow and increasingly ochre-brown towards base, and covered in a fine concolorous net. **HABITAT** Deciduous woodland, usually, but not exclusively, with oak. **STATUS** Occasional; mainly in S.

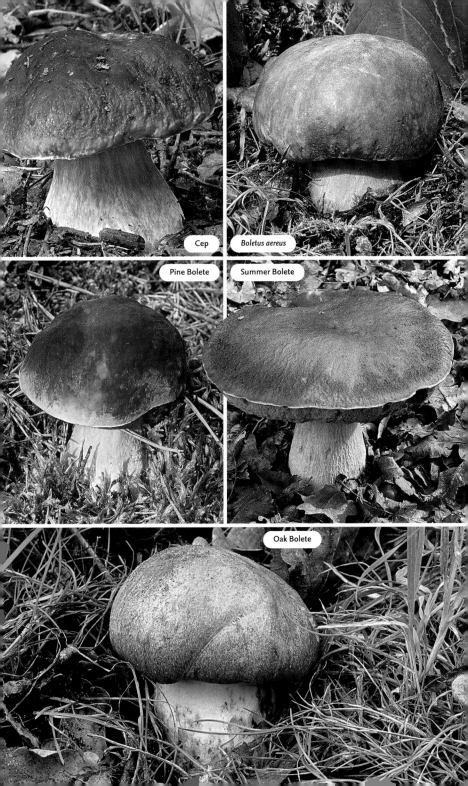

Cep

Boletus aereus

Pine Bolete

Summer Bolete

Oak Bolete

Rooting Bolete *Boletus radicans (= B. albidus)*

Bolete with a pale cap and yellow pores, sometimes
found on roadside verges. **CAP** To 26cm across;
hemispherical, then convex, somewhat uneven and
lumpy; surface crazed in centre with age; dingy white,
discolouring brownish. **PORES** Small and rounded;
yellow. Flesh and pores discolouring pale blue, very
bitter to taste. **STIPE** To 14cm long; stout and swollen

in lower half, with a tapered, rooting base; yellow, discolouring brownish, sometimes with
sparse red spots and covered in a yellowish net. **HABITAT** Usually with oak in open deciduous
woodland or in grass among solitary trees. **STATUS** Occasional; most frequent in S.

Bitter Beech Bolete *Boletus calopus*

Similar to Rooting Bolete but with a bright red stipe. **CAP** To 15cm across; hemispherical,
becoming convex or flatter; surface dull, velvety and sometimes cracking in centre; cream
to clay-coloured. **PORES** Medium and rounded; yellow, bruising blue. **STIPE** To 9cm long;
stout and swollen in lower half; yellow at apex with remainder carmine-red, and covered
in a whitish net that becomes stretched towards base. **HABITAT** Mixed deciduous woodland,
usually with Beech, on acid soil; also with conifers. **STATUS** Widespread but occasional.

Iodine Bolete *Boletus impolitus*

Pale bolete with a distinctive smell of iodine in the stipe base. **CAP** To 15cm across;
hemispherical, becoming flattish convex; surface finely felty, then smooth; greyish
beige with pinkish or brown tones. **PORES** Small and rounded; lemon-yellow, maturing
somewhat darker. Damage causes little or no discolouring of flesh or pores. **STIPE** To
10cm long, stout and cylindrical or spindle-shaped; surface granular, yellow covered in
concolorous dots, apex unmarked. **HABITAT** Associated with broadleaved trees, especially
oak, in parkland, open woodland, gardens and roadside verges. **STATUS** Occasional; more
frequent in S.

The Pretender *Boletus pseudoregius*

Similar to Oak Bolete (p. 30) but cap has pink tones. **CAP** To 20cm across; convex, becoming
flatter; dry and felty or finely scaly; warm pinkish brown. **PORES** Smallish and rounded;
bright yellow. Flesh and pores discolour blue. **STIPE** To 10cm long; stout and cylindrical
or slightly club-shaped; yellow flushed reddish on lower half, with upper part covered in
a yellow net. **HABITAT** Associated with oak in parkland or open woodland. **STATUS** Rare.

Inkstain Bolete *Boletus pulverulentus*

Drab bolete whose entire fruit body immediately discolours
dark blue to almost black on cutting or bruising. **CAP** To 10cm
across; hemispherical, then convex or flatter; surface felty at
first, then smoother, with cracked or fissured centre; colour
varies from dark reddish brown to yellowish brown. **PORES**
Small and rounded; yellow, becoming more olive. **STIPE** To 7cm
long; cylindrical and tapering downward; yellow at apex but
increasingly purple-brown towards base. **HABITAT** Open
deciduous woodland, parkland and gardens, occasionally
heathland; usually associated with oak. **STATUS** Occasional.

Devil's Bolete *Boletus satanas*

Poisonous bolete with a pale cap and contrasting red pores. Develops an unpleasant
putrid garlic smell on ageing. **CAP** To 25cm across; hemispherical, then flattish convex;
uneven, undulating and lumpy; surface suede-like, later smoother; dirty white or greyish
with a hint of olive or brown. **PORES** Small and rounded; yellow at first, soon maturing
blood-red but with margin more orange; bruises greenish but flesh discolours pale blue.
STIPE To 9cm long; very stout and bulbous; yellow at apex, becoming increasingly red below
and covered in a red net. **HABITAT** Mixed deciduous woodland or parkland, particularly
with Beech on calcareous soil. **STATUS** Occasional; more frequent in S.

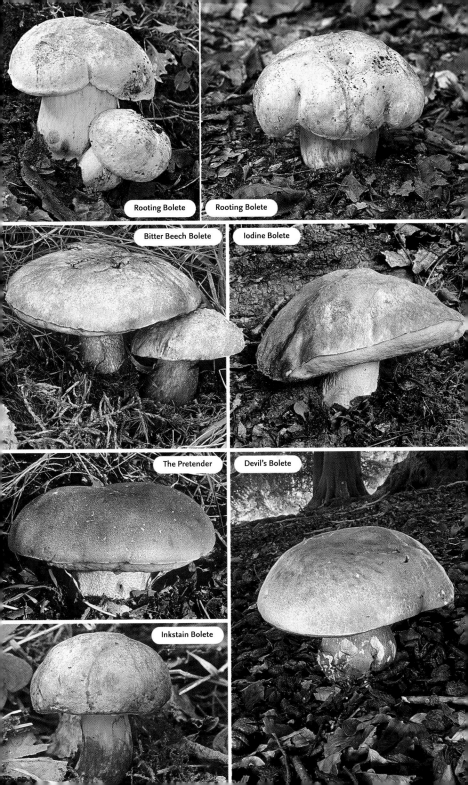

Rooting Bolete

Rooting Bolete

Bitter Beech Bolete

Iodine Bolete

The Pretender

Devil's Bolete

Inkstain Bolete

Scarletina Bolete *Boletus luridiformis (= B. erythropus)*

Red-pored bolete without a net on the stipe but densely covered in tiny red dots. **CAP** To 20cm across; hemispherical, then convex and finally flatter; surface slightly greasy, drying velvety then smooth; dark brown, sometimes with yellowish edge and becoming paler with age. **PORES** Small and rounded; orange to red, strongly bruising blue. **STIPE** To 15cm long; stout and cylindrical to slightly club-shaped; yellowish but appearing bright red from the dots. **HABITAT** Woodland or parkland; generally associated with deciduous trees (usually oaks), but occasionally pines. **STATUS** Widespread and common.

Lurid Bolete *Boletus luridus*

Similar to Scarletina Bolete but with a distinctive red net on the stipe. **CAP** To 15cm across; hemispherical, then convex or flatter; surface slightly greasy, then drying finely felty or smooth; variable in colour, from yellowish to dark brown with orange or apricot shades. **PORES** Small and rounded; red or orange, discolouring dark blue. **STIPE** To 15cm long; stout and bulbous, becoming more cylindrical with a tapered base; yellow or red with a red net. **HABITAT** Deciduous woodland on calcareous soil. **STATUS** Widespread but occasional.

Deceiving Bolete *Boletus queletii*

Orange-pored bolete with reddish-purple flesh in base of stipe. **CAP** To 15cm across; hemispherical, becoming convex or flatter; surface dull and felty, becoming smoother; reddish brown and often with yellowish or olive tones. **PORES** Small and rounded; peach or orange. Flesh and pores bluing slightly but red in stipe. **STIPE** To 10cm long; stout and slightly barrel-shaped; yellow in upper part but increasingly covered in purple or wine-red dots below. **HABITAT** Parkland or open deciduous woodland. **STATUS** Occasional; more frequent in S.

Boletus legaliae (= B. satanoides)

Mature specimens recall Devil's Bolete (p. 32) but have pink-purple tones in the pale cap. **CAP** To 14cm across; hemispherical, then convex or flatter; surface suede-like, then smooth; light beige or greyish brown with pinkish or purple overtones that become more intense with age. **PORES** Small and rounded; orange at first, then red. Flesh and pores discolouring pale blue. **STIPE** To 12cm long; stout and club-shaped; yellowish but increasingly wine-red towards base and covered in an orange net that is more distinct at apex. **HABITAT** Mixed deciduous woodland, usually with oaks. **STATUS** Uncommon; more frequent in S.

Oldrose Bolete *Boletus rhodopurpureus (= B. purpureus)*

Distinctive bolete with a variable wrinkled, misshapen cap and bright red pores. **CAP** To 20cm across; hemispherical, then convex or flatter; surface dull and finely suede-like, becoming smoother; pinkish or creamy white, soon turning deep purple-pink or wine-red mottled with yellow. **PORES** Fine and rounded; yellowish, becoming more orange or red. Flesh and pores strongly discolouring blue-black and beetroot in base of stipe. **STIPE** To 12cm long; cylindrical or slightly club-shaped; yellowish but increasingly purple-red towards base and covered in a red net. **HABITAT** Mixed deciduous woodland or parkland, usually with oaks. **STATUS** Uncommon and confined to S.

Bay Bolete *Boletus badius (= Xerocomus badius)* (Top 100)

This good edible species has a brown cap and stipe without any net or dots. **CAP** To 14cm across; hemispherical, then flattish convex; greasy and drying velvety or smooth; shades of dark brown. **PORES** Large and angular; pale cream, maturing greenish yellow. Flesh and pores readily discolour blue. **STIPE** To 10cm long; cylindrical, often with a tapered base; paler than cap and longitudinally streaked with brown fibrils. **HABITAT** Common with both conifers and Beech on acid soil. **STATUS** Widespread and common.

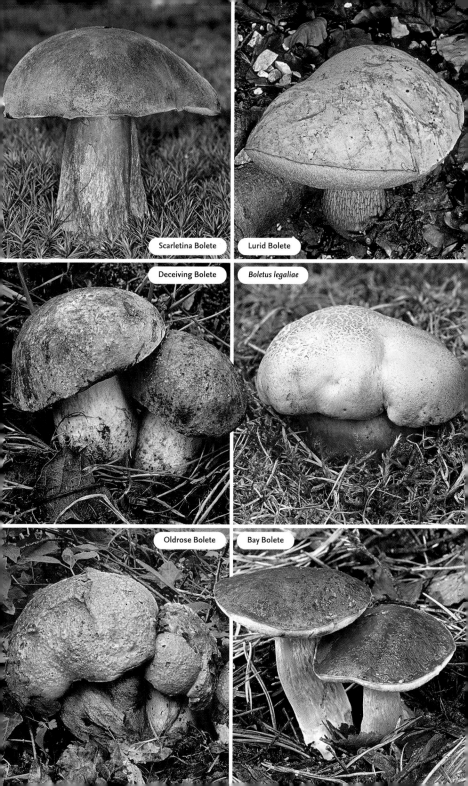

Scarletina Bolete

Lurid Bolete

Deceiving Bolete

Boletus legaliae

Oldrose Bolete

Bay Bolete

Ruby Bolete *Boletus rubellus (= Xerocomus versicolor)*
Small bolete of intense red colour that discolours deep blue. **CAP** To 5cm across; hemispherical, becoming convex or flatter; finely velvety, dry and sometimes cracking; blood-red, fading to reddish brown. **PORES** Large and angular; yellow with an olive tint. **STIPE** To 10cm long; slender, cylindrical or slightly club-shaped; yellow at apex and increasingly red and longitudinally fibrillose downward. **HABITAT** Open deciduous woodland, usually in grass with oaks or in parkland where trees are present. **STATUS** Occasional to common in S.

Suede Bolete *Boletus subtomentosus (= B. lanatus)*
The distinctive feature of this variable bolete is the velvety or suede-like texture of the cap. **CAP** To 10cm across; hemispherical, then convex or flatter; surface dry and suede-like, sometimes cracking when old; shades of pale brown or even bright yellow with olive or reddish overtones. **PORES** Large and angular; bright yellow later, with an olive flush. Little discoloration to flesh or pores. **STIPE** To 8cm long; slender and cylindrical, but sometimes thickened towards base; yellow to yellow-brown with reddish-brown longitudinal veins. **HABITAT** Open deciduous woodland. **STATUS** Widespread and common.

Sepia Bolete *Boletus porosporus*
Bolete whose cap surface develops wide cracks to reveal the cream flesh beneath. **CAP** To 8cm across; convex or flatter; beige, olive-brown or sepia, with surface extensively cracking like crazy paving. **PORES** Large, compound and angular; lemon-yellow, darkening with age. Flesh and pores discolour blue. **STIPE** To 6cm long; slender and cylindrical; yellow, becoming increasingly olive-brown below and with a faint red zone at apex. **HABITAT** Mixed deciduous and coniferous woodland, parkland and gardens. **STATUS** Widespread but occasional to rare.

Boletus cisalpinus
Brown bolete whose cap cracks in a similar way to Sepia Bolete but reveals red, not cream, flesh beneath. Until recently was confused with *Boletus chrysenteron*. **CAP** To 12cm across; hemispherical, then convex or flatter; surface velvety at first, then smooth and finally cracking; variable shades of brown with reddish or olive tones. **PORES** Large and angular; yellow, maturing more olive, and bruising blue or green. **STIPE** To 8cm long; slender and cylindrical, and sometimes bent; two-toned, yellow above and brighter reddish below. **HABITAT** Mixed deciduous and coniferous woodland and parkland. **STATUS** Widespread and common.

Matt Bolete *Boletus pruinatus*
Similar to a young *B. cisalpinus* but shows no cracking to cap; mycelium is apricot. **CAP** To 10cm across; convex, then flatter; surface wrinkled and with texture of suede, and young specimens covered in distinctive hoary bloom; dark red-brown or chestnut, lightening with age. **PORES** Small and angular; yellow, bruising blue or green. **STIPE** To 10cm long; slender and cylindrical; yellow with fine red dots, flesh golden yellow when young. **HABITAT** Deciduous woodland. **STATUS** Widespread and common.

Parasitic Bolete *Pseudoboletus parasiticus (= Xerocomus parasiticus)*
Unmistakable bolete growing out of old fruit bodies of Common Earthball (p. 278). **CAP** To 4cm across; hemispherical, then convex or flatter; surface dry, matt or satiny, and sometimes finely cracking in centre; olive-yellow to olive-brown. **PORES** Rounded and slightly decurrent; yellow, maturing ochre or rust-brown. Damage causes no significant colour change to flesh or pores. **STIPE** To 4cm long; cylindrical and usually curved or bent to follow contours of host; concolorous with cap, and with areas of longitudinal reddish fibrils. **HABITAT** Found with host in deciduous woodland and heathland on acid soil. **STATUS** Widespread but occasional, predominantly in S.

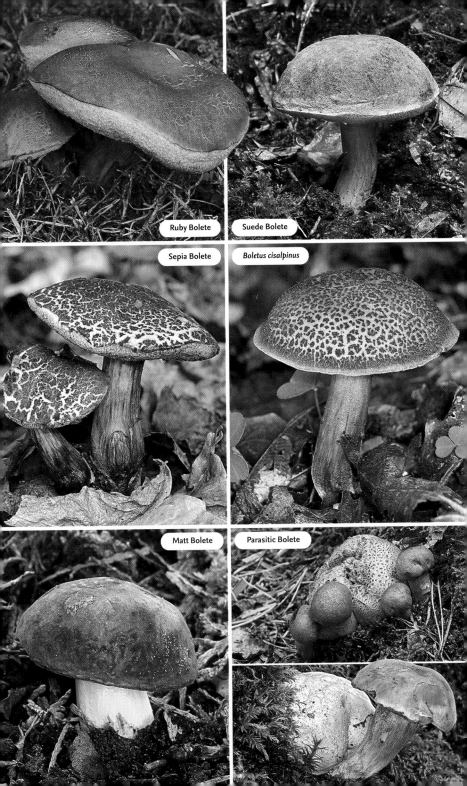

Ruby Bolete

Suede Bolete

Sepia Bolete

Boletus cisalpinus

Matt Bolete

Parasitic Bolete

Wood Bolete *Buchwaldoboletus lignicola (= Pulveroboletus lignicola)*

Rather ugly, misshapen bolete, usually found growing at the base of rotting conifers. **CAP** To 10cm across; convex with an incurved margin; surface dull and felty or finely scaly; shades of yellow-orange, discolouring brown in a patchy manner. **PORES** Small, irregular, rather distorted and slightly decurrent; rust-yellow, bruising reddish brown. **STIPE** To 10cm long; cylindrical, sometimes off-centre and tapering towards base; surface felty or scaly; rust-yellow or reddish brown. **HABITAT** Usually on conifer stumps. **STATUS** Widespread but uncommon. **SIMILAR SPECIES Golden Bolete** *Buchwaldoboletus sphaerocephalus* (p. 342).

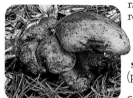

Golden Bolete

Peppery Bolete *Chalciporus piperatus (= Buchwaldoboletus piperatus)*

Smallish bolete with a hot, peppery taste, often found in close proximity to Fly Agaric (p. 90). **CAP** To 7cm across; hemispherical, then flattish convex; slightly greasy when wet, drying smooth and shiny; reddish brown with coppery tones. **PORES** Large and angular; cinnamon-brown with no discoloration of either pores or flesh. **STIPE** To 7cm long; slender, cylindrical and tapering downward; concolorous with cap, and with a distinct yellow base. **HABITAT** Deciduous woodland, especially with birches but also other broadleaved trees and, occasionally, pines. **STATUS** Widespread and common.

Dusky Bolete *Porphyrellus porphyrosporus (= P. pseudoscaber)*

Remarkable bolete with a very dark brown cap and stipe. **CAP** To 15cm across; hemispherical, then flattish convex; surface velvety, becoming smooth; found in variable shades of grey or dark brown with olive tones. **PORES** Large, irregular and angular; greyish brown with a paler or pinkish margin. **STIPE** To 12cm long; cylindrical or slightly bulbous and with a tapered base; velvety; concolorous with cap, and with darker fibrils. **HABITAT** Deciduous woodland; more rarely with conifers. **STATUS** Widespread but occasional, predominantly in N or W.

Bitter Bolete *Tylopilus felleus*

Distinctive bolete with a very bitter taste. Has pinkish pores and a similar-coloured or reddish spore print. **CAP** To 12cm across; hemispherical, then convex or flatter; slightly greasy when moist but drying felty and dull with a rough texture; light ochre-brown to dark grey-brown, sometimes with olive tones. **PORES** Large and angular; creamy white, maturing flesh-pink and bruising brownish. **STIPE** To 10cm long; stout and cylindrical to slightly club-shaped; creamy ochre or yellowish, mostly covered with a coarse brown net. **HABITAT** Deciduous woodland, occasionally with conifers. **STATUS** Widespread but occasional.

Old Man Of The Woods *Strobilomyces strobilaceus (= S. floccopus)*

Dramatic medium to large bolete whose cap and stipe are covered in large blackish scales, creating a very shaggy appearance. **CAP** To 15cm across; hemispherical, becoming flatter; surface densely covered in large, dark grey or brown scales with the whitish flesh beneath showing through; margin ragged from overhanging scales. **PORES** Large, angular and slightly decurrent; whitish, then grey-brown and bruising red, and finally becoming black; black spore print. **STIPE** To 12cm long; cylindrical; covered in scales, concolorous with cap up to ring, paler above. **HABITAT** Deciduous woodland, usually with Beech; more rarely with conifers. **STATUS** Widespread but rare to occasional.

Chestnut Bolete *Gyroporus castaneus*

Warm brown bolete with a yellow spore print. **CAP** To 10cm across; convex or flatter; surface smooth or finely downy; yellow-brown or cinnamon. **PORES** Small, unequal and rounded; white, maturing greenish yellow. **STIPE** To 8cm long; cylindrical or slightly club-shaped; colour and texture similar to cap but brittle and hollow with age. **HABITAT** Deciduous woodland, most commonly with oak. **STATUS** Widespread but occasional, mainly in S.

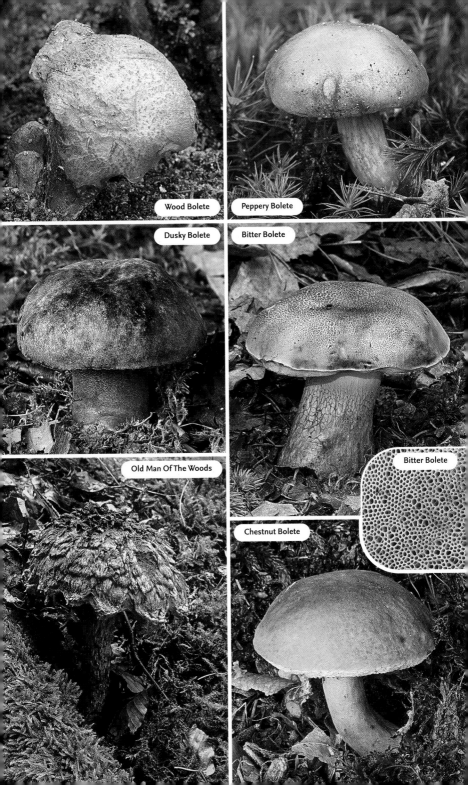

Wood Bolete

Peppery Bolete

Dusky Bolete

Bitter Bolete

Old Man Of The Woods

Bitter Bolete

Chestnut Bolete

The genus *Leccinum* includes many highly variable species that have been the subject of numerous taxonomic changes over the years. They are generally tall and elegant, with a smallish cap relative to the length of the stipe. The most distinctive feature is the stipe, which is densely covered in woolly scales; the colour of these scales in young fruit bodies, together with the habitat and flesh discoloration on cutting, are the field characteristics to look for. To separate some similar species with certainty it is necessary to examine the structure of the cap cuticle microscopically.

Orange Birch Bolete *Leccinum versipelle*

Frequently large, bright orange-capped *Leccinum*, strictly associated with birches. **CAP** To 20cm across; hemispherical, then convex or flatter; slightly greasy when moist, drying downy or smooth; orange or yellowish orange. **PORES** Small and rounded; dark grey, almost black at first, maturing ochre or buff. **STIPE** To 20cm long; cylindrical or slightly bulbous; whitish ground colour densely covered in dark grey to black scales. Flesh lavender, discolouring greyish brown to black when cut. **HABITAT** Heaths and birch woodland on acid soils. **STATUS** Widespread but occasional.

Orange Oak Bolete *Leccinum aurantiacum (= L. quercinum)*

Recalls Orange Birch Bolete but has a redder cap and stipe and different habitat. **CAP** To 15cm across; hemispherical to convex, becoming flatter; surface smooth or slightly felty or scaly; fox-red or reddish brown. **PORES** Small and rounded, whitish, becoming rufous and bruising brownish. **STIPE** To 18cm long; cylindrical or slightly swollen towards base; densely covered in reddish-brown scales on a whitish ground. Flesh discolours grey to pink. **HABITAT** Open deciduous woodland or parkland, particularly, but not exclusively, with oaks. **STATUS** Occasional. **SIMILAR SPECIES *L. albostipitatum*** (often erroneously called *L. aurantiacum*) is distinguished by the white stipe (whitish scales on a white ground), and by its association with poplars and Aspen.

Foxy Bolete *Leccinum vulpinum*

This rare *Leccinum* is similar to Orange Oak Bolete and *L. albostipitatum* but is associated with pines. **CAP** To 15cm across; hemispherical, becoming convex or flatter; surface felty; fox-red or reddish brown. **PORES** Small; dark cream. **STIPE** To 20cm long; cylindrical; white ground covered in dark reddish-brown scales. Flesh discolours smoky grey to purple before becoming blackish. **HABITAT** Confined to Scottish pinewoods. **STATUS** Rare.

Saffron Bolete *Leccinum crocipodium*

Distinctive *Leccinum* with a cracking yellow cap and yellow flesh that usually discolours pale reddish brown and then black. Not to be confused with Sepia Bolete (p. 36). **CAP** To

10cm across; saffron-yellow to yellowish brown, with a smooth or felty surface breaking up into a crazy paving-like pattern. **PORES** Very small and rounded; yellow, bruising brown. **STIPE** To 10cm long; often stout, cylindrical or tapering upwards; pale yellowish ground colour with woolly flecks concolorous with cap, often in irregular longitudinal lines. **HABITAT** Strictly associated with oaks. **STATUS** Widespread but occasional, mostly in S.

Cap surface

Ghost Bolete *Leccinum holopus*

Relatively small *Leccinum* with a distinctive uniformly pale, ghostly appearance. **CAP** To 7cm across; hemispherical, then convex or flatter; surface is slightly greasy when moist, drying dull and felty; whitish, becoming dingy and somewhat greenish with age. **PORES** Small and whitish. **STIPE** To 11cm long; cylindrical or tapering upwards; white, covered in dingy white scales that become more brownish with age. Base may exhibit a faint blue colour when cut. **HABITAT** Deciduous woodland or moorland, usually associated with birches and often found in wet areas, sometimes among *Sphagnum* moss. **STATUS** Occasional.

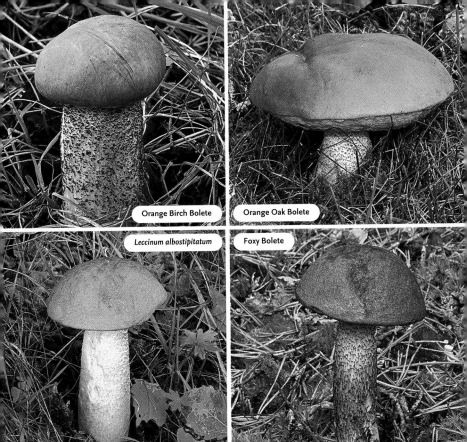

Orange Birch Bolete

Orange Oak Bolete

Leccinum albostipitatum

Foxy Bolete

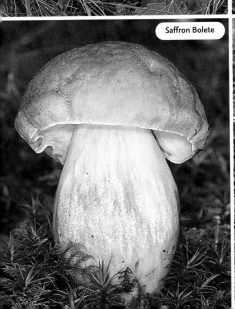

Saffron Bolete

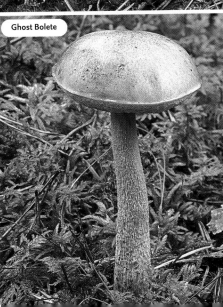

Ghost Bolete

Brown Birch Bolete *Leccinum scabrum* (Top 100)

Many brown-capped *Leccinum* are commonly found with birch, and until recently they comprised several different species separated by their colour, texture and flesh discoloration. However, recent examination of the genus has concluded that there is little justification for these divisions and most have now been absorbed into *L. scabrum*. Accordingly, this is now an extremely variable bolete. The former species assimilated into *L. scabrum* include *L. roseofractum*, *L. rigidipes* and *L. molle*. **CAP** To 15cm across; hemispherical, becoming convex or flatter; surface sticky when moist, drying smooth or slightly felty or scurfy; various shades of brown from light to dark, rarely all white. Flesh firm at first but maturing soft; previously, the flesh of *L. scabrum* was considered to show little or no discoloration when cut, but the amalgamation of previous separate species means that flesh discoloration now ranges from unchanging to pinkish red; there is, however, an absence of bluish discoloration at base of stipe. **PORES** Small; whitish, becoming dingy and bruising brown. **STIPE** To 10cm long; cylindrical or thickening towards base; whitish ground densely covered in coarse dark scales, particularly concentrated in lower half. **HABITAT** Strictly associated with birches. **STATUS** Widespread and very common. **SIMILAR SPECIES** *L. melaneum* (considered by some to merely be a form of *L. scabrum*) has very dark, almost black, colours.

Leccinum cyaneobasileucum (= *L. brunneogriseolum*)

Similar to, and previously confused with, Brown Birch Bolete, but the uniformly pale colour and blue stain at the base of the stipe are distinctive. **CAP** To 15cm across; convex or flatter, with a dry and felty surface; pale brown but an all-whitish form exists (not to be confused with Ghost Bolete, p. 40) **PORES** Small and whitish, becoming pale brown but bruising darker. **STIPE** To 10cm long; cylindrical; pale mouse-grey or brown, covered in concolorous woolly scales. Flesh discolours pale pink, but blue at base of stipe. **HABITAT** Strictly associated with birches. **STATUS** Common, particularly in S.

Hazel Bolete *Leccinum pseudoscabrum* (= *L. carpini*)

Leccinum with a distinctive wrinkled cap and flesh discolouring violet-black when cut. Appears as early as midsummer. **CAP** To 9cm across; convex, becoming flatter; surface wrinkled, lumpy and finally cracking; shades of light mid-brown, often with a hint of yellow or olive. **PORES** Small; whitish, then greyish yellow and bruising black. **STIPE** To 9cm long; cylindrical or slightly bulbous; brown or blackish-grey scales on a paler ground. **HABITAT** Deciduous woodland, always with Hazel or Hornbeam. **STATUS** Occasional; most frequent in SE.

Slate Bolete *Leccinum duriusculum*

Similar to *L. pseudoscabrum* but habitat and cap texture different. **CAP** To 15cm across; surface dull, dry and finely felty, cracking with age; shades of brown, often with greyish tones. **PORES** Very small; white or cream, bruising pale brown. **STIPE** To 16cm long; stout, cylindrical to slightly bulbous; whitish covered with dark brown scales, paler in upper part. Flesh discolours pink at first, then dark grey or blue at stipe base. **HABITAT** Found with poplars and Aspen. **STATUS** Occasional; mainly in S.

Mottled Bolete *Leccinum variicolor*

Leccinum with a distinctive mottled cap. **CAP** To 10cm across; hemispherical, then convex or flatter; surface felty or downy at first, becoming smooth; greyish or shades of brown with paler patches or streaks. **PORES** Small; white or pale cream, bruising ochre-pink. **STIPE** To 18cm long; cylindrical or swollen towards base; white ground covered in scales that are concolorous with cap. Flesh discolours pink, but blue or green at base. **HABITAT** Damp areas of deciduous woodland or heathland with birches. **STATUS** Widespread and common.

Cut section showing flesh discoloration

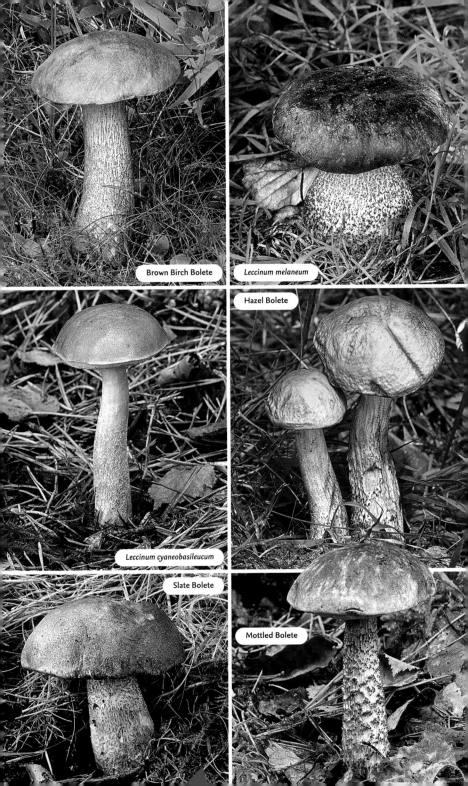

Brown Birch Bolete

Leccinum melaneum

Hazel Bolete

Leccinum cyaneobasileucum

Slate Bolete

Mottled Bolete

Species belonging to the genus *Suillus* all have mycorrhizal associations with conifers. Most have a slimy cap and stipe, and some have a ring. There is little significant colour change to the flesh on cutting.

Slippery Jack *Suillus luteus*
Very slimy bolete with a large, floppy ring. **CAP** To 10cm across; hemispherical, then convex or flatter; surface slimy but becoming shiny and wrinkled on drying; chestnut or sepia, often with a hint of purple, maturing paler. **PORES** Medium and rounded; yellow, becoming more olive or brownish with age. **STIPE** To 10cm long; cylindrical or slightly thickened towards base; yellow with small brownish dots above a large, floppy brownish ring, whitish below, streaked with brown slimy fibrils. **HABITAT** Pines. **STATUS** Widespread and common.

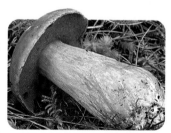

Weeping Bolete *Suillus granulatus*
Unusual bolete that exudes milky droplets of moisture from pores and apex of stipe. **CAP** To 9cm across; convex or flatter; sticky when moist and drying shiny; shades of yellowish brown or fawn. **PORES** Small; cream or yellow, becoming more olive with age. **STIPE** To 8cm long; stout and cylindrical; cream or pale yellow with small brownish dots or glands developing at apex, flushed vinaceous towards base. **HABITAT** Acid heathland; less frequently in woodland with pines. **STATUS** Widespread and common. **SIMILAR SPECIES** *S. collinitus* is distinguished by having glandular dots not only restricted to stipe apex, and by pink, not white, mycelium.

Suillus collinitus

Bovine Bolete *Suillus bovinus*
Bolete with pink mycelium and no ring; often found clustered or in groups. **CAP** To 10cm across; convex, becoming flatter and somewhat undulating; sticky but drying smooth and shiny; shades of orange or rust-brown, often with a pronounced paler or white margin. **PORES** Large, angular and irregular; orange-brown, becoming more olive. **STIPE** To 6cm long; cylindrical and sometimes bent; concolorous with cap but somewhat streaked. **HABITAT** With conifers (usually pine) on acid soil. **STATUS** Widespread and common.

Larch Bolete *Suillus grevillei*
Easily recognised golden bolete found under larches. **CAP** To 10cm across; convex, becoming flatter; very slimy when moist, shiny when dry; shades of bright yellow or orange. **PORES** Small and angular; lemon-yellow, darkening to rust-brown and bruising darker. **STIPE** To 11cm long; yellow with whitish or yellow ascending ring; plain or finely spotted above, flushed and streaked rust below. **HABITAT** Associated with larches. **STATUS** Widespread and common.

Velvet Bolete *Suillus variegatus*
Bolete with a velvety or scaly cap and cinnamon pores. **CAP** To 13cm across; convex, becoming flatter; generally dry, and greasy only in damp conditions; surface velvety, breaking up into flattened, darker scales; shades of brown, often with an olive or yellow tint. **PORES** Small and unequal; dark ochre, maturing olive-brown or cinnamon and bruising blue. **STIPE** To 9cm long; cylindrical or slightly club-shaped; colour similar to cap but more yellow towards apex and flushed reddish brown below. **HABITAT** Open acidic woodland or heathland with pine, sometimes on decayed conifer wood. **STATUS** Occasional in N and W.

Sticky Bolete *Suillus viscidus* (= *S. aeruginascens*)
Grubby-looking, slimy bolete with olive tones. **CAP** To 10cm across; hemispherical, then convex or flatter; variable in colour from greyish white to hazel-brown, patchily streaked with thick brownish gluten; dries satiny and shiny. **PORES** Large, angular and unequal; off-white, maturing fawn and bruising darker. **STIPE** To 9cm long; cylindrical, sometimes thickening towards base; whitish, often streaked with brown below ring zone; short-lived whitish ring covered in gluten. **HABITAT** With larches on sandy or calcareous soil. **STATUS** Widespread but occasional.

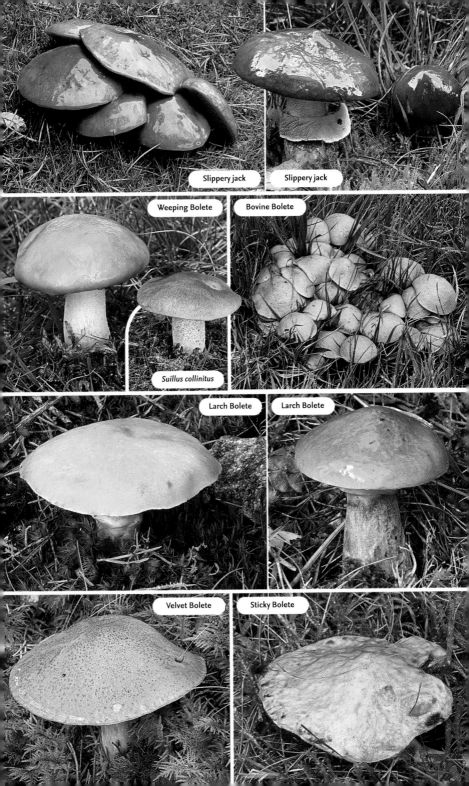

Slippery jack

Slippery jack

Weeping Bolete

Bovine Bolete

Suillus collinitus

Larch Bolete

Larch Bolete

Velvet Bolete

Sticky Bolete

The most distinctive feature of members of the genus *Lactarius* is droplets of latex exuded from their cap and gills when these are damaged. The properties of this milk are a valuable aid to identification, as it varies from species to species and may be abundant or sparse. The milk comes in a variety of colours, some of which change on drying and/or on exposure to air or the flesh. The taste may be mild, bitter or acrid, the effect of which can be delayed. Some species have a distinctive smell. The cap margin is usually inrolled at first, and by maturity many have become funnel-shaped. Spore prints are generally white or in shades of ochre or cream. The stipe is frequently covered in a short-lived white bloom. Most milkcaps are found in late summer or autumn, and are mycorrhizal with all types of trees.

Fleecy Milkcap *Lactarius vellereus*

Large white milkcap with a velvety cap and relatively short, stout stipe, giving it a squat appearance. **CAP** To 30cm across; convex with a depressed centre, becoming funnel-shaped with age; white or cream, discolouring ochre in places; surface is finely velvety. **GILLS** Slightly decurrent; white or ochreous cream. **MILK** Abundant; white; mild or slightly bitter. **STIPE** To 7cm long; cylindrical and tapering downward; colour and surface texture are consistent with cap. **HABITAT** Mixed deciduous woodland. **STATUS** Widespread but occasional.

Peppery Milkcap *Lactarius piperatus*

Similar to Fleecy Milkcap but with a smooth cap, acrid milk, very crowded gills and a taller appearance. **CAP** To 16cm across; convex with a depressed centre, becoming more pronounced with age; smooth, dry and somewhat wrinkled, particularly towards margin; dull white or cream, discolouring ochre in parts. **GILLS** Adnate or decurrent; cream with flesh-coloured tints. **MILK** Not abundant; white; slowly acrid. **STIPE** To 10cm long; cylindrical, tapering downward; colour and surface texture consistent with cap. **HABITAT** Mixed deciduous woodland, particularly with Beech and oaks. **STATUS** Widespread but occasional.

Lactarius controversus

Large whitish milkcap with pink gills, resembling a young *Agaricus*. **CAP** To 30cm across; convex with a depressed centre and undulating margin; greasy; ivory to pale buff, extensively discolouring vinaceous buff and sometimes faintly zoned. **GILLS** Adnate or slightly decurrent; crowded; buff. **MILK** Sparse; white; becoming acrid. **STIPE** To 5cm long; cylindrical, stout and tapering downward; concolorous with cap and with a smooth texture. **HABITAT** In small groups in deciduous woodland; associated with willows. **STATUS** Widespread but occasional.

Pine Milkcap *Lactarius musteus*

Medium-sized cream-coloured milkcap found under pines. **CAP** To 9.5cm across; convex with a depressed centre and undulating margin; ivory or pale cream, spotted ochre and sometimes indistinctly zonate; greasy. **GILLS** Broadly adnate or decurrent; crowded; paler than cap. **MILK** Sparse; white; mild at first but becoming acrid. **STIPE** To 8cm long; cylindrical and usually curved; greasy; concolorous with gills and occasionally with darker spots (pits). **HABITAT** Coniferous woodland. **STATUS** Very uncommon; found only in Caledonian pinewoods.

Pale Milkcap *Lactarius pallidus*

Similar to Pine Milkcap but much more common and found in a different habitat. **CAP** To 10cm across; flattened-convex with a depressed centre; surface sticky; pale buff or ochre, but darker where bruised and sometimes faintly zonate. **GILLS** Adnate or decurrent; concolorous with cap. **MILK** White or pale cream; mild to slightly acrid. **STIPE** To 8.5cm long; cylindrical, smooth and sticky; colour similar to cap. **HABITAT** Usually in small groups in deciduous woodland; commonly associated with Beech. **STATUS** Widespread but occasional.

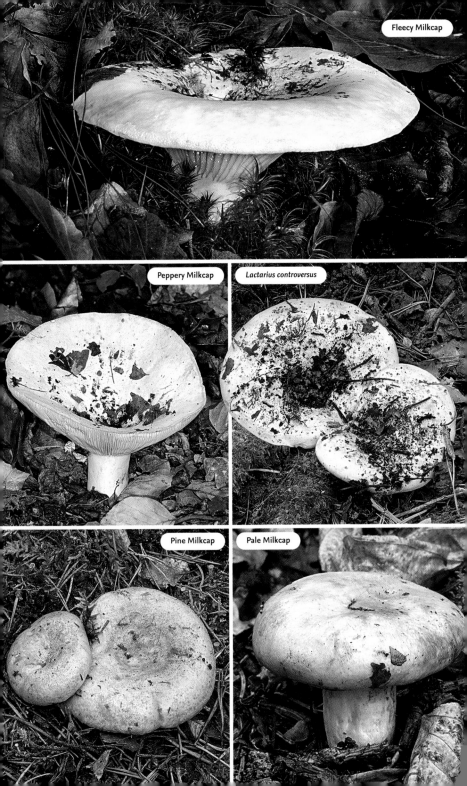

Fleecy Milkcap

Peppery Milkcap

Lactarius controversus

Pine Milkcap

Pale Milkcap

Woolly Milkcap *Lactarius torminosus*

Milkcap whose cap surface is covered in long, tangled hairs, these overhanging the margin to create a bearded appearance. **CAP** To 12cm across; broadly convex with a depressed centre that becomes more pronounced with age; shades of salmon-pink with indistinct concentric bands of a deeper colour. **GILLS** Adnate or decurrent; crowded; cream with a salmon flush. **MILK** Sparse; white; immediately very hot and acrid. **STIPE** To 7cm long; cylindrical; paler than cap and occasionally with darker spots. **HABITAT** Birch woodland. **STATUS** Widespread and common.

Bearded Milkcap *Lactarius pubescens*

Similar to Woolly Milkcap but smaller, less hairy and paler in colour, and with a non-zonate cap. **CAP** To 10cm across; convex, becoming more expanded and with a depressed centre; smoothish but slightly hairy towards margin; creamy white with a salmon flush and darker patches. **GILLS** Adnate or decurrent; crowded; concolorous with cap. **MILK** Not abundant; white; immediately very acrid. **STIPE** To 6.5cm long; cylindrical with a slightly tapered base; smooth, dry and concolorous with cap. **HABITAT** Birch woodland. **STATUS** Widespread and common.

Lilacscale Milkcap *Lactarius spinosulus*

Small vinaceous-coloured milkcap. **CAP** To 6cm across; convex, becoming flatter and with a depressed centre; smooth at centre but becoming increasingly scaly towards slightly hairy margin; vinaceous pink with distinct darker zones or bands. **GILLS** Decurrent; crowded; cream with a pink flush. **MILK** Sparse; watery white; mild but slowly becoming acrid. **STIPE** To 5cm long; cylindrical and sometimes compressed; smooth and occasionally faintly pitted; concolorous with cap or paler. **HABITAT** Deciduous woodland, usually birch. **STATUS** Rare.

Lemon Milkcap *Lactarius citriolens*

Striking milkcap with a matted, bearded margin to cap and thick, hard flesh that rapidly discolours yellow when cut. **CAP** To 20cm across; convex with a depressed centre, becoming increasingly funnel-shaped; smooth centre with a scattering of ochre fibrils on the remainder; cream or yellow with apricot or buff blotches. **GILLS** Adnate or decurrent; fairly crowded; concolorous with cap or slightly paler. **MILK** Not plentiful; white but soon turning yellow; bitter and acrid. **STIPE** To 8cm long; cylindrical, fibrillose with a hairy base; cream; not pitted. **HABITAT** Deciduous woodland, particularly with birches. **STATUS** Distinctly uncommon.

Yellow Bearded Milkcap *Lactarius repraesentaneus*

Large ochre or yellow milkcap with a very shaggy cap and flesh that turns violet when cut. **CAP** To 16cm across; convex but flattening with a slightly depressed centre; becoming increasingly scaly and hairy towards persistent inrolled margin; outer half zonate. **GILLS** Adnate or decurrent; crowded; cream, turning lilac where bruised. **MILK** White, sometimes discolouring lilac on drying; mild then bitter. **STIPE** To 12.5cm long; cylindrical to slightly club-shaped; concolorous with cap or paler, and usually with darker pits. **HABITAT** Woodland with pines and birches on acid soil. **STATUS** Rare; virtually confined to Scotland. **SIMILAR SPECIES** *Lactarius mairei* is equally rare but is smaller and lacks the flesh discoloration; it is found in deciduous woodland, usually with oaks; mainly in S.

Yellowdrop Milkcap *Lactarius chrysorrheus*

Distinctive milkcap with a dry, zonate pinkish cap and bright yellow milk. **CAP** To 9cm across; convex to flat with a depressed centre; buff or pinkish salmon with darker bands or spots; margin paler and becoming irregular and wavy. **GILLS** Adnate or slightly decurrent; cream with a pink flush. **MILK** Abundant; white, rapidly turning yellow; mild then slightly hot. **STIPE** To 7cm long; cylindrical, sometimes with a wider base; cream or buff, becoming darker. **HABITAT** Deciduous woodland, usually with oaks. **STATUS** Widespread and common.

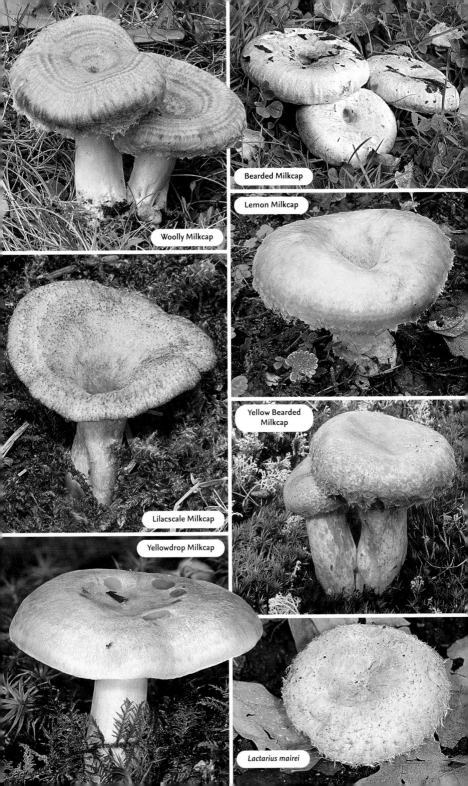

Woolly Milkcap

Bearded Milkcap

Lemon Milkcap

Lilacscale Milkcap

Yellow Bearded Milkcap

Yellowdrop Milkcap

Lactarius mairei

Saffron Milkcap *Lactarius deliciosus*
Medium-sized, chunky, bright orange milkcap with a pitted stipe. **CAP** To 15cm across; flat-convex with a depressed centre; orange or carrot-coloured with darker spots, blotches and concentric bands; discolours grey or green. **GILLS** Decurrent; crowded; colour similar to cap. **MILK** Sparse; carrot-coloured; mild taste. **STIPE** To 6cm long; cylindrical and stout; concolorous with gills, and with darker pits. Flesh pale yellow, discolouring orange (up to 1 hour). **HABITAT** Strictly associated with pines on acid soil. **STATUS** Widespread and frequent.

False Saffron Milkcap *Lactarius deterrimus*
Spruce (*Picea*) counterpart of Saffron Milkcap, with which it is often confused. Has more subdued colours with greenish tones, and salmon or orange flesh that discolours vinaceous red in around 30 minutes. Also less zonate and stipe generally lacks pits. **CAP** To 11cm across; flat-convex with a depressed centre, sometimes becoming funnel-shaped with age; shades of dull orange, sometimes suffused with green and fading greyish or green. **GILLS** Adnate or slightly decurrent; crowded; concolorous with cap. **MILK** Reddish orange; bitter taste. **STIPE** To 6cm long; cylindrical; concolorous with cap, and with a white collar at top. **HABITAT** Spruce woods, particularly plantations. **STATUS** Widespread and frequent.

Lactarius salmonicolor
Bright, medium-sized milkcap whose cap, gills and stipe are generally uniform in colour. Similar to Saffron Milkcap but found in a different habitat. Flesh and milk discolours vinaceous red. **CAP** To 12cm across; flat-convex with a depressed centre, sometimes becoming funnel-shaped; occasionally faintly zonate; salmon or dull orange. **GILLS** Adnate or slightly decurrent; fairly crowded. **MILK** Sparse; reddish orange but discolouring vinaceous. **STIPE** To 7cm long; cylindrical; rarely pitted. **HABITAT** Associated with fir (*Abies*) trees. **STATUS** Uncommon to rare.

Lactarius quieticolor
Medium-sized milkcap with variable colours and a slightly frosted appearance. **CAP** To 11cm across; somewhat irregular, flat-convex with a depressed centre; mixtures of grey or buff or orange, sometimes with shades of blue or grey, and with darker zones and pits. **GILLS** Adnate or decurrent; crowded; usually brighter than cap and staining green. **MILK** Sparse; orange, turning vinaceous red; mild or slightly bitter taste. **STIPE** To 6cm long; cylindrical; similar in colour to cap; few, if any, pits. **HABITAT** Coniferous woodland on acid soil, usually with pines. **STATUS** Uncommon.

Lilac Milkcap *Lactarius lilacinus*
Similar to Lilacscale Milkcap (p. 48), but with a less zonate cap and associated with Alders. **CAP** To 5cm across; convex with an inrolled margin, but becoming flatter with a depressed centre; surface dry and felty; pinkish lilac. **GILLS** Adnate or slightly decurrent; pinkish buff or ochre. **MILK** Sparse; white and somewhat watery, with a bitter and slightly hot taste. **STIPE** To 6cm long; cylindrical; pale pinkish buff. **HABITAT** Wet areas, including ditches; always associated with Alders. **STATUS** Widespread but rare.

Lactarius evosmus
Medium-sized to large milkcap with a faintly and indistinctly zonate cap and a stipe that lacks pits. **CAP** To 15cm across; flat-convex, gradually becoming funnel-shaped; dull cream or honey-coloured with faint concentric bands. **GILLS** Decurrent; crowded; chrome-white or pale cream, discolouring ochre. **MILK** Plentiful; watery white; acrid or hot. **STIPE** To 5cm long; cylindrical and somewhat compressed; dry; concolorous with gills. **HABITAT** Deciduous woodland and scrub. **STATUS** Rare.

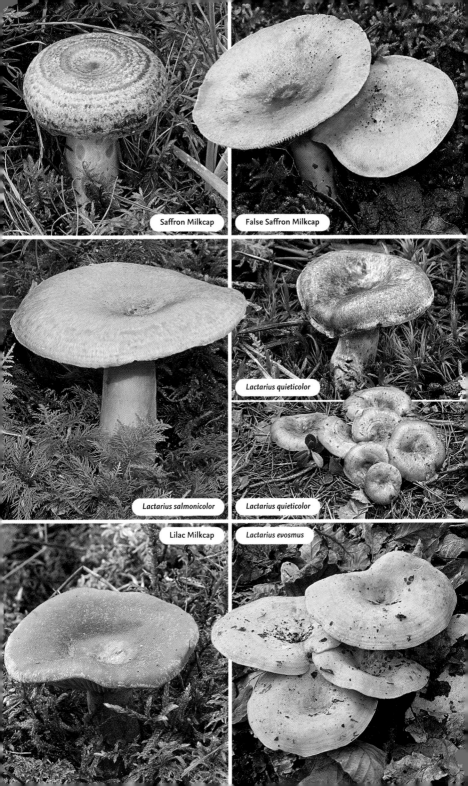

Saffron Milkcap

False Saffron Milkcap

Lactarius salmonicolor

Lactarius quieticolor

Lactarius quieticolor

Lilac Milkcap

Lactarius evosmus

Beech Milkcap *Lactarius blennius* (Top 100)
Slimy milkcap in variable colours. **CAP** To 9.5cm across; convex, then expanded with a depressed centre; drab brownish or grey with olivaceous tones, sometimes heavily spotted. **GILLS** Adnate or decurrent; crowded; white, darkening to cream. **MILK** Plentiful; white, drying grey; hot taste. **STIPE** To 7cm long; cylindrical or tapering downward; paler than cap. **HABITAT** Deciduous woodland, usually with Beech. **STATUS** Widespread and very common.

Lactarius fluens
Very similar to Beech Milkcap but less viscid and with a pale edge to cap and darker gills. **CAP** To 15cm across; shallow convex, becoming flat; shades of grey or fawn, often with an olivaceous tinge and a darker centre and zones; whitish edge to margin. **GILLS** Adnate or decurrent; crowded; ochre-cream with rusty stains. **MILK** Abundant; white, drying grey; bitter or hot taste. **STIPE** To 7cm long; cylindrical or tapering downward; smooth; paler than cap, but bruising darker. **HABITAT** Deciduous woodland, often on calcareous soil and usually associated with Beech. **STATUS** Widespread but occasional.

Lactarius circellatus
Similar to *L. fluens* but lacking the distinctive pale cap edge and normally associated with Hornbeam. **CAP** To 10cm across; irregular or shallow convex, becoming flatter with a depressed centre; surface rough or finely scaly and slightly viscid when wet; shades of grey or pale brown, often with a hint of pink. **GILLS** Adnate or slightly decurrent; crowded; cream, becoming ochre and staining pale brown. **MILK** Abundant; white, drying buff; tastes mild, then hot. **STIPE** To 5cm long; spindle-shaped; concolorous with cap or paler. **HABITAT** Deciduous woodland. **STATUS** Widespread but occasional.

Fiery Milkcap *Lactarius pyrogalus*
Similar to *L. circellatus* but with a less zonate cap and usually found under Hazel. **CAP** To 10cm across; irregular and convex, becoming flatter with a slightly depressed centre; smooth and slightly viscid; shades of grey or fawn with a hint of lilac, and paler towards margin. **GILLS** Adnate or decurrent; distant; cream or ochre. **MILK** Abundant; white, drying grey; very hot taste. **STIPE** To 6.5cm long; cylindrical, but sometimes compressed or furrowed and with a tapered base; smooth and dry; concolorous with cap or paler. **HABITAT** Generally confined to Hazel. **STATUS** Widespread and common.

Grey Milkcap *Lactarius vietus*
Pale milkcap with gills heavily stained by drying milk. **CAP** To 7.5cm across; convex, with a wavy margin and depressed centre, sometimes expanding to funnel-shaped with a small umbo; suede-like texture; shades of grey, buff or pale flesh-pink with lilac tones; margin often paler when young. **GILLS** Adnate or decurrent; crowded; pale cream but becoming darker and stained. **MILK** White, drying greenish grey; very hot taste. **STIPE** To 8cm long; cylindrical, sometimes with a tapered base; similar colour to cap, with a paler zone at apex. **HABITAT** Wet birch woods, often in *Sphagnum* moss. **STATUS** Widespread and common.

Lactarius uvidus
Medium-sized viscid milkcap with milk and flesh discolouring lilac. **CAP** To 10cm across; convex with a depressed centre, becoming flatter, sometimes even funnel-shaped, with a wavy margin; pinkish buff with lilac tones. **GILLS** Adnate or decurrent; crowded; light cream to pinkish buff, stained lilac by drying milk. **MILK** Plentiful; white, remaining unchanged when isolated but turning lilac when in contact with the flesh. **STIPE** To 7cm long; cylindrical, often with a tapered base; pale cream or shades of grey. **HABITAT** Wet deciduous woodland, particularly where birches are present. **STATUS** Occasional; mainly in Scotland.

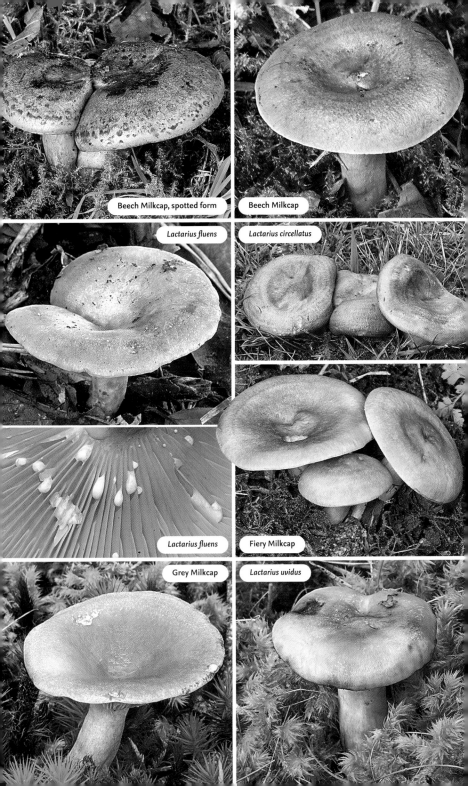

Beech Milkcap, spotted form

Beech Milkcap

Lactarius fluens

Lactarius circellatus

Lactarius fluens

Fiery Milkcap

Grey Milkcap

Lactarius uvidus

Sooty Milkcap *Lactarius fuliginosus*

Variable brown-coloured milkcap with a suede-like cap and stipe, and flesh turning pink on exposure to milk. **CAP** To 10cm across; convex with a slightly depressed centre, becoming flat, occasionally umbonate, sometimes with a grooved margin; coffee-coloured or shades of brown. **GILLS** Adnate or slightly decurrent; fairly crowded; cream, becoming ochre and stained. **MILK** Sparse; white, turning pink only on contact with the flesh. **STIPE** To 8cm long; cylindrical with a tapered base; concolorous with cap. **HABITAT** Mixed woodland. **STATUS** Widespread but uncommon.

Lactarius azonites

Similar to Sooty Milkcap, but paler and with a greater contrast in colour between cap and stipe. **CAP** To 8cm across; convex, becoming flatter with a slightly depressed centre; smooth or suede-like texture; coffee-coloured with a dappled appearance. **GILLS** Adnate; irregular and often anastomosing; white, becoming ochre and staining pink. **MILK** Abundant; white but turning pink when in contact with the flesh; mild taste, becoming slightly acrid. **STIPE** To 6cm long; cylindrical with a tapered base; white, becoming brownish. **HABITAT** Deciduous woodland. **STATUS** Uncommon, least so in S England.

Lactarius acris

Red-staining milkcap whose milk changes colour even when isolated. **CAP** To 8cm across; convex with a slightly depressed centre, becoming flatter and even funnel-shaped; sometimes umbonate; viscid but becoming dry and wrinkled; coffee-coloured or sepia with a marbled appearance. **GILLS** Adnate or slightly decurrent; cream, then ochre and stained. **MILK** Plentiful; white, quickly turning rose-red; taste mild, then very acrid. **STIPE** To 8cm long; cylindrical and tapering downward; white or pale cream. **HABITAT** Deciduous woodland. **STATUS** Widespread but uncommon.

Lactarius hysginus

Medium-sized milkcap with a distinctive aromatic smell. **CAP** To 8cm across; convex, with a slightly depressed centre and inrolled margin; buff, cinnamon or orange-brown, and sometimes faintly zonate; surface viscid when moist. **GILLS** Adnate or slightly decurrent; shades of cream. **MILK** Plentiful; white and unchanging, with a very acrid, spicy taste. **STIPE** To 6cm long; cylindrical or tapering downward; pinkish buff with darker, irregular spots. **HABITAT** Generally associated with pines and birches. **STATUS** Widespread but uncommon.

Lactarius acerrimus

Milkcap with an asymmetrical cap, gills and stipe, giving it a squat, contorted appearance. **CAP** To 12cm across; convex, becoming flattened and sometimes funnel-shaped; irregular and wavy; shades of buff with ochre tints, sometimes with darker zones or spots. **GILLS** Adnate or slightly decurrent; strongly anastomosing and appearing very crumpled; cream, darkening to cap colour. **MILK** Not plentiful; white and unchanging; very hot. **STIPE** To 5cm long; cylindrical, relatively short and stout, irregular and often eccentric; white or cream, becoming darker. **HABITAT** Deciduous woodland, particularly with oaks. **STATUS** Widespread but occasional.

Anastomosing gills

Coconut Milkcap *Lactarius glyciosmus*

Pale, uniformly coloured milkcap with a distinct smell of coconut. **CAP** To 5cm across; convex with a decurved margin, becoming depressed, sometimes with a small umbo; felty texture; shades of pinkish buff, paler near margin and faintly zonate. **GILLS** Decurrent; crowded; similar in colour to cap or paler. **MILK** Plentiful; white and unchanging; mild or slightly acrid in taste. **STIPE** To 7cm long; cylindrical; similar in colour to cap. **HABITAT** Deciduous woodland, particularly with birches. **STATUS** Widespread and common.

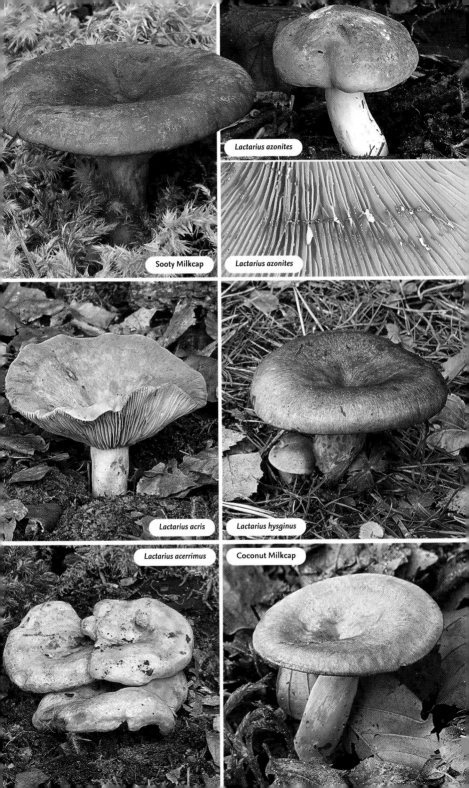

Sooty Milkcap

Lactarius azonites

Lactarius azonites

Lactarius acris

Lactarius hysginus

Lactarius acerrimus

Coconut Milkcap

Lactarius volemus

Bright milkcap with a velvety cap and stipe that become smooth with age. Has a fishy smell. **CAP** To 16cm across; convex, becoming expanded, with a slightly depressed centre and sometimes cracked or wrinkled; cinnamon or reddish orange. **GILLS** Slightly decurrent; rather crowded; cream or buff, bruising darker. **MILK** Abundant; white, staining brown on the flesh; mild taste. **STIPE** To 9cm long; club-shaped; concolorous with cap. **HABITAT** Mixed woodland. **STATUS** Widespread but uncommon.

Lactarius porninsis

Rare milkcap, similar to *L. volemus* but lacking that species' fishy smell. **CAP** To 10cm across; convex, becoming flat with a depressed centre; felty, becoming smooth and wrinkled; greasy; shades of orange or brown, sometimes with faint concentric zones. **GILLS** Slightly decurrent; crowded; cream or buff. **MILK** White and unchanging; mild or slightly bitter taste. **STIPE** To 7cm long; slightly club-shaped and compressed; concolorous with gills. **HABITAT** Strictly associated with larches. **STATUS** Recorded only from N Scotland.

Orange Milkcap *Lactarius aurantiacus (= L. mitissimus)*

Small to medium-sized, bright orange milkcap. **CAP** To 6cm across; convex with a depressed centre and small umbo, becoming flat to almost funnel-shaped; greasy, then smooth and dry; apricot or orange-brown, becoming paler, particularly near margin. **GILLS** Adnate; crowded. **MILK** Abundant; white and unchanging; mild or slightly bitter taste. **STIPE** To 7cm long; cylindrical, smooth and dry; concolorous with cap. **HABITAT** Mixed deciduous and coniferous woodland. **STATUS** Frequent.

Tawny Milkcap *Lactarius fulvissimus (= L. britannicus)*

Similar to Orange Milkcap but gills with decurrent tooth and cap surface more granular. **CAP** To 7cm across; convex, becoming flat with a depressed centre, sometimes funnel-shaped; orange or brown with a paler margin and sometimes indistinctly zonate. **GILLS** Adnate with decurrent tooth; cream or buff, becoming darker and occasionally spotted. **MILK** Abundant; white, somewhat watery and sometimes drying pale yellow when isolated from the flesh; mild or slightly bitter taste. **STIPE** To 7cm long; cylindrical or slightly club-shaped and smooth; concolorous with cap. **HABITAT** Mixed deciduous woodland. **STATUS** Occasional; more frequent in S.

Mild Milkcap *Lactarius subdulcis* (Top 100)

One of the most common milkcaps, but frequently misidentified. **CAP** To 7cm across; convex, becoming flat, sometimes funnel-shaped and usually with a small umbo; variable colours in shades of orange-brown, drying lighter and with a paler margin. **GILLS** Adnate or slightly decurrent; crowded; cream with a pink flush, becoming darker. **MILK** Plentiful; white and unchanging; taste mild, then slightly bitter. **STIPE** To 6cm long; cylindrical or slightly club-shaped; smooth and dry with a white-hairy base; buff with a pink tinge, becoming progressively darker downward. **HABITAT** Deciduous woodland. **STATUS** Widespread and very common.

Birch Milkcap *Lactarius tabidus* (Top 100)

Similar to Mild Milkcap and equally common, but milk discolours yellow. **CAP** To 5cm across; convex, becoming depressed or funnel-shaped with a small umbo; sometimes with a striate or grooved margin; smooth, becoming progressively wrinkled; orange-brown, becoming paler from centre outwards and drying pinkish buff. **GILLS** Adnate or decurrent; fairly crowded; white maturing pinkish buff. **MILK** White, slowly turning yellow on handkerchief; mild, then slightly bitter. **STIPE** To 6cm long; cylindrical or club-shaped; similar in colour to cap with a paler apex, but darkening with age. **HABITAT** Damp deciduous woodland, particularly, but not exclusively, associated with birches. **STATUS** Widespread and very common.

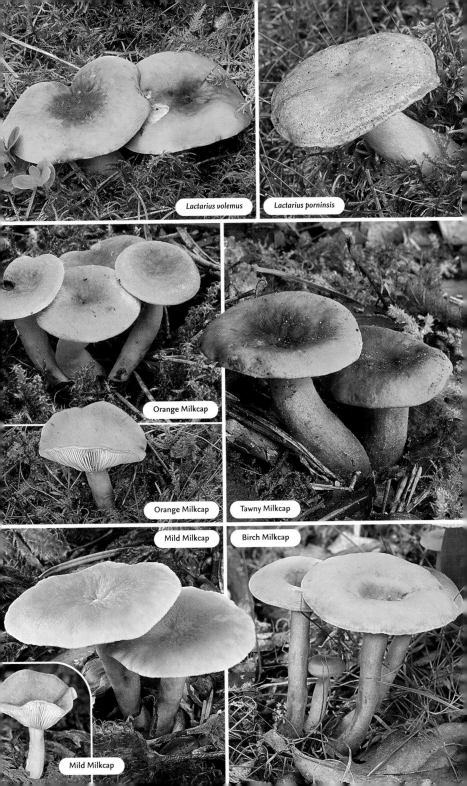

Lactarius volemus

Lactarius porninsis

Orange Milkcap

Orange Milkcap

Tawny Milkcap

Mild Milkcap

Birch Milkcap

Mild Milkcap

Curry Milkcap *Lactarius camphoratus*

Dark brown milkcap with a strong smell of curry when dry. **CAP** To 5cm across; convex, becoming depressed to almost funnel-shaped with a small umbo; smooth and dry; dark red or orange-brown, becoming paler from centre; margin grooved. **GILLS** Adnate or slightly decurrent; crowded; ochre, becoming reddish brown. **MILK** Plentiful; watery white; mild or slightly bitter taste. **STIPE** To 5cm long; cylindrical with a tapered base; brick or vinaceous brown. **HABITAT** Mixed woodland, often on acid soil. **STATUS** Widespread and common.

Lactarius subumbonatus (= *L. cimicarius*)

Very similar to Curry Milkcap but with unpleasant smell not unlike that of Oakbug Milkcap (*see* below). **CAP** To 7cm across; convex, becoming depressed to almost funnel-shaped and usually umbonate; dry, smooth and felty, with margin sometimes furrowed; vinaceous brown, becoming paler with age. **GILLS** Adnate or slightly decurrent; pinkish buff, becoming darker. **MILK** Rather sparse; watery; mild taste. **STIPE** To 5cm long; cylindrical, usually with a tapered base; dry and smooth; fawn, becoming darker. **HABITAT** Deciduous woodland, particularly with oaks. **STATUS** Common in England and Northern Ireland.

Lactarius decipiens

Pale milkcap with yellowing milk and a smell of pelargoniums. **CAP** To 7cm across; convex, becoming depressed to almost funnel-shaped and usually with a small umbo; dry and smooth with margin sometimes striate; light pinkish ochre, drying paler. **GILLS** Slightly decurrent; cream, becoming flesh-coloured. **MILK** Plentiful; white, turning yellow on handkerchief; mild, then acrid and bitter. **STIPE** To 6cm long; cylindrical or spindle-shaped; concolorous with cap. **HABITAT** Deciduous woodland, particularly with Hornbeam. **STATUS** Widespread but uncommon.

Alder Milkcap *Lactarius obscuratus*

Very small milkcap found with Common Alder. **CAP** To 3cm across; slightly convex, becoming flatter with an indented centre and often umbonate; surface smooth or sometimes wrinkled, margin striate; variable shades of dull brown, sometimes with an ochreous tinge and centre usually darker. **GILLS** Adnate or decurrent; cream or straw-coloured, becoming darker. **MILK** Sparse; watery, unchanging or occasionally turning pale yellow on handkerchief; mild or slightly acrid. **STIPE** To 3cm long; cylindrical; smooth and dry; similar colour to cap but lighter. **HABITAT** Wet soils with Common Alder. **STATUS** Widespread but occasional.

Lactarius lacunarum

Similar to *L. decipiens* (*see* above) but darker, more reddish and often found in wet areas. **CAP** To 6cm across; convex, becoming depressed and sometimes funnel-shaped, and often umbonate; dry, smooth or scurfy; margin sometimes irregular or grooved; shades of orange or reddish brown, fading with age. **GILLS** Adnate or decurrent; pale buff, becoming darker and sometimes spotted from dried milk. **MILK** Plentiful; white, usually turning yellow; mild or slightly bitter. **STIPE** To 6cm long; cylindrical; smooth and dry; similar colour to cap, with a darker base. **HABITAT** Deciduous woodland. **STATUS** Widespread but occasional.

Oakbug Milkcap *Lactarius quietus* (Top 100)

Milkcap with a distinctive smell variously likened to bedbugs, wet laundry, oil, etc. **CAP** To 8cm across; convex, becoming flatter with a shallow depression; dry and smooth; reddish brown with a hint of grey or lilac, darker in centre and with indistinct concentric bands or spots. **GILLS** Adnate or slightly decurrent; crowded; white or cream, maturing brownish. **MILK** Plentiful; white; mild taste. **STIPE** To 7cm long; slender cylindrical, sometimes with a tapered base; smooth and dry; similar in colour to cap, with a paler apex and darker towards base. **HABITAT** Oak woodland. **STATUS** Widespread and very common.

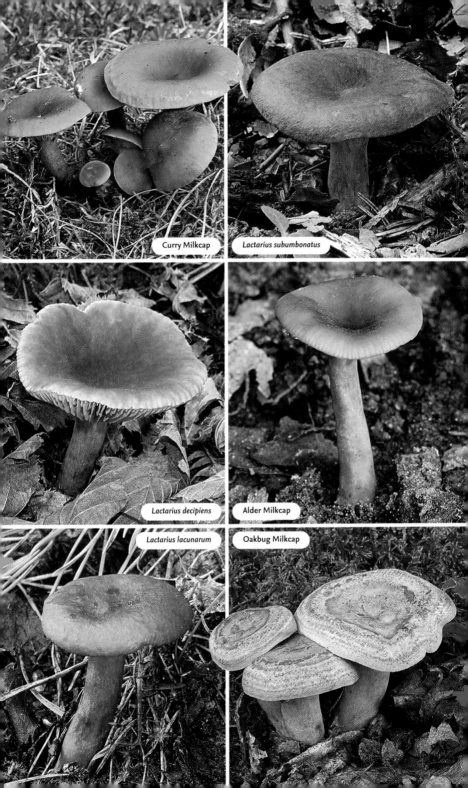

Curry Milkcap

Lactarius subumbonatus

Lactarius decipiens

Alder Milkcap

Lactarius lacunarum

Oakbug Milkcap

Ugly Milkcap *Lactarius turpis* (= *L. plumbeus*) (Top 100)

Very dark to blackish milkcap, discolouring purple on application of ammonia; viscid when young. **CAP** To 15cm across; convex, becoming flatter with a depressed centre; surface slightly woolly and occasionally grooved; dark olive-brown and sometimes faintly zonate. **GILLS** Adnate or decurrent; crowded; cream or pale buff, but darker where bruised. **MILK** Abundant; white, drying olivaceous; hot. **STIPE** To 7cm long; stout and cylindrical with a tapered base, rarely compressed; concolorous with cap or paler, sometimes pitted. **HABITAT** Mixed woods and heathland, often with birches. **STATUS** Widespread and very common.

Liver Milkcap *Lactarius hepaticus*

Frequent in S pinewoods; milk stains yellow on handkerchief. **CAP** To 6cm across; convex, becoming flat with a depressed centre and small umbo; margin decurved and often grooved; smooth and dry or slightly greasy; liver-coloured with a darker centre but paler when dry. **GILLS** Decurrent; crowded; pale buff, then reddish brown. **MILK** Plentiful; white, becoming yellow; bitter. **STIPE** To 6cm long; cylindrical; smooth and dry; concolorous with cap but darker in lower part. **HABITAT** Pines and heaths on acid soil. **STATUS** Widespread but occasional.

Rufous Milkcap *Lactarius rufus*

Similar to Liver Milkcap and found in the same habitat, but more reddish in colour and with unchanging white milk. **CAP** To 10cm across; convex, then flat or funnel-shaped with a small, persistent umbo; surface dry, matt and velvety; brick-red or orange-brown, usually with paler margin. **GILLS** Adnate or slightly decurrent; crowded. **MILK** White and unchanging; mild at first, then hot. **STIPE** To 8cm long; cylindrical; dry and slightly velvety; white or cream at base and apex, flushed with cap colour, particularly in centre. **HABITAT** Acid conifer woods and heathland, occasionally where birches are present. **STATUS** Widespread and common.

Lactarius flexuosus

Variable, medium-sized milkcap with a large, flabby cap. **CAP** To 11cm across; convex, then expanded with a slightly depressed centre and incurved margin; flexible and becoming undulating and lumpy, sometimes with centre cracking or becoming scurfy; zonate in var. *roseozonatus*; various shades of grey with lilac or pink tones. **GILLS** Adnate or slightly decurrent; rather distant; cream, becoming ochre with a hint of lilac. **MILK** Abundant; white and unchanging; hot taste. **STIPE** To 6cm long; cylindrical or tapering towards base; similar in colour to cap. **HABITAT** Mixed woodland. **STATUS** Widespread but uncommon.

Lactarius trivialis

Large milkcap, variable in colour and with a slimy or greasy cap and stipe. **CAP** To 15cm across; convex, becoming flat or funnel-shaped; ochre with a hint of lilac or vinaceous brown, and with darker dots that form a short-lived, indistinct zone. **GILLS** Adnate or decurrent; rather crowded; cream, darkening to ochre. **MILK** Plentiful; cream, drying grey and turning yellowish on handkerchief; mild, then acrid. **STIPE** To 12cm long; cylindrical or club-shaped; cream, discolouring ochre. **HABITAT** Pine and birch woodland on acid soil. **STATUS** Found only in Scotland.

Fenugreek Milkcap *Lactarius helvus*

Uniformly pale milkcap with a spicy or fenugreek smell, even when fresh, and colourless watery milk. **CAP** To 15cm across; convex to flat or funnel-shaped and sometimes umbonate; dry and felty but becoming coarser with age; shades of grey, beige and pink, faintly zonate and with a paler margin. **GILLS** Adnate or decurrent; cream, darkening to buff or ochre. **MILK** Sparse; colourless; mild or slightly bitter. **STIPE** To 12cm long; cylindrical or spindle-shaped; velvety to smooth; cream, flushed with cap colour. **HABITAT** Pine and birch woodland, heathland and moorland, on acid soils. **STATUS** Widespread but occasional.

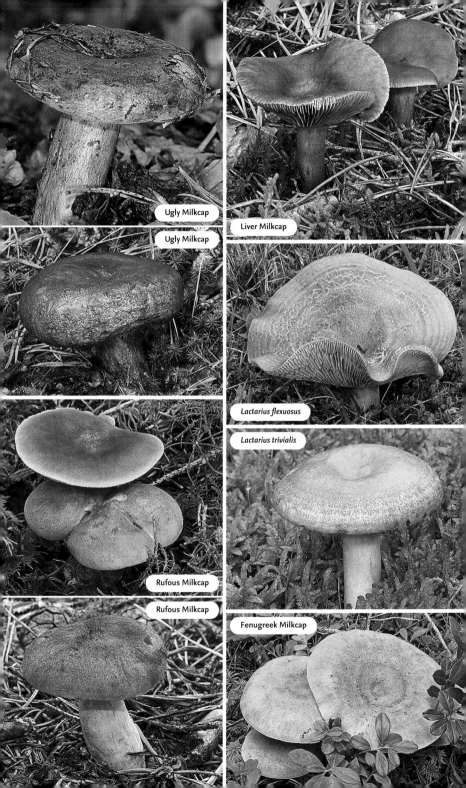

Ugly Milkcap

Liver Milkcap

Ugly Milkcap

Lactarius flexuosus

Lactarius trivialis

Rufous Milkcap

Rufous Milkcap

Fenugreek Milkcap

Many members of the genus *Russula* have brightly coloured caps that contrast with white or cream gills and stipe. Their colour is often fugitive and fades with age or after heavy rain. The cap cuticle can often be peeled, the extent of this varying between species. The gills are mostly extremely brittle and crumble on handling. The stipe generally has a chalk-like texture, often with fine, longitudinal veins; an application of iron salts usually provokes a colour reaction, mainly to pink or green. Fruiting is usually in summer and autumn. This is a difficult genus to separate: spore-print colour, reaction to iron salts, extent of peeling and habitat are the important field characteristics that will aid identification.

Blackening Brittlegill *Russula nigricans* (Top 100)
The most common member of the group in which the cap and stipe flesh turns black on cutting or bruising, in this case with a red intermediate stage. The very widely spaced gills make this an easy species to identify. **CAP** To 20cm across; convex, becoming flat with a depressed centre; dirty white at first, but developing large brownish patches before

blackening; ¾ peeling. Flesh white at first, initially changing to red before finally turning blackish brown. **GILLS** Adnate and very distant; white or cream with a white spore print. **STIPE** To 7cm long; stout and cylindrical; colour and change similar to cap. Iron reaction faint pink then greenish. **HABITAT** Mixed woodland. **STATUS** Widespread and common.

Crowded Brittlegill *Russula densifolia*
Similar to Blackening Brittlegill but with very crowded gills. **CAP** To 12cm across; flattened-convex, becoming flatter with a depressed centre and then funnel-shaped; dirty white, becoming blackish brown; ⅓ peeling. Flesh white, then red and finally blackish. **GILLS** Slightly decurrent; crowded; cream or ochre with a white or pale cream spore print. **STIPE** To 6cm long; stout and cylindrical; concolorous with cap. Iron reaction pink then greenish. **HABITAT** Deciduous woodland; rarely with conifers. **STATUS** Widespread but occasional.

Russula anthracina
Although similar to the previous two species, the flesh discoloration has no intermediate reddish stage. Has a faintly fruity smell. **CAP** To 17cm across; flattened-convex, becoming flatter with a depressed centre and sometimes funnel-shaped; dirty white, discolouring greyish brown; barely peeling. **GILLS** Slightly decurrent; fairly crowded; concolorous with cap and with a cream spore print. **STIPE** To 9cm long; stout and cylindrical with a grooved or irregular base; concolorous with cap. Iron reaction greyish pink then greenish. **HABITAT** Mixed deciduous woodland. **STATUS** Widespread and common. **SIMILAR SPECIES Winecork Brittlegill** *R. adusta* smells of old wine corks or barrels.

Milk White Brittlegill *Russula delica*
Uniformly white brittlegill with non-blackening flesh and a squat appearance. **CAP** To 16cm across; hemispherical, becoming flat with a depressed centre and often funnel-shaped; white, discolouring ochre or brown and often covered with particles of soil; barely or not peeling. **GILLS** Decurrent; fairly distant; concolorous with cap; white or very pale cream spore print. **STIPE** To 6cm long; cylindrical or spindle-shaped; same colour as cap. Iron reaction pale pink. **HABITAT** Deciduous woodland. **STATUS** Widespread but uncommon.

Blue Band Brittlegill *Russula chloroides*
Similar to Milk White Brittlegill but smaller and with a pale bluish-green band to apex of stipe. **CAP** To 12cm across; convex, then flat with a depressed centre and sometimes funnel-shaped; dull white, discolouring ochre; barely or not peeling. **GILLS** Decurrent; crowded; pure white or pale cream. **STIPE** To 8cm long; cylindrical and stout; similar in colour to cap with a coloured apex. Iron reaction pink. **HABITAT** Deciduous woodland; rarely with conifers. **STATUS** Frequent.

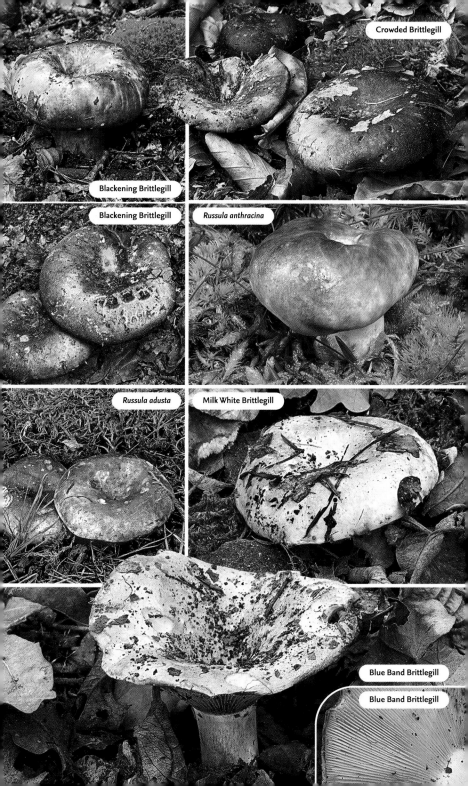

Crowded Brittlegill

Blackening Brittlegill

Blackening Brittlegill

Russula anthracina

Russula adusta

Milk White Brittlegill

Blue Band Brittlegill

Blue Band Brittlegill

Ochre Brittlegill *Russula ochroleuca* (Top 100)

Very common yellow brittlegill found in both deciduous and coniferous woodland. **CAP** To 10cm across; convex, becoming flat with a slightly depressed centre; margin with short grooves; yellow-ochre with olive-brown tones; up to ⅔ peeling. **GILLS** Adnexed; white or pale cream with a similar-coloured spore print; little smell but a slightly hot taste. **STIPE** To 7cm long; cylindrical; white or cream, later yellowish or becoming greyish, particularly in wet weather. Iron reaction salmon-pink. **HABITAT** Mixed woodland. **STATUS** Widespread and very common.

Yellow Swamp Brittlegill *Russula claroflava*

Easy to distinguish from Ochre Brittlegill as habitat, taste and spore print are all different. **CAP** To 10cm across; convex, becoming flat with a slightly depressed centre; margin with short grooves; bright chrome-yellow; ½ peeling. **GILLS** Adnexed; white then ochre, with an ochre spore print; mild taste with little smell. **STIPE** To 6cm long; cylindrical; white to greying. Iron reaction pink or wine-red. **HABITAT** Boggy deciduous woodland, especially with birches and sometimes *Sphagnum* moss. **STATUS** Widespread and very common.

Geranium Brittlegill *Russula fellea* (Top 100)

Uniformly honey-coloured brittlegill, differing from other yellow *Russula* species by the faint geranium scent and burning-hot taste. **CAP** To 9cm across; convex, becoming flat with a slightly depressed centre and short grooves to margin, sometimes with a small umbo; ochre or honey-coloured; ¼ peeling. **GILLS** Adnexed; paler in colour than cap, with a pale pinkish-cream spore print; burning-hot taste and a smell of geraniums or stewed apples. **STIPE** To 7cm long; cylindrical; concolorous with cap or paler. Iron reaction pinkish buff. **HABITAT** Deciduous woodland, usually on acid soils and associated with Beech. **STATUS** Widespread and very common.

Golden Brittlegill *Russula risigallina*

Small, fragile brittlegill, variable in colour; several different forms have been identified. **CAP** To 6cm across; convex, becoming flat with a depressed centre; margin smooth or short-grooved; yolk-yellow with a slightly darker central area in the typical form, although pink and apricot varieties are also found; ¼ to completely peeling. **GILLS** Adnexed and strongly inter-veined; ochre, with a deep ochre spore print. Flesh odourless at first, then fruity, and with a mild taste. **STIPE** To 6cm long; cylindrical or slightly club-shaped; white, discolouring ochre. Iron reaction pink. **HABITAT** Deciduous woodland. **STATUS** Widespread but occasional.

Velvet Brittlegill *Russula violeipes*

Brittlegill with a finely velvety cap found in a wide variety of colours. **CAP** To 8cm across; hemispherical, becoming flat with a depressed centre; commonly yellow (var. *citrina*), but may be purple or lilac with paler areas, and sometimes with olivaceous tones. **GILLS** Slightly decurrent; buff or straw-coloured with a very pale cream spore print. Flesh smelling of Jerusalem artichokes or fish and with a mild taste. **STIPE** To 7cm long; cylindrical, sometimes tapering towards base; white, frequently tinged yellow and usually with a violet flush. Iron reaction pink. **HABITAT** Deciduous woodland. **STATUS** Widespread but occasional.

Gilded Brittlegill *Russula aurea*

Colourful brittlegill in a mixture of reds and yellows. **CAP** To 10cm across; hemispherical, becoming flat with a depressed centre and an undulating, occasionally striate margin; orange or red, heavily suffused with yellow; ½ peeling. **GILLS** Adnexed or free; fairly distant; cream, turning ochre with bright yellow edges; ochre spore print. No distinctive taste or smell. **STIPE** To 8cm long; cylindrical, often with a tapered base; white, flushed yellow. Iron reaction pale pink. **HABITAT** Deciduous woodland. **STATUS** Uncommon or rare.

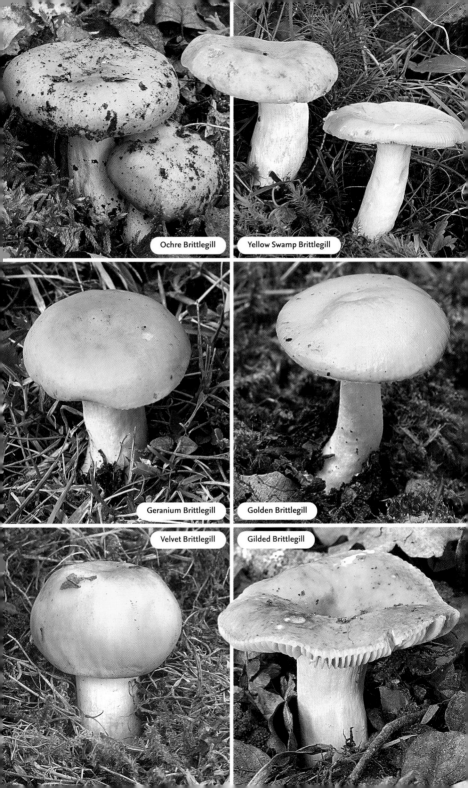

Ochre Brittlegill

Yellow Swamp Brittlegill

Geranium Brittlegill

Golden Brittlegill

Velvet Brittlegill

Gilded Brittlegill

Green Brittlegill *Russula aeruginea*

The most common of the green brittlegills. Often confused with the green variety of Charcoal Burner (*see* below). CAP To 9cm across; convex, becoming flat with a depressed centre; slightly greasy; margin sometimes grooved; green to pale grey-green, usually with a darker centre; ½ peeling. GILLS Adnexed or almost free; crowded; white, maturing yellow or ochre, with a cream spore print. Little smell or taste. STIPE To 7cm long; cylindrical and stout; whitish, becoming brown-spotted, particularly towards base. Iron reaction light pink. HABITAT Deciduous woodland. STATUS Widespread and common.

Greencracked Brittlegill *Russula virescens*

Similar to Green Brittlegill but surface of green cap breaks up to form a mosaic pattern. CAP To 12cm across; hemispherical, becoming convex or flat with a slightly depressed centre; margin often wavy or lobed; dry and velvety; shades of green, disintegrating into its distinctive pattern; ½ peeling. GILLS Adnexed or almost free; fairly distant; white or cream with a pale cream spore print. Smell is weak and fruity, and taste is mild. STIPE To 8cm long; stout and cylindrical, sometimes with a tapered base; white or cream, becoming brown-spotted. Iron reaction orange or pink. HABITAT Deciduous woodland. STATUS Occasional.

Powdery Brittlegill *Russula parazurea*

Grey or green brittlegill with a powdery cap and stipe and brittle flesh. CAP To 8cm across; convex, becoming flatter with a slightly depressed centre; surface dull and floury; grey or bluish green, sometimes with an olivaceous or purplish-brown centre; margin slightly striate; ½ peeling. GILLS Adnexed or nearly free; crowded; pale cream with a similar-coloured spore print. No distinctive smell or taste. STIPE To 7cm long; cylindrical or slightly club-shaped; white, discolouring ochre or brown from base upward. Iron reaction salmon-pink. HABITAT With oak and pine. STATUS Widespread and common in England.

Russula grisea

Similar to Powdery Brittlegill but more lilaceous in colour and lacking a powdery cap and stipe. CAP To 8cm across; convex, becoming flatter or even funnel-shaped; margin irregular and sometimes grooved; shades of lilac-grey, often with olivaceous tints, particularly in centre; ½ peeling. GILLS Adnexed; fairly distant; cream with a similar-coloured spore print. No distinctive smell or taste. STIPE To 7cm long; cylindrical, sometimes with a tapered base; white, spotted or flushed lilac or brown from base upward. Iron reaction salmon-pink. HABITAT Mixed woodland. STATUS Widespread and frequent. SIMILAR SPECIES **Oilslick Brittlegill** *R. ionochlora* has a paler spore print but can be separated with certainty only microscopically; it has a more S distribution.

Charcoal Burner *Russula cyanoxantha* (Top 100)

Very common and extremely variable brittlegill. Unlike most russulas, the gills are not brittle and a finger run across the surface will not cause them to crumble. Has virtually no reaction to the application of iron salts (at most, a faint greenish tint after some time), in contrast to most other members of the genus. CAP To 15cm across; hemispherical with a slightly depressed centre, becoming flat or even funnel-shaped; greasy when moist but drying smooth and hard; sometimes uniformly coloured but generally a mixture of shades of grey, violet, olive, wine, brown, etc., which blend into each other (an entirely green form, var. *peltereaui*, is common); ½ peeling. GILLS Adnexed or slightly decurrent; crowded; rubbery and flexible; white or cream with a white spore print. Flesh hard, with no distinctive smell or taste. STIPE To 10cm long; cylindrical, sometimes with a tapered base; white, occasionally with a reddish flush. HABITAT Mixed deciduous woodland. STATUS Widespread and very common.

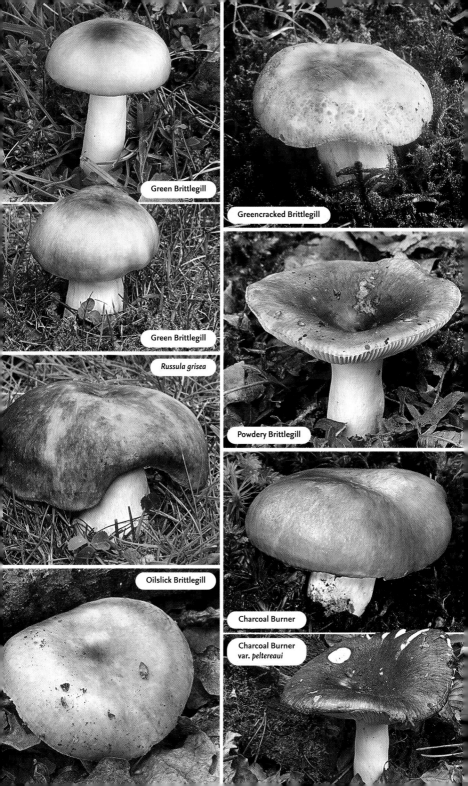

Green Brittlegill

Greencracked Brittlegill

Green Brittlegill

Russula grisea

Powdery Brittlegill

Oilslick Brittlegill

Charcoal Burner

Charcoal Burner
var. *peltereaui*

Stinking Brittlegill *Russula foetens*

Large, dull, often slightly misshapen brittlegill with a strong, unpleasant smell. **CAP** To 20cm across; hemispherical, becoming flatter with a depressed centre; margin incurved and deeply furrowed; ochre-brown or honey-coloured with paler areas; ⅔ peeling. **GILLS** Adnexed; dingy cream, usually with brown staining; spore print cream. Flesh with a rancid, oily smell and an acrid taste. **STIPE** To 12cm long; cylindrical or sometimes club-shaped and veined; white, discolouring ochre, particularly at base. Iron reaction pink. **HABITAT** Old deciduous woodland, usually with Beech and oaks. **STATUS** Occasional. **SIMILAR SPECIES** *R. subfoetens* is smaller, with a less strong taste and smell and flesh that discolours yellow.

Bitter Almond Brittlegill *Russula grata (= R. laurocerasi)*

Similar to Stinking Brittlegill but smaller and with a different smell. **CAP** To 8cm across; hemispherical, then convex or flat with a slightly depressed centre; margin incurved and furrowed; yellow-ochre, becoming darker; ¼–½ peeling. **GILLS** Adnexed; pale cream, developing brown spots; spore print pale ochre. Flesh with a smell of bitter almonds or marzipan and an acrid taste. **STIPE** To 8cm long; cylindrical and veined; white with brown spots. Iron reaction pink. **HABITAT** Deciduous woodland, particularly with Beech. **STATUS** Widespread but uncommon.

Russula farinipes

Small straw-coloured brittlegill with distant, flexible gills. **CAP** To 8cm across; convex, then flat with a depressed centre and striate margin; yellow or ochre; barely peeling. **GILLS** Slightly decurrent; distant; cream with a white spore print. Flesh white but yellowing, with a fruity smell and hot taste. **STIPE** To 7cm long; cylindrical with a tapered base; veined and with a powdery apex; white, discolouring ochre. Iron reaction dull pink. **HABITAT** Deciduous woodland. **STATUS** Widespread but occasional.

Russula amoenolens

Small brown brittlegill with a distinctive smell of Camembert cheese. **CAP** To 6cm across; hemispherical, but flattening and with a striate or furrowed margin; sepia or grey-brown, often with a darker centre. **GILLS** Adnexed; dirty white to pale cream, discolouring brownish; spore print very pale cream. Flesh smelling cheesy or of Jerusalem artichokes and with a hot taste. **STIPE** To 6cm long; cylindrical and stout with a tapered base; white, becoming brownish. Iron reaction pink. **HABITAT** Deciduous woodland, particularly with oaks. **STATUS** Widespread but occasional.

Russula praetervisa *(= R. pectinatoides in part)*

Recalls *R. amoenolens* but paler and with an oily or rubbery smell. **CAP** To 8cm across; hemispherical, then flat with a depressed centre; margin furrowed and sometimes with warts; yellow-ochre or more brownish, with a darker and olivaceous centre; ⅔ peeling. **GILLS** Adnexed; white then cream, with a cream spore print; unpleasant smell but a mild taste. **STIPE** To 5cm long; cylindrical, sometimes slightly club-shaped, veined; white but discolouring reddish brown at extreme base. Iron reaction pink. **HABITAT** Deciduous woodland; sometimes in open spaces where trees are present. **STATUS** Widespread but uncommon.

Russula graveolens

Part of the difficult *xerampelina* group, with a green iron reaction and crabby smell. **CAP** To 8cm across; convex, becoming flat with a depressed centre; colour variable, in shades of brown with a flush of violet or red, but sometimes entirely ochre; barely peeling. **GILLS** Adnexed; rather crowded; ivory, discolouring ochre with a pale ochre spore print. Flesh with a mild taste but strong smell of shellfish when old. **STIPE** To 7cm long; cylindrical and slightly club-shaped, with a finely veined surface; white, staining ochre. **HABITAT** Deciduous woodland or clearings with scattered trees. **STATUS** Widespread and frequent.

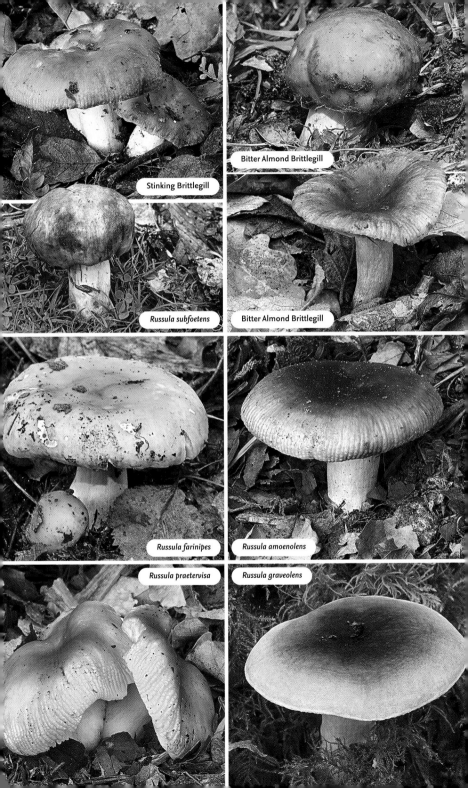

Stinking Brittlegill

Bitter Almond Brittlegill

Russula subfoetens

Bitter Almond Brittlegill

Russula farinipes

Russula amoenolens

Russula praetervisa

Russula graveolens

Birch Brittlegill *Russula betularum*

Small, fragile brittlegill with a pink cap that soon fades. **CAP** To 5cm across; convex, becoming flat with a depressed centre; margin usually slightly furrowed, with wart-like bumps; pale pink to pale cream, particularly in centre; colour very fugitive and often fades to white at maturity; virtually completely peeling. **GILLS** Adnexed or almost free; white then cream, with a white spore print. Little smell but a hot taste. **STIPE** To 5cm long; slender and slightly club-shaped; veined; white but yellowing. Iron reaction pink. **HABITAT** Associated with birches in damp woodland. **STATUS** Widespread and common.

Bleached Brittlegill *Russula exalbicans (= R. pulchella)*

Medium-sized brittlegill found in variety of fugitive colours. **CAP** To 10cm across; convex with a depressed centre, becoming flat; pink, apricot or olive-buff, fading to grey or olive but with marginal zone often retaining its colour; occasionally entirely pink or red; ½ peeling. **GILLS** Adnexed; crowded; dingy cream with an ochre spore print. Indistinct smell and a moderately hot taste. **STIPE** To 5cm long; stout and cylindrical with base sometimes tapered; finely veined; white, becoming grey. Iron reaction dingy pink. **HABITAT** Mixed woodland, with a preference for birches. **STATUS** Widespread but occasional.

Slender Brittlegill *Russula gracillima*

Distinctive brittlegill with a fading pink cap and greenish centre. **CAP** To 6cm across; convex with a depressed centre, becoming flat to almost funnel-shaped; red or pink, with centre soon turning greenish and margin pale pink; up to ½ peeling. **GILLS** Adnexed or slightly decurrent; cream, becoming darker and with a cream spore print. Weak smell; slightly hot taste. **STIPE** To 7cm long; slender, cylindrical; white, frequently flushed red and becoming greyish. Iron reaction pink. **HABITAT** Mixed deciduous woodland, usually with birches. **STATUS** Widespread but occasional.

Greasy Green Brittlegill *Russula heterophylla*

Similar to Green Brittlegill (p. 66) but distinguished by its white spore print. **CAP** To 10cm across; convex, but becoming flatter with a smooth or finely wrinkled surface; variable in colour, usually in shades of green, but ochreous or brown forms also found; up to ¼ peeling. **GILLS** Adnexed to slightly decurrent and crowded; white to cream with a white spore print. **STIPE** To 6cm long; cylindrical with a firm texture; white, discolouring brown where bruised. Iron reaction salmon-pink. **HABITAT** Mixed deciduous woodland. **STATUS** Widespread and occasional.

The Flirt *Russula vesca*

Cap cuticle does not extend to margin, so teeth-like gill edges are exposed. **CAP** To 10cm across; hemispherical, then flatter with a slightly depressed centre; colour variable, like old ham, in shades of wine, red and pinkish brown; ½ peeling. **GILLS** Adnexed; white then pale cream, with a cream spore print. No distinctive taste or smell. **STIPE** To 10cm long; stout and cylindrical, sometimes tapering towards base; white, usually with a slight pink flush. Iron reaction dark salmon-pink. **HABITAT** Deciduous woodland. **STATUS** Widespread and common.

The Flirt

Russula robertii (= R. sphagnophila in Europe)

Small brittlegill found in marshy places, usually among *Sphagnum* moss. **CAP** To 6cm across; convex, becoming flat with a slightly depressed centre; margin furrowed; colour variable in shades of wine, pink and ochre with olivaceous tones; completely peeling. **GILLS** Adnexed; fairly distant; white then cream, with a deep cream spore print. Flesh is fragile with no distinctive taste or smell. **STIPE** To 5cm long; cylindrical or slightly club-shaped; white, discolouring yellow. Iron reaction pale pink. **HABITAT** Wet or damp deciduous woodland, often with birches. **STATUS** Uncommon; more frequent in S.

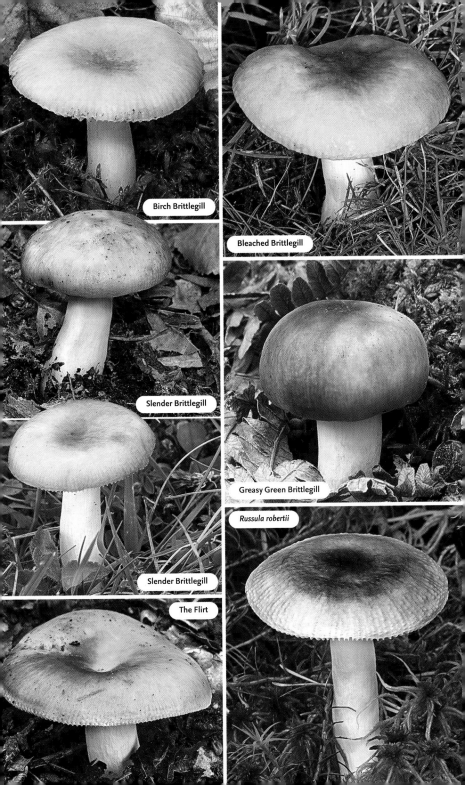

Birch Brittlegill

Bleached Brittlegill

Slender Brittlegill

Greasy Green Brittlegill

Slender Brittlegill

Russula robertii

The Flirt

Burning Brittlegill *Russula badia*

The brittlegill with probably the hottest taste. **CAP** To 10cm across; hemispherical, then flat with an indented centre; wine-red or dark purple, sometimes with brownish tones; ½ peeling. **GILLS** Adnexed or almost free; yellow-ochre with a deep cream spore print. Flesh with a faint smell of cedarwood pencils and a burning-hot taste that is sometimes slow to develop. **STIPE** To 10cm long; cylindrical and stoutish; white, sometimes flushed pink and discolouring ochre. Iron reaction pink. **HABITAT** Coniferous woodland. **STATUS** Rare; mainly in N.

Humpback Brittlegill *Russula caerulea (= R. amara)*

Unmistakable brittlegill with an umbonate cap (a rare feature in *Russula* species). **CAP** To 10cm across; rounded conical, then convex and finally flat with a depressed centre, always with a persistent umbo; shades of dark purple or violet with a hint of brown, sometimes spotted russet; up to ½ peeling. **GILLS** Adnexed; ivory, maturing yellow-ochre and with an ochre spore print. Flesh with no distinct taste or smell, but cap cuticle bitter. **STIPE** To 8cm long; cylindrical or slightly club-shaped with a tapered base; white, discolouring ochre. Iron reaction pink. **HABITAT** Pinewoods on acid soil. **STATUS** Widespread but occasional.

Russula cessans

Rather nondescript brittlegill in variable dull colours. **CAP** To 8cm across; hemispherical, becoming flat with a slightly indented centre and, occasionally, an undulating margin; found in shades of purple, wine-red, violet-pink and olive; ½ peeling. **GILLS** Adnexed; white, becoming cream or yellow and with a deep ochre spore print. No distinct taste or smell. **STIPE** To 5cm long; fairly stout and cylindrical; white but discolouring ochreous from base upward. Iron reaction pink. **HABITAT** Pinewoods. **STATUS** Widespread but uncommon.

Copper Brittlegill *Russula decolorans*

Brittlegill of unusual colour and flesh that turns grey to almost black with age or damage. **CAP** To 11cm across; hemispherical, becoming flat with a shallowly depressed centre and a slightly furrowed margin; coppery orange, occasionally with reddish-brown tones; ⅔ peeling. **GILLS** Adnexed to almost free; white then cream, usually with a blackish edge; cream spore print. No distinct smell or taste. **STIPE** To 10cm long; fairly stout, cylindrical and usually with a club-shaped base; white, then blackening. Iron reaction pink. **HABITAT** Virtually confined to Caledonian pinewoods. **STATUS** Rare.

Russula paludosa

Similar to reddish forms of Copper Brittlegill but flesh does not discolour. **CAP** To 15cm across; hemispherical, then convex or flat with a slightly indented centre; margin striate with age; scarlet to purple-red or ochre, sometimes with paler areas; ½ peeling. **GILLS** Adnexed; cream to light ochre, occasionally with a reddish flush to edge; deep cream spore print. No distinct taste or smell. **STIPE** To 10cm long; cylindrical or slightly club-shaped; white, usually flushed pink. Iron reaction pink. **HABITAT** Damp coniferous woodland. **STATUS** Virtually confined to Scotland and uncommon.

Sickener *Russula emetica*

Poisonous, bright red brittlegill with a burning-hot taste; frequent in pinewoods. **CAP** To 10cm across; hemispherical, becoming convex or flat with a shallow depressed centre; margin furrowed with age; bright scarlet-red, sometimes fading, particularly after rain; almost completely peeling. **GILLS** Adnexed or free; white with a whitish spore print. Flesh fragile with a fruity smell and burning-hot taste. **STIPE** To 8cm long; cylindrical and slightly swollen towards base; white. Iron reaction pink. **HABITAT** Pinewoods or heathland on acid soil, sometimes among *Sphagnum* moss. **STATUS** Widespread and very common.

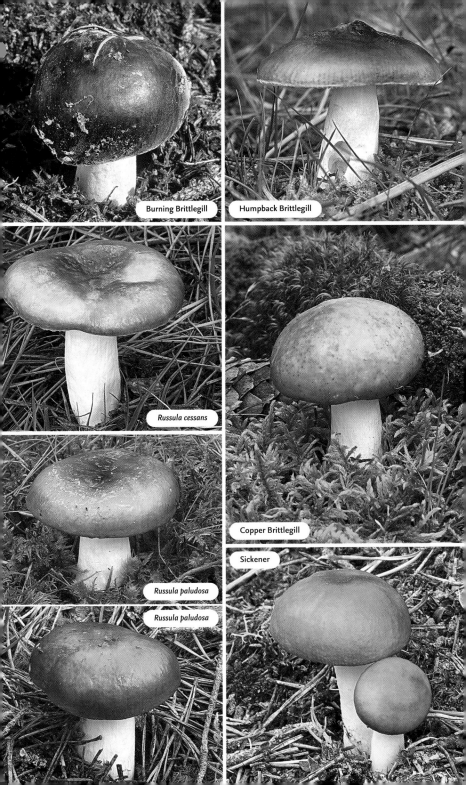

Burning Brittlegill

Humpback Brittlegill

Russula cessans

Copper Brittlegill

Russula paludosa

Russula paludosa

Sickener

Fruity Brittlegill *Russula queletti*

Red or purple brittlegill found in coniferous woodland. **CAP** To 8cm across; hemispherical, then flat with a shallow depressed centre; margin irregular and faintly grooved; dark wine-red or brownish with a darker centre and sometimes with olive tones; up to ⅔ peeling. **GILLS** Adnexed; white then cream, with a pale cream spore print. Flesh with a smell of apples and a hot taste. **STIPE** To 8cm long; cylindrical and grooved or wrinkled; pale ground suffused with wine-red. Iron reaction pale pink. **HABITAT** Coniferous woodland. **STATUS** Widespread but uncommon.

Russula fuscorubroides

Similar to Fruity Brittlegill but darker and without olive tones. Microscopic examination is required to identify it with certainty. **CAP** To 8cm across; hemispherical, becoming flat with a depressed centre; margin slightly striate; dark wine-red to purple-brown; ⅔ peeling. **GILLS** Adnexed; white then cream, with a cream spore print. Flesh with a fruity smell and hot, bitter taste. **STIPE** To 6cm long; cylindrical; pale ground covered in fine reddish veins. Iron reaction pink. **HABITAT** Coniferous woodland. **STATUS** Extremely rare.

Primrose
Brittlegill

Russula
torulosa

Primrose Brittlegill *Russula sardonia*

Reddish-purple brittlegill distinguished by its contrasting yellow gills. **CAP** To 10cm across; convex, becoming flat with a depressed centre; occasionally umbonate; shades of reddish purple or brownish red with a darker centre; an entirely yellow form is also found; barely peeling. **GILLS** Adnexed or slightly decurrent; primrose then golden yellow, with a cream spore print. Flesh has a faint smell and hot taste. **STIPE** To 8cm long; cylindrical; wine-red or lilac with a paler base. Iron reaction salmon-pink; ammonia reaction rose-pink. **HABITAT** Coniferous woodland. **STATUS** Widespread and very common. **SIMILAR SPECIES** *R. torulosa*, with white gills and no ammonia reaction.

Russula turci

Brittlegill with a washed-out or faded appearance, and a floury cap and stipe when dry. **CAP** To 9cm across; convex, becoming flat and usually with a shallow depressed centre; slimy when moist but dull and wrinkled when dry; margin striate; shades of wine or violet with brownish tones, becoming paler in places; ⅓ peeling. **GILLS** Adnexed; whitish, maturing pale ochre with an ochre spore print. Flesh with a mild taste and antiseptic smell, particularly at base of stipe. **STIPE** To 7cm long; cylindrical, sometimes with a club-shaped lower half. Iron reaction salmon-pink. **HABITAT** Spruce woods. **STATUS** Occasional.

Darkening Brittlegill *Russula vinosa*

Similar to several other vinaceous pinewood brittlegills, but gills and stipe discolour grey or black. **CAP** To 10cm across; convex, becoming flat with a depressed centre; wine-red or purple-red with a darker or brownish centre; ½ peeling. **GILLS** Adnexed; fairly distant; light ochre but discolouring; spore print cream. Flesh has an apple-like smell and mild taste. **STIPE** To 8cm long; cylindrical; white but discolouring. Iron reaction faintly grey or black. **HABITAT** Coniferous woodland. **STATUS** Uncommon to rare; possibly confined to Scotland.

Crab Brittlegill *Russula xerampelina*

Variable, comprising several similar species and forms, all with the same smell and iron reaction. **CAP** To 15cm across; convex, becoming flat with a depressed centre; matt and hard when dry, slimy when moist; margin furrowed with age; variable in colour, from purple to red or wine, and with centre usually darker or brownish; ¼ peeling. **GILLS** Adnexed; cream to ochre with an ochre spore print. Flesh has a mild taste and strong smell of crab. **STIPE** To 7cm long; cylindrical or club-shaped; white, flushed red and discolouring brownish. Iron reaction dull green. **HABITAT** The form illustrated is found in coniferous woodland, usually with pines. **STATUS** Widespread and common.

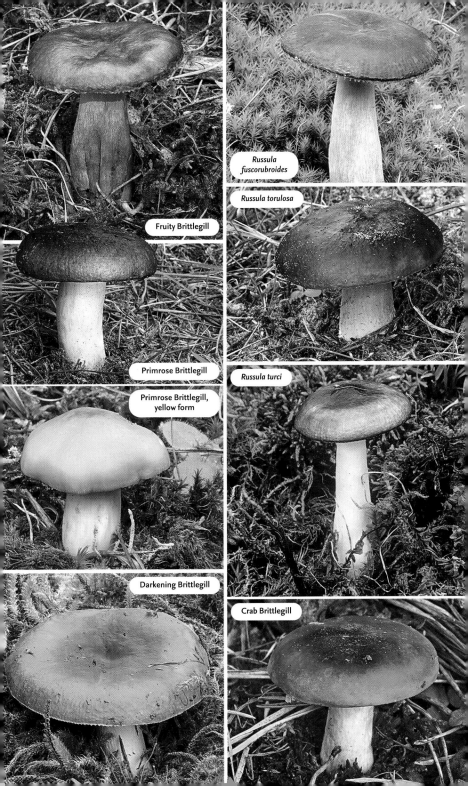

Fruity Brittlegill

Russula fuscorubroides

Russula torulosa

Primrose Brittlegill

Primrose Brittlegill, yellow form

Russula turci

Darkening Brittlegill

Crab Brittlegill

Fragile Brittlegill *Russula fragilis*

Fragile brittlegill with a finely toothed gill edge, rare in *Russula* species. **CAP** To 6cm across; convex, becoming flat with a depressed, darker centre; margin grooved; colour variable, in mixtures of pinkish violet or reddish purple, often with olive tones; to ¾ peeling. **GILLS** Adnexed; white then pale cream, with a whitish spore print. Fruity smell and hot taste. **STIPE** To 5cm long; cylindrical or slightly club-shaped; white, discolouring yellowish. Iron reaction pink. **HABITAT** Deciduous and coniferous woodland. **STATUS** Widespread and common.

Russula intermedia

Brittlegill found mainly in the N in association with birches. **CAP** To 15cm across; convex, then flattening with a depressed centre and furrowed margin; various shades of red or wine, fading to cream or yellow in places, particularly in centre; ⅓ peeling. **GILLS** Adnexed; whitish then ochre, with an ochre spore print. Flesh is hard and has a moderately hot, bitter taste. **STIPE** To 10cm long; cylindrical; white, sometimes flushed with cap colour and discolouring brownish. Iron reaction salmon-pink. **HABITAT** Mixed deciduous woodland. **STATUS** Uncommon to rare.

Beechwood Sickener *Russula nobilis* (= *R. mairei*)

Beechwood counterpart of Sickener (p. 72) and equally poisonous. **CAP** To 7cm across; hemispherical, then convex and finally flat with a shallow depressed centre; margin uplifted and slightly furrowed with age; shades of bright red with paler areas and occasionally entirely white; ¼ peeling, revealing pink flesh beneath. **GILLS** Adnexed to almost free; pure white, becoming pale cream with a white spore print. Flesh is hard and has a faint smell of coconut and a very hot taste. **STIPE** To 5cm long; cylindrical or slightly club-shaped; white, tinged ochre. Iron reaction salmon-pink. **HABITAT** Deciduous woodland associated with Beech. **STATUS** Widespread and common.

Russula silvestris

Similar to Beechwood Sickener but cuticle peels almost completely and has white (pale pink at most) flesh beneath. **CAP** To 6cm across; hemispherical, becoming flat with a depressed centre, generally undulating with striate margin; bright red with paler patches and fading to pink or cream. **GILLS** Adnexed; pure white with a whitish spore print. Flesh has a fruity smell and hot taste. **STIPE** To 5cm long; cylindrical or slightly bulbous in the middle; white, discolouring ochre towards base. Iron reaction pink. **HABITAT** Deciduous and coniferous woodland on sandy or acid soil. **STATUS** Widespread but uncommon.

Scarlet Brittlegill *Russula pseudointegra*

Bright red brittlegill with a pure white stipe. **CAP** To 10cm across; hemispherical, becoming flat with a depressed centre; margin furrowed when old; scarlet, fading white or cream in places, sometimes with a white bloom, particularly near margin; up to ⅔ peeling. **GILLS** Adnexed; white, becoming deep ochre and with an ochre spore print. Odd menthol-flora smell, and a slightly bitter or hot taste. **STIPE** To 7cm long; cylindrical with a tapered base; white. Iron reaction pink. **HABITAT** Deciduous woodland, particularly with oaks. **STATUS** Widespread but occasional.

Coral Brittlegill *Russula velenovskyi*

Smallish brick-red or coral brittlegill, usually with a paler centre when mature. **CAP** To 8cm across; hemispherical, flattening with a depressed centre, somewhat undulating with a furrowed margin, usually with a low umbo; various shades of red, fading yellowish from centre outwards; ⅔ peeling. **GILLS** Adnexed; white then cream, with edges sometimes tinged red; spore print cream. **STIPE** To 6cm long; cylindrical, sometimes tapering upward; white, occasionally flushed pink, particularly near base. Iron reaction pink. **HABITAT** Usually deciduous woodland but occasionally with conifers. **STATUS** Widespread but occasional.

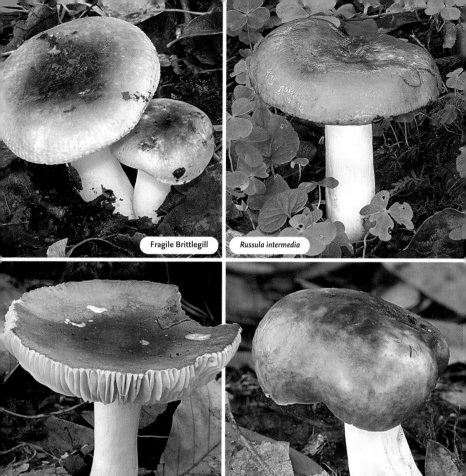

Fragile Brittlegill

Russula intermedia

Beechwood Sickener

Russula silvestris

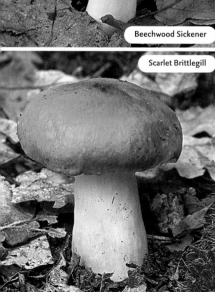

Scarlet Brittlegill

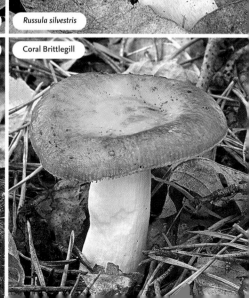

Coral Brittlegill

Purple Brittlegill *Russula atropurpurea* (Top 100)

Medium-sized brittlegill with a shiny purple cap. **CAP** To 10cm across; hemispherical, becoming convex or flat with a depressed centre; purple or wine-red, and almost black in centre; sometimes mottled with cream, particularly at margin; up to ½ peeling. **GILLS** Adnexed; crowded; pale cream then darker, with a whitish spore print. Faint smell of apples and a slightly hot taste. **STIPE** To 6cm long; cylindrical or slightly club-shaped; white, sometimes greyish, and discolouring light brown. Iron reaction pink. **HABITAT** Usually deciduous woodland (sometimes conifers) on acid soil. **STATUS** Widespread and very common.

Russula integra

Rare, fleshy brittlegill with a variable cap colour; restricted to Caledonian pinewoods. **CAP** To 12cm across; hemispherical, becoming convex or flatter with a shallow depressed centre; margin slightly grooved; variable mixture of colours, including purple, olive, yellow and wine on a brownish ground; ½ peeling. **GILLS** Adnexed; cream to yellow-ochre with a paler edge; spore print dark ochre. **STIPE** To 10cm long; cylindrical or slightly club-shaped; white, discolouring ochre. Iron reaction pink. **HABITAT** Pine and birch woods. **STATUS** Uncommon to rare.

Purple Swamp Brittlegill *Russula nitida*

Fragile brittlegill with washed-out colours and a conspicuously grooved margin. **CAP** To 6cm across; convex, becoming flat with an indented centre and occasionally umbonate. Variable colour, usually wine-red or reddish brown with olive tones but fading with age; up to ⅔ peeling. **GILLS** Adnexed or free; distant; cream, becoming ochre and occasionally flushed red near margin; spore print ochre. **STIPE** To 7cm long; cylindrical or slightly club-shaped; white, flushed pink or red from base upward. Iron reaction dull pink. **HABITAT** Birch or pine woodland and heathland on acid soils; occasionally with *Sphagnum* moss. **STATUS** Widespread and common.

Yellowing Brittlegill *Russula puellaris*

Similar to Purple Swamp Brittlegill but entire fruit body discolours yellow. **CAP** To 5cm across; hemispherical, becoming convex or flatter with a depressed centre; margin furrowed; wine, purple or reddish shades of brown with a darker centre; fading noticeably; ⅔ peeling. **GILLS** Adnexed or free; cream, becoming darker and discolouring; spore print cream. **STIPE** To 6cm long; cylindrical or slightly club-shaped; white but discolouring yellow. Iron reaction pink. **HABITAT** Mixed deciduous and coniferous woodland. **STATUS** Widespread but occasional.

Bloody Brittlegill *Russula sanguinaria* (= *R. sanguinea*)

Similar to Scarlet Brittlegill (p. 76), but that species has a darker spore print and is generally found with oaks. **CAP** To 10cm across; hemispherical, becoming flat with a shallow depressed centre; margin hardly furrowed; blood-red or deep pink, fading to cream in places and flushing yellow; barely peeling. **GILLS** Adnate or decurrent; cream, becoming ochre and with a cream spore print. Slightly fruity smell and moderately hot or bitter taste. **STIPE** To 6cm long; cylindrical, sometimes with a tapered base; white, flushed red and discolouring yellowish. Iron reaction pink. **HABITAT** Conifer woods (mainly pine). **STATUS** Widespread and common.

Russula aquosa

Recalls Fragile Brittlegill (p. 76) but has a milder taste. **CAP** To 7cm across; hemispherical, becoming flat with a depressed centre; margin faintly grooved; carmine-red with purplish tones and a darker or brownish centre; almost entirely peeling. **GILLS** Adnexed; creamy white with a white spore print. Flesh is soft and watery with pleasant fruity smell and only moderately hot taste. **STIPE** To 8cm long; cylindrical or widening towards base; white, maturing greyish ochre. Iron reaction pink. **HABITAT** Damp deciduous and coniferous woodland, marshy places, often with *Sphagnum* moss. **STATUS** Widespread but uncommon.

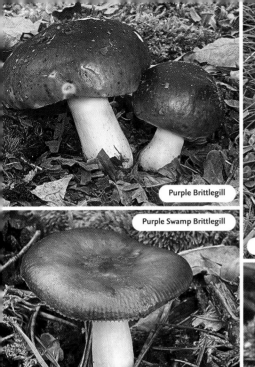

Purple Brittlegill

Purple Swamp Brittlegill

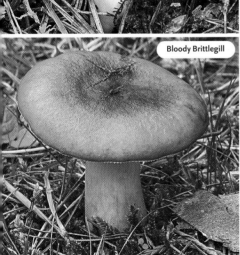

Bloody Brittlegill

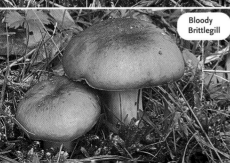

Bloody Brittlegill

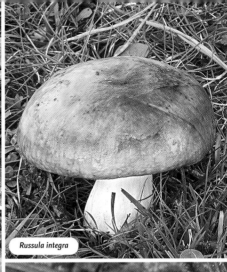

Russula integra

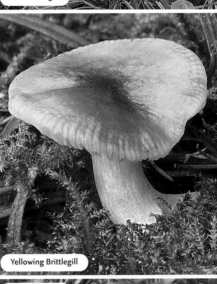

Yellowing Brittlegill

Russula aquosa

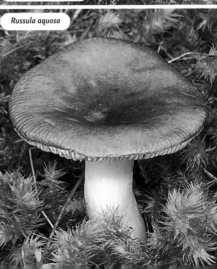

The parasols are now divided into two genera that share many field characteristics. The caps are various shades of brown and break up into large or fine scales that radiate out from the persistent centre, with the underlying paler flesh showing through. The gills are crowded and free, with a white spore print. The stipe is usually relatively slender and cylindrical, and tapers upward from a bulbous base. Most have a thick double ring that becomes detached and can slip up and down the stipe. Parasols are usually found singly or in small groups in late summer and autumn.

Parasol *Macrolepiota procera*

Distinctive statuesque mushroom with a long, slender stipe and wide cap that resembles a parasol. **CAP** To 25cm across; spherical to flat and umbonate; whitish ground covered in reddish-brown scales radiating out from a central disc. **GILLS** White but discolouring. **STIPE** To 30cm long; fawn ground covered in fine, dark brown scales that break up below ring to give a snakeskin-like effect. Collar-like moveable ring with a fringed brownish edge. **HABITAT** In grass, often on roadside verges and in clearings in deciduous woodland. **STATUS** Widespread and common.

Macrolepiota excoriata

Recalls the Parasol, but smaller and paler with a less well-defined central disc. **CAP** To 10cm across; oval, becoming flattish convex and sometimes umbonate; surface pale hazel or ochre, covered in fine scales that break apart at cap edge to reveal white ground beneath. **GILLS** White or cream. **STIPE** To 7cm long; white and smooth with surface discolouring brownish. Single, thin, moveable white ring with fringed brownish margin. **HABITAT** In grass, meadows, pastures and woodland glades. **STATUS** Widespread but occasional.

Macrolepiota konradii

Similar to the Parasol (*see* above) but central disc on cap breaks up into a cogwheel- or star-shaped pattern. **CAP** To 10cm across; oval, becoming flat with a depressed centre and small umbo; margin incurved and appendiculate; cream ground covered in reddish-brown scales with a central star-shaped pattern. **GILLS** White or cream. **STIPE** To 15cm long; surface covered in fine brown scales that form an indistinct zigzag pattern. White collar-like double ring. **HABITAT** Open woodland, copses and grassy areas. **STATUS** Uncommon.

Slender Parasol *Macrolepiota mastoidea* (= *M. gracilenta*)

Medium-sized slender parasol. **CAP** To 12cm across; rounded, becoming flattish convex with a darker, nipple-like umbo; white or cream ground covered in tiny coffee-coloured scales that become scarcer towards margin. **GILLS** Whitish. **STIPE** To 10cm long; cylindrical and slender; white or cream with surface densely covered in pale ochre scales. Thin white ring with brown upper surface. **HABITAT** In open deciduous woodland and grassy places. **STATUS** Occasional; more frequent in S.

Shaggy Parasol *Chlorophyllum (Macrolepiota) rhacodes*

Although in a different genus it resembles the Parasol (*see* above), but is stouter, with more shaggy scales on the cap and lacking the snakeskin-like markings on the stipe. **CAP** To 18cm across; spherical or convex, becoming flat; surface densely covered in large, upturned brown scales on a paler ground with a smooth central disc. Flesh reddening when cut. **GILLS** White or cream, discolouring brown. **STIPE** To 15cm long; stout, smooth and whitish but readily discolouring brown. Thick, moveable double ring. **HABITAT** Woodland, parks and gardens. **STATUS** Widespread and common. **SIMILAR SPECIES** *C. brunneum* (= *M. rhacodes* var. *hortensis* or *M. r.* var. *bohemica*) is scarcer and stouter, with cap covered in large, irregular reddish-brown scales on a whitish ground. Found in rich soil, including gardens and compost heaps.

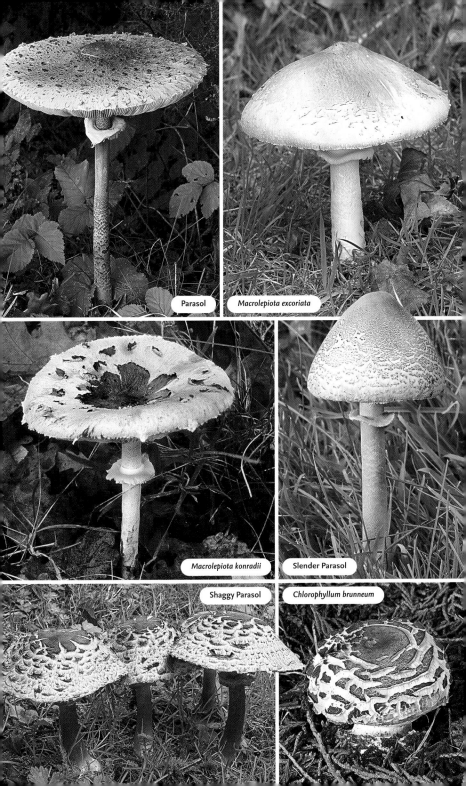

Parasol

Macrolepiota excoriata

Macrolepiota konradii

Slender Parasol

Shaggy Parasol

Chlorophyllum brunneum

Members of the genus *Lepiota* are generally much smaller than *Macrolepiota* species but share many of their field characteristics. Most are densely covered in warts or scales in various shades of brown, these disrupting concentrically from a darker central disc and becoming more dispersed towards the margin to reveal the underlying paler flesh. The gills are free and generally crowded, with a white spore print. The stipe is equal and cylindrical, and usually ends in a thickened base. Dapperlings are generally found singly or in small groups in late summer and autumn.

Lepiota hystrix

Medium-sized dapperling with dark brown pyramidal scales on cap and a distinctive dark brown edge to gills. **CAP** To 6cm across; convex, but becoming flatter with an inrolled and overhanging margin; occasionally broadly umbonate; surface is covered with concentric scales on a pale ground. **GILLS** Crowded and narrow, not forked; white or cream. **STIPE** To 6cm long; white; fibrillose above annular zone, and below with crowded dark brown scales on a lighter ground. Ring narrow, with lower surface brown and woolly. **HABITAT** Deciduous woodland. **STATUS** Uncommon.

Freckled Dapperling *Lepiota aspera*

Similar to *L. hystrix* but commoner and lacking the coloured gill edge. **CAP** To 10cm across; conical, becoming flatter with an incurved margin; surface densely covered with concentric brown scales on a white or cream ground; scales conical at first but becoming flattened. **GILLS** Many forked, particularly near stipe; white or cream. **STIPE** To 6cm long, with a small bulb; white, with light brown fibrils above ring and darker below. Pendulous whitish ring with woolly lower surface, often remaining attached to cap edge. **HABITAT** Deciduous woodland, very occasionally on decayed wood. **STATUS** Common in S England. **SIMILAR SPECIES** *L. echinacea* is scarcer and smaller, with a less well-developed ring and a preference for calcareous woodland.

Lepiota fuscovinacea

Medium-sized dapperling with vinaceous-brown tones. **CAP** To 5cm across; hemispherical, becoming flatter and slightly undulating, with an incurved and projecting margin; surface covered in large, irregular vinaceous-brown scales on a paler ground. **GILLS** White or cream but discolouring. **STIPE** To 6cm long; enlarged towards base; surface above ring is white to pale pink, and below is concolorous but covered in darker woolly scales, particularly when young. Ring insignificant. **HABITAT** Mixed woodland on calcareous soils. **STATUS** Uncommon.

Green Dapperling *Lepiota grangei*

Distinctive small dapperling with greenish colours to cap and orange on lower half of stipe. **CAP** To 3cm across; broadly conical but becoming flatter; darker green centre on a cream ground, covered in fine brown or green scales, these becoming paler and scarcer towards the appendiculate margin. **GILLS** Cream. **STIPE** To 6cm long; cylindrical with a swollen base; cream-coloured and covered with green or brown scales, these coarser and more prominent towards base, which discolours orange. Ring insignificant. **HABITAT** Deciduous woodland. **STATUS** Widespread but uncommon.

Lepiota pseudolilacea (= *L. pseudohelveola*)

Not unlike the very common Stinking Dapperling (p. 84) but lacking its unpleasant smell. **CAP** To 3cm across; convex, becoming flatter and slightly umbonate; surface covered in concentric brown scales on a paler ground. **GILLS** White. **STIPE** To 4cm long, with a slightly thickened base; white, flushed pinkish brown. Concolorous ring with lower part brown. **HABITAT** Deciduous woodland; occasionally on grass where trees are present. **STATUS** Widespread and fairly common in England. **SIMILAR SPECIES** *L. felina* has darker scales and a preference for coniferous woodland.

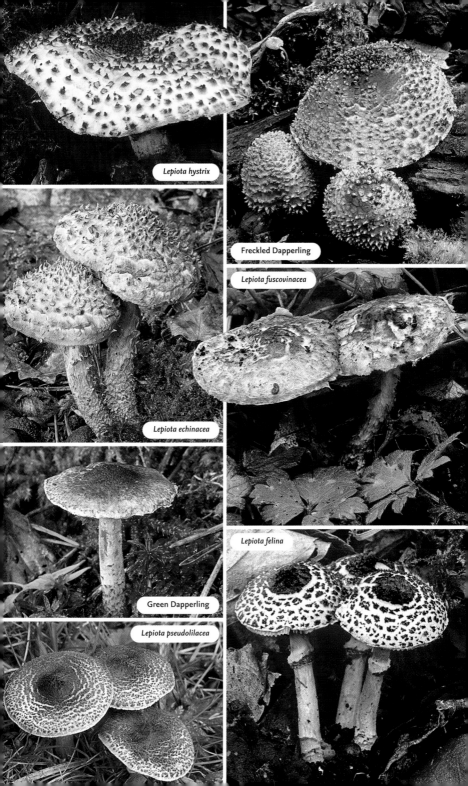

Lepiota hystrix

Freckled Dapperling

Lepiota fuscovinacea

Lepiota echinacea

Lepiota felina

Green Dapperling

Lepiota pseudolilacea

Lepiota oreadiformis

Small, pale dapperling whose cap surface appears smooth superficially but is covered with fine, indistinct scales (use a hand lens). CAP To 4cm across; flattish convex; cream to light ochre with a slightly darker central area. GILLS White, ageing light ochre. STIPE To 5cm long; cylindrical; surface covered in pale cottony fibrils and with an indistinct ring zone. HABITAT Acidic grassland. STATUS Uncommon.

Lepiota erminea (= L. alba)

Pale dapperling, similar to *L. oreadiformis* but even paler. CAP To 5cm across; broadly conical, becoming convex to flat with an obtuse umbo; white or cream with a slightly darker, ill-defined central area; smooth at first but becoming fleecy, especially at margin. GILLS White or cream. STIPE To 6cm long; cylindrical with a pointed base; surface white and fleecy on a pale brown ground. Short-lived white ring. HABITAT Sandy grassland; frequent in coastal dunes. STATUS Widespread but uncommon.

Stinking Dapperling *Lepiota cristata* (Top 100)

By far the most common dapperling. Very variable, with several different varieties described, including a very pale form. Differs from similar *Lepiota* species by its strong, unpleasant smell. CAP To 4cm across; hemispherical, then convex to flat with a blunt umbo; white or cream ground covered in concentric, flattened reddish-brown scales radiating from a concolorous central disc and becoming more dispersed towards incurved and sometimes appendiculate margin. GILLS White to cream, discolouring with age. STIPE To 5cm long; cylindrical; occasionally with an enlarged base; white, smooth above ring zone and fibrillose below; discolouring with age. White ascending ring. HABITAT Deciduous woodland, scrub, gardens and waste ground. STATUS Widespread and very common.

Chestnut Dapperling *Lepiota castanea*

Small chestnut-coloured dapperling with a distinctive upturned margin. CAP To 4cm across; conical, becoming flat with a small umbo; surface with concentric bay or chestnut-brown scales on a paler ground; the scales are formed by minute tufts of hair (use a hand lens); centre dark brown. GILLS Cream, discolouring brownish. STIPE To 4cm long; cylindrical with a slightly thickened base; concolorous with cap and scaly up to inconspicuous ring zone. HABITAT Deciduous woodland. STATUS Widespread, particularly on calcareous soils, but occasional.

Lepiota magnispora (= L. ventriosospora)

Medium-sized dapperling with thick, shaggy pinkish-ochre scales on lower half of stipe. CAP To 8cm across; hemispherical, becoming flat with a broad umbo and appendiculate margin; ochre ground covered with orange or brown scales, and with a darker, smooth centre. GILLS White or cream. STIPE To 4cm across; concolorous with cap, covered in large ochreous woolly scales, especially in lower half. Ring generally indistinct. HABITAT Mixed deciduous and coniferous woodland. STATUS Widespread but occasional. SIMILAR SPECIES Shield Dapperling *L. clypeolaria* has a white fleecy stipe and a preference for deciduous woodland on calcareous soils.

Lepiota ignivolvata

Medium-sized, robust dapperling with distinctive orange or brown edges to annular zones on stipe. CAP To 10cm across; hemispherical, becoming convex or flat with a broad umbo; surface covered in small, concentric ochre-brown scales on a paler ground and with a darker, smooth centre; margin appendiculate. GILLS White or cream. STIPE To 12cm long; sometimes bent, with a slightly bulbous base; surface white and wreathed in oblique cottony rings with coloured edges; discolours brownish when bruised or old. HABITAT Mixed deciduous and coniferous woodland, particularly with Beech. STATUS Uncommon.

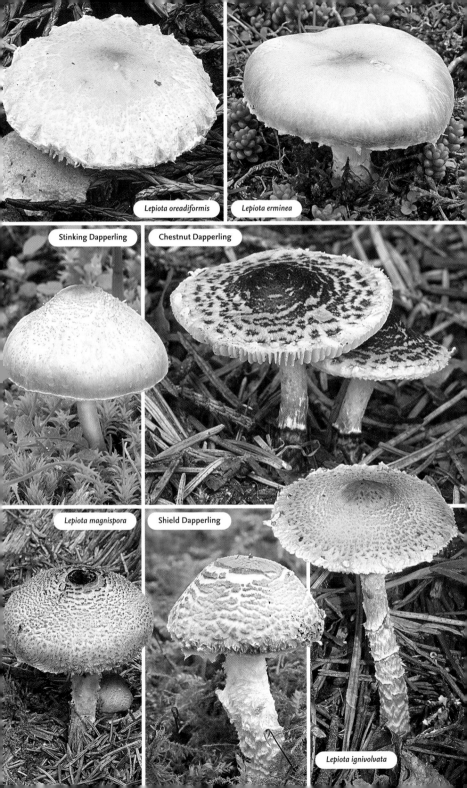

Lepiota oreadiformis

Lepiota erminea

Stinking Dapperling

Chestnut Dapperling

Lepiota magnispora

Shield Dapperling

Lepiota ignivolvata

Cystolepiota adulterina

Small cream or light brown dapperling that discolours pinkish brown. **CAP** To 3cm across; hemispherical, becoming convex or flatter; surface densely covered in light brown scales on a cream or pale beige ground that becomes darker with age. **GILLS** Cream. **STIPE** To 4cm long; cylindrical and slender with a slightly widened base; white or beige; smooth above an indistinct annular zone and woolly to floccose below, which is easily rubbed off. **HABITAT** Mixed woodland, particularly with Beech, in calcareous soil; also associated with ground cover of Dog's Mercury. **STATUS** Uncommon. **SIMILAR SPECIES** *C. seminuda* is found in the same habitat. It is smaller and white with a cream centre, and lacks scales but is covered in a mealy powder when young.

Lilac Dapperling *Cystolepiota bucknallii*

Attractive, small lilac dapperling with a powdery surface when young and an unpleasant smell of coal gas. **CAP** To 4cm across; broadly conical, becoming flatter; margin appendiculate; shades of violet when young, becoming cream or ochre with age; violet colour intensifies on bruising. **GILLS** Cream or white. **STIPE** To 4.5cm long; cylindrical and slender; concolorous with cap. Short-lived annular zone. **HABITAT** Mixed deciduous woodland and scrub on calcareous soil. **STATUS** Uncommon; more frequent in S.

Cystolepiota moelleri (= C. rosea)

Small rosy-coloured dapperling with a mealy surface. **CAP** To 3cm across; broadly conical, then expanded with a pronounced overhanging, appendiculate margin, giving it a toothed appearance; pink, becoming browner with age; surface mealy. **GILLS** White or cream. **STIPE** To 6cm long; cylindrical; concolorous with cap below indistinct ring zone and white above. Narrow, short-lived ring. **HABITAT** Mixed woodland on calcareous soil. **STATUS** Widespread but uncommon.

White Dapperling *Leucoagaricus leucothites*

Strongly resembles white species of *Agaricus* and *Amanita*, but lacks the pink or brown gills of the former and volva of the latter. **CAP** To 6cm across; convex, expanding with a somewhat flattened central disc and appendiculate margin; white silky-smooth surface, discolouring with age. **GILLS** Crowded; greyish but becoming pinkish. **STIPE** To 8cm long; cylindrical with a small bulbous base; concolorous with cap; smooth above ring and longitudinally fibrillose below. Detachable ring. **HABITAT** Grass and grassy areas in woodland; sometimes gardens and roadsides in urban areas. **STATUS** Widespread and fairly common.

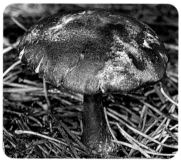

Blushing Dapperling *Leucoagaricus badhamii*

Medium-sized dapperling that dramatically discolours blackish brown with age and reddish when bruised. **CAP** To 8cm across; conical, then flatter with an umbo and appendiculate margin; creamy white, becoming increasingly spotted red or brown, particularly in centre; slightly scaly. **GILLS** White but discolouring. **STIPE** To 8cm long; somewhat club-shaped; white or cream but discolouring. Fragile ascending ring. **HABITAT** Mixed woodland on calcareous soil; occasionally with woodchip mulch in flowerbeds. **STATUS** Widespread but occasional in England.

Skullcap Dapperling *Leucocoprinus brebissonii*

Small, delicate dapperling with a contrasting central disc and deeply striate or grooved margin. **CAP** To 4cm across; convex, becoming flatter; white with a dark brown centre and concolorous scales, these becoming dispersed and paler towards margin. **GILLS** White. **STIPE** To 5cm long; cylindrical, thickening towards base; white with a floury surface. Fragile white ring. **HABITAT** Mixed woodland, particularly where conifers are present. **STATUS** Widespread but occasional.

Leucocoprinus cretaceus See p. 336.

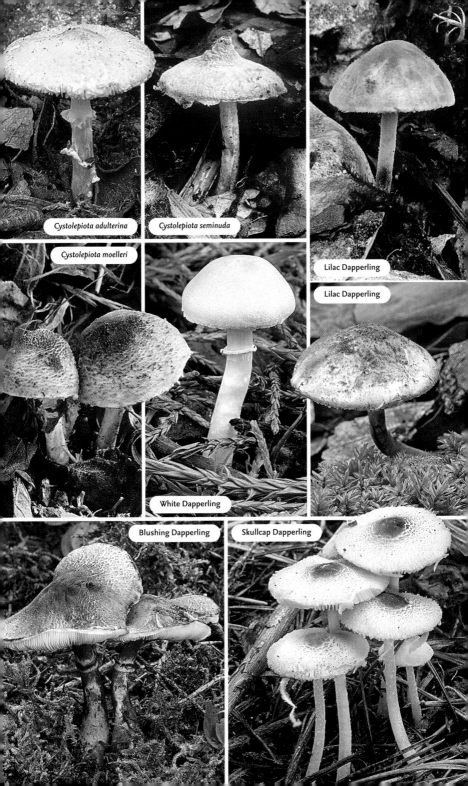

Cystolepiota adulterina

Cystolepiota seminuda

Cystolepiota moelleri

Lilac Dapperling

Lilac Dapperling

White Dapperling

Blushing Dapperling

Skullcap Dapperling

Earthy Powdercap *Cystoderma amianthinum*
The most common powdercap, found in a wide variety of habitats. Variable in texture and colour, ranging from pale yellow to dark reddish brown. **CAP** To 5cm across; broadly conical, becoming flattened-convex with an appendiculate margin; sometimes umbonate; surface finely granular or wrinkled in var. *rugosoreticulatum*. **GILLS** Adnate; white or cream. **STIPE** To 5cm long; cylindrical; concolorous with cap, covered in fine scales above ring and coarsely scaly below. Short-lived fleecy ring. **HABITAT** Deciduous and coniferous woodland, and in mosses and grass on heathland and moorland. **STATUS** Widespread and common.

Cystoderma granulosum
Very similar to Earthy Powdercap but generally darker. **CAP** To 5cm across; convex, becoming flat and sometimes undulating; dark reddish brown with a granular surface; margin paler and appendiculate. **GILLS** Adnexed; white or cream. **STIPE** To 6cm long; cylindrical; concolorous with cap, but paler and somewhat smooth above ring zone and scaly below. Short-lived fleecy ring. **HABITAT** Woodland on acidic soil and heathland, usually with pines and Heather. **STATUS** Widespread but occasional. **SIMILAR SPECIES** *C. jasonis* is slightly paler in colour, with the cap margin adorned with veil remnants when young. Microscopic examination is needed to separate these species with certainty.

Pearly Powdercap *Cystoderma carcharias*
Easily identified member of the genus, with a pale colour and strong, gas-like smell. **CAP** To 6cm across; broadly conical, becoming flat with a blunt umbo and appendiculate margin; surface finely granular or wrinkled; white, flushed pink and with a darker umbo. **GILLS** Adnate; white or cream. **STIPE** To 6cm long; cylindrical; concolorous with cap; smooth above ascending, persistent ring and granular below. **HABITAT** Woodland, usually with conifers; occasionally in mossy grassland in upland areas. **STATUS** Uncommon to rare.

Greenspored Dapperling *Melanophyllum eyrei*
Unmistakable small dapperling with distinctively coloured gills and spore print. **CAP** To 3cm across; hemispherical, becoming flat with an appendiculate margin; dingy white, sometimes with a brownish centre; surface granular or powdery. **GILLS** Bluish green with a pale green spore print; free. **STIPE** To 3cm long; slender; similar in colour and texture to cap. No ring. **HABITAT** Usually deciduous woodland with scrub on calcareous soil. **STATUS** Uncommon to rare. **SIMILAR SPECIES** Redspored Dapperling *M. haematospermum* has red gills.

Redspored Dapperling

Greenspored Dapperling

Dewdrop Dapperling *Chamaemyces fracidus* (= *Drosella fracida*)
Oozes brownish droplets of moisture from cap, gills and stipe, causing spotty stains. **CAP** To 9cm across; convex, becoming flat with an appendiculate margin and blunt umbo; pale ochre to buff but with brown spots; surface greasy when moist, becoming dry and matt. **GILLS** White or cream; free. **STIPE** To 6cm long; concolorous with cap, and with brownish spots concentrated below short-lived ring zone. **HABITAT** Deciduous woodland, particularly on calcareous soil; occasionally in grass. **STATUS** Uncommon.

Powdercap Strangler *Squamanita paradoxa*
One of our most remarkable species. Parasitic on Earthy Powdercap (*see* above), it takes over the host and replaces the cap and gills with its own but retains the original stipe, creating in effect a hybrid between the two. **CAP** To 3cm across; convex, becoming flatter and somewhat undulating; greyish brown with violet tints; surface covered in shaggy scales. **GILLS** White but discolouring. **STIPE** To 7cm long; cylindrical. Merges with host's stipe but with a clear division between the two parts: upper (*Squamanita*) part is paler than cap and covered in darker scales; for lower (*Cystoderma*) part, *see* Earthy Powdercap description above. **HABITAT** As for Earthy Powdercap (*see* above). **STATUS** Extremely rare.

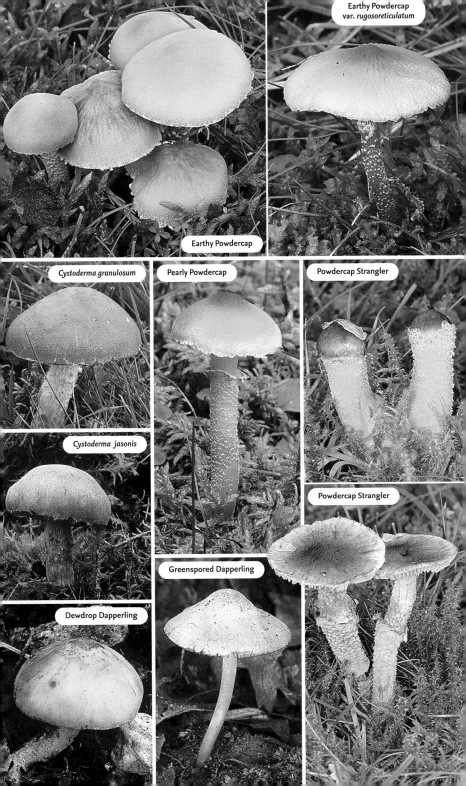

Earthy Powdercap
var. *rugosoreticulatum*

Earthy Powdercap

Cystoderma granulosum

Pearly Powdercap

Powdercap Strangler

Cystoderma jasonis

Powdercap Strangler

Greenspored Dapperling

Dewdrop Dapperling

The genus *Amanita* includes some of our most poisonous mushrooms. Species are generally medium-sized and typically mushroom-shaped, and come in a variety of colours. One of the most distinctive features is the presence of both a universal and partial veil, and as a consequence many species have a ring and remnants of the ruptured universal veil adhering to the cap and stipe. Another feature is a volva, which may be large and bag-like or insignificant and deeply buried. Gills are generally free or adnexed, and the spore print is white. Amanitas should not be tasted and most lack any distinctive smell. They are generally found in late summer and autumn. Species within the grisette group (p. 94) lack a ring.

Fly Agaric *Amanita muscaria* (Top 100)

Probably the most easily recognised mushroom in the British Isles, with a scarlet cap spotted with conical white fleecy scales. **CAP** To 20cm across; hemispherical, then convex and finally flat. Margin somewhat striate. The fugitive cap colour fades to orange or yellow with age or after heavy rain, which can also wash off the white scales. Not to be confused with the rare form var. *aureola*, which is naturally orange and lacks velar scales. **GILLS** Crowded; white. **STIPE** To 23cm long; cylindrical, with a bulbous base encased in a small volva and covered in scales. Ring pendulous, with a scaly edge. **HABITAT** In acidic woodland, particularly where birches are present. **STATUS** Widespread and very common in its favoured habitat.

Blusher *Amanita rubescens* (Top 100)

Variable *Amanita*, discolouring reddish when damaged or bruised. **CAP** To 15cm across; hemispherical, then convex and finally flat. Variable colours, from pinkish ivory to reddish brown, and covered in reddish or grey velar scales. **GILLS** White but becoming reddish where damaged. **STIPE** To 15cm long; cylindrical, tapering to a bulbous base. White above ring, but flushed with cap colour and floccose below. Large pendulous ring with striate upper surface. **HABITAT** Mixed deciduous woodland, particularly where birches are present. **STATUS** Widespread and very common. **NOTE** Var. *annulosulphurea* is less common and has a yellow ring.

Grey Spotted Amanita *Amanita excelsa* var. *spissa*

Similar to, and much confused with, the Blusher, but lacks the red discoloration and has an unpleasant radish-like smell. **CAP** To 10cm across; spherical, becoming convex or flat. Grey to shades of brown, covered in patches or spots of grey velar remains. **GILLS** Crowded; white. **STIPE** To 12cm long; club-shaped, ending in a bulbous base. White or greyish and lined above ring, white and scaly below. Large, pendulous ring with striate upper surface. **HABITAT** Deciduous or mixed woodland. **STATUS** Widespread and common. **NOTE** The form var. *excelsa* is less common, more slender and lacks the unpleasant smell.

Grey Veiled Amanita *Amanita porphyria*

Relatively slender, smoky-grey *Amanita* with lilaceous tints. **CAP** To 8cm across; convex, becoming flat. Shades of grey to reddish brown, and irregularly and fugaciously covered with velar remains. **GILLS** Crowded; white or greyish. **STIPE** To 10cm long; cylindrical and widening towards bulbous base. Ring pendent with striate upper surface, but short-lived and soon collapsing against stipe. **HABITAT** Mixed acidic woodland and, occasionally, heathland; usually associated with pines. **STATUS** Uncommon; probably more frequent in N.

Amanita franchetii (= *A. aspera*)

Yellowish-brown *Amanita*, easily confused with other brown-capped species but with a yellow universal veil. **CAP** To 8cm across; hemispherical, becoming flat and covered with greyish-yellow velar remains. **GILLS** White. **STIPE** To 9cm long; cylindrical, widening to a somewhat rounded base. Whitish and faintly striate above ring, banded with yellow squamules below. Ring large and pendent with brownish scales on margin. **HABITAT** Mixed deciduous woodland. **STATUS** Uncommon.

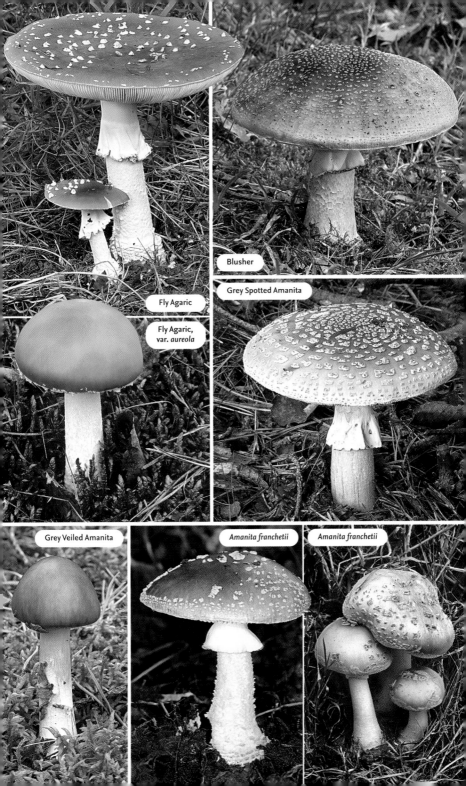

Blusher

Grey Spotted Amanita

Fly Agaric

Fly Agaric,
var. *aureola*

Grey Veiled Amanita

Amanita franchetii

Amanita franchetii

Deathcap *Amanita phalloides*

One of the most poisonous mushrooms in the British Isles. **CAP** To 12cm across; hemispherical, then convex to flat. Generally shades of yellow or green, or white in var. *alba*. Veil remnants rapidly disintegrate, leaving a smooth, shiny surface. **GILLS** Crowded; white. **STIPE** To 15cm long; cylindrical, widening downward into a persistent, large, bag-like white volva. White but mottled with cap colour below ring zone. Ring pendulous, fragile and short-lived. **HABITAT** Deciduous woodland, particularly where oaks and Beech are present. **STATUS** Occasional; more frequent in S, where it is widespread.

Panthercap *Amanita pantherina*

This very poisonous *Amanita* is similar to Grey Spotted Amanita (p. 90), but with white velar scales on cap and a distinctive girdle on lower part of stipe. **CAP** To 10cm across; hemispherical to flat or convex. Shades of brown, with veil remnants evenly spaced and more concentrated at centre. Margin incurved and normally striate. **GILLS** Crowded; white. **STIPE** To 10cm long; cylindrical, widening downward into a tight-fitting volva that has a prominent rim and is ringed by diagonal woolly bands. Ring pendulous and thin. **HABITAT** Deciduous woodland, usually with oaks and Beech. **STATUS** Widespread but occasional.

False Deathcap *Amanita citrina* (Top 100)

Although poisonous, not as dangerous as the Deathcap (*see* above). Generally more slender than that species, with persistent, irregular ochreous veil remnants on cap and a strong smell of raw potatoes. **CAP** To 10cm across; hemispherical, then flat. Ivory or yellowish, but white in var. *alba*. **GILLS** Crowded; yellowish white. **STIPE** To 8cm long; cylindrical, thickening downward into a bulbous base that is fringed by rim of volva. Ring pendulous. **HABITAT** Deciduous and mixed woodland. **STATUS** Widespread and common.

Destroying Angel *Amanita virosa*

Another poisonous white *Amanita*, recalling some white edible species of *Agaricus*. **CAP** To 10cm across; broadly conical, but developing unevenly and becoming flatter with a lopsided appearance. Greasy when moist and silky when dry, with an inrolled margin sometimes fringed with veil remnants. **GILLS** Crowded; white. **STIPE** To 12cm long; cylindrical with a basal bulb and bag-like volva; white. Surface below ring floccose. Ring fugacious and pendulous. **HABITAT** Mixed woodland. **STATUS** Uncommon; most frequent in Scotland, where it is widespread.

Jewelled Amanita *Amanita gemmata*

Bright, colourful *Amanita* with velar remnants on cap and very fugacious ring that is absent in many mature specimens. **CAP** To 7cm across; hemispherical, becoming convex to flat. Pale or yolk-yellow; velar remains eventually disappear leaving a glabrous surface. Margin somewhat striate. **GILLS** Crowded; white. **STIPE** To 10cm long; cylindrical with basal bulb encased in a short, thin volva. White and floccose below annular zone and smooth above. **HABITAT** Open mixed woodland, often with birches and pines. **STATUS** Widespread, but uncommon to rare.

Solitary Amanita *Amanita echinocephala* (= A. solitaria)

Sturdy *Amanita* whose cap is covered in pyramidal scales and, occasionally, with faint greenish tints. **CAP** To 20cm across; spherical, then convex or flat. White or pale coffee-coloured. Becoming smooth with age as veil remnants wear off. **GILLS** White but yellowing. **STIPE** To 15cm long; cylindrical, widening to a deeply rooted, swollen base that is encircled by bands of scales. Smooth above ring and woolly below. Ring large and pendulous, with striations on upper surface. **HABITAT** Warm, dry calcareous soil with grass and deciduous trees. **STATUS** Rare; mostly in S. **SIMILAR SPECIES Warted Amanita** *A. strobiliformis* is found in similar habitats. Its cap and stipe are covered in a soft veil that hangs down from the cap edge.

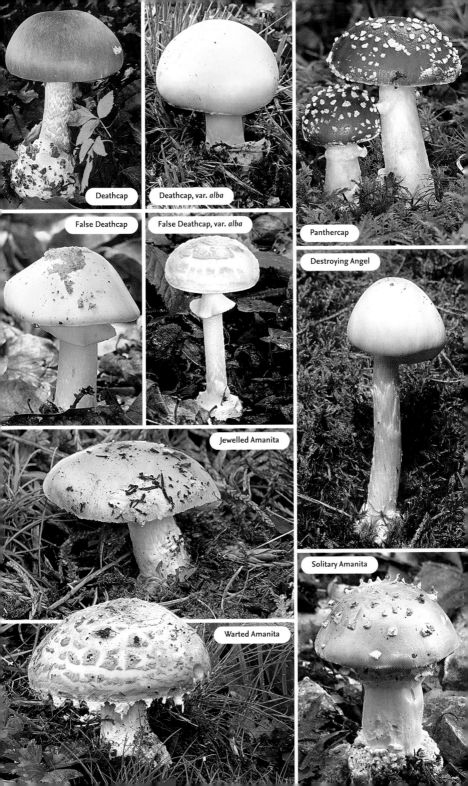

Deathcap

Deathcap, var. *alba*

Panthercap

False Deathcap

False Deathcap, var. *alba*

Destroying Angel

Jewelled Amanita

Warted Amanita

Solitary Amanita

Grisette *Amanita vaginata*

The type species of the grisette group. Variable, with numerous varieties and forms, lacking both a ring and veil remnants on cap. **CAP** To 12cm across; ovoid, becoming flat with a depressed centre and umbo. Various shades of grey, often with brownish tones and white in var. *alba*. Surface smooth and satiny with a deeply striated margin. **GILLS** Crowded; white. **STIPE** To 20cm long; cylindrical, widening downward into a woolly bag-like volva. Whitish, flushed with cap colour, and floccose. **HABITAT** Mixed deciduous woodland. **STATUS** Widespread but occasional. **SIMILAR SPECIES** *A. argentea* (= *A. mairei*) is silvery-grey and not umbonate; it is found in a similar habitat but is scarcer.

Tawny Grisette *Amanita fulva* (Top 100)

Bright grisette found in acid woodland. **CAP** To 10cm across; ovoid, soon becoming convex and then flat with a depressed centre and broad umbo. Orange or brown with a darker centre and lighter, deeply striated margin. Smooth and satiny. **GILLS** Crowded; white. **STIPE** To 12cm long; whitish; cylindrical, widening downward into a woolly bag-like volva flushed with cap colour. **HABITAT** Open deciduous woodland, sometimes heathland; often with birches. **STATUS** Widespread and common.

Orange Grisette *Amanita crocea*

Similar to Tawny Grisette but even more brightly coloured and with a strongly marked stipe. **CAP** To 10cm across; ovoid to hemispherical, becoming flat with an upturned margin that has a striate edge; often broadly umbonate. Yellowish orange to apricot. Smooth and satiny. **GILLS** Crowded; cream. **STIPE** To 15cm long; cylindrical, widening downward into a woolly white bag-like volva whose interior is flushed with cap colour. Stipe surface banded or mottled with cap-coloured squamules on a paler ground. **HABITAT** Open, mixed acidic deciduous woodland, especially with birches. **STATUS** Widespread but occasional.

Mountain Grisette *Amanita nivalis*

Small, rare grisette confined to upland regions. **CAP** To 8cm across; hemispherical, becoming convex with a broad umbo. Grey, beige or putty-coloured, with a smooth texture when dry and greasy when moist, sometimes flecked with veil remnants. Margin striate. **GILLS** Close; white, maturing cream. **STIPE** To 7cm long; cylindrical, widening downward into a scaly whitish bag-like volva. Surface smooth and concolorous with cap. **HABITAT AND STATUS** Rare; associated with Dwarf Willow in upland and N parts of region.

Snakeskin Grisette *Amanita ceciliae*

One of the larger grisettes, with distinctive grey scaly, snake-skin-like markings on stipe. **CAP** To 15cm across; convex, becoming flat, with a dull satiny surface covered with thick greyish veil remnants, these concentrated at centre. Yellowish brown but darker towards centre, and with a paler, striated margin. **GILLS** Adnate; crowded; white. **STIPE** To 20cm long; cylindrical, widening downward to an enlarged base girdled with oblique remnants of volva. **HABITAT** Deciduous woodland or scrub; occasionally grass where trees are present. **STATUS** Widespread but uncommon in S England.

Amanita battarrae

Medium grisette without veil remnants on cap, which separates it from the superficially similar *A. submembranacea* (not described). **CAP** To 10cm across; ovoid to expanded umbonate. In various shades of olive-brown with a darker ring at inside edge of marginal striations. Surface smooth. **GILLS** Close; whitish. **STIPE** To 12cm long; cylindrical, only slightly thickening to bag-like volva. Surface covered in fine brownish-grey markings on a pale ground. **HABITAT** Mixed deciduous and coniferous woodland. **STATUS** Uncommon to rare.

Dripping Slimecap *Limacella illinita* See p. 336.

Amanita inopinata See p. 336.

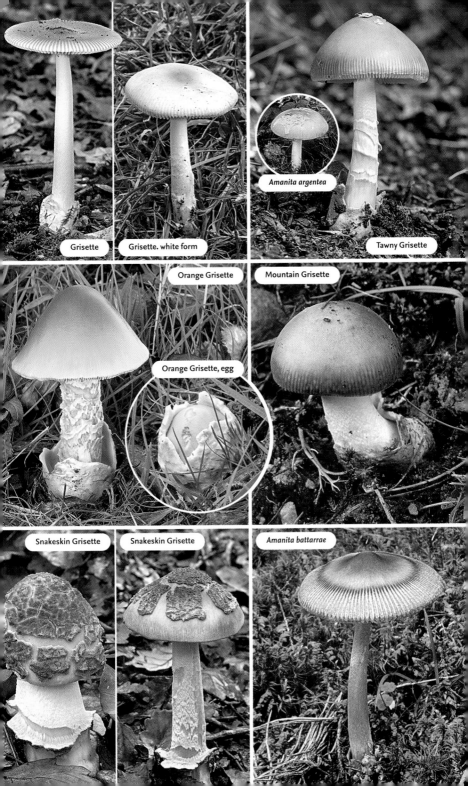

Grisette

Grisette. white form

Amanita argentea

Tawny Grisette

Orange Grisette

Mountain Grisette

Orange Grisette, egg

Snakeskin Grisette

Snakeskin Grisette

Amanita battarrae

The genus *Hygrocybe* includes some of our most colourful species. Intra-species colour variation means that this character is a less important aid to identification than cap and stipe texture, which may be dry, greasy or viscid. Spores are white. Most species favour unimproved grassland, particularly where it is grazed or cut; they fruit in late summer and continue through to very late autumn.

Golden Waxcap *Hygrocybe chlorophana* (Top 100)

Medium-sized yellow waxcap with a viscid cap and dryish stipe. **CAP** To 7cm across; convex to flat; bright lemon-yellow, rarely orange; viscid and slightly striate. **GILLS** Adnate and decurrent; broad; whitish, maturing yellow or orange; paler than cap. **STIPE** To 8cm long; cylindrical or compressed, with longitudinal grooves; same colour as cap or slightly paler. Surface usually dry and smooth but sometimes moist, particularly when handled. **HABITAT** Grassland. **STATUS** Widespread and common.

Heath Waxcap *Hygrocybe laeta*

Small to medium waxcap with a viscid cap, stipe and gill edge; smells of burnt rubber. **CAP** To 5cm across; flattened to convex, often with a depressed centre. Dull brownish orange, often with narrow, pale margin and translucent striations. **GILLS** Decurrent; greyish. **STIPE** To 6cm long; similar colour as cap or paler, with a greyish apex. **HABITAT** Unimproved acid grassland and heaths. **STATUS** Widespread and common, especially in N and W.

Crimson Waxcap *Hygrocybe punicea*

Large, fleshy waxcap with a greasy cap and thick, fibrillose stipe. **CAP** To 15cm across; convex to flat and broadly umbonate. Red, tinged brown; margin sometimes yellowish, turning buff. **GILLS** Adnate, sometimes with a decurrent tooth; distant. Yellowish, becoming flushed with cap colour. **STIPE** To 15cm long; thick, cylindrical, dry and coarsely fibrillose. Yellow, flushed with red, becoming paler towards pointed base. **HABITAT** Improved and unimproved grassland. **STATUS** Widespread and common.

Splendid Waxcap *Hygrocybe splendidissima*

Medium to large, bright red waxcap; size and shape variable. Recalls Crimson Waxcap but with an irregular, compressed, twisted stipe. Smells of honey when dried. **CAP** To 10cm across; scarlet; broadly conical, then flattening. Dry or only slightly greasy. **GILLS** Adnate; same colour as cap but with a paler edge. **STIPE** To 10cm long; same colour as cap although lower base fades yellow. Stout, rather spindle-shaped and irregularly flattened, twisted and grooved; dry. **HABITAT** Upland grassland and moors. **STATUS** Occasional but locally common in N and W.

Splendid Waxcap

Scarlet Waxcap *Hygrocybe coccinea* (Top 100)

Medium-sized, variable scarlet waxcap with a greasy cap and dry stipe. **CAP** To 6cm across; bell-shaped at first, then convex or flat, occasionally with a small umbo (var. *umbonata*). Scarlet, fading with age. **GILLS** Broadly adnate; similar colour to cap with a paler edge. **STIPE** To 6cm long; cylindrical, occasionally with a longitudinal groove. Same colour as cap but sometimes paler towards base; dry. **HABITAT** Grassland. **STATUS** Widespread and common.

Scarlet Waxcap

Honey Waxcap *Hygrocybe reidii*

Small to medium-sized orange to orange-red waxcap. Smells of honey. **CAP** To 5cm across; convex, becoming flat with a depressed centre. Dry, matt and scaly, sometimes cracking. **GILLS** Broadly adnate to decurrent; distant; similar colour to cap or paler. **STIPE** To 5cm long; cylindrical, sometimes irregularly compressed and grooved. Similar colour to cap, often paler towards base. **HABITAT** Grassland. **STATUS** Widespread and common.

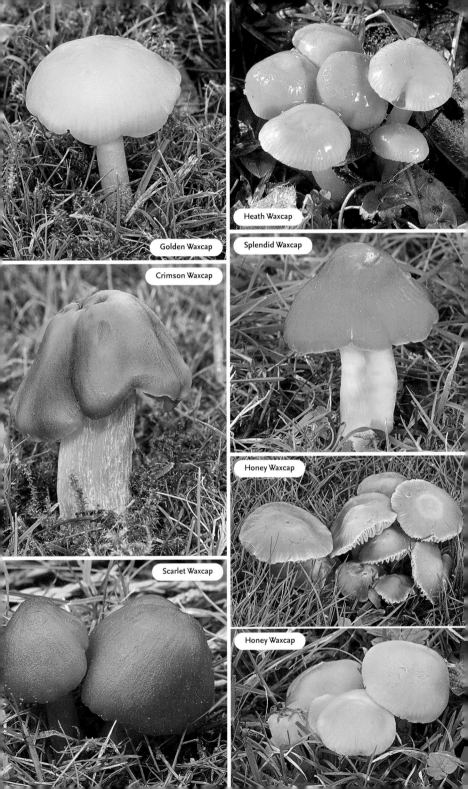

Golden Waxcap

Heath Waxcap

Splendid Waxcap

Crimson Waxcap

Honey Waxcap

Scarlet Waxcap

Honey Waxcap

Meadow Waxcap *Hygrocybe pratensis* (Top 100)

Distinctive medium to large waxcap with a dry, dull apricot or orange cap that has a lightly frosted appearance. **CAP** To 12cm across; hemispherical to broadly conical, sometimes umbonate; flattening with maturity. **GILLS** Very decurrent; distant and broad; paler than cap. **STIPE** To 15cm long; cylindrical, narrowing towards base; dry; whitish, flushed with cap colour (similar colour to gills). **HABITAT** Grassland. **STATUS** Widespread and common; usually found in groups. **NOTE** A white form var. *pallida* is common.

Meadow
Waxcap

Slimy Waxcap *Hygrocybe irrigata* (= *H. unguinosa*)

Small to medium-sized waxcap with subdued and varied colours, and a very viscid cap and stipe. **CAP** To 5cm across; campanulate to convex, in various shades of brown and dark grey, and usually translucent-striate. **GILLS** Adnate to short decurrent; ventricose; grey or white but distinctly paler than cap and stipe. **STIPE** To 10cm long; cylindrical, sometimes compressed and with longitudinal grooves. Paler than cap. **HABITAT** Grassland. **STATUS** Widespread and common.

Yellow Foot Waxcap *Hyrocybe flavipes*

Small to medium-sized waxcap with subdued colours and a distinctive yellowish base to stipe. **CAP** To 4cm across; convex to conical, flattening with maturity and even becoming infundibuliform. Margin translucent-striate. Various shades of grey to greyish brown, often with a paler edge. Greasy at first and hygrophanous. **GILLS** Decurrent to deeply decurrent. Similar in colour to cap, with a paler edge. **STIPE** To 5cm long; cylindrical sometimes tapering downward. Similar in colour to cap but paler and with a whitish bloom. **HABITAT** Grassland. **STATUS** Widespread but occasional.

Yellow Foot
Waxcap

Blushing Waxcap *Hygrocybe ovina*

Coarse medium to large, dark waxcap whose flesh reddens on handling. **CAP** To 9cm across; hemispherical to campanulate with an inrolled margin; irregular. Purple-brown or grey, becoming almost black with age. Dry and cracked, with surface breaking up into squamules. **GILLS** Adnexed; very broad and thick. Paler than cap, discolouring red. **STIPE** To 12cm long; thick, spindle- to club-shaped, and often irregularly furrowed and grooved; dry. Colour as cap. **HABITAT** Grassland. **STATUS** Rare.

Blushing
Waxcap

Blackening Waxcap

Hygrocybe conica (= *H. nigrescens*) (Top 100)

One of our most familiar waxcaps, in variable shades of red, orange and yellow, discolouring black either in part or whole. A number of subspecies have been identified, including the yellow form var. *chloroides*. **CAP** To 10cm across; narrow and conical, later expanding, often with a distinct umbo. Frequently wavy, irregularly lobed and split. Viscid at first but soon drying and developing radial fibrils. **GILLS** Free to adnexed, in pale shades of grey or yellow; darkening with age and finally blackening. **STIPE** To 10cm long; cylindrical. Viscid, then drying. Yellow or orange, before blackening. **HABITAT** Grassland. **STATUS** Widespread and very common. **SIMILAR SPECIES** Dune Waxcap *Hygrocybe conicoides* (p. 340).

Butter Waxcap *Hygrocybe ceracea*

Small yellow waxcap with a greasy cap and dry stipe. **CAP** To 3cm across; hemispherical to convex, later flattening and sometimes with a depressed centre and/or upturned margin. Striate when wet, with a translucent eye in centre. **GILLS** Broadly adnate, sometimes decurrent; thin and crowded; concolorous with cap. **STIPE** To 5cm long; cylindrical, occasionally compressed. Dry and smooth. **HABITAT** Grassland. **STATUS** Widespread and common; usually occurs in groups. **SIMILAR SPECIES** Glutinous Waxcap *Hygrocybe glutinipes* is scarcer and has a distinctly viscid cap and stipe and paler gills.

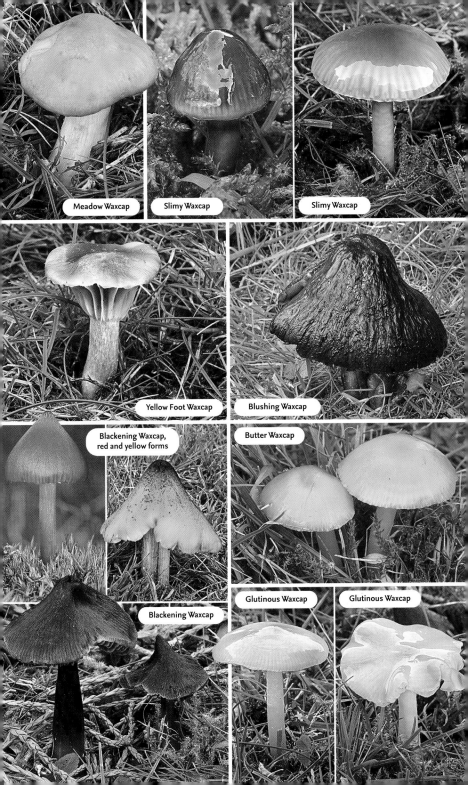

Meadow Waxcap

Slimy Waxcap

Slimy Waxcap

Yellow Foot Waxcap

Blushing Waxcap

Blackening Waxcap, red and yellow forms

Butter Waxcap

Blackening Waxcap

Glutinous Waxcap

Glutinous Waxcap

Pink Waxcap *Hygrocybe calyptriformis*

Unmistakable medium-sized waxcap with a rosy or pale lilac cap. **CAP** To 7cm across; narrowly conical and irregularly lobed, later widely expanding and with a sharply pointed umbo. Margin splitting with age. Dry or slightly greasy; finely radially fibrillose. No distinct taste or smell. **GILLS** Free or adnexed; edges crenate. Pink or whitish. **STIPE** To 11cm long; cylindrical, sometimes twisted. Dry, smooth and finely fibrillose. White or pink. **HABITAT** Grassland. **STATUS** Widespread but occasional; approximately 50 per cent of the known European sites for this species are found in the British Isles.

Hygrocybe helobia

Small, bright red or orange waxcap with a dull, dry, scurfy, granular cap and a faint smell of garlic. Often one of the earliest waxcaps to appear. **CAP** To 2.5cm across; flattish convex with an incurved, wavy margin and, occasionally, a depressed centre. Squamules concolorous with cap but soon drying yellow. **GILLS** Broadly adnate to slightly decurrent. Whitish with a red or yellow tinge. **STIPE** To 4cm long; dry, smooth and matt. Concolorous with cap. **HABITAT** Damp acid grassland. **STATUS** Widespread but uncommon.

Goblet Waxcap *Hygrocybe cantharellus*

Small reddish or orange waxcap with a dry, scurfy cap, sometimes found in swamps and bogs as well as unimproved grassland. **CAP** To 4cm across; convex, becoming flatter with a depressed centre. Margin usually crenate. Squamules becoming paler on drying. **GILLS** Decurrent; whitish, in marked contrast to cap and stipe. **STIPE** To 6cm long; cylindrical and slender. Dry with a slight silky sheen. **STATUS** Widespread but occasional.

Goblet
Waxcap

Date Waxcap *Hygrocybe spadicea*

Medium waxcap with a brittle brown cap that splits on maturity to show yellow flesh beneath. **CAP** To 7cm across; conical at first, but expanding and with a prominent umbo. Radially fibrillose, with translucent cuticle and paler flesh visible. Dry, but greasy in young specimens or after rain. **GILLS** Free to adnexed, undulating or serrated. Yellow, in marked contrast to cap. **STIPE** To 9cm long; cylindrical, fibrous and brittle, with brownish fibrils that give the yellow colour a subdued appearance. Growth sometimes clustered. **HABITAT** Upland grassland. **STATUS** Rarely reported and generally found in upland regions.

Date
Waxcap

Fibrous Waxcap *Hygrocybe intermedia*

Chunky, medium-sized, dull reddish or orange waxcap with a coarsely fibrillose cap and stipe. **CAP** To 5cm across; broadly conical and then flattening, sometimes lobed. Centre is finely squamulose, giving it a lightly frosted appearance in addition to the radial fibrils. **GILLS** Adnexed to free, often with a serrated edge; ventricose and distant. Whitish to pale yellow. **STIPE** To 6cm long; thick and cylindrical. Pale yellow, covered by coarse red or orange fibrils; base paler. **HABITAT** Grassland. **STATUS** Widespread but occasional.

Persistent Waxcap *Hygrocybe persistens*

Medium-sized, bright yellow or occasionally orange waxcap with an acutely conical cap. A variable species with several identified forms. **CAP** To 4cm across; narrowly conical at first, later considerably expanded and with a distinct umbo. Margin irregularly lobed, frequently split and occasionally uplifted. Translucent-striate. Viscid at first but drying. **GILLS** Adnexed to free; broad with an undulating or serrated edge. Pale yellow. **STIPE** To 8cm long; thick, cylindrical, dry and fibrillose. Frequently grooved and splitting into fibres. Generally dry but occasionally moist or greasy. Concolorous with cap but with a whitish base. **HABITAT** Possibly restricted to alkaline grassland. **STATUS** Widespread but occasional.

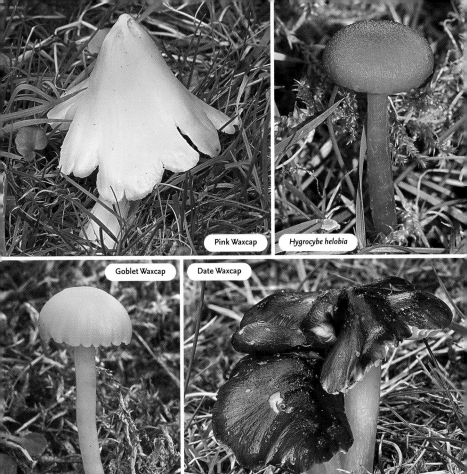

Pink Waxcap

Hygrocybe helobia

Goblet Waxcap

Date Waxcap

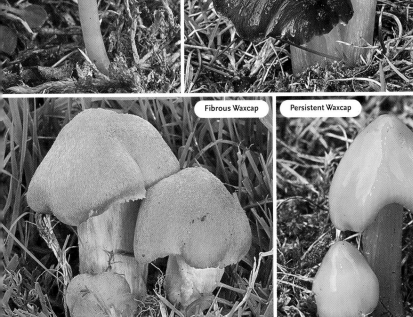

Fibrous Waxcap

Persistent Waxcap

Cedarwood Waxcap *Hygrocybe russocoriacea*

Small waxcap with an ivory or pale buff cap, gills and stipe, and with a distinctive smell of cedar wood or lead pencils. **CAP** To 3cm across; hemispherical at first, then flattening, often with a depressed centre or small umbo. Slightly greasy; hygrophanous, becoming paler when dry. Margin translucent striate. **GILLS** Decurrent and broad. **STIPE** To 5cm long; cylindrical, often tapering downward. Dry and smooth. **HABITAT** Grassland. **STATUS** Widespread and occasional to common.

Snowy Waxcap *Hygrocybe virginea* (Top 100)

Small to medium-sized waxcap, generally with a white or ivory cap, gills and stipe, but extremely variable – fawn and fawn-centred varieties have been identified. Similar to Cedarwood Waxcap but usually a purer colour and lacking any distinctive smell. **CAP** To 5cm across; flattish hemispherical, sometimes with an upturned margin and small umbo, occasionally becoming infundibuliform. Hygrophanous, usually drying pure white; somewhat greasy at first. **GILLS** Decurrent; broad, with a smooth edge. **STIPE** To 6cm long; cylindrical, sometimes tapering downward. Dry and finely fibrillose. **HABITAT** Grassland. **STATUS** Widespread and common. **NOTE** Specimens with a pinkish base to stipe are sometimes encountered; this is the result of a fungal infection and not an indication of a distinct variety or form.

Parrot Waxcap *Hygrocybe psittacina* (Top 100)

Small to medium-sized waxcap, often uniquely coloured green. Extremely variable and found in a wide range of other colours, sometimes mixed, but the green tint is almost always present to a greater or lesser degree. A brick-red form (var. *perplexa*), lacking any green hue, has been recognised. **CAP** To 4cm across; hemispherical or campanulate, later flattening, sometimes umbonate. Very viscid and hygrophanous. **GILLS** Adnate, often sinuate. Concolorous with cap or paler. **STIPE** To 7cm long; cylindrical, often flexuose. Viscid. Generally concolorous with cap but with a green apex. **HABITAT** Grassland. **STATUS** Widespread and common.

Oily Waxcap *Hygrocybe quieta*

Medium-sized, dull yellowish or orange waxcap with darker gills. **CAP** To 8cm across; convex or campanulate, then flattening; sometimes umbonate; slightly greasy when young but generally dry. **GILLS** Adnate; broad and ventricose. Orange. **STIPE** To 9cm long; cylindrical, somewhat flexuose, occasionally compressed and grooved. Similar colour to cap but with a darker apex. Dry and smooth. **HABITAT** Grassland. **STATUS** Widespread and common.

Orange Waxcap *Hygrocybe aurantiosplendens*

Medium-sized orange waxcap with a sticky cap. **CAP** To 5cm across; broadly conical with an undulating margin that frequently splits, and with short translucent striations; greasy to viscid; colour varies from orange-yellow to orange-red, but hygrophanous and drying paler. **GILLS** Adnate and fairly distant; yellow with paler edges. **STIPE** To 8cm long; cylindrical with a smooth or finely fibrillose surface; bright yellow with a whitish bloom towards base when young. **HABITAT** Grassland, usually on acid soils. **STATUS** Widespread and occasional.

Spangle Waxcap *Hygrocybe insipida*

Small yellow or reddish-orange waxcap, variable in colour and stature, and with a greasy cap. **CAP** To 2.5cm across; convex to hemispherical, sometimes with a depressed centre and/or upturned margin. Striate when wet and occasionally with a translucent eye in centre. **GILLS** Adnate to very decurrent. Concolorous with cap but with a paler edge. **STIPE** To 5.5cm long; cylindrical, sometimes tapering downward and flexuose. Moist or greasy at first, soon drying similar in colour to cap but with reddish bands that create a two-tone effect. **HABITAT** Grassland. **STATUS** Widespread and common.

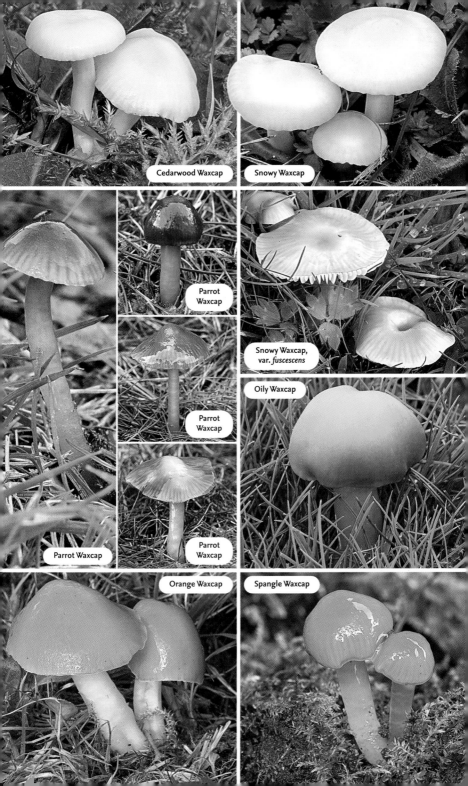

Cedarwood Waxcap

Snowy Waxcap

Parrot Waxcap

Parrot Waxcap

Parrot Waxcap

Snowy Waxcap, var. *fuscescens*

Oily Waxcap

Parrot Waxcap

Orange Waxcap

Spangle Waxcap

Members of the genus *Hygrophorus* are robust, sometimes stout fungi, most with adnate to decurrent gills and some with a distinct annular zone on the stipe. Although related to the waxcaps, they usually lack the bright colours of those species. Spore print is white or pallid. They are generally found in woodland, both deciduous and coniferous. Although 22 species are on the British Isles list, few of these are common.

Ivory Woodwax *Hygrophorus eburneus*
Slender, uniformly coloured ivory or white woodwax with a viscid cap and stipe. **CAP** To 7cm across; convex at first, then flattening and undulating; ivory or white; has a distinctive pleasant smell, sometimes likened to mandarin oranges. **GILLS** Decurrent; fairly broad and distant. **STIPE** To 10cm long; tall in relation to cap; cylindrical but tapering downward. **HABITAT** In small groups in leaf litter in deciduous woodland, particularly with Beech. **STATUS** Widespread but occasional; may be locally common. **SIMILAR SPECIES Yellowing Woodwax** *H. discoxanthus* is more stocky and lacks the pleasant smell; discolours yellow with age; it is particularly associated with Beech on chalk and is more common in S and W parts of England. A third white species, **H. cossus**, may also be found, but this is generally restricted to oak and has a rather unpleasant smell.

Hygrophorus lindtneri
Rare, smallish woodwax with a slimy cap and stipe. **CAP** To 5cm across; convex, becoming flatter and usually with a low, broad umbo; creamy white with an ochre centre. **GILLS** Adnate/sub-decurrent; cream, sometimes with hint of pink. **STIPE** To 7cm long; generally cylindrical and occasionally bent; ochre with a floury surface. **HABITAT** Mixed deciduous woodland on calcareous soil. **STATUS** Rare; known only from S England.

Herald of Winter *Hygrophorus hypothejus*
Distinctive viscid woodwax with a pronounced annular zone and bright yellow flesh. A late-fruiting species, often appearing only after the first frosts. **CAP** To 6cm across; convex, then flattening and with a small umbo, or sometimes with a depressed centre; olive-brown with a darker centre. **GILLS** Adnate to decurrent; fairly broad and distant; yellow, darkening with age. **STIPE** To 8cm long; cylindrical; yellowish up to ring zone. **HABITAT** In small groups in pinewoods. **STATUS** Widespread but occasional; may be locally common.

Herald
of Winter

Hygrophorus persoonii
Viscid brown woodwax with a distinctive annular zone similar to that of Herald of Winter. **CAP** To 6cm across; convex, becoming flatter and with a sharp umbo; brown with olive tones and a darker centre. **GILLS** Adnate to decurrent; whitish. **STIPE** To 10cm long; cylindrical; with olive-brown banding or mottling on a pale background up to the ring zone, and a well-defined white apex; slimy, particularly at ring zone. **HABITAT** Solitary or in small groups in deciduous woodland. **STATUS** Probably widespread and not uncommon. **SIMILAR SPECIES** *H. olivaceoalbus* is restricted to coniferous woodland.

Blotched Woodwax *Hygrophorus erubescens*
Distinctive large woodwax that changes from white to pale vinaceous red as it ages. **CAP** To 9cm; convex with a blunt umbo, becoming depressed and undulating; viscid but becoming dry; white at first, then discolouring pink and finally vinaceous with yellowish blotches; pleasant smell and mild taste. **GILLS** Decurrent; similar colour to cap but paler. **STIPE** To 8cm long; cylindrical and sometimes bent; white with pink dots and fibrils, yellowing with age. **HABITAT** Usually found in groups in deciduous woodland, especially with Beech. In Continental Europe it is more usually associated with spruces. **STATUS** Although accorded a common name, this species is far from common.

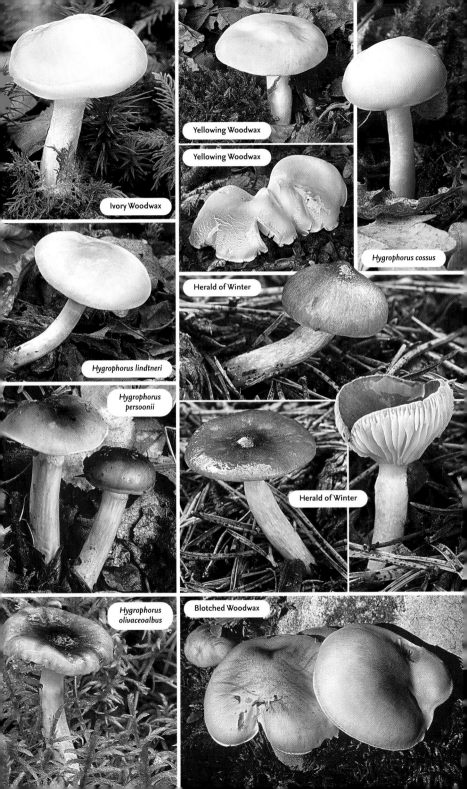

Ivory Woodwax

Yellowing Woodwax

Yellowing Woodwax

Hygrophorus cossus

Herald of Winter

Hygrophorus lindtneri

Hygrophorus persoonii

Herald of Winter

Hygrophorus olivaceoalbus

Blotched Woodwax

The genus *Armillaria* includes some virulent parasites that are responsible for the death of many trees and shrubs, and for which there is no effective means of control. These fungi are robust, relatively tough and mostly honey-coloured, and usually have a minutely scaly cap. Their whitish gills often exhibit rusty spots and produce a whitish spore print. With two exceptions all have a ring that can be short-lived or persistent. They are associated with dead or living wood in a wide range of both deciduous and coniferous tree species, with exception of *A. ectypa* (not described in this book), which lives in bogs. The honey fungi are sometimes solitary but usually found in clusters, these often large and spectacular. Their presence outside the fruiting season can usually be detected by a network of black bootlace-like rhizomorphs found under the bark of infected trees or in the adjacent soil.

Honey Fungus *Armillaria mellea* (Top 100)

The most feared of the honey fungi, responsible for the death of many trees and shrubs in gardens and woodland. CAP To 12cm across; convex, then flatter, usually with a depressed centre and wavy margin; shades of yellow-brown, often with an olive tint but fading to honey-yellow; with scattered, minute yellowish scales, mostly at centre. GILLS Adnate or slightly decurrent; crowded; whitish, maturing yellowish brown. STIPE To 15cm long; cylindrical and tapering below, with a persistent yellowish ring; white or yellowish, discolouring brown towards base and with irregular, coarse yellowish-white scales, particularly below ring. HABITAT Found in dense clusters on or around the base of deciduous trees and shrubs, less frequently on conifers. STATUS Widespread and common in England. SIMILAR SPECIES *A. borealis* has an umbonate cap and striate marginal zone devoid of scales. It is widespread but most frequent in Scotland, often high up the trunk of birch trees.

Honey
Fungus

Ringless Honey Fungus *Armillaria tabescens*

Similar to Honey Fungus but smaller and lacking a ring. CAP To 8cm across; convex, becoming flatter, irregular and undulating, usually with a depressed centre; ochre or brown with darker fibrous scales, these mostly towards centre. GILLS Adnate or slightly decurrent; crowded; whitish, maturing pinkish brown. STIPE To 8cm long; cylindrical or slightly tapering; fibrous and concolorous with cap, darker towards base. HABITAT Usually densely clustered or in groups on the roots of deciduous trees in old woodland, especially with oak. STATUS Occasional in hot summers in S England.

Bulbous Honey Fungus *Armillaria gallica*

Distinguished from other members of the genus by the club-shaped or bulbous stipe. CAP To 10cm across; convex, becoming flatter and undulating, and with a depressed centre; ochre or brown with fine yellowish scales that have darker tips. GILLS Adnexed or slightly decurrent; whitish, maturing yellowish brown. STIPE To 12cm long; club-shaped with a short-lived whitish cobwebby ring; concolorous with cap but paler above ring zone. HABITAT Solitary, loosely clustered or grouped on or near deciduous (more rarely coniferous) trees or stumps; often emerging from soil but attached to buried wood. STATUS Widespread and common.

Dark Honey Fungus *Armillaria ostoyae*

Strongly pathogenic honey fungus with a distinctive dark edge to the underside of the ring. CAP To 15cm across; convex, becoming flatter and undulating, and with a depressed centre; reddish brown or grey-brown, but hygrophanous and drying paler, and with relatively short-lived scales; margin translucent striate, paler and adorned with veil remnants. GILLS Adnexed or slightly decurrent; white, maturing cream or pinkish brown. STIPE To 15cm long; cylindrical; thick woolly ring with the underside edged with dark brown or black scales. HABITAT Loosely clustered in small groups on living and dead wood of deciduous and coniferous trees; prefers acid soils. STATUS Widespread and locally common.

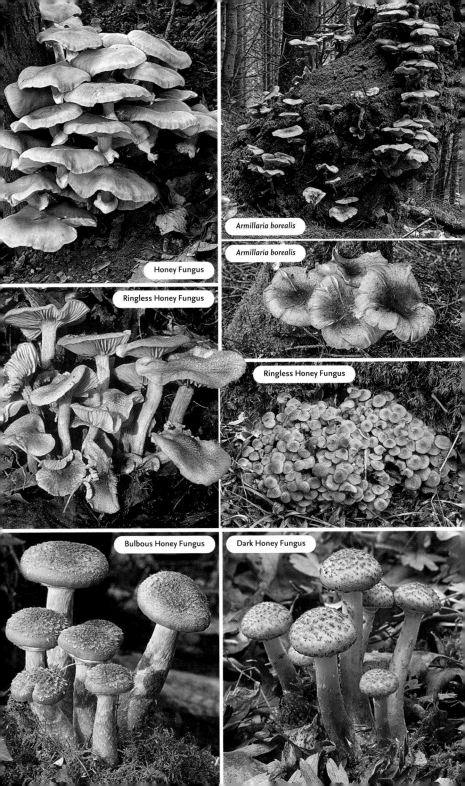

Honey Fungus

Armillaria borealis

Armillaria borealis

Ringless Honey Fungus

Ringless Honey Fungus

Bulbous Honey Fungus

Dark Honey Fungus

Tricholoma species are rather thickset, fleshy and often broadly umbonate, and come in a variety of colours, usually shades of white, yellow, grey or brown. The cap surface can be dry or greasy, smooth or scaly; some have fine, hair-like fibrils. With many, the gill is notched as it joins the stipe (sinuate), making a narrow attachment. The gills are generally pale and produce a white spore print. Some are difficult to identify; taste, smell, discoloration and habitat are often the determining characters of similar species. Found with broadleaved and conifer trees. The fruiting season is usually late, often extending into early winter.

Yellow Knight *Tricholoma equestre (= T. flavovirens)*

Yellowish knight, ranging in stature from robust to slender. **CAP** To 8cm across; convex, becoming flatter and usually with a broad umbo; shades of yellow with brown or green tints; often with fine dark brown scales, mainly in centre. **GILLS** Adnexed; yellow and virtually unchanging except for a little browning with age. **STIPE** To 10cm long; broadly cylindrical and usually stout; surface smooth and somewhat fibrous; similar in colour to cap and gills, with a paler apex. **HABITAT** Generally with conifers on sandy acid soil; less often with deciduous trees. **STATUS** Occasional in Scotland but uncommon elsewhere.

Sulphur Knight *Tricholoma sulphureum*

Similar in colour to Yellow Knight but with a very strong smell of coal gas. **CAP** To 8cm across; convex, becoming flatter, sometimes broadly umbonate; surface smooth and matt; sulphur-yellow, often with a hint of reddish brown in centre. **GILLS** Sinuate and concolorous with cap. **STIPE** To 10cm long; cylindrical but sometimes slightly swollen in centre; concolorous with cap and covered in purplish-red longitudinal fibrils. **HABITAT** Deciduous woodland on acid soil; rarely with conifers. **STATUS** Widespread and common. **SIMILAR SPECIES** *T. bufonium* has a cap that is flushed reddish brown; it is considered by some to be merely a colour form of *T. sulphureum*.

Deceiving Knight *Tricholoma sejunctum*

Variable yellowish knight with a streaky cap, a strong mealy smell and a slightly bitter taste. **CAP** To 10cm across; conical at first, becoming convex or flatter, somewhat undulating and often broadly umbonate; greasy; variable in colour but generally in shades of greenish yellow with a paler margin and covered in streaky brownish fibrils. **GILLS** Sinuate; white, discolouring yellowish. **STIPE** To 8cm long; cylindrical; concolorous with gills and having the same discoloration; longitudinally fibrillose. **HABITAT** Deciduous woodland, generally with oaks and birches; occasionally with pines. **STATUS** Widespread but uncommon.

Girdled
Knight

Girdled Knight *Tricholoma cingulatum*

Grey-coloured knight with a prominent woolly ring, an unusual feature in *Tricholoma*. **CAP** To 6cm across; convex, becoming flatter, usually with a broad umbo; greyish brown, covered in darker radial fibrils that erupt into felt-like scales. **GILLS** Adnexed; whitish but yellowing with age. **STIPE** To 8cm long; cylindrical and with a woolly ring; white but yellowing with age and longitudinally fibrillose. **HABITAT** Solitary or in small groups in damp deciduous woodland, usually with willows. **STATUS** Widespread and common.

Grey Knight *Tricholoma terreum*

Grey knight with a felty cap. Lacks any distinctive taste or smell, and is probably the most common *Tricholoma* found with pines. **CAP** To 7cm across; broadly conical, then convex or flatter and usually with a broad, shallow umbo; surface felty and becoming scaly; light to dark grey. **GILLS** Adnexed and finely toothed; greyish white. **STIPE** To 8cm long, cylindrical; greyish white; apex finely downy but remainder smooth. **HABITAT** Solitary or, more usually, grouped; found in association with pines. **STATUS** Common.

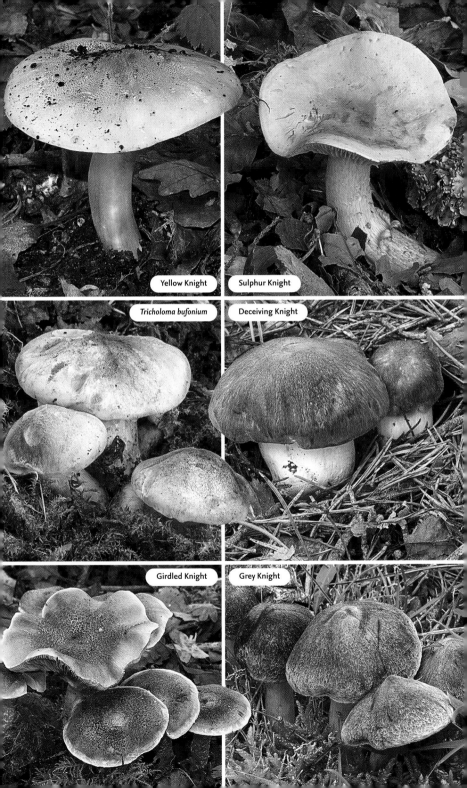

Yellow Knight

Sulphur Knight

Tricholoma bufonium

Deceiving Knight

Girdled Knight

Grey Knight

Tricholoma portentosum

Greyish knight whose cap is streaked with dark, hair-like fibrils. Has only a slight smell and a relatively mild taste. **CAP** To 10cm across; bell-shaped or convex, becoming flatter and umbonate; slightly greasy when moist; shades of greyish brown, often with olive or violet tones, heavily streaked with dark grey or black radial fibrils. **GILLS** Adnate; broad and fairly distant; white but yellowing with age. **STIPE** To 10cm long; stout, cylindrical but with a broader base; white, developing brownish spots, and longitudinally fibrillose. **HABITAT** Associated with pines on acid soil. **STATUS** Uncommon, least so in Scotland.

Ashen Knight *Tricholoma virgatum*

Similar to *T. portentosum* but with a burning-hot taste and generally found with broadleaved trees. **CAP** To 7cm across; conical, then bell-shaped or flatter with a broad umbo and incurved margin; surface dry and silky; shades of grey, often with a hint of violet, with darker radial fibrils or fine scales. **GILLS** Sinuate; greyish white. **STIPE** To 9cm long; cylindrical or slightly club-shaped with a truncated base; white with concolorous or greyish fibrils. **HABITAT** Deciduous woodland, rarely with conifers. **STATUS** Occasional.

Soapy Knight *Tricholoma saponaceum*

Highly variable in colour, texture and form, but always with a smell of unperfumed soap. Damaged parts often discolour, or spot pinkish, particularly at base of stipe. **CAP** To 10cm across; convex, becoming flatter and broadly umbonate; margin incurved and splitting; surface greasy when moist, drying smooth, finely fibrillose or scaly, sometimes cracking with age; found in various shades of greyish brown, often with olive tints, sometimes with darker spots or mottling. **GILLS** Sinuate and rather distant; cream with greenish or ochre tints. **STIPE** To 10cm long; cylindrical; whitish with greyish or brownish fibrils or scales. **HABITAT** Deciduous and coniferous woodland, most frequently on acid soil. **STATUS** Widespread but occasional.

Yellowing Knight *Tricholoma scalpturatum* (= *T. argyraceum*)

Grey knight with a strong mealy smell and mild taste. Discolours yellow but only after a considerable period of time. **CAP** To 8cm across; convex, becoming flatter with a broad umbo; margin somewhat irregular and wavy; greyish brown and covered in fine, darker fibrils or scales. **GILLS** Sinuate; white but yellowing with age. **STIPE** 8cm long; cylindrical, sometimes thicker towards base; greyish white, flecked with fine, darker scales. **HABITAT** Deciduous woodland; more rarely with pines. **STATUS** Widespread but occasional.

Tricholoma sciodes

Grey *Tricholoma* with an earthy smell and burning-hot taste; distinguished from other grey knights by the black flecks on gill edges. **CAP** To 7cm across; conical or convex, becoming flatter with a broad umbo; grey with pinkish or lilac tones, with darker fibrils or fine scales. **GILLS** Sinuate; very broad and distant; greyish with black-flecked edges. **STIPE** To 8cm long; cylindrical and somewhat thickened towards base; greyish with darker longitudinal fibrils. **HABITAT** Deciduous woodland, usually with Beech. **STATUS** Uncommon.

Matt Knight *Tricholoma imbricatum*

Dull brown knight with a dry, matt cap and pale apex to stipe. **CAP** To 10cm across; conical or convex, becoming flatter and sometimes umbonate; reddish brown with a paler margin; surface towards centre breaking up into fine scales. **GILLS** Adnate; whitish, maturing light pinkish buff and spotting brown. **STIPE** To 12cm long; cylindrical, usually with a tapered base; concolorous with cap but with a paler, scurfy apex. **HABITAT** Usually with pines on acid soil; rarely in mixed deciduous and coniferous woodland. **STATUS** Widespread but occasional.

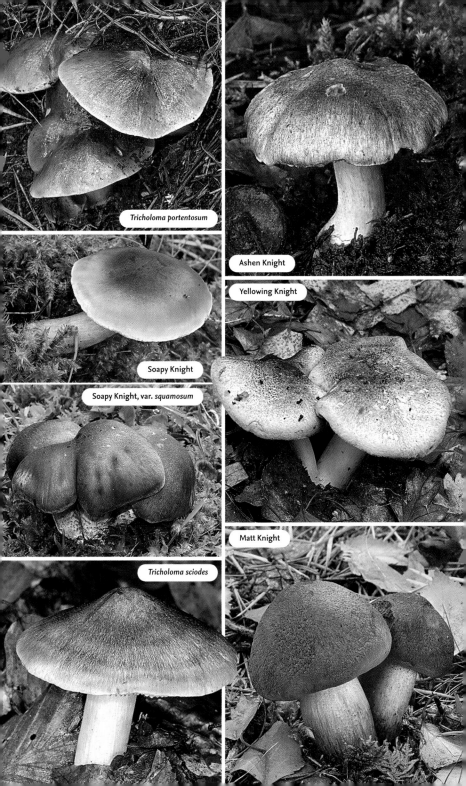

Tricholoma portentosum

Ashen Knight

Yellowing Knight

Soapy Knight

Soapy Knight, var. *squamosum*

Matt Knight

Tricholoma sciodes

Birch Knight *Tricholoma fulvum*

Brown knight with distinctive yellowish flesh, particularly in the stipe. **CAP** To 10cm across; convex, becoming flatter and usually with a low umbo; surface finely fibrillose and sticky when moist; shades of brown with reddish or yellowish tones and darkening with age. **GILLS** Sinuate; crowded; yellowish, spotting rust with age. **STIPE** To 11cm long; slender, cylindrical but sometimes spindle-shaped; yellow ground with reddish-brown longitudinal fibrils and a paler apex; sticky when moist. **HABITAT** Singly or in groups in deciduous woodland, particularly with birches. **STATUS** Widespread and very common.

Birch
Knight

Burnt
Knight

*Tricholoma
ustaloides*

Burnt Knight
Tricholoma ustale

Brown viscid knight with whitish flesh and a slightly bitter taste. **CAP** To 12cm across; convex, becoming flatter with an incurved margin; slimy when moist and drying shiny; radially fibrillose and occasionally scaly; red-brown or chestnut, often with a paler margin. **GILLS** Sinuate; crowded; creamy white but spotting rust. **STIPE** To 9cm long; cylindrical, sometimes club-shaped and fairly stout; whitish ground densely covered in brown longitudinal fibrils but increasingly paler towards apex; no obvious ring zone. **HABITAT** Deciduous woodland, particularly with Beech but sometimes with oaks. **STATUS** Widespread but occasional. **SIMILAR SPECIES** *T. ustaloides* has a distinct white apex to the stipe.

Booted Knight *Tricholoma focale*

Fleshy reddish-brown knight with a thick ring. **CAP** To 9cm across; convex, then flatter with a finely scaly texture, becoming shiny and cracking with age; colour varies from orange-brown to reddish brown. **GILLS** Adnexed to free; whitish. **STIPE** To 8cm long; stout and tapering downward, with a shaggy ring; whitish and smooth above ring, with bands of rough brown scales below. **HABITAT** Restricted to Caledonian pinewoods. **STATUS** Occasional in Scotland.

Aromatic Knight *Tricholoma lascivum*

Whitish, relatively slender knight with a sweet, flowery smell. **CAP** To 8cm across; convex, becoming flatter and irregularly undulating; surface smooth and silky, sometimes cracking with age; whitish or cream but spotted or flecked with ochre. **GILLS** Adnexed with a decurrent tooth; concolorous with cap. **STIPE** To 8cm long; cylindrical; whitish with longitudinal fibrils, discolouring ochre; apex powdery. **HABITAT** With deciduous trees, often on calcareous soil. **STATUS** Widespread but occasional; more frequent in S England.

Blue Spot Knight *Tricholoma columbetta*

Pure white knight with virtually no smell and only a slight taste. Sometimes has tiny bluish spots on the cap and stipe base. **CAP** To 10cm across; convex, becoming flat and somewhat undulating, usually with a broad umbo; slightly greasy when moist and drying smooth; whitish, becoming creamy with age. **GILLS** Sinuate; concolorous with cap. **STIPE** To 10cm long; white with concolorous fibrils and a floury apex. **HABITAT** Mixed deciduous woodland, usually with Beech and oaks. **STATUS** Widespread but occasional. **SIMILAR SPECIES** *T. stiparophyllum* (= *T. pseudoalbum*) has an unpleasant gas smell and a bitter taste.

Tricholoma aestuans

Similar in colour to Yellow Knight (p. 108), with pale flesh and an acrid taste. **CAP** To 8cm across; conical or convex, becoming flatter with a small umbo; slightly greasy when moist and drying matt; yellowish brown with a slightly darker centre and paler margin. **GILLS** Sinuate; pale yellow. **STIPE** To 8cm long; cylindrical, slightly thicker towards base; yellow, often with light brown fibrils or scales. **HABITAT** Pinewoods. **STATUS** Uncommon; mostly confined to Scotland.

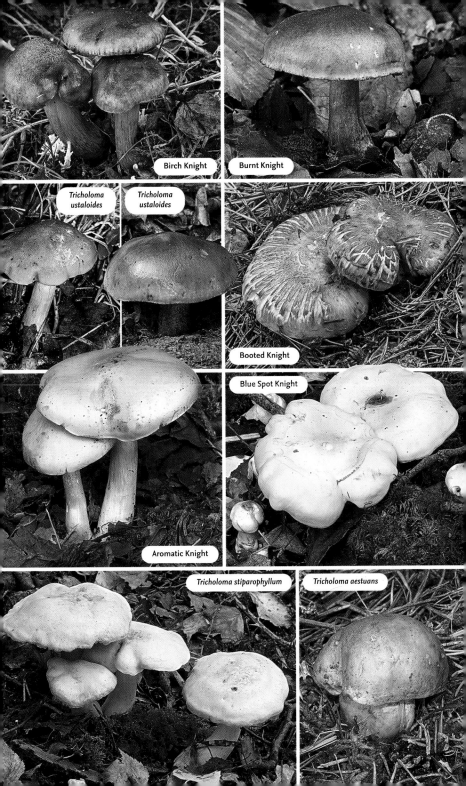

Birch Knight

Burnt Knight

Tricholoma ustaloides

Tricholoma ustaloides

Booted Knight

Blue Spot Knight

Aromatic Knight

Tricholoma stiparophyllum

Tricholoma aestuans

St George's Mushroom
Calocybe gambosa (= Tricholoma gambosum)
Variable dingy-white mushroom with a strong, mealy
taste and smell. Found in spring and early summer,
and reputed to start fruiting on St George's Day (23 April),
hence its common name. **CAP** To 12cm across; rounded or
convex, but becoming flatter, irregular and undulating; surface
finely suede-like at first but becoming smooth and sometimes cracking;
dingy white, discolouring brownish or yellow with age. **GILLS** Adnexed
with a decurrent tooth; narrow and very crowded; white or cream.
STIPE To 8cm long; usually cylindrical but sometimes bulbous, stout
and fibrous; concolorous with cap. **HABITAT** In groups or troops in
grassy places, often at the edge of deciduous and coniferous woodland.
STATUS Widespread and common.

Violet Domecap *Calocybe ionides*
Distinguished from other similarly coloured fungi by its
strong mealy smell. **CAP** To 6cm across; convex, becoming
flatter and undulating; surface dull with fine radial
fibrils and becoming somewhat wrinkled; shades of
lilac or violet, flushed with pale brown and with a
darker centre and paler margin. **GILLS** Sinuate; crowded; white
or cream, in marked contrast to cap. **STIPE** To 5cm long; cylindrical
and fairly slender; longitudinally fibrillose with a white-downy base;
concolorous with cap but becoming paler downward. **HABITAT**
Deciduous woodland, and occasionally with larches, on calcareous
soil. **STATUS** Occasional to rare; predominantly in S.

Violet
Domecap

Pink Domecap *Calocybe carnea*
Similar in stature to Violet Domecap but with distinctive flesh-
pink colours. **CAP** To 4cm across; convex, becoming flatter and
with a depressed centre, occasionally with a small umbo; surface
smooth, dull and finely fibrillose; flesh-pink, but sometimes flushed brown in centre. **GILLS**
Adnate; very crowded; white or cream, in marked contrast to cap and stipe. **STIPE** To 4cm
long; longitudinally fibrillose and occasionally with a white-downy base; concolorous
with cap. **HABITAT** Solitary or in small groups in short turf, in grassy places in woodland,
and on heathland. **STATUS** Widespread but occasional.

Clustered Domecap *Lyophyllum decastes*
Very variable domecap, possibly comprising several different species. The densely clustered
mode of growth is distinctive. **CAP** To 10cm across; hemispherical or convex, becoming
flatter, undulating and a little distorted, often with a broad umbo; surface smooth and
shiny, with cuticle peelable almost to centre; flexible and elastic; shades of grey or brown,
sometimes darker and with a paler margin. **GILLS** Adnate; fairly crowded; whitish or grey.
STIPE To 8cm long; cylindrical or club-shaped, often fused, twisted and off-centre on
account of the crowded mode of growth; tough and longitudinally fibrillose; dingy
white, discolouring brownish with a powdered white apex. **HABITAT** Usually clustered in
deciduous woodland or scrub, in grassy places near trees, and on waste ground. **STATUS**
Widespread but occasional. **SIMILAR SPECIES** *L. loricatum* is usually darker, with a tough,
cartilaginous cap cuticle that breaks with an audible snap; very shiny when dry. It is
considered by some merely to be a form of *L. decastes*.

White Domecap *Lyophyllum connatum*
Uniformly white domecap with a pleasant smell. **CAP** To 7cm across; hemispherical, then
convex and becoming flatter and undulating; surface dull or satiny; white, ageing greyish.
GILLS Adnate or slightly decurrent; white, maturing cream or yellowish. **STIPE** To 8cm
long; variable, often cylindrical but sometimes swollen in centre or with a tapering base;
concolorous with cap and finely fibrillose. **HABITAT** Clustered in deciduous woodland
or in grass close to trees. **STATUS** Uncommon; most frequent in N.

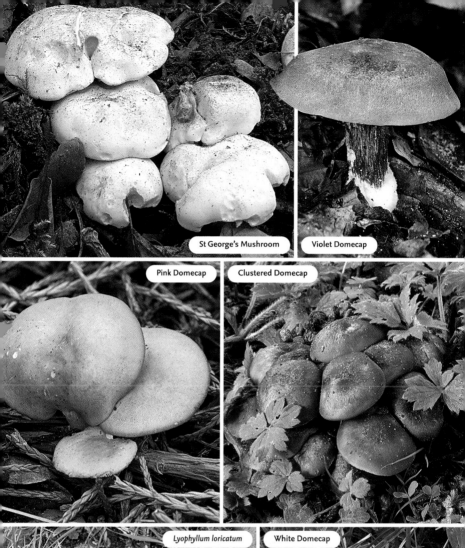

St George's Mushroom

Violet Domecap

Pink Domecap

Clustered Domecap

Lyophyllum loricatum

White Domecap

Prunes and Custard *Tricholomopsis decora*

Striking golden fungus, often found growing laterally out of decayed conifer wood. **CAP** To 10cm across; convex, becoming flatter, often centrally depressed with a broad, shallow umbo; margin wavy; golden yellow, covered in fine blackish-brown scales, these particularly concentrated in centre. **GILLS** Sinuate; crowded; deep yellow. **STIPE** To 8cm long; cylindrical, sometimes with a tapered base; concolorous with cap and covered in fine brownish scales, apex and base paler. **HABITAT** Solitary or, more often, in small groups, usually on fallen trunks or stumps of pine. **STATUS** Occasional in Scotland, rare elsewhere.

Plums and Custard *Tricholomopsis rutilans* (Top 100)

Very attractive fungus with a wine-red or plum-coloured cap in marked contrast to the yellow gills. **CAP** To 10cm across; conical or convex, becoming flatter and often with a broad umbo and incurved margin; yellow ground colour densely covered in wine-red or purplish tufts or fine scales, these sparser towards margin, allowing ground colour to show through. **GILLS** Adnate; crowded; rich yellow. **STIPE** To 10cm long; cylindrical or club-shaped; colour similar to cap but paler and with fewer scales. **HABITAT** Usually grouped on decayed conifer wood, mainly on large stumps or fallen trunks of pines. **STATUS** Widespread and common.

Whitelaced Shank *Megacollybia platyphylla* (= *Tricholomopsis platyphylla*)

Drab shank with an extensive, long rooting system. **CAP** To 15cm across; convex, becoming flatter, occasionally with a depressed centre and shallow umbo; surface radially fibrillose or scaly, often splitting with age; shades of greyish brown. **GILLS** Adnexed; distant; greyish white, maturing creamy. **STIPE** To 15cm long; cylindrical with long white mycelia strands that resemble rootlets; white or greyish brown, flushed with cap colour; fibrillose with a white-downy apex. **HABITAT** Attached to very decayed wood of deciduous trees or, rarely, conifers, or arising out of the ground from buried wood. **STATUS** Widespread and common.

Hydropus floccipes

Small *Mycena*-like fungus with dark flecks on the stipe. **CAP** To 2cm across; conical or convex, becoming flatter and slightly umbonate; smooth and sometimes striate or grooved; greyish brown, often with a paler margin. **GILLS** Adnexed or free; fairly distant; whitish. **STIPE** To 4cm long; cylindrical and often rooting; whitish with a dusting of fine greyish-brown particles. **HABITAT** Deciduous woodland on very decayed or sometimes burnt wood; also amongst cedar debris. **STATUS** Widespread but uncommon; predominantly in S.

Spring
Cavalier

Common
Cavalier

Spring Cavalier *Melanoleuca cognata*

Variable cavalier whose main fruiting season is in spring, followed by a later, smaller flush in autumn. **CAP** To 10cm across; convex, becoming flatter with a broad umbo; surface smooth and dull; various shades of brown, but hygrophanous and drying paler. **GILLS** Sinuate; fairly crowded; creamy-yellow to pale ochre. **STIPE** To 12cm long; cylindrical with an enlarged base and longitudinally fibrillose; cream, flushed with cap colour and with a white powdery apex. **HABITAT** Usually in groups in deciduous woodland, occasionally with conifers; also on compost heaps, mulched flowerbeds and roadside verges. **STATUS** Occasional.

Common Cavalier *Melanoleuca polioleuca*

Epitomises the genus, with its marked contrast between the dark cap colour and contrasting pale gills. Formerly confused with *M. melaleuca*. **CAP** To 8cm across; convex, then flattened and often with a depressed centre and a small umbo; dark greyish brown but drying paler. **GILLS** Sinuate; crowded; white, then creamy. **STIPE** To 7cm long; cylindrical with an enlarged base; whitish, covered in dark greyish-brown fibrils. Flesh at base of stipe is blackish brown. **HABITAT** Usually in small groups in deciduous and coniferous woodland; occasionally in grassland. **STATUS** Widespread and common.

Warty Knight *Melanoleuca verrucipes* See p. 342.

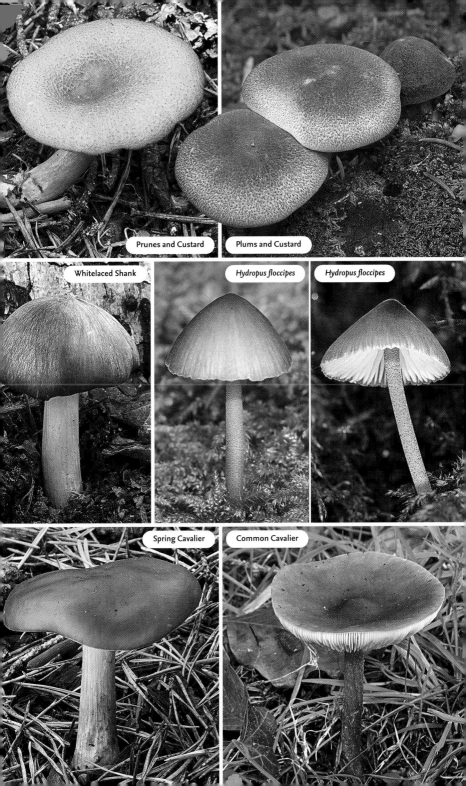

Prunes and Custard

Plums and Custard

Whitelaced Shank

Hydropus floccipes

Hydropus floccipes

Spring Cavalier

Common Cavalier

Clitocybe species are usually convex or hemispherical at first, expanding to the typical funnel shape that gives the genus its common name. Colours are generally muted, and some species are hygrophanous with a marked colour contrast between wet and dry. Gills are decurrent, frequently deeply so, and rarely forked, and spore prints are white or cream. The stipe is often slender, sometimes curved, and usually has longitudinal fibrils. Many funnels have strong, distinctive smells, usually either pleasant and aniseed-like or unpleasant and mealy. They are generally found in late summer to autumn in a range of habitats, usually in association with trees.

Trooping Funnel *Clitocybe geotropa*

Large, robust, rather statuesque funnel with a smallish cap relative to the length and diameter of the stipe. **CAP** To 20cm across; conical or bell-shaped, soon becoming funnel-shaped with a distinct umbo; margin strongly inrolled; surface dry, smooth and felty; whitish or cream-beige. **GILLS** Strongly decurrent; crowded; concolorous with cap. **STIPE** To 15cm long; stout and cylindrical with a downy bulbous base; concolorous with cap. **HABITAT** Often in groups, sometimes in rings, in deciduous and coniferous woodland, particularly with Beech and oaks. **STATUS** Widespread but occasional; most frequent in S.

Clouded Funnel *Clitocybe nebularis* (Top 100)

Large, fleshy funnel in cloudy or misty colours. **CAP** To 20cm across; convex, becoming flatter and generally only slightly depressed in centre with, at most, a shallow umbo; surface slightly greasy at first, later dull and felty; often covered in a white bloom; variable in colour but usually in shades of beige or grey, often with a darker centre. **GILLS** Decurrent; crowded; cream or greyish. **STIPE** To 10cm long; cylindrical or club-shaped; similar in colour to cap but a little paler. **HABITAT** Generally in groups or rings in deciduous and coniferous woodland. **STATUS** Widespread and very common.

Common Funnel *Clitocybe gibba* (= *C. infundibuliformis*)

Pale funnel with the typical *Clitocybe* stature and a distinct sweetish or almond smell. **CAP** To 8cm across; funnel-shaped even when young, becoming more expanded and with an undulating or wavy margin; shades of cream, pinkish buff or ochre. **GILLS** Long, decurrent and crowded; whitish or cream with a hint of pink. **STIPE** To 8cm long; cylindrical and fairly slender, often with a slightly swollen base; concolorous with cap or paler, and covered in fine whitish fibrils. **HABITAT** In scattered groups in deciduous woodland or grassy clearings, occasionally with conifers. **STATUS** Widespread and common.

Aniseed Funnel *Clitocybe odora*

Unmistakable funnel with a bluish-green cap and strong smell of aniseed. **CAP** To 7cm across; convex with a low umbo, becoming flatter with an irregular, wavy margin; finely fibrillose or slightly scurfy in centre; bluish green, fading to greyish green; an all-white form is also found. **GILLS** Adnate or slightly decurrent; whitish, tinged with cap colour. **STIPE** To 6cm long; cylindrical with a white-downy base; whitish, flushed with cap colour. **HABITAT** Mixed deciduous and coniferous woodland. **STATUS** Widespread and common.

Fragrant Funnel *Clitocybe fragrans*

When dry, is similar to the white form of Aniseed Funnel, with the same aniseed smell but rarely as white. **CAP** To 4cm across; convex, then flatter with a slightly depressed centre; margin finely translucent-striate and becoming undulating and wavy; dull beige or greyish with a darker centre but drying paler. **GILLS** Adnate or slightly decurrent; crowded; whitish buff. **STIPE** To 6cm long; cylindrical and fairly slender with a white-downy base; concolorous with cap or darker. **HABITAT** Deciduous and coniferous woodland, often in mosses and grasses; also on woodchip mulch in gardens. **STATUS** Widespread and common.

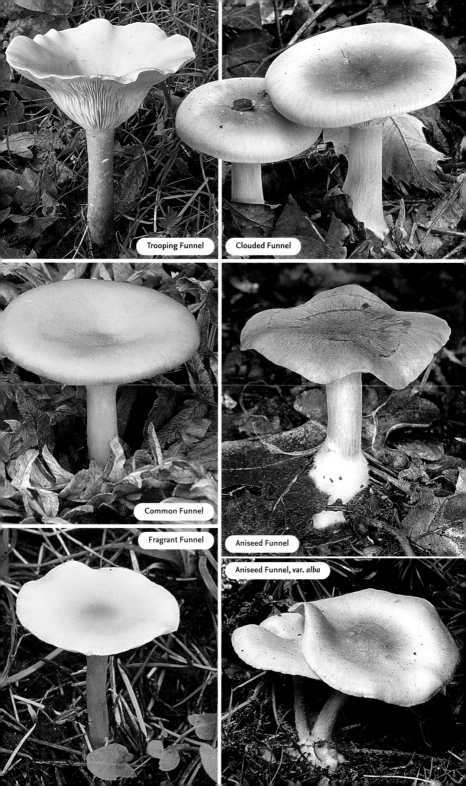

Trooping Funnel

Clouded Funnel

Common Funnel

Fragrant Funnel

Aniseed Funnel

Aniseed Funnel, var. *alba*

Ivory Funnel *Clitocybe dealbata (= C. rivulosa)*

Extremely poisonous white funnel, commonly found in short grass. **CAP** To 4cm across; flattish convex, expanding almost to funnel-shaped; margin inrolled; white or ivory, discolouring pinkish brown in places and covered in a fine whitish bloom that gives it a frosted or silky appearance. **GILLS** Adnate or slightly decurrent; crowded; white, maturing pinkish buff. **STIPE** To 4cm long; cylindrical with a powdery apex; whitish then pinkish brown. **HABITAT** Generally in groups in short turf, including lawns. **STATUS** Widespread and common.

Frosty Funnel *Clitocybe phyllophila (= C. cerussata)*

Uniformly white funnel, similar to Ivory Funnel but with a dark cream spore print, a pleasant aromatic smell and a different habitat. **CAP** To 10cm across; convex, becoming funnel-shaped with an undulating, wavy margin; white and covered in a dull white bloom, developing pale ochre spots or patches with age. **GILLS** Decurrent; crowded; white, later cream. **STIPE** To 8cm long; cylindrical with a swollen downy base; white with similar discoloration to cap. **HABITAT** Varied, but usually associated with deciduous and coniferous trees; also found in gardens on compost heaps, and on dunes. **STATUS** Widespread but occasional.

Clitocybe sinopica

Spring-fruiting funnel with a warm brown cap and strong, mealy smell. **CAP** To 6cm across; convex, becoming flatter and usually with a depressed centre; margin inrolled and later undulating; surface dull and slightly scurfy; tan or orange-brown. **GILLS** Decurrent; crowded, maturing ochre. **STIPE** To 5cm long, cylindrical with a downy rooting base; concolorous with cap. **HABITAT** Open ground adjoining mixed woodland, often on old bonfire sites. **STATUS** Widespread but uncommon to rare.

Clitocybe metachroa (= C. dicolor)

Drab brownish *Clitocybe* with a deeply indented centre and lacking any distinctive smell. **CAP** To 6cm across; flattish convex with a finely striate margin; beige or coffee-coloured with a darker centre, but strongly hygrophanous and drying almost white; greasy, but smooth and satiny when dry. **GILLS** Slightly decurrent; crowded; greyish white, maturing beige. **STIPE** To 6cm long; cylindrical and fairly slender, with a swollen downy base; greyish brown with a paler apex, and entire length covered in white fibrils. **HABITAT** Usually in small groups in leaf or needle litter. **STATUS** Widespread but occasional.

Mealy Funnel *Clitocybe vibecina*

Similar to *C. metachroa* but with a mealy smell and drying less pale. **CAP** To 5cm across; flattish convex with a depressed centre, becoming almost funnel-shaped; grey-brown, but hygrophanous and drying cream. **GILLS** Decurrent; fairly crowded; greyish beige. **STIPE** To 5cm long; cylindrical, often widening to the downy base; similar colour to cap but paler and coated in a fine white down. **HABITAT** Generally in groups in coniferous woodland, less often with deciduous trees. **STATUS** Widespread and common.

Chicken Run
Funnel

Chicken Run Funnel

Clitocybe phaeophthalma (= C. hydrogramma)

Similar to several related species, but the strong, unpleasant smell (reminiscent of a hen house) is a distinctive feature. **CAP** To 6cm across; convex then funnel-shaped; slightly greasy when moist, and with a striate margin; greyish beige, but hygrophanous and drying almost white, sometimes with a darker 'eye'. **GILLS** Decurrent; fairly distant; white or cream, maturing ochre. **STIPE** To 5cm long; cylindrical, tapering towards the downy base; cream or light brown with a dusting of white powder. **HABITAT** Usually in small groups in, or close to, deciduous woodland, particularly with Beech; more rarely in conifer needle litter. **STATUS** Widespread and common in S England.

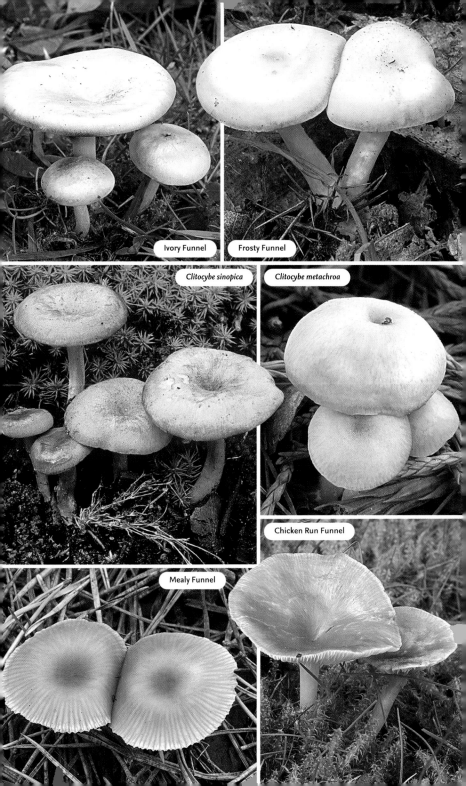

Ivory Funnel

Frosty Funnel

Clitocybe sinopica

Clitocybe metachroa

Chicken Run Funnel

Mealy Funnel

The Goblet *Pseudoclitocybe cyathiformis (= Cantharellula cyathiformis)*

Deeply funnel-shaped fungus, reminiscent of a goblet when mature. Frequently fruits in winter. **CAP** To 8cm across; convex with a depressed centre and small umbo, but becoming deeply funnel-shaped; margin inrolled and lacking striations; dark brown, but hygrophanous and drying paler. **GILLS** Adnate or decurrent; often forked (unusual in *Clitocybe*); greyish beige, maturing light brown. **STIPE** To 10cm long; cylindrical with an enlarged white-downy base; reddish brown but covered in whitish net-like fibrils, giving it a paler appearance. **HABITAT** Usually in soil in deciduous and coniferous woodland, but sometimes on decayed wood. **STATUS** Widespread and common.

Club Foot *Ampulloclitocybe clavipes (= Clitocybe clavipes)*

Flat-topped fungus with deeply decurrent gills and a very distinctive club-shaped stipe. **CAP** To 8cm across; convex, becoming flattish or slightly depressed and with a broad umbo; surface smooth and velvety; drab greyish brown with a darker centre and paler margin. **GILLS** Decurrent; crowded; cream, maturing yellowish. **STIPE** To 7cm long; club-shaped, tapering upward from the greatly enlarged white-downy base; ochre. **HABITAT** Deciduous and mixed woodland on acid soil; also found on heaths and moorland. **STATUS** Widespread and common.

Giant Funnel *Leucopaxillus giganteus*

The very large cap and relatively short stipe gives this funnel a squat look. Similar to Fleecy Milkcap (p. 46) but lacking any milk. **CAP** To 30cm across; flattish, becoming funnel-shaped and with a strongly inrolled margin; surface is suede-like, becoming cracked, scaly and somewhat grubby with age; whitish or ivory, flushed tan in places. **GILLS** Decurrent; crowded, with many forked; cream, becoming buff. **STIPE** To 7cm long; stout with a thickened base, tough, and finely downy; white. **HABITAT** Often in large groups or rings in woodland, woodland edges or grassy places. **STATUS** Widespread but occasional.

Leucopaxillus gentianeus

Large, fleshy, very rare *Leucopaxillus* with a strong mealy smell and bitter taste. **CAP** To 15cm across; flattish convex with an inrolled margin; surface dry and slightly velvety; pinkish brown or salmon, partially covered in a whitish bloom. **GILLS** Adnate; crowded; white or cream. **STIPE** To 10cm long; stout and cylindrical or club-shaped; white, discolouring pale brown. **HABITAT** Deciduous and coniferous woodland. **STATUS** Very rare; confined to S.

Velvet Shank *Flammulina velutipes* (Top 100)

Winter-fruiting shank distinguished from similar-looking species by its dark velvety stipe and white spore print. Widely cultivated in the Far East. **CAP** To 10cm across; convex, becoming flatter, irregular and undulating; surface smooth and slimy when wet, then dry and shiny; yellowish or orange-brown with a darker centre and paler, faintly striate margin. **GILLS** Adnexed; white, maturing dirty yellow. **STIPE** To 10cm long; cylindrical, often curved and tough; surface velvety; dark brown with a smoother and yellowish apex. **HABITAT** Clustered on dead and dying wood of deciduous trees. **STATUS** Widespread and very common.

Cucumber Cap *Macrocystidia cucumis*

Unusual dark brown velvety fungus with a strong cucumber or fishy smell. Gives a brown spore print, rare in Tricholomataceae. **CAP** To 5cm across; conical or bell-shaped, becoming flatter with a broad umbo; surface smooth, dull and finely velvety; reddish brown or dark brown with a hint of purple and a paler margin, but hygrophanous and drying paler. **GILLS** Adnexed; white, maturing reddish ochre. **STIPE** To 6cm long; slender with a velvety surface; dark reddish brown or blackish brown with a paler apex. **HABITAT** Troops occur in deciduous woodland, occasionally with conifers and also in woodchip mulch. **STATUS** Widespread but occasional.

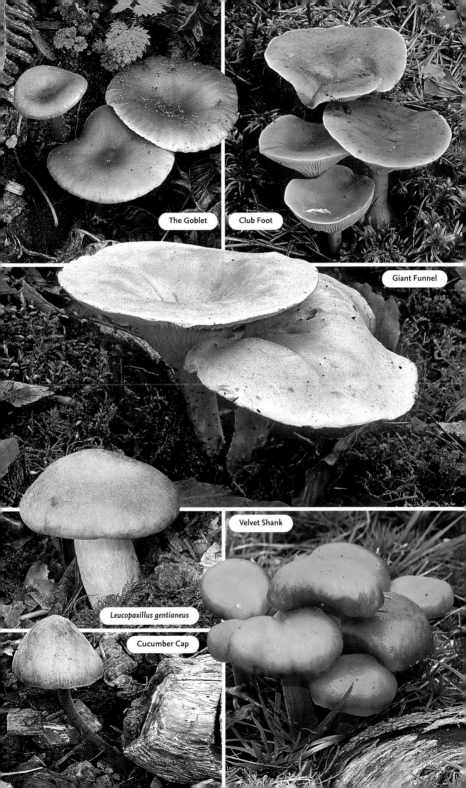

The Goblet

Club Foot

Giant Funnel

Velvet Shank

Leucopaxillus gentianeus

Cucumber Cap

The Deceiver *Laccaria laccata* (Top 100)

Extremely variable in size, colour, stature and habitat, hence its common name. **CAP** To 5cm across; convex, becoming flatter with a depressed centre and wavy margin, occasionally with a small umbo; surface dull and finely scurfy, particularly in centre; margin faintly striate when wet; orange-brown, but hygrophanous and drying pinkish beige. **GILLS** Adnate to slightly decurrent; fairly distant and often crinkled; light flesh-pink or pinkish brown with a dusting from the fallen white spores. **STIPE** To 10cm long; cylindrical, often compressed or twisted; tough and fibrous; concolorous with cap and covered in whitish fibrils. **HABITAT** Solitary or in small groups in deciduous woodland of all types; also in heathland and moorland. **STATUS** Widespread and common. **SIMILAR SPECIES Scurfy Deceiver** *Laccaria proxima* is larger, has a scalier cap and is generally found on poor acid soil in woodland, heathland and moorland, often with birches.

The Deceiver

Amethyst Deceiver *Laccaria amethystina* (Top 100)

Instantly recognisable when wet, but dries out and fades to such an extent that the original amethyst colour is barely perceptible. **CAP** To 5cm across; convex at first, then flatter with a depressed centre; margin incurved and becoming undulating and furrowed; surface dull and finely felty or scurfy, particularly in centre; violet or amethyst, but hygrophanous and fading to cream or tan with only a hint of the original colour. **GILLS** Adnate or slightly decurrent; often distant; violet with a very pale lilac spore print. **STIPE** To 10cm long; cylindrical with a downy base, apex sometimes broader; concolorous with cap and streaked with whitish fibrils. **HABITAT** Usually in small groups in deciduous woodland. **STATUS** Widespread and very common.

Bicoloured Deceiver *Laccaria bicolor*

Tall, slender species similar to The Deceiver (*see* above) but with a distinctive lilac base to stipe. **CAP** To 5cm across; convex, becoming flatter with a slightly depressed centre and incurved margin; surface finely scurfy; cinnamon-brown, but hygrophanous and drying ochre or tan. **GILLS** Adnate or slightly decurrent; distant; greyish pink with a hint of lilac, and with a white spore print. **STIPE** To 14cm long; cylindrical and slender; tough and coarsely fibrillose; concolorous with cap and with a downy lilac base. **HABITAT** Solitary or in small groups in mixed deciduous and coniferous woodland; also on heathland and moors. **STATUS** Widespread but occasional to rare.

Bicoloured Deceiver

Laccaria purpureobadia

Uncommon purplish-brown deceiver found in wet places. **CAP** To 5.5cm across; convex with a broad umbo, becoming flatter and centrally depressed with a wavy margin; surface smooth or finely scurfy; dark purple-brown but drying paler. **GILLS** Adnate; fairly distant; pinkish, maturing brownish with a white spore print. **STIPE** To 6cm long; cylindrical, often with a thickened base; fibrous; concolorous with cap but with a paler apex. **HABITAT** Wet areas, including margins of lakes and ditches, often with Common Alder, birches and willows; also in *Sphagnum* moss. **STATUS** Widespread but uncommon to rare.

Twisted Deceiver *Laccaria tortilis*

Small, squat and somewhat deformed-looking deceiver found on bare, wet soil. **CAP** To 1.5cm across; hemispherical, becoming flatter with a depressed centre and wavy, grooved margin; pinkish brown with a darker centre, but drying paler and slightly scurfy. **GILLS** Adnate with a decurrent tooth; distant; light pinkish brown with a white spore print. **STIPE** To 2cm long; cylindrical and usually bent, with a white-downy base; concolorous with cap. **HABITAT** Usually in small groups where water collects, particularly on the edges of ditches, ponds and car tracks. **STATUS** Widespread but occasional.

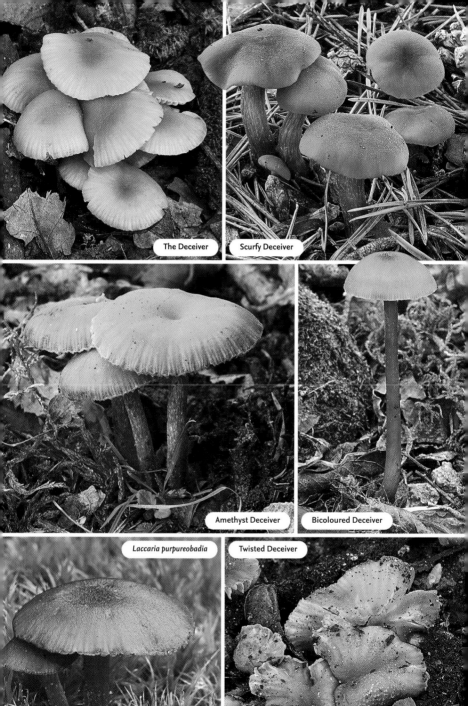

The Deceiver

Scurfy Deceiver

Amethyst Deceiver

Bicoloured Deceiver

Laccaria purpureobadia

Twisted Deceiver

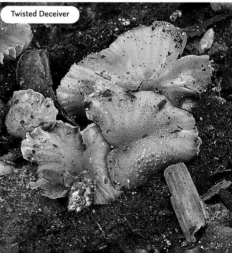

Recent DNA analysis has determined that many of the species in the genus *Collybia* are not closely related and consequently it is being dismantled. It will be retained for some species, but many will be moved to two new genera: *Gymnopus* and *Rhodocollybia*. The allocation of all the '*Collybia*' species has not yet been settled and pending completion of this the Kew Checklist has not been updated. This book, therefore, follows the original concept of the genus but many of the '*Collybia*' species will, in due course, be moved to other genera. Toughshanks have a tough fibrous stipe and, like most of the *Tricholoma* family, give a white or cream spore print.

Russet Toughshank *Collybia dryophila* (Top 100)

Extremely common but variable toughshank whose fruiting season extends from early summer to late autumn. **CAP** To 5cm across; convex, becoming flatter with a wavy margin; surface smooth and dull; variable but usually orange-brown or tan; hygrophanous, drying much paler. **GILLS** Adnexed or free; crowded; white, maturing buff. **STIPE** To 6cm long; cylindrical and often slender; flexible with a smooth surface; orange-brown with a paler apex. **HABITAT** Deciduous and coniferous woodland; moorland with heathers and *Sphagnum* moss. **STATUS** Widespread and very common. **SIMILAR SPECIES** *Collybia aquosa* is paler and very hygrophanous, with a bulbous stipe base and pinkish mycelium.

Clustered Toughshank *Collybia confluens* (Top 100)

The pale colours and densely clustered mode of growth of this species are distinctive features. **CAP** To 5cm across; convex or bell-shaped, becoming flatter, often with a wavy margin and/or a small umbo; surface dry and dull, becoming wrinkled with age; tan or coffee-coloured, sometimes with a pinkish tinge, but hygrophanous and drying almost white. **GILLS** Adnexed; very crowded; cream or buff. **STIPE** To 8cm long; cylindrical, sometimes tapering downward and often flattened or compressed; minutely velvety with a white-downy base; similar in colour to cap but sometimes progressively darker downward. **HABITAT** Usually in deciduous woodland, often with Beech; occasionally with conifers. **STATUS** Widespread and common.

Redleg Toughshank *Collybia erythropus*

Toughshank with a pale cap and a contrasting shiny reddish stipe. **CAP** To 4cm across; convex, becoming flatter and undulating, with a somewhat depressed centre; smooth, with a striate margin when moist; pale tan, but hygrophanous and drying even paler. **GILLS** Adnexed or free; white, maturing pale buff. **STIPE** To 7cm long; cylindrical with a downy base; smooth and silky or shiny; reddish brown or blood-red but paler towards apex. **HABITAT** On decayed fallen wood and stumps, or in grassland on buried wood. **STATUS** Widespread but occasional.

Collybia ocior

Similar to Russet Toughshank (*see* above) but with a darker cap and yellowish gills. Frequently fruits in spring. **CAP** To 4cm across; conical or convex, then flatter, often with a wavy margin; rich reddish brown or orange-brown, but hygrophanous and drying paler; smooth and slightly greasy when moist. **GILLS** Adnate; crowded; yellow. **STIPE** To 6cm long; cylindrical or sometimes slightly widening downward; ochre or reddish brown, occasionally darker towards base. **HABITAT** Deciduous woodland, occasionally on decayed wood; more rarely associated with conifers. **STATUS** Frequent in England, less common elsewhere.

Collybia acervata

Similar in mode of growth to Clustered Toughshank (*see* above), but with richer colours and restricted to conifers. **CAP** To 5cm across; hemispherical or convex with an incurved margin, becoming flatter, sometimes with a small, blunt umbo; reddish brown, but hygrophanous and drying paler. **GILLS** Adnate; crowded; pale pink. **STIPE** To 10cm long; cylindrical or sometimes compressed, with a downy base; smooth or finely grooved; reddish brown or greyish brown. **HABITAT** In dense clusters in soil, moss, needle litter or decayed wood, in coniferous woodland. **STATUS** Uncommon; restricted to Caledonian pine forests.

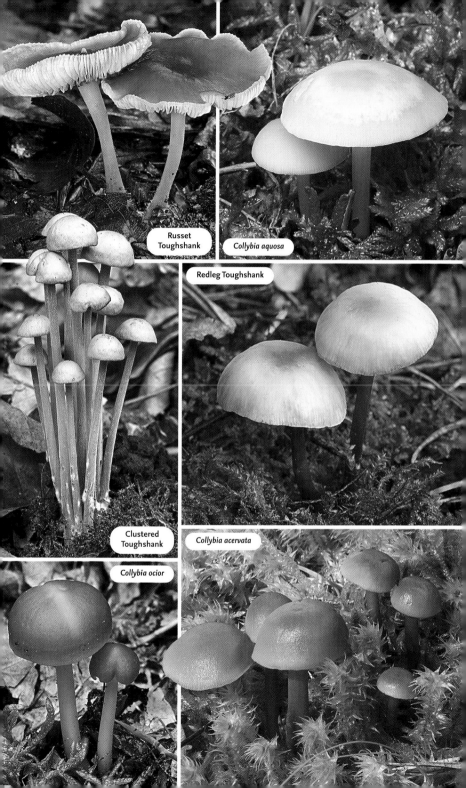

Russet Toughshank

Collybia aquosa

Redleg Toughshank

Clustered Toughshank

Collybia acervata

Collybia ocior

Spindleshank *Collybia fusipes*

The densely clustered mode of growth at the base of deciduous trees and the grossly distorted spindle-shaped stipe make this an easy fungus to identify. CAP To 7cm across; conical or convex, becoming flatter and irregularly distorted, sometimes with a shallow umbo; slightly greasy when moist but drying smooth; dull dark brown, but hygrophanous and drying paler in a patchy manner and with rust-coloured spots or blotches. GILLS Adnexed or free; very distant; white, tinged reddish brown and with rust-coloured spots. STIPE To 9cm long; stout, tough and spindle-shaped; grooved, twisted and deformed, and frequently fused at base. HABITAT Densely tufted at the base or on the roots of deciduous trees, usually oaks; rarely on conifers. STATUS Widespread and common.

Wood Woolly-foot *Collybia peronata* (Top 100)

Unmistakable *Collybia*, with the lower part of the stipe covered in dense, long woolly hairs that are frequently matted with the leaf-litter substrate. CAP To 6cm across; convex, becoming flatter with a shallow umbo; surface finely scurfy but becoming wrinkled and leathery with age; colour variable, in shades of pale brown or tan. GILLS Adnexed or free; distant; cream or yellow-brown. STIPE To 6cm long; slender and cylindrical; yellowish, somewhat felty with a matted, hairy lower part and base. HABITAT Solitary or in groups in deciduous woodland; occasionally with conifers. STATUS Widespread and common.

Cabbage Parachute *Micromphale brassicolens*

It is probable that this species will be moved to the new genus *Gymnopus*. The strong smell of rotten cabbage given off by this species is very distinctive, and is a character it shares with Foetid Parachute (p. 134). CAP To 3cm across; convex, becoming flatter and undulating; smooth, with a striate margin when moist; dull red-brown, sometimes spotty, but drying patchy and paler. GILLS Adnate or almost free; rather distant; pinkish brown but drying paler. STIPE To 3cm long; slender and cylindrical; pale pinkish brown at apex and progressively dark red-brown downward. HABITAT Clustered in decaying leaf litter, especially under Beech, but sometimes on fallen wood. STATUS Occasional in S England.

Spotted Toughshank *Collybia maculata* (Top 100)

Large whitish toughshank, heavily spotted or blotched reddish brown on maturity. CAP To 10cm across; convex, then flatter with an incurved margin that becomes undulating with age; white or creamy white, spotted reddish brown, particularly in centre. GILLS Adnexed; crowded; concolorous with cap and similarly spotted. STIPE To 10cm long; cylindrical with longitudinal grooves or fibrils; concolorous with cap, and with any discoloration confined to lower part. HABITAT Generally in groups on acid soils in mixed woodland, especially with pine and birch; also on heathland and moorland. STATUS Widespread and very common.

Spotted
Toughshank

Butter Cap *Collybia butyracea* (Top 100)

The distinctive feature of this common *Collybia* is the greasy surface to the cap, which has the texture of butter. It is found in two distinct forms. CAP To 6cm across; convex, becoming flatter and broadly umbonate; surface smooth and greasy with a translucent-striate margin; dark reddish brown, but hygrophanous and drying horn-brown or ivory with a darker centre; var. *asema* is much lighter in colour at all stages. GILLS Adnexed to almost free; crowded; whitish. STIPE To 8cm long; noticeably widening downward towards the white-downy base; surface dull, dry and fibrous; reddish brown, in marked contrast to pale gills. HABITAT Deciduous and coniferous woodland, with the type species having a preference for conifers; var. *asema* is found with broadleaved trees. STATUS Widespread and frequent; var. *asema* is more common. SIMILAR SPECIES *C. prolixa* is much rarer and confined to coniferous woodland.

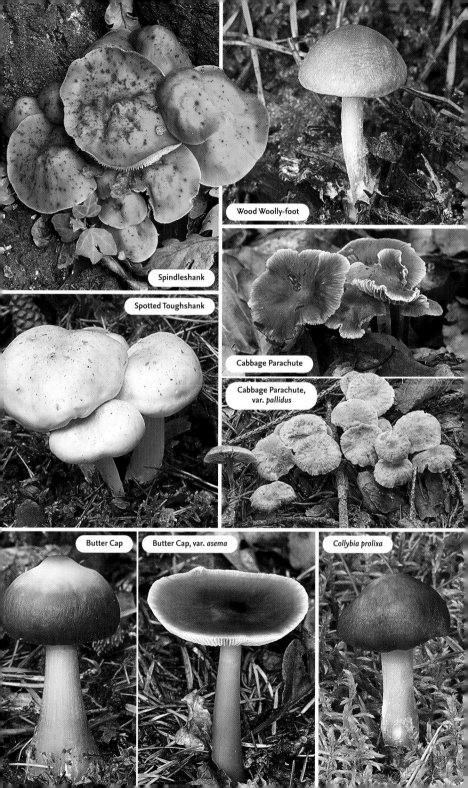

Wood Woolly-foot

Spindleshank

Spotted Toughshank

Cabbage Parachute

Cabbage Parachute, var. *pallidus*

Butter Cap

Butter Cap, var. *asema*

Collybia prolixa

Lentil Shanklet *Collybia tuberosa*

Very small *Collybia* growing on the decaying remains of mushrooms and arising from a seed-like sclerotium. **CAP** To 1.5cm across; convex, then flatter, often with a depressed centre and somewhat wrinkled; margin wavy; dull white with an ochre centre. **GILLS** Adnate; crowded; white. **STIPE** To 3cm long; cylindrical and sometimes twisted, with a downy base and attached to a shiny reddish-brown sclerotium; whitish or light brown, with a paler apex. **HABITAT** On the decaying remains of fleshy mushrooms, especially large species of *Russula* and *Lactarius*. **STATUS** Widespread and common. **SIMILAR SPECIES** Splitpea Shanklet *C. cookei* is equally common and found on the same substrate, but has a yellowish sclerotium.

Lentil
Shanklet

Piggyback Shanklet *Collybia cirrhata*

Similar to Lentil Shanklet but lacks a sclerotium. **CAP** To 1.5cm across; convex, then flatter with a depressed centre; margin sometimes radially grooved; white or pale greyish brown with a slightly darker centre. **GILLS** Adnate or slightly decurrent; white or cream. **STIPE** To 5cm long; cylindrical with a white-hairy base; white or pallid but becoming increasingly brownish downward. **HABITAT** On the mummified or decaying remains of large, fleshy mushrooms, including some non-gilled species. **STATUS** Widespread but occasional.

Rancid Greyling *Tephrocybe rancida*

Greyling in sombre colours with a strong, rancid mealy smell and a long, well-developed taproot. **CAP** To 4cm across; hemispherical, becoming convex or flatter with a distinct umbo and wavy margin; smooth and satiny but slimy when wet; greyish brown or dark grey and covered in a whitish bloom. **GILLS** Almost free; crowded; similar colour to cap, and with a white spore print. **STIPE** To 8cm long; cylindrical and rooting; smooth or slightly fibrillose; greyish brown with a paler apex and a white-downy base. **HABITAT** Mixed deciduous woodland. **STATUS** Widespread but occasional.

Sphagnum Greyling *Tephrocybe palustris*

Small brown greyling found in wet places, often starting to fruit in spring. **CAP** To 3cm across; convex, becoming flatter with a slightly depressed centre and occasionally umbonate; margin incurved and translucent-striate; light brown or ochre, drying paler. **GILLS** Adnexed; fairly distant; pale buff with a white spore print. **STIPE** To 7cm long; cylindrical and somewhat slender; smooth and slightly fibrillose; concolorous with cap or darker. **HABITAT** Parasitic on *Sphagnum* moss in bogs, woodland swamps and other wet places. **STATUS** Widespread but occasional; may be locally abundant.

Crazed Cap *Dermoloma cuneifolium*

Small, drab, mealy-smelling fungus found in unimproved grassland, frequently with waxcaps. **CAP** To 4cm across; convex becoming flatter; surface dull and usually finely cracking or crazing with age; sometimes covered with a whitish bloom when young; dull greyish brown with a darker centre. **GILLS** Adnexed; fairly distant and ventricose; whitish or pale grey with a white spore print. **STIPE** To 4.5cm long; cylindrical and fibrillose or powdery; white, maturing light brown. **HABITAT** Grows singly or in small groups in short turf in unimproved grassland. **STATUS** Widespread but occasional.

Delicatula integrella

Small, uniformly white *Hemimycena*-like fungus found in wet places. **CAP** To 1.2cm across; campanulate or convex, then expanded with a flattish or depressed centre, becoming irregular and undulating; dull white and translucent-striate. **GILLS** Sparse, very narrow, ridge-like and very distant; white. **STIPE** To 2cm long; cylindrical; translucent white. **HABITAT** In groups on plant debris, on soil or, more rarely, on decayed wood. **STATUS** Occasional in England; rare elsewhere.

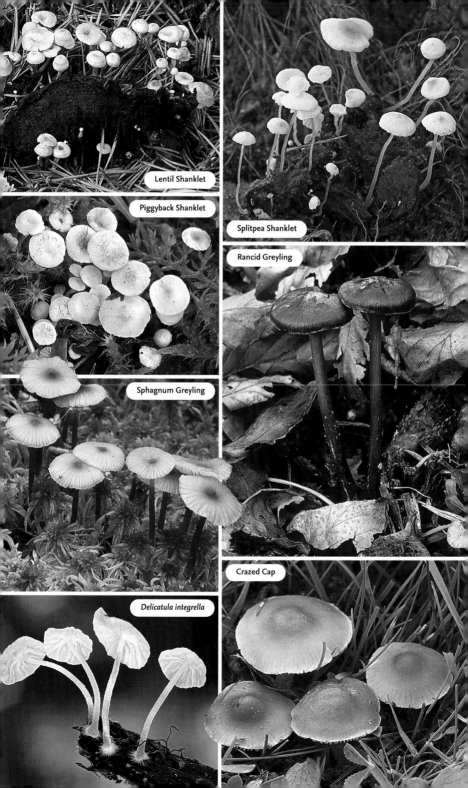

Lentil Shanklet

Piggyback Shanklet

Splitpea Shanklet

Rancid Greyling

Sphagnum Greyling

Crazed Cap

Delicatula integrella

Fairy Ring Champignon *Marasmius oreades* (Top 100)

Familiar grassland species, often found in groups or forming rings. **CAP** To 5cm across; convex, becoming flatter with a broad umbo; surface smooth; orange-ochre or tan, drying dull cream or buff. **GILLS** Adnexed or free; distant; white, maturing creamy with a white spore print. **STIPE** To 9cm long; cylindrical and sometimes widening towards the white-downy base; very tough; whitish or pale buff, often with a darker lower half. **HABITAT** Grassland of all types, including lawns, meadows and dunes. **STATUS** Widespread and very common.

Pearly Parachute

Pearly Parachute *Marasmius wynnei*

Hygrophanous *Marasmius* with a two-tone white or yellowish-red stipe. **CAP** To 6cm across; hemispherical or convex, becoming flatter and somewhat undulating; finely wrinkled and lined at margin; greyish beige with lilac tones, drying cream or buff. **GILLS** Adnexed; distant; beige but drying lighter, and with a white spore print. **STIPE** To 8cm long; cylindrical, slender, and sometimes compressed or tapering towards the white-downy base; surface finely velvety; whitish or cream in upper part, becoming increasingly yellow or dark red downward. **HABITAT** Usually grouped in decayed leaf litter in deciduous woodland, especially with Beech on calcareous soils. **STATUS** Common in S; less frequent elsewhere.

Marasmius cohaerens

Similar to Pearly Parachute but smaller. **CAP** To 3.5cm across; hemispherical, becoming flatter and broadly umbonate; margin lined or grooved when moist; beige or yellowish brown but progressively paler towards edge. **GILLS** Adnexed or free; distant; whitish or cream, often with brownish edges; white spore print. **STIPE** To 8cm long; cylindrical, slender and rigid; whitish but increasingly smooth, shiny and reddish brown downward. **HABITAT** Leaf litter and woody debris in deciduous woodland, often with Beech or Ash on calcareous soils. **STATUS** Widespread but occasional; most frequent in SE.

Marasmius cohaerens

Leaf Parachute *Marasmius epiphyllus*

Small white parachute, usually found on fallen leaves. **CAP** To 1cm across; convex, becoming flatter with a slightly depressed centre; surface dull, radially grooved and wrinkled; white or creamy white. **GILLS** Rudimentary and vein-like, with some forked or fused; adnate or decurrent; extremely distant; white. **STIPE** To 3cm long; cylindrical and very thin or hair-like; apex whitish, increasingly reddish brown downward; usually powdery. **HABITAT** Fallen and decayed leaves; occasionally fallen twigs. **STATUS** Common in England, less so elsewhere.

Garlic Parachute

Collared Parachute *Marasmius rotula*

Small white parachute-like *Marasmius* with a distinctive gill attachment. **CAP** To 1.5cm across; flattish convex with a depressed centre, and deeply grooved or ribbed with an undulating and scalloped margin; white, becoming ochreous with a darker centre. **GILLS** Very distant; separated from stipe by a ring or collar; white, becoming more ochreous and with a white spore print. **STIPE** To 7cm long; cylindrical and slender; shiny, dark reddish brown but paler towards apex. **HABITAT** Usually in groups in woodland on the debris of deciduous trees and shrubs; very rarely with conifers. **STATUS** Widespread and very common.

Garlic Parachute *Marasmius alliaceus*

The strong smell of garlic is the distinctive feature of this parachute. **CAP** To 4cm across; convex, becoming flatter or bell-shaped; surface dull, smooth or slightly wrinkled; margin striate when moist; darkish or mid-brown but drying paler. **GILLS** Adnexed or free; white or greyish with a white spore print. **STIPE** To 20cm long; rigid and very slender; smooth or finely velvety; blackish brown but paler towards apex. **HABITAT** Decayed wood of deciduous trees, usually on the fallen trunks or branches of Beech. **STATUS** Uncommon.

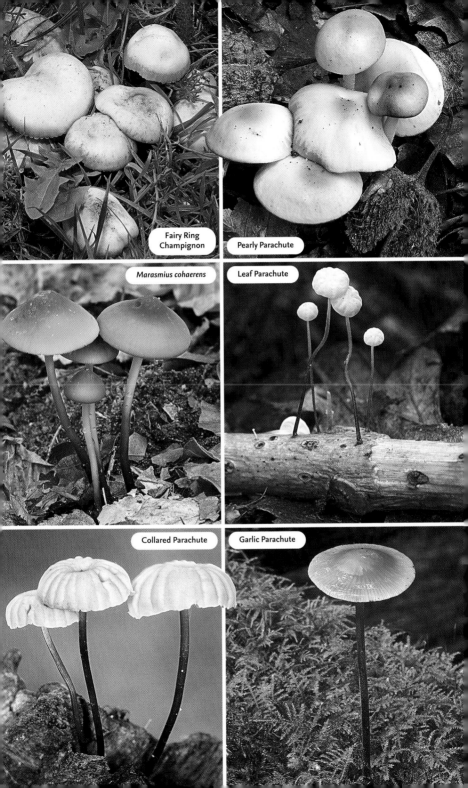

Fairy Ring Champignon

Pearly Parachute

Marasmius cohaerens

Leaf Parachute

Collared Parachute

Garlic Parachute

Horsehair Parachute *Marasmius androsaceus*
Small but conspicuous parachute with a very long, horsehair-like black stipe. **CAP** To 1cm across; convex, becoming flatter and usually with a depressed centre; strongly radially grooved, furrowed and wrinkled; pinkish brown but sometimes paler towards margin. **GILLS** Adnate; distant; concolorous with cap. **STIPE** To 5cm long; cylindrical, thin, tough and wiry; black. **HABITAT** Usually on plant debris, often of heathers and conifers; less frequently associated with deciduous trees. **STATUS** Widespread and very common.

Marasmius quercophilus
Small *Marasmius*, the mycelium of which distinctively bleaches the leaf-litter substrate. **CAP** To 1cm across; hemispherical or convex, often with a slightly depressed centre; margin striate or grooved; pinkish brown but drying paler and with a brownish centre. **GILLS** Adnate; rather distant; white. **STIPE** To 3.5cm long; cylindrical and slender; smooth or finely hairy in young specimens; reddish brown with a paler apex. **HABITAT** Attached to the fallen and decayed leaves of broadleaved trees, usually oaks. **STATUS** Uncommon but widespread.

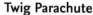

Marasmius quercophilus

Twig Parachute
Marasmiellus ramealis (Top 100)
Small parachute, often found clustered on stems of Bramble. **CAP** To 1.5cm across; convex, becoming flatter with a depressed centre; margin striate when moist, later somewhat upturned and lined; white or cream with a pinkish tinge and slightly darker centre. **GILLS** Adnate; distant; concolorous with cap, and with a white spore print. **STIPE** To 2cm long; cylindrical, slender and often curved; whitish, but reddish brown towards base. **HABITAT** Clustered or in groups on stems and twigs of deciduous trees and shrubs. **STATUS** Widespread and common.

Goblet Parachute *Marasmiellus vaillantii*
Similar to Twig Parachute but generally found in a different habitat and sometimes can be separated only microscopically. **CAP** To 1.7cm across; convex with a depressed centre and sometimes a small umbo; radially grooved, furrowed and wrinkled; white or cream with a hint of pink and a pinkish-brown centre. **GILLS** Adnate or decurrent; distant; white or cream with a white spore print. **STIPE** To 2.5cm long; cylindrical; apex white or cream, increasingly reddish brown and darker downward. **HABITAT** Dead stems and debris of grasses and herbaceous plants, and occasionally twigs of deciduous trees. **STATUS** Common in England, less so but widespread elsewhere.

Foetid Parachute *Micromphale (Marasmiellus) foetidum*
Fetid-smelling parachute, similar to Cabbage Parachute (p. 128) but found on fallen wood. **CAP** To 3cm across; convex, becoming flatter, undulating and furrowed with a depressed centre; dark reddish brown but drying paler. **GILLS** Adnate or decurrent; distant; pinkish brown with paler edges and a white spore print. **STIPE** To 2.5cm long; cylindrical and tough, with a finely velvety surface; dark brown or black at base and progressively paler upward. **HABITAT** Decayed woody debris of broadleaved trees, especially Hazel and Beech. **STATUS** Widespread but occasional in S England.

Rooting Shank

Rooting Shank *Xerula radicata* (= *Oudemansiella radicata*) (Top 100)
This early-fruiting shank has a wrinkled cap and long, rooting base. **CAP** To 10cm across; convex or bell-shaped, becoming flatter and usually umbonate; sticky when moist but drying rubbery and radially wrinkled; variable in colour, from pale to dark brown. **GILLS** Adnexed or decurrent; distant; white, sometimes with a brown edge; spore print white. **STIPE** To 20cm long; cylindrical, slender and deeply rooting; longitudinally grooved and sometimes twisted; white but increasingly flushed with cap colour downward. **HABITAT** On soil arising from buried wood. **STATUS** Widespread and common.

Horsehair Parachute

Marasmius quercophilus

Twig Parachute

Goblet Parachute

Foetid Parachute

Rooting Shank

Tawny Funnel *Lepista flaccida* (Top 100)

Similar to several species of *Clitocybe*, especially Common Funnel (*see* p. 118), which has a paler cap and sweetish smell. **CAP** To 9cm across; convex, then funnel-shaped with an inrolled margin that becomes undulating with age; flexible, with a dry, smooth surface; tawny or orange-brown, developing darker blotches. **GILLS** Deeply decurrent; crowded; whitish, maturing tawny with a white or cream spore print. **STIPE** To 5cm long; cylindrical, the downy base matted with the leaf-litter substrate; similar colour to cap but paler; sometimes fibrillose. **HABITAT** Deciduous and coniferous woodland. **STATUS** Widespread and very common.

Wood Blewit *Lepista nuda* (Top 100)

Variable blewit, superficially resembling a purple *Cortinarius* when young. This good edible species has a pleasant aromatic smell and often fruits well into winter. **CAP** To 15cm across; convex with a broad umbo, but becoming depressed with an irregular and undulating margin; bluish lilac, becoming brownish and fading with age. **GILLS** Sinuate; crowded; bluish lilac, fading to buff and with a pale pink spore print. **STIPE** To 10cm long; cylindrical with a slightly bulbous base; bluish lilac, fading to almost white, with longitudinal fibrils. **HABITAT** Variable, including deciduous and coniferous woodland, parkland and gardens, and woodchip mulch. **STATUS** Widespread and very common.

Wood Blewit

Lepista panaeola (= *L. luscina*)

Robust *Lepista* with a distinctive ring of spots on the cap. **CAP** To 12cm across; convex, becoming flatter and depressed with a wavy, undulating margin; smooth or finely floury; greyish brown. **GILLS** Adnate or decurrent; crowded; whitish, maturing dingy greyish pink with a pale pink spore print. **STIPE** To 6cm long; cylindrical and fairly stout; finely fibrillose; light greyish brown with a paler apex. **HABITAT** Meadows, pastures and unimproved grassland; sometimes found growing in rings. **STATUS** Widespread but uncommon to rare.

Lepista sordida

Similar to Wood Blewit (*see* above) and equally variable. Generally smaller, with darker, more intense colours. **CAP** To 8cm across; convex, becoming flatter or depressed, usually umbonate; margin incurved at first then wavy and undulating; lilac or lilac-brown, but hygrophanous and drying paler. **GILLS** Sinuate; crowded; greyish lilac, fading to buff. **STIPE** To 6cm long; cylindrical with a white-downy base; fibrillose; similar colour to cap. **HABITAT** Varied, including woodland edges, roadside verges and compost heaps. **STATUS** Widespread but occasional.

Flowery Blewit *Lepista irina*

Blewit whose strong perfumed odour distinguishes it from other similar-looking species. **CAP** To 10cm across; hemispherical or convex, becoming flatter and wavy or undulating; greyish buff with a slightly darker centre, but drying paler with a pinkish tint. **GILLS** Adnate or sinuate; crowded; cream, maturing darker with a pale pink spore print. **STIPE** To 10cm long; cylindrical sometimes with a swollen base; pinkish brown and covered longitudinally with coarse, darker fibrils. **HABITAT** Deciduous woodland, especially with Beech and Ash; sometimes with conifers. **STATUS** Occasional in England; rare elsewhere.

Field Blewit *Lepista saeva*

Similar to Wood Blewit and *L. sordida* (*see* above), but the pale beige cap and contrasting violet stipe are distinctive. **CAP** To 12cm across; convex, becoming flatter, depressed and undulating; beige but drying paler. **GILLS** Sinuate; crowded; whitish or light beige with a pale pink spore print. **STIPE** To 10cm long; stout and cylindrical with a slightly swollen base; whitish ground covered in coarse violet or blue fibrils. **HABITAT** Grassland in scrubby deciduous woodland, gardens and roadsides. **STATUS** Occasional in England.

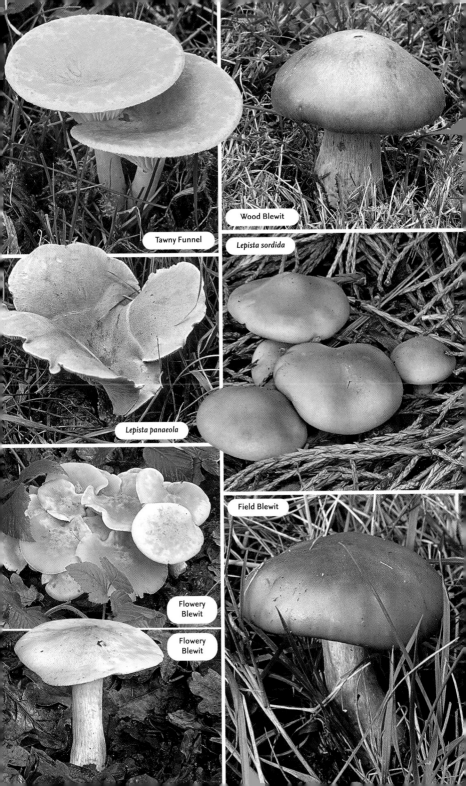

Tawny Funnel

Wood Blewit

Lepista sordida

Lepista panaeola

Field Blewit

Flowery
Blewit

Flowery
Blewit

Porcelain Fungus *Oudemansiella mucida*

This predominantly white, porcelain-like fungus is one of the attractions in Beech woods in autumn. **CAP** To 10cm across; convex, becoming flatter with a broad umbo; slimy and translucent, creating an impression of porcelain; white or ivory but sometimes greyish when young with an ochre centre. **GILLS** Adnate; distant; white or ivory with a white spore print. **STIPE** To 10cm long; slender and cylindrical with a thicker base; prominent ring has a greyish underside and white upper surface; smooth or finely scaly below ring and striate above; white with a brownish base. **HABITAT** Grouped or clustered on dead or dying broadleaved trees, especially Beech; often high up. **STATUS** Widespread and common.

Porcelain
Fungus

Myxomphalia maura

Hygrophanous fungus found on burnt ground. **CAP** To 4cm across; convex, becoming flatter with a strongly indented centre; translucent-striate; greyish brown but drying paler and shiny. **GILLS** Adnate or decurrent; whitish or pale grey with a white spore print. **STIPE** To 4cm long; cylindrical and tough, surface finely velvety; similar colour to cap. **HABITAT** Burnt areas in coniferous woodland and heaths. **STATUS** Occasional in England; rare elsewhere.

Myxomphalia
maura

Conifercone Cap *Baeospora myosura*

Distinctive autumn-fruiting fungus found growing out of fallen conifer cones. **CAP** To 2cm across; convex, becoming flatter, usually with a broad umbo; light brown to hazel-brown, but slightly hygrophanous and drying paler. **GILLS** Adnate or adnexed; very crowded; white or beige with a white spore print. **STIPE** To 5cm long; cylindrical; finely velvety with a hairy base; pallid, flushed with cap colour. **HABITAT** Usually in small groups on fallen, often partly buried cones of conifers. **STATUS** Widespread and common.

Heath Navel *Lichenomphalia umbellifera* (= Omphalina ericetorum)

Small yellowish fungus often found in upland regions. **CAP** To 2cm across; convex with a depressed centre and becoming funnel-shaped; radially striate or fluted; brownish shades of yellow. **GILLS** Decurrent; broad and very distant; pale yellowish cream with a white spore print. **STIPE** To 2cm long; cylindrical and often curved, with a downy base; similar in colour to cap but usually with a darker apex. **HABITAT** In small groups on acid soils, peat and mosses on heaths and moors. **STATUS** Common in Scotland; occasional elsewhere.

Arrhenia rustica (= Omphalina rustica)

Similar to Heath Navel in stature, but smaller and of a different colour. **CAP** To 1.25cm across; convex with a depressed centre and becoming funnel-shaped; radially striate or fluted with a crenulated margin; shades of darkish brown but hygrophanous and drying paler. **GILLS** Strongly decurrent; broad and very distant; similar to cap or paler and with a white spore print. **STIPE** To 1.5cm long; cylindrical with a smooth surface; concolorous with cap or slightly darker. **HABITAT** Solitary or in small groups on poor sandy soil in mosses and lichens, in heathland and along roadsides in woodland. **STATUS** Uncertain due to confusion with similar species but certainly far from common.

Xeromphalina campanella

Small, bright fungus found in dense clusters on decayed conifer wood. **CAP** To 1.5cm across; convex, becoming flatter with a depressed centre and a striate or grooved margin; surface smooth and slightly greasy at first; orange-brown with a darker centre. **GILLS** Adnate or decurrent; distant; cream, maturing darker with a whitish spore print. **STIPE** To 4cm long; cylindrical and often curved, with a swollen downy base; yellowish at apex and progressively reddish brown downward. **HABITAT** Decayed conifer wood, especially pine stumps. **STATUS** Fairly common in Scotland and N England; virtually unknown elsewhere.

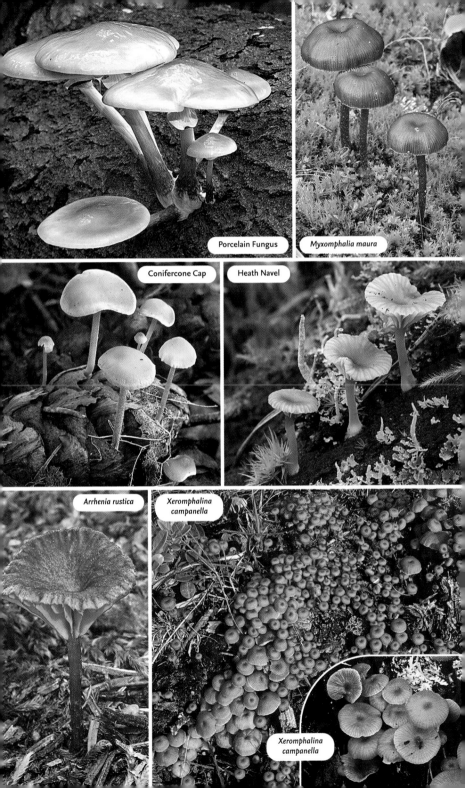

Porcelain Fungus

Myxomphalia maura

Conifercone Cap

Heath Navel

Arrhenia rustica

Xeromphalina campanella

Xeromphalina campanella

Members of the genus *Mycena* are small fungi with distinctive conical or bell-shaped caps (like a pixie's bonnet) and a long, very slender stipe. Cap colours are variable, with many sombre grey or brown; when moist they are usually strongly striated or grooved. The gills tend to be adnexed, and some have a coloured edge that can be faint (use a hand lens). The spore print is white. Stipe consistency can be significant and may be tough, elastic or brittle. Another important field characteristic is the 'milk' exuded from the broken stem of some species, which can be white or coloured. Bonnets are found in a wide range of habitats, from all types of woodland to grass. They can appear in many months of the year but predominantly fruit from summer to late autumn.

Grooved Bonnet *Mycena polygramma*
Bonnet with a distinctly longitudinally grooved stipe. **CAP** To 5cm across; conical, becoming flatter with a broad umbo; margin sometimes upturned with age; slightly greasy when moist and translucent-striate; grey or grey-brown with a paler margin. **GILLS** Adnexed; distant; white or greyish, sometimes with a pinkish tinge. **STIPE** To 10cm long; cylindrical, slender, fairly tough and with fine silvery longitudinal grooves; similar colour to cap but paler, and with a woolly rooting base. **HABITAT** Solitary or grouped on dead and buried wood of deciduous trees, rarely conifers. **STATUS** Widespread and very common.

Common Bonnet

Common Bonnet *Mycena galericulata* (Top 100)
Very common bonnet whose gills are connected by prominent veins. **CAP** To 6cm across; conical, expanding to bell-shaped with a shallow umbo; surface dull, smooth and striate; greyish brown, becoming paler towards margin. **GILLS** Adnate; fairly distant, with linking veins; whitish or grey, developing a pink tint with age. **STIPE** To 10cm long; cylindrical but sometimes flattened; smooth, shiny and tough, with a woolly rooting base; grey or beige, becoming brown. **HABITAT** Usually clustered, occasionally solitary, on decayed and buried wood of deciduous trees, rarely conifers. **STATUS** Widespread and very common.

Mycena stipata
Brown bonnet with a distinctive smell of ammonia. **CAP** To 3cm across; conical, becoming bell-shaped with the margin often uplifted; shiny when moist and translucent-striate; greyish brown or sometimes more reddish, but hygrophanous and paler when dry. **GILLS** Adnate; edges whitish. **STIPE** To 7cm long; cylindrical and sometimes compressed; fairly stiff but fragile; whitish at apex and increasingly grey-brown below to a whitish base. **HABITAT** Solitary or, more usually, in groups on decayed conifer wood. **STATUS** Widespread but uncommon.

Mycena stipata

Snapping Bonnet *Mycena vitilis*
Bonnet with a stiff stipe that snaps audibly when broken. **CAP** To 2cm across; conical or convex, becoming bell-shaped with a broad, shallow umbo; greasy when moist and translucent-striate; shades of greenish brown with a paler margin. **GILLS** Adnate; edges whitish and very finely toothed; white, maturing grey and spotted brown in places. **STIPE** To 11cm long; slender and cylindrical with a white-woolly rooting base; lower part pinkish brown and progressively paler upward. **HABITAT** Usually in small groups in leaf litter and woody debris in deciduous woodland. **STATUS** Widespread and common.

Iodine Bonnet *Mycena filopes*
Brownish bonnet smelling of iodine. **CAP** To 2cm across; conical, becoming bell-shaped; hygrophanous and translucent-striate; greyish brown but increasingly paler towards margin. **GILLS** Adnate; broad with smooth white edges; whitish or grey-brown. **STIPE** To 7cm long; cylindrical and slender with a finely hairy base; greyish brown but paler at apex. **HABITAT** On soil or decaying woody debris in mixed woodland. **STATUS** Widespread and common.

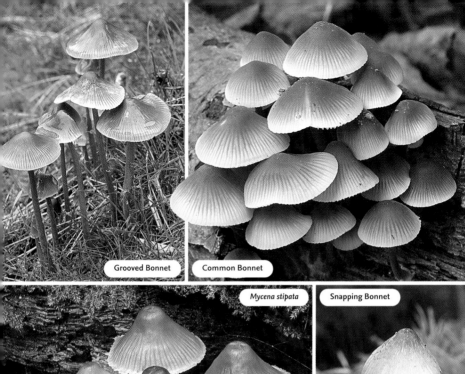

Grooved Bonnet

Common Bonnet

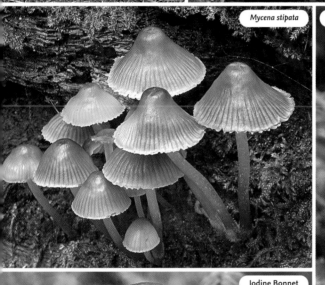

Mycena stipata

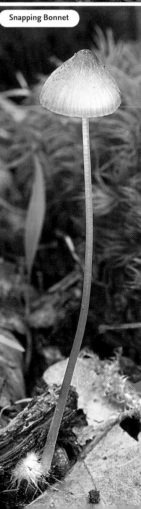

Snapping Bonnet

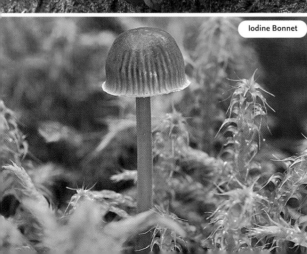

Iodine Bonnet

Milking Bonnet *Mycena galopus* (Top 100)

Young specimens of this common bonnet exude a white milk from the stem when broken. Found in a wide variety of colour forms and habitats. **CAP** To 2cm across; conical, bell-shaped or flatter; striate, with margin often scalloped. Typically whitish beige, often with a darker centre, but uniformly white in var. *candida* and dark brown to almost black in var. *nigra*; both varieties exude white milk. **GILLS** Adnate; fairly distant; white or greyish white. **STIPE** To 8cm long; cylindrical and somewhat elastic; concolorous with cap, including the varieties; rooting and with a white-hairy base. **HABITAT** Usually trooping in deciduous and coniferous woodland, occasionally on dead wood. Var. *nigra* is sometimes found on burnt ground. **STATUS** Widespread and very common; the varieties are less common.

Bleeding Bonnet *Mycena sanguinolenta*

This bonnet bleeds reddish milk from the stipe when broken and has coloured gill edges. **CAP** To 2cm across; conical, becoming bell-shaped or flatter; umbonate; surface smooth, dull and translucent-striate; pinkish with a darker centre. **GILLS** Adnate; edges smooth and reddish brown; dingy white or grey, flushed with cap colour. **STIPE** To 7cm long; cylindrical, slender and delicate; similar colour tones to cap but darker and with a finely hairy base; exudes red liquid when broken. **HABITAT** Debris from conifers, including twigs, fallen branches and needle litter. **STATUS** Widespread and common.

Burgundydrop Bonnet *Mycena haematopus*

Similar to Bleeding Bonnet, with the same coloured milk and gill edges, but more robust and generally found on dead wood of deciduous trees. **CAP** To 4cm across; conical, then bell-shaped or flatter; umbonate; smooth, dull or satiny and translucent-striate; pinkish brown with a paler margin and darker centre. **GILLS** Adnate; fairly distant; light creamy pink, often with dark spots where damaged and darker edges. **STIPE** To 7cm long; cylindrical; fragile, smooth and silky; pinkish brown, exuding a red liquid when broken. **HABITAT** Decayed wood, often stumps of deciduous trees, rarely with conifers. **STATUS** Widespread and common.

Saffrondrop Bonnet *Mycena crocata*

This bonnet is distinguished by an abundance of saffron or orange milk exuded from both stipe and cap when damaged. **CAP** To 3cm across; conical, becoming bell-shaped and umbonate; surface smooth, silky and striate to centre; variable in colour, from whitish fawn to grey-brown, and often suffused or spotted saffron or orange from the milk. **GILLS** Adnate; fairly distant; white, staining saffron or orange. **STIPE** To 9cm long; slender and cylindrical with a white-hairy base; bright orange on lower half and progressively paler towards apex. **HABITAT** Woody debris and leaf litter in deciduous woodland, particularly with Beech. **STATUS** Locally common in S; less frequent elsewhere.

Saffrondrop Bonnet

Angel's Bonnet *Mycena arcangeliana* (= *M. oortiana*)

Angel's Bonnet

Greyish-yellow bonnet smelling of iodine, particularly when dried. **CAP** To 5cm across; conical, becoming bell-shaped with a broad umbo; surface smooth and usually translucent-striate; greyish brown with a hint of yellow or olive, but hygrophanous and drying paler. **GILLS** Adnexed; crowded, with slightly toothed edges; whitish with a hint of pink. **STIPE** To 7cm long; cylindrical, smooth and slightly silky with a white-hairy base; olive-grey with a lilac tint when young, apex whitish. **HABITAT** On decayed wood of deciduous trees, typically stumps or fallen branches of Beech or Ash. **STATUS** Widespread and common, predominantly in S. **SIMILAR SPECIES** *M. flavescens* has a whiter cap and radish-like smell. It is also found in a different habitat: typically decayed leaf and needle litter in deciduous and coniferous woodland, but also in grass. It is less common but with the same S bias.

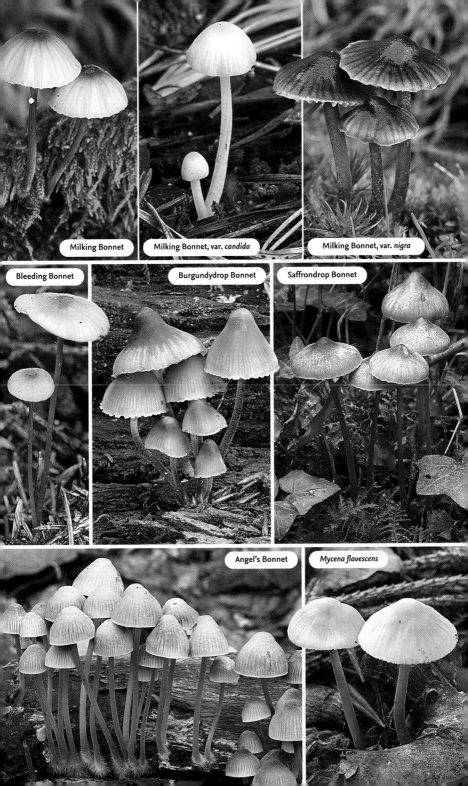

Milking Bonnet

Milking Bonnet, var. *candida*

Milking Bonnet, var. *nigra*

Bleeding Bonnet

Burgundydrop Bonnet

Saffrondrop Bonnet

Angel's Bonnet

Mycena flavescens

Lilac
Bonnet

Lilac Bonnet *Mycena pura* (Top 100)

Extremely variable both in size and colour, with numerous varieties described. The distinctive radish-like smell is, however, a constant feature. **CAP** To 5cm across; convex, becoming flatter or bell-shaped, usually umbonate and sometimes with the margin uplifted with age; surface smooth and striate or lined; generally in shades of lilac, but yellowish, whitish and even multicoloured forms are found; hygrophanous and drying paler. **GILLS** Adnate; white or greyish with a lilac tint. **STIPE** To 6.5cm long; cylindrical or slightly thickened towards base; smooth, silky and fragile; similar in colour to cap. **HABITAT** Typically in groups in leaf litter in deciduous and coniferous woodland, especially with Beech. **STATUS** Widespread and very common. **SIMILAR SPECIES** *M. rosea* is larger and more robust; considered by some merely to be a pink form of *M. pura*.

Blackedge Bonnet *Mycena pelianthina*

Similar to Lilac Bonnet but with a more restricted colour range and distinctive coloured gill edges. **CAP** To 4cm across; convex or bell-shaped, becoming flatter and usually with a broad umbo; surface smooth, with fine radial fibrils and a translucent-striate margin; greyish brown with a lilac tint, but hygrophanous and drying whitish or beige. **GILLS** Adnate; distant; greyish violet with purple-black edges. **STIPE** To 6cm long; cylindrical and somewhat fibrous; beige with a violet tint. **HABITAT** Deciduous woodland, typically with Beech on calcareous soil. **STATUS** Widespread and common, mainly in S.

Mycena diosma

Similar to Lilac Bonnet (*see* above) but with a restricted colour range and smelling of tobacco. A late-autumn species. **CAP** To 4cm across; convex, becoming flatter with a sharp umbo; surface smooth and finely fibrillose, with a striate margin; dark violet with shades of grey or brown and a concentric marginal zone, but hygrophanous and drying beige or pinkish violet from centre outwards to create a two-tone effect. **GILLS** Adnate; brownish or greyish violet with whitish edges. **STIPE** To 10cm long; cylindrical; smooth and satiny; concolorous with gills. **HABITAT** Deciduous woodland, usually with Beech, on calcareous soils. **STATUS** Uncommon or rare; predominantly in S.

Blackedge Bonnet

Mycena pearsoniana

Close to Lilac Bonnet (*see* above) but much smaller and with only a faint smell of radish. **CAP** To 2cm across; convex, becoming flatter with a sharp umbo; margin striate and often uplifted with age; pinkish buff, sometimes with a violet tint and paler at margin. **GILLS** Adnate; broad and crowded; whitish or lilac-pink. **STIPE** To 5cm long; cylindrical; surface, with a velvety apex; fibrillose and rooting; concolorous with cap or paler. **HABITAT** Soil or leaf litter in deciduous and coniferous woodland. **STATUS** Uncommon but widespread.

Mycena megaspora (= *M. uracea*)

Dark brown bonnet found with Heather on moorland and heathland. **CAP** To 3cm across; conical or convex and usually umbonate; margin deeply striated or grooved; greyish brown often with a darker centre. **GILLS** Adnate; white then pinkish grey. **STIPE** To 4cm long; cylindrical but sometimes thickening towards base; greyish brown with a whitish bloom when young; base rooting, and with fine white hairs. **HABITAT** Associated with Heather on peaty acid heaths and moors, especially after burning. **STATUS** Widespread but occasional; may be abundant where suitable habitat or conditions occur. **SIMILAR SPECIES Nitrous Bonnet** *M. leptocephala* is similar in colour but is smaller, dries lighter and gives off a strong smell of ammonia. It is a widespread and common species, found on decaying wood and leaf litter in deciduous and coniferous woodland.

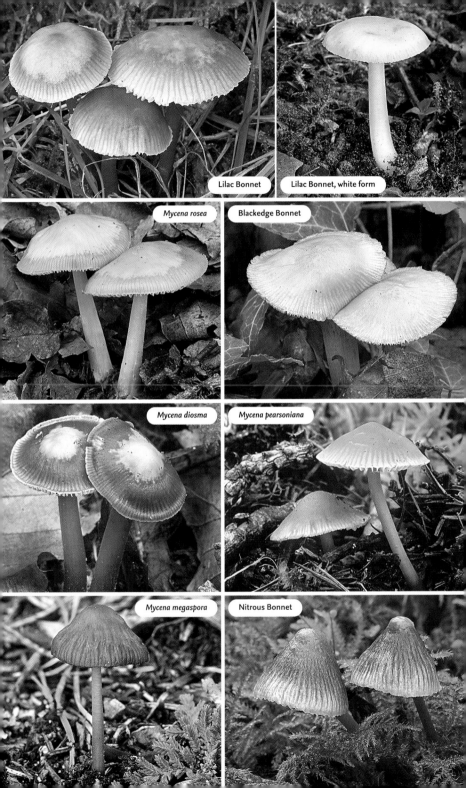

Lilac Bonnet

Lilac Bonnet, white form

Mycena rosea

Blackedge Bonnet

Mycena diosma

Mycena pearsoniana

Mycena megaspora

Nitrous Bonnet

Clustered Bonnet *Mycena inclinata* (Top 100)

Bonnet with a strong soapy or rancid smell. Typically found in dense clusters on the stumps or dead wood of broadleaved trees. **CAP** To 4cm across; conical, becoming bell-shaped and usually umbonate; surface smooth; striate almost to centre, with a finely scalloped or toothed margin; shades of grey, ageing brownish. **GILLS** Adnate; distant; white or greyish with a pinkish tint. **STIPE** To 10cm long; cylindrical and flexible; apex whitish but increasingly reddish brown towards the white-woolly base. **HABITAT** Clustered on the dead wood of deciduous trees, especially oaks. **STATUS** Widespread and very common. **SIMILAR SPECIES** *M. maculata* is also clustered but is less common and found on a wider range of wood, although rarely conifers. Its cap and gills are spotted reddish brown and the margin is strongly translucent-striate.

Mealy Bonnet *Mycena cinerella*

Small grey bonnet with a farinaceous smell. **CAP** To 1.5cm across; convex becoming flatter, sometimes with a slightly depressed centre; margin translucent-striate almost to the centre; grey to grey-brown often with a darker centre, paler when dry. **GILLS** Decurrent and fairly distant; pale grey or whitish. **STIPE** To 4.5cm long, cylindrical and sometimes bent; greyish brown with a paler apex. **HABITAT** Usually needle litter in acid, coniferous woodland; more rarely with deciduous trees. **STATUS** Widespread and occasional.

Drab Bonnet *Mycena aetites*

Featureless bonnet with a faint smell of ammonia; found in grassland. **CAP** To 2cm across; conical or bell-shaped, sometimes flatter and with a broad umbo; smooth and markedly grooved or striated; greyish brown, but hygrophanous and drying beige. **GILLS** Adnate and somewhat ascending; greyish with paler and finely felty edges. **STIPE** To 5cm long; cylindrical, silky and fragile; greyish brown but increasingly darker towards downy base. **HABITAT** Usually in open, short grass, including lawns and pastures. **STATUS** Widespread and fairly common.

Yellowleg Bonnet *Mycena epipterygia*

Highly variable bonnet, usually with a yellow or greenish stipe. Cap and stipe both have a peelable layer. **CAP** To 2cm across; conical, becoming convex or bell-shaped; margin striate and sometimes scalloped; cream to greenish yellow, although a brownish form exists. **GILLS** Adnate or slightly decurrent; edges smooth and gelatinous; white, maturing yellowish. **STIPE** To 5cm long; cylindrical; fragile and sticky; pale to greenish yellow with a darker base. **HABITAT** Grouped on debris in deciduous and coniferous woodland on acid soil; occasionally in grass or moss on heathland. **STATUS** Widespread and common.

Brownedge Bonnet *Mycena olivaceomarginata*

Bonnet with distinct brown edges to its gills, frequent in old unimproved lawns in summer. **CAP** To 2.5cm across; convex, becoming bell-shaped and often umbonate; margin delicately scalloped and deeply striate; olive-brown with yellow tones and a darker centre. **GILLS** Adnate; concolorous with cap but edges brownish. **STIPE** To 6cm long; cylindrical and smooth; concolorous with cap or slightly darker, and with a pale apex and white-downy base. **HABITAT** Grouped or clustered in short turf. **STATUS** Widespread and occasional to common.

Yellowleg
Bonnet

Pinkedge Bonnet *Mycena capillaripes*

Small pinkish bonnet with reddish gill edges and a strong alkaline smell. **CAP** To 2cm across; conical or bell-shaped; margin translucent-striate; shades of pinkish or reddish brown with a darker centre. **GILLS** Broadly adnate; pale cream with a pink flush and reddish edges. **STIPE** To 6cm long; cylindrical; light reddish brown with a darker base. **HABITAT** Needle litter in coniferous woodland. **STATUS** Widespread but occasional; may be locally abundant. **SIMILAR SPECIES** **Red Edge Bonnet** *M. rubromarginata* lacks the strong smell and is found on decayed conifer wood.

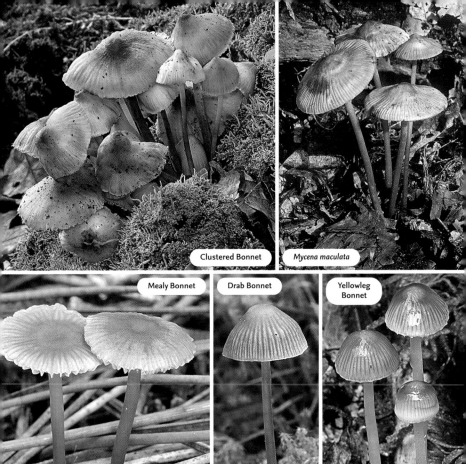

Clustered Bonnet

Mycena maculata

Mealy Bonnet

Drab Bonnet

Yellowleg Bonnet

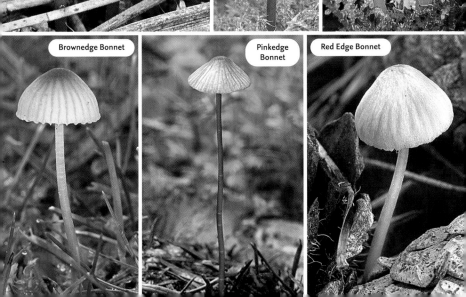

Brownedge Bonnet

Pinkedge Bonnet

Red Edge Bonnet

Dripping Bonnet *Mycena rorida*

Distinctive bonnet whose stipe is encased in a thick, slimy gluten. **CAP** To 1cm across; broadly convex with a flat or slightly depressed centre; deeply grooved or striate; off-white or cream with a brownish or greyish centre. **GILLS** Adnate or decurrent; distant; white. **STIPE** To 3cm long; cylindrical; coated in a transparent gluten that, when fresh, flows downward to base; concolorous with cap. **HABITAT** Woody and herbaceous debris in deciduous and coniferous woodland; frequently on Bramble. **STATUS** Widespread but occasional.

Dripping Bonnet

Bulbous Bonnet

Bulbous Bonnet *Mycena stylobates*

Very small bonnet with a distinctive disc at base of stipe. **CAP** To 1cm across; convex, becoming bell-shaped or flatter; surface somewhat granular with scattered fine outgrowths (visible only through a hand lens); translucent-striate; whitish or pale shades of grey or beige. **GILLS** Adnexed or free; white or greyish. **STIPE** To 4cm long; slender and cylindrical or slightly tapering upward; attached to substrate by a small white disc with a woolly margin; concolorous with cap. **HABITAT** Decayed leaf litter and woodland debris; also on dead grasses. **STATUS** Common in England; less frequent elsewhere.

Bark Bonnet *Mycena speirea*

Small bonnet with arching decurrent gills. **CAP** To 1.5cm across; convex, becoming flatter, sometimes depressed at centre and with a sharp umbo; translucent-striate almost to centre; shades of pale grey or ochre with a darker centre and paler margin. **GILLS** Arching and broadly adnate or decurrent; whitish cream. **STIPE** To 6cm long; cylindrical and slender, usually powdery and with a downy base; light grey or ochre-brown, becoming darker towards base, sometimes yellowing in old specimens. **HABITAT** Decayed wood of deciduous trees, often moss-covered trunks or pieces of bark. **STATUS** Widespread and occasional to common.

Orange Bonnet *Mycena acicula*

Small (often very small) bonnet with an orange or red cap. **CAP** To 1cm across; convex, becoming flatter; surface often finely powdery; margin undulating and translucent-striate almost to centre; red or orange, sometimes yellowish. **GILLS** Adnexed and ascending; white or yellowish with paler edges. **STIPE** To 5cm long; cylindrical and very slender; smooth or finely powdery with a downy base; yellow, but increasingly paler downward. **HABITAT** Leaf litter and woody and herbaceous debris in deciduous woodland. **STATUS** Widespread and common.

Scarlet Bonnet *Mycena adonis*

Similar to Orange Bonnet but more robust, redder and usually with a white stipe. **CAP** To 2cm across; conical to bell-shaped with a broad umbo; margin striate and sometimes uplifted; surface smooth and dull or silky; rose-red or coral-pink, fading with age and often with a paler margin. **GILLS** Adnate or slightly decurrent; white with a pink tint. **STIPE** To 3cm long; cylindrical, with a smooth surface; white but pinkish in var. *coccinea*. **HABITAT** Debris in deciduous and coniferous woodland; occasionally in grass near trees and also with *Sphagnum* moss. **STATUS** Widespread but occasional.

Milky Bonnet *Hemimycena lactea* (= *M. lactea*)

Small, uniformly white bonnet, usually found trooping on coniferous debris. **CAP** To 1.5cm across; conical, becoming bell-shaped or flatter with an upturned, wavy, striate margin; smooth, dull and powdery in places; white, often with a creamy centre. **GILLS** Adnate with a decurrent tooth; crowded; white. **STIPE** To 5cm long; cylindrical and slender; smooth and dull with a hairy base; creamy white and lightly powdery. **HABITAT** Conifer debris and needle litter. **STATUS** Widespread and common; locally abundant. **SIMILAR SPECIES** **Dewdrop Bonnet** *H. tortuosa* is smaller and holds water droplets when wet; it is found on decayed wood and debris in damp places.

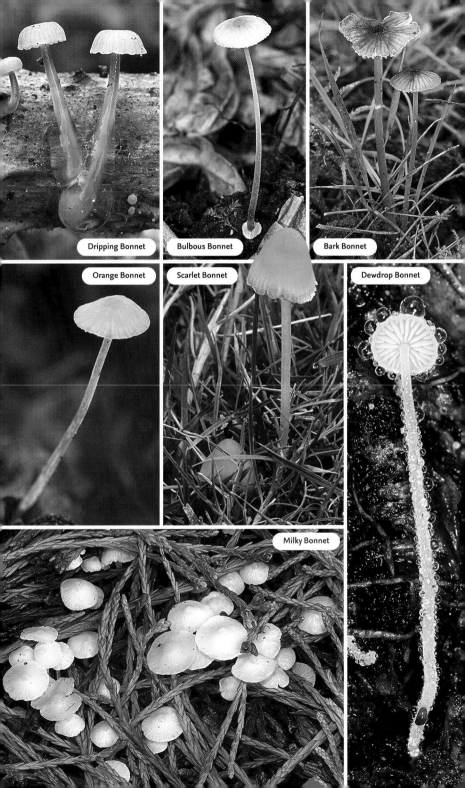

Dripping Bonnet

Bulbous Bonnet

Bark Bonnet

Orange Bonnet

Scarlet Bonnet

Dewdrop Bonnet

Milky Bonnet

Collared Mosscap *Rickenella swartzii*

The deeply decurrent gills and two-tone cap make this an easy fungus to identify. **CAP** To 1.5cm across; flattish convex with a depressed centre, often becoming funnel-shaped; margin undulating and striate or grooved; shades of light brown, sometimes with a hint of violet and a contrasting darker, almost black, centre. **GILLS** Deeply decurrent; distant; white or pale cream with a white spore print. **STIPE** To 4cm long; slender and cylindrical, sometimes wider at top; pallid with a violet tinge, particularly at apex. **HABITAT** Usually solitary amongst mosses in grassland and woodland. **STATUS** Widespread and very common.

Orange Mosscap *Rickenella fibula* (Top 100)

Similar to Collared Mosscap in stature and habitat, but orange in colour. **CAP** To 1cm across; convex with a depressed centre, sometimes becoming funnel-shaped; surface finely downy; margin undulating and striate; yellow-orange with a slightly darker centre. **GILLS** Deeply decurrent; distant; white or yellowish with a white spore print. **STIPE** To 4cm long; cylindrical and slender; pale orange and finely downy. **HABITAT** Solitary or in small groups growing in moss in lawns, woodland, unimproved grassland and heaths. **STATUS** Widespread and very common.

Powdery Piggyback *Asterophora lycoperdoides* (= *Nyctalis asterophora*)

An unusual and primitive fungus that carries special spores (chlamydospores) on the cap surface in a brown powdery mass. **CAP** To 2cm across; rounded, hardly expanding and barely opening; whitish at first and covered in a flour-like or mealy coating that soon becomes coarser and discolours cinnamon. **GILLS** Very rudimentary and vein-like; thick and distant; greyish. **STIPE** To 3cm long; somewhat bent; whitish with a cottony surface that discolours brown with age. **HABITAT** Usually grouped or clustered on decaying fruit bodies of *Russula* species, particularly Blackening Brittlegill (p. 62). **STATUS** Widespread but occasional.

Silky Piggyback *Asterophora parasitica* (= *Nyctalis parasitica*)

This could be confused with a young specimen of Powdery Piggyback, but the gills are more highly developed and the cap is not coated with spores. **CAP** To 2cm across; convex or bell-shaped with the margin inrolled, becoming flatter and undulating; surface smooth and covered in fine white fibrils, creating a silky appearance; white or light grey with a hint of lilac, discolouring brownish with age. **GILLS** Adnate or slightly decurrent; white or grey-brown. **STIPE** To 3cm long; cylindrical; greyish-brown ground covered in white fibrils. **HABITAT** Usually grouped or clustered on decaying fruit bodies of *Russula* species. **STATUS** Widespread but occasional.

Silky
Piggyback

Sprucecone Cap *Strobilurus esculentus* (= *Pseudohiatula esculenta*)

Smallish brown fungus growing out of fallen spruce cones. Generally fruits in spring. **CAP** To 2.5cm across; convex, becoming flatter; surface smooth or finely wrinkled; shades of mid-brown but drying paler. **GILLS** Adnexed; white or greyish white with a white spore print. **STIPE** To 7cm long; cylindrical and slender with a rooting base; ochre, but darker below. **HABITAT** Solitary or in small groups on buried or partially decayed spruce cones. **STATUS** Widespread but occasional.

Pinecone Cap *Strobilurus tenacellus* (= *Pseudohiatula tenacella*)

Similar to Conifercone Cap (p. 138) and also grows on pine cones, but generally fruits in spring. **CAP** To 2.5cm across; convex, becoming flatter, sometimes with a small umbo; smooth and striate when moist; shades of darkish brown or grey, often with a paler centre. **GILLS** Adnexed; crowded; white or greyish with a white spore print. **STIPE** To 7cm long; cylindrical with a rooting base; ochre with a paler apex. **HABITAT** Solitary or in small groups on buried or partly decayed pine cones. **STATUS** Widespread but occasional.

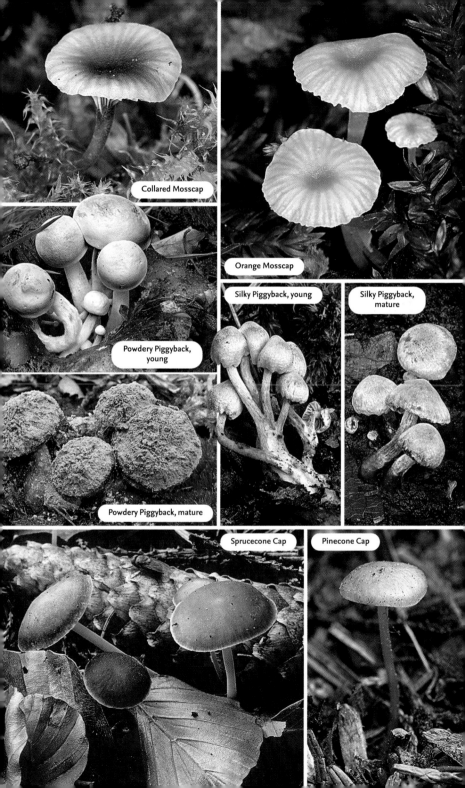

Collared Mosscap

Orange Mosscap

Powdery Piggyback, young

Silky Piggyback, young

Silky Piggyback, mature

Powdery Piggyback, mature

Sprucecone Cap

Pinecone Cap

Bitter Oysterling *Panellus stipticus*
Light brown oysterling with a very bitter taste and an extended fruiting season. CAP To 4cm across; kidney- or irregular fan-shaped, and flattish with an undulating margin; surface scurfy or granular; brownish yellow and occasionally concentrically zoned. GILLS Adnate or decurrent; very crowded; darker than cap with a white spore print. STIPE Lateral, short, stout and tapering sharply downward; attached to cap on one side; concolorous with cap and finely scurfy. HABITAT Usually clustered in overlapping tiers on dead or, occasionally, living deciduous trees, particularly oaks. STATUS Widespread and very common.

Olive Oysterling *Panellus serotinus*
Slimy greenish oysterling, generally found in winter. CAP To 10cm across; kidney-shaped, becoming flattish with an incurved and undulating margin; smooth and very slimy when moist but drying matt; olive-green but occasionally with grey or lilac tones. GILLS Adnate; crowded; orange or yellowish with a white spore print. STIPE Somewhat rudimentary, short and stout, usually wider at apex and attached to cap on one side; ochre or yellowish ground colour and covered in darker scales. HABITAT Usually grouped on decayed wood of deciduous trees, often in wet places. STATUS Frequent in England.

Elastic Oysterling *Panellus mitis*
Elastic bracket-like oysterling found on fallen conifer wood. CAP To 2cm across; fan- or kidney-shaped; surface gelatinous with a peelable cuticle, drying matt; whitish with a pink tint, becoming more ochreous with age. GILLS Adnate; crowded, with a gelatinous edge; white, maturing creamy with a white spore print. STIPE Rudimentary, short and laterally attached to the substrate; white or off-white and scurfy. HABITAT Dead conifer wood, including twigs. STATUS Widespread but occasional.

Wrinkled Peach *Rhodotus palmatus*
Unmistakable, unusually coloured fungus with a wrinkled cap surface. CAP To 10cm across; convex, sometimes irregular with an inrolled margin; surface gelatinous with a peelable cuticle and wrinkled even when young; pinkish, becoming apricot or peach. GILLS Sinuate, with interconnecting veins; paler than cap with a pinkish spore print. STIPE To 7cm long; fairly stout and off-centre; white or pink, covered in white fibrils. HABITAT Clustered on fallen and decayed wood of broadleaved trees, especially elms. STATUS Occasional and may be locally abundant, but possibly declining owing to the loss of elm trees.

Angel's Wings *Pleurocybella porrigens*
Lateral-growing bracket-like fungus found clustered on decayed conifer wood. CAP To 10cm across; circular or tongue-shaped with an incurved margin, becoming undulating or lobed with age; surface finely felty with a smoother margin; white or ivory. GILLS Decurrent; crowded, converging to the point of attachment; white, maturing cream with a white spore print. STIPE Absent; cap is attached to the substrate by a stipe-like thickening of cap edge. HABITAT Usually in groups or overlapping tiers on decayed conifer wood. STATUS Common in Scotland but rare elsewhere.

Hohenbuehelia atrocoerulea
Bracket-like fungus with a gelatinous layer under the cap cuticle. CAP To 5cm across; circular or kidney-shaped; dark olive-brown, sprinkled with greyish granules concentrated around the point of attachment; margin incurved and paler. GILLS White, maturing yellowish with a white spore print. STIPE Absent or rudimentary; cap is attached to the substrate by a thickening of the edge. HABITAT Dead and decayed wood of deciduous trees. STATUS Occasional in England; widespread elsewhere. SIMILAR SPECIES **Woolly Oyster** *H. mastrucata* is scarcer.

Woolly Oyster

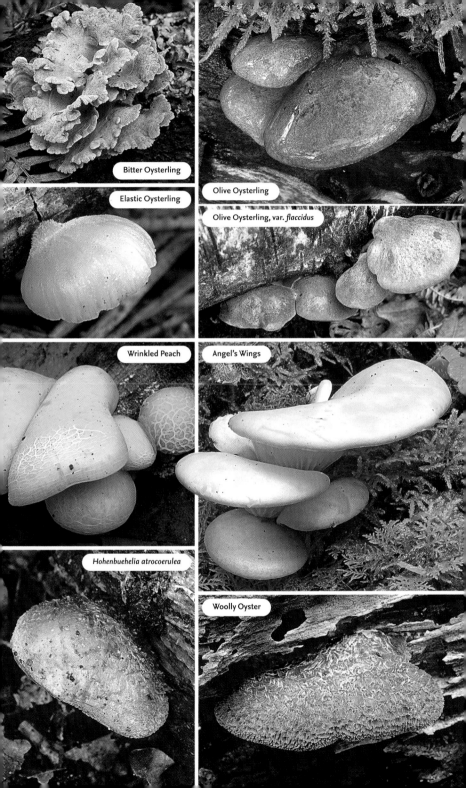

Bitter Oysterling

Olive Oysterling

Elastic Oysterling

Olive Oysterling, var. *flaccidus*

Wrinkled Peach

Angel's Wings

Hohenbuehelia atrocoerulea

Woolly Oyster

Entoloma species are variable in size, shape and hue; features in common are pinkish gills and polygonal pink spores when mature. Often sombre, some are nevertheless colourful and one group has a blue cap and/or stipe. Care is needed with this group, as the blue colour often fades to brown with age: an examination of young specimens is essential. Fibrils on the stipe sometimes run diagonally downward, giving it a twisted appearance. The majority are found in grassland, but some are woodland species and a few are found on other substrates. They generally fruit in the autumn but some are found in the spring or early summer. A microscope is needed to identify many species.

Star Pinkgill *Entoloma conferendum* (Top 100)
The most common brown pinkgill found in grassland; has a mealy smell. CAP To 3.5cm across; convex with an indistinct umbo or bell-shaped, and with a translucent-striate margin; surface smooth and finely radially fibrillose; dark brown at first, but hygrophanous and drying greyish beige in streaks. GILLS Adnexed; whitish, maturing pink. STIPE To 7cm long; slender and cylindrical; concolorous with cap or paler, and covered in fine whitish fibrils. HABITAT Grouped or clustered in all types of grassland; occasionally in bogs and along woodland edges. STATUS Widespread and very common.

Silky Pinkgill *Entoloma sericeum*
Hygrophanous brown pinkgill with a strong mealy smell, frequently found in lawns. CAP To 5cm across; conical, becoming convex and umbonate; margin incurved and striate when moist; warm greyish brown but drying paler in streaks and becoming silky and shiny. GILLS Sinuate; greyish white and maturing brownish. STIPE To 6cm long; cylindrical, often with a white felty base; concolorous with cap and covered in silky white fibrils. HABITAT Grassland of all types. STATUS Widespread and common. SIMILAR SPECIES *E. undatum* is not a true grassland species and is generally found in soil or on decayed wood, both standing and buried.

Shield Pinkgill *Entoloma clypeatum*
Large pinkgill with an irregular, shield-shaped cap. Fruits in spring and early summer. CAP To 10cm across; convex, becoming flatter with a broad umbo; margin incurved but later undulating; smooth at first but ageing somewhat scaly; greyish brown. GILLS Sinuate; pale grey, maturing pink. STIPE To 8cm long; cylindrical and stoutish; whitish, flushed with cap colour and covered in silky fibrils. HABITAT Usually grouped in soil or grass and associated with plants of the family Rosaceae, especially hawthorns. STATUS Widespread and common.

Wood Pinkgill *Entoloma rhodopolium* (= *E. nidorosum*)
The typical pale-coloured *Entoloma* of deciduous woodland. The form previously known as *E. nidorosum* has a nitrous smell. CAP To 5cm across; convex and then flatter, often with a small umbo at first; usually becoming undulating with a depressed centre; creamy beige but drying with greyish tints. GILLS Adnate; crowded; whitish, maturing pink. STIPE To 9cm long; cylindrical; whitish or beige ground covered with silky fibrils. HABITAT Solitary or, more usually, in large groups in damp deciduous woodland. STATUS Widespread and common.

Aromatic Pinkgill *Entoloma pleopodium*
Yellowish pinkgill with a pleasant smell reminiscent of pear drops. CAP To 2cm across; convex, becoming flatter and often with a depressed centre; margin incurved at first then undulating, slightly striate when moist; surface smooth and somewhat dull; shades of yellow, usually with an olive tint, but hygrophanous and drying paler. GILLS Adnate or slightly decurrent; creamy white, maturing pink. STIPE To 5cm long; cylindrical, often with an enlarged base; olive-brown or pinkish with longitudinal white fibrils. HABITAT Deciduous woodland, often with nettles. STATUS Widespread but uncommon.

Livid Pinkgill *Entoloma sinuatum* (= *E. lividum*)
Chunky, poisonous pinkgill with distinctive yellowish gills. Sometimes spring fruiting. CAP To 20 cm across; convex then flatter with an inrolled and undulating margin; ivory to pale greyish ochre. GILLS Adnexed; dull yellow or ochre maturing pink. STIPE To 10cm long, stout with an enlarged or bulbous base; concolorous with cap. HABITAT Solitary or grouped in deciduous woodland. STATUS Widespread but generally uncommon.

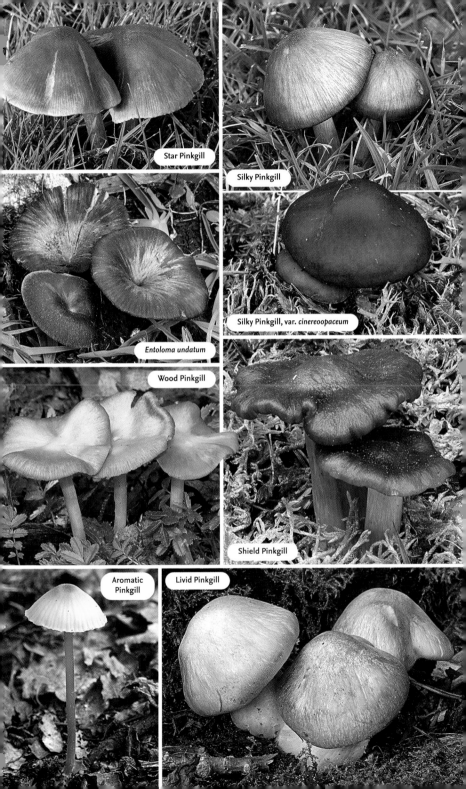

Star Pinkgill

Silky Pinkgill

Silky Pinkgill, var. *cinereoopaceum*

Entoloma undatum

Wood Pinkgill

Shield Pinkgill

Aromatic Pinkgill

Livid Pinkgill

Entoloma nitidum

One of several similar dark blue pinkgills, this woodland species has uncoloured gill edges. **CAP** To 4cm across; conical, then convex or flatter with a broad umbo; margin incurved, becoming wavy with age; smooth, silky and finely fibrillose; dark blue, fading to greyish blue but with the centre often remaining darker. **GILLS** Adnate; edges smooth and uncoloured; whitish, maturing pinkish. **STIPE** To 7cm long; cylindrical and sometimes twisted; similar in colour to cap with a white felty base; fibrillose. **HABITAT** Boggy acid coniferous and mixed woodland. **STATUS** Widespread but uncommon.

Blue Edge Pinkgill *Entoloma serrulatum*

Blue-capped pinkgill that discolours brownish with age. **CAP** To 3cm across; convex, becoming flatter with a depressed centre; surface fibrillose or finely scaly; blue-black, ageing brownish. **GILLS** Adnate; whitish with a blue flush and blue-black serrated edges, maturing pinkish brown. **STIPE** To 3cm long; cylindrical, slender and smoothish; similar in colour to cap but fading brownish and with a white felty base. **HABITAT** Grassland and, occasionally, open woodland. **STATUS** Widespread but occasional; common in Scotland.

Indigo Pinkgill *Entoloma chalybaeum* var. *lazulinum*

Blue-capped pinkgill with a striate cap. **CAP** To 2cm across; convex, becoming flatter with a depressed centre; surface dull and radially fibrillose with a scaly centre; striate almost to centre; blue-black but fading brownish with age. **GILLS** Sinuate; bluish white, maturing pinkish beige; edges smooth and sometimes brown. **STIPE** To 4cm long; cylindrical, slender and sometimes compressed or flattened, with longitudinal grooves; similar colour to cap, sometimes with a white felty base. **HABITAT** Unimproved grassland. **STATUS** Widespread but occasional. **SIMILAR SPECIES** *Entoloma chalybaeum* var. *chalybaeum* has a non-striate cap and generally uncoloured gill edges.

Indigo
Pinkgill

Mousepee Pinkgill *Entoloma incanum*

Striking bright yellow pinkgill with a strong smell of mouse urine. **CAP** To 3cm across; convex, becoming flatter with an indented centre; surface smooth and satiny with a striate or grooved margin; shades of yellow with olive or greenish tones and a darker centre. **GILLS** Sinuate; pale yellow, maturing pink. **STIPE** To 4cm long; cylindrical and fragile; surface smooth and shiny; yellow but progressively greenish brown downward to a white-downy base; discolours intense blue or green when damaged. **HABITAT** Unimproved grassland and heaths. **STATUS** Widespread but occasional.

Cream Pinkgill *Entoloma sericellum*

Small pinkgill that, unusually for an *Entoloma*, is white. **CAP** To 2cm across; conical, then convex or flatter and becoming undulating with age; smooth or finely silky; white, maturing to pale ochre, particularly in centre. **GILLS** Sinuate; white then pale pink. **STIPE** To 3cm long; cylindrical and sometimes grooved; white, discolouring yellowish with age or when handled. **HABITAT** Mosses, grassland, open deciduous woodland and dunes. **STATUS** Widespread and common.

The Miller *Clitopilus prunulus*

White fungus that has a strong mealy smell and whose cap surface is the texture of chamois leather. **CAP** To 10cm across; variable in shape but usually convex and becoming flatter, often depressed in centre; margin incurved and undulating; white or pale cream, sometimes with greyish or pinkish tones. **GILLS** Very decurrent; crowded; whitish, maturing pink with a pink spore print. **STIPE** To 4cm long; cylindrical or tapering upward, often off-centre; similar in colour and texture to cap. **HABITAT** Grass in open deciduous woodland; rarely with conifers. **STATUS** Widespread and common.

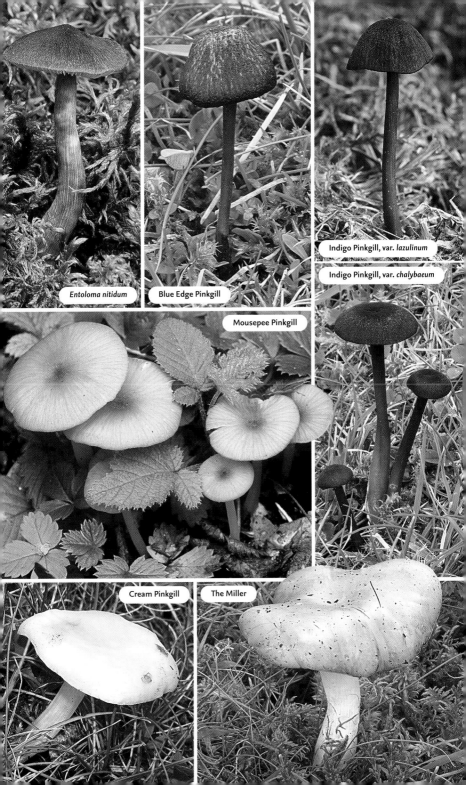

Entoloma nitidum

Blue Edge Pinkgill

Indigo Pinkgill, var. *lazulinum*

Indigo Pinkgill, var. *chalybaeum*

Mousepee Pinkgill

Cream Pinkgill

The Miller

Members of the genus *Pluteus* are variable in size, ranging from small to large. They are mostly in shades of brown, although grey and yellow species are not uncommon. The free gills produce a pink spore print. They grow on wood or wood debris, standing or buried, from both broadleaved and conifer trees. They are also often found on woodchip mulch, where they can grow to a considerable size. Many start fruiting in summer. This is a difficult genus; a microscope is needed to identify many species.

Deer Shield *Pluteus cervinus* (Top 100)

Variable in size and colour, the Deer Shield is our most common *Pluteus*. Often found on piles of woodchip mulch or sawdust, where it can grow to a large size and form spectacular clumps. **CAP** To 12cm across; bell-shaped, becoming convex or flatter, usually with a broad umbo; surface dull and smooth or finely radially fibrillose, with the centre sometimes slightly scurfy; usually dark brown but paler forms also found. **GILLS** Free; crowded; whitish, maturing pinkish brown. **STIPE** To 10cm long; cylindrical with an often slightly enlarged base; whitish ground colour covered in dark brown longitudinal fibrils. **HABITAT** Decayed wood of deciduous trees or, more rarely, conifers. **STATUS** Widespread and very common. **SIMILAR SPECIES** *P. pouzarianus* is mainly greyish but is far less common and confined to decayed conifer wood.

Pluteus podospileus

Small shield with a brown velvety cap and distinctly spotted stipe. **CAP** To 3cm across; convex, becoming flatter and sometimes umbonate and irregular in shape; surface velvety and covered in fine scales concentrated around centre; dark brown. **GILLS** Free; crowded; whitish, maturing pink or pinkish brown. **STIPE** To 4cm long; cylindrical and sometimes with a bulbous base; dingy white and covered in tiny blackish dots. **HABITAT** Decayed wood of deciduous trees. **STATUS** Occasional; most frequent in S England.

Velvet Shield *Pluteus umbrosus*

Brown shield with distinctively coloured gill edges. **CAP** To 9cm across; convex, becoming flatter and often umbonate with an incurved margin; surface densely covered in fine brown fibrils on a paler ground, creating a velvety appearance; centre often darker, with fibrils arranged in radiating lines or veins. **GILLS** Free; crowded; white, maturing pink with dark brown edges. **STIPE** To 9cm long; cylindrical, base sometimes enlarged; whitish and covered in dark brown velvety scales. **HABITAT** Decayed wood of deciduous trees, often large fallen and decayed trunks or stumps. **STATUS** Widespread but occasional in S England.

Willow Shield *Pluteus salicinus*

Shield of unusual and distinctive grey coloration. **CAP** To 7cm across; convex, becoming flatter and sometimes slightly umbonate; margin faintly striate when moist; surface generally smooth but occasionally finely scaly in centre; light grey or grey-brown, usually with a darker centre and sometimes with bluish or greenish tints. **GILLS** Free; crowded; white, maturing pink. **STIPE** To 7cm long; slender, cylindrical and often curved; white, sometimes greyish towards base and covered in fine white fibrils. **HABITAT** Decayed wood of deciduous trees, but despite its name somewhat uncommon on willows. **STATUS** Widespread and common.

Veined Shield *Pluteus thomsonii*

Small brown shield with a network of prominent raised veins on the cap. **CAP** To 3cm across; convex, becoming flatter and undulating; margin striate when moist; surface dull and wrinkled or veined; dark brown, sometimes with reddish tints and drying hazel-brown; centre often darker and veins paler. **GILLS** Free; crowded; white, maturing pink. **STIPE** To 5cm long; cylindrical; greyish or brown with a powdery surface. **HABITAT** Decayed wood of deciduous trees. **STATUS** Occasional in S England.

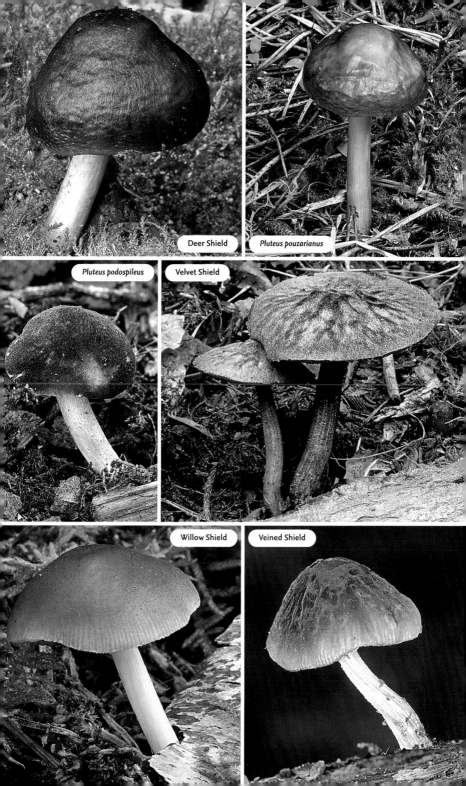

Deer Shield

Pluteus pouzarianus

Pluteus podospileus

Velvet Shield

Willow Shield

Veined Shield

Yellow Shield *Pluteus chrysophaeus (= P. luteovirens)*

Variable yellow shield with a greenish hue. **CAP** To 4cm across; convex, becoming flatter and often broadly umbonate; margin striate when moist; smooth or slightly wrinkled, particularly in centre; mustard-yellow with olivaceous tones. **GILLS** Free; crowded; white, usually without yellow tints and maturing pink. **STIPE** To 6cm long; somewhat slender; white or cream and longitudinally fibrillose, sometimes with pale yellow tones. **HABITAT** Very decayed wood of deciduous trees. **STATUS** Widespread but occasional.

Lion Shield *Pluteus leoninus*

Similar to Yellow Shield but lacking any greenish hue. **CAP** To 5cm across; convex, becoming flatter, sometimes with a small umbo; surface dull and finely velvety; margin faintly striate when moist; golden yellow with a slightly darker centre. **GILLS** Free; crowded; white, sometimes with yellowish edges, and maturing pink. **STIPE** To 7cm long; cylindrical and slender; smooth or slightly fibrillose; white, becoming flushed yellow from base upward. **HABITAT** Very decayed wood of deciduous trees. **STATUS** Widespread but uncommon.

Goldleaf Shield *Pluteus romellii*

Brown shield with a yellow stipe. **CAP** To 4cm across; convex and then flatter, often with an indented centre and becoming undulating; surface finely wrinkled, particularly at centre; shades of yellowish brown. **GILLS** Free; crowded; yellowish, maturing pink. **STIPE** To 7cm long; cylindrical, sometimes with an enlarged base; light or lemon-yellow, with the base usually darker and covered in longitudinal fibrils. **HABITAT** Decayed wood of deciduous trees. **STATUS** Widespread but occasional.

Pluteus petasatus

Large, pale-coloured shield with a short stipe relative to the diameter of the cap. **CAP** To 14cm across; convex, becoming flatter and umbonate; surface finely radially fibrillose, sometimes with a scaly centre; beige or pale brown. **GILLS** Free; crowded and very broad at outer margin; white, maturing greyish pink. **STIPE** To 10cm long; cylindrical and stout; whitish, with the lower part covered in brownish fibrils. **HABITAT** Decayed wood of deciduous trees, and often found on piles of sawdust or wood-chippings. **STATUS** Widespread but uncommon in England.

Pluteus ephebeus

Highly variable shield whose cap surface sometimes cracks radially. **CAP** To 7cm across; convex, then flatter and sometimes slightly umbonate; surface felty or fibrillose with the centre becoming scaly; cuticle often splitting radially to reveal the white flesh beneath; colour variable, ranging from grey through beige to sepia. **GILLS** Free; white, maturing dingy pink. **STIPE** To 7cm long; cylindrical, usually with an enlarged base; whitish ground with varying amounts of fine grey or brown fibrils. **HABITAT** Soil, buried wood and, occasionally, sawdust. **STATUS** Widespread but uncommon in England. **SIMILAR SPECIES** *P. robertii* considerably more rare and has a pale brown or golden centre. It is considered by some to be a synonym of *P. ephebeus*.

Wrinkled Shield *Pluteus phlebophorus*

Brown shield with a wrinkled cap and white or yellowish stipe. **CAP** To 5cm across; convex, then flatter and undulating; surface finely radially wrinkled; warm brown with a darker centre, but weakly hygrophanous and drying ochre or yellowish. **GILLS** Free; crowded with white cottony edges; whitish, maturing dingy pink. **STIPE** To 6cm long; cylindrical, sometimes enlarged towards base; white, discolouring cream or pale yellow and with longitudinal white fibrils in places. **HABITAT** Decayed wood of deciduous trees, mainly Beech and birches. **STATUS** Occasional in England, especially in S.

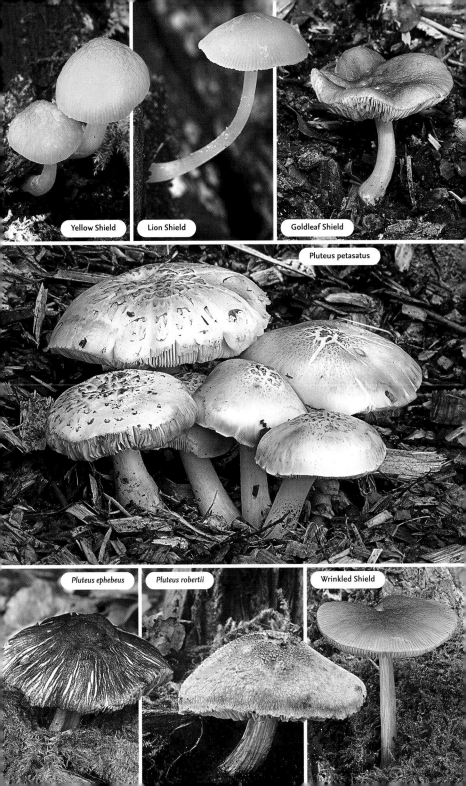

Yellow Shield

Lion Shield

Goldleaf Shield

Pluteus petasatus

Pluteus ephebeus

Pluteus robertii

Wrinkled Shield

Pluteus exiguus

Small shield with a pale powdery or mealy cap. **CAP** To 1.5cm across; hemispherical, becoming flattish or convex and sometimes slightly undulating; margin striate; densely covered in pale fawn scales on a greyish ground. **GILLS** Free, with finely toothed edges; white, maturing creamy pink. **STIPE** To 2cm long; cylindrical and slightly bulbous; white, covered in fine concolorous hairs. **HABITAT** Decayed or buried wood of deciduous trees. **STATUS** Very uncommon to rare.

Satin Shield *Pluteus plautus*

Highly variable hygrophanous shield found in a wide range of colours. Split into several different species by some authors. **CAP** To 4cm across; convex, becoming flatter with a shallow umbo; surface felty, with the margin striate or grooved when moist; white or pale buff, disrupting into ochre scales in centre; brown-coloured forms are also found. **GILLS** Free; crowded, with smooth edges; white, maturing pink. **STIPE** To 3cm long; slender and cylindrical, often with a slightly enlarged base; white, with the entire length covered in fine white hairs or fibrils; base often discolouring yellowish. **HABITAT** Decayed wood of deciduous trees (more rarely conifers) in old woodland. **STATUS** Widespread but occasional. **SIMILAR SPECIES** *P. inquilinus* has a smooth creamy-white cap.

Stubble Rosegill *Volvariella gloiocephala (= V. speciosa)*

Our most common rosegill, found in a wide range of habitats. **CAP** To 12cm across; oval, becoming convex or flatter, usually with a broad umbo; surface smooth and sticky when moist; greyish or creamy white, drying to a milky coffee colour. **GILLS** Free; crowded; white, maturing pink with a pink spore print. **STIPE** To 16cm long; fairly stout and usually tapering upward from the broad base, which is enclosed in a bag-like volva; whitish, covered in pale brown longitudinal fibrils. **HABITAT** Wide-ranging, including fields, soil, composted areas, woodchip mulch, dunes, woodland and grassland. **STATUS** Widespread and common.

Stubble Rosegill

Silky Rosegill *Volvariella bombycina*

Large, robust rosegill with a distinctive furry white cap. **CAP** To 20cm across; egg-shaped, becoming convex with a broad umbo; white or creamy white to yellowish, and densely covered in short, fine silky fibres. **GILLS** Free; crowded; white, maturing pink with a pink spore print. **STIPE** To 15cm long; often curved and tapering upward, with the base enclosed in a lobed, bag-like white volva that discolours ochre with age; white with a smooth surface but powdery towards apex. **HABITAT** Decayed wood of deciduous trees, usually large fallen or standing trunks and stumps. **STATUS** Uncommon to rare.

Volvariella caesiotincta

Rare steely-grey rosegill found on the decayed wood of deciduous trees. **CAP** To 8cm across; conical or egg-shaped, becoming flatter with a broad umbo; surface dry and covered in fine silky fibrils; grey with a hint of blue, and with a darker centre and paler margin. **GILLS** Free, with white felty edges; white, maturing deep pink with a pink spore print. **STIPE** To 10cm long; cylindrical, with the bulbous base enclosed in a greyish lobed, sack-like volva; whitish and powdery. **HABITAT** On large trunks and stumps of deciduous trees. **STATUS** Uncommon to rare.

Piggyback Rosegill *Volvariella surrecta*

Rosegill that grows out of the decaying fruit bodies of other mushrooms. **CAP** To 7cm across; domed or egg-shaped, becoming convex or flatter with a broad umbo; greyish white with a pinkish tinge, and covered in concolorous fine silky fibrils. **GILLS** Free; crowded; white, maturing light pink with a pink spore print. **STIPE** To 8cm long; cylindrical, with a bulbous base enclosed in a lobed volva; whitish and covered in concolorous fibrils when young. **HABITAT** On partially decayed fruit bodies of Clouded Funnel (p. 118). **STATUS** Uncommon to rare.

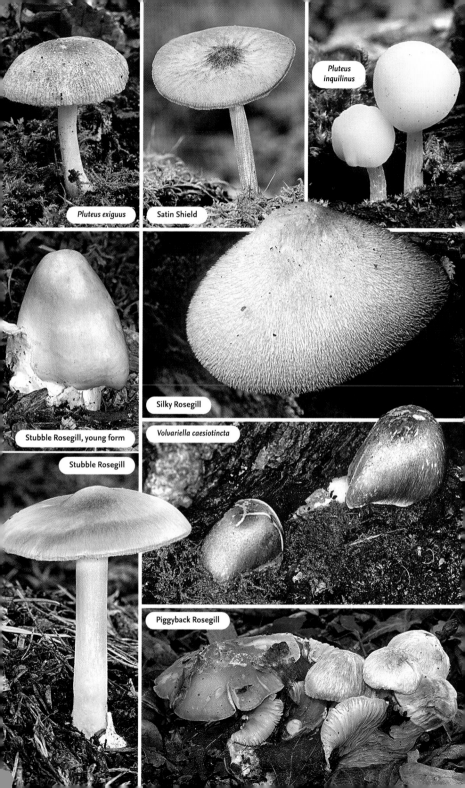

Pluteus exiguus

Satin Shield

Pluteus inquilinus

Stubble Rosegill, young form

Silky Rosegill

Volvariella caesiotincta

Stubble Rosegill

Piggyback Rosegill

Cortinarius is the largest macro-fungus genus in Britain and probably the most difficult to identify. It is extremely variable and divided into several groups, each with its own characteristics. Some are hygrophanous and others slimy. The size is usually medium to small, and some have large, bulbous bases. Virtually all have both a universal and partial veil, the latter fine and cobweb-like (called a cortina), hence the family name. Gills are variable in colour and range from cream to red, many with violet or lilac tones. Spores are brown, and the gills and cortina change colour as the spores mature. To identify many species it is necessary to note these changes by examining several specimens at different stages of development, something that is not always possible.

Cortinarius anthracinus
Small, inconspicuous webcap; easily overlooked. **CAP** To 3cm across; conical, usually umbonate and becoming flatter; smooth or slightly fibrillose; dark reddish brown with a carmine margin, but hygrophanous and drying paler. Brownish-orange veil with a greyish-pink cortina. **GILLS** Adnate, with paler, minutely serrated (crenate) edges; light brown, maturing rust-brown. **STIPE** To 5cm long; cylindrical; brown, densely covered in longitudinal fibrils that are concolorous with cap. **HABITAT** Deciduous woodland. **STATUS** Occasional in S England.

Cortinarius venustus

Cortinarius venustus
Attractive webcap in soft shades of cinnamon and lilac. **CAP** To 6cm across; conical or convex, becoming flatter; cinnamon, covered in soft brownish fibrils that are paler towards the margin, this hung with white or lilac patches. **GILLS** Adnate; pale yellowish brown with serrated edges. **STIPE** To 9cm long; cylindrical or widening downward into a broad base; greyish brown, densely covered in soft lilac fibrils and girdled with bands of white. **HABITAT** Pinewoods on acid soils. **STATUS** Rare; confined to a few sites in Scotland.

Cortinarius biformis
Small brown webcap found in groups. **CAP** To 6cm across; conical, becoming convex or flatter, usually with a broad umbo; surface drying smooth and dull, with an incurved margin and adorned with veil remnants; chestnut-brown, but hygrophanous and drying paler. Veil and cortina whitish. **GILLS** Adnate; ochre at first, then rusty brown with paler, crenate edges. **STIPE** To 12cm long; tall and slender; concolorous with cap but covered with white fibrils; sometimes with a distinct ring zone. **HABITAT** Coniferous woodland. **STATUS** Uncommon to rare.

Cortinarius brunneus

Cortinarius brunneus
Variable, chunky brown webcap with a distinct white ring zone.
CAP To 10cm across; conical, becoming flatter with a broad umbo; hygrophanous, with surface drying smooth and dull; sepia-brown but somewhat blackening with age. Veil and cortina whitish. **GILLS** Adnate; distant; ochre-brown, maturing dark red-brown with paler and smooth edges. **STIPE** To 6cm long; narrow and enlarged towards base; concolorous with cap but covered with veil remnants. **HABITAT** Coniferous woodland. Var. *glandicolor* is found in mixed woodland, often where birches are present. **STATUS** Widespread but uncommon.

Cortinarius saturninus (= C. cohabitans)
Medium-sized brown webcap, usually found grouped or in circles in woodland, often with willows. **CAP** To 8cm across; convex, becoming flat with a broad umbo; hygrophanous, with surface drying smooth and paler; shades of reddish brown with a paler margin. Whitish veil and cortina. **GILLS** Adnate, with smooth, pale edges; pale brown with a hint of violet, maturing rusty brown. **STIPE** To 8cm long; cylindrical with an enlarged base; white fibrils on brown ground with a white annular zone. **HABITAT** In rings around willows along tracks and streamsides. **STATUS** Widespread but uncommon.

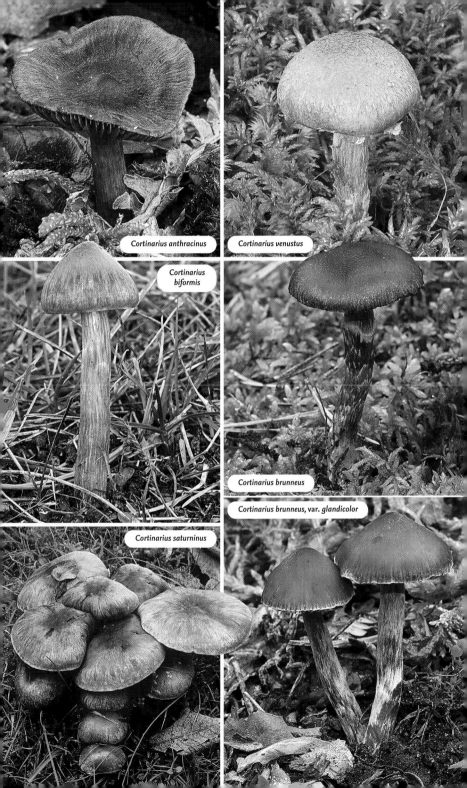

Cortinarius anthracinus

Cortinarius venustus

Cortinarius biformis

Cortinarius brunneus

Cortinarius brunneus, var. *glandicolor*

Cortinarius saturninus

Pelargonium Webcap *Cortinarius flexipes (= C. paleaceus)*

Cortinarius with a strong smell of pelargoniums. **CAP** To 3cm across; convex, then bell-shaped and becoming sharply umbonate; shades of brown, with lilac tones in some forms, covered in white fibres or scales that give it a greyish appearance; hygrophanous, drying lighter. Copious white or grey veil and similar-coloured cortina. **GILLS** Adnate, with smooth or slightly toothed edges; buff-grey, maturing rust-brown. **STIPE** To 7cm long; cylindrical, with a slightly bulbous base; brownish but banded with white-cottony velar remains. **HABITAT** Deciduous and coniferous woodland and heathland, particularly where birches are present. **STATUS** Common.

Frosty Webcap *Cortinarius hemitrichus*

Similar to Pelargonium Webcap but lacks the distinctive smell. **CAP** To 5cm across; convex, then bell-shaped and becoming flatter with a sharp umbo; shades of brown, covered in very fine white scales; hygrophanous, drying lighter. White veil and cortina. **GILLS** Adnate; distant; very pale greyish buff, maturing reddish brown. **STIPE** To 5cm long; cylindrical, with a slightly enlarged base; brown and with surface densely covered in white-cottony veil remnants, breaking up into bands or zones and with a short-lived ring zone. **HABITAT** Acidic woodland, often with birches. **STATUS** Widespread and common.

Sepia Webcap *Cortinarius decipiens*

One of the commoner webcaps, often found in groups. **CAP** To 4cm across; conical or convex, becoming flatter and often umbonate; surface dull and finely fibrillose; dark reddish brown with a hint of violet; hygrophanous, drying paler but with a blackish-brown centre. Veil and cortina greyish white. **GILLS** Adnexed; greyish brown, maturing cinnamon brown. **STIPE** To 6cm long; cylindrical, enlarged towards base; grey-brown ground covered with bands of whitish fibrils; faint lilac in young fruit bodies above an indistinct ring zone. **HABITAT** Mixed deciduous woodland, often with willows. **STATUS** Widespread and common.

Cortinarius evernius

Violet-brown webcap with an incurved cap margin edged with veil remnants. **CAP** To 9cm across; conical or bell-shaped but flattening; broadly umbonate; surface smooth and dull or satiny; chestnut or umber-brown, usually flushed violet; strongly hygrophanous, drying to ochre-brown from centre outwards. Copious whitish veil and cortina. **GILLS** Adnate; distant; reddish brown with lilac tones, becoming rust-brown. **STIPE** To 10cm long; cylindrical with a tapered base; reddish violet, covered in white fibrils that may form loose bands. **HABITAT** With birches and pines on acid soil. **STATUS** Rare; possibly confined to Scotland.

Earthy Webcap *Cortinarius hinnuleus*

Highly variable webcap with an unpleasant earthy or gassy odour. **CAP** To 7cm across; conical or bell-shaped, then flatter; sharply umbonate; surface smooth or finely fibrillose; shades of orange-brown; strongly hygrophanous, drying yellow-ochre with radial streaks; margin with veil remnants. Copious whitish veil and cortina. **GILLS** Adnate; distant; buff, maturing reddish brown. **STIPE** To 10cm long; cylindrical, sometimes a slightly enlarged base; concolorous with cap, and surface covered in whitish fibrils that form a woolly ring zone. **HABITAT** Deciduous woodland. **STATUS** Widespread but occasional.

Cortinarius cinnabarinus

Striking webcap with a cinnabar-red cap, gills and stipe. **CAP** To 6cm across; conical or convex, becoming flatter and sometimes with a shallow umbo; matt and felty when dry; cinnabar-red, but hygrophanous and drying more brownish. Sparse red veil and cortina. **GILLS** Adnate, with toothed edges; cinnabar-red. **STIPE** To 6cm long; cylindrical, sometimes with a swollen base; surface covered with fine, longitudinal, dark red fibrils. **HABITAT** Deciduous woodland. **STATUS** Uncommon.

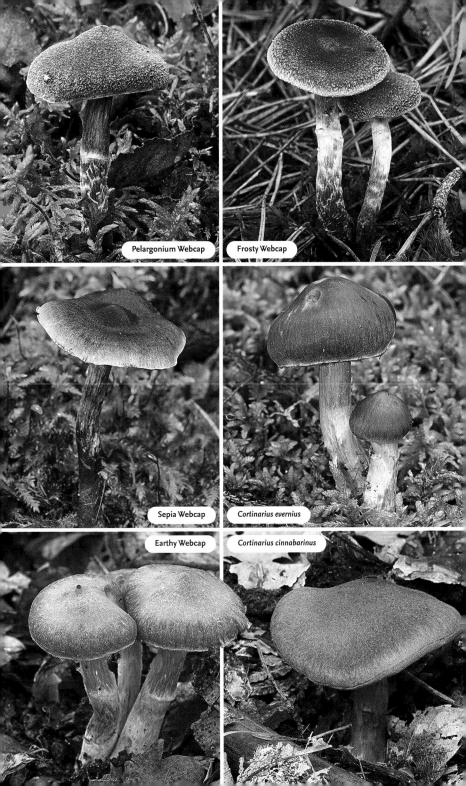

Pelargonium Webcap

Frosty Webcap

Sepia Webcap

Cortinarius evernius

Earthy Webcap

Cortinarius cinnabarinus

Stocking Webcap *Cortinarius torvus*

Medium-sized brown webcap with a prominent sheathing ring and pungent sweetish smell. **CAP** To 10cm across; hemispherical to convex, becoming flatter; smooth or finely fibrillose; dark violet-brown, drying ochre-brown with lilac tints. Whitish veil and cortina. **GILLS** Adnate, with toothed or fringed edges; violet-buff, maturing rust-brown. **STIPE** To 8cm long; cylindrical or slightly club-shaped; buff flushed with violet above ring zone, brownish below and sheathed in a pale 'sock' with a projecting upper edge. **HABITAT** Deciduous woodland, especially with Beech. **STATUS** Widespread but occasional; more frequent in S.

Stocking Webcap

Cortinarius subbalaustinus

Medium-sized hygrophanous webcap with a wavy or undulating brown cap. **CAP** To 8cm across; hemispherical or convex, becoming flatter; umbonate; orange-brown but drying ochre-yellow with a darker centre. Sparse white veil and cortina. **GILLS** Adnate, with smooth edges; light brown, darkening to rust-brown. **STIPE** To 7cm long; cylindrical or slightly club-shaped; dark brown ground covered with short-lived whitish fibrils that persist at base. **HABITAT** Deciduous woodland, especially with birches. **STATUS** Uncommon; predominantly in S.

Red Banded Webcap *Cortinarius armillatus*

One of the easier webcaps to identify owing to the distinctive stipe banded with orange-red remnants of the veil. **CAP** To 12cm across; hemispherical, becoming flatter with a broad umbo; surface radially fibrillose, becoming scaly; margin incurved and often hung with veil remnants; orange-brown; barely hygrophanous. Reddish veil and white cortina. **GILLS** Adnate or free, with toothed and lighter edges; light ochre, becoming rust-brown. **STIPE** To 15cm long; fairly slender with a swollen base; whitish with orange-red banding. **HABITAT** Damp acidic woodland, usually with birches. **STATUS** Widespread but occasional.

Cortinarius laniger

Weakly hygrophanous webcap whose stipe is wreathed in a woolly cortina when young. **CAP** To 10cm across; hemispherical or broadly conical, becoming flatter and barely umbonate; surface dull and fibrillose or scaly; margin incurved and hung with veil remnants; orange to red-brown. Copious white veil and cortina. **GILLS** Adnexed, with smooth edges; reddish brown, maturing deep rust-brown. **STIPE** To 10cm long; cylindrical with a bulbous base; brownish, sometimes with a lilac tint at apex; entire length is smothered in a white-woolly veil but breaking up into bands. **HABITAT** Coniferous woodland on acid soil. **STATUS** Rare; predominantly in N.

Pearly Webcap *Cortinarius alboviolaceus*

The most frequent of the attractive lilac or lavender webcaps. **CAP** To 7cm across; convex, then bell-shaped and finally flatter with a broad umbo; dry with a silky sheen; pale violet or lavender with a hint of ochre in centre, but becoming paler, almost white, with age. Whitish veil and cortina. **GILLS** Adnexed, with smooth edges; greyish lilac then rust-brown. **STIPE** To 10cm long; cylindrical with a swollen base; concolorous with cap but developing ochre zones. **HABITAT** Mixed deciduous woodland on acid soil. **STATUS** Widespread but occasional.

Variable Webcap *Cortinarius anomalus*

A problem webcap in identification terms; very variable, with many varieties and similar species. **CAP** To 6cm across; convex, becoming flatter with a shallow umbo; surface dry, smooth or finely scurfy; brownish ochre, often with lilac or grey tints. Sparse white veil and whitish cortina. **GILLS** Adnate or slightly decurrent; grey-violet, maturing rust-brown. **STIPE** To 10cm long; cylindrical with a slightly thickened base; greyish ochre, covered in veil remnants that break up into irregular yellowish or greyish diagonal bands (often short-lived); apex lilac. **HABITAT** Deciduous woodland. **STATUS** Widespread but occasional.

Variable Webcap

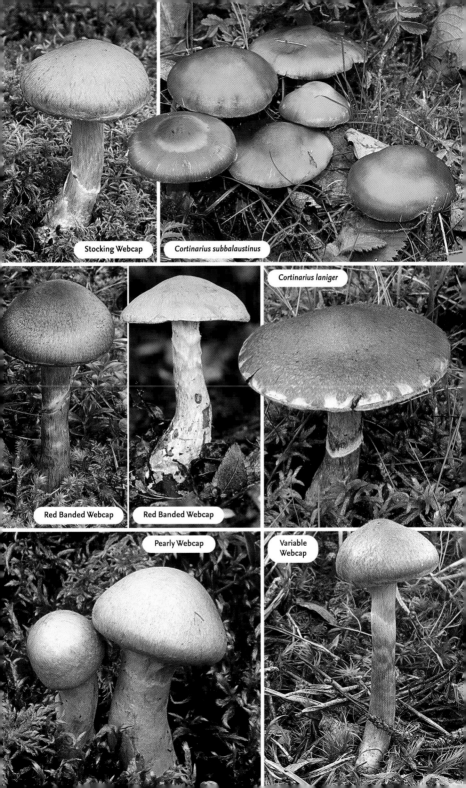

Stocking Webcap

Cortinarius subbalaustinus

Cortinarius laniger

Red Banded Webcap

Red Banded Webcap

Pearly Webcap

Variable Webcap

Goatcheese Webcap *Cortinarius camphoratus*

Similar to Pearly Webcap (p. 168) but with a strong, repulsive smell of goats or ripe cheese. Flesh violet. **CAP** To 10cm across; convex, becoming flattish bell-shaped and barely umbonate; surface dull, satiny or finely scurfy; pale lilac or violet, discolouring ochre-brown from centre. Copious greyish-white veil and cortina. **GILLS** Adnate; edges smooth or slightly toothed and paler; violet-blue. **STIPE** To 10cm long; cylindrical with a bulbous base; pale ground colour densely covered in a lilac or violet veil that often forms a ring zone. **HABITAT** Coniferous woodland. **STATUS** Rare; probably confined to Scotland.

Gassy Webcap *Cortinarius traganus*

Similar to Goatcheese Webcap but with a smell of acetylene gas or ripe pears. **CAP** To 12cm across; hemispherical, convex or flatter, and generally broadly umbonate; margin incurved and often hung with veil remnants; surface becoming scaly and frequently cracking; pale bluish lilac or silvery grey, fading to ochre or light brown. Copious lilac veil with greyish cortina. **GILLS** Adnate with toothed edges; yellow ochre maturing rust-brown. **STIPE** To 9cm long; club-shaped with a bulbous base; whitish, covered in a woolly veil up to ring zone, discolouring light ochre; apex violet. **HABITAT** Mixed deciduous and coniferous woodland on acid soil. **STATUS** Uncommon; more frequent in Scottish pinewoods.

Gassy Webcap

Cortinarius malachius

Resembles Variable Webcap (p. 168) but lacks the yellow bands on the stipe. **CAP** To 11cm across; convex, becoming flatter and barely umbonate; pale brown with lilac tones, becoming ochre-brown. White veil with a violet tinge, greyish-violet cortina. **GILLS** Adnate, with toothed and whitish edges; violet-blue, maturing rust-brown. **STIPE** To 14cm long; bulbous; greyish lilac, covered with white down that develops into bands with a ring zone; apex remaining lilac. **HABITAT** Coniferous woodland, usually with pines. **STATUS** Rare.

Scaly Webcap *Cortinarius pholideus*

Distinctive webcap with a very scaly cap and stipe. **CAP** To 10cm across; convex or campanulate, becoming flatter and wavy; margin incurved and hung with veil remains; pale brown, densely covered in darker, concentric scales. Copious grey-brown veil with a lighter cortina. **GILLS** Adnate; light violet, becoming reddish brown. **STIPE** To 12cm long; club-shaped; ochre ground covered in dark brown scales, usually with a distinct annular zone; apex pale lilac when young. **HABITAT** Birches and pines on acid soil. **STATUS** Widespread but occasional.

Scaly Webcap

Freckled Webcap *Cortinarius spilomeus*

Small, pale webcap whose stipe is flecked or banded with reddish scales. **CAP** To 5cm across; conical or campanulate, becoming flatter with a shallow umbo; surface dull or satiny; yellow-brown, sometimes with a lilac tint; hygrophanous, drying paler. Sparse red-brown veil and greyish cortina. **GILLS** Adnate; light violet, maturing rust-brown. **STIPE** To 8cm long; cylindrical with a slightly widened base; grey-beige with the lower part irregularly flecked or banded; apex smooth with a hint of lilac. **HABITAT** Deciduous or mixed woodland. **STATUS** Widespread but rare.

Violet Webcap *Cortinarius violaceus*

Beautiful and unmistakable webcap, uniformly dark violet in colour. **CAP** To 10cm across; hemispherical, then convex or flatter with an incurved margin, sometimes slightly umbonate; surface dry and granular; dark blue-violet, occasionally with a hint of brown. Copious blackish-violet veil with concolorous cortina. **GILLS** Adnate; deep violet, maturing violet-brown. **STIPE** To 16cm long; cylindrical with a bulbous base; surface dry and longitudinally fibrillose, forming bands or zones; concolorous with cap. **HABITAT** Deciduous or mixed woodland on acidic or peaty soil. **STATUS** Widespread but occasional; more frequent in N.

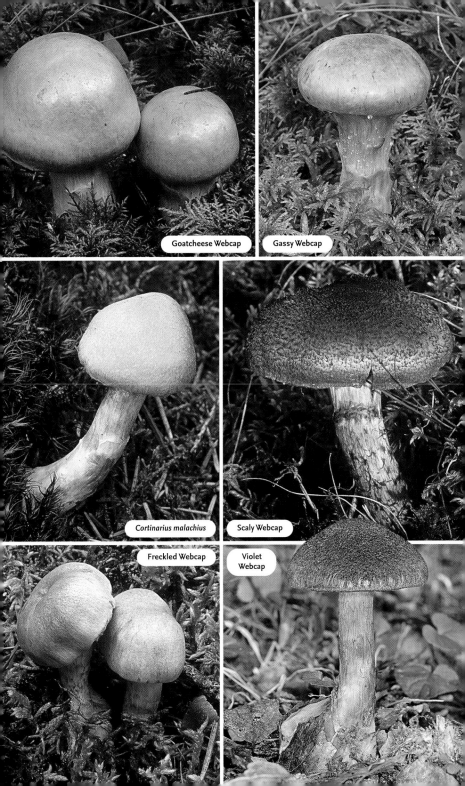

Goatcheese Webcap

Gassy Webcap

Cortinarius malachius

Scaly Webcap

Freckled Webcap

Violet Webcap

Cortinarius collinitus (= C. muscigenus)

Medium-sized webcap with a very slimy cap and stipe, mild taste and little smell. **CAP** To 10cm across; convex, becoming flatter with a broad umbo; margin incurved and slightly grooved; ochre or reddish brown, then rust-brown. Violet veil and white cortina. **GILLS** Adnate, with smooth and sometimes paler edges; ochre with violet tints, maturing rust-brown. **STIPE** To 12cm long; cylindrical, sometimes with a tapered base; whitish with a hint of violet, fading to yellow-ochre and often banded with veil remnants. **HABITAT** Acid coniferous woodland. **STATUS** Uncommon.

Cortinarius mucifluoides (= C. pseudosalor)

Similar to *C. collinitus* but with a mild taste and a slight smell of honey at the base of the stipe. **CAP** To 10cm across; hemispherical or convex, then flatter with a broad umbo; very slimy; shades of ochre or brown with a hint of lilac; margin usually slightly striate. Faintly

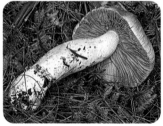

violet veil and whitish cortina. **GILLS** Adnate or free, with white fleecy edges; yellowish buff with a lilac tint, maturing rust-brown. **STIPE** To 10cm long; slightly spindle-shaped and fairly stout; white, covered in a slimy violet veil up to ring zone. **HABITAT** Mixed deciduous woodland on acid soil, occasionally with pines. **STATUS** Widespread and common. **SIMILAR SPECIES Purple Stocking Webcap** *C. stillatitius* a northern species confined to pine.

Purple Stocking Webcap

Wrinkled Webcap *Cortinarius elatior (= C. lividoochraceus)*

Similar to *C. collinitus* and Purple Stocking Webcap but with a distinctly wrinkled or fluted cap. **CAP** To 12cm across; conical, becoming flatter with a broad umbo; surface slimy and soon radially wrinkled or striate from margin inwards; honey-ochre or reddish brown. Violet veil and greyish-white cortina. **GILLS** Adnate; cross-veined or wrinkled, with toothed and whitish edges; brown with a violet tint, maturing rust-brown. **STIPE** To 13cm long; spindle-shaped; violet slimy veil up to indistinct ring zone. **HABITAT** Acidic deciduous woodland, especially with Beech. **STATUS** Widespread but occasional.

Cortinarius arvinaceus

Distinctive viscid webcap with a bright yellow cap and white stipe. **CAP** To 12cm across; conical, becoming flatter; barely, if at all, umbonate; margin undulating and translucent-striate or grooved; slimy; yellow or yellow-ochre with a slightly darker centre. Faintly violet veil and whitish cortina. **GILLS** Adnate, with smoothish and white edges; cream, maturing rust-brown. **STIPE** To 12cm long; cylindrical; sheathed with a slimy white veil; apex fibrillose with a lilac tint. **HABITAT** Deciduous and mixed woodland. **STATUS** Rare.

Girdled Webcap *Cortinarius trivialis*

Its coarsely banded stipe makes this one of the easier webcaps to recognise in the field. **CAP** To 10cm across; conical, then convex and finally flatter, sometimes broadly umbonate; slimy; light ochre to red-brown, sometimes more yellowish. Copious grey-brown veil and pale grey-blue cortina. **GILLS** Adnate or free, with slightly toothed and whitish edges; buff with a lilac tint, maturing rust-brown. **STIPE** To 12cm long; broadly spindle-shaped; slimy; surface above ring zone smooth and whitish, below girdled by prominent glutinous brownish bands on a paler ground. **HABITAT** Damp woodland, usually with willows. **STATUS** Occasional.

Orange Webcap *Cortinarius mucosus*

Slimy orange webcap, associated with pines and often found in heathland and coastal dunes. **CAP** To 10cm across; convex, becoming flatter and barely umbonate; slimy; margin incurved at first and faintly striate; orange to reddish brown with a darker centre. White veil and cortina. **GILLS** Adnate, with slightly toothed edges; whitish, becoming rust-clay. **STIPE** To 12cm long; cylindrical, sometimes with a tapered base; apex whitish; area below ring zone covered in a slimy white veil that breaks up to form pale ochre bands, these darkening towards base. **HABITAT** Pinewoods on sandy soil. **STATUS** Widespread but occasional.

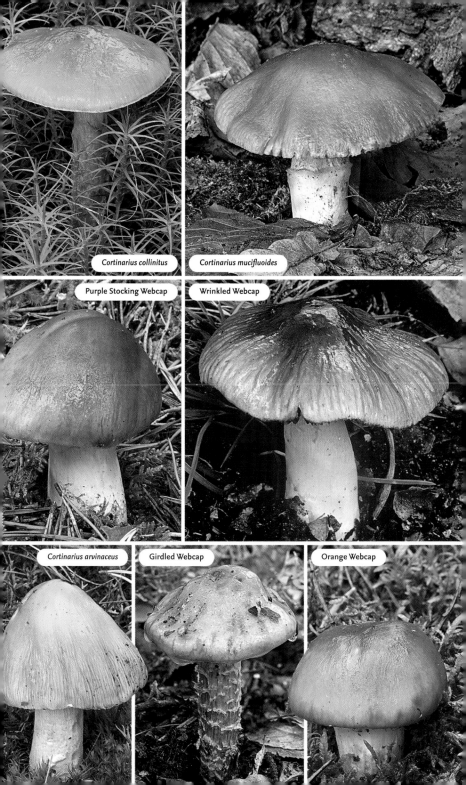

Cortinarius collinitus

Cortinarius mucifluoides

Purple Stocking Webcap

Wrinkled Webcap

Cortinarius arvinaceus

Girdled Webcap

Orange Webcap

Cortinarius croceocaeruleus

Small, colourful webcap with an unpleasant smell and bitter taste. CAP To 5cm across; convex, becoming flatter and sometimes with a slightly depressed centre; margin irregular; sticky when moist; violet or lilac, discolouring pale ochre from centre. Sparse white veil and cortina. GILLS Adnate or free; greyish with a lilac tint at first but becoming brown. STIPE To 6cm long; fairly stout and spindle-shaped, tapering to a pointed base that is usually rooting; yellowish white with a fibrillose ring zone stained brown by spores. HABITAT Beech woods on calcareous soil. STATUS Occasional in S England.

Cortinarius salor

Very rare webcap, similar to *C. croceocaeruleus* but with little smell and a mild taste. CAP To 8cm across; hemispherical or convex, becoming flatter, sometimes umbonate or with a depressed centre; slimy but drying dull and finely fibrillose; margin incurved; lilac, fading ochre from centre. Sparse colourless or violet veil and pale blue cortina. GILLS Adnate, with smooth edges; lilac, maturing ochre or rust-brown. STIPE To 10cm long; cylindrical with a slightly widened base; smooth with longitudinal fibrils; surface covered in a slimy lilac veil on a white ground and with a fibrillose ring zone. HABITAT Mixed deciduous and coniferous woodland. STATUS Rare.

Cortinarius vibratilis

Small yellow webcap with a very bitter taste. CAP To 5cm across; hemispherical to convex, becoming flatter and usually with a shallow, broad umbo; margin incurved; slimy; orange-yellow, but hygrophanous and drying paler. Sparse white veil and cortina. GILLS Adnate, with slightly toothed and whitish edges; pale ochre, maturing reddish brown. STIPE To 7cm long; cylindrical or slightly spindle-shaped; whitish with longitudinal fine fibrils, and covered with a slimy white veil; discolouring brownish. HABITAT Coniferous and mixed woodland. STATUS Widespread but uncommon.

Yellow Webcap *Cortinarius delibutus*

Distinctive webcap with a yellow cap and contrasting lilac gills. CAP To 8cm across; convex, becoming flatter and sometimes broadly umbonate; slimy; greyish yellow with a paler incurved margin. Yellowish veil and whitish cortina. GILLS Adnate or free; fairly distant; lilac, becoming reddish brown. STIPE To 10cm long; slender and cylindrical with a broader base; whitish with a lilac tinge around ring zone, covered in a sticky veil that forms bands. HABITAT Acid deciduous woodland, especially with birches. STATUS Widespread but occasional.

Yellow Webcap

Cortinarius ochroleucus

Uniformly whitish-buff webcap – an unusual colour for *Cortinarius*. CAP To 8cm across; convex, becoming flatter with an inrolled margin and usually with a broad umbo; slightly sticky when wet; ivory or pale ochre. White veil. GILLS Adnate or free; concolorous with cap at first but maturing rust-brown. STIPE To 9cm long; fairly slender, cylindrical with a tapered base; concolorous with cap. HABITAT Deciduous woodland. STATUS Widespread but uncommon.

Cortinarius amoenolens (= C. anserinus)

Chunky yellowish webcap with a broad basal bulb and violet stipe flesh. Has a pleasant plum-like smell and a bitter-tasting cuticle. CAP To 10cm across; hemispherical, becoming flatter; streaky or slightly fibrous but sticky when wet; pale yellow or ochre, sometimes with an olivaceous tint. Sparse olive-grey veil with a hint of violet; abundant whitish cortina. GILLS Adnate; lilac, fading to ochre. STIPE To 10cm long; bulbous with a distinctive margin to bulb; pale violet with a whitish apex; basal bulb yellowing with age. HABITAT Deciduous woodland, particularly with Beech on chalk. STATUS Widespread but occasional.

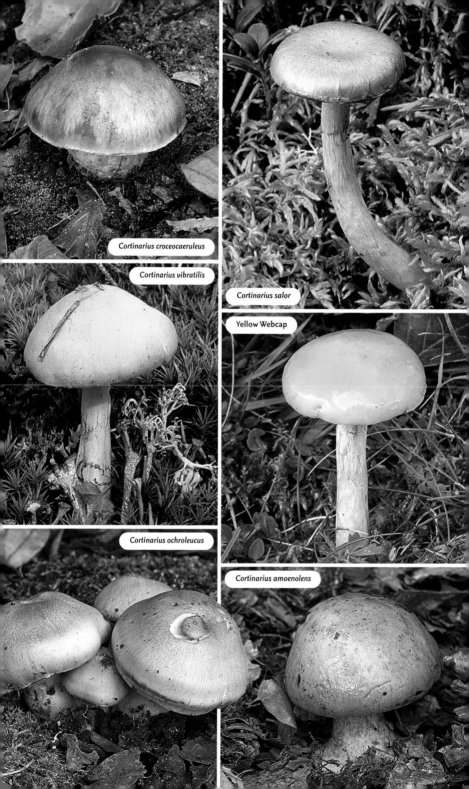

Cortinarius croceocaeruleus

Cortinarius vibratilis

Cortinarius salor

Yellow Webcap

Cortinarius ochroleucus

Cortinarius amoenolens

Cortinarius subtortus

Small yellow webcap with a smell of incense or cedarwood pencils. **CAP** To 6cm across; convex, then flatter, sometimes with an indented centre; greasy when moist but drying dull or satiny; margin incurved and joined to stipe by whitish cortina; yellow or ochre with an olive tint, becoming browner. Sparse greenish-yellow veil. **GILLS** Adnate; distant; pale olive-grey, maturing reddish brown with paler edges. **STIPE** To 9cm long; cylindrical, sometimes with a bulbous base; olive-grey or yellowish, covered in veil remnants below ring zone. **HABITAT** Mixed woodland, usually with birches and pines. **STATUS** Occasional; commoner in N.

Birch Webcap *Cortinarius triumphans (= C. crocolitus)*

Medium-sized yellow webcap whose stipe is distinctively girdled with ochre veil remnants. **CAP** To 12cm across; hemispherical or convex, becoming flatter and often umbonate; surface greasy when moist with a scaly centre; shades of yellow with brownish tints. Copious yellow or brown veil and white cortina. **GILLS** Adnate, with toothed edges; creamy with a lilac tint, maturing yellow-ochre or brownish. **STIPE** To 15cm long; cylindrical with a pointed base; white above ring zone, with lower part banded with ochre veil remnants on a paler ground. **HABITAT** Mixed deciduous woodland, usually with birches. **STATUS** Widespread but occasional.

Splendid Webcap *Cortinarius splendens*

Deadly poisonous webcap with yellow flesh and an unpleasant peppery smell. **CAP** To 7cm across; hemispherical to convex, becoming flatter and undulating; greasy when moist but smooth and satiny when dry; bright yellow, spotted reddish brown in places, particularly in centre. Yellowish-brown veil and whitish cortina. **GILLS** Adnate; sulphur-yellow, maturing rust-brown. **STIPE** To 6cm long; cylindrical with a bulbous base that has a distinct rim; sulphur yellow, smooth above faint ring zone and covered in sparse longitudinal brown fibrils below. **HABITAT** Old Beech woods on chalk. **STATUS** Rare.

Cortinarius elegantior

Similar to Splendid Webcap but with little smell and paler flesh. **CAP** To 14cm across; hemispherical to convex, becoming flatter, sometimes with a depressed centre; surface greasy when moist, drying smooth or with fine fibrils; dull brownish yellow. Sparse brownish veil and greyish-white cortina. **GILLS** Adnate, with toothed edges; pale yellow, maturing reddish brown. **STIPE** To 12cm long; cylindrical with a bulbous base that has a distinct rim; apex white, remainder covered in brown fibres on a paler ground. **HABITAT** Generally associated with conifers, but the few British records have been with Beech. **STATUS** Very rare.

Cortinarius elegantissimus (= C. aurantioturbinatus)

Similar to Splendid Webcap and found in the same habitat, but with paler flesh and a sweetish smell. **CAP** To 11cm across; hemispherical or convex, then flatter; slimy when moist; margin incurved and joined to stipe by copious yellowish cortina; bright golden yellow, becoming orange with rusty spots or patches. Sparse yellow veil. **GILLS** Adnate; yellowish, maturing rusty brown. **STIPE** To 10cm long; cylindrical with an abrupt bulb; yellowish, covered in brownish fibrils. **HABITAT** Old Beech woods on chalk. **STATUS** Rare to locally frequent.

Cortinarius elegantissimus

Cortinarius olearioides (= C. subfulgens)

Bright yellow webcap that differs from similar species in having a uniformly coloured cap. **CAP** To 12cm across; convex, becoming flatter; margin incurved and joined to stipe by a pale yellow cortina when young; golden yellow, tinged brown with age. Sparse orange or brown veil. **GILLS** Adnate or free; yellow, maturing rusty ochre. **STIPE** To 8cm long; cylindrical with a bulbous base that stains brown; yellow-buff, streaked with veil remnants, apex paler. **HABITAT** Generally broadleaved woodland on chalk, but occasionally where conifers are present. **STATUS** Uncommon.

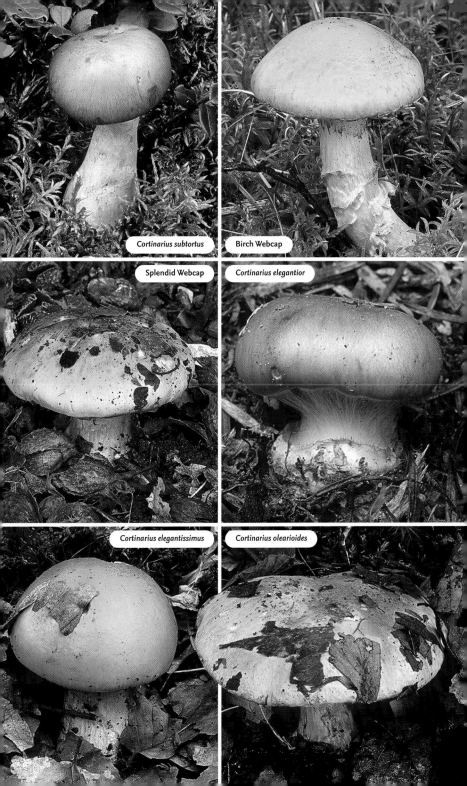

Cortinarius subtortus

Birch Webcap

Splendid Webcap

Cortinarius elegantior

Cortinarius elegantissimus

Cortinarius olearioides

Bitter Webcap *Cortinarius infractus*
Variable webcap with little smell but a bitter taste and unusual
gill colour. **CAP** To 10cm across; hemispherical, becoming
flatter, usually with a shallow umbo; surface greasy when moist
and drying dull or finely fibrillose; variable in colour, in streaky
shades of brown, often with an olive tint. Olive-brown veil
and grey cortina. **GILLS** Adnate, with wavy and slightly toothed
edges; olive-grey, becoming olive-brown. **STIPE** To 7cm long;
cylindrical and stout, with a bulbous or thickened base; ochre-brown,
sparsely covered in whitish fibrils; apex smooth and greyish violet.
HABITAT Usually grouped or clustered in deciduous woodland, especially
with Beech. **STATUS** Widespread but occasional.

Cortinarius variicolor
Medium-sized webcap that lives up to its name and changes colour from violet when young
to brown when mature. **CAP** To 10cm across; hemispherical or convex, becoming flatter;
surface sticky when moist, drying fibrillose or scaly in centre; margin incurved and joined
to stipe by whitish cortina; dark violet with a brownish tint, finally greyish brown. Violet veil.
GILLS Adnate; greyish violet then light brown. **STIPE** To 10cm long; club-shaped; whitish
with a violet sheen, browning at base. **HABITAT** Pines on acid soil. **STATUS** Uncommon.

Cortinarius largus (= C. nemorensis)
The deciduous woodland equivalent of *C. variicolor*. **CAP** To 12cm across; hemispherical or
convex, becoming flatter; margin incurved; surface slightly sticky when moist, drying dull
or satiny; pale lilac, becoming increasingly buff or ochre from centre outwards. Sparse
whitish or grey-brown veil and white or violet-grey cortina. **GILLS** Adnate, with toothed
edges; pale lilac, maturing rust-brown. **STIPE** To 10cm long; stout and club-shaped; pale
lilac, fading to light ochre with a browner base; apex retaining its lilac colour. **HABITAT**
Generally grouped or clustered in deciduous woodland. **STATUS** Widespread but occasional.

Bitter Bigfoot Webcap *Cortinarius sodagnitus*
Spectacular purple webcap with a large marginate bulb. **CAP** To 8cm across; hemispherical
or convex, becoming flatter and sometimes slightly umbonate; surface greasy when moist
and drying satiny; margin incurved and joined to stipe by whitish cortina when young;
intense violet, but soon fading to yellow-ochre. Violet or lilac veil. **GILLS** Adnate or free,
with smooth edges; violet, maturing rust-brown. **STIPE** To 9cm long; cylindrical with a
very wide bulb that has a distinct rim; concolorous with cap but discolouring ochre;
surface covered in veil remnants but apex remaining pale violet. **HABITAT** Old Beech
woods on chalk. **STATUS** Occasional in S England.

Dappled Webcap *Cortinarius bolaris*
Distinctive small webcap with a red-dappled cap. **CAP** To 6cm across; hemispherical to
convex, becoming flatter and often broadly umbonate; yellowish-white ground covered
in flat reddish scales. Copious red veil with a whitish cortina. **GILLS** Adnate; yellow-ochre,
maturing browner. **STIPE** To 7cm long; cylindrical with a somewhat enlarged base;
yellowish white covered in red or brown scales or veil remnants. **HABITAT** Acid
deciduous woodland. **STATUS** Widespread but occasional.

Cortinarius betuletorum (= C. raphanoides)
Umbonate webcap, frequently found in groups or clusters; often
has a faint smell of radishes. **CAP** To 6cm across; bluntly conical to
campanulate, then bell-shaped or flatter and broadly umbonate;
olive-brown, but slightly hygrophanous and drying streaky and
paler. Olive-brown veil and grey cortina. **GILLS** Adnate or free,
with paler edges; pale ochre, maturing rust-brown. **STIPE** To
8cm long; cylindrical, often with a swollen base; pale buff
with remnants of veil below ring zone. **HABITAT** Mixed
deciduous woodland, usually with birches. **STATUS**
Occasional.

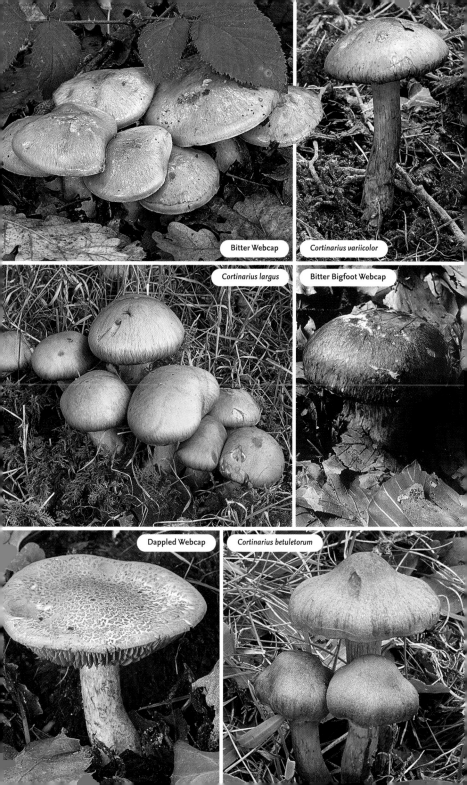

Bitter Webcap

Cortinarius variicolor

Cortinarius largus

Bitter Bigfoot Webcap

Dappled Webcap

Cortinarius betuletorum

Cortinarius gentilis

Small hygrophanous webcap with a fugitive yellow cap margin. **CAP** To 3cm across; campanulate or convex, becoming flatter and usually sharply umbonate; surface finely downy; incurved margin hung with veil remnants when young; tawny brown and drying paler. Veil and cortina yellowish. **GILLS** Adnate; fairly distant with paler cottony edges; saffron-yellow, maturing rust-brown. **STIPE** To 6cm long; tall and slender; concolorous with cap and banded with veil remnants. **HABITAT** Acid pinewoods. **STATUS** Occasional; most frequent in Caledonian pinewoods.

Deadly Webcap

Deadly Webcap *Cortinarius rubellus* (= *C. speciosissimus*)

Deadly poisonous hygrophanous webcap, especially dangerous on account of its superficial similarity to the edible chanterelles (p. 228). **CAP** To 7cm across; conical, then campanulate or flatter; surface finely scaly with a smoother centre; bright orange or rust-brown with a paler margin. Yellowish veil and paler or white cortina. **GILLS** Adnate; rather distant; ochre-brown, maturing rust-brown with paler edges. **STIPE** To 10cm long; cylindrical; concolorous with cap, fibrillose and irregularly banded with veil remnants. **HABITAT** Coniferous woodland on sandy acid soil. **STATUS** Widespread but occasional in N, rare in S.

Sunset Webcap *Cortinarius limonius*

Orange webcap, similar to Deadly Webcap but with brighter colours, more crowded gills and an oily smell. **CAP** To 8cm across; hemispherical or convex, becoming flatter and sometimes broadly umbonate; surface smooth or finely floury; orange-brown, but hygrophanous and drying yellow. Yellow veil and paler cortina. **GILLS** Adnate, with smooth and paler edges; yellow, maturing orange-brown. **STIPE** To 8cm long; cylindrical; similar in colour to cap and striated with brownish fibrils. **HABITAT** Coniferous woodland, often in wet and boggy areas. **STATUS** Rare.

Cortinarius venetus

Small olive webcap that discolours reddish brown with age. **CAP** To 6cm across; convex or flatter, often with a broad umbo; surface finely downy, becoming more granular; olive-brown, then more reddish from centre outwards. Sparse olive veil with a yellowish cortina. **GILLS** Adnate, with smooth and paler edges; yellowish olive, maturing browner. **STIPE** To 7cm long; cylindrical with an enlarged base; olive-green or browner, flecked with longitudinal fibres. **HABITAT** Deciduous and mixed woodland; also heathland and moors. **STATUS** Widespread but uncommon.

Cinnamon Webcap *Cortinarius cinnamomeus*

Similar to *C. venetus* but with a more yellowish cap. **CAP** To 5cm across; convex, becoming flatter, usually with a broad umbo; surface dry, smooth or finely radially fibrillose; olive-yellow or more brownish, sometimes paler towards margin. Yellow-brown veil and pale yellow cortina. **GILLS** Adnate, with smooth edges; yellowish orange, then browner. **STIPE** To 6cm long; cylindrical; yellow or olive-yellow and becoming browner towards base, and covered in brown longitudinal fibrils. **HABITAT** Mixed woodland, usually with birches and pines, but also with willows in wet areas around edges of ponds and lakes. **STATUS** Widespread but occasional.

Cortinarius croceus

Cortinarius croceus (= *C. cinnamomeobadius*)

Small, uniform brownish webcap with a smooth, velvety-textured cap. **CAP** To 6cm across; hemispherical or convex, becoming flatter, usually with a broad umbo; surface somewhat radially streaked and covered with tiny fibrils; yellow-brown with a more reddish centre and paler towards incurved margin. Yellow-brown veil and yellowish cortina. **GILLS** Adnate, with smooth and somewhat paler edges; yellow, maturing browner. **STIPE** To 7cm long; cylindrical; similar in colour to cap but becoming browner from base upward; irregularly fibrillose. **HABITAT** Deciduous and mixed woodland on acid soil. **STATUS** Widespread but occasional.

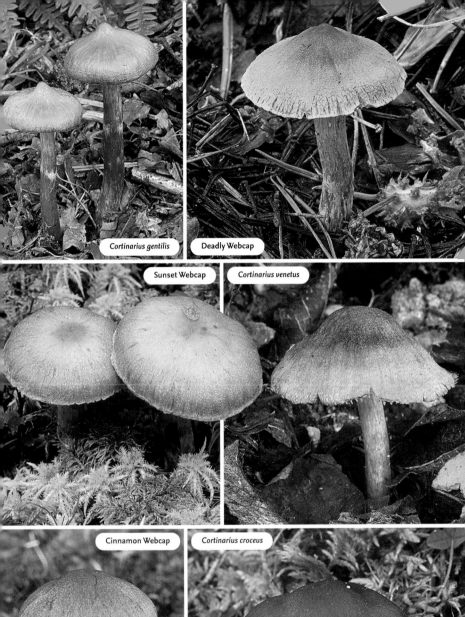

Cortinarius gentilis

Deadly Webcap

Sunset Webcap

Cortinarius venetus

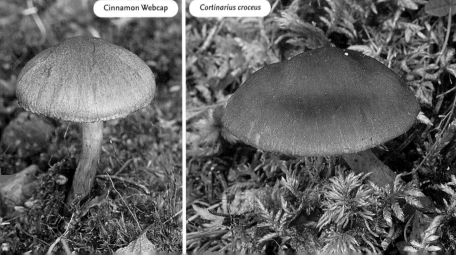

Cinnamon Webcap

Cortinarius croceus

Blood Red Webcap *Cortinarius sanguineus (= C. puniceus)*
One of the most striking webcaps, with all parts deep red. CAP To 5cm across; convex, becoming flatter and barely umbonate; surface dry and covered in very fine fibrils, giving it a velvety appearance; blood-red or reddish brown. Veil and cortina red. GILLS Adnate, with smooth and slightly toothed edges; blood-red, darkening to reddish brown. STIPE To 6cm long; slender and cylindrical with a slightly enlarged base; covered in dark red or red-brown fibrils on a lighter red ground, often with a paler base. HABITAT Deciduous, coniferous and mixed woodland, usually on acid soil. STATUS Widespread but occasional.

Surprise Webcap *Cortinarius semisanguineus*
Rather nondescript yellow-olive webcap with contrasting deep red gills. CAP To 6cm across; convex, becoming flatter with a distinct umbo; surface with very fine fibrils that sometimes disrupt into small scales; margin incurved at first, then wavy; yellow or olive-brown and later reddish brown, paler towards margin. Yellowish veil and cortina. GILLS Adnate, with smooth or slightly toothed edges; blood-red, maturing red-brown. STIPE To 9cm long; slender and cylindrical; olive-yellow, covered in brownish fibrils; apex paler but base sometimes covered in reddish down. HABITAT Usually with conifers but occasionally with broadleaved trees. STATUS Widespread but occasional.

Surprise Webcap

Cortinarius uliginosus
Small orange-red webcap found in wet areas. CAP To 4.5cm across; conical or convex, becoming flatter and usually umbonate; surface smooth and dull with radial fibrils; copper-red with a paler marginal zone, then orange-brown. Orange veil and yellow cortina. GILLS Adnate, with toothed edges; yellow-ochre, maturing orange or rust-brown. STIPE To 6.5cm long; cylindrical with a slightly thickened base; yellowish, covered in longitudinal red fibrils, and with a paler apex and reddish-brown base. HABITAT Often found in small groups in wet areas, usually with willows and Common Alder. STATUS Widespread but occasional.

Bruising Webcap *Cortinarius purpurascens*
Very slimy webcap that bruises purple-red when damaged. CAP To 12cm across; convex, becoming flatter; surface very slimy when moist; deep ochre to reddish brown, sometimes with a paler or violet margin and often with darker streaks or blotches. GILLS Adnate; dark blue-violet, maturing reddish brown. STIPE To 9cm long; stout, widening downward to a large, marginated bulb; deep violet ground covered with longitudinal fibrils, usually stained brown by fallen spores. HABITAT Mixed deciduous or coniferous woodland, usually on acid soils. STATUS Widespread and occasional.

Honey Webcap *Cortinarius talus (= C. melliolens)*
Rare, unusually coloured webcap that smells of honey when cut or bruised. CAP To 9cm across; hemispherical, becoming flattish convex; surface smooth or finely fibrillose and sticky when moist, drying somewhat streaky; yellow-ochre, sometimes paler or almost white. Sparse white veil and cortina. GILLS Adnate; crowded, with toothed edges; white to pale grey. STIPE To 10cm long; cylindrical with a bulbous base; whitish but flushing brown with age. HABITAT Mixed deciduous and coniferous woodland. STATUS Rare.

Honey Webcap

Cortinarius humicola
Resembles Shaggy Scalycap (p. 202), but not clustered or found on dead wood. CAP To 5cm across; conical or convex, becoming flatter and usually umbonate; orange-yellow ground with a paler margin and densely covered in reddish-brown scales. GILLS Adnate and distant; whitish, maturing ochre to rust. STIPE To 7cm long; cylindrical with a thickened base; concolorous with cap and equally scaly below ring zone. HABITAT Solitary or in small groups in deciduous woodland, particularly with Beech. STATUS Rare.

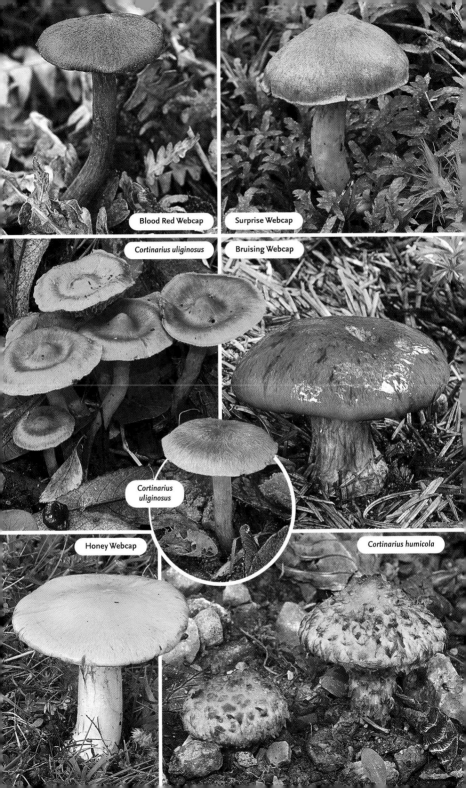

Blood Red Webcap

Surprise Webcap

Cortinarius uliginosus

Bruising Webcap

Cortinarius uliginosus

Honey Webcap

Cortinarius humicola

The Gypsy *Cortinarius caperatus (= Rozites caperatus)* (Cortinariaceae)
Cortinarius with a distinctive pale, frosted cap. **CAP** To 10cm across; egg-shaped and then convex, before becoming flatter, usually with a broad umbo; surface dull, dry and often scurfy; light ochre or beige, sometimes more yellowish with a hint of lilac; young specimens covered with very fine mica-like flakes of veil, particularly in centre. **GILLS** Free or adnate; crowded, with paler and toothed edges; pale brown with a similar-coloured spore print. **STIPE** To 11cm long; cylindrical or tapering upward, with a slightly bulbous base and a thin, persistent whitish ring; concolorous with cap; fibrillose below ring and woolly or scaly above. **HABITAT** Coniferous or, sometimes, deciduous woodland (as illustration). **STATUS** Occasional; locally frequent in Scottish pinewoods but scarcer elsewhere.

Golden Bootleg *Phaeolepiota aurea* (Cortinariaceae)
Large, striking golden fungus, often found grouped or clustered in humus-rich soil. **CAP** To 25cm across; hemispherical, then convex or flatter and broadly umbonate; margin often hung with veil remnants; surface dry and granular to powdery; orange-brown or golden brown. **GILLS** Adnate or free; crowded; whitish, maturing russet with a yellowish-brown spore print. **STIPE** To 15cm long; cylindrical or widening towards base; concolorous with cap; smooth above persistent sheathing ring and powdery or granular below. **HABITAT** Parks and gardens; occasionally grassland. **STATUS** Widespread but occasional.

Brown Rollrim

Brown Rollrim *Paxillus rubicundulus*

Paxillus involutus (Paxillaceae) (Top 100)
Very common fungus with strongly decurrent gills and a persistent inrolled cap margin. **CAP** To 12cm across; convex, becoming flatter with a depressed centre; sticky when moist but drying finely downy; margin strongly inrolled and woolly; shades of yellowish brown with olive tints, bruising dark brown. **GILLS** Decurrent; crowded; ochre, becoming olive-ochre with a reddish-brown spore print. **STIPE** To 7cm long; rather stout and cylindrical or slightly thickened towards base, sometimes bent; concolorous with cap, bruising dark brown; covered with longitudinal fibrils. **HABITAT** Deciduous woodland and heathland on acid soil, usually with birch. **STATUS** Widespread and very common. **SIMILAR SPECIES** **P. rubicundulus** has a less inrolled margin with dark striations and yellower gills, and its flesh bruises reddish brown. It is far less common than Brown Rollrim, and is found in wet, swampy places in association with Common Alder.

Oyster Rollrim *Tapinella panuoides* (Paxillaceae)
Unusual *Tapinella* that superficially resembles a bracket fungus. **CAP** To 6cm across; semicircular or bracket-like, becoming fan- or shell-shaped; surface finely felty at first but becoming scaly; margin usually incurved; ochre or buff with a hint of lilac. **GILLS** Decurrent; crowded and undulating; buff or yellowish brown with a brown spore print. **STIPE** Frequently absent, or at best rudimentary and lateral. **HABITAT** Found in large, overlapping groups on decaying conifer wood, most frequently on pine stumps and branches but also on sawdust and wood-chippings. **STATUS** Widespread but occasional.

Velvet Rollrim *Tapinella atrotomentosa (= Paxillus atrotomentosus)* (Paxillaceae)
Large, bracket-like *Tapinella* with a conspicuous dark brown velvety stipe. **CAP** To 27cm across; convex, then flatter with a depressed centre and inrolled margin; finely felty and sometimes cracking with age; ochre or reddish brown with darker patches or streaks. **GILLS** Decurrent; crowded; creamy yellow, maturing darker with a brown spore print. **STIPE** To 8cm long; stout, cylindrical or slightly swollen in the middle, sometimes off-centre; dark brown and velvety, in marked contrast to gills. **HABITAT** On decaying wood of conifers, usually pine stumps. **STATUS** Very common in Scotland; widespread but occasional elsewhere.

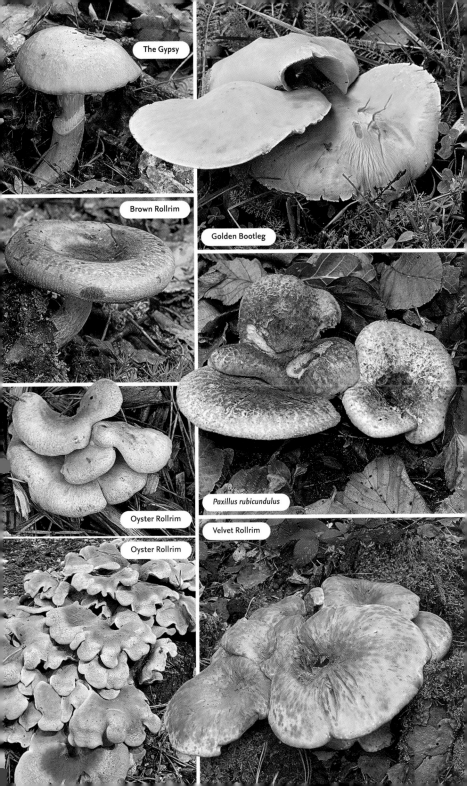

The Gypsy

Golden Bootleg

Brown Rollrim

Paxillus rubicundulus

Oyster Rollrim

Velvet Rollrim

Oyster Rollrim

Common Rustgill *Gymnopilus penetrans* (Top 100)

Variable in size and stature, and by far the most common
rustgill. CAP To 8cm across; convex, becoming flatter;
surface smooth or slightly felty but never scaly; shades
of orange-brown, usually with a paler margin. GILLS
Adnate or slightly decurrent; crowded; light
yellow, maturing reddish brown and spotted
rust-brown with age; similar-coloured spore
print. STIPE To 7cm long; cylindrical with a
poorly defined ring zone; yellowish, becoming
reddish yellow or darker towards downy base;
covered in whitish fibrils in places. HABITAT Solitary or
clustered on decaying wood of conifers, including sawdust
and wood-chippings. STATUS Widespread and very common.

Scaly Rustgill *Gymnopilus sapineus*

Similar to Common Rustgill but with a felty or scaly cap. CAP To 8cm
across; convex, becoming flatter; barely umbonate, if at all; felty when young
but later breaking up into fine scales; shades of orange-brown with darker scales. GILLS
Adnate; crowded; yellowish, maturing reddish brown. STIPE To 7cm long; cylindrical and
sometimes bent; yellowish, then reddish brown and longitudinally fibrillose in places.
HABITAT On decaying wood of conifers. STATUS Widespread and fairly common.

Gymnopilus decipiens

Small orange-brown rustgill with bright yellow gills and a short stipe. CAP To 3cm across;
convex or flatter; surface granular, finely scaly or fibrillose; dull orange-brown, sometimes
with a paler centre. GILLS Adnate; fairly distant, with finely toothed edges; bright yellow,
maturing rusty orange. STIPE To 2cm long; cylindrical; light greyish brown, covered in
whitish longitudinal fibrils. HABITAT On burnt ground and wood. STATUS Uncommon.
SIMILAR SPECIES *G. fulgens* is similar in size and colour but has a slightly striate cap
margin when moist. Although it also occurs on burnt ground, it is more generally found
on acid sandy heathland and moorland, often in wet areas.

Spectacular Rustgill *Gymnopilus junonius*

An aptly named rustgill found in large groups or clusters. CAP To 15cm across; convex,
becoming flatter and usually broadly umbonate; surface finely fibrous or scaly; margin
incurved and hung with velar remains when young; yellowish orange or orange-brown.
GILLS Adnate or slightly decurrent; crowded; yellow, maturing rust-brown. STIPE To 15cm
long; stout, very fibrous and usually swollen in lower part, with a tapered base; persistent
ascending ring; similar in colour to cap but with a paler, powdery apex. HABITAT
Clustered on decayed wood of deciduous trees; also on the ground arising from buried
wood and roots. STATUS Widespread and common.

Gymnopilus dilepis See p. 342.

Dingy Twiglet *Simocybe centunculus*

Small, hygrophanous *Simocybe* with a striate cap margin, usually found grouped on the
dead wood of deciduous trees. CAP To 3cm across; convex, becoming flatter and not
usually umbonate; surface velvety; hygrophanous and translucent-striate; deep reddish
brown, sometimes with olive tones, and ochre when dry. GILLS Adnate, with whitish
toothed edges; spore print ochre; light brown, maturing rust-brown with olive tints. STIPE
To 3cm long; cylindrical, often bent as a result of its mode of growth; white pruinose on a
brown ground with a white cottony base. HABITAT On decayed wood of deciduous trees,
usually Beech, often growing sideways out of large fallen trunks and branches. STATUS
Uncommon, but frequent in S England. SIMILAR SPECIES *S. sumptuosa* has a similar
colour and mode of growth, but its cap margin is smooth and non-striate.

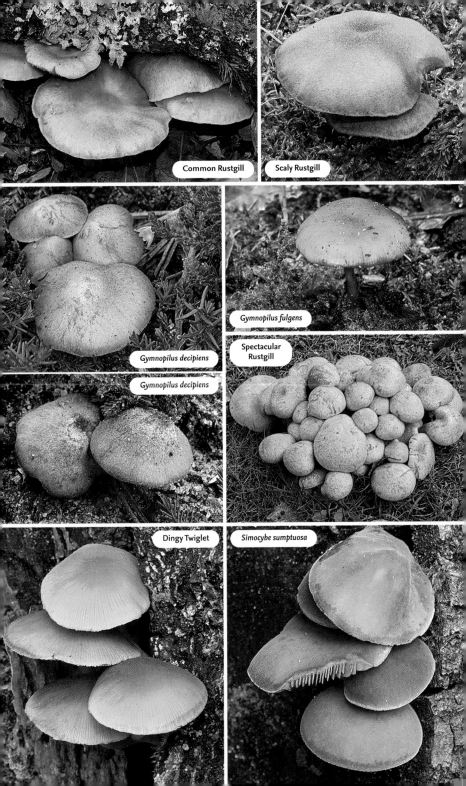

Common Rustgill

Scaly Rustgill

Gymnopilus decipiens

Gymnopilus fulgens

Gymnopilus decipiens

Spectacular Rustgill

Dingy Twiglet

Simocybe sumptuosa

Funeral Bell *Galerina marginata (= Galerina autumnalis)*

Dangerously poisonous *Galerina*, usually found clustered on dead wood. Not to be confused with Sheathed Woodtuft (p. 200), which has a very scaly stipe below the ring. CAP To 5cm across; hemispherical, becoming convex or flatter; hygrophanous and greasy; margin sometimes striate when moist but drying smooth; ochre or reddish brown. GILLS Adnate or slightly decurrent, with white cottony edges; light ochre, maturing reddish brown with a similar-coloured spore print. STIPE To 7cm long; cylindrical with a flimsy, short-lived ring that is often stained brown from deposited spores; ochre-brown, with longitudinal whitish fibrils below ring and paler and powdery above. HABITAT On decayed wood and sawdust of deciduous and coniferous trees. STATUS Widespread and common.

Galerina laevis

Small *Galerina* frequently found in old mossy lawns. CAP To 1cm across; hemispherical, becoming convex or flatter; hygrophanous; translucent-striate almost to centre when moist; ochre or pale orange-brown, drying paler. GILLS Adnate; fairly distant, with white cottony edges; concolorous with cap, and with a reddish-brown spore print. STIPE To 3cm long; cylindrical; cream or pale yellow, almost translucent and powdery white, particularly at top and bottom. HABITAT Grassy and mossy places in woodland and on unimproved lawns. STATUS Widespread and common.

Moss Bell *Galerina hypnorum*

Small *Galerina* with an unpleasant mealy smell. CAP To 1cm across; hemispherical to bell-shaped, becoming convex; hygrophanous; translucent-striate almost to centre when moist; surface drying smooth and silky; orange-brown, maturing light ochre. GILLS Adnate; fairly distant, with finely toothed white edges; pale ochre, maturing darker with a reddish-brown spore print. STIPE To 3cm long; slender and cylindrical; light brown, covered in fleeting velar remains; apex white and powdery. HABITAT Moss in woodland, on heathland and, occasionally, in grass. STATUS Widespread and common.

Bog Bell *Galerina paludosa*

Galerina with a distinctively banded stipe and flour-like smell; often found in early summer. CAP To 3cm across; conical, becoming convex and usually umbonate; hygrophanous; translucent-striate up to halfway to centre when moist; reddish brown, drying ochre. GILLS Adnate, with whitish toothed edges; light yellowish ochre, maturing reddish brown with a similar-coloured spore print. STIPE To 6cm long; cylindrical; ochre or reddish brown, encircled by whitish bands of velar remains; paler and powdery above an indistinct annular zone. HABITAT In bogs and marshes amongst *Sphagnum* moss. STATUS Widespread but occasional; common in Scotland. SIMILAR SPECIES **G. sphagnorum** has a similar smell and is found in the same habitat, but with sparse or no bands of velar remains on the stipe.

Ochre Aldercap *Naucoria escharioides (= Alnicola escharioides)*

Small *Naucoria* with a non-striate cap margin; found in groups or trooping in damp and boggy places. CAP To 4cm across; conical, becoming convex or flatter, sometimes shallowly umbonate; surface felty or scurfy, then smooth; hygrophanous; light ochre, drying paler from margin inwards to give a two-tone effect. GILLS Adnexed; yellow-ochre, maturing darker with a brown spore print. STIPE To 4cm long; cylindrical, sometimes with a bulbous base; concolorous with cap but becoming progressively darker from base upward; covered in longitudinal white fibrils. HABITAT Damp and waterlogged soil; always with Common Alder. STATUS Widespread and common. SIMILAR SPECIES **Striate Aldercap** *N. striatula* is found in the same habitat but has a striated cap that is particularly noticeable when moist.

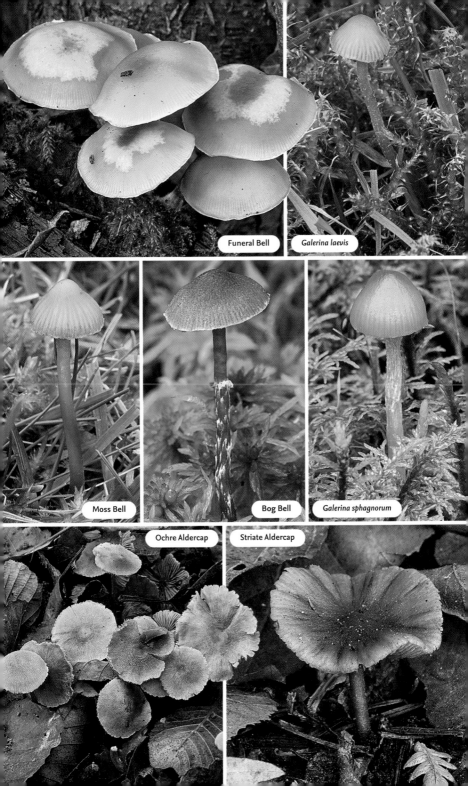

Funeral Bell

Galerina laevis

Moss Bell

Bog Bell

Galerina sphagnorum

Ochre Aldercap

Striate Aldercap

Many species of the genus *Hebeloma* fall into one of two groups: the species complex around *H. crustuliniforme*, which have a strong radish-like smell; and those close to *H. sacchariolens*, with a sickly sweet smell. Some exude liquid droplets from the gills and stipe apex, but this may not be apparent in dry weather. Generally associated with trees, they are usually found in autumn. The spore print is tobacco-brown. Most are poisonous.

Bitter Poisonpie *Hebeloma sinapizans*

Medium or large poisonpie with cottony fibres covering the stipe and a strong smell of radishes. **cap** To 12cm across; convex, becoming flatter and undulating, sometimes with a shallow umbo; surface slimy when wet but drying smooth and satiny; ochre or yellowish brown, sometimes with a paler margin. **gills** Sinuate; crowded; clay-buff, maturing darker. **stipe** To 12cm long; cylindrical and stout; whitish, covered in cottony bands, particularly in upper part; when cut lengthwise, the hollow stem has a tongue of flesh protruding into the cavity where it joins the cap. **habitat** Usually clustered in deciduous woodland on calcareous soil; more rarely with conifers. **status** Widespread but occasional.

Poisonpie *Hebeloma crustuliniforme* (Top 100)

Similar to Bitter Poisonpie but with weeping gills and stipe apex. **cap** To 10cm across; convex, becoming flatter and undulating, often with a shallow umbo; slimy when fresh; cream or pinkish buff with a paler margin. **gills** Adnate; crowded; with white-fringed edges; white, maturing pale buff, the liquid droplets drying as brown spots. **stipe** To 7cm long; cylindrical; white with concolorous fleecy or granular bands. Flesh with a bitter taste and radish-like smell. **habitat** Gregarious in deciduous woodland, less frequently with conifers and, occasionally, in sand dunes with willow. **status** Widespread and common. **similar species** *H. leucosarx* is considerably smaller and often associated with willows and birches; it is now considered to be more common than Poisonpie.

Rooting Poisonpie *Hebeloma radicosum*

Easily recognised poisonpie with a ring, a rooting stipe and a smell of marzipan or bitter almonds. **cap** To 10cm across; hemispherical or convex, becoming flatter, sometimes with a low umbo; surface slimy when moist and often covered in flat scales; buff or ochreous. **gills** Adnexed; crowded, with white cottony edges; cream, then ochre or brown. **stipe** To 12cm long; cylindrical with a spindle-shaped base and long taproot; surface above ring greyish and powdery, below cream, discolouring brown and with coarse scales. **habitat** Originating from underground animal latrines or the decaying remains of small mammals. **status** Widespread but uncommon.

Rooting
Poisonpie

Veiled Poisonpie *Hebeloma mesophaeum*

A smallish but highly variable poisonpie with a two-tone cap and persistent veil remnants on cap and stipe. **cap** To 5cm across; convex, becoming flatter and often umbonate; slimy when moist; cream or buff, becoming progressively dark brown towards centre. **gills** Adnate or free, with paler cottony edges; sometimes with droplets in damp conditions; pale buff, maturing dark brown. **stipe** To 5cm long; cylindrical; covered in longitudinal fibrils, with a pale and powdery apex; whitish but discolouring brown. **habitat** With coniferous and deciduous trees, usually on acid sandy soil. **status** Widespread and common.

Sweet Poisonpie *Hebeloma sacchariolens* (= *H. pallidoluctuosum*)

Pale-coloured poisonpie with a strong, sickly, sweetish smell. **cap** To 6cm across; convex, becoming flatter, sometimes with a shallow umbo; greasy when moist; cream or shades of buff, slightly darker in centre. **gills** Adnate to almost free; beige with no droplets. **stipe** To 6cm long; cylindrical; surface finely fibrillose and powdery at apex; white or pale cream, discolouring brown from base upward. **habitat** Mixed deciduous woodland. **status** Uncommon.

Hebeloma anthracophilum See p. 346.

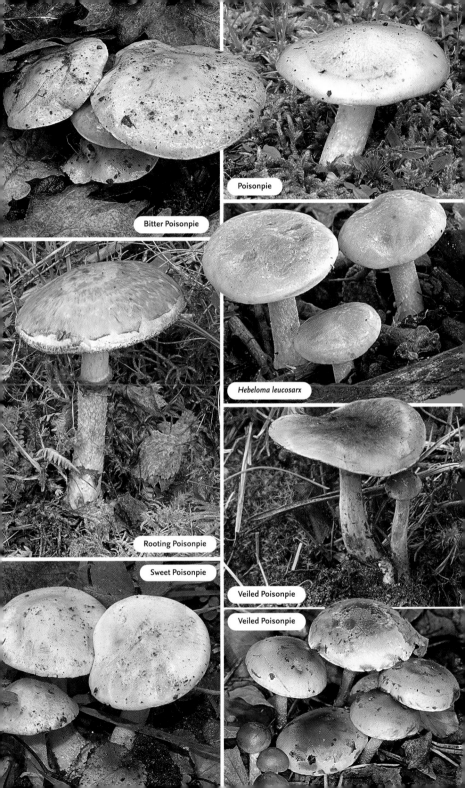

Bitter Poisonpie

Poisonpie

Hebeloma leucosarx

Rooting Poisonpie

Sweet Poisonpie

Veiled Poisonpie

Veiled Poisonpie

Inocybe is a complex genus, with many species needing microscopic examination for identification. The fibrecaps are generally small with dull colours. Many have distinctive campanulate caps. Some have a bulbous base and others have fine hairs on the stipe (visible with a hand lens); care must be taken when collecting specimens, as these are important field characteristics that can easily be lost. Gills are usually adnate or adnexed, crowded and produce a tobacco-brown spore print. Generally found in autumn in a variety of habitats.

Inocybe godeyi

Fibrecap with a rimmed bulb and with all parts strongly discolouring red on handling. **CAP** To 5cm across; conical, becoming flatter and usually with a small umbo; surface smooth, then increasingly fibrillose and with margin splitting; cream then ochre and discolouring red. **GILLS** Adnexed; crowded; greyish white, maturing reddish brown. **STIPE** To 6cm long; cylindrical with a marginate bulb; white or pale ochre with a powdery surface. **HABITAT** Deciduous woodland, usually on calcareous soil. **STATUS** Widespread but uncommon; more frequent in S.

Greenfoot Fibrecap *Inocybe calamistrata*

Easily recognised scaly brown fibrecap with a blue-green base to the stipe and a strong acidic smell. **CAP** To 4cm across; conical, becoming bell-shaped; surface smooth or granular at first, then scaly; dark grey-brown. **GILLS** Adnate; crowded; whitish, maturing reddish brown. **STIPE** To 6cm long; cylindrical; concolorous with cap but with a paler apex, covered in darker scales and with a blue-green base. **HABITAT** Usually with conifers on acid soil; more rarely with deciduous trees. **STATUS** Widespread but uncommon.

Deadly Fibrecap *Inocybe erubescens* (= I. patouillardii)

Deadly Fibrecap

Extremely poisonous red-staining fibrecap found in summer. **CAP** To 8cm across; conical, becoming bell-shaped or flatter, usually with a broad umbo; fibrillose, with an incurved margin and splitting radially; whitish, becoming more ochre and developing red patches or blotches. **GILLS** Adnexed or almost free; crowded; beige or clay-coloured, maturing darkish brown. **STIPE** To 10cm long; stout and cylindrical, with a somewhat enlarged or bulbous base; surface covered in longitudinal fibrils; dingy white or ochre, discolouring red. **HABITAT** Deciduous woodland. **STATUS** Most frequent in S.

Split Fibrecap *Inocybe rimosa* (= I. fastigiata)

One of the commonest but most variable fibrecaps, with a distinctively split cap margin and spermatic smell. **CAP** To 7cm across; conical, becoming bell-shaped or flatter and sharply umbonate; covered in coarse fibrils and the incurved margin usually splitting; variable in colour but generally ochre or shades of brown. **GILLS** Adnate or adnexed; crowded; whitish, maturing olive-brown. **STIPE** To 8cm long; cylindrical, sometimes with an enlarged base; white

Straw Fibrecap, showing characteristic bulbous base to stipe

Split Fibrecap

or cream. **HABITAT** Usually deciduous woodland. **STATUS** Widespread and common. **SIMILAR SPECIES Straw Fibrecap** *I. cookei* is less common, with a distinct marginate basal bulb and a smell of honey.

Frosty Fibrecap *Inocybe maculata*

Similar to Split Fibrecap but with a darker brown cap and frosted centre. **CAP** To 8cm across; conical or bell-shaped, becoming flatter with a broad umbo; covered in radial fibres, with the margin usually split; chestnut-brown but paler towards margin, centre with persistent white remnants of veil. **GILLS** Adnate; crowded with finely toothed white edges; greyish white, maturing olive-brown. **STIPE** To 8cm long; cylindrical or slightly enlarged towards base, which often ends in a small bulb; cream, progressively flushed ochre or reddish brown towards base, which is often white and powdery. **HABITAT** Deciduous woodland, often on calcareous soil. **STATUS** Widespread but occasional.

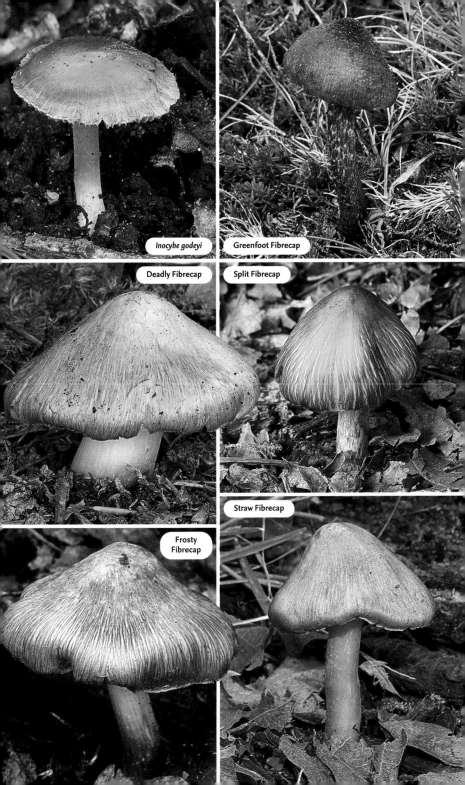

Inocybe godeyi

Greenfoot Fibrecap

Deadly Fibrecap

Split Fibrecap

Straw Fibrecap

Frosty Fibrecap

White Fibrecap *Inocybe geophylla*

Common fibrecap found in two distinct colour forms. **CAP** To 4cm across; conical, then bell-shaped or flatter with a sharp umbo; surface smooth and silky; white with a greyish flush, particularly at centre; a violet or lilac form (var. *lilacina*) is also found. **GILLS** Adnexed; crowded; creamy white, maturing ochre-brown. **STIPE** To 6cm long; cylindrical with a slightly thickened base; covered in white silky fibrils on a concolorous ground. **HABITAT** Mixed woodland, sometimes mossy lawns. **STATUS** Widespread and very common.

White Fibrecap

Lilac Leg Fibrecap *Inocybe griseolilacina*

Fibrecap with a hint of lilac in cap, stipe and flesh, and a strong mealy smell. **CAP** To 3cm across; conical or bell-shaped, then convex or flatter, sometimes with a shallow umbo; surface with fine scales at first, becoming coarser and more erect; greyish brown with a darker centre. **GILLS** Adnate, with finely toothed white edges; whitish, maturing brown. **STIPE** To 5cm long; cylindrical with a slightly swollen base; greyish lilac when young and later covered in fine longitudinal white fibrils. **HABITAT** Deciduous and mixed woodland, and along wooded roadsides and tracks. **STATUS** Widespread but occasional.

Fruity Fibrecap *Inocybe bongardii*

Fibrecap with a distinct fruity smell, recalling ripe pears. **CAP** To 5cm across; convex, becoming flatter with a broad umbo; surface covered in fibrils or scales; light ochre, sometimes with an orange or pinkish flush. **GILLS** Adnate; fairly crowded; olive-grey, maturing light brown. **STIPE** To 8cm long; cylindrical; whitish, becoming light reddish brown with darker fibrils, particularly towards base. **HABITAT** Deciduous woodland, usually on calcareous soil. **STATUS** Widespread but occasional; most frequent in S.

Pear Fibrecap *Inocybe fraudans* (= *I. pyriodora*)

Similar to Fruity Fibrecap but with a paler cap and stronger smell of ripe pears. **CAP** To 7cm across; bell-shaped, becoming flatter and often with a broad umbo; surface smooth or finely fibrillose with an inrolled margin; yellow-ochre to pale brown. **GILLS** Adnate; crowded, with finely toothed white edges; cream, maturing light reddish brown. **STIPE** To 8cm long; cylindrical, with base sometimes thickened; white, flushed with cap colour, but apex remaining white and powdery. **HABITAT** Deciduous woodland on calcareous soil. **STATUS** Widespread but occasional; mainly in S.

Inocybe sindonia

Pale fibrecap with a rather scaly cap. **CAP** To 4cm across; conical, becoming bell-shaped or flatter with a prominent umbo; fibrillose, then breaking up into coarse, erect scales, particularly in centre; ivory-white or pale buff with a paler margin. **GILLS** Adnate, with white edges; pale buff, maturing brown. **STIPE** To 7cm long; cylindrical, sometimes with a swollen base; pale ochre, occasionally with a pinkish tinge; powdery, this sometimes confined to the upper half. **HABITAT** Deciduous and coniferous woodland. **STATUS** Widespread and common.

Fleecy Fibrecap *Inocybe flocculosa*

Variable fibrecap whose cap is covered in a light bloom. **CAP** To 5cm across; bell-shaped or flatter with a broad umbo; fibrillose, breaking up into scales that are coarser and more erect in centre; margin incurved; ochre or greyish brown. **GILLS** Adnexed; crowded, with white-woolly edges; pale fawn, maturing darker. **STIPE** To 5cm long; cylindrical with a slightly enlarged base and longitudinally fibrillose; whitish, flushed reddish brown, with a powdery apex and white base. **HABITAT** Deciduous woodland; more rarely with conifers. **STATUS** Widespread but occasional. **SIMILAR SPECIES** Woolly Fibrecap *I. lanuginosa* is slightly smaller, darker and generally more scaly, particularly on the stipe.

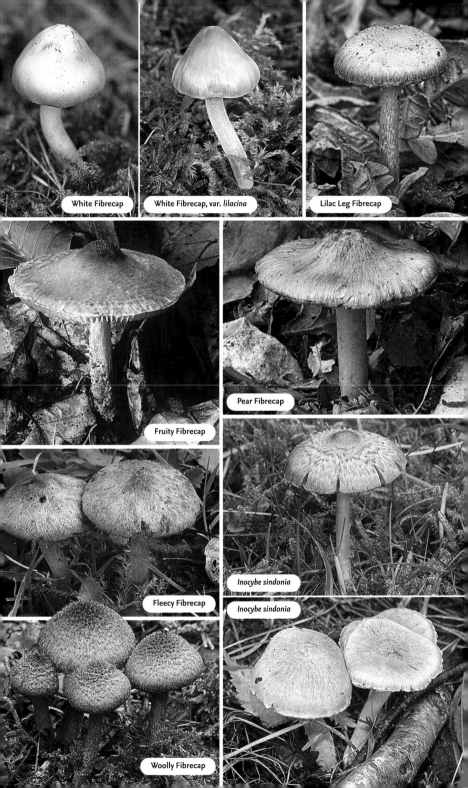

White Fibrecap

White Fibrecap, var. *lilacina*

Lilac Leg Fibrecap

Fruity Fibrecap

Pear Fibrecap

Fleecy Fibrecap

Inocybe sindonia

Inocybe sindonia

Woolly Fibrecap

Torn Fibrecap *Inocybe lacera*

Very variable, scaly brown fibrecap with several identified varieties. **CAP** To 3cm across; convex, becoming flatter, usually umbonate, with an incurved margin that often splits; surface scaly; dark brown but paler towards margin. **GILLS** Adnexed; crowded; whitish, maturing dark brown but with edges remaining pale. **STIPE** To 3cm long; cylindrical or slightly thickened towards base; brown, paler towards apex and covered in longitudinal fibrils. **HABITAT** Deciduous and coniferous woodland on sandy soil; also heathland and dunes. **STATUS** Widespread and common. **SIMILAR SPECIES** Scaly Fibrecap *I. hystrix* is noticeably more scaly; it is much less common and mostly confined to Scotland.

Inocybe praetervisa

Similar to Split Fibrecap (p. 192) but with a distinct basal bulb. **CAP** To 5cm across; conical or bell-shaped, or sometimes flatter, with a prominent umbo and incurved margin that splits or cracks; ochre, sometimes with a darker centre. **GILLS** Adnexed; crowded, with toothed white edges; whitish, maturing buff. **STIPE** To 6cm long; cylindrical, ending in an abrupt bulb; off-white, discolouring ochre or darker, and with the upper half powdery. **HABITAT** Deciduous woodland; more rarely with conifers. **STATUS** Widespread but uncommon.

Inocybe tenebrosa (= *I. atripes*)

Fibrecap with a distinctive dark brown to blackish colour to the lower half of the stipe. **CAP** To 3.5cm across; convex, becoming flatter with a broad umbo; surface covered in radial fibrils that disrupt into fine scales; hazel to reddish brown, sometimes darker in centre. **GILLS** Adnate; fairly distant, with toothed white edges; white or light ochre, maturing buff or brown. **STIPE** To 7cm long; cylindrical or slightly bulbous; white, but soon discolouring dark brown or blackish from base upward; powdery over entire length. **HABITAT** Deciduous woodland. **STATUS** Uncommon; mainly in S.

Bulbous Fibrecap *Inocybe napipes*

Brown fibrecap with a sharply umbonate cap and onion-shaped bulb. **CAP** To 5cm across; conical or bell-shaped, becoming flatter, always with a pronounced umbo; surface developing radial fibrils; margin incurved; hazel to chestnut-brown. **GILLS** Adnexed; crowded, with white cottony edges; dingy white, maturing brown. **STIPE** To 6cm long; cylindrical with a bulbous base; whitish, but with central area flushed with cap colour; upper half fibrillose. **HABITAT** Deciduous woodland; more rarely with conifers. **STATUS** Widespread and common.

Star Fibrecap *Inocybe asterospora*

Similar to Bulbous Fibrecap but with a less sharply umbonate cap and a marginate bulb. **CAP** To 6cm across; conical, becoming flatter, usually with a broad umbo; surface fibrillose, becoming scaly in centre; reddish brown. **GILLS** Adnexed; fairly crowded, with white cottony edges; greyish beige, maturing brown. **STIPE** To 6cm long; cylindrical with a large whitish basal bulb; pale brown but darker in lower half. **HABITAT** Deciduous and coniferous woodland, and sometimes parkland. **STATUS** Widespread and common. **SIMILAR SPECIES** *I. assimilata* is less common and has a smaller, non-marginate bulb.

Star Fibrecap

Inocybe fuscidula

Brown fibrillose fibrecap with a spermatic smell. **CAP** To 6cm across; convex, becoming flatter with a distinct umbo; margin incurved and often hung with veil remnants; pale brown, covered with darker fibrils. **GILLS** Adnexed, with undulating, finely toothed white edges; light beige, maturing darker brown. **STIPE** To 7cm long; cylindrical; upper part powdery, remainder fibrillose; whitish or light ochre, often flushed brown. **HABITAT** Deciduous woodland; less frequently with conifers. **STATUS** Widespread but occasional.

Inocybe serotina See p. 340.

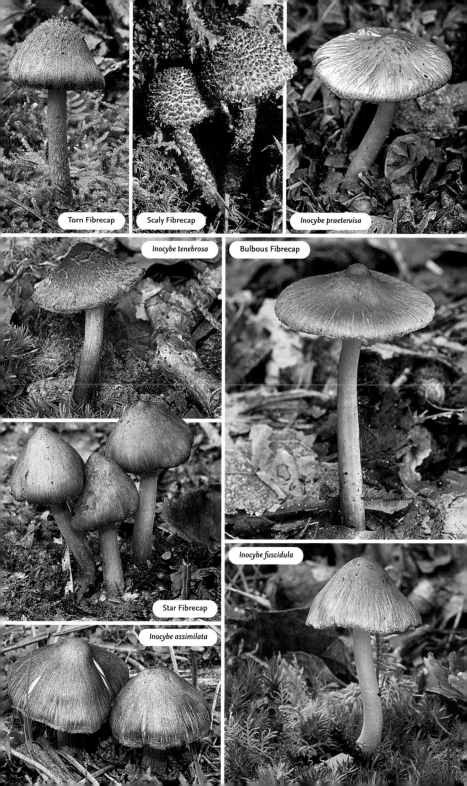

Torn Fibrecap

Scaly Fibrecap

Inocybe praetervisa

Inocybe tenebrosa

Bulbous Fibrecap

Star Fibrecap

Inocybe fuscidula

Inocybe assimilata

Yellow Fieldcap *Bolbitius titubans* (= *B. vitellinus*) (Top 100)

Bright yellow sticky fieldcap with a delicate and very fragile cap and stipe. **CAP** To 4cm across; oval, becoming bell-shaped and finally flattish; margin undulating and striate with age; bright yellow, but hygrophanous and drying cream with only a hint of yellow. **GILLS** Adnexed or free; crowded; pale yellow, maturing reddish brown. **STIPE** To 8cm long; slender and cylindrical; pale yellow ground covered in a fine white powder. **HABITAT** Varied, including dung, rotting straw, manured grass and woodchip mulch. **STATUS** Widespread and common. **SIMILAR SPECIES** **Netted Fieldcap** *B. reticulatus* with a violaceous netted cap and found on dead wood.

Milky Conecap *Conocybe apala* (= *C. lactea*)

The only white conecap. The distinctively shaped cap and contrasting rusty-brown gills make this an easy species to identify. **CAP** To 1.5cm across; elongated conical, becoming narrow bell-shaped; margin lined when wet; surface smooth, dull, dry and finely scurfy; cream or ivory, drying pale beige. **GILLS** Adnexed or free; crowded; pale ochre, maturing rusty brown with a similar-coloured spore print. **STIPE** To 11cm long; cylindrical, slender and with a small bulb; very fragile; white or pale cream with white down. **HABITAT** Grass, dunes and, sometimes, woodchip-mulched flowerbeds. **STATUS** Widespread and common.

Conocybe rugosa

One of several conecaps with a ring. This is a difficult group that can only be separated microscopically. **CAP** To 2.5cm across, conical, convex or bell-shaped; wrinkled when young with a wavy and striate margin; yellow-brown but hygrophanous and drying paler. **GILLS** Adnexed; pale ochre maturing darker with a rust-brown spore print. **STIPE** To 4cm long; cylindrical with a moveable white ring that has a striate or grooved upper surface; pale brown becoming dark brown and sparsely covered with lighter fibrils. **HABITAT** Soil in woodland, parkland, tracks and roadsides, and also woodchip-mulched areas and flowerbeds. **STATUS** Widespread and occasional.

Conocybe rickenii

Has the typical cone-shaped cap and ginger colour of a *Conocybe*. **CAP** To 2.5cm across; conical, becoming bell-shaped, rarely flatter; surface smooth or finely wrinkled and slightly greasy when moist; margin without striations and often serrated; orange-brown, drying cream or pale ochre. **GILLS** Adnate; cream, maturing rust-brown with a concolorous spore print. **STIPE** To 5.5cm long; slender and cylindrical; whitish, discolouring brown with age and covered in a white down. **HABITAT** On weathered dung and rich soils in parks and gardens. **STATUS** Uncommon.

Conocybe pubescens See p. 344.

Spring Fieldcap *Agrocybe praecox*

Our most common fieldcap. Usually fruits in spring and early summer. **CAP** To 6cm across; convex, becoming flatter, usually with a broad umbo; surface smooth but extensively cracking in dry weather; ochre or light brown with a darker centre, drying paler. **GILLS** Adnate; crowded; pale buff, maturing dark brown with a tobacco-brown spore print. **STIPE** To 8cm long; cylindrical, with a short-lived ring, the base rooting and somewhat enlarged; creamy, covered with brown fibrils. **HABITAT** Usually clustered or grouped in grassy areas in parkland, woodland edges and gardens. **STATUS** Widespread and common.

Spring
Fieldcap

Bearded Fieldcap *Agrocybe molesta* (= *A. dura*)

Spring- or summer-fruiting whitish fieldcap. **CAP** To 7cm across; convex, then flatter and often broadly umbonate; margin incurved and hung with veil remnants; pale tan or ivory, drying cream or white. **GILLS** Adnate; pale tan, maturing darkish brown with a similar-coloured spore print. **STIPE** To 7cm long; cylindrical, with a short-lived ring zone; surface felty or fibrillose; white, discolouring brownish, particularly near base. **HABITAT** Solitary or grouped in scrub, woodland and grassland, roadside verges and gardens. **STATUS** Occasional.

Agrocybe rivulosa and *Agrocybe arvalis* See p. 342.

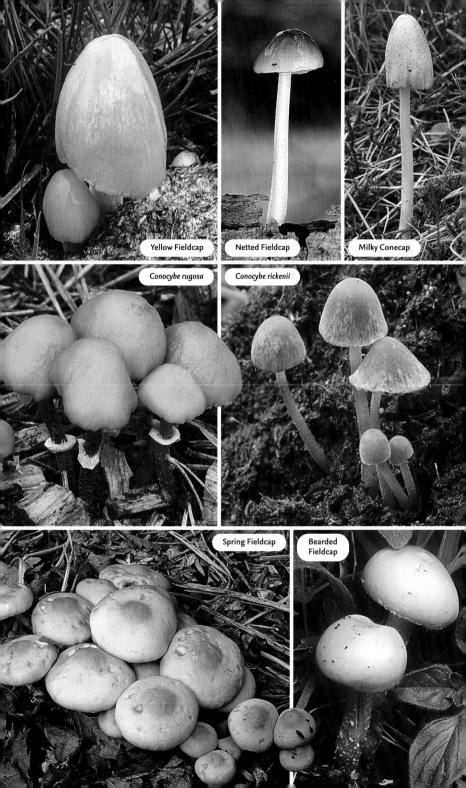

Yellow Fieldcap

Netted Fieldcap

Milky Conecap

Conocybe rugosa

Conocybe rickenii

Spring Fieldcap

Bearded Fieldcap

Sulphur Tuft *Hypholoma fasciculare* (Top 100)
Familiar yellow fungus found in dense, sometimes spectacular, clumps on dead wood. The bitter taste separates it from similar species. **CAP** To 7cm across; convex, becoming flatter, often umbonate; margin hung with veil remnants when young; surface smooth and dull; yellow but orange-tan towards centre. **GILLS** Adnate; crowded; distinctive yellowish green then purple-black; a sterile form with yellow gills is sometimes found. **STIPE** To 9cm long; cylindrical and often curved; concolorous with cap but darkening towards base with age; ring zone often discoloured by fallen spores. **HABITAT** Densely tufted on decayed wood of both deciduous and coniferous trees. **STATUS** Widespread and very common.

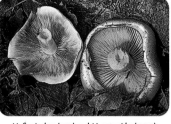

H. fasciculare (LEFT) **and** *H. capnoides* (RIGHT)

Conifer Tuft *Hypholoma capnoides*
Similar to Sulphur Tuft but with a mild taste and gills lacking any greenish tints. **CAP** To 6cm across; convex, becoming flatter and often umbonate; shades of ochre or yellow, flushed tan in centre and with the incurved margin paler and hung with veil remnants when young. **GILLS** Adnate; whitish, maturing greyish or lilac with a dark brown spore print. **STIPE** To 7cm long; cylindrical and often bent; concolorous with cap and flushed reddish brown from base upward. **HABITAT** Densely tufted on decayed conifer wood. **STATUS** Uncommon.

Brick Tuft *Hypholoma lateritium* (= *H. sublateritium*)
Similar to the previous two species but with a brick-red cap colour. Fruits from late autumn to winter. **CAP** To 9cm across; convex, becoming flatter, usually with a broad umbo; surface smooth and dull; brick-red in centre and increasingly paler outward; margin inrolled, with a wide band of woolly veil remnants when young. **GILLS** Adnate; crowded; cream or light yellow, maturing grey or olive-brown with a purplish-brown spore print. **STIPE** To 12cm long; cylindrical; apex whitish or light yellow and progressively ochre or reddish brown downward, with an indistinct, paler ring zone. **HABITAT** Decayed wood of deciduous trees, particularly old stumps of oaks. **STATUS** Widespread but occasional.

Rooting Brownie *Hypholoma radicosum*
Rare brownie with a rooting base. **CAP** To 8cm across; convex, becoming flatter and slightly umbonate; surface greasy when moist, drying smooth or silky; margin edged with veil remnants; pale ochreous with orange patches. **GILLS** Adnate; crowded; creamy, maturing olive or purplish brown with a similar-coloured spore print. **STIPE** To 15cm long; cylindrical, with a rooting base; similar colour to cap and flushed reddish brown from base upward; ring zone whitish. **HABITAT** Decayed conifer wood, both standing and buried. **STATUS** Rare.

Rooting Brownie

Sphagnum Brownie *Hypholoma elongatum*
Small brownie found in *Sphagnum* moss. **CAP** To 2cm across; convex or bell-shaped, becoming flatter; surface greasy and striate when moist, drying smooth and dull; honey-yellow, drying ochre. **GILLS** Adnate; whitish, maturing violet-brown with a purple-brown spore print. **STIPE** To 6cm long; slender and often bent; surface dull and smooth; similar colour to cap but slightly darker towards base. **HABITAT** Boggy areas with *Sphagnum* moss. **STATUS** Widespread but occasional.

Sheathed Woodtuft *Kuehneromyces mutabilis* (Top 100)
Very similar to Funeral Bell (p. 188) but with a very scaly stipe. **CAP** To 6cm across; convex, becoming flatter with a broad umbo; surface smooth and dull; yellowish brown, but hygrophanous and drying paler from centre outward to create a two-tone effect. **GILLS** Adnate; crowded; pale ochre, maturing reddish brown with a similar-coloured spore print. **STIPE** To 8cm long; slender and cylindrical, with a short-lived ring; cream above ring zone, darker below it and covered in coarse scales. **HABITAT** Usually clustered on decayed wood of deciduous trees. **STATUS** Widespread and very common.

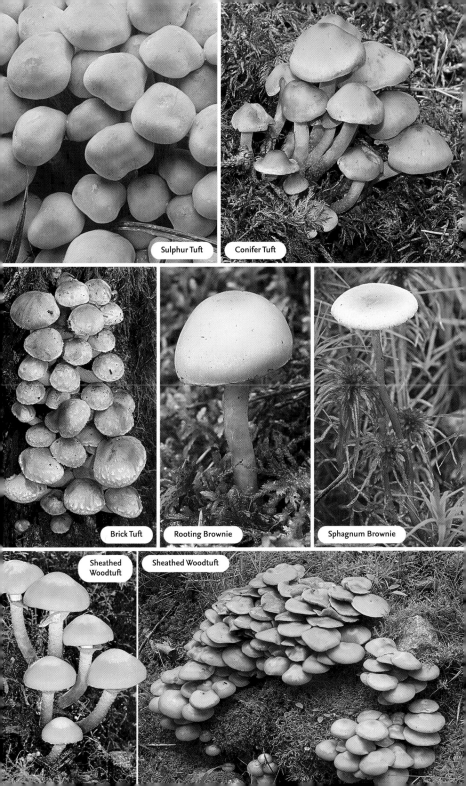

Sulphur Tuft

Conifer Tuft

Brick Tuft

Rooting Brownie

Sphagnum Brownie

Sheathed Woodtuft

Sheathed Woodtuft

Pholiota species are generally fleshy, medium to large fungi, in shades of yellow or orange-brown. They are usually on, or associated with, wood, sometimes forming large and impressive clumps. Most have short-lived rings that leave remnants on the cap edge when young. The gills are adnate and crowded, and the spore print is rusty brown.

Golden Scalycap *Pholiota aurivella*
The most common of several scalycaps with a slimy or greasy, scaly cap. CAP To 12cm across; convex, becoming flatter with a broad umbo; golden yellow or rusty brown and covered in darker scales that are easily shed, leaving the cap smooth. GILLS Adnate; creamy, maturing rust-brown. STIPE To 9cm long; cylindrical and often curved; yellowish with darker scales. HABITAT Clustered on dead wood of deciduous trees, especially large logs and trunks of Beech. STATUS Widespread but occasional; more frequent in S.

Sticky Scalycap *Pholiota gummosa*
Drab, pale scalycap with greenish tones. CAP To 5cm across; convex, becoming flatter; greasy at first but soon drying dull; dingy whitish beige with a greenish hue and covered in large, inconspicuous scales. GILLS Adnate; cream or pale yellow, maturing reddish brown. STIPE To 8cm long; cylindrical; light yellowish beige with a reddish-brown base; fibrillose or felty below ring zone. HABITAT Clustered on decayed wood of deciduous trees, often growing out of the ground from buried wood. STATUS Widespread and common.

Shaggy Scalycap *Pholiota squarrosa*
Scalycap found in spectacular clusters at the base of broadleaved trees. CAP To 11cm across; convex, becoming flatter; surface dry; pale straw-yellow, densely covered with concentric rings of darker, upturned scales that are concentrated towards centre. GILLS Adnate; pale yellow, maturing rust-brown. STIPE To 15cm long; somewhat curved; pale yellow but darkening towards base and covered in recurved brown scales below ring zone. HABITAT Clustered on dead and living wood of deciduous trees or, rarely, conifers. STATUS Widespread and common.

Pholiota tuberculosa
Small scalycap with a dry felty surface. CAP To 4cm across; rounded or convex and becoming flatter; yellowish with small rusty scales when mature. GILLS Adnate; yellow then rust-brown. STIPE To 5cm long; cylindrical; yellow and smooth above ring zone, darker and sparsely scaly below. HABITAT Decayed wood of deciduous trees; occasionally on sawdust. STATUS Widespread but occasional.

Flaming Scalycap *Pholiota flammans*
Uniformly coloured *Pholiota* whose cap and stipe are covered in upturned fleecy scales, creating a shaggy appearance. CAP To 7cm across; convex then flatter; bright chrome-yellow, maturing orange-yellow and covered in concolorous or paler fleecy scales. GILLS Adnate; similar in colour to cap. STIPE To 8cm long; cylindrical; concolorous with cap, and with surface smoothish above ring zone and very scaly below. HABITAT Solitary or grouped on decayed conifer wood, more rarely with broadleaved trees. STATUS Occasional and rare.

Alder Scalycap *Pholiota alnicola*
Pale yellow scalycap, usually found in wet places. CAP To 8cm across; convex, becoming flatter and usually umbonate; surface smooth and greasy; pale yellow, sometimes with rusty spots. GILLS Adnate; concolorous with cap at first, maturing reddish brown. STIPE To 8cm long; cylindrical and often curved; surface dry; pale yellow but discolouring rusty brown from base upward. HABITAT Solitary or grouped on decayed wood of deciduous trees, including Common Alder, but especially (despite its name) birches. STATUS Widespread and common.

Bonfire Scalycap *Pholiota highlandensis* See p. 346.

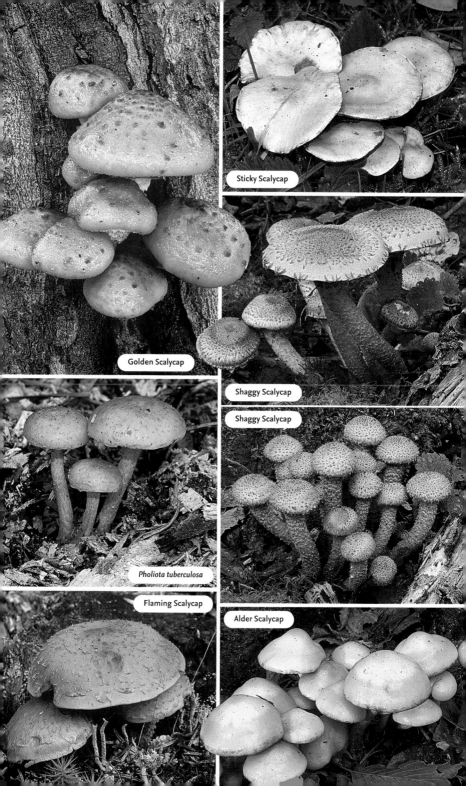

Sticky Scalycap

Golden Scalycap

Shaggy Scalycap

Shaggy Scalycap

Pholiota tuberculosa

Flaming Scalycap

Alder Scalycap

Members of the genus *Stropharia* are highly variable in colour and size, ranging from small to quite large. The adnate gills are sometimes very deep and broad, appearing to fill the underside of the cap. They mature purple-brown with a similar-coloured spore print. The ring is usually rudimentary or short-lived.

Stropharia aeruginosa

Roundhead with an unusual blue-green cap. **CAP** To 8cm across; convex, becoming flatter with a broad, shallow umbo; covered in thick slime and flecked with persistent white scales; blue-green, developing yellowish patches. **GILLS** Adnate, with white felty edges; whitish, maturing purple-brown. **STIPE** To 10cm long; cylindrical, with a distinct and persistent ring; blue-green; smooth above ring zone and densely covered in erect white scales below. **HABITAT** On soil in wooded areas, gardens and parkland. **STATUS** Widespread, but occasional to rare.

Blue Roundhead *Stropharia caerulea*

Similar to *S. aeruginosa* but generally paler with age and lacking the white gill edges. **CAP** To 8cm across; convex, then flatter and umbonate; sticky, with any velar remains normally confined to margin and soon vanishing; blue-green but fading yellowish. **GILLS** Adnate; light reddish brown, maturing dark brown. **STIPE** To 10cm long; bluish green, covered in erect white scales below ring zone and paler and smoother above. **HABITAT** Woodland, waste areas and mulched flowerbeds in parks and gardens. **STATUS** Widespread and common. **SIMILAR SPECIES Peppery Roundhead** *S. pseudocyanea* has a peppery smell and is often found in grassland.

Blue Roundhead

Conifer Roundhead *Stropharia hornemannii*

Large, fleshy roundhead with subdued colours. **CAP** To 15cm across; domed, becoming convex with a broad umbo; surface sticky when wet but drying smooth; variable in colour but usually pale brown with a hint of violet; yellowish and whitish forms also occur. **GILLS** Adnate; greyish, maturing purple-brown. **STIPE** To 14cm long; cylindrical; white; smooth above ring zone and covered in large, shaggy white scales below. **HABITAT** On decayed, sometimes buried, wood of pine. **STATUS** Rare; confined to Caledonian pinewoods.

Dung Roundhead *Stropharia semiglobata* (Top 100)

Small roundhead, usually found growing out of cow-pats. **CAP** To 4cm across; rounded, becoming convex (umbonate in var. *stercoraria*); surface sticky, drying smooth and satiny; creamy yellow but developing grubby greyish-brown patches with age. **GILLS** Adnate; very deep and broad; greyish, maturing purple-brown. **STIPE** To 10cm long; slender and cylindrical; cream or ochre; smooth and dry above ring zone and slimy with brown fibrils below. **HABITAT** Dung of herbivores; occasionally manured grassland. **STATUS** Widespread and very common.

Redlead Roundhead *Leratiomyces ceres* (*Stropharia aurantiaca*)

Dull red roundhead, often found in large drifts on woodchip mulch. **CAP** To 6cm across; convex, becoming flatter, the margin usually with white velar remains; orange or red, with paler patches when dry. **GILLS** Adnate, with a whitish gill edge; olive, maturing brown. **STIPE** To 10cm long; cylindrical; whitish, flushed red below, and covered with concolorous scales when young. **HABITAT** Twigs and decayed woodchip mulch. **STATUS** Widespread but occasional; increasing.

Garland Roundhead *Stropharia coronilla*

Small yellow roundhead found in grass and resembling a small *Agaricus*. **CAP** To 4cm across; convex, becoming flatter; surface drying felty or finely scaly; yellow-ochre. **GILLS** Adnate, with white felty edges; pale greyish brown, maturing purple-brown. **STIPE** To 4cm long; small white ring with a striated upper surface that is often darkened by fallen spores; white, sometimes yellowing with age; surface finely fibrillose, with a smoother apex. **HABITAT** In grass, lawns and pastures. **STATUS** Widespread but occasional; more frequent in S.

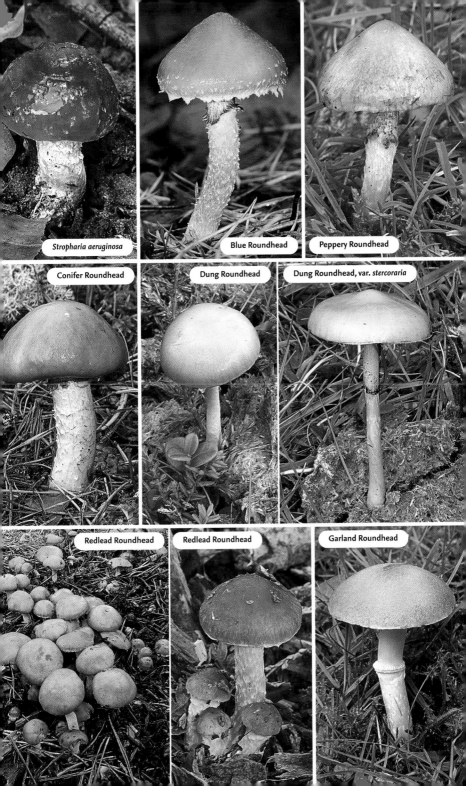

Stropharia aeruginosa

Blue Roundhead

Peppery Roundhead

Conifer Roundhead

Dung Roundhead

Dung Roundhead, var. *stercoraria*

Redlead Roundhead

Redlead Roundhead

Garland Roundhead

Blueleg Brownie *Psilocybe cyanescens*

Brownie with a blue discoloration of the stipe. **CAP** To 6cm across; convex, becoming flatter, wavy and undulating with an uplifted margin; sticky when wet; reddish brown, but hygrophanous and drying ochre or cream, often with a darker marginal zone. **GILLS** Adnate; pale ochre, maturing dark brown with a purple-brown spore print. **STIPE** To 5cm long; cylindrical, with an indistinct ring zone; white but discolouring bluish. **HABITAT** Dead wood of deciduous trees, often forming clumps on woodchip mulch. **STATUS** Now widespread and locally abundant.

Psilocybe merdaria

Small, hygrophanous *Psilocybe* found on dung. **CAP** To 2cm across; hemispherical, becoming convex, with the margin translucent-striate and hung with veil remnants; surface greasy and shiny; olive-brown or dark brown, but hygrophanous and drying pale ochre or tan. **GILLS** Adnate, with white felty edges; light ochre, maturing purple-brown with a similar-coloured spore print. **STIPE** To 4cm long; cylindrical; brown, covered in woolly white scales, but fading with age. **HABITAT** Weathered dung of herbivores. **STATUS** Widespread but occasional.

Liberty Cap or Magic Mushroom *Psilocybe semilanceata*

It is now illegal to possess this small, pixie-capped brownie owing to its hallucinogenic properties. **CAP** To 1.5cm across; elongated conical with a sharp-pointed umbo, becoming bell-shaped but never flatter; margin translucent-striate and becoming wrinkled and blackened by fallen spores; surface greasy at first with a detachable gelatinous cuticle; yellow to greyish brown, but hygrophanous and drying dirty white or ochre. **GILLS** Adnate, with white felty edges; light brown, maturing purple-brown with a similar-coloured spore print. **STIPE** To 8cm long; cylindrical and very slender; whitish, discolouring pale brown and bruising greenish blue towards base. **HABITAT** Unimproved grassland on acid soils. **STATUS** Widespread and common, with a W and N bias.

Egghead Mottlegill *Panaeolus semiovatus*

Distinctively shaped cream-coloured mottlegill common on cow-pats. **CAP** To 6cm across; egg-shaped, becoming bell-shaped but never flatter, with veil remnants on margin; surface greasy when moist and drying shiny, sometimes wrinkled and/or cracking; light cream, tinged yellowish towards centre. **GILLS** Adnate, with white-fringed edges; whitish, maturing mottled blackish brown with a black spore print. **STIPE** To 15cm long; slender, cylindrical and stiff, with a short-lived ring; whitish, discolouring yellowish and covered in a fine powder. **HABITAT** Weathered dung of herbivores. **STATUS** Widespread and common.

Petticoat Mottlegill *Panaeolus papilionaceus (= P. sphinctrinus)*

Mottlegill whose veil remnants form a distinct pale, serrated edge to the cap. **CAP** To 4cm across; conical or convex, becoming bell-shaped, sometimes umbonate; surface smooth and dull or satiny; dark grey or brown, drying pale grey with a darker centre. **GILLS** Adnate, with white-fringed edges; grey, maturing mottled brown-black and with a black spore print. **STIPE** To 12cm long; cylindrical and slender; light grey or dark brown and covered in a white powder. **HABITAT** Weathered dung of herbivores and manured soil with grass. **STATUS** Widespread and common.

Turf Mottlegill *Panaeolus fimicola (= P. ater)*

Dark brown mottlegill found in grass. **CAP** To 4cm across; hemispherical or convex, and barely umbonate; surface smooth and satiny; dark reddish brown, fading somewhat with age. **GILLS** Adnate, with white toothed edges; greyish brown, maturing mottled black with a concolorous spore print. **STIPE** To 8cm long; slender and cylindrical, with a white-downy base; reddish brown with a whitish bloom, apex paler. **HABITAT** Short grass, including lawns. **STATUS** Widespread and common.

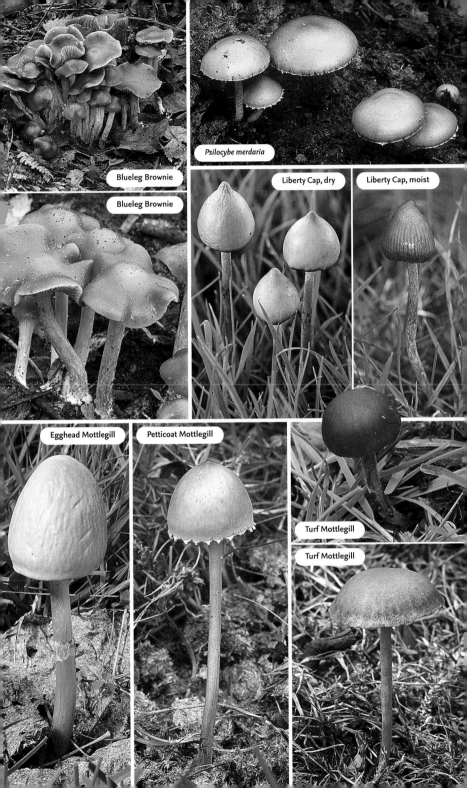

Blueleg Brownie

Psilocybe merdaria

Blueleg Brownie

Liberty Cap, dry

Liberty Cap, moist

Egghead Mottlegill

Petticoat Mottlegill

Turf Mottlegill

Turf Mottlegill

The genus *Agaricus* includes many of our best edible mushrooms and one widely cultivated species. The mushrooms are mostly large and fleshy, with a dry, smooth or scaly texture; at first many are globular and may remain in this familiar button stage for some time. All have a white ring, which may be persistent or short-lived (fugacious), and in several species it splits to form a cogwheel effect. The gills are generally crowded and free, changing from a pale colour at first to dark brown or blackish on maturity and with a similar dark-coloured spore print. Some species have a white or pale gill edge as a result of being sterile. Many exhibit colour changes to the surface and/or flesh of the cap and stipe when cut or bruised. Some also have a distinctive smell, which can be pleasant like aniseed or almonds, or unpleasant like phenol or ink. Most are found from early summer to autumn.

Blushing Wood Mushroom *Agaricus silvaticus*
Highly variable species, strongly discolouring red on cutting and lacking a distinctive smell. **CAP** To 10cm across; convex, becoming flatter and broadly umbonate; generally reddish brown and scaly on a whitish ground, but an all-white form exists. **GILLS** Greyish pink, maturing dark brown, with sterile edges. **STIPE** To 12cm long; cylindrical with a slightly bulbous base. Smooth and sometimes pinkish above ring zone, white and occasionally floccose below. Ring floppy and pendulous with a brown margin. **HABITAT** Grouped or, occasionally, solitary, in woodland where conifers are present. **STATUS** Widespread and common.

Scaly Wood Mushroom *Agaricus langei*
Very similar to Blushing Wood Mushroom, but more robust and with broader scales on the cap, and lacking a bulbous stipe base. **CAP** To 10cm across; hemispherical; becoming flatter; various shades of brown, breaking up into large scales to reveal the white colour beneath. **GILLS** Pink, maturing to dark purple or brown, with sterile edges. **STIPE** To 12cm long; cylindrical and tapering upward; surface smooth and white, occasionally pink above ring and darker and squamulose below. Ring pendent, with a brown lower surface. **HABITAT** Deciduous and coniferous woodland. **STATUS** Widespread but occasional.

Agaricus impudicus
Medium-sized, late season mushroom with large, trapezoidal scales; has a slightly nauseous smell and flesh that hardly discolours. **CAP** To 10cm across; convex and sometimes broadly flattening, covered in large blackish-brown scales on a paler ground. **GILLS** Greyish, becoming brown; edges sterile. **STIPE** To 10cm long; cylindrical with a bulbous base; ring pendulous. **HABITAT** Mainly coniferous woodland but also in deciduous and mixed woodland and occasionally even grassland. **STATUS** Widespread but occasional.

Agaricus impudicus

Agaricus porphyrocephalus
Rarely encountered species that exhibits little or no discoloration or smell. **CAP** To 8cm across; truncated convex, becoming flat; whitish with purple-brown scales. **GILLS** Pink, maturing to chocolate-brown. **STIPE** To 7cm long; narrowing towards base. Ring thin, fragile and fugacious. **HABITAT** Clustered in grassland and, occasionally, heathland. **STATUS** Widespread but uncommon.

Field Mushroom *Agaricus campestris*
Familiar mushroom of pastures, particularly those grazed by cattle. Very variable, with numerous identified varieties. **CAP** To 10cm across; rounded and remaining in the button stage for some time, before flattening and developing indistinct scales; margin appendiculate; generally white, but brown in var. *squamulosus*; scarcely discolouring except in var. *equestris*, where it becomes yellowish. **GILLS** Deeper pink initially than most *Agaricus*, maturing dark brown. **STIPE** To 8cm long; tapered towards base. Ring poorly developed and fugacious. **HABITAT** Found clustered, sometimes massed, in grassland of all types. **STATUS** Widespread and fairly common, although declining in some areas.

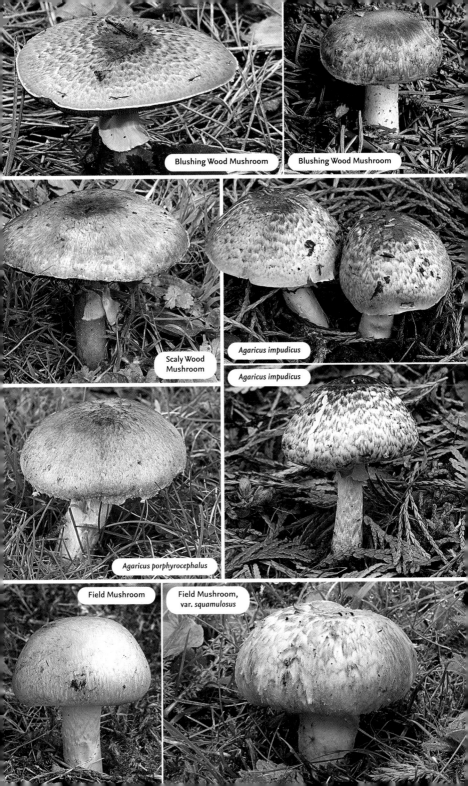

Blushing Wood Mushroom

Blushing Wood Mushroom

Scaly Wood Mushroom

Agaricus impudicus

Agaricus impudicus

Agaricus porphyrocephalus

Field Mushroom

Field Mushroom, var. *squamulosus*

Clustered Mushroom *Agaricus pseudovillaticus (= A. vaporarius)*

Scaly mushroom with a sweetish smell. **CAP** To 20cm across; hemispherical or trapezoidal with an incurved margin, eventually becoming flat; dark brown, breaking up into large scales. **GILLS** Pale pink, maturing dark brown. **STIPE** To 12cm long; cylindrical and tapered at base; smooth and whitish above ring zone, brownish and floccose below. Ring thick and duplicated by basal sheaf, which forms zones on lower part of stipe. **HABITAT** Generally clustered in humus-rich soils, especially compost heaps, gardens, parks and roadsides. **STATUS** Widespread but uncommon. **SIMILAR SPECIES** *A. subperonatus* tends to be more solitary and is considered by some to be synonymous.

Cultivated Mushroom *Agaricus bisporus*

As its common name suggests, this species is cultivated. Both white and brown forms are sold; the former is rarely found in the wild. It has a typical mushroom taste and smell. **CAP** To 10cm across; flat-topped hemispherical, becoming flat; greyish brown with radiating fibres and scales; margin appendiculate. **GILLS** Dusky pink, maturing dark brown. **STIPE** To 8cm long; sometimes tapering at base. Ring thick and scaly. **HABITAT** Grassland in parks, pastures and, occasionally, manure and compost heaps. **STATUS** Widespread but occasional.

Pavement Mushroom *Agaricus bitorquis*

A distinctive feature of this species is its occurrence beside paths or roadsides, pushing up through hard, compacted soil or even, occasionally, asphalt. Tends to discolour reddish and has an almond smell. **CAP** To 12cm across; spherical to hemispherical, but soon flattening with a depressed centre; margin inrolled and sometimes appendiculate; surface grey or white, yellowing with age, smooth with flaking scales but frequently obscured by debris from soil. **GILLS** Pink, maturing to dark chocolate-brown. **STIPE** To 8cm long; cylindrical with a tapering base. Double ring, with the lower a volva-like sheath. **HABITAT** Clustered on roadsides, path edges and bare soil. **STATUS** Widespread but occasional.

Agaricus bernardii

Distinctive sturdy mushroom whose white cap is disrupted into coarse brown scales, giving it a deeply fissured appearance. Flushes vinaceous and has an unpleasant fishy smell. **CAP** To 15cm across; hemispherical, becoming flattened-convex with a depressed centre. **GILLS** Pink, maturing dark brown. **STIPE** To 7cm long; stout and rather spindle-shaped. Narrow, sheathing and barely discernible second ring. **HABITAT** Typically found in coastal grassland and dunes, but increasingly spreading inland to roadsides that are exposed to winter salting. **STATUS** Uncommon. **SIMILAR SPECIES** *A. devoniensis* (p. 340).

Rosy Wood Mushroom *Agaricus dulcidulus (= A. semotus)*

Small whitish mushroom with vinaceous or lilaceous tints, discolouring yellow with age and giving off a faint aniseed smell. **CAP** To 5cm across; hemispherical, expanding to flattened-convex. White and smooth at first, soon covered in lilaceous fibrils and scales, these particularly concentrated in centre. **GILLS** Whitish, then greyish pink and maturing to brown. **STIPE** To 5cm long; cylindrical with a bulbous base; sometimes lilac above the thin, pendulous ring, white below. **HABITAT** Solitary to gregarious in coniferous and mixed woodland, and occasionally in grassland near trees. **STATUS** Widespread but uncommon.

Agaricus comptulus

Similar to Rosy Wood Mushroom, with a similar smell and discoloration, but confined to grassland. **CAP** To 4cm across; hemispherical then flat, occasionally with a small umbo. **GILLS** Pale pink, maturing dark purple-brown. **STIPE** To 4cm long; cylindrical; white and smooth above the thin, pendulous ring, silky and fibrillose below. **HABITAT** Grass in parks, cemeteries and, occasionally, lawns and open woodland. **STATUS** Widespread but uncommon.

Agaricus subrufescens (= A. rufotegulis) See p. 342.

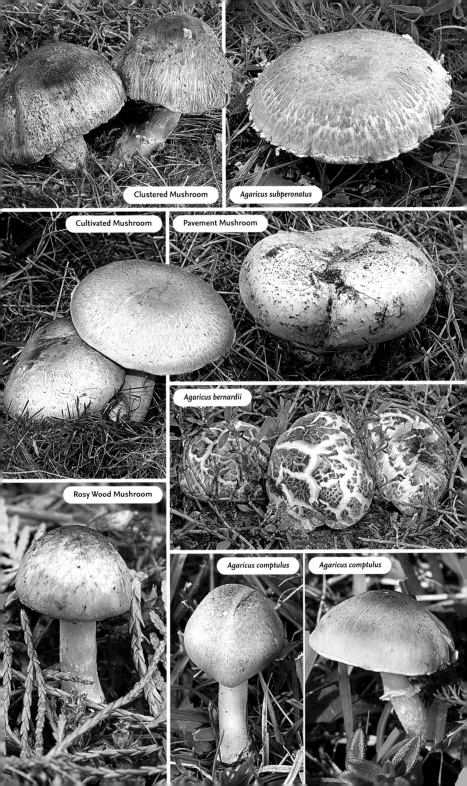

Clustered Mushroom

Agaricus subperonatus

Cultivated Mushroom

Pavement Mushroom

Agaricus bernardii

Rosy Wood Mushroom

Agaricus comptulus

Agaricus comptulus

The Prince *Agaricus augustus*

Large mushroom discolouring yellowish, with a typical pleasant aniseed smell and a cogwheel ring. Prized edible species. **CAP** To 25cm across; hemispherical or trapezoidal, expanding to flat-convex; surface covered with large brown scales on a creamy ground, with most in centre; margin incurved and appendiculate. **GILLS** Whitish, then reddish grey and finally dark purple-brown. **STIPE** To 20cm long; cylindrical, wider towards base; smooth above the large, persistent ring, woolly below. **HABITAT** Usually in groups in coniferous and deciduous woodland and parkland. **STATUS** Widespread but occasional.

Horse Mushroom *Agaricus arvensis*

Large mushroom smelling strongly of aniseed. Flesh turns dull yellow when cut or handled. Good edible species. **CAP** To 15cm across; hemispherical, maturing to flat-convex; surface white and covered with fine squamules. **GILLS** Pale pink, turning dark purple-brown. **STIPE** To 12cm long; cylindrical, enlarged towards base; smooth above ring and slightly floccose below. Ring large, pendent, persistent and forming a cogwheel. **HABITAT** In groups in meadows and pastures, and occasionally in open woodland. **STATUS** Widespread but occasional. **SIMILAR SPECIES Macro Mushroom** *A. urinascens* (= *A. macrosporus*) is larger and more robust with a more scaly cap and stipe; has a typical aniseed smell that becomes unpleasant with age.

Wood Mushroom *Agaricus silvicola*

Slender white or cream mushroom, strongly discolouring yellow, with an aniseed smell. **CAP** To 18cm across; flattish convex, becoming flat and usually with a shallow umbo; white, then cream and finally ochre with a dull satiny texture. **GILLS** Grey or white, finally becoming purple or dark brown. **STIPE** To 10cm long; cylindrical, somewhat slender with a bulbous base; surface flushed grey or pink above the floppy white ring, slightly fibrillose below. **HABITAT** In groups in coniferous and deciduous woodland. **STATUS** Widespread but occasional; most frequent in S.

Inky Mushroom *Agaricus moelleri* (= *A. placomyces*)

Flat-topped medium-sized mushroom with a distinctive smoky-grey or brown cap. **CAP** To 10cm across; hemispherical, becoming convex and finally flat, occasionally broadly umbonate; densely covered with grey or reddish-brown scales, these concentrated in centre. **GILLS** Light pink, maturing to chocolate-brown. Flesh rapidly discolouring yellow, particularly at base of stipe; unpleasant taste with a smell of ink. **STIPE** To 8cm long; cylindrical, slender and occasionally bent, with a bulbous base and large, floppy ring. **HABITAT** In groups in deciduous woodland, especially on chalk. **STATUS** Widespread but occasional.

Yellow Stainer

Yellow Stainer *Agaricus xanthodermus*

Probably responsible for more gastric upsets than any other mushroom, as it is easily confused with edible *Agaricus*. Base of stipe strongly discolours chrome-yellow; this, together with its unpleasant taste and smell, are good identification features. **CAP** To 10cm across; trapezoidal or hemispherical with a flattened top, then convex and finally flat; margin incurved and appendiculate. **GILLS** Pale pink, becoming dark purple or brown. **STIPE** To 10cm long; cylindrical and bulbous at base; smooth above the large, floppy ring, paler below. **HABITAT** In small groups in grassland and along woodland edges. **STATUS** Widespread and common. Probably the most common *Agaricus* species.

Agaricus bresadolanus (= *A. romagnesii*)

Agaricus bresadolanus

Medium-sized mushroom, extensively rooting at stipe base. **CAP** To 8cm across; hemispherical, then convex to flat with an indented centre; white with large, light brown scales, these more densely clustered in centre; margin incurved and fringed. **GILLS** Light pink, maturing blackish brown. **STIPE** To 6cm long; cylindrical to club-shaped. Ring thin and fugacious. **HABITAT** Parkland, gardens and deciduous woodland. **STATUS** Uncommon, least so in S.

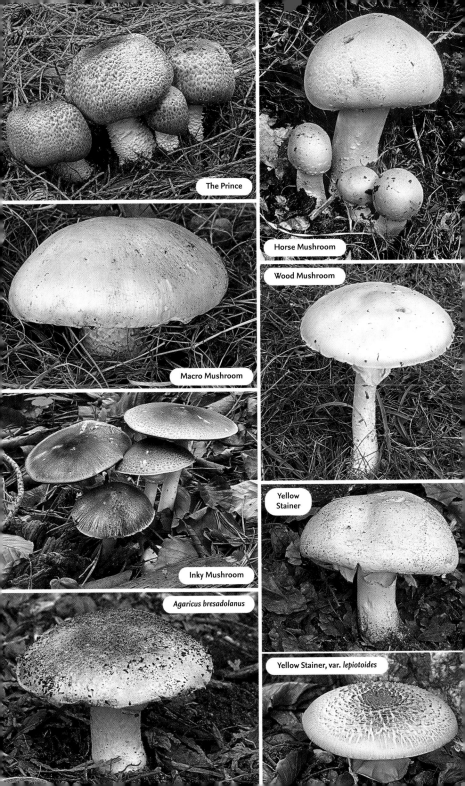

The Prince

Horse Mushroom

Wood Mushroom

Macro Mushroom

Inky Mushroom

Yellow Stainer

Agaricus bresadolanus

Yellow Stainer, var. *lepiotoides*

Weeping Widow *Lacrymaria lacrymabunda (= L. velutina)* (Top 100)

Variable fungus with weeping gills when moist. **CAP** To 10cm across; convex, becoming flatter with a broad umbo; margin fringed with hanging veil remnants when young; surface felty or woolly but becoming smoother with age; ochre or light brown. **GILLS** Adnate or adnexed; crowded; yellowish, maturing black with a paler margin and a blackish spore print. **STIPE** To 10cm long; cylindrical; short-lived ring accentuated by blackish fallen spores; yellowish with brownish hairy zones, these sometimes forming mottled bands. **HABITAT** Usually in groups on soil and in grass, often on disturbed ground. **STATUS** Widespread and common.

Brown Mottlegill, Mower's Mushroom or Brown Haycap
Panaeolina foenisecii

Familiar to gardeners on account of its occurrence in lawns shortly after mowing. **CAP** To 2cm across; bell-shaped, becoming convex or flatter; dark brown, but hygrophanous and drying cream or beige from centre outwards. **GILLS** Adnate; pale brown, maturing mottled dark brown and with a similar-coloured spore print. **STIPE** To 7cm long; cylindrical; surface smooth and satiny; cream or whitish, flushed with cap colour towards base, and finely fibrillose. **HABITAT** Grass, especially lawns and roadside verges. **STATUS** Widespread and very common.

Pale Brittlestem *Psathyrella candolleana* (Top 100)

Very fragile, pale *Psathyrella*, rather variable in appearance; often fruits in early summer. **CAP** To 6cm across; convex, then bell-shaped and finally flatter; surface smooth and dull, often with a fine bloom and/or margin hung with veil remnants when young; pale ochre, drying almost white. **GILLS** Adnate; crowded, with toothed white edges; greyish, maturing purple-brown with a similar-coloured spore print. **STIPE** To 8cm long; cylindrical and very fragile; white and smooth with a powdery apex. **HABITAT** Solitary or grouped on soil and decayed wood in grass and deciduous woodland. **STATUS** Widespread and very common.

Clustered Brittlestem *Psathyrella multipedata*

Found in large clumps arising from a common base. **CAP** To 3cm across; conical or convex, becoming bell-shaped or slightly flatter; surface smooth and silky; clay-brown, but hygrophanous and drying pale ochre or beige, occasionally reddish brown in centre. **GILLS** Adnate or adnexed, with white edges; light greyish brown, maturing dark purple-brown with a similar-coloured spore print. **STIPE** To 10cm long; cylindrical, with many fruit bodies fused into a common base; white but slightly darker towards base. **HABITAT** In large, dense clumps on soil in open woodland, grassy areas and lawns. **STATUS** Widespread but occasional.

Common Stump Brittlestem
Psathyrella piluliformis (Top 100)

Similar to Clustered Brittlestem but found on decaying wood. **CAP** To 6cm across; bell-shaped or convex, becoming flatter; margin often hung with veil remnants; reddish brown, but hygrophanous and drying tan or ochre from centre outward. **GILLS** Adnate or adnexed; light beige, maturing dark brown and with a dark purple-brown spore print. **STIPE** To 7cm long; cylindrical; whitish, flushed with cap colour and progressively darker towards base. **HABITAT** Decayed wood of deciduous trees, usually in large clumps. **STATUS** Widespread and common. **SIMILAR SPECIES** *P. laevissima* is smaller with closer gills and forms lesser clumps.

Common Stump Brittlestem

Psathyrella pygmaea

Very small brittlestem that is virtually identical macroscopically to Fairy Inkcap (p. 220) and so can only be separated microscopically. **CAP** To 1.5cm across; conical or convex, becoming flatter; margin striate when moist; light pinkish brown, drying greyish brown. **GILLS** Adnate; whitish, maturing reddish brown with a purple-brown spore print. **STIPE** To 2cm long; cylindrical and often bent; whitish. **HABITAT** Densely clustered on decayed wood of deciduous trees. **STATUS** Widespread but occasional; most frequent in S.

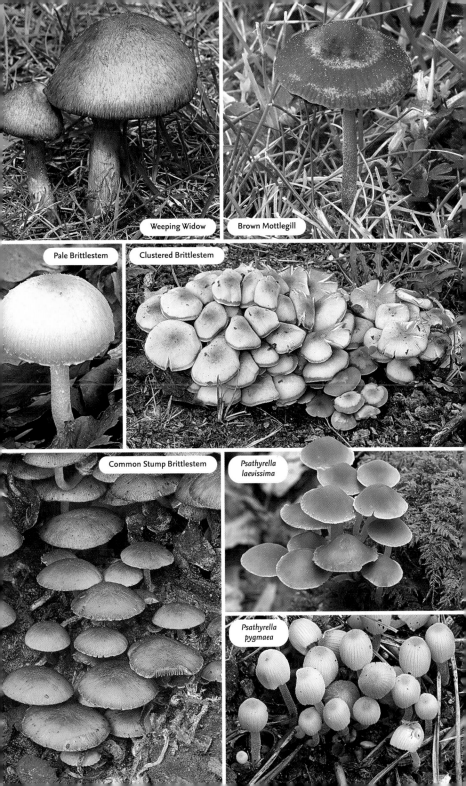

Weeping Widow

Brown Mottlegill

Pale Brittlestem

Clustered Brittlestem

Common Stump Brittlestem

Psathyrella
laevissima

Psathyrella
pygmaea

Petticoat Brittlestem *Psathyrella artemisiae*
Smallish brittlestem whose cap and stipe are densely covered in shaggy fibrils. **CAP** To 3.5cm across; oval, becoming bell-shaped, convex or flatter, and sometimes slightly umbonate; ochre with young fruit bodies conspicuously covered in whitish velar remains, ageing smooth and paler and sometimes splitting. **GILLS** Adnate, with white felty edges; cream, maturing dark purple-brown with a purple-black spore print. **STIPE** To 5cm long; cylindrical; light brown, densely covered in white cottony fibrils. **HABITAT** Open deciduous woodland, usually attached to buried woody debris. **STATUS** Widespread but uncommon in England.

Conical Brittlestem *Psathyrella conopilus*
Tall, elegant brittlestem. **CAP** To 4cm across; conical or bell-shaped and remaining so throughout its life; surface shiny when moist, with a striate margin, but becoming smooth and felty; reddish brown but drying beige or greyish beige. **GILLS** Adnate or adnexed, with white serrated edges; light greyish brown, maturing dark brown with a black spore print. **STIPE** To 14cm long; slender and cylindrical; smooth and satiny; whitish with a powdery apex and downy base. **HABITAT** Usually grouped on decayed wood of deciduous trees, sometimes appearing terrestrial when growing out of buried wood. **STATUS** Widespread and common.

Rootlet
Brittlestem

Red-edge Brittlestem *Psathyrella corrugis* (= *P. gracilis*)
One of several brittlestems with a red edge to the gills. **CAP** To 3cm across; conical or bell-shaped, becoming flatter; reddish brown, but hygrophanous and drying cream or pale ochre. **GILLS** Adnate, with white-fringed edges underlined with red; greyish, maturing blackish brown and with a purple-black spore print. **STIPE** To 10cm long; cylindrical, tall and slender; white. **HABITAT** Usually on woody debris; terrestrial on buried wood and woodchip-mulched flowerbeds. **STATUS** Widespread but uncommon. **SIMILAR SPECIES Rootlet Brittlestem** *P. microrrhiza* has veil remnants on the cap; its gills are also red-edged but lack the white fringe.

Psathyrella prona
Highly variable greyish brittlestem with red gill edges. **CAP** To 2cm across; convex, becoming flatter and often with a broad umbo; surface smooth and powdery when young; striate margin hung with veil remnants; greyish brown, but hygrophanous and drying brownish grey or almost white. **GILLS** Adnate, with white edges underlined with red; greyish, maturing dark purple-brown with a purple-black spore print. **STIPE** To 7cm long; cylindrical with a small bulb; whitish or cream, discolouring light brown towards base; fibrillose with a powdery apex. **HABITAT** Grass in light woodland, fields and gardens. **STATUS** Uncommon.

Psathyrella bipellis
Brown brittlestem with purplish tints. **CAP** To 4cm across; conical or convex, becoming flatter with a broad umbo; margin striate and densely covered with veil remnants when young; chestnut-brown with purple tones, but hygrophanous and drying paler. **GILLS** Adnate, with white-fringed edges; greyish pink, maturing dark grey with a blackish spore print. **STIPE** To 6cm long; cylindrical; white, flushed pink and discolouring brown in lower part; fibrillose. **HABITAT** Soil along path edges in open woodland. **STATUS** Uncommon.

Psathyrella marcescibilis
Small, pale brittlestem without red gill edges; fruiting starts in early summer. **CAP** To 3cm across; conical or bell-shaped, sometimes umbonate; surface smooth and dull; margin striate and hung with veil remnants when young; greyish brown, drying cream or whitish with a hint of pink. **GILLS** Adnate, with white-fringed edges; whitish, maturing purple-brown and with a similar-coloured spore print. **STIPE** To 6cm long; cylindrical; whitish, with a felty texture and powdery apex. **HABITAT** Soil and buried woody debris. **STATUS** Widespread but uncommon.

Psathyrella pennata See p. 346.

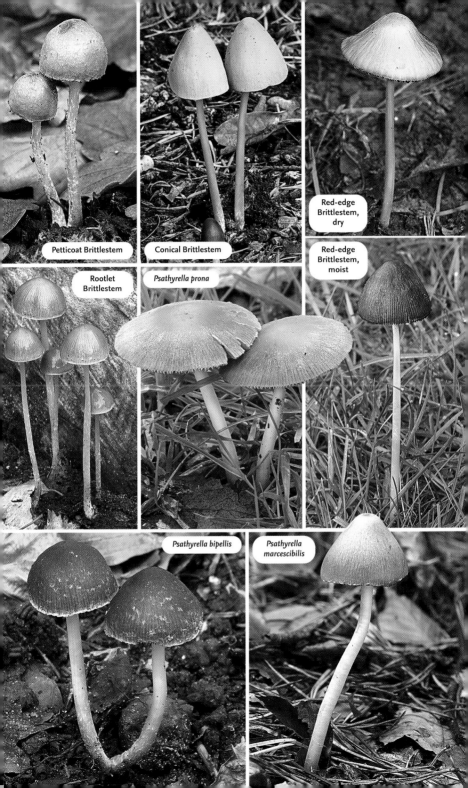

Petticoat Brittlestem

Conical Brittlestem

Red-edge Brittlestem, dry

Rootlet Brittlestem

Psathyrella prona

Red-edge Brittlestem, moist

Psathyrella bipellis

Psathyrella marcescibilis

The genus *Coprinus* has been revised after DNA analysis and major classification changes made. Shaggy Inkcap and a few related species remain in genus *Coprinus* (now placed in family Agaricaceae), but all other species are assigned three new genera: *Coprinellus*, *Coprinopsis* and *Parasola* (all in the new family Psathyrellaceae). The four genera all have gills that darken on maturity to blackish, but little else in common. Most liquefy or deliquesce to aid spore dispersal; many are fragile; several small species grow on dung.

Shaggy Inkcap or Lawyer's Wig *Coprinus comatus* (Agaricaceae) (Top 100)

This tall, shaggy white inkcap is a familiar sight in early autumn. CAP To 12cm across and 15cm high; elongated egg-shaped or cylindrical, becoming bell-shaped with an upturned, split and blackening margin; white with a brownish centre and covered in white fibrils that break up into large, shaggy, brown-tipped scales. GILLS Adnexed or free; crowded; white, maturing black and deliquescing. STIPE To 30cm long; cylindrical, fragile; persistent white mobile ring, often blackened from fallen spores; white, with the entire length covered in concolorous fibrils. HABITAT Solitary or grouped on soil, grass and waste areas, particularly where disturbed by man. STATUS Widespread and very common.

Magpie Inkcap *Coprinopsis picacea* (= *Coprinus picaceus*) (Psathyrellaceae)

Elongated inkcap with a distinct black and white appearance. CAP To 8cm across and 6cm high; elongated egg-shaped, then bell-shaped with an upturned and blackening margin; surface shiny and faintly striate; dark greyish brown with contrasting patches of felty white fibrils that become stretched as the fruit body matures. GILLS Adnate or free; crowded; white, deliquescing black. STIPE To 20cm long; cylindrical with a small bulb; white with fine concolorous fibrils. HABITAT Soil and leaf litter, frequently with Beech on calcareous soil, rarely with conifers. STATUS Frequent in S England but rare elsewhere.

Common Inkcap

Coprinopsis atramentaria (= *Coprinus atramentarius*) (Psathyrellaceae) (Top 100)
Robust greyish inkcap, usually found in clusters arising from buried wood. CAP To 7cm across and 8cm high; egg-shaped or conical, expanding and with the margin becoming uplifted and split; strongly furrowed or grooved; greyish, covered in small tan scales around centre. GILLS Adnexed or free; greyish then black and deliquescing. STIPE To 17cm long; cylindrical and tapering upward; white, with fibrils above ring zone and scaly below. HABITAT Decayed wood of deciduous trees. STATUS Widespread and common. SIMILAR SPECIES *Coprinopsis romagnesiana* (= *Coprinus romagnesianus*) has brownish velar scales on the cap and stipe.

Hare'sfoot Inkcap *Coprinopsis lagopus* (= *Coprinus lagopus*) (Psathyrellaceae)

Smallish inkcap whose cap and stipe are both densely covered in furry white fibrils when young. CAP To 4cm across; elongated egg-shaped, then convex and finally flatter; margin striate, becoming uplifted and split before deliquescing; greyish, covered in short-lived shaggy white scales, becoming smooth. GILLS Adnexed or free; crowded; white, maturing black and deliquescing. STIPE To 13cm long; cylindrical; white, initially densely covered in felty scales. HABITAT On soil with wood debris and woodchips. STATUS Widespread and common.

Snowy Inkcap *Coprinopsis nivea* (= *Coprinus niveus*) (Psathyrellaceae)

Dung-inhabiting pure-white inkcap whose cap and stipe are completely covered in fleecy cottony fibrils. CAP To 4cm across; elongated egg-shaped or conical, then flattish bell-shaped with the margin uplifted and split with age; entire surface completely covered in fleecy white fibrils that rub off to leave a smooth greyish surface. GILLS Adnate or free; whitish, maturing black and deliquescing. STIPE To 9cm long; cylindrical; similar colour and texture to cap. HABITAT Weathered dung of herbivores. STATUS Widespread and common.

Coprinopsis stercorea (= *Coprinus stercoreus*) (Psathyrellaceae) See p. 344.

Coprinopsis radiata (= *Coprinus radiatus*) (Psathyrellaceae) See p. 344.

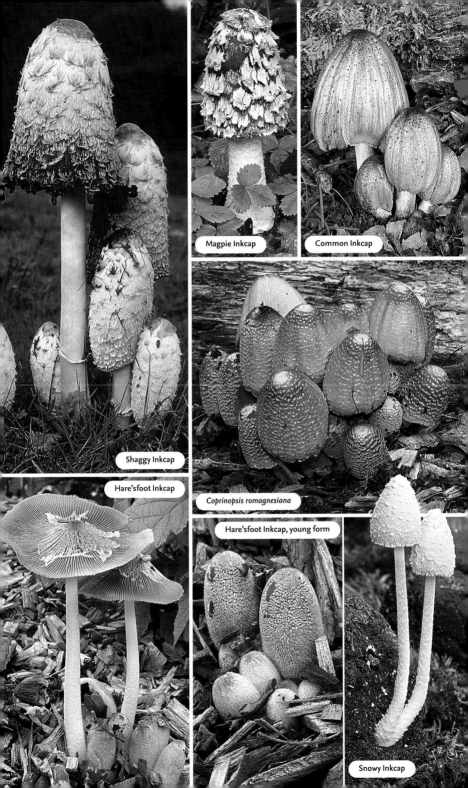

Magpie Inkcap

Common Inkcap

Shaggy Inkcap

Coprinopsis romagnesiana

Hare'sfoot Inkcap

Hare'sfoot Inkcap, young form

Snowy Inkcap

Glistening Inkcap *Coprinellus micaceus (= Coprinus micaceus)* (Top 100)
Inkcap that glistens with dense mica-like scales or flecks. **CAP** To 3cm across; elongated egg-shaped, later bell-shaped and deeply grooved; margin uplifted, split and blackening with age; honey-brown with a darker centre, but fading and with the fine scales soon disappearing. **GILLS** Adnexed or free; white, maturing black and slowly deliquescing. **STIPE** To 10cm long; cylindrical and fragile; white, discolouring yellowish in lower part, and covered in fine powder at first. **HABITAT** Clustered on decayed stumps and buried wood of deciduous trees or, more rarely, conifers. **STATUS** Widespread and very common.

Firerug Inkcap *Coprinellus domesticus (= Coprinus domesticus)*
Pale inkcap, often growing out of a ginger-coloured shaggy mat of mycelium. **CAP** To 4cm across; elongated egg-shaped, becoming bell-shaped or flatter and deeply grooved; cream with a pale ochre centre but maturing dark grey; covered in fine white scales that soon disappear. **GILLS** Adnate or free; white, maturing black and deliquescing. **STIPE** To 8cm long; cylindrical and fragile; white, discolouring yellowish towards base, and powdery at first. **HABITAT** Solitary or in small groups on dead and decaying wood of deciduous trees; sometimes on burnt ground arising from buried wood. **STATUS** Widespread and common.

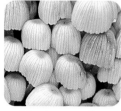

Fairy Inkcap *Coprinellus disseminatus (= Coprinus disseminatus)*
Small, very fragile inkcap found in dense, often spectacular swarms on dead wood. **CAP** To 1.2cm across; oval, becoming convex or bell-shaped and deeply furrowed; creamy buff, then greyish with an ochre centre, and covered in a short-lived fine woolly veil at first. **GILLS** Adnate or adnexed; white, maturing blackish but not deliquescing. **STIPE** To 4cm long; cylindrical; translucent white with base discolouring buff; powdered at first. **HABITAT** Usually in dense swarms on large stumps of deciduous trees. **STATUS** Widespread and common.

Fairy Inkcap, young form

Coprinellus impatiens (= Coprinus impatiens)
Smallish, fragile inkcap with a distinctive grooved cap resembling piano keys. **CAP** To 4cm across; oval, becoming convex or flatter, and with surface deeply grooved almost to centre; ochre or orange-brown, but drying greyish beige with a smooth orange central disc. **GILLS** Adnate; creamy beige, maturing grey-brown. **STIPE** To 6cm long; cylindrical; white with a smooth, satiny surface. **HABITAT** In small groups in decayed leaf litter in deciduous woodland, usually with Beech on chalky soils. **STATUS** Occasional; more frequent in S England.

Coprinellus angulatus (= Coprinus angulatus) See p. 346.

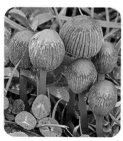

Pleated Inkcap
Parasola plicatilis (= Coprinus plicatilis) (Top 100)
Small inkcap whose cap is shaped like a Japanese parasol. **CAP** To 1.5cm across; elongated egg-shaped at first, becoming convex and then flattish with an uplifted margin; grooved almost to the depressed centre; buff with an orange-brown central disc, fading greyish with the disc retaining its colour. **GILLS** Free, usually with a collar-like separation from stipe; greyish buff, maturing greyish black; hardly deliquescing. **STIPE** To 6cm long; cylindrical, sometimes with a small bulb; white, discolouring buff from base upward. **HABITAT** Unimproved grassland. **STATUS** Widespread and common.

Pleated Inkcap, young form

Parasola auricoma (= Coprinus auricomus)
Similar to Pleated Inkcap but with minute erect hairs on the cap centre, visible under a hand lens. **CAP** To 2.5cm across; elongated egg-shaped, then bell-shaped and finally flattish; grooved to central disc; reddish brown, fading to greyish brown with a tawny centre. **GILLS** Free; white, maturing blackish and slowly deliquescing. **STIPE** To 7cm long; cylindrical; white and finely fibrillose. **HABITAT** Solitary or in small groups on soil in woodland and woodchip-mulched flowerbeds. **STATUS** Widespread and common.

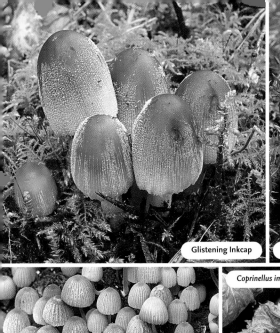
Glistening Inkcap

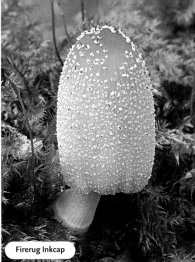
Firerug Inkcap

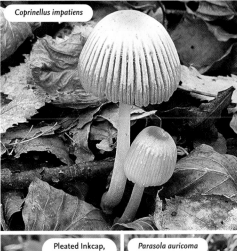
Coprinellus impatiens

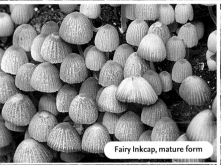
Fairy Inkcap, mature form

Fairy Inkcap

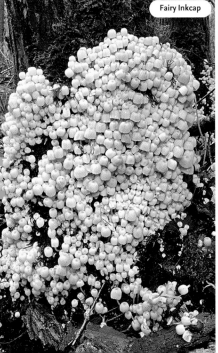

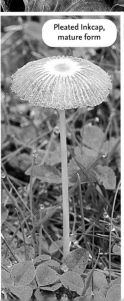
Pleated Inkcap, mature form

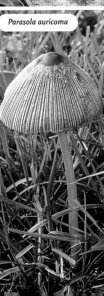
Parasola auricoma

Oyster Mushroom *Pleurotus ostreatus* (Lentinaceae)

Very common but highly variable oyster mushroom that is widely cultivated for human consumption. **CAP** To 20cm across; rounded or shell-shaped and usually depressed towards stipe; often irregularly undulating, with a smooth silky surface; highly variable in colour, from beige to deep blue-grey. **GILLS** Decurrent; crowded; white or cream with a pale lavender spore print. **STIPE** Rudimentary and occasionally absent, tapering downward to a woolly base, sometimes off-centre and often laterally attached to substrate; white. **HABITAT** Grouped or clustered on living and fallen decayed wood of both deciduous and coniferous trees. **STATUS** Widespread and very common.

Branching Oyster *Pleurotus cornucopiae* (Lentinaceae)

Funnel-shaped oyster with a well-developed stipe and a mealy or slight ammonia smell. **CAP** To 12cm across; convex, becoming depressed and then funnel-shaped; margin wavy and often splitting; cream or ochre, initially with a whitish bloom. **GILLS** Deeply decurrent, developing grooves or ridges running down stipe; distant; white, maturing buff. **STIPE** To 5cm long; tapering downward, usually off-centre, with several fused into a common base; whitish, flushed with cap colour. **HABITAT** Dead wood of deciduous trees. **STATUS** Very common following the spread of Dutch elm disease, but declining and now widespread but only occasional.

Pale Oyster *Pleurotus pulmonarius* (Lentinaceae)

Similar to, and frequently confused with, Oyster Mushroom (*see* above), but smaller, paler and with a tendency to dry yellowish. **CAP** To 10cm across; fan-shaped or semicircular, with the margin becoming irregular and undulating; white or cream with a smooth surface. **GILLS** Decurrent, developing into grooves or ridges that run down the stipe to base; crowded; white, maturing pale ochre. **STIPE** Lateral and very short; white. **HABITAT** In overlapping groups on dead wood of deciduous trees, especially Beech. **STATUS** Widespread and very common in summer.

Veiled Oyster *Pleurotus dryinus* (Lentinaceae)

Differs from other oysters by its felty or scaly cap and presence of a veil. **CAP** To 15cm across; convex, becoming flatter and bracket-like; white or cream. **GILLS** Decurrent, developing into grooves or ridges running down stipe; white, maturing creamy and with a white spore print. **STIPE** To 6cm long; eccentric, often lateral and tapering downward, with several fused at base; surface felty; short-lived ring zone; white or cream. **HABITAT** Living and dead wood of deciduous trees, more rarely with conifers. **STATUS** Occasional in England.

Lilac Oysterling *Panus conchatus* (= *Lentinus torulosus*) (Lentinaceae)

Resembles Oyster Mushroom (*see* above) when mature. **CAP** To 7cm across; circular or fan-shaped, sometimes with a depressed centre; surface fibrillose or with fine scales that become coarser with age; pinkish lilac, fading to ochre or yellowish brown. **GILLS** Very decurrent; whitish or cream with a hint of pink or lilac and maturing ochre. **STIPE** To 3cm long; eccentric, usually lateral and tapering towards base; concolorous with cap, initially with a lilac bloom. **HABITAT** Decayed wood of deciduous trees. **STATUS** Widespread but occasional.

Lilac Oysterling

Splitgill *Schizophyllum commune* (Schizophyllaceae)

Distinctive bracket-like fungus whose gill edges split and turn up when dry and close up when rehydrated. **CAP** To 3cm across; fan-shaped and lobed, with a narrow stipe-like attachment to substrate; margin irregular and undulating, with tooth-like projections; surface velvety or hairy; greyish beige to white and concentrically zoned with age. **GILLS** Fanning out from point of attachment; pinkish grey. **STIPE** Absent or rudimentary. **HABITAT** Fallen wood of deciduous trees; bizarrely, also increasingly found on polythene-wrapped straw bales (*see* right photograph). **STATUS** Locally common in SE England.

Splitgill

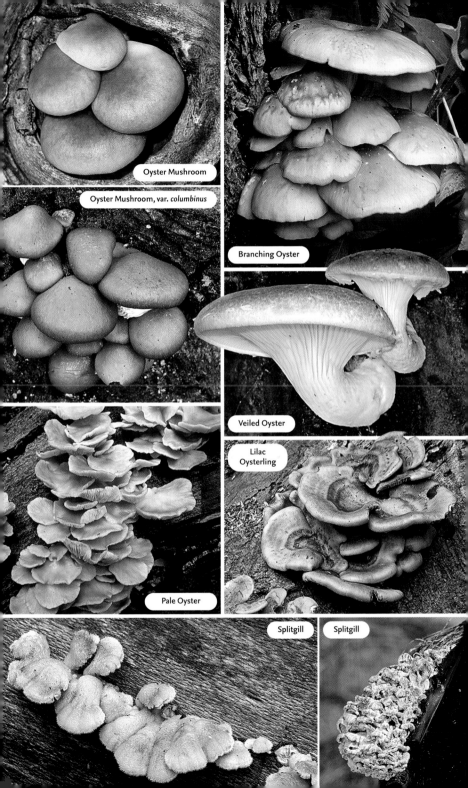

Oyster Mushroom

Oyster Mushroom, var. *columbinus*

Branching Oyster

Veiled Oyster

Lilac Oysterling

Pale Oyster

Splitgill

Splitgill

Peeling Oysterling *Crepidotus mollis*

Bracket-like oysterling with a peelable cap cuticle. **CAP** To 7cm across; flat, oyster-shaped or elongated and laterally attached to substrate; surface smooth and sticky at first, becoming gelatinous and elastic; margin incurved, then irregular and undulating, faintly striate when moist; greyish brown, but hygrophanous and drying whitish; downy at point of attachment. **GILLS** Radiating outwards; greyish brown with a reddish tint and mid-brown spore print. **STIPE** Absent or rudimentary. **HABITAT** Usually grouped on decayed wood of deciduous trees, especially Ash and Beech. **STATUS** Widespread and common.

Flat Oysterling *Crepidotus applanatus*

Similar to Peeling Oysterling but lacks the gelatinous cuticle. **CAP** To 4cm across; flat, kidney- or shell-shaped, with the margin incurved and faintly striate when moist; surface smooth, dull and finely felty; creamy white, becoming ochreous and downy at point of attachment. **GILLS** Radiating outwards and crowded; white, maturing ochre with a mid-brown spore print. **STIPE** Absent or rudimentary. **HABITAT** In groups on decayed wood of deciduous trees; rarely with conifers. **STATUS** Widespread but occasional.

Variable Oysterling *Crepidotus variabilis* (Top 100)

Laterally attached or resupinate oysterling. **CAP** To 3cm across; approximately semicircular or circular if attached centrally to substrate, but more kidney- or shell-shaped if attached laterally; margin very undulating and deeply folded or lobed; surface finely felty. **GILLS** Radiating outwards; white, maturing pinkish brown with a concolorous spore print. **STIPE** Absent or rudimentary. **HABITAT** Woody debris, particularly twigs, of deciduous trees. **STATUS** Widespread and common. **SIMILAR SPECIES** *C. cesatii* is indistinguishable in the field from Variable Oysterling but is possibly equally or even more common than that species.

Crepidotus cesatii

Crepidotus epibryus

Small oysterling, frequently found on the dead stems of herbaceous plants. **CAP** To 1.5cm across; laterally or centrally attached to substrate; circular or semicircular, with an inrolled margin; surface finely felty; white, sometimes tinged buff. **GILLS** Radiating outwards; white, maturing pinkish brown with a pale ochre spore print. **STIPE** Absent or rudimentary. **HABITAT** Twigs of deciduous trees, herbaceous stems and leaf litter. **STATUS** Widespread and common.

Scurfy Twiglet *Tubaria furfuracea* (Top 100)

Small brown fungus, commonly found on fallen twigs. Tends to fruit in autumn and winter. **CAP** To 4cm across; convex, becoming flatter; margin striate when moist and edged with velar remains when young; surface dull, smooth or finely fibrillose or scurfy; reddish brown, but hygrophanous and drying cream or beige. **GILLS** Adnate; cream, maturing ochre or reddish brown with an ochre spore print. **STIPE** To 4cm long; cylindrical with a felty white base; similar in colour to cap and covered in white fibrils. **HABITAT** Usually grouped on twigs, sticks and wood-chippings in deciduous woodland and gardens. **STATUS** Widespread and very common.

Felted Twiglet *Tubaria conspersa*

Similar to Scurfy Twiglet but with a paler felty cap and generally found on soil. Usually starts to fruit in summer. **CAP** To 3cm across; convex, becoming flatter; surface smooth, dull and finely felty; shades of mid- or light brown or cinnamon, and only weakly hygrophanous. **GILLS** Adnate, with fine, white-fringed edges; greyish brown, maturing orange-brown. **STIPE** To 4cm long; cylindrical; pink or brown ground covered in longitudinal fibrils. **HABITAT** On soil and leaf litter in woodland; occasionally in grass. **STATUS** Widespread and common. **SIMILAR SPECIES** *T. dispersa* (= *T. autochthona*) has a less felted cap and is associated with hawthorns, growing out of their buried berries.

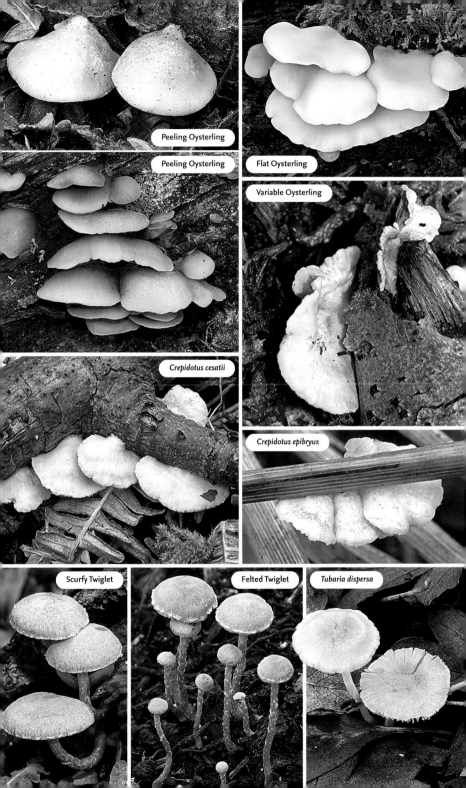

Peeling Oysterling

Flat Oysterling

Peeling Oysterling

Variable Oysterling

Crepidotus cesatii

Crepidotus epibryus

Scurfy Twiglet

Felted Twiglet

Tubaria dispersa

Aniseed Cockleshell *Lentinellus cochleatus* (Lentinellaceae)

Has a shell-like shape and, sometimes, an aniseed smell. **CAP** To 6cm across; irregularly trumpet-shaped, with flared and inrolled margin; surface smooth and shiny; flesh-coloured or reddish brown. **GILLS** Long decurrent, forming grooves or ridges down stipe; cream or pale brown with a serrated edge and whitish spore print. **STIPE** To 8cm long; tapering downward; centrally, eccentrically or laterally attached to cap; upper half same colour as cap, lower part darker. **HABITAT** In clusters on decayed deciduous tree stumps and wood. **STATUS** Widespread but occasional.

Lentinellus ursinus (Lentinellaceae)

More circular than Aniseed Cockleshell and stipe usually absent. **CAP** To 5cm across; directly attached to substrate; convex or kidney-shaped, then flatter with an incurved margin; texture variable, from smooth to felty; reddish brown, drying beige, margin paler. **GILLS** Decurrent; cream or flesh-coloured with a white spore print. **STIPE** Absent or rudimentary. **HABITAT** In groups on decayed wood of deciduous trees, usually Beech and sometimes willows. **STATUS** Uncommon to rare. **SIMILAR SPECIES** *L. vulpinus* is more densely clustered and has a smoother texture and paler cap.

Rosy Spike *Gomphidius roseus* (Gomphidiaceae)

Bright pink-red slimy *Gomphidius*, frequently found in association with Bovine Bolete (p. 44). **CAP** To 5cm across; convex, becoming flatter, sometimes with a depressed centre; margin inrolled; coral or carmine-red but fading with age. **GILLS** Decurrent; distant; maturing grey with a blackish spore print. **STIPE** To 5cm long; tapering downward towards base; white, sometimes flushed pink, and fibrillose below indistinct ring zone. **HABITAT** Coniferous woodland (usually pines) on acid soils. **STATUS** Widespread but occasional.

Rosy
Spike

Slimy Spike *Gomphidius glutinosus* (Gomphidiaceae)

Largish spike whose entire fruit body is covered in a thick layer of slime. **CAP** To 13cm across; shaped rather like a spinning-top or flattish convex, with the centre sometimes becoming depressed; margin incurved; greyish brown, usually with purple or violet tones. **GILLS** Decurrent; distant; greyish white, maturing very dark grey with a dark reddish-brown spore print. **STIPE** To 10cm long; cylindrical or tapering upward, with a ring-like slimy zone stained black by fallen spores; whitish, strongly discolouring yellow at base. **HABITAT** Coniferous woodland, usually on acid soils. **STATUS** Uncommon to rare.

Slimy Spike

Larch Spike *Gomphidius maculatus* (Gomphidiaceae)

Blackening spike found with larches. **CAP** To 6cm across; convex, becoming flatter, sometimes with a small umbo or indented centre; surface smooth and greasy or slimy when moist; yellow-ochre or more brownish, particularly towards centre. **GILLS** Deeply decurrent; distant; light grey, reddening when bruised and maturing almost black, with a similar-coloured spore print. **STIPE** To 8cm long; cylindrical or sometimes slightly tapering downward; surface dryish, particularly towards apex; white, dotted or streaked reddish brown or black. **HABITAT** Strictly associated with larches. **STATUS** Widespread but rare.

Copper Spike *Chroogomphus rutilus* (Gomphidiaceae)

Our most common spike, usually recognised by the coppery colour. **CAP** To 15cm across; convex or conical, becoming flatter and usually sharply umbonate; greasy when moist but drying silky and shiny; shades of brown, usually with coppery tones. **GILLS** Deeply decurrent; distant, and protected by a silky veil when young; olive-brown, maturing almost black with a similar-coloured spore print. **STIPE** To 12cm long; cylindrical or tapering downward, with a distinct ring zone; yellowish brown, sometimes mottled or banded with orange or ochre fibrils. **HABITAT** Associated with pines. **STATUS** Widespread and frequent.

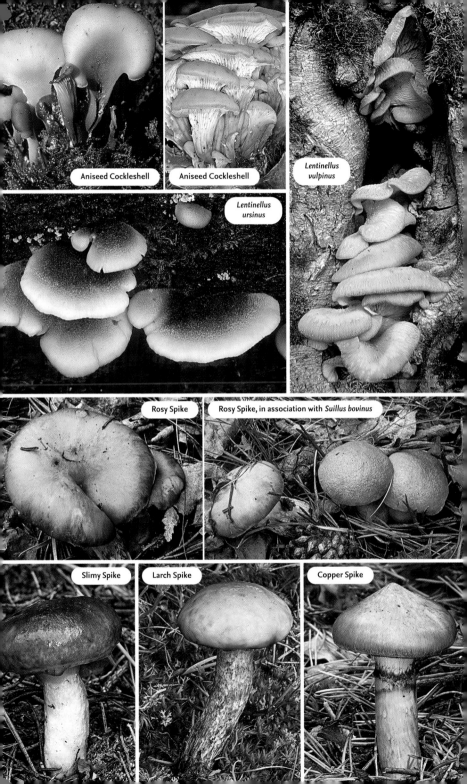

Aniseed Cockleshell

Aniseed Cockleshell

Lentinellus vulpinus

Lentinellus ursinus

Rosy Spike

Rosy Spike, in association with *Suillus bovinus*

Slimy Spike

Larch Spike

Copper Spike

Chanterelle *Cantharellus cibarius* (Cantharellaceae) (Top 100)
Uniformly coloured chanterelle with a pleasant smell of apricots. Widely collected and sold for human consumption. **CAP** To 12cm across; cushion-shaped at first with an inrolled margin, but expanding with a depressed centre and becoming very undulating, wavy and finally irregularly funnel-shaped; pale or bright golden yellow but fading with age; undersurface consists of shallow, forking concolorous gill-like veins or ridges that run down stipe; spore print yellowish orange. **STIPE** To 8cm long; cylindrical or tapering downward; concolorous with cap or paler. **HABITAT** In leaf litter and moss in deciduous woodland; occasionally with conifers. **STATUS** Widespread and common.

Trumpet Chanterelle *Cantharellus tubaeformis* (= *C. infundibuliformis*) (Cantharellaceae)
Much smaller and more slender than Chanterelle, and a different colour. Just as edible. **CAP** To 6cm across; convex with an indented centre, becoming funnel-shaped with an irregular, undulating margin; upper surface smooth or finely scaly, brown or yellowish brown; undersurface with shallow, irregularly forking, decurrent veins or ridges; yellow, maturing greyish; spore print yellowish. **STIPE** To 8cm long; usually tapering and distorted, grooved or flattened; dirty yellow. **HABITAT** Deciduous and mixed woodland on acid soils. **STATUS** Widespread and common. **SIMILAR SPECIES Golden Chanterelle** *C. aurora* (= *C. lutescens*) has an orange stipe and grows under conifers.

Ashen Chanterelle *Cantharellus cinereus* (Cantharellaceae)
Dark-capped chanterelle with a contrasting pale underside. **CAP** To 6cm across; funnel-shaped, even when young, but expanding and with a flared, undulating, inrolled margin; surface radially grooved or wrinkled; grey-brown or blackish; undersurface ash-grey with irregularly forked, decurrent, distant ridges. **STIPE** To 7cm long; cylindrical and longitudinally fibrillose; dark grey. **HABITAT** Usually clustered in leaf litter in deciduous woodland, especially with Beech. **STATUS** Widespread but uncommon to rare.

Horn of Plenty *Craterellus cornucopioides* (Craterellaceae)
Unmistakable trumpet-shaped fungus with no clearly defined cap or stipe. Hollow trumpet-shaped tube with a flared, wavy, undulating margin up to 8cm across; inner surface dark brown or almost black, but drying paler and often scaly with age; outer surface with faint longitudinal grooves or wrinkles running down to base; ash-grey. **HABITAT** On soil, leaf litter and moss in deciduous acid woodland, particularly with Beech. **STATUS** Widespread but occasional.

Horn of Plenty

Sinuous Chanterelle
Pseudocraterellus undulatus (= *P. sinuosus*) (Craterellaceae)
Small, sinuous brownish chanterelle, superficially similar to Trumpet Chanterelle (*see* above). **CAP** To 5cm across; irregularly funnel-shaped, with a flared, wavy or crinkled margin; surface lined or wrinkled; greyish brown with a paler edge; outer surface with fibrous decurrent veins or wrinkles; greyish brown with a white spore print. **STIPE** To 6cm long; irregularly cylindrical, distorted and tapering towards base; yellowish. **HABITAT** Usually grouped or clustered in leaf litter in deciduous woodland. **STATUS** Widespread but occasional.

False Chanterelle *Hygrophoropsis aurantiaca* (Hygrophoropsidaceae) (Top 100)
As its name suggests, this species is similar in appearance to Chanterelle, but note the gills. Not edible. **CAP** To 7cm across; convex, then shallow funnel-shaped with an inrolled, undulating margin; surface finely felty; colour variable but usually yellow or orange-brown, although pale and even white forms are found. **GILLS** Decurrent; crowded, with many forked; similar in colour to cap with a whitish spore print. **STIPE** To 4cm long; cylindrical or tapering downward and often curved; concolorous with cap or darker. **HABITAT** Needle litter, less often on decayed wood, in coniferous woodland, also frequent with birches on heaths; rarely with other deciduous trees. **STATUS** Widespread and very common.

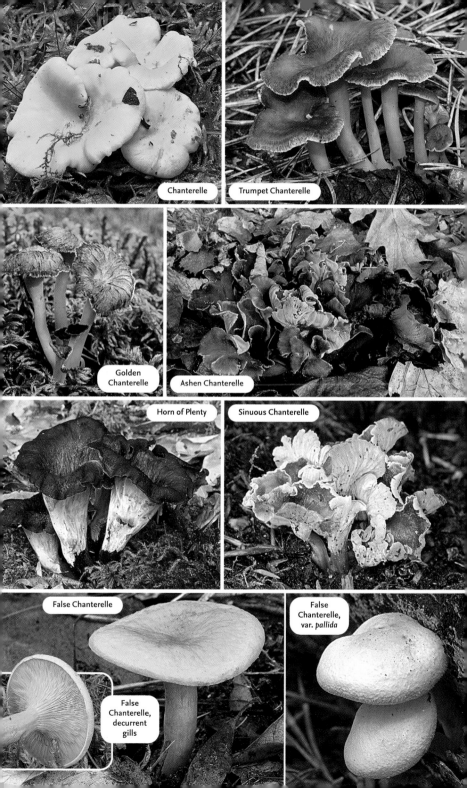

Chanterelle

Trumpet Chanterelle

Golden Chanterelle

Ashen Chanterelle

Horn of Plenty

Sinuous Chanterelle

False Chanterelle

False Chanterelle, decurrent gills

False Chanterelle, var. *pallida*

Members of the genus *Polyporus* come in a variety of shapes and sizes. They generally comprise a cap and stipe, with some of typical mushroom shape. They do not have gills, the white spores instead being produced in decurrent tubes that open as pores on the underside of the cap.

Pores

Dryad's Saddle *Polyporus squamosus* (Top 100)
Large, spectacular bracket with a circular or fan-shaped cap and a stipe. **CAP** To 60cm across; shallow convex or flat with a slightly depressed centre; ochre or yellowish brown with coarse, concentric, flat, dark brown scales. **UNDERSIDE** Large, angular cream or ochre pores. **STIPE** To 10cm long; sometimes rudimentary, and lateral or off-centre; base black and woody. **HABITAT** Solitary or in small tiers on wood of deciduous trees; more rarely on conifers. **STATUS** Widespread and common.

Bay Polypore *Polyporus durus* (= *P. badius*)
Large bay-coloured polypore. **CAP** To 25cm across; shallow convex, then funnel-shaped and very undulating; smooth and shiny; bay-brown with a darker centre. **UNDERSIDE** White or cream-buff with fine, rounded or angular pores. **STIPE** To 7cm long; central or off-centre; black-brown with a felty surface. **HABITAT** Decayed wood of deciduous trees, usually Beech. **STATUS** Common in S England; occasional elsewhere. **SIMILAR SPECIES** **Blackfoot Polypore** *P. leptocephalus* (= *P. varius*) is smaller and generally paler, and only the stipe base is black.

Pores

Winter Polypore *Polyporus brumalis*
Winter-fruiting polypore with the stature of a typical mushroom. **CAP** To 10cm across; convex, becoming flatter with a depressed centre and undulating margin; shades of brown. **UNDERSIDE** With slightly decurrent, fairly large, rounded or oblong pores; white, maturing tan. **STIPE** To 7cm long; well developed, cylindrical, sometimes off-centre; similar colour to cap. **HABITAT** Dead wood (usually small branches and twigs) of deciduous trees. **STATUS** Widespread and common.

Polyporus melanopus
Rare polypore with a fibrillose cap and short stipe. **CAP** To 10cm across; convex, becoming flatter with a depressed centre and undulating margin; surface fibrillose or scaly, becoming crazed or wrinkled with age; greyish brown. **UNDERSIDE** With somewhat decurrent, small, irregularly rounded pores. **STIPE** To 5.5cm long; central or off-centre; brown with a blackish base. **HABITAT** Arising from tree roots and buried wood of deciduous trees, usually Beech on chalk. **STATUS** Rare.

Pores

Tuberous Polypore *Polyporus tuberaster*
Polypore with a thin, circular or semicircular cap and a short or rudimentary stipe. Reported to arise from a sclerotium, but this is rarely found in British specimens. **CAP** To 10cm across; convex, then flattening and usually depressed at stipe attachment; margin inrolled and slightly undulating; yellowish or orange-brown with fine, tufted, dark scales. **UNDERSIDE** With decurrent, large, angular pores; cream or ochre. **STIPE** To 6cm long; sometimes off-centre or lateral; whitish. **HABITAT** Fallen branches and twigs of deciduous trees. **STATUS** Occasional.

Umbrella Polypore *Polyporus umbellatus*
Large, polypore consisting of numerous individual, umbrella-shaped caps arising from a much-branched common stipe. Found in summer. **FRUIT BODY** To 50cm across; dome-shaped, with the individual caps to 5cm across; irregularly circular, with a depressed centre and undulating margin; greyish or brown. **UNDERSIDE** With decurrent, fine white or cream pores. **STIPE** To 5cm thick at base; trunk-like and branching progressively into thinner stems that carry the caps; white or cream, flushed with cap colour. **HABITAT** Arising from a sclerotium buried in the soil and associated with deciduous trees. **STATUS** Occasional.

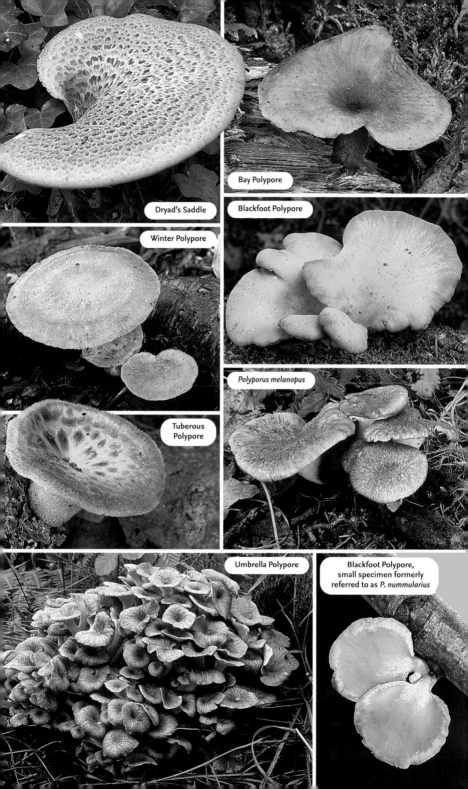

Dryad's Saddle

Bay Polypore

Blackfoot Polypore

Winter Polypore

Tuberous Polypore

Polyporus melanopus

Umbrella Polypore

Blackfoot Polypore,
small specimen formerly
referred to as *P. nummularius*

In *Stereum* species the fruit body is always flattened on the woody substrate and mostly resupinate, but with some the edge may turn up to form a thin, shelf-like bracket. Crusts often start as small spots that then coalesce into large, irregular patches. They are generally tough and leathery, and usually persist through the winter. The spore-bearing surface produces white spores and is smooth and without pores. Crusts are usually found on wood and plant debris in tiered or overlapping groups.

Hairy Curtain Crust *Stereum hirsutum* (Top 100)

Stereum rameale

Curtain crust with a cap or semi-cap directly attached to the substrate; sometimes fully resupinate. **FRUIT BODY** Projecting to 3cm; semicircular or fan-shaped with an undulating, paler margin, usually coalescing to form overlapping rows or tiers; upper surface velvety with greyish-white hairs; yellow-orange or yellow-brown in zones and fading greyish. **UNDERSIDE** Smooth with small bumps or warts; bright yellow-brown, maturing grey-brown. **HABITAT** Living and dead wood of deciduous trees and shrubs; rarely with conifers. **STATUS** Widespread and extremely common. **SIMILAR SPECIES** *Stereum rameale* is scarcer, has a paler and more subdued underside, and is generally found on slender branches and twigs of oaks.

Bleeding Oak Crust *Stereum gausapatum*

Similar to Hairy Curtain Crust but more resupinate and bleeds red when damaged. **FRUIT BODY** Generally fully resupinate, but sometimes with the margin crinkled and uplifted to form a narrow, shelf-like bracket; initially comprises small patches that coalesce to cover the substrate; upper surface smooth or finely velvety but ageing hard and brittle; shades of reddish brown or ochre in zones, with a fringed white margin. **UNDERSIDE** Smooth; in shades of brown. **HABITAT** Dead wood of deciduous trees, almost exclusively on oaks. **STATUS** Widespread and very common.

Bleeding Broadleaf Crust *Stereum rugosum* (Top 100)

Similar to Bleeding Oak Crust but generally paler in colour and found on a range of broadleaved trees. **FRUIT BODY** Usually fully resupinate, but occasionally with a narrow, projecting, uplifted marginal zone; upper surface smooth or slightly warty, becoming hard and crusty when old; buff, tinged pink, with the margin distinctly paler; bleeds red when damaged; sometimes found on thin twigs of birch, when it appears as small, rounded patches. **HABITAT** Living and dead wood of deciduous trees and shrubs, particularly Hazel and Beech. **STATUS** Widespread and common.

Bleeding Conifer Crust *Stereum sanguinolentum*

Another red-bleeding *Stereum*, similar to the two previous species but associated with conifers. **FRUIT BODY** Sometimes fully resupinate, but often with an undulating, scalloped margin that projects up to 1.5cm to form thin, shelf-like brackets. **UPPER SURFACE** Finely downy or hairy, with concentric zones in shades of brown and a distinctly paler margin. **UNDERSIDE** Smooth or slightly warty; variable in colour, ranging from yellowish grey to ochre, often with a hint of violet and a whitish margin; bleeds red when damaged. **HABITAT** Decayed wood of various conifers. **STATUS** Widespread and common.

Yellowing Curtain Crust *Stereum subtomentosum*

Typical bracket shape and far less resupinate than other crusts. **FRUIT BODY** Projecting to 7cm; undulating, fan-shaped or semicircular; usually fused in rows or overlapping tiers. **UPPER SURFACE** Velvety, becoming smoother; in shades of grey, ochre or brown with a whitish margin, but colouring green from algae. **UNDERSIDE** Smoothish; grey or ochre, discolouring yellow when damaged (particularly noticeable at the paler margin – scrape a fingernail along the edge). **HABITAT** Dead wood of deciduous trees, often large logs and branches; particularly common on Alder or willows in wet places. **STATUS** A rarity until recently, but now widespread and common in England and Wales.

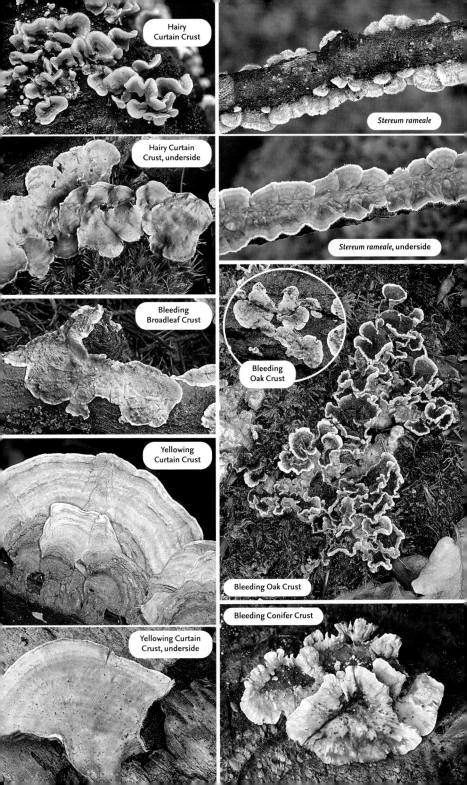

Hairy Curtain Crust

Stereum rameale

Hairy Curtain Crust, underside

Stereum rameale, underside

Bleeding Broadleaf Crust

Bleeding Oak Crust

Yellowing Curtain Crust

Yellowing Curtain Crust, underside

Bleeding Oak Crust

Bleeding Conifer Crust

Members of the family Clavariaceae are diverse in shape and colour. Some are simple, upright, unbranched clubs or spindles, while others form coral-like clumps. Many simpler forms have a stem that is barely distinct from the rest of the fruit body. Some repeatedly fork and have either pointed or blunt tips. Spores, which are white or pale yellow, are produced on the outer surface of the fruit body; the stem is sterile. Some are attacked by parasitic fungi, which alter their colour.

Violet Coral *Clavaria zollingeri*
Distinctive coral-like fungus of an intense amethyst colour. **FRUIT BODY** To 8cm high; comprises a thick, rudimentary stem, out of which arises a clump of erect branches, these dividing and ending in shallow-forked, blunt tips; branches becoming compressed, wrinkled and longitudinally lined; amethyst or pinkish lilac with paler tips. Stipe base white or cream. **HABITAT** Solitary or in small groups in woodland and rough grassland. **STATUS** Widespread but rare.

Moor Coral *Clavaria argillacea*
Bright yellow club fungus, considered to be mycorrhizal with Heather on heathland. **FRUIT BODY** To 3.5cm high; comprises upright clubs with a small stipe and broad, blunt tips; finger-shaped at first, but expanding and becoming flattened and grooved with a smooth surface; bright yellow, with a slightly darker stipe. **HABITAT** In small groups in short turf and moss on heathland and moorland. **STATUS** Widespread and frequent where suitable habitat occurs.

White Spindles *Clavaria fragilis* (= *C. vermicularis*)
Worm-shaped clusters of upright white spindles. **FRUIT BODY** To 10cm high; straight or bent; generally simple, with blunt-pointed tips, occasionally forked near top; rounded or slightly compressed and grooved in cross-section; white, occasionally with yellowish tips. **HABITAT** Usually clustered, more rarely solitary, in basic, unimproved grassland. **STATUS** Widespread and common.

Rose Spindles *Clavaria rosea*
Brittle, rose-coloured spindles. **FRUIT BODY** To 5cm high; spindle-shaped, unforked and narrowing towards base; tips pointed, rounded or sometimes flattened; circular, compressed in cross-section, and with a smooth surface; rose-pink with a paler base. **HABITAT** Solitary or in loose groups amongst grass in open woodland and grassland. **STATUS** Widespread but uncommon to rare.

Smoky Spindles *Clavaria fumosa*
Similar to White Spindles (*see* above) but smoky greyish or ochre in colour. **FRUIT BODY** To 12cm high; club-shaped, becoming more spindle-like, unbranched and often bent or curved, with pointed or blunt tips; rounded or slightly compressed in cross-section and sometimes furrowed; greyish pink or pale ochre. **HABITAT** On soil in deciduous woodland and short grass. **STATUS** Widespread and common.

Ivory Coral *Ramariopsis kunzei* (= *Clavaria kunzei*)
Whitish coral fungus with the appearance of a *Ramaria* (pp. 240–3). **FRUIT BODY** To 10cm high, comprising a slender stem that divides into several rounded branches that end in two or more blunt tips; white or ivory but discoloring pale brown when damaged. **HABITAT** Generally in soil or mosses in open woodland, but sometimes in grassland. **STATUS** Widespread and occasional.

Pointed Club *Clavaria acuta*
Fragile white spindle with a clearly defined stem. **FRUIT BODY** To 6cm high; worm-shaped, sometimes bent, with pointed or rounded tips; generally unbranched but occasionally forked; rounded or slightly flattened in cross-section; smooth and white, becoming greyish ochre. Stem more slender than the upper part; opaque or translucent greyish white. **HABITAT** Solitary or gregarious in deciduous woods and unimproved grassland; occasionally under Common Yew. **STATUS** Widespread and common.

Pointed Club

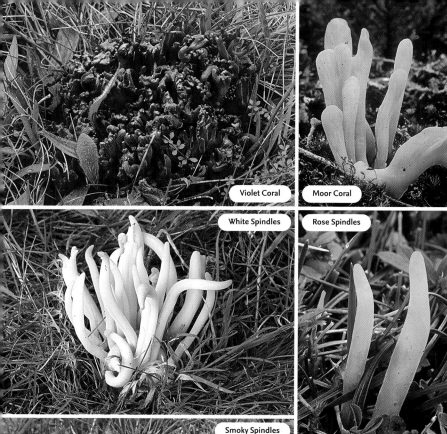

Violet Coral

Moor Coral

White Spindles

Rose Spindles

Smoky Spindles

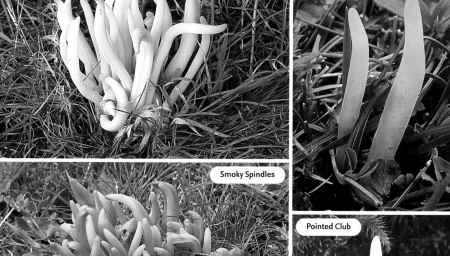

Pointed Club

Ivory Coral

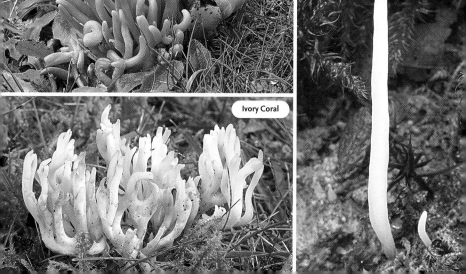

Golden Spindles *Clavulinopsis fusiformis*

Clustered bundle of spindles similar to White Spindles (p. 234) but bright yellow in colour. **FRUIT BODY** To 12cm high; spindle-shaped, tapering sharply at both ends; upright or wavy and often twisted, with pointed or blunt, unbranched tips; rounded or slightly compressed in cross-section, usually with longitudinal grooves; bright golden yellow, darker towards base and with tips becoming brown with age. **HABITAT** Found in dense clusters in unimproved grassland on acid soils. **STATUS** Widespread and common.

Yellow Club *Clavulinopsis helvola*

Small, upright, bright yellow club found in unimproved grassland. **FRUIT BODY** To 7cm high; upright and often curved, spindle-shaped club, somewhat irregular and twisted, with a distinct narrowing toward base; tips generally unbranched, rarely with a single fork, and usually blunt, irregularly rounded or flattened in cross-section, with longitudinal grooves; surface smooth or slightly uneven; bright yellow or orange-yellow, paler toward base. **HABITAT** Solitary or in small groups in grass and mosses in acidic unimproved grassland. **STATUS** Widespread and common. **SIMILAR SPECIES Apricot Club** *C. luteoalba* has whitish or pallid tips and, despite its name, is usually found in a yellow form. Can only be separated with certainty microscopically.

Yellow Club

Handsome Club *Clavulinopsis laeticolor*

Similar to Yellow and Apricot clubs, requiring an inspection of the spores to be identified with certainty. **FRUIT BODY** To 4cm high; erect, cylindrical or spindle-shaped club, narrowing towards base, and somewhat sinuous and slightly wavy; rounded or flattened in cross-section, and often wrinkled or longitudinally grooved; tips unbranched and usually blunt; surface smooth; orange-yellow, or sometimes apricot or peach. **HABITAT** Unimproved grassland, heaths and moors. **STATUS** Widespread but occasional.

Meadow Coral *Clavulinopsis corniculata*

Sinuous, somewhat tangled yellow coral-like fungus. **FRUIT BODY** Simple or, more usually, multi-branched stems arising from a thickened base and forking antler-like near top to form a loose clump; forks U-shaped, with blunt, sometimes incurved tips; surface smooth and slightly flattened in cross-section; light yolk-yellow, maturing ochre, with a white-downy base. **HABITAT** Solitary or, more usually, grouped or clustered in grassland and, occasionally, deciduous woodland. **STATUS** Widespread and common.

Slender Club *Macrotyphula juncea*

Extremely slender (0.5–1mm), thread-like club with an indistinct stalk. **FRUIT BODY** To 10cm high; upright, extremely slender and club-shaped, with unbranched tips that are pointed at first but become blunter; often bent or wavy; cylindrical in cross-section, with a smooth or finely granular surface; ochre with a somewhat darker base. Stem barely distinct from rest of fruit body. **HABITAT** Leaf litter and woody debris in damp deciduous woodland, sometimes in swarms covering a large area. **STATUS** Widespread and common.

Meadow Coral

Pipe Club *Macrotyphula fistulosa*

Similar to Slender Club but more substantial and found in two distinct forms. **FRUIT BODY** To 25cm high; erect, slender, needle-like club with unbranched tips that are pointed at first but later become blunt; surface smooth or finely granular, with the base sometimes downy; ochre or tawny. **HABITAT** On soil and woody debris in deciduous woodland. **STATUS** Common in England. **NOTE** The less common var. *contorta* is much shorter and thicker, with a very contorted appearance, and is found attached to fallen wood of broadleaved trees.

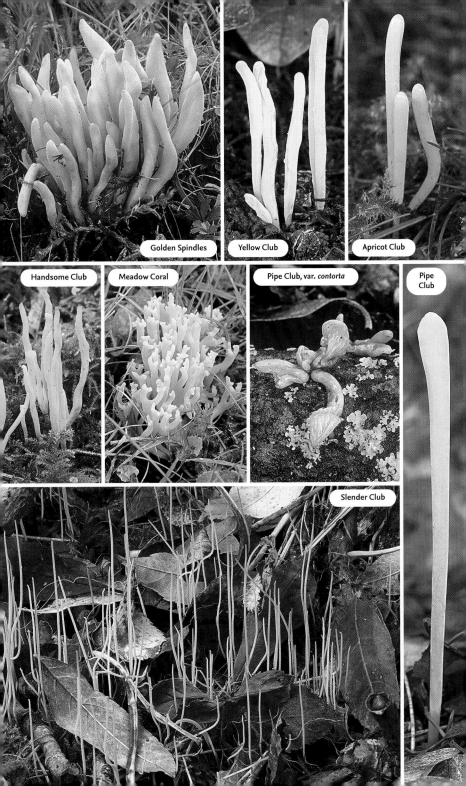

Golden Spindles

Yellow Club

Apricot Club

Handsome Club

Meadow Coral

Pipe Club, var. *contorta*

Pipe Club

Slender Club

Ramariopsis subtilis (Clavariaceae)
White coral fungus with antler-like branches. **FRUIT BODY** To 4cm high; often with a distinct stalk that forks into several curved, bent or twisted branches; tips simple or branching, with blunt ends; surface smooth; white or, more rarely, pale beige, sometimes with brownish tips. Stem to 1.5cm high, stout and irregular, with the surface somewhat wrinkled or granular; concolorous with rest of fruit body. **HABITAT** Grouped or clustered in deciduous woodland, short grass, mosses and, occasionally, on bare soil. **STATUS** Widespread but uncommon.

Giant Club _Clavariadelphus pistillaris_ (Clavariadelphaceae)
Spectacular, very large, unbranched club fungus with a smooth, rounded top. **FRUIT BODY** To 30cm high; usually broad club-shaped, but sometimes more slender or even cylindrical with a blunt, rounded top, tapering markedly to a narrow base; surface smooth and longitudinally wrinkled or grooved, particularly in lower part; light yellow when young, later deep ochre and bruising violet-brown. **HABITAT** Solitary or gregarious in calcareous woodland, usually with Beech. **STATUS** Widespread, occasional to rare, and possibly in decline.

Wrinkled Club _Clavulina rugosa_ (Clavulinaceae)
Flattened, irregular or deformed, pale club, usually found in clusters. **FRUIT BODY** To 10cm high; upright single or clustered branches, generally unforked but sometimes with a few side branches near the blunt or flattened tips; exaggeratedly uneven, grooved and twisted; dingy white, sometimes becoming ochreous with age. **HABITAT** Soil and mosses in deciduous woodland; occasionally with conifers. **STATUS** Widespread and common.

Grey Coral _Clavulina cinerea_ (Clavulinaceae)
Common grey coral, sometimes attacked by the parasitic fungus _Helminthosphaeria clavariorum_ (not described separately), which results in violet- or amethyst-coloured fruit bodies. **FRUIT BODY** To 11cm high; comprises a stem or base, out of which a dense clump of rounded or flattened branches arises; these divide into V-shaped forks and end in blunt tips. Branches sinuous and longitudinally grooved; greyish lilac with a paler base. **HABITAT** On soil in deciduous and mixed woodland. **STATUS** Widespread and very common.

Crested Coral _Clavulina coralloides_ (= _C. cristata_) (Clavulinaceae)
Variable white coral fungus, similar to Wrinkled Club (_see_ above) but with sharp, pointed or fringed tips. Also attacked by the ascomycete _Helminthosphaeria clavariorum_, which turns the fruit body grey or lilac, when it can be confused with Grey Coral. **FRUIT BODY** To 8cm high; comprises a stout, flattened stem that divides repeatedly into irregular, compressed branches, these ending in multi-branched tips with sharp points or teeth, giving it a fringed appearance; surface smooth or finely grooved; usually white but sometimes cream or ochre. Stem stout and flattened; concolorous with rest of fruit body. **HABITAT** Usually on soil in deciduous woodland, rarely short turf and even shingle beaches. **STATUS** Widespread and common.

Grey Coral

Pterula multifida (Pterulaceae)
Unusual coral fungus comprising dense clumps of thread-like stems. **FRUIT BODY** To 6cm high; clusters of individual, upright stems arising directly from the ground or a rudimentary base and forming dense clumps; individual branches fine, delicate and thread-like, with simple, occasionally branched, sharp-tipped ends; white or ochre, darker towards base, and with a smooth surface. **HABITAT** Soil and leaf litter in damp woodland. **STATUS** Uncommon to rare.

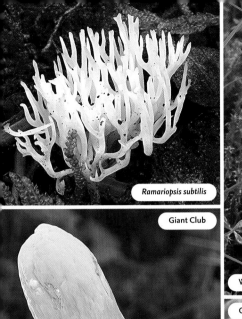
Ramariopsis subtilis

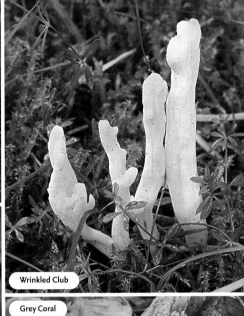
Wrinkled Club

Giant Club
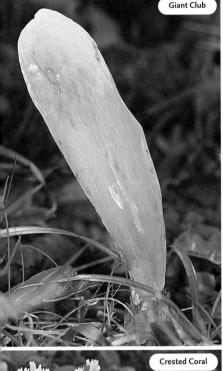

Grey Coral
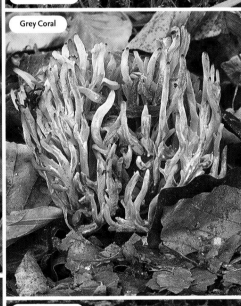

Crested Coral
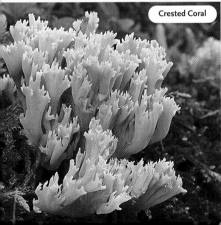

Pterula multifida
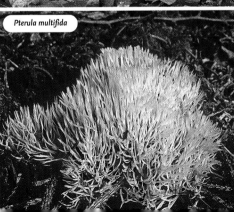

Members of the genus *Ramaria* are similar to some species of Clavariaceae (pp. 234–9) but are less brittle. They comprise a common stem or trunk, from which several branches arise and branch repeatedly, ending in sharp or blunt, thorn-like tips. They usually have several fruit bodies that fuse together to form a clump of coral-like fungus. Clumps can be tight and dense, loose and flaccid, and upright or sprawling. Flesh can change colour on bruising, and a distinctive smell or taste is sometimes present; these are important diagnostic features. The spore print is shades of yellow. Most of the species illustrated have distinctive field characteristics, but there are many others that do not; in these cases microscopic examination is needed.

Rosso Coral *Ramaria botrytis*
Distinctive red-tipped coral fungus. **FRUIT BODY** To 15cm high and 20cm wide; comprises a short, very thick stipe that divides into numerous branches, these in turn subdividing, the outermost branches ending in 2–4 flattened tips; branches thick and short with a smooth surface, and rounded or flattened in cross-section; trunk and branches white, discolouring ochre, with tips a contrasting wine or red; flesh white with a pleasant smell and mild taste. **HABITAT** Soil, leaf litter and grass in old deciduous woodland, usually with Beech. **STATUS** Rare.

Upright Coral *Ramaria stricta*
Elegant, upright coral with long, dense, slender branches. **FRUIT BODY** To 10cm high and 8cm wide; comprises a short stipe that divides repeatedly into numerous parallel branches, these ending in thorn-like tips; branches long and slender, smooth and circular in cross-section; base short, relatively thin and densely rooting in the substrate; ochre, with yellow tips when young; distinctively discolours wine-red when bruised; flesh elastic and tough, with a faint aniseed smell and bitter taste. **HABITAT** On decayed wood of deciduous trees or, rarely, conifers; sometimes abundant on flowerbeds mulched with wood-chippings, where it can attain a considerable size. **STATUS** Widespread and common to occasional.

Ramaria abietina
Similar to Upright Coral in colour and habitat, but less upright and discolours green. **FRUIT BODY** To 6cm tall and 12cm wide; comprises a short, squat stipe, out of which numerous branches arise, these repeatedly dividing and ending in thorn-like tips; branches rounded or flattened in cross-section and fibrous; yellow-olive with a white base and discolouring green when handled or with age. **HABITAT** Usually soil and needle litter in coniferous woodland; most frequent in commercial plantations and only very rarely associated with deciduous trees. **STATUS** Widespread and uncommon to rare.

Ramaria gracilis
Whitish coral fungus with a strong smell of aniseed. **FRUIT BODY** To 6cm high and 5cm wide; comprises a short, rooting stem, out of which numerous branches arise, these ending in thorn-like tips, the whole forming a loose-knit clump; branches fairly long, slender and somewhat wrinkled; rounded or flattened in cross-section; white, sometimes with pink tones and becoming ochreous; no discoloration when bruised. **HABITAT** Usually with conifers on calcareous soil. **STATUS** Uncommon.

Ramaria flaccida
Similar in structure to Upright Coral (*see* above) but generally restricted to coniferous woodland. **FRUIT BODY** To 5cm tall and 4cm wide; comprises a stipe-like rooting trunk that divides into several branches, these dividing further and ending in 2–3 sharp points; branches straight, erect and slender; circular or slightly flattened in cross-section, with a smooth surface; ochre, with no discoloration when bruised. **HABITAT** On soil or needle litter in coniferous woodland, rarely with deciduous trees. **STATUS** Widespread but uncommon.

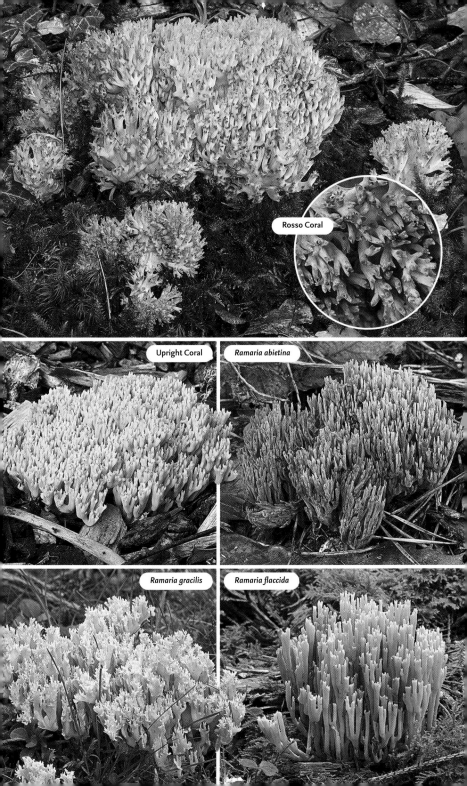

Rosso Coral

Upright Coral

Ramaria abietina

Ramaria gracilis

Ramaria flaccida

Ramaria flava (Ramariaceae)

Bright yellow coral fungus. **FRUIT BODY** To 20cm across and 15cm high; comprises a sturdy trunk, out of which several branches arise and then repeatedly divide, ending in short, blunt points, sometimes with thorn-like outgrowths; sulphur to light yellow with concolorous tips, becoming ochreous with age. Flesh whitish and fragile, with no distinctive taste or smell. Stem short and sturdy with a whitish base that sometimes discolours reddish when bruised. **HABITAT** On soil and amongst leaf litter in deciduous woodland, usually with Beech and oaks. **STATUS** Widespread but uncommon to rare.

Ochre Coral *Ramaria decurrens*

Ochre coral fungus found in dense clumps. **FRUIT BODY** To 20cm across and 15cm high, comprising a stem or trunk out of which many densely packed branches arise and repeatedly divide, ending in pointed tips; branches rounded or somewhat flattened in cross section; ochre or brownish beige with a paler stem and darker tips. **HABITAT** On soil and leaf litter with deciduous trees, and occasionally with yew. **STATUS** Uncertain due to confusion with *R. curta* (below). Most British records re-examined and considered to be *R. curta*. Probably rare or uncommon and confined to S. **SIMILAR SPECIES R. curta** probably more widespread and less rare and can only be separated microscopically.

Ramaria pallida

Pallid coral fungus. **FRUIT BODY** To 15cm high and across, comprising a base that divides into several rounded branches that repeatedly divide and end in pointed or blunt tips; whitish at first but soon becoming the colour of milky coffee; not significantly discolouring when damaged. **HABITAT** Deciduous woodland with beech and oak. **STATUS** Rare.

Candelabra Coral *Clavicorona pyxidata* (Clavicoronaceae)

Distinctive pale coral fungus with the upper part resembling a candelabra. **FRUIT BODY** To 15cm high comprising dense clusters of upright branches arising from a short base and flattening into a broad head that divides into several curved thinner branches ending in 3–6 thorn-like tips; dirty white, cream or buff. **HABITAT** On soil in woodland or decayed wood, particularly Aspen. **STATUS** Rare. Not recorded in Britain for over 100 years and possibly extinct.

Cauliflower Fungus

Cauliflower Fungus or Wood Cauliflower

Sparassis crispa (Sparassidaceae)

Large fungus resembling a cauliflower and found at the base of conifers. Reputed to be good to eat if you don't mind a mouthful of grit: they are difficult to clean. **FRUIT BODY** To 40cm across and 20cm high; cauliflower- or sponge-shaped, with many densely packed branches that divide from a short stem and end in flattened, curly, flower-like lobes. Stem stout, usually very short, and obscured by the dense network of branches; surface smooth with a tough elastic consistency; cream-ochre and discolouring brown with age. **HABITAT** Parasitic on the roots of conifers, usually pine. **STATUS** Widespread and common. **SIMILAR SPECIES S. spathulata** (= *S. laminosa*) is the deciduous-tree equivalent; it is very rare in the British Isles but frequent on the Continent.

Sparassis spathulata

Bracken Club *Typhula quisquiliaris* (Typhulaceae)

Tiny club fungus, usually found in rows on dead Bracken stems; it is frequent after periods of wet weather. **FRUIT BODY** To 0.4cm high; consists of a single unbranched, club-shaped head with a distinct stem, growing out of a sclerotium that is embedded in the substrate; surface white with a smooth texture. Stem sterile, rounded in cross-section and finely downy; concolorous with head but somewhat translucent. **HABITAT** Scattered in rows along the ribs of dead Bracken, rarely on other substrates. **STATUS** Widespread and common.

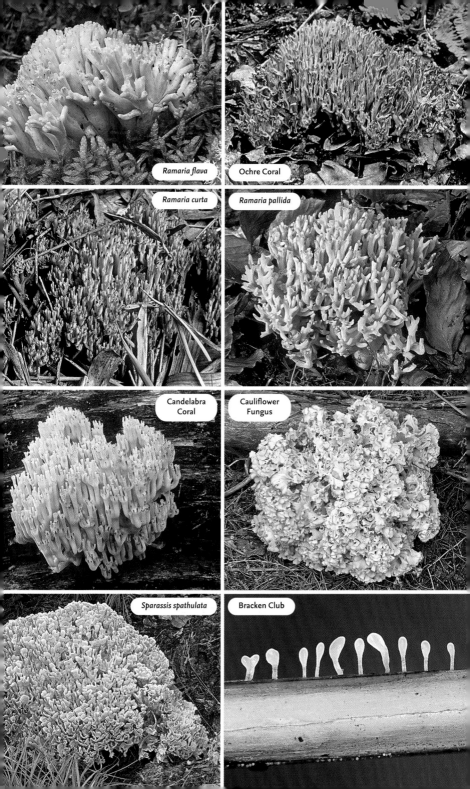

Ramaria flava

Ochre Coral

Ramaria curta

Ramaria pallida

Candelabra Coral

Cauliflower Fungus

Sparassis spathulata

Bracken Club

The stinkhorns and their allies have a unique method of spore dispersal. The spores are contained in a fetid slime (gleba), smelling of faeces, carrion or rotten meat, that coats parts of the fruit body; they are dispersed by flies attracted to the odour. Stinkhorns start off as a gelatinous whitish 'egg' with root-like mycelium strands. This 'egg' contains the embryonic fruit body, which is surrounded in gleba; on maturity it erupts, and the fruit body emerges with the gleba adhering to various parts. Indigenous members of the family Phallaceae have phallus-shaped fruit bodies with the gleba on the outside. Clathraceae is a mainly tropical family with a single species native to Europe and a few recent introductions; in these the gleba is on the inside.

Stinkhorn *Phallus impudicus* (Phallaceae) (Top 100)

The most common of the British stinkhorns, with a powerful smell that is often detected before the fungus is found. **FRUIT BODY** Initial 'egg' to 6cm across, whitish and smooth. Fruit body emerges as a thick stem to 20cm high, topped by a cone-shaped head covered in dark brown or olive-brown gleba, this soon disappearing to reveal the white honeycomb-like surface. **STEM** To 20cm high; hollow cylindrical or slightly tapering upward, with the base encased in a volva-like bag; white with a spongy or granular texture. **HABITAT** Varied, including soil in woodland, dunes and gardens; associated with stumps of both broadleaved and coniferous trees. **STATUS** Widespread and common. **SIMILAR SPECIES Sand Stinkhorn** *P. hadriani* (not illustrated) is smaller, has a pinkish-lilac 'egg' and is found in sand dunes.

egg

Dog Stinkhorn *Mutinus caninus* (Phallaceae)

Smaller, more slender and with a less powerful smell than Stinkhorn. **FRUIT BODY** Initial 'egg' to 2cm across, whitish with a smooth surface that splits. Emergent fruit body is a slender stem with an orange or red conical-shaped head, covered in dark olive gleba that soon disappears to reveal the bare spongy head. **STEM** To 10cm high; cylindrical, hollow and spongy, with an extensively pitted surface; white or buff, mottled with orange or apricot. **HABITAT** Soil, decayed wood or woody debris in deciduous woodland or, less frequently, with conifers. **STATUS** Widespread and common, especially in S England.

Devil's Fingers *Clathrus archeri* (= *Anthurus archeri*) (Clathraceae)

Squid-like fungus. **FRUIT BODY** 'Egg' to 4cm across, white or ochre, sometimes pinkish, with a smooth surface. Short column emerges from 'egg', with 4–6 arms extending upward and then spreading outward, and with dark greenish gleba spreading along inner surfaces. Arms to 7cm long and tapering to a blunt point; very fragile; bright red or pink, with a spongy texture. Column to 5cm high; cylindrical and hollow; whitish. **HABITAT** Deciduous woodland, parkland, and flowerbeds mulched with wood-chippings. **STATUS** Uncommon to rare in S and W England.

Red Cage *Clathrus ruber* (Clathraceae)

Unique cage-like red sessile stinkhorn. **FRUIT BODY** Dingy-white 'egg' ruptures at the top, from which emerges a stalkless, cage-like structure, up to 12cm high and 9cm wide. Cage consists of a lattice-like network of connecting spongy branches, with the inner surfaces covered in a greenish gleba; bright red or salmon. **HABITAT** On soil in woodland, parkland and gardens; often coastal. **STATUS** Rare.

Starfish Fungus *Aseroë rubra* (Clathraceae)

Starfish-shaped stinkhorn. **FRUIT BODY** 'Egg' to 3cm across, dirty white or pale brown. Out of this emerges the thick stem, its top flattened to form a platform from which 5–11 arms extend outward. Arms initially joined at tips, then divided into pairs, hollow, brittle and tapering to a point; bright red. **STEM** To 9cm tall; cylindrical or tapering downward, with olive or brown gleba contained on the flat top; pale pink with a spongy texture. **HABITAT** Leaf litter in mixed acidic woodland. **STATUS** Rare; known from only one site in Britain.

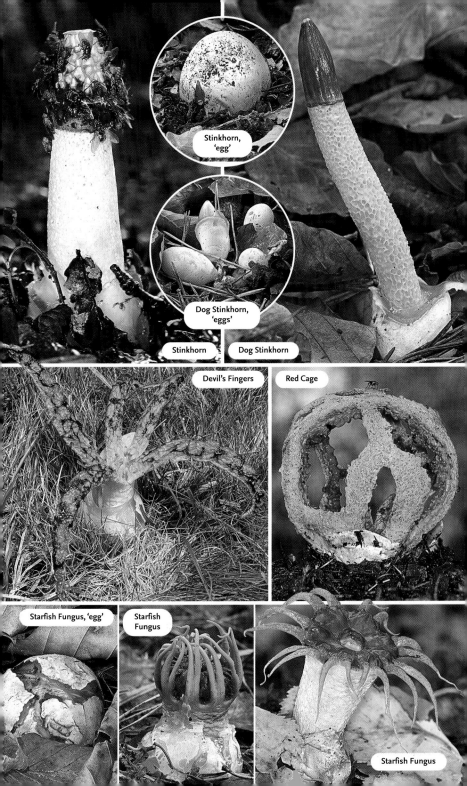

Stinkhorn, 'egg'

Dog Stinkhorn, 'eggs'

Stinkhorn

Dog Stinkhorn

Devil's Fingers

Red Cage

Starfish Fungus, 'egg'

Starfish Fungus

Starfish Fungus

The family Coniophoraceae includes some of the most virulent wood-rotting fungi, responsible for extensive damage to buildings. They normally start as small spots, these coalescing to form patches that can cover a large area. They are usually fully resupinate with a soft consistency, and have a yellowish or brown spore print.

Dry Rot *Serpula lacrymans*
The dreaded Dry Rot fungus was formerly common in older buildings but nowadays all structural timber is treated with a fungicide and the problem has been largely eradicated. More virulent and damaging than Wet Rot (*see* below), it has the ability to, in effect, generate its own moisture from the decomposing timber and mortar to ensure its survival and expansion; accordingly, an external source of moisture is needed only to start growth. **FRUIT BODY** Fully resupinate or, occasionally, with the margin turning up to form a narrow, shelf-like bracket when growing vertically; initially small, rounded white spots that coalesce to form patches to 1cm thick with a blunt and inflated margin, these eventually covering a wide area. Pore surface comprises crinkled, maze-like folds with a sticky spongy texture; shades of yellow or orange-brown with a white sterile marginal zone, and with a texture resembling cotton wool; smells fungoid at first but becoming putrid with age. Affected timber rapidly loses its strength and breaks up into cubes, before disintegrating into crumbs. **HABITAT** Found on timber in damp and poorly ventilated buildings; never found in the wild. **STATUS** Formerly widespread and common but now less so.

Serpula himantioides
The wild equivalent to Dry Rot but thinner and smaller. **FRUIT BODY** Fully resupinate; initially small whitish spots that coalesce to form thin patches with an irregular felty margin. Pore surface with crinkled, maze-like folds and a sticky spongy texture; golden brown, maturing darker and with a white marginal zone, occasionally with a hint of lilac. **HABITAT** Decayed wood of conifers, frequently on the underside of fallen logs; more rarely on the wood of deciduous trees. **STATUS** Widespread and common in England.

Wet Rot *Coniophora puteana*
The most common of the wet rots in buildings; unlike Dry Rot (*see* above), it cannot survive without a constant supply of moisture. **FRUIT BODY** Fully resupinate and tightly attached to the substrate; initially small, rounded spots that coalesce to form large, irregular patches with a broad, fringed margin; fleshy, with the surface usually roughened with numerous warts or lumps, rarely smooth; cream at first, becoming ochre or dark brown and paler towards margin. **HABITAT** Decayed wood of deciduous trees and conifers, as well as on timber in buildings. **STATUS** Widespread and very common. **SIMILAR SPECIES** *Coniophora arida* is thinner and not so fleshy; it is found on decayed wood and bark of conifers, less frequently on broadleaved trees.

Coniophora olivacea
Similar to *C. arida* (*see* above) but more olive in colour. **FRUIT BODY** Fully resupinate and tightly attached to the substrate, forming thin, irregular parchment-like patches several centimetres in extent; olive or olive-brown with a finely fringed white margin and a smoothish surface. **HABITAT** Decayed wood of conifers; rarely on deciduous trees. **STATUS** Uncommon.

Pseudomerulius aureus
Bright golden resupinate, usually found on the underside of pine logs. **FRUIT BODY** Fully resupinate and loosely attached to the substrate, forming soft, fleshy patches to 2cm thick and several centimetres in extent, these consisting of tightly packed, radial, maze-like, crinkled folds; orange or golden brown with a felty yellowish margin. **HABITAT** Decayed wood of pines. **STATUS** Rare.

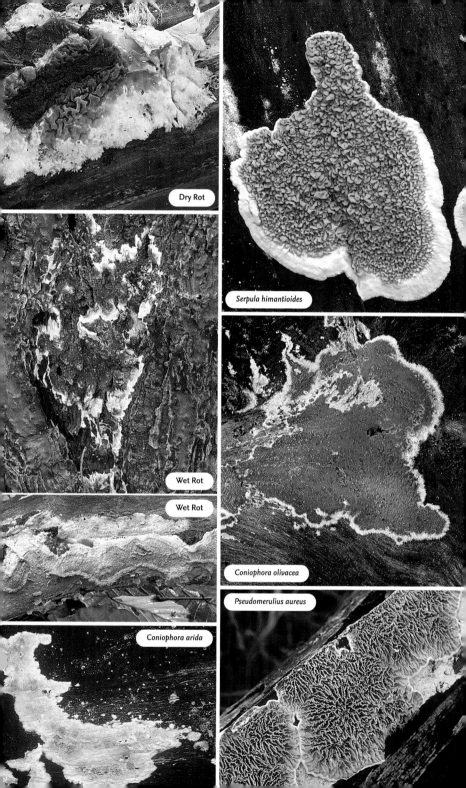

Dry Rot

Serpula himantioides

Wet Rot

Wet Rot

Coniophora olivacea

Coniophora arida

Pseudomerulius aureus

Common Jellyspot *Dacrymyces stillatus* (Dacrymycetaceae) (Top 100)

Variable in form and colour, this orange jelly fungus can be found after wet periods throughout the year. **FRUIT BODY** To 1.5cm across; cushion-, knob- or, occasionally, cup-shaped, and anchored to the substrate by a short, stipe-like attachment; several fruit bodies often coalesce, becoming brain-shaped. Smooth and undulating but later wrinkled. Flesh gelatinous but deliquescing into a slimy mass when old. Light yellow or orange but drying darker; occasionally almost white forms are found. **HABITAT** Decayed wood of deciduous and coniferous trees; also on wet timber in buildings. **STATUS** Widespread and very common.

Small Stagshorn *Calocera cornea* (Dacrymycetaceae) (Top 100)

Small stagshorn, similar to some club fungi but less brittle and found on wood. **FRUIT BODY** To 1cm tall; thorn-like spine tapering to a blunt or pointed tip, usually unbranched but occasionally forked near top. Flesh tough and gelatinous with a smooth, greasy surface; yellow or yellow-orange. **HABITAT** Decayed wood, usually on deciduous trees (particularly fallen trunks of Beech) but occasionally on conifers. **STATUS** Widespread and very common.

Pale Stagshorn *Calocera pallidospathulata* (Dacrymycetaceae)

Small, pallid stagshorn, first found in the British Isles in 1969 but now widely distributed and common as a result of rapid expansion. **FRUIT BODY** To 1.5cm tall; stipe-like stem flattening out into a broad head with a rounded or flattish top; sometimes spatula-shaped but generally very irregular with a contorted appearance. Stem longitudinally furrowed. Flesh tough and gelatinous with a greasy surface. Dull pale yellow at first, becoming pallid and somewhat translucent. **HABITAT** Decayed wood of conifers, but increasingly found on wood of deciduous trees. **STATUS** Widespread and locally common.

Yellow Stagshorn *Calocera viscosa* (Dacrymycetaceae) (Top 100)

Easily confused with some species in the family Clavariaceae (p. 234) but less brittle and found growing on wood. **FRUIT BODY** To 8cm high; short, rooting trunk that divides into several branches, these ending in 2 or 3 branched, blunt tips; clustered and coral-like when several fruit bodies fuse at base; branches flattened in lower part, more cylindrical above and sometimes longitudinally grooved. Flesh tough and rubbery. Yellow or orange and drying darker, although a white form (var. *cavarae*) is sometimes found. **HABITAT** Solitary or clustered on dead wood of conifers. **STATUS** Widespread and very common.

Ditiola peziziformis (= *Femsjonia peziziformis*) (Dacrymycetaceae)

Small gelatinous yellow dacrymycete of variable shape. **FRUIT BODY** To 1cm high and the same across; broad cylindrical or spinning-top-shaped and appearing truncated with a flattish top, sometimes cup- or disc-shaped and *Peziza*-like; compressed and irregular when fruit bodies are clustered. Margin generally even but occasionally slightly undulating. Upper part or top yellow with a whitish margin and a smooth or finely wrinkled surface. Outer surface whitish, finely downy, and sometimes elongated and stipe-like. **HABITAT** Decayed wood of deciduous trees, more rarely conifers. **STATUS** Widespread but occasional.

Cowberry Redleaf *Exobasidium vaccinii* (Exobasidiaceae)

Parasitic fungus found on Cowberry plants, turning their leaves a distinctive red colour (several other redleaf species are also associated with plants of the Ericaceae family). No fruit body is produced, but the leaves and shoots of the host plant are infected and the leaves become distorted, discoloured and sometimes even gall-like; the upper surface becomes a bright purple or light wine-red, while the lower surface is covered in a whitish spore-bearing powder and has darker, more prominent veins. **HABITAT** Plants of Cowberry *Vaccinium vitis-idaea*. **STATUS** Widespread and frequent where host plants are common.

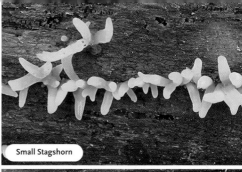
Small Stagshorn

Common Jellyspot

Pale Stagshorn

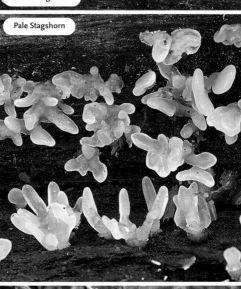

Yellow Stagshorn

Yellow Stagshorn, var. *cavarae*

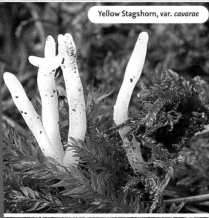

Ditiola peziziformis

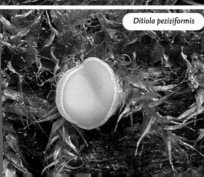

Cowberry Redleaf

Members of the family Exidiaceae are gelatinous or jelly fungi in varied irregular shapes and usually dull colours. They are generally associated with dead wood, both standing and fallen; some are host-specific. Like most jelly fungi, they are conspicuous only in wet weather and when dry shrivel to a hard, thin membrane; they rehydrate rapidly, revive and swell to resume growth and spore production; accordingly, they can be found at any time of the year. Spores are white.

Exidia plana

Brain-shaped black jelly fungus. **FRUIT BODY** Gradually spreading up to 30cm across; initially disc- or cup-shaped, developing undulating folds or wrinkles and eventually becoming brain-shaped. Attached to the substrate at centre, with margins free and the whole becoming a floppy mass. Black or blackish brown with a shiny surface. **HABITAT** Dead wood of deciduous trees. **STATUS** Widespread and common.

Witches' Butter *Exidia glandulosa (= E. truncata)*

Similar to *E. plana* but flatter, truncated and not brain-like. **FRUIT BODY** To 6cm across; disc- or cushion-shaped buttons with tiny glandular warts, becoming fused and very undulating. Upper surface scurfy and granular, lower surface smooth and shiny; black or blackish brown. **HABITAT** Dead, standing or fallen wood of deciduous trees. **STATUS** Widespread and common.

White Brain *Exidia thuretiana*

Whitish brain-shaped jelly fungus. **FRUIT BODY** Small, cushion-shaped knobs that coalesce to form irregular patches to 10cm across, these comprising wrinkled folds with deep furrows; dull white or bluish white with an ochre or pink tint, and opalescent with a smooth surface. **HABITAT** Usually in rows along fallen branches of deciduous trees. **STATUS** Widespread but occasional. **SIMILAR SPECIES Crystal Brain** *E. nucleata* is usually softer, with granules or crystals visible in the fruit body.

Exidia recisa

Floppy brown jelly fungus. **FRUIT BODY** To 3cm across; irregular cushion-shaped knobs with undulating wrinkled folds, attached to the substrate by a short, indistinct stipe; amber to dark reddish brown and somewhat translucent, with a shiny surface. **HABITAT** Dead branches and twigs of willow. **STATUS** Widespread but uncommon. **SIMILAR SPECIES** *E. saccharina* is confined to pine.

Eichleriella deglubens

Bright pink resupinate. **FRUIT BODY** Fully resupinate and tightly attached to the substrate, forming thin patches several centimetres in extent, and with the margin sometimes uplifted; surface waxy, with isolated warts or spines; flesh-coloured with margin often paler when in growth, and wine-red when damaged. **HABITAT** Fallen wood of deciduous trees. **STATUS** Widespread but occasional.

Jelly Tongue *Pseudohydnum gelatinosum*

Firm, gelatinous bracket with teeth on the underside. **FRUIT BODY** To 6cm across; tongue- or spatula-shaped with a stem-like base. Upper surface rough or granular but smoother towards margin; colour somewhat variable, ranging from whitish to brown and darkening with age; underside densely covered in whitish spines. **HABITAT** Decayed wood of conifers. **STATUS** Widespread but occasional.

Jelly Tongue

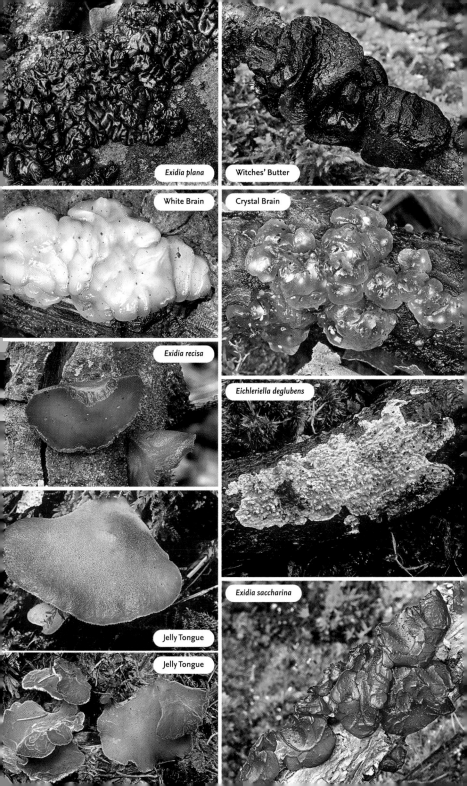

Exidia plana

Witches' Butter

White Brain

Crystal Brain

Exidia recisa

Eichleriella deglubens

Jelly Tongue

Jelly Tongue

Exidia saccharina

The Coriolaceae family includes many of our commonest brackets. Diverse in form and colour, most are firmly attached to the substrate, generally without a stipe. Often with a leathery or woody texture, they are found on both conifer and broadleaved trees. Some are perennial, attaining a large size over time. The spores develop in tubes on the underside, and the spore print is white.

Hen of the Woods *Grifola frondosa*
Large, spherical cluster of fruit bodies similar to Umbrella Polypore (p. 230). **FRUIT BODY** To 50cm across; comprises many densely packed branches that divide from a thick whitish base and end in flattened, undulating, leaf-like lobes or fronds. **UPPER SURFACE** Mixture of ochre or grey-brown, ageing darker, with a tough, leathery, fibrous texture. **UNDERSIDE** Fine circular or angular pores; whitish, maturing light ochre. **HABITAT** Deciduous trees, usually on the roots of oak trees and often at the base of a trunk where lightning has struck; rarely on conifers. **STATUS** Widespread but occasional; most frequent in S.

Giant Polypore *Meripilus giganteus*
Very large polypore, similar to Hen of the Woods but overall much larger and with flesh that discolours blackish. **FRUIT BODY** To 80cm across; comprises several overlapping tiers or rosettes fanning out from a sturdy base. Individual brackets to 30cm across, undulating and with a fleshy texture. **UPPER SURFACE** Concentrically zoned in shades of yellow to reddish brown with a whitish margin. **UNDERSIDE** Whitish or cream pores that discolour greyish black when bruised. **HABITAT** Most frequently found on dead stumps and at the base of deciduous trees; very rarely on conifers. **STATUS** Widespread and common.

Dyer's Mazegill *Phaeolus schweinitzii*
Distinctive large bracket with a yellowish velvety cap and a short, thick brown stem. **FRUIT BODY** To 30cm across; irregularly circular, cushion-shaped or flatter with a depressed centre, more bracket-like if growing vertically; sometimes several fruit bodies fuse together. **UPPER SURFACE** Soft and spongy with a hairy or velvety texture; shades of yellow or yellow-brown, often in zones, with a dark brown centre and paler margin; brown colour gradually extends over entire fruit body, which eventually becomes blackish. **UNDERSIDE** Labyrinth of elongated pores; yellowish but bruising brown. **HABITAT** Usually on the roots of conifers, occasionally on upright trunks and rarely with deciduous trees. **STATUS** Widespread and common.

Chicken of the Woods *Laetiporus sulphureus*
Similar to Giant Polypore (*see* above) but bright yellow and usually found on the trunks of standing trees, often high up. **FRUIT BODY** To 40cm across; comprises several thick, overlapping brackets. Irregularly semicircular or fan-shaped, undulating and lumpy, and with a somewhat incurved margin; texture is rather like cooked chicken and becomes crumbly with age. **UPPER SURFACE** Finely velvety or suede-like; bright yellow, becoming orange with a zoned margin. **UNDERSIDE** Yellow circular or oval pores that sometimes weep droplets of moisture. **HABITAT** Wood of deciduous trees, usually standing oak; rarely found with conifers. **STATUS** Widespread and common.

Cinnamon Bracket *Hapalopilus nidulans*
Bracket that stains an intense violet colour when ammonia is applied to its surface. **FRUIT BODY** To 12cm across; semicircular or fan-shaped with an undulating margin. **UPPER SURFACE** Finely felty but becoming rough and pitted with age; cinnamon or ochre-brown, with margin paler when young. **UNDERSIDE** Large, round to angular pores, sometimes absent at margin; greyish brown or reddish brown. **HABITAT** Dead and decayed wood of deciduous trees and shrubs. **STATUS** Occasional.

Cinnamon Bracket reacting to ammonia

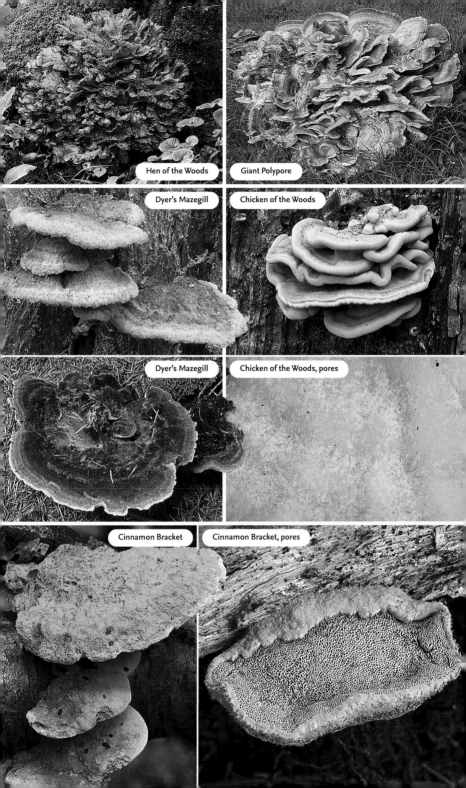

Hen of the Woods

Giant Polypore

Dyer's Mazegill

Chicken of the Woods

Dyer's Mazegill

Chicken of the Woods, pores

Cinnamon Bracket

Cinnamon Bracket, pores

Blushing Rosette *Abortiporus biennis (= Heteroporus biennis)*

Distinctively blushes reddish when handled and sometimes exudes red droplets in damp weather. **FRUIT BODY** To 20cm across; variable in form – funnel-shaped, bracket-like or a rosette, and sometimes even spinning-top-shaped; occasionally has a short stem; margin thin and undulating. **UPPER SURFACE** Pale ochre or brown, with a paler margin and a finely downy or velvety surface; blushes reddish when handled. **UNDERSIDE** Irregular, with angular pores that become labyrinth-like and run down stem; whitish, discolouring red. **HABITAT** Decayed wood of deciduous trees; often appears to grow out of the ground but is attached to buried wood. **STATUS** Common in S England; widespread but occasional elsewhere.

Root Rot *Heterobasidion annosum* (Top 100)

Virulent pathogen of conifers, responsible for much damage in commercial plantations. **FRUIT BODY** To 15cm wide; variable in shape – large, resupinate patches forming at the base of trees, or sometimes a semicircular or elongated bracket. **UPPER SURFACE** Initially felty, but later smooth and very uneven with concentric raised zones and bumps; reddish brown, becoming progressively darker from centre outward and blackening with age; margin inflated and rounded, white when in active growth. Flesh with a strong aroma. **UNDERSIDE** Fine, rounded, angular or elongated white pores. **HABITAT** Usually parasitic on conifers but sometimes found on dead broadleaved trees. **STATUS** Widespread and common.

Birch Polypore or **Razorstrop Fungus** *Piptoporus betulinus* (Top 100)

One of the most widespread and common brackets, present in virtually every birch wood. **FRUIT BODY** To 30cm wide; thick, rounded or hoof-shaped fungus with a short, lateral attachment to the substrate, sometimes typically bracket-shaped and undulating; margin usually blunt and rounded. **UPPER SURFACE** Smooth with a parchment-like surface that becomes fissured with age; cream, ochre or greyish brown with a white margin. **UNDERSIDE** Extremely small, rounded or slightly angular pores; creamy white, maturing greyish brown. **HABITAT** Living and dead wood of birches; restricted to this host. **STATUS** Widespread and very common.

Oak Polypore *Piptoporus quercinus*

Rare yellowish polypore restricted to old oak trees. Fruits in summer. **FRUIT BODY** To 15cm across; rounded, then bracket-like with a thick, wavy margin; texture soft at first but ageing tough and leathery. **UPPER SURFACE** Yellow, streaked or mottled with reddish brown but fading with age. **UNDERSIDE** Fine white pores that discolour brown. **HABITAT** Trunks of old oaks and on their fallen branches. **STATUS** Rare; mainly in S.

Rigidoporus ulmarius

Large, thick, perennial bracket, typically associated with elms. **FRUIT BODY** To 50cm across; woody bracket with a thick, rounded margin. **UPPER SURFACE** Irregular and covered in large knobs, warts and bumps; variable in colour, from white or ochre at first through to dirty brown at maturity; margin white or cream when in growth. **UNDERSIDE** Rounded or angular pores; pinkish orange, maturing buff. **HABITAT** Wood of deciduous trees, usually large trunks and stumps of elms. **STATUS** Widespread but occasional in England; decreasing owing to the loss of elms.

Benzoin Bracket *Ischnoderma benzoinum*

Very dark, almost black bracket. **FRUIT BODY** To 20cm across; narrow or broadly attached bracket with a thin, undulating margin. **UPPER SURFACE** Lumpy and wrinkled, with radial furrows or ridges; dark red or brown to almost black, with a paler, often almost white, marginal zone; surface felty at first but becoming smooth. **UNDERSIDE** Fine, rounded pores; white or ochre, discolouring brown. **HABITAT** Dead and decayed wood of conifers. **STATUS** Uncommon; more frequent in S and SE.

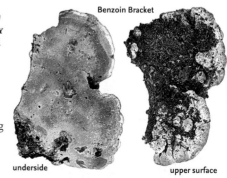

Benzoin Bracket

underside

upper surface

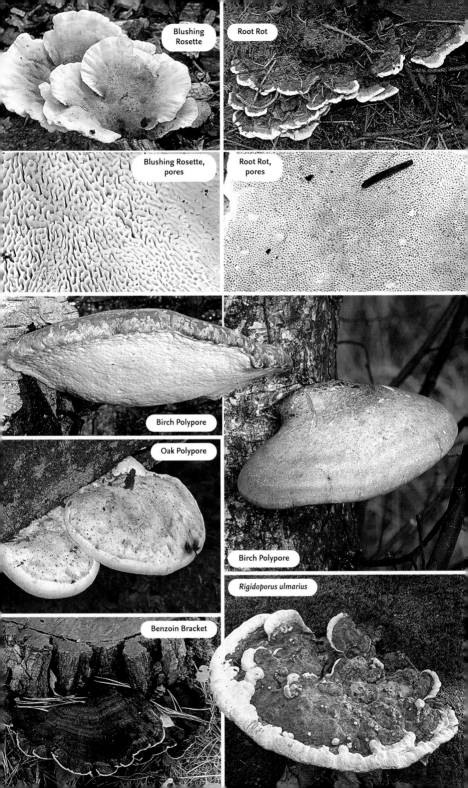

Blushing Rosette

Root Rot

Blushing Rosette, pores

Root Rot, pores

Birch Polypore

Oak Polypore

Birch Polypore

Benzoin Bracket

Rigidoporus ulmarius

Pores

Red-belted Bracket *Fomitopsis pinicola*
Woody bracket with a resinous surface that melts with heat (apply a lighted match). **FRUIT BODY** To 25cm across; bracket- or hoof-shaped, very broadly attached to the substrate and with a blunt, rounded margin. **UPPER SURFACE** Smooth, with bumps, warts and thick, concentric furrows and ridges; greyish with orange or red growth zones and a whitish margin. **UNDERSIDE** Rounded pores; cream or yellowish, becoming brown; pores and margin exude droplets of moisture in damp conditions. **HABITAT** Dead wood of conifers; rarely on birches. **STATUS** Rare in the British Isles; more common on the Continent, particularly Scandinavia.

Hoof Fungus or Tinder Bracket *Fomes fomentarius*
Hoof-shaped fungus, similar to Red-belted Bracket but with a cap crust that merely chars with heat and does not melt. **FRUIT BODY** To 25cm across; broadly attached to the substrate; sometimes bracket-like with an umbonate attachment, but more typically hoof-shaped with broad, concentric growth zones or ridges; margin blunt and rounded. **UPPER SURFACE** Tough, leathery and somewhat bumpy; variable in colour but usually in shades of light brown or grey, with a whitish margin during growth periods. **UNDERSIDE** Rounded pores; cream, maturing light ochre or brown. **HABITAT** Deciduous trees, especially birches. **STATUS** Common in Scotland, less so S of the border but perhaps increasing.

Bitter Bracket *Postia stiptica* (= *Tyromyces stipticus*)
White bracket with a strong fungoid odour and very bitter taste. **FRUIT BODY** To 8cm across; semicircular or shell-shaped bracket, broadly attached and triangular when viewed in cross-section; margin thin and blunt. **UPPER SURFACE** Uneven with some warts and bumps, soft and fleshy with a felty surface; white, becoming cream. **UNDERSIDE** Small white rounded or elongated pores that exude milky droplets of moisture in damp conditions. **HABITAT** Singly or in small, overlapping groups on decayed wood of conifers, typically the cut end of large trunks and logs; very rarely with deciduous trees. **STATUS** Widespread and common.

Blueing Bracket *Postia subcaesia* (= *Tyromyces subcaesius*)
Thin blueing *Postia* associated with deciduous trees. **FRUIT BODY** To 6cm across; thin, narrowly attached, semicircular or shell-shaped bracket, sometimes decurrent onto the substrate; margin thin and sharp. **UPPER SURFACE** Undulating, wrinkled and finely hairy; white or pale ochre, developing a blue or grey flush and sometimes faintly zoned. **UNDERSIDE** Rounded or angular pores; whitish, becoming blue or grey with age. **HABITAT** Solitary or in overlapping groups on fallen and decayed wood of deciduous trees. **STATUS** Common in England, more frequent in S. **SIMILAR SPECIES Conifer Blueing Bracket** *P. caesia* is less common and is a deeper blue colour; it is found on dead wood of conifers.

Greyling Bracket *Postia tephroleuca* (= *Tyromyces tephroleucus*)
Whitish *Postia* with a mild taste. **FRUIT BODY** To 6cm across; semicircular or fan-shaped bracket broadly attached to the substrate and with a blunt margin. **UPPER SURFACE** White, then greyish or brown with a finely felty or smooth surface. **UNDERSIDE** Fine white rounded or angular pores. **HABITAT** Decayed wood of deciduous trees. **STATUS** Common in England, less so elsewhere.

Postia balsamea (= *Tyromyces balsameus*)
Irregular-shaped bracket, usually found clustered in tiers on conifers. **FRUIT BODY** To 5cm across; undulating bracket with a blunt, sometimes inflated, margin, often semi-resupinate. **UPPER SURFACE** Shades of fawn or brown in weak zones, with a broad white or cream margin when in growth. **UNDERSIDE** Fine pores, sometimes decurrent down the substrate, generally angular but more elongated when decurrent; white, maturing cream or brownish. **HABITAT** Dead and decayed wood of conifers; more rarely with deciduous trees. **STATUS** Occasional in England.

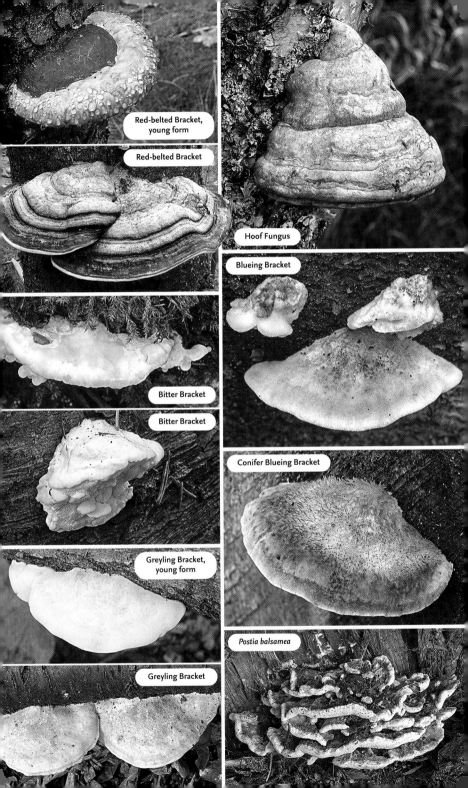

Red-belted Bracket, young form

Red-belted Bracket

Hoof Fungus

Blueing Bracket

Bitter Bracket

Bitter Bracket

Conifer Blueing Bracket

Greyling Bracket, young form

Greyling Bracket

Postia balsamea

Poplar Bracket *Oxyporus populinus*

Perennial bracket that distinctively builds up multiple layers of tubes over the years. **FRUIT BODY** To 10cm across; usually an undulating semicircular or fan-shaped bracket with a thin margin, but occasionally fully resupinate. **UPPER SURFACE** Felty but becoming smooth and slightly uneven and bumpy; shades of cream, grey or ochre, with a white marginal zone when in growth; often stained green from algae. **UNDERSIDE** Multiple layers of tubes ending in fine, rounded or angular pores; white or cream. **HABITAT** In overlapping tiers on wood of deciduous trees, frequently in wounds and knotholes. **STATUS** Widespread but occasional.

Blushing Bracket *Daedaleopsis confragosa* (Top 100)

Large, very common bracket, the underside of which distinctively blushes reddish when bruised. **FRUIT BODY** To 20cm across; semicircular or fan-shaped bracket with a thin, undulating margin; sometimes umbonate at point of attachment. **UPPER SURFACE** Uneven and wrinkled, with concentric ridges or furrows; zones of ochre and brown with a paler margin when in growth, ageing dark reddish brown. **UNDERSIDE** Labyrinth of variable rounded or very elongated pores, sometimes even gill-like; white or light grey when young, maturing dark reddish brown and bruising brownish red. **HABITAT** Solitary or in tiers on dead wood of deciduous trees, especially willows. **STATUS** Widespread and very common.

Birch Mazegill *Lenzites betulinus* (= *L. betulina*)

Similar to several other brackets, but the gill-like underside is distinctive. **FRUIT BODY** To 9cm across; semicircular or fan-shaped bracket with a thinnish margin, sometimes forming a rosette on horizontal substrates. **UPPER SURFACE** Undulating and concentrically furrowed or grooved, with a downy surface; narrow, concentric zones of cream, ochre and light brown, usually coloured green by algae. **UNDERSIDE** Thin, close, often forked, gill-like ridges of unequal length; cream or ochre. **HABITAT** Solitary or grouped on dead wood of broadleaved trees, usually, but not exclusively, birches. **STATUS** Widespread and common.

Tyromyces chioneus (= *T. albellus*)

Similar to, and confused with, Greyling Bracket (p. 256) but becoming wrinkled and yellowish with age. **FRUIT BODY** To 10cm across; semicircular or fan-shaped bracket with a thin margin; flesh soft at first but becoming hard and brittle. **UPPER SURFACE** White, maturing creamy or ochre, with a suede-like surface at first but developing a wrinkled yellowish coating when dry. **UNDERSIDE** White circular or angular pores. **HABITAT** Solitary or in small groups on dead wood of deciduous trees in woodland and heathland. **STATUS** Occasional in England.

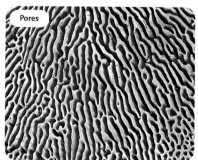

Pores

Oak Mazegill *Daedalea quercina*

Hard woody bracket with a maze of widely spaced, gill-like ridges on the underside. **FRUIT BODY** To 20cm across; semicircular or fan-shaped bracket, broadly attached to the substrate and sometimes with an umbo; margin undulating and sharp. **UPPER SURFACE** Very uneven and covered with lumps and warts, these often in concentric ridges; shades of grey to brown with a paler margin. **UNDERSIDE** Deep, irregular, gill-like ridges, forming into a maze-like pattern; beige. **HABITAT** Dead wood of oaks, rarely Sweet Chestnut. **STATUS** Widespread but occasional.

Perenniporia fraxinea

Similar to and often confused with *Rigidoporus ulmarius* (p. 254) but with a pale pore surface. **FRUIT BODY** To 20cm across; woody, semicircular bracket with a thick rounded margin; upper surface irregular and covered in warts and bumps; variable in colour ranging from cream to light ochre at first, to shades of brown or black at maturity; margin whitish when in growth. **UNDERSIDE** Fine rounded or angular pores; cream, sometimes with a pinkish flush, and bruising brown. **HABITAT** On trunks of deciduous trees, usually low down or at the base. **STATUS** Widespread but uncommon, more frequent in S.

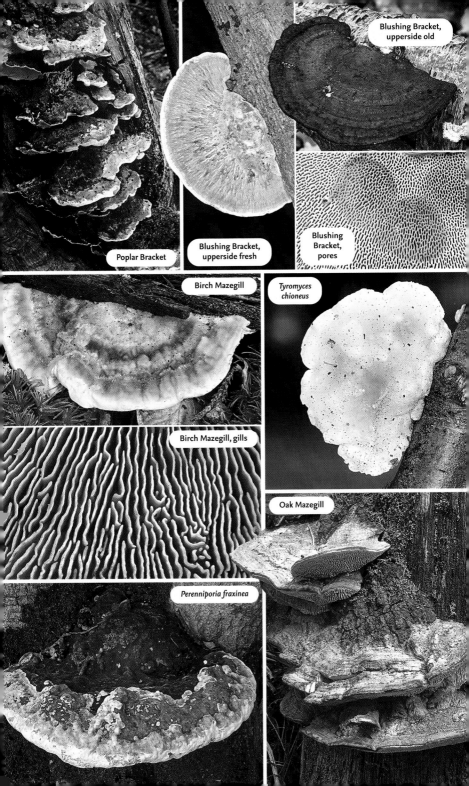

Poplar Bracket

Blushing Bracket, upperside fresh

Blushing Bracket, upperside old

Blushing Bracket, pores

Birch Mazegill

Tyromyces chioneus

Birch Mazegill, gills

Oak Mazegill

Perenniporia fraxinea

Conifer Mazegill *Gloeophyllum sepiarium*

Bracket with a distinctive gill-like underside. **FRUIT BODY** To 12cm across; generally a thin, semicircular or fan-shaped bracket, but sometimes forming a rosette when growing horizontally, or even fully or partially resupinate. **UPPER SURFACE** Uneven with concentric undulations and ridges; indistinct zones of yellow and reddish brown with a yellow margin. **UNDERSIDE** Deep, gill-like ridges, closely spaced and radially arranged in a maze-like pattern; similar colour to the upper surface, with toothed yellowish edges. **HABITAT** Dead wood of conifers. **STATUS** Widespread and common in Scotland; less frequent to S.

Anise Mazegill *Gloeophyllum odoratum*

Conifer Mazegill, gills

Similar in colour to Conifer Mazegill but with distinct pores and a smell of aniseed. **FRUIT BODY** To 20cm across; rounded or cushion-shaped with an inflated margin, or sometimes a semicircular bracket with a thin, undulating margin. **UPPER SURFACE** Yellowish brown with a darker, nearly black centre and an orange margin. **UNDERSIDE** Rounded, angular or elongated pores; golden yellow, maturing brown. **HABITAT** Decayed wood of conifers. **STATUS** Extremely rare.

Hazel Bracket *Skeletocutis nivea* (= *Incrustoporia semipileata*)

Pores

Distinguished by the minute pores on the underside, which are barely visible to the naked eye. **FRUIT BODY** Variable in form; usually a semi-resupinate, fan-shaped bracket to 6cm across, often growing in rows along the substrate; also found in a fully resupinate form. **UPPER SURFACE** Finely downy or smooth, with small warts or pits; uniform white at first, later brown with a broad white marginal zone. **UNDERSIDE** Appearing smooth, but actually covered in minute white or cream rounded pores. **HABITAT** Small branches and twigs of deciduous trees. **STATUS** Widespread and very common.

Skeletocutis amorpha

Bracket with a salmon-coloured underside, in marked contrast to the upper surface. **FRUIT BODY** Variable in form – often fully resupinate or semi-resupinate, or forming a thin, fan-shaped bracket to 2.5cm across. **UPPER SURFACE** Weak zones of greyish white with a paler, fringed margin and a finely felty texture. **UNDERSIDE** Medium-sized rounded or angular pores; whitish at first, then salmon-coloured. **HABITAT** Usually on decayed wood of conifers; rarely with deciduous trees. **STATUS** Widespread and common.

Greasy Bracket *Aurantiporus fissilis*

Similar to *Spongipellis spumeus* but with a strong smell and flesh that turns pink on drying. **FRUIT BODY** To 12cm across; thick, irregular bracket with a convex top; broadly attached to the substrate, sometimes with a stipe-like structure. **UPPER SURFACE** Felty with a spongy texture; white, becoming ochre or brown. **UNDERSIDE** Rounded or angular pores, these sometimes elongated and decurrent; white or cream. **HABITAT** Dead wood of deciduous trees, most frequently on dead trunks of Beech. **STATUS** Occasional in England. **SIMILAR SPECIES** *A. alborubescens* has a deeper pink coloration and stronger smell.

Purplepore Bracket *Trichaptum abietinum* (= *Hirschioporus abietinus*)

Distinctive bracket with a deep purple or brown pore surface. **FRUIT BODY** Generally a fan-shaped bracket to 5cm across with a thin, undulating margin, usually in rows or overlapping

tiers; also resupinate or semi-resupinate, when it can extensively cover the underside of dead wood. **UPPER SURFACE** Bumpy and ridged, with a felty or hairy surface; faintly concentrically zoned in grey, white and pale brown with a pinkish or purple margin; often discoloured green by algae. **UNDERSIDE** Rounded or elongated pores stretching into a net-like pattern; violet, becoming brownish but with margin retaining its original colour. **HABITAT** Usually fallen and decayed wood of conifers. **STATUS** Widespread and very common.

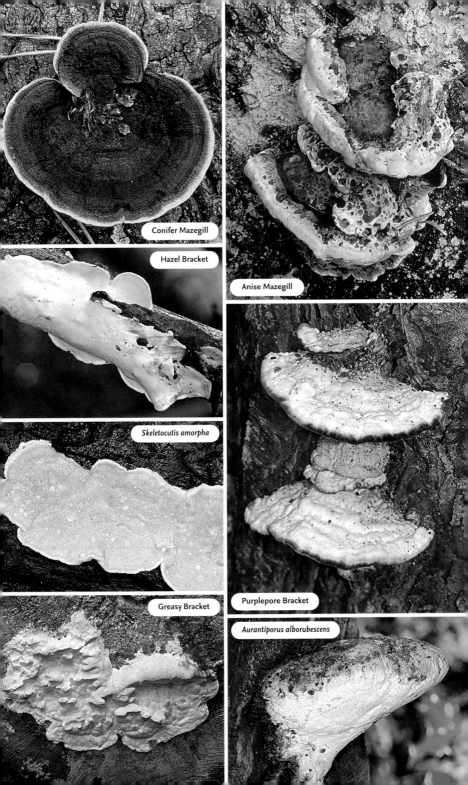

Conifer Mazegill

Anise Mazegill

Hazel Bracket

Skeletocutis amorpha

Purplepore Bracket

Aurantiporus alborubescens

Greasy Bracket

Common Mazegill *Datronia mollis*

Blackish bracket with a contrasting whitish pore surface. **FRUIT BODY** Fully resupinate, or with margin turned up to form undulating, narrow, shelf-like brackets running along the substrate. **UPPER SURFACE** Initially felty; brown, becoming almost black. **UNDERSIDE** Angular pores, but elongated and slit-like when growing vertically, generally forming a maze-like pattern; greyish white but discolouring brown when bruised. **HABITAT** Dead and dying branches of deciduous trees; very rarely with conifers. **STATUS** Widespread and common.

Lumpy Bracket *Trametes gibbosa* (= *Pseudotrametes gibbosa*)

Large, lumpy whitish bracket, frequently stained green by algae. **FRUIT BODY** To 20cm across; semicircular bracket with a thick, umbonate attachment to the substrate; margin thick and rounded but becoming thinner and undulating. **UPPER SURFACE** Very irregular and lumpy, with a soft felty texture; greyish white but flushed ochre and usually stained green. **UNDERSIDE** Rounded or elongated pores in a maze-like pattern; white or cream, maturing ochre. **HABITAT** Dead wood of deciduous trees, usually on stumps and trunks. **STATUS** Widespread and very common.

Pores

Turkeytail *Trametes versicolor* (= *Coriolus versicolor*) (Top 100)

Turkeytail, upperside

Very thin multicoloured bracket. **FRUIT BODY** To 10cm across; semicircular or shell-shaped bracket with a thin, wavy margin; sometimes forms a rosette when growing horizontally. **UPPER SURFACE** Undulating and velvety, with a tough, leathery texture; dries hard and retains its colour for a long time; strongly zoned concentrically in various colours that range from pale beige through to black, usually with a cream margin. **UNDERSIDE** Generally fine, rounded pores, but occasionally angular or elongated and slightly decurrent; whitish or cream, maturing ochre. **HABITAT** Densely fused rows or overlapping tiers on wood of deciduous trees and shrubs; rarely on conifers. **STATUS** Widespread and extremely common.

Hairy Bracket *Trametes hirsuta*

Thicker and paler in colour than Turkeytail but with a distinctly hairy upper surface. **FRUIT BODY** To 10cm across; semicircular or shell-shaped bracket with a thin, undulating margin, sometimes forming rosettes on horizontal surfaces. **UPPER SURFACE** Concentric undulations and ridges covered in silvery hairs, the longest of these around centre; white or cream, sometimes shades of ochre or brown, becoming greyish with age. **UNDERSIDE** Rounded or angular pores; white or cream. **HABITAT** Dead wood of deciduous trees; occasionally on stems of gorse. **STATUS** Occasional in England.

Trametes pubescens

Similar to Hairy Bracket but with a velvety, not hairy, upper surface. **FRUIT BODY** To 10cm across; semicircular or shell-shaped bracket with a thin, sharp margin; occasionally forms rosettes on horizontal surfaces. **UPPER SURFACE** Radially wrinkled and finely silky or velvety but becoming smoother; white or cream with any concentric zones indistinct. **UNDERSIDE** Rounded or angular pores, occasionally elongated; white or ochre. **HABITAT** Dead wood of deciduous trees; occasionally on gorse. **STATUS** Widespread but uncommon.

Trametes ochracea (= *T. multicolor*)

Similar to Turkeytail (*see above*) but paler and thicker, and with a thin orange or brown line between the flesh and pore surface. **FRUIT BODY** To 5cm across; semicircular or shell-shaped bracket, broadly attached to the substrate, usually by a prominent umbo; rarely found in rosette form; margin thin, sharp and undulating. **UPPER SURFACE** Finely velvety with concentric undulations; shades of white, grey or ochre with orange or brown zones. **UNDERSIDE** Fine, rounded or angular pores, sometimes elongated; cream or ochre. **HABITAT** Dead wood of deciduous trees. **STATUS** Widespread but uncommon.

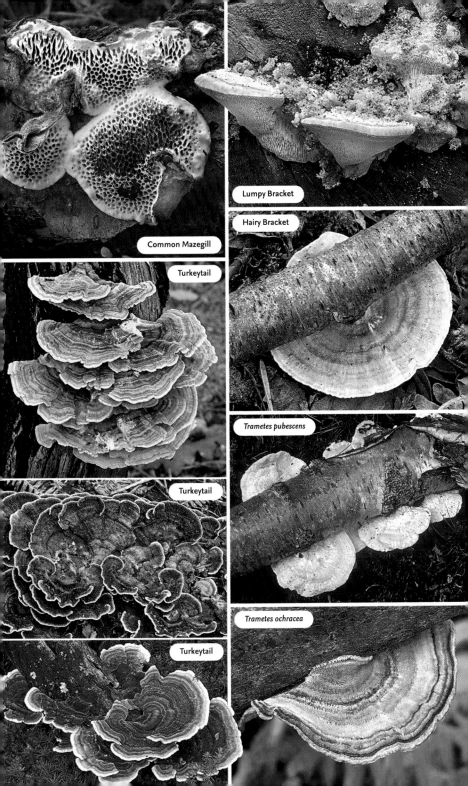

Common Mazegill

Lumpy Bracket

Hairy Bracket

Turkeytail

Trametes pubescens

Turkeytail

Trametes ochracea

Turkeytail

Smoky Bracket *Bjerkandera adusta* (Top 100)

Fleshy bracket with a distinctive dark grey pore surface. **FRUIT BODY** To 6cm across; variable – usually an undulating semicircular or fan-shaped bracket, but also found as a rosette when growing horizontally or fully resupinate. **UPPER SURFACE** Felty, becoming smooth; in concentric zones of ochre to greyish brown but darkening to almost black; marginal zone white when in growth. **UNDERSIDE** Very small, irregularly rounded pores; light grey, becoming darker with age. **HABITAT** Usually in tiers or overlapping groups on dead and dying wood of deciduous trees; rarely with conifers. **STATUS** Widespread and very common.

Brownflesh Bracket *Coriolopsis gallica*

Rare and unusual bracket with a thick, matted hairy surface and brown flesh. **FRUIT BODY** To 15cm across; semicircular or fan-shaped bracket with a sharp, slightly undulating margin; more rarely entirely resupinate. **UPPER SURFACE** Densely hairy, sometimes matted or in tufts, often with longest hairs near point of attachment; ochre to dark brown with a paler, often whitish margin. **UNDERSIDE** Usually angular pores but sometimes rounded or elongated; ochre, maturing darker. **HABITAT** Solitary or in overlapping groups on dead wood of deciduous trees, usually on calcareous soils. **STATUS** Rare to uncommon.

Pink Porecrust *Ceriporiopsis gilvescens*

Resupinate bracket that discolours red on handling. **FRUIT BODY** Fully resupinate, forming irregular patches to 0.5cm thick, and with margin somewhat fringed; surface with medium-sized rounded or angular pores; texture soft and waxy when young but becoming hard and brittle when dry; white at first, sometimes with a pinkish gleam, maturing ochre or reddish brown; distinctly and quickly discolours reddish brown when bruised. **HABITAT** Decayed wood of deciduous trees, especially large trunks of Beech; rarely on conifers. **STATUS** Widespread but occasional in S England; rarer to N.

Green Porecrust *Ceriporiopsis pannocincta*

Yellowish resupinate with green overtones, formerly rare but now spreading widely through S England. **FRUIT BODY** Fully resupinate, forming thin, irregular patches with a fluffy sterile margin, often covering large areas; surface lumpy with fine, rounded pores and a soft texture but drying hard and fissured; yellow with a hint of green and a white margin, becoming brown with age. **HABITAT** Decayed wood of deciduous trees. **STATUS** Uncommon but increasing.

Bleeding Porecrust *Physisporinus sanguinolentus*

Similar in discoloration to Green Porecrust (*see* above) but more rampant and usually found in wet places. **FRUIT BODY** Fully resupinate, densely covering the substrate with irregular patches; surface with coarse rounded or angular pores; texture fluffy, soft and watery, but becoming shrivelled when dry; white or cream, becoming brown, and readily discolouring red, then brown, when bruised. **HABITAT** Decayed and sodden wood, in wet places, occasionally encrusting wet soil and plants. **STATUS** Widespread and common.

Antrodia albida

White resupinate or semi-resupinate bracket whose long tubes are exposed when it grows vertically. **FRUIT BODY** Usually fully resupinate, forming medium-sized patches; when growing on a vertical surface the margin turns up, forming a shallow, shelf-like projection with a felty top; surface with rounded or angular pores in a honeycomb pattern; white or cream, maturing pale buff. **HABITAT** Dead wood of deciduous trees and shrubs, usually on small fallen branches. **STATUS** Common in England, especially in calcareous woodland in S; less frequent elsewhere. **SIMILAR SPECIES** *A. serialis* is associated with conifers.

Pycnoporus cinnabarinus See p. 338.

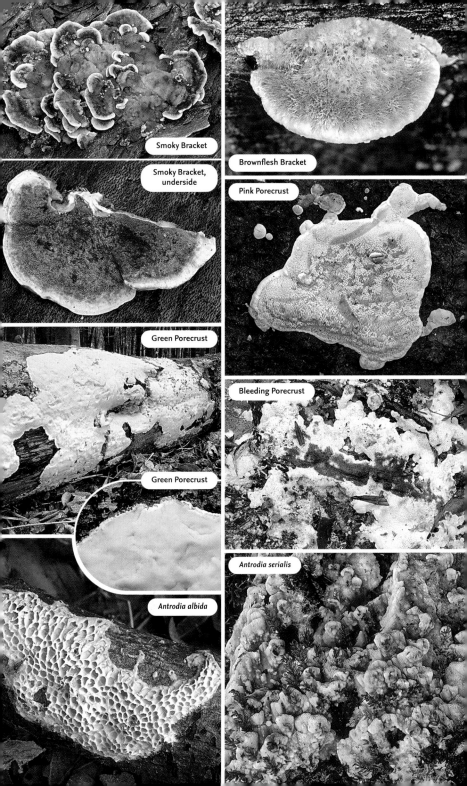

Smoky Bracket

Smoky Bracket, underside

Green Porecrust

Green Porecrust

Antrodia albida

Brownflesh Bracket

Pink Porecrust

Bleeding Porecrust

Antrodia serialis

Waxy Crust *Vuilleminia comedens* (Corticiaceae)

The distinctive feature of this species is the way the bark of the substrate is rolled back as the fruit body expands. **FRUIT BODY** Fully resupinate, forming irregular patches to 13cm across; surface smooth, shiny and waxy when moist; translucent grey with pale pink and lilac tints, but white when dry, before fading and becoming fissured and inconspicuous. **HABITAT** Barkless parts of branches of both living and dead deciduous trees, usually oak. **STATUS** Widespread and very common. **SIMILAR SPECIES** *V. coryli* is usually found on hazel

Cobalt Crust *Terana caerulea* (= *Pulcherricium caeruleum*) (Corticiaceae)

Unmistakable resupinate of a vivid dark blue colour that loses its intensity with age. **FRUIT BODY** Fully resupinate, comprising individual rounded spots, some of which coalesce to form irregular patches; surface smooth or slightly bumpy and finely velvety, with a soft waxy texture; intense dark blue with violet tones and a whitish fringed margin. **HABITAT** Decayed wood of fallen deciduous trees. **STATUS** Occasional in England and Wales; less frequent elsewhere.

Amylostereum chailletii (Stereaceae)

Resupinate, or occasionally semi-resupinate, bracket with a cinnamon pore surface. **FRUIT BODY** Several centimetres in extent; irregular shape and loosely attached to the substrate; surface smooth and dull with small bumps or warts with the margin occasionally lifting to form a narrow shelf; cinnamon or shades of brown becoming greyish with age. **HABITAT** Decayed wood of various conifers and often found in plantations. **STATUS** Widespread and occasional, may be locally common.

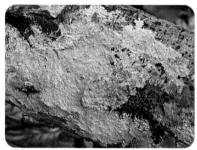

Yellow Cobweb *Phlebiella sulphurea*
(= *Trechispora vaga*) (Xenasmataceae)

Distinctive dirty-yellow resupinate with a finely fringed margin. **FRUIT BODY** Fully resupinate, forming thin, irregular patches that are firmly attached to the substrate; surface parchment-like, with margin developing creeping, thread-like strands of mycelium; dull yellow-brown but sulphur-yellow at edges. **HABITAT** Decayed wood of deciduous trees or, occasionally, conifers, usually on the underside of fallen logs. **STATUS** Widespread and very common.

Toothed Crust *Basidioradulum radula* (= *Hyphoderma radula*) (Schizoporaceae)

Pale, rounded resupinate that resembles an open double flower. **FRUIT BODY** Fully resupinate, comprising individual rounded spots, some of which coalesce to form irregular, elongated patches; surface uneven, with blunt teeth or folds arranged in whorls, and with a soft wax-like texture when fresh; combination of white, cream and ochre with a whitish fringed margin. **HABITAT** Decayed wood of deciduous trees. **STATUS** Widespread but occasional.

Steccherinum fimbriatum (Steccherinaceae)

Resupinate with a distinctly fringed margin. **FRUIT BODY** Fully resupinate, forming fleshy patches several centimetres in extent; margin fringed with conspicuous thin strands of mycelium that spread out like tentacles; surface uneven and wrinkled, with warts or short, blunt teeth, particularly near centre; shades of ochre or greyish brown, often with a lilac tint and a paler margin. **HABITAT** Dead and decayed wood of deciduous trees. **STATUS** Widespread and common in S England, especially in calcareous areas.

Steccherinum ochraceum (Steccherinaceae)

Ochreous bracket with a distinctly spiny spore surface. **FRUIT BODY** Usually fully resupinate but sometimes with margin turning up to form a narrow, shelf-like velvety bracket with an undulating margin; spore surface densely covered with fine, blunt teeth; greyish ochre with a pinkish tint and a whitish margin when in growth. **HABITAT** Decayed wood of deciduous trees. **STATUS** Widespread but occasional; more frequent in S England.

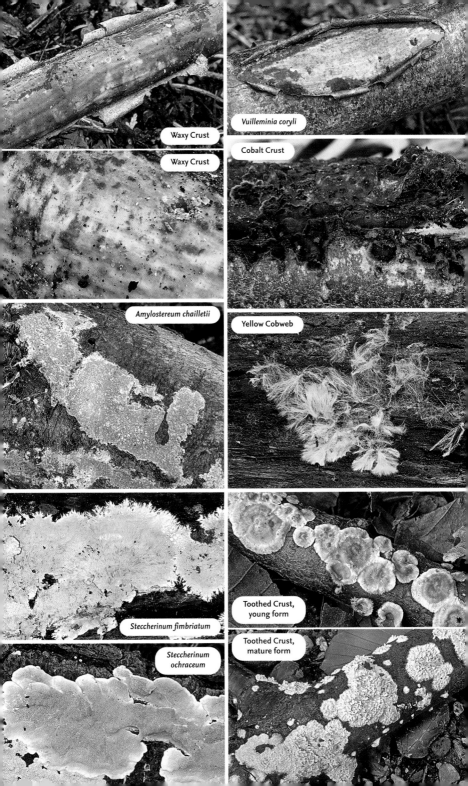

Waxy Crust

Waxy Crust

Vuilleminia coryli

Cobalt Crust

Amylostereum chailletii

Yellow Cobweb

Steccherinum fimbriatum

Steccherinum ochraceum

Toothed Crust, young form

Toothed Crust, mature form

Four of the six British *Ganoderma* brackets are perennial; three build on the previous year's growth and so can attain considerable size. The underside is a thin whitish surface with fine pores that stain dark brown when scratched. The flesh is a rich reddish brown. Some have a shiny upper surface but this can be dulled or obscured by a dusting of fallen spores. The spore print is brown. All are associated with living and dead wood, especially Beech.

Pore surface

Southern Bracket *Ganoderma australe* (= *G. adspersum*) (Top 100)

One of our largest and most common *Ganoderma* species. **FRUIT BODY** To 60cm across; hard and woody semicircular bracket with a thick, inflated margin. **UPPER SURFACE** Smooth but becoming very uneven with knobbly and concentric ridges; reddish brown with a softer creamy margin when in growth. **UNDERSIDE** Fine, rounded pores; white or cream with the same artistic opportunities as Artist's Bracket (*see* below). **HABITAT** Solitary or in small, often tiered, groups on living and dead wood of deciduous trees, usually Beech; rarely on conifers. **STATUS** Widespread and common.

Artist's Bracket *Ganoderma applanatum*

Similar to Southern Bracket but usually thinner, generally with paler spores and with whitish streaks in the brown flesh; often has nipple-like galls on the pore surface. **FRUIT BODY** To 40cm across; usually a hard woody semicircular bracket, but sometimes forms a rosette when horizontal in growth; margin thick and inflated. **UPPER SURFACE** Smooth, then very uneven with knobbly and concentric ridges; shades of brown with a white or cream margin when in growth. **UNDERSIDE** Fine, rounded pores with a thin white or cream surface, rather like an artist's canvas, on which writing or drawings can be scratched. **HABITAT** Solitary or in small, often tiered, groups on living and dead wood of deciduous trees, usually Beech; rarely on conifers. **STATUS** Widespread but occasional.

Lacquered Bracket *Ganoderma lucidum*

Annual *Ganoderma* whose distinct stem can be relatively long when the substrate on which it grows is buried wood. **FRUIT BODY** To 25cm across; kidney-shaped bracket with a lateral stem and a thick, irregular margin. **UPPER SURFACE** Uneven and concentrically grooved with a smooth, highly polished surface; reddish brown, becoming dark purple-brown. **STEM** Dark brown or blackish with a glossy surface. **UNDERSIDE** White or cream fine, rounded pores that become browner. **HABITAT** Roots and stumps of deciduous trees; rarely with conifers. **STATUS** Widespread but occasional.

Beeswax Bracket *Ganoderma pfeifferi*

Similar to Southern Bracket (*see* above) but with a yellowish waxy coating on the upper surface. **FRUIT BODY** To 45cm across; hard woody semicircular or fan-shaped bracket with a blunt margin; broadly attached to the substrate and sometimes with a rudimentary stem. **UPPER SURFACE** Uneven, with concentric ridges and knobs; reddish brown or greyish with a white or cream margin. **UNDERSIDE** White or grey fine, rounded pores, bruising brown. **HABITAT** Trunks and stumps of deciduous trees, usually Beech; rarely on conifers. **STATUS** Widespread but occasional.

Beeswax Bracket

Ganoderma resinaceum

Ganoderma with a shiny upper surface and an inflammable resinous coating. **FRUIT BODY** To 40cm across, semicircular or fan-shaped bracket joined to the substrate only in centre, sometimes with a rudimentary stem; margin rounded and inflated. **UPPER SURFACE** Soft at first but becoming harder and shiny; copper or reddish brown with a yellowish margin; becoming dull and darker with age. **UNDERSIDE** Fine rounded pores; white or cream. **HABITAT** Solitary or in small, overlapping groups on living and dead wood of deciduous trees. **STATUS** Widespread but occasional in England; scarcer elsewhere.

Ganoderma resinaceum

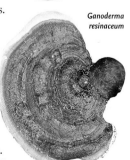

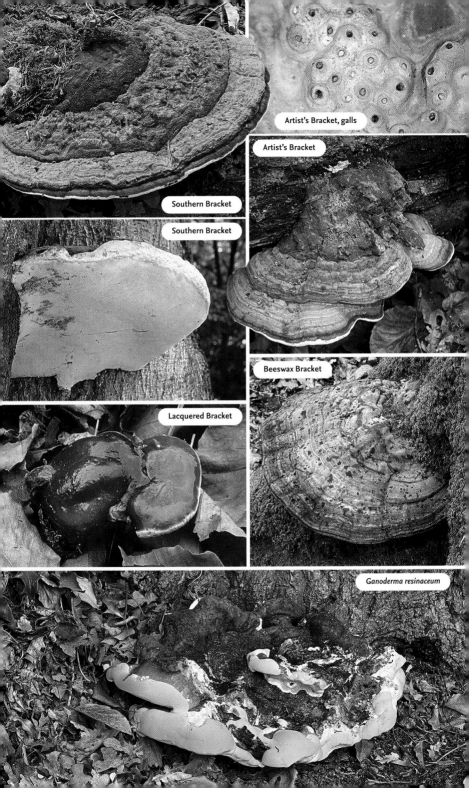

Southern Bracket

Artist's Bracket, galls

Artist's Bracket

Southern Bracket

Beeswax Bracket

Lacquered Bracket

Ganoderma resinaceum

Members of the genus *Geastrum* are bizarre fungi whose fruit bodies start life as onion-shaped 'eggs'. The outer skin splits and spreads into star-like rays, revealing a puffball-like spore sac. Spores exit via a central pore when the sac is impacted (e.g. by raindrops); the pore margins are fibrous or pleated according to the species. The sac is stalked in some species, and in a few the fruit body is hygroscopic – rays enclose the spore sac protectively in dry weather and open when damp. Very small specimens are sometimes found, and both minimum and maximum sizes are given in the text. Most earthstars grow under mature trees; churchyard conifers are particularly rewarding sites. They appear in autumn, although fruit bodies persist intact for several years if dry.

Collared Earthstar *Geastrum triplex*

Our most familiar earthstar. Onion-shaped at first, the outer layer then splitting into 5–7 segments. **RAYS** 5–11cm across when open; fleshy and creamy buff at first, but flesh cracks and browns with age; a fleshy collar usually forms at base of spore sac. **SPORE SAC** 2–4cm across; unstalked, smooth and creamy buff; pore is fibrous. **HABITAT** Grows on free-draining soils rich in humus; sometimes in woodchip-mulched borders. **STATUS** Widespread and locally common, especially in S and E England.

Collared Earthstar

Rosy Earthstar *Geastrum rufescens*

Charming little earthstar. Recalls Collared Earthstar but note the rosy ray colour and short-stalked spore sac. **RAYS** 4–9cm across when open; the 5–8 segments recurve with age and their flesh cracks; a partial collar sometimes forms at base of spore sac. **SPORE SAC** 1–3cm across; buff at first, darkening with age; pore is fibrous. Short stalk is often hard to see. **HABITAT** Grows on free-draining soils, including both chalk and sand. **STATUS** Local, mainly in S and E England.

Sessile Earthstar *Geastrum fimbriatum*

Distinctive little earthstar, onion-like at first but resembling an ornate button when mature. **RAYS** 2–5cm across; creamy white, with 5–9 segments that become neatly recurved. **SPORE SAC** 1–2cm across; grey-buff and slightly downy; pore is fibrous. **HABITAT** In woods on free-draining soils, mainly chalk but sometimes sand. **STATUS** Widespread and fairly locally common in England, mainly in S.

Daisy Earthstar *Geastrum floriforme*

Amazing hygroscopic earthstar. **RAYS** 1.5–2.5 cm across when open flat; 7–10 segments, recurved when damp but folding back to protect spore sac when dry. **SPORE SAC** 8–12mm across; grey-buff and unstalked; pore is fibrous. **HABITAT** In needle litter under mature conifers, mainly Common Yew and Leyland Cypress; often in churchyards. **STATUS** Rare, but may be increasing.

Daisy Earthstar

Four-rayed Earthstar *Geastrum quadrifidum*

Elegant earthstar whose arching rays elevate the fruit body. **RAYS** 1.5–3cm across; 4–5 segments, soon losing fleshy layer. **SPORE SAC** 8–15mm across; stalked and grey-buff; fibrous pore is borne on a raised rim. **HABITAT** Under mature trees (e.g. churchyard Common Yews) on chalk. **STATUS** Rare in S.

Arched Earthstar *Geastrum fornicatum*

Our most impressive earthstar, whose arched rays remain attached to the outer layer of the fruit body, which itself remains attached to the growing substrate. Consequently, the fruit body is up to 10cm tall. **RAYS** 4–8cm across; 4–5 brown segments, fleshy at first. **SPORE SAC** Grey-buff and stalked; pore is fibrous. **HABITAT** Grows under deciduous trees and conifers, particularly ancient Common Yews. **STATUS** Local in S England.

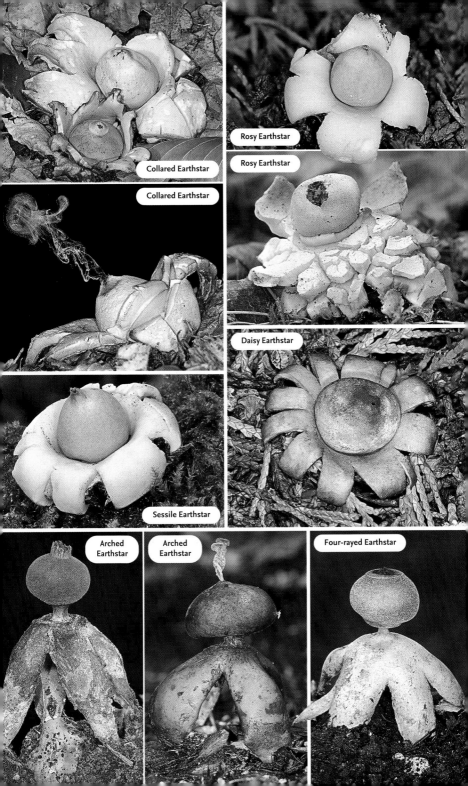

Collared Earthstar

Rosy Earthstar

Rosy Earthstar

Collared Earthstar

Daisy Earthstar

Sessile Earthstar

Arched Earthstar

Arched Earthstar

Four-rayed Earthstar

Striated Earthstar *Geastrum striatum* (Geastraceae)

An elegant earthstar. Its combination of spore sac features (stalk, pleated pore and basal collar) is diagnostic. **RAYS** 3–6cm across when spread, but often recurved; 6–9 segments, these fleshy at first. **SPORE SAC** 1–2cm across; has a buffish powdery layer that is easily rubbed off and soon lost; looks inflated and slightly flattened-spherical when damp, but contracts when dry, showing radiating striations. Basal collar often partly hides stalk. **HABITAT** On free-draining soils, under trees and often in troops. **STATUS** Widespread but scarce, least so in E England.

Beaked Earthstar *Geastrum pectinatum* (Geastraceae)

Similar in many respects to Striated Earthstar but spore sac lacks a basal collar. **RAYS** 3–7cm across when spread flat; 6–9 arching segments, these fleshy at first and not usually as recurved as in Striated Earthstar. **SPORE SAC** 1.5–2.5cm across; usually rather spherical, often with a bluish tint. Stalk relatively long and pleated pore surrounded by a well-defined border. **HABITAT** On free-draining soils, often on sand under conifers, including Common Yew. **STATUS** Widespread but local, mainly in S Britain.

Field Earthstar *Geastrum campestre* (Geastraceae)

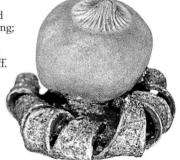

Hygroscopic earthstar. **RAYS** 2–5cm across when spread flat in damp weather; 7–10 segments, tips usually curling; undersurface coated in soil debris. In dry weather, segments curl inwards to base of spore sac. **SPORE SAC** Spherical and coated in grey-buff granules that wear off. Note the short stalk and pale, pleated pore with its well-defined margin. **HABITAT** On free-draining soils, usually under conifers. **STATUS** Rare in S.

Tiny Earthstar *Geastrum minimum* (Geastraceae)

See p. 340.

Dwarf Earthstar *Geastrum schmidelii* (Geastraceae)

See p. 340.

Pepperpot *Myriostoma coliforme* (Geastraceae) *See* p. 338.

Field Earthstar

In the bird's nest fungi (family Nidulariaceae), the fruit body comprises a tiny cup containing what fancifully resembles a clutch of bird's eggs. The 'eggs' are in fact spore packets, liberated by the splashing of heavy raindrops. Bird's nest fungi appear in late summer and autumn.

Field Bird's Nest *Cyathus olla* (Nidulariaceae)

Our most familiar bird's nest fungus. **FRUIT BODY** 1–1.5cm across; tumbler-shaped cup at first; initially covered with a membrane that tears as rim opens and flares, revealing 8–10 flattened, seed-like 'eggs' inside. Inner cup surface is smooth and greyish. **HABITAT** In troops on humus-enriched ground and woodchip mulch. **STATUS** Locally common in England and Wales.

Fluted Bird's Nest *Cyathus striatus* (Nidulariaceae)

Well-marked, cluster-forming bird's nest fungus. **FRUIT BODY** 1–1.5cm tall; cup brown and hairy on outside, smooth inside but with distinct fluting around outer margin and rim; contains 10–15 'eggs'. **HABITAT** Grows on decaying fallen timber and mature woodchip mulch. **STATUS** Widespread, but commonest in England and Wales.

Common Bird's Nest *Crucibulum laeve* (Nidulariaceae)

Cluster-forming bird's nest fungus. **FRUIT BODY** 0.5–1cm tall; cup contains 10–15 'eggs'; initially covered with a speckled buff membrane, the whole resembling a baked soufflé. **HABITAT** Grows in groups on dead wood and mature woodchip mulch. **STATUS** Widespread and common throughout England and Wales. **SIMILAR SPECIES** *Nidularia deformis* has a more irregular 'nest' and is less common.

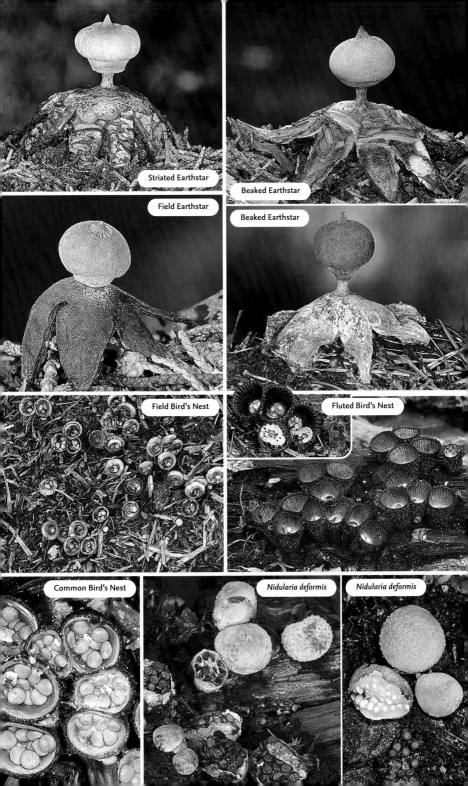

Striated Earthstar

Beaked Earthstar

Field Earthstar

Beaked Earthstar

Field Bird's Nest

Fluted Bird's Nest

Common Bird's Nest

Nidularia deformis

Nidularia deformis

Puffballs are distinctive fungi whose spores mature as a ball-like mass inside a rounded spore sac. On reaching maturity the spores are liberated in several ways: in *Handkea* and *Calvatia*, the fruit body disintegrates, exposing the spore mass to the elements; in other genera, especially *Lycoperdon*, the spores exit via an apical pore on the fruit body; and with *Bovista*, the outer skin disintegrates and the fruit body becomes detached from the substrate, allowing it to roll around in the wind. Puffballs appear in late summer and autumn.

Pestle Puffball *Lycoperdon excipuliforme (= Handkea excipuliformis)*
Impressive pestle-shaped puffball whose spore sac is borne on a tall, stout stalk. **FRUIT BODY** To 20cm tall; creamy white at first and covered in spiny warts, becoming brown and losing warts as it ages; apex of pestle head splits to expose spore mass. **HABITAT** Woodland, hedgerows and, occasionally, grassland. **STATUS** Widespread and common.

Mosaic Puffball *Lycoperdon utriforme (= Handkea utriformis)*
Similar to Pestle Puffball but with a shorter stalk and more textured surface. **FRUIT BODY** To 15cm across; white, covered in a mosaic-like pattern of warty scales that wear off to expose the brown skin below; in maturity, apex of spore sac disintegrates, exposing spore mass within. **HABITAT** Unimproved grassland. **STATUS** Widespread but occasional.

Mosaic
Puffball

Common Puffball *Lycoperdon perlatum* (Top 100)
Familiar woodland puffball, sometimes confused with Pestle Puffball (*see* above) but with a distinctive apical pore. **FRUIT BODY** To 9cm tall; pear-shaped with a rounded head and thick, stumpy stalk; whitish, covered in conical spines that are shed to leave a distinct reticulate pattern; becomes brown with age. **HABITAT** All types of woodland. **STATUS** Widespread and common.

Dusky Puffball *Lycoperdon nigrescens (= L. foetidum)* (Top 100)
Similar to Common Puffball but darker overall, and with more persistent, darker spines and an unpleasant gassy smell. **FRUIT BODY** To 5cm tall; pale brown, even when young, and covered in sooty-brown conical spines that persist into maturity. **HABITAT** On rich, free-draining ground, often on sandy acid soils. **STATUS** Widespread and common.

Stump Puffball *Lycoperdon pyriforme* (Top 100)
Familiar woodland puffball with a pear- or lightbulb-shaped fruit body. **FRUIT BODY** To 6cm tall; whitish at first and covered in warty spines, becoming brown and papery in maturity, with little or no patterning, and losing spines. **HABITAT** Woodland, growing in troops on dead, sometimes part-buried, wood. **STATUS** Widespread and very common.

Common
Puffball

Spiny Puffball *Lycoperdon echinatum*
Distinctive spiny puffball with the appearance of a tiny, rolled-up hedgehog. **FRUIT BODY** To 6cm across; rounded; brown, covered at first in a dense coat of groups of relatively long spines that cross at the tips, these wearing away in time. **HABITAT** Mature woodland on calcareous soils, usually under Beech. **STATUS** Widespread but occasional; most common in S.

Flaky Puffball *Lycoperdon mammiforme*
Distinctive puffball whose mature colour and surface texture are strangely skin-like in appearance. **FRUIT BODY** To 6cm tall; pear-shaped and usually with a small umbo; covered at first with a whitish veil-like outer layer that soon flakes away, revealing a rather smooth surface and pinkish-buff colour. **HABITAT** Mature woodland on calcareous soils, often under Beech. **STATUS** Widespread but scarce; recorded most often in S and W England.

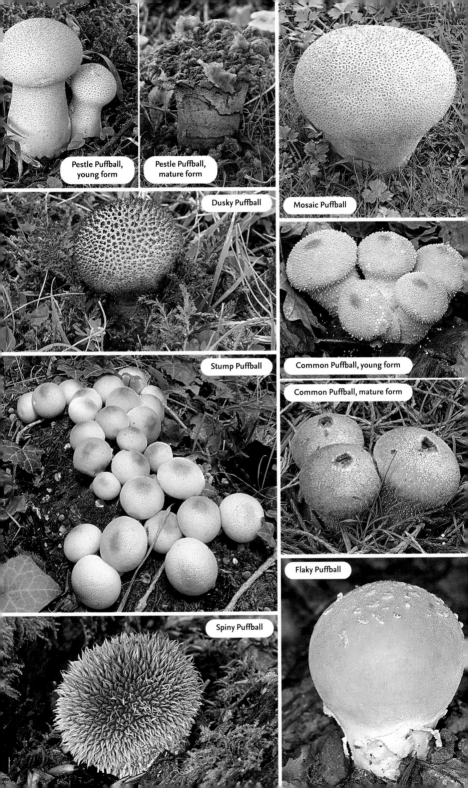

Pestle Puffball, young form

Pestle Puffball, mature form

Mosaic Puffball

Dusky Puffball

Stump Puffball

Common Puffball, young form

Common Puffball, mature form

Flaky Puffball

Spiny Puffball

Soft Puffball *Lycoperdon molle*

Puffball with a soft texture. **FRUIT BODY** To 5cm tall; pyriform or top-shaped with a short, but pronounced, stem; surface with soft or downy short spines that rub off leaving a smooth texture; cream, yellow-brown or milky-coffee coloured, maturing darker. **HABITAT** Occasionally solitary, but usually grouped in soil in deciduous or mixed deciduous and coniferous woodland. **STATUS** Widespread and fairly common, more frequent in S.

Grassland Puffball *Lycoperdon lividum*

Widespread grassland puffball with a distinct stalk-like base. **FRUIT BODY** To 4cm tall; the spherical head, containing the spore mass, is borne on a stout, tapering stalk; whitish at first, browning with age; coated in warts rather than spines, these wearing off to leave a mosaic-patterned papery skin. **HABITAT** Found in short grassland on free-draining soils, especially calcareous sites on dunes and downs. **STATUS** Widespread and locally common.

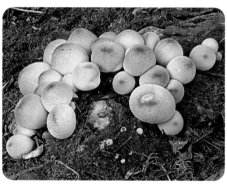

Soft Puffball

Soft Puffball *Lycoperdon umbrinum*

Rather dark puffball. **FRUIT BODY** To 4cm across; the rounded head, containing the spore mass, is borne on a stout, tapering stalk; pale brown at first and covered in dense, fine spines that wear away to reveal a papery skin. **HABITAT** Grows on free-draining acid soils, mostly under conifers and often in mature plantations. **STATUS** Widespread but generally rare.

Meadow Puffball *Lycoperdon pratense*
(= *Vascellum pratense*)

Familiar species, both as a mature puffball and as the odd-looking, plug-like, stumpy stalk that persists after the spores have dispersed. **FRUIT BODY** To 3.5cm tall; flat-topped sphere with a thick, tapering base; white or ochre; scurfy at first but becoming brown and smooth with age. Spore mass separated from base by a skin-like membrane (seen in cross-section). **HABITAT** Meadows, lawns and other grassy places. **STATUS** Widespread and common.

Grey Puffball *Bovista plumbea*

Recalls Meadow Puffball, alongside which it often grows, but not flat-topped and further distinguished by the absence of a membrane separating the spore mass from the base. In maturity, *Bovista* fruit bodies detach from the substrate and blow around in the wind. **FRUIT BODY** To 2.5cm across; spherical; white and smooth at first but the outer layer is soon shed, revealing the lead-grey spore sac, which has an irregular apical slit. **HABITAT** Short, unimproved grassland; rarely in woodland. **STATUS** Widespread and common.

Brown Puffball *Bovista nigrescens*

Similar to Grey Puffball but larger and with a rich brown (not grey) mature spore sac. **FRUIT BODY** To 6cm across; spherical; white and smooth at first, but outer layer soon lost, revealing a dark brown underskin with an irregular apical slit. **HABITAT** Grassland and woodland on free-draining, often acid, soils. **STATUS** Widespread and common; most frequent in N.

Giant Puffball *Calvatia gigantea*

Truly impressive fungus, often 2–5kg in weight (sometimes even heavier) when fully formed. **FRUIT BODY** To 70cm across; irregularly spherical; white and smooth at first, but browns and disintegrates as the spore mass inside matures. Spore dispersal is achieved through the disintegration of the whole fruit body. **HABITAT** Grows in troops in grassy habitats (especially on nitrogen-enriched soils), compost heaps and, occasionally, light woodland. **STATUS** Widespread but occasional.

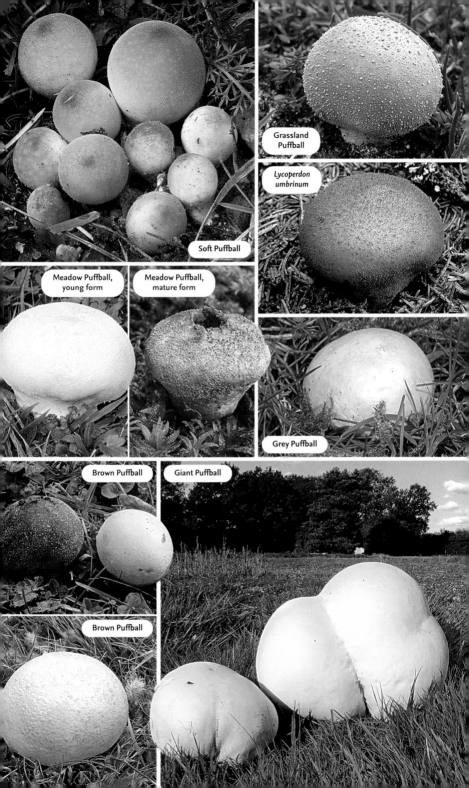

Soft Puffball

Grassland Puffball

Lycoperdon umbrinum

Meadow Puffball, young form

Meadow Puffball, mature form

Grey Puffball

Brown Puffball

Giant Puffball

Brown Puffball

Earthballs are tough, puffball-like fungi whose fruit body lacks the apical opening seen in the true puffballs. Instead, spore release is achieved when the fruit body splits widely and irregularly on maturity. Some *Scleroderma* species form mycorrhizal associations with tree roots, and the fruit bodies remain firmly attached in maturity. Only one stalkball species is regularly encountered in Britain; its fruit body comprises a puffball-like spore sac with an apical opening, borne on a slender stem. The Barometer Earthstar is unrelated to true earthstars. In this species, hygroscopic 'arms' envelop and protect the puffball-like spore sac in dry weather but spread and expose it when wet.

Common Earthball *Scleroderma citrinum* (Sclerodermataceae) (Top 100)
Our most familiar earthball. **FRUIT BODY** To 10cm across; irregularly flattish spherical; thick, tough skin is yellowish buff and adorned with coarse scales; fruit body tears open on maturity, revealing blackish spore mass. **HABITAT** Favours acid soils with deciduous trees, usually oak, Beech or birches. **STATUS** Widespread and common.

Leopard Earthball *Scleroderma areolatum* (Sclerodermataceae)
Small, well-marked earthball, usually with a distinct but short stem. **FRUIT BODY** To 3cm across; rounded, with yellowish-brown skin and covered in small, dark scales, each with a ring zone, these rubbing off to reveal a leopard-skin pattern. Mature fruit body tears open irregularly at apex, revealing the purplish-black spore mass. **HABITAT** Soil or grass in woodland, often in the vicinity of oaks. **STATUS** Widespread but occasional.

Leopard Earthball

Scaly Earthball *Scleroderma verrucosum* (Sclerodermataceae)
Very similar to, and often confused with, Leopard Earthball but generally distinguished by its long stem. **FRUIT BODY** To 5cm across; roughly spherical, with yellowish-brown tough skin and small, dark scales; fruit body tears open irregularly at apex on maturity. **HABITAT** Rich sandy soils, often on wooded heaths. **STATUS** Widespread and common.

Scaly Earthball

Scleroderma cepa (Sclerodermataceae)
Sessile, tough, near-spherical earthball. **FRUIT BODY** To 6cm across; smooth, yellowish brown and rather onion-like when young, with irregular plates forming on skin and cracking with age; tears open on maturity. **HABITAT** Sandy soils in woodland, often with oak. **STATUS** Widespread but occasional.

Winter Stalkball *Tulostoma brumale* (Tulostomataceae)
Distinctive lollipop-shaped puffball. **FRUIT BODY** To 3cm tall; comprises a spherical head (containing the spores) with an apical opening, borne on a long stalk; whitish yellow, but binding sand often masks the colour. Fruit body develops underground and emerges only when mature, making it easiest to spot in the winter or spring. **HABITAT** Mainly on calcareous dunes; sometimes on old walls with lime mortar. **STATUS** Widespread but occasional; rarely at non-coastal downland sites. **SIMILAR SPECIES Scaly Stalkball** *T. melanocyclum* has a reddish-brown stipe and is very rare.

Barometer Earthstar *Astraeus hygrometricus* (Astraeaceae)
Truly bizarre, hygroscopic fungus whose fruit body can persist for several years. Easily overlooked in dry weather, as the arms fold tightly around the spore sac, which itself shrivels. **FRUIT BODY** 6–9cm across when fully spread; comprises a central sac-like body, containing the spores and with an apical pore, surrounded by 7–13 radiating leathery arms; yellowish tan, becoming dark brown. **HABITAT** Usually on sandy soils with deciduous trees. **STATUS** Widespread but rare, although possibly overlooked. A prize find for any mycologist.

Barometer Earthstar

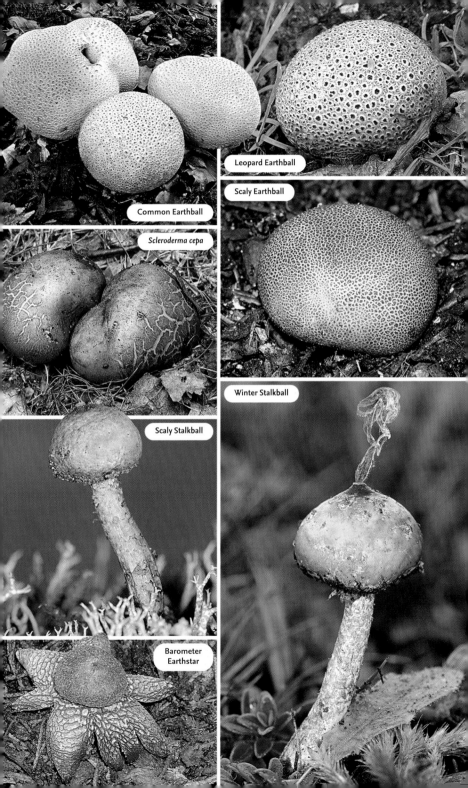

Common Earthball

Leopard Earthball

Scaly Earthball

Scleroderma cepa

Scaly Stalkball

Winter Stalkball

Barometer Earthstar

Coral Tooth *Hericium coralloides* (Hericiaceae)
Arguably our most beautiful fungus, which, as its name
implies, has the appearance of a cascade of white coral.
FRUIT BODY To 25cm across and 60cm high; comprises
a basal trunk that divides into multiple-forked branches,
from which clusters of spines hang down from the
underside, the spines tending to be longest towards the
base; branches somewhat compressed, with a soft,
brittle texture; trunk short and fleshy, usually obscured
by dense network of branches; entire fruit body white or
cream. **HABITAT** Living and dead wood of deciduous trees, usually
dead standing trunks of Beech and Ash. **STATUS** Rare.

Coral Tooth

Bearded Tooth *Hericium erinaceus* (Hericiaceae)
Large, rounded clump of very long, hanging spines. **FRUIT BODY**
To 8cm across; comprises a base from which a pendulous clump of
spines emerges, forming a compact, spiky ball; spines to 6cm long,
thick but progressively thinner towards the sharp tip; texture soft
and elastic; white, discolouring yellowish with age. **HABITAT** Living
and dead trunks of deciduous trees, usually Beech. **STATUS** Rare;
virtually confined to S and W England and Wales.

Tiered Tooth *Hericium cirrhatum* (= *Creolophus cirrhatus*) (Hericiaceae)
Tiered bracket, similar to Bearded Tooth but more irregular in
shape and with much shorter spines. **FRUIT BODY** To 20cm across;
tiers of irregular semicircular or fan-shaped, bracket-like structures
with long spines hanging from the underside; decurrent on the

Bearded Tooth

substrate. **UPPER SURFACE** Irregular, with a felty or scaly texture, and with scattered, erect,
sterile teeth near margin; white or pale ochre. **UNDERSIDE** Dense clumps of hanging
spines to 1.5cm long; white or cream, discolouring ochre. **HABITAT** Fallen and decayed
wood of deciduous trees. **STATUS** Widespread but uncommon to rare.

Aromatic Earthfan *Sistotrema confluens* (Sistotremataceae)
Small white toothed fungus of very irregular shape. **FRUIT BODY** Semicircular or rosette-
shaped bracket with an irregular margin; joined to the substrate by a primitive stem-like
attachment. **UPPER SURFACE** Soft, with a felty texture; white or cream, discolouring ochre.
UNDERSIDE Densely covered in short, blunt teeth; white, discolouring ochre. **HABITAT**
Encrusting soil, moss, leaf litter and twiggy debris. **STATUS** Widespread but rare.

Ear Pick Fungus *Auriscalpium vulgare* (Auriscalpiaceae)
Inconspicuous, small, toothed fungus growing out of pine cones. **FRUIT BODY** Comprises
a domed cap with a long, eccentrically attached stem. **CAP** To 2cm across; kidney-shaped
and indented at the point of stem attachment; tough, with the surface velvety or covered
in stiff hairs but becoming smoother with age; light to dark brown. **UNDERSIDE** Long,
pointed spines, sometimes slightly decurrent; greyish brown. **STEM** To 6cm
long; slender, eccentric and cylindrical or tapering upward; dark brown
with a velvety surface. **HABITAT** Exclusively on pine cones that are usually
fully or partially buried. **STATUS** Widespread and common.

Ear Pick
Fungus

Beefsteak Fungus *Fistulina hepatica* (Fistulinaceae)
Soft reddish bracket fungus that periodically exudes blood-like droplets of
moisture. **FRUIT BODY** To 25cm across; rounded at first but developing into a
tongue-shaped bracket, sometimes attached to the substrate by a short, lateral
stipe; margin inflated at first but becoming thinner. **UPPER SURFACE** Convex
or flat, sometimes depressed at point of attachment; sticky, with a rough
surface like fine sandpaper and punctuated by fine pores; texture soft and
succulent; orange-red, maturing purple-brown. **UNDERSIDE** Rounded pores;
white or yellowish, bruising and maturing reddish. **HABITAT** Deciduous
trees, usually oaks. **STATUS** Widespread and very common.

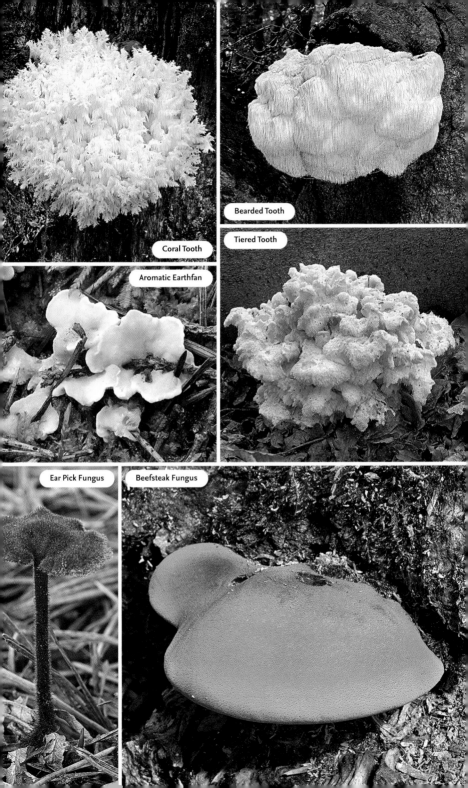

Coral Tooth

Bearded Tooth

Tiered Tooth

Aromatic Earthfan

Ear Pick Fungus

Beefsteak Fungus

Phellinus species are variable in form, with some typically bracket-shaped and others resupinate. Most, however, are perennial woody brackets that develop large fruit bodies as each new season's growth is added. They generally persist in a hard, dry state throughout the year. The upper surface is often cracked and fissured with age, and overgrown with mosses and algae. The bracket species are mostly found on upright trunks of deciduous and conifer trees, with some host-specific. Those that are resupinate are normally found on horizontal substrates. The spore print is mostly white or pale yellow.

Willow Bracket *Phellinus igniarius*

Large blackish perennial bracket that can persist for several years. **FRUIT BODY** To 40cm across; hoof-shaped or semicircular bracket, very broadly attached to the substrate, usually by a thick umbo; margin inflated when young. **UPPER SURFACE** Hard and woody, with broad, concentric undulations and ridges, and becoming fissured with age; dull blackish grey with a reddish-brown margin when in growth. **UNDERSIDE** Fine, rounded pores; reddish brown, maturing greyish. **HABITAT** Typically on living trunks of willows; occasionally on other deciduous trees. **STATUS** Widespread but occasional.

Aspen Bracket *Phellinus tremulae*

Similar to Willow Bracket but confined to Aspen in Britain. **FRUIT BODY** To 25cm across; irregular hoof-shaped bracket, usually with a slanted pore surface and sometimes decurrent; triangular in cross-section and broadly attached to the substrate. **UPPER SURFACE** Woody and crusty, with concentric ridges and undulations, becoming fissured or cracked with age; greyish black with a whitish or cream marginal zone. **UNDERSIDE** Fine, rounded or angular pores; grey-brown, maturing tobacco-brown. **HABITAT** Aspen. **STATUS** Rare; only from Scotland.

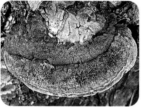

Phellinus pini

Phellinus with a hairy surface, found on pine. **FRUIT BODY** To 20cm across; hoof-shaped or semicircular bracket with a thin margin. **UPPER SURFACE** Hard, woody and concentrically ridged, with a hairy texture; tawny or reddish-brown zones with a paler margin, ageing blackish brown. **UNDERSIDE** Fine, circular or angular pores; dirty white or yellowish, maturing brown. **HABITAT** Living trunks of pines, usually Scots Pine. **STATUS** Uncommon; more frequent in Scotland.

Rusty Porecrust *Phellinus ferruginosus*

Familiar rust-brown velvety resupinate, common on fallen branches and logs of deciduous trees. **FRUIT BODY** Fully resupinate, starting as small, rounded cushions that coalesce to form

irregular patches to 0.5cm thick that can cover a large area. Surface with small, rounded pores; uneven, with bumps and warts, and with a soft velvety texture but ageing hard and brittle; rust-brown or ginger, with a paler felty margin. **HABITAT** Dead wood of deciduous trees. **STATUS** Widespread and common. **SIMILAR SPECIES Cinnamon Porecrust** *P. ferreus* is just as common and found in the same habitat, but is sometimes paler. A microscopic examination of the spores is necessary to separate the two with certainty.

Cinnamon Porecrust

Phellinus lundellii

Similar to Aspen Bracket (*see* above) in form but virtually confined to birches. **FRUIT BODY** To 30cm across; semi-resupinate or hoof-shaped, with a narrow projection from the substrate and a long, sloping pore surface; margin often inconspicuous, or sometimes inflated when in growth. **UPPER SURFACE** Hard and woody, with concentric ridges and lumps, becoming fissured with age; dark grey or black. **UNDERSIDE** Yellowish or brown rounded pores, sometimes elongated when running down the substrate. **HABITAT** Solitary or several joined together on decayed wood of deciduous trees, virtually exclusively birches. **STATUS** Very rare.

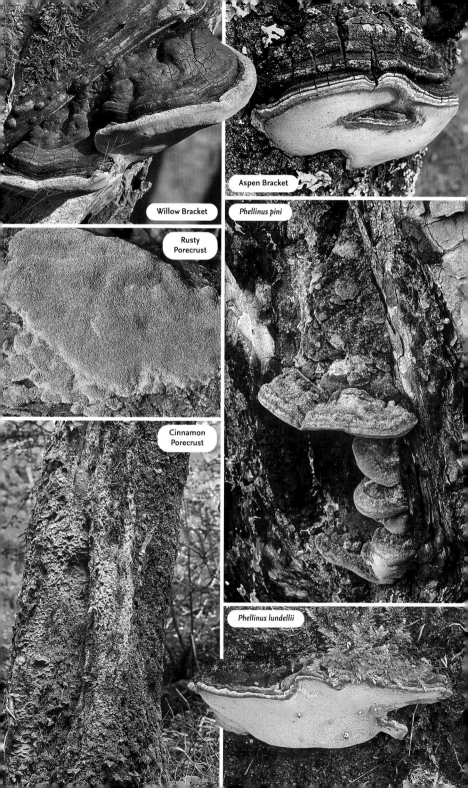

Willow Bracket

Aspen Bracket

Phellinus pini

Rusty Porecrust

Cinnamon Porecrust

Phellinus lundellii

Robust Bracket *Phellinus robustus*
Similar in form to Aspen Bracket (p. 282) but generally associated with oaks. **FRUIT BODY** To 25cm across; semicircular or hoof-shaped bracket, usually with a slanted pore surface; broadly attached to the substrate and triangular in cross-section. **UPPER SURFACE** Hard and woody, with concentric undulations and ridges, becoming fissured with age; rust or grey-brown with a yellow-brown growth zone, darkening to greyish black with age. **UNDERSIDE** Very small, rounded pores; yellowish or rust-brown. **HABITAT** Generally solitary but sometimes in small groups on ancient oak. **STATUS** Uncommon to rare.

Phellinus hippophaeicola
One of the smaller *Phellinus*, with a velvety cap. In Britain it is confined to Sea-buckthorn. **FRUIT BODY** To 6cm across; semicircular or hoof-shaped bracket, sometimes circular when growing on a horizontal branch. **UPPER SURFACE** Smooth or, occasionally, with concentric undulations; texture velvety or furry, becoming smoother with age; fawn, yellowish or rust-brown, ageing greyish. **UNDERSIDE** Fine, rounded pores; rust- or dark brown. **HABITAT** Living wood of Sea-buckthorn. **STATUS** Uncommon.

Tufted Bracket *Phellinus torulosus*
Cushion-shaped bracket, usually found grouped on deciduous trees. **FRUIT BODY** To 20cm across; irregular cushion-shaped or semicircular bracket with an inflated, rounded margin. **UPPER SURFACE** Hard, woody and undulating, with numerous bumps and outgrowths; reddish brown, becoming almost black with age. **UNDERSIDE** Fine pores; cream or ochre with rusty streaks and blotches. **HABITAT** Usually grouped or overlapping on deciduous trees, particularly oaks. **STATUS** Uncommon; most frequent in S.

Phellinus cavicola
Rare resupinate, distinguished from other *Phellinus* by its rust-coloured spore print. **FRUIT BODY** Fully resupinate, forming large, irregular patches with a felty margin; surface with large, round or angular pores and small lumps or outgrowths; ochre or brown, with a paler margin when in active growth. **HABITAT** Dead wood of deciduous trees in old woodland, usually on Beech and often inside hollow trunks and stumps. **STATUS** Rare.

Cushion Bracket *Phellinus pomaceus* (= *P. tuberculosus*)
Dull-coloured *Phellinus* that is somewhat variable in form. **FRUIT BODY** To 10cm across; hoof-shaped bracket with a slightly inflated margin, but sometimes a rounded or cushion-shaped bulge; also found in semi- or fully resupinate forms, with the pore surface running down the substrate. **UPPER SURFACE** Finely velvety at first but becoming smoother and eventually fissured; fawn or greyish brown with a cinnamon margin when in growth. **UNDERSIDE** Fine, rounded or angular pores, sometimes decurrent onto the substrate; cinnamon, maturing greyish brown. **HABITAT** Wood of deciduous trees, typically species of *Prunus* and consequently sometimes found in suburban gardens and roadsides. **STATUS** Widespread but occasional.

Phylloporia ribis (= *Phellinus ribis*)
Plate-like bracket, usually encasing the base of the substrate on which it grows. **FRUIT BODY** To 15cm across; irregularly circular or plate-shaped bracket with an undulating and, sometimes, inflated margin. **UPPER SURFACE** Lumpy, with concentric ridges and undulations; rust-brown, becoming hard and blackish with age, and with a cinnamon margin when in growth. **UNDERSIDE** Fine, rounded pores; cinnamon or reddish brown. **HABITAT** Several fruit bodies usually join and overlap at the base of deciduous trees and shrubs, typically Spindle and currant bushes. **STATUS** Frequent in S England.

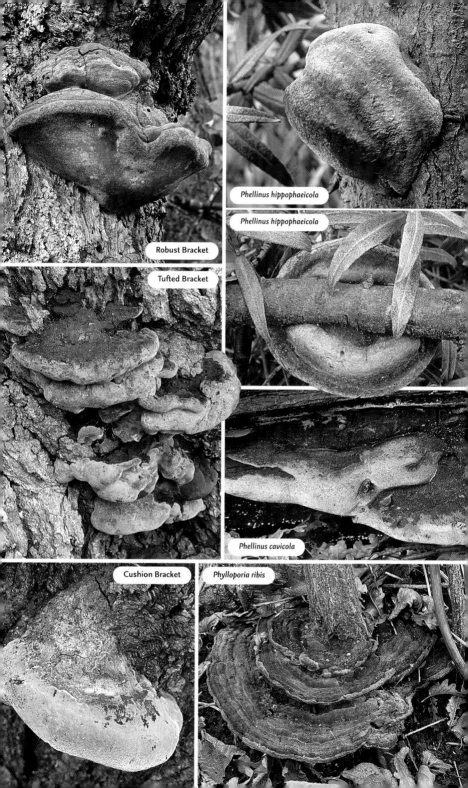

Robust Bracket

Tufted Bracket

Cushion Bracket

Phellinus hippophaeicola

Phellinus hippophaeicola

Phellinus cavicola

Phylloporia ribis

Inonotus species are mostly large and typically bracket-shaped, and have brown flesh. They are found on a range of deciduous trees; some are host-specific or have a strong preference for one particular species. Some exude droplets of moisture during damp weather. The underside generally has fine pores that are iridescent; a distinctive feature is the manner in which the pores shine silvery when tilted or angled towards the light. They produce white, yellowish or brown spores.

Clustered Bracket *Inonotus cuticularis*

Rusty-coloured bracket, usually associated with Beech. **FRUIT BODY** To 20cm across; fan-shaped bracket with a thin, irregular margin. **UPPER SURFACE** Lined and pitted with concentric undulations; initially soft and fleshy with a velvety or hairy surface, but smoother, hard and fibrous with age; apricot, then reddish brown with a paler margin and ageing dark brown. **UNDERSIDE** Fine, rounded or irregular pores; yellowish ochre, maturing brown. **HABITAT** Solitary or, more usually, in overlapping groups on living and dead wood of deciduous trees, particularly Beech. **STATUS** Widespread but occasional. **SIMILAR SPECIES Alder Bracket** *I. radiatus* is smaller, more common and usually found on Common Alder.

Alder Bracket

Shaggy Bracket *Inonotus hispidus*

Blackish bracket with a matted hairy upper surface. **FRUIT BODY** To 30cm across; semicircular or fan-shaped bracket, initially with an inflated margin, then thinner but blunt. **UPPER SURFACE** Soon developing bristly, matted hairs, but becoming smoother; reddish brown with a yellowish margin and ageing blackish. **UNDERSIDE** Rounded or angular pores; pale ochre, maturing brown. **HABITAT** Usually solitary on living and dead wood of deciduous trees, frequently on Ash and apples. **STATUS** Common in S England; widespread but less frequent elsewhere.

Oak Bracket *Inonotus dryadeus*

Large, fleshy bracket associated with oaks. Probably 'weeps' more than any other *Inonotus*. **FRUIT BODY** To 25cm across; thick, cushion- or hoof-shaped bracket with a broad, rounded margin. **UPPER SURFACE** Uneven, pitted and lumpy, with a felty texture; cream, then orange-brown or darker with a paler margin. **UNDERSIDE** Fine, rounded or angular pores; greyish white, maturing yellowish or reddish brown. **HABITAT** Solitary or in groups on oaks, often at the base. **STATUS** Widespread but occasional.

Inonotus obliquus

The life cycle of this fungus involves two distinct stages. The first stage produces non-viable (asexual) spores and is called the 'imperfect state'. Later, on a distinct and separate fruit body, sexual spores are produced; this is known as the 'perfect state'. **IMPERFECT FRUIT BODY** To 40cm across; irregular, crusty black lump with a hard, brittle texture, reminiscent of charred wood or charcoal. **PERFECT FRUIT BODY** Fully resupinate and inconspicuous, comprising small patches located in cracks on the surface of the imperfect fruit body or under the bark of the host tree; surface with small, angular or elongated pores; whitish, maturing brown. **HABITAT** Usually on the living trunks of birches, rarely on other deciduous trees. **STATUS** Common in Scotland; rare elsewhere.

Inonotus nodulosus

Variable semi-resupinate bracket, confined to Beech. **FRUIT BODY** To 3cm across; generally resupinate, with the margin turning up to form narrow, shelf-like brackets, many coalescing to form large patches; often barely projecting and forming only knobs or bumps. **UPPER SURFACE** Irregular and undulating with a wrinkled and velvety texture; brown, in indistinct zones, with a paler margin but becoming darker with age. **UNDERSIDE** Decurrent rounded or angular pores, occasionally with small outgrowths or bumps; white or ochre, ageing brown. **HABITAT** Dead wood (usually fallen branches) of Beech. **STATUS** Uncommon to rare.

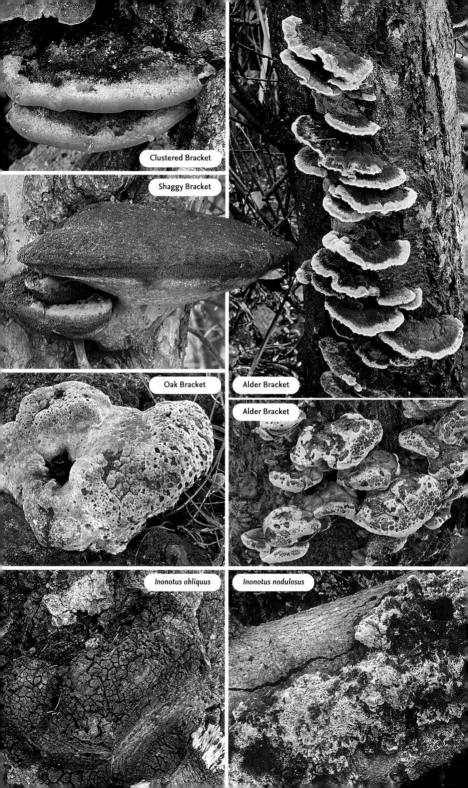

Clustered Bracket

Shaggy Bracket

Oak Bracket

Alder Bracket

Alder Bracket

Inonotus obliquus

Inonotus nodulosus

Oak Curtain Crust
Hymenochaete rubiginosa (Hymenochaetaceae)
Very undulating, semi-resupinate bracket in a distinctive tobacco-brown colour. **INDIVIDUAL FRUIT BODY** To 4cm across; semi-resupinate, with edge turned up to form a shelf-like bracket with a thin, wavy margin; usually found growing together in large, densely packed rows or overlapping tiers. **UPPER SURFACE** Tough and leathery with concentric ridges, initially with a velvety surface that later becomes smooth; concentric zones of reddish brown with a paler margin, but blackening with age. **UNDERSIDE** Uneven, smooth and lacking pores; dull orange-brown, maturing dark brown with a paler edge. **HABITAT** Dead wood of deciduous trees, usually the stumps and logs of oaks. **STATUS** Widespread and very common.

Glue Crust *Hymenochaete corrugata* (Hymenochaetaceae)
Resupinate fungus with very fine, bristle-like hairs (setae) on the pore surface, visible only with a hand lens. Similar to resupinate species of *Peniophora* (p. 292), but these lack setae. **FRUIT BODY** Fully resupinate and tightly attached to the substrate, forming irregular, crusty patches that cover a large area; surface uneven and usually fissured like crazy-paving, with fine hairs; pale ochre or light grey with a hint of lilac, but becoming brown with a paler-fringed margin. **HABITAT** Dead and living wood of deciduous trees and shrubs, especially Hazel. **STATUS** Widespread and common.

Hymenochaete tabacina (Hymenochaetaceae)
Similar to Oak Curtain Crust (*see* above) but generally more resupinate and paler in colour. **FRUIT BODY** Usually fully resupinate, initially comprising small, rounded spots that coalesce to form large patches running down the substrate; however, when growing vertically it can produce overlapping tiers of velvety brackets whose margin is usually uplifted and crinkled. Surface dull and uneven, with bristle-like hairs; shades of reddish brown with a yellowish or ochre margin. **HABITAT** Dead wood of deciduous trees, especially Hazel and willows. **STATUS** Widespread but uncommon.

Tiger's Eye *Coltricia perennis* (Hymenochaetaceae)
Unusual mushroom-shaped polypore comprising a thin-fleshed cap and short stem. **FRUIT BODY** To 8cm across; flat with a central depression, rather like a satellite dish, and with a wavy, thin margin. **UPPER SURFACE** Initially finely velvety, then smooth; shades of ochre through to cinnamon in distinctive concentric bands, with a paler margin. **UNDERSIDE** Rounded or angular pores running down stem, often with a smooth marginal zone; brown or greyish beige. **STEM** To 4cm high; cylindrical, compressed and usually central; rust- or dark brown and felty. **HABITAT** Generally solitary but sometimes in fused groups on soil, often in sandy and acidic heathland and moorland. **STATUS** Widespread but occasional.

Zoned Rosette *Podoscypha multizonata* (Podoscyphaceae)
Large, rosette-shaped fungus, similar in form to Cauliflower Fungus (p. 242). **FRUIT BODY** To 20cm across; spherical rosette with many densely packed lobes arising from a short, thick stem; lobes flat and closely packed in vertical, overlapping layers, and with an undulating or crinkly margin. Surface suede-like with a tough leathery texture; pale brown to dark reddish brown with a hint of purple and darker bands or streaks, margin paler. Underside of lobes smooth, and bearing spores. **HABITAT** Parasitic on the living roots of oaks or, rarely, Beech. **STATUS** Widespread but uncommon in S England.

Lindtneria trachyspora (Lindtneriaceae)
Yellow resupinate fungus, somewhat inconspicuous despite its bright colour. **FRUIT BODY** Fully resupinate, forming smallish, irregular patches; surface with a soft texture and large, angular pores arranged in a honeycomb-like pattern; golden yellow with a paler cobwebby margin. **HABITAT** Decayed wood and herbaceous debris. **STATUS** Uncommon to rare.

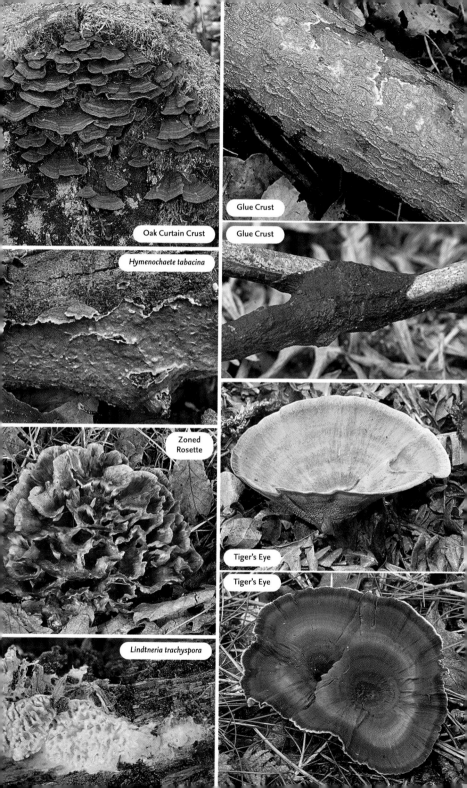

Oak Curtain Crust

Glue Crust

Glue Crust

Hymenochaete tabacina

Zoned Rosette

Tiger's Eye

Tiger's Eye

Lindtneria trachyspora

Tremella species are parasitic on other fungi, but usually only on the mycelium and consequently the host is not always visible. They are soft and gelatinous, and like most jelly fungi respond to being wet, hence can be found at any time of the year when conditions are suitable. On drying they become shrivelled and inconspicuous, but revive into growth and resume spore production when rehydrated. They give a white spore print.

Yellow Brain *Tremella mesenterica* (Tremellaceae) (Top 100)

Bright yellow brain-shaped fungus that is parasitic on species of *Peniophora* (p. 292). **FRUIT BODY** To 8cm across; comprises several distorted lobes and folds that arise from a common base and form an irregular, floppy cluster; soft and gelatinous when young, with a clammy feel; bright yellow but becoming orange and shrivelled with age, although paler and even white forms exist. **HABITAT** Typically on gorse and Hazel. **STATUS** Widespread and very common. **SIMILAR SPECIES** *T. aurantia* is virtually identical in colour and form but is parasitic on Hairy Curtain Crust (p. 232).

Leafy Brain *Tremella foliacea* (Tremellaceae)

Rounded cluster of compact lobes, parasitic on *Stereum* species (p. 232). **FRUIT BODY** To 10cm across; comprises numerous tightly packed, leaf-like lobes arising from a common base; individual lobes (spore-bearing surface) undulating and ruffled, with a soft gelatinous texture and clammy feel when young; reddish brown, although a pale form is also found. **HABITAT** Deciduous and coniferous trees and shrubs. **STATUS** Widespread and common.

Jelly Ear *Auricularia auricula-judae* (Auriculariaceae) (Top 100)

Gelatinous fungus, distinctively shaped like a floppy ear. **FRUIT BODY** To 8cm across; cup- or ear-shaped, usually attached to the substrate by the back surface but sometimes with a rudimentary stem; tough gelatinous, elastic texture when fresh but drying hard and brittle. **UPPER SURFACE** Sometimes smooth but often undulating with folds and wrinkles, and usually finely downy; bright reddish brown with a purple tint, but darker with age. **UNDERSIDE** Sometimes smooth but usually undulating with wrinkles and veins that are often contorted; similar in colour to upper surface but a little more greyish. **HABITAT** Wood of deciduous trees and shrubs, often Elder. **STATUS** Widespread and very common.

Tripe Fungus

Tripe Fungus *Auricularia mesenterica* (Auriculariaceae)

Semi- or fully resupinate fungus whose underside is covered in veins and wrinkles, giving it the appearance of tripe. **FRUIT BODY** Initially circular patches that join and spread, usually laterally, to form narrow, shelf-like brackets, frequently in overlapping tiers; has a tough gelatinous texture that dries hard and brittle; margin thin and undulating. **UPPER SURFACE** Distinctly velvety or hairy; greyish with a pink tint at first, but soon becoming greyish brown in concentric zones, with a paler margin. **UNDERSIDE** Generally a series of irregular lobes, those near the margin particularly covered in a dense network of veins and wrinkles; similar in colour to upper part at first but maturing reddish purple, sometimes with a white bloom. **HABITAT** Dead and decayed wood of deciduous trees and shrubs. **STATUS** Common in England but less frequent elsewhere.

Henningsomyces candidus (Schizophyllaceae)

Minute hollow tube, usually found in dense swarms. Structures in this form are rarely found in other fungi. **FRUIT BODY** To 1mm high and with a diameter of 0.4mm; comprises a hollow cylinder, with the spores developing on the inner wall; outer surface smooth or slightly scurfy, with a soft, fragile texture; white or very pale cream; inner wall smooth and concolorous. **HABITAT** Decayed wood of deciduous trees, especially Beech and elms. **STATUS** Widespread and common.

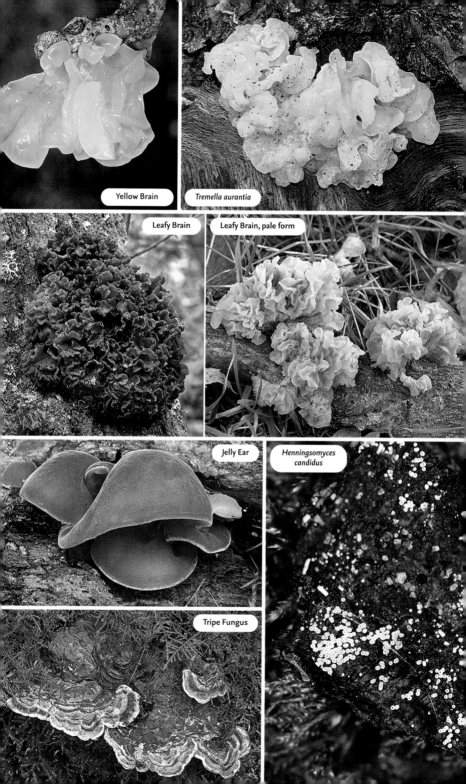

Yellow Brain

Tremella aurantia

Leafy Brain

Leafy Brain, pale form

Jelly Ear

Henningsomyces candidus

Tripe Fungus

Peniophora quercina (Peniophoraceae)

Resupinate pink or lilac fungus whose margin is distinctively rolled back when dry, revealing the dark underside. **FRUIT BODY** To 0.5mm thick; fully resupinate and forming irregular patches, often several centimetres in extent; firmly attached to the substrate at first, but margins become detached and roll upward on drying; surface initially waxy or gelatinous with a smooth or slightly warty texture, but drying crusty and often faintly fissured; dull blue or lilac when moist but drying bright pink or grey with a lilac tint. **HABITAT** Typically on dead and attached, or fallen, branches of oaks but occasionally on other deciduous trees. **STATUS** Widespread and very common.

Peniophora cinerea (Peniophoraceae)

Nondescript grey resupinate fungus. **FRUIT BODY** From 0.05–0.1mm thick, fully resupinate forming irregular patches several centimetres in extent; surface smooth or slightly warty becoming hard and crusty when dry with a tendency to craze; grey or bluish grey, often with a lilac tint, but fading with age. **HABITAT** Dead wood of deciduous trees or shrubs. **STATUS** Widespread and very common. **SIMILAR SPECIES** *P. limitata* is concolorous, but with the margin edged in black and slightly uplifting with age; virtually confined to ash.

Rosy Crust Peniophora incarnata (Peniophoraceae)

Bright pink *Peniophora*, frequently found on gorse and one of the common hosts of Yellow Brain (p. 290). **FRUIT BODY** Fully resupinate, forming thin, irregular patches that are tightly attached to the substrate; margin slightly fringed when young; surface smooth or irregularly warty with a soft waxy texture when fresh, but drying hard and crusty; generally salmon- or flesh-pink but occasionally reddish orange. **HABITAT** Dead wood of deciduous trees and shrubs; rarely on conifers. **STATUS** Widespread and common. **SIMILAR SPECIES** *P. proxima* is restricted to Box (*Buxus*).

Cylindrobasidium laeve (= C. evolvens) (Hyphodermataceae)

Common pinkish fungus, usually fully resupinate. **FRUIT BODY** Generally resupinate but forming narrow, shelf-like brackets when growing vertically; margin initially tightly attached to the substrate but becoming loose when dry. **UPPER SURFACE** If formed, finely velvety; whitish or pinkish beige, usually in zones and often stained green with algae. **SPORE SURFACE** Uneven, with warts and bumps; texture soft and fragile when fresh but drying crusty and fissured; white or pinkish ochre with a finely fringed white margin. **HABITAT** Dead wood and bark of deciduous trees; rarely on conifers. **STATUS** Widespread and very common.

Split Porecrust

Split Porecrust Schizopora paradoxa

(Hyphodermataceae) (Top 100)

Resupinate fungus with a variable pore surface. **FRUIT BODY** Generally fully resupinate, initially as small spots that expand and coalesce to form irregular patches up to several centimetres in extent; texture soft when fresh, but drying hard and crusty; pores variable, circular, oblong or angular, and often in a maze-like arrangement; creamy white or ochre with a white-fringed margin. Rarely forms shelf-like brackets when growing vertically. **HABITAT** Dead wood of deciduous trees; rarely on conifers. **STATUS** Widespread and very common.

Elder Whitewash

Hyphodontia sambuci (Hyphodermataceae)

Thin, resupinate fungus with the appearance of whitewash. **FRUIT BODY** Fully resupinate, extensively covering the substrate with a very thin, whitewash-like coating and fading away towards margin; surface mealy, with a dry texture; dull white or off-white and often fissured when dry. **HABITAT** Living and dead wood of deciduous trees, especially Elder; frequently found at the base of trunks. **STATUS** Widespread and very common.

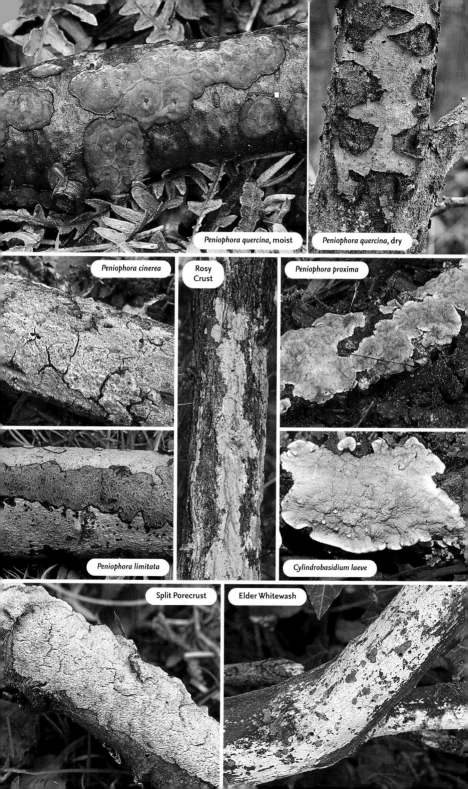

Peniophora quercina, moist

Peniophora quercina, dry

Peniophora cinerea

Rosy Crust

Peniophora proxima

Peniophora limitata

Cylindrobasidium laeve

Split Porecrust

Elder Whitewash

Silverleaf Fungus *Chondrostereum purpureum*
Similar to some species of *Stereum* (p. 232) but the spore surface does not bleed when cut. A parasite of fruit trees, responsible for so-called 'silver leaf' disease. **FRUIT BODY** Sometimes fully resupinate, but typically forming thin, undulating, shelf-like brackets to 2cm deep, usually fused in rows or tiers; margin thin and undulating or crinkled; flesh tough and leathery but drying hard and brittle. **UPPER SURFACE** Velvety or with whitish hairs in concentric bands; lilac-brown with a paler margin. **UNDERSIDE** Smooth or slightly wrinkled; pinkish violet but becoming violet-brown with age. **HABITAT** Dead and dying deciduous trees; rarely on conifers. **STATUS** Widespread and very common.

Wrinkled Crust *Phlebia radiata*
Variable fungus with a distinctive spore surface. **FRUIT BODY** Fully resupinate and tightly attached to the substrate, initially as rounded spots that coalesce to form large patches. Surface uneven and wrinkled, with tightly packed radial furrows (merulioid) usually arranged in whorls, and with a fringed marginal zone; variable in colour from greyish violet through to dark orange. **HABITAT** Decayed wood of deciduous trees. **STATUS** Widespread and common. **SIMILAR SPECIES** *P. rufa* is paler in colour and has a less merulioid surface.

Jelly Rot *Phlebia tremellosa* (= *Merulius tremellosus*)
Pale bracket with a rubbery gelatinous texture. **FRUIT BODY** Generally undulating bracket to 5cm across, with several joining together and covering a large area; sometimes fully resupinate when growing on the underside of the substrate. **UPPER SURFACE** Gelatinous and covered in bristle-like hairs; white or cream with a pinkish tint. **UNDERSIDE** Tight, dense, radial folds; orange or salmon-pink with a smooth and paler margin. **HABITAT** Decayed wood of deciduous trees; rarely on conifers. **STATUS** Widespread and very common.

Gloeoporus taxicola (= *Meruliopsis taxicola*)
Brightly coloured resupinate fungus with a merulioid pore surface. **FRUIT BODY** Fully resupinate, forming large, irregular patches with a distinctly paler felty margin; surface uneven and slightly waxy or gelatinous, with irregularly rounded, small pores; initially whitish or pinkish ochre, but maturing dark reddish brown with a whitish margin. **HABITAT** Dead wood of conifers, mostly pine; rarely on broadleaved trees. **STATUS** Widespread but uncommon. **SIMILAR SPECIES** *G. dichrous* is rare but increasing; it is semi-resupinate with a woolly upper surface and pores on the underside, and is found on dead wood of deciduous trees.

Byssomerulius corium (= *Meruliopsis corium*)
Resupinate or semi-resupinate with a distinctive mode of growth. **FRUIT BODY** Forms patches covering a large area; typically found on fallen branches and resupinate on the underside, but developing rows of fused, narrow brackets projecting along the sides of the substrate. **UPPER SURFACE** Felty; white or ochre and often slightly darker at the point of attachment. **UNDERSIDE** Initially smooth but becoming merulioid, and with a network of pores; concolorous with upper surface, becoming browner with age. **HABITAT** Fallen and decayed wood of deciduous trees; rarely on conifers. **STATUS** Widespread and common.

Mycoacia uda
Yellowish resupinate whose pore surface is covered in spines. **FRUIT BODY** Fully resupinate and forming large patches on the underside of fallen logs and branches; comprises a thin waxy base fused to the substrate, from which densely crowded, long, slender, pointed spines arise; shades of cream-yellow to yellow, paler at margin and with shorter spines here. **HABITAT** Decayed wood of deciduous trees. **STATUS** Widespread and common.

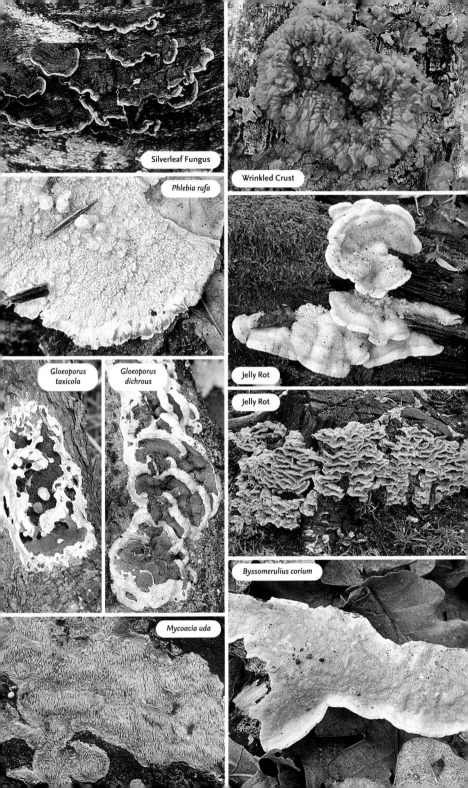

Silverleaf Fungus

Wrinkled Crust

Phlebia rufa

Jelly Rot

Gloeoporus taxicola

Gloeoporus dichrous

Jelly Rot

Byssomerulius corium

Mycoacia uda

Thelephoraceae members are variable, some species having a cap and stem, and others branched or coral-like, frequently with several fused, clustered fruit bodies. Genera *Sarcodon* and *Hydnellum* have distinctive undersides (spore surfaces), which comprise densely packed spines or teeth that usually run down the stem. *Hydnellum* species also have a short, often rudimentary stem but appear resupinate, growing into, and becoming entangled with, adjoining twigs and plants. They produce a brown spore print. Smell, taste and flesh colour can play an important part in identifying species in this family, with the *Hydnellum* species usually having a spicy odour.

Bitter Tooth

Bitter Tooth *Sarcodon scrabrosus*
Toothed fungus with a blue-green base to the stem and a bitter taste to the flesh. **CAP** To 14cm across; flattish convex with a depressed centre and undulating margin; initially felty but soon cracking and breaking up into coarse, overlapping scales that are uplifted at the centre; pale brown with darker scales, ageing blackish brown. **UNDERSIDE** Thin spines to 1cm long; whitish, maturing purple-brown. **STEM** To 8cm long; cylindrical or tapering downward; white, discolouring brown, and with a blue-green base. **HABITAT** Solitary or in fused groups, associated with oak on sandy acidic soils. **STATUS** Rare; largely confined to S England. **SIMILAR SPECIES Scaly Tooth** *S. squamosus* lacks the blue-green stem base and is found with pine. It is equally rare but more frequent in Scotland.

Scaly Tooth

Blue Tooth *Hydnellum caeruleum*
Distinctive toothed fungus with bluish colours to the surface and flesh of the cap. **CAP** To 7cm across; irregularly circular and flattish, with the centre somewhat depressed; surface uneven and wrinkled, with a velvety texture but later becoming smoother; cream or light brown with a white or bluish margin, but turning brown with age. **UNDERSIDE** Thin spines to 0.5cm long; brownish blue but losing the blue colour at maturity. **STEM** To 5cm long; orange-brown, with the flesh a similar colour. **HABITAT** On soil with conifers, particularly pine. **STATUS** Rare; virtually confined to Scotland.

Zoned Tooth *Hydnellum concrescens*
Toothed fungus with a concentrically zoned cap, found in large, fused groups. **CAP** To 7cm across; irregular rosette shape, flattish and slightly depressed, with a thin, wavy margin; surface uneven, with radial ridges, erect scales, outgrowths and small secondary caps; texture tough and fibrous, surface velvety; initially whitish or pink, but darkening to shades of reddish brown in concentric zones with a paler or whitish margin. **UNDERSIDE** Decurrent thin spines to 0.3cm long; pinkish, maturing purple-brown. **STEM** To 3cm long; merges with cap and has a slightly enlarged base; concolorous with cap and finely felty. **HABITAT** Solitary or in fused groups on soil in mixed deciduous and coniferous woodland. **STATUS** Widespread but occasional. **SIMILAR SPECIES Ridged Tooth** *H. scrobiculatum* is less zonate but can be reliably separated only by an examination of the spores.

Devil's Tooth *Hydnellum peckii*
Toothed fungus that frequently exudes blood-red liquid droplets when in active growth, and whose flesh tastes burning-hot. **CAP** To 7cm across; irregular rosette, flattish and somewhat depressed, with a thin, wavy margin; surface radially grooved and pitted, with erect, lumpy scales; whitish, then wine-red or reddish brown with the margin remaining white, ageing blackish brown. **UNDERSIDE** Decurrent, thin spines to 0.5cm long; white, maturing reddish brown. **STEM** To 5cm long; reddish brown. **HABITAT** Solitary or in groups, sometimes fused, on soil in pinewoods. **STATUS** Occasional or locally abundant in Caledonian pinewoods.

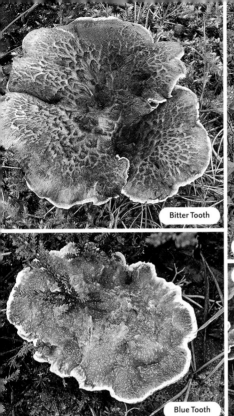

Bitter Tooth

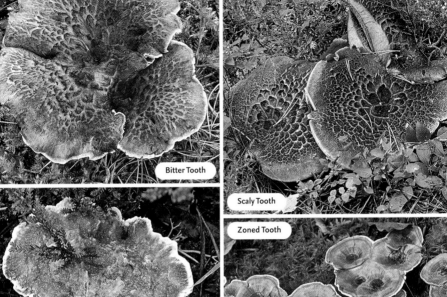

Scaly Tooth

Zoned Tooth

Blue Tooth

Blue Tooth

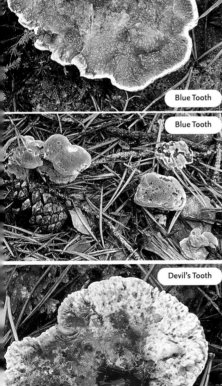

Devil's Tooth

Ridged Tooth

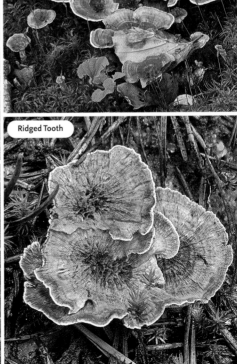

Velvet Tooth *Hydnellum spongiosipes*

Toothed fungus with a suede-like texture and an irregular, rosette-shaped, generally non-zonate cap. **CAP** To 7cm across; flattish convex or slightly depressed with an undulating and lobed margin; surface with numerous bumps and depressions and a finely velvety or suede-like texture; whitish or light brown with a paler margin, but becoming dark cinnamon-brown with age. **UNDERSIDE** Thin spines to 0.5cm long and barely decurrent; whitish but maturing reddish brown. **STEM** To 6cm long; irregular and swollen, with a spongy, felty texture; dark brown. **HABITAT** Occasionally solitary but usually in fused groups in deciduous woodland, frequently with oaks or Sweet Chestnut. **STATUS** Uncommon; mostly found in S. **SIMILAR SPECIES Mealy Tooth** *H. ferrugineum* is found with conifers and is more frequent in N. Exudes red droplets similar to *H. peckii* (p. 296) but lacks the burning hot taste.

Orange Tooth *Hydnellum aurantiacum*

Bright orange rosette-shaped, toothed fungus. **CAP** To 7cm across; flattish convex or depressed, with an undulating, scalloped margin; surface uneven, with radial ridges, grooves and knob-like outgrowths and a velvety texture; whitish at first but becoming progressively orange or brown from centre outward, and with margin remaining white; sometimes with faint concentric zones. **UNDERSIDE** Thin, decurrent spines to 0.5cm long; whitish, maturing brown or orange-brown. **STEM** To 5cm long; merges with cap, and irregular and swollen towards base; orange or dark brown with a finely felty texture. **HABITAT** Solitary or in fused groups in pinewoods. **STATUS** Virtually restricted to Caledonian pinewoods.

Earthfan *Thelephora terrestris*

Distinctive fan-shaped rosette with a creeping mode of growth over soil, debris and fallen branches. **FRUIT BODY** To 10cm across; rosette- or fan-shaped, with a wavy, fringed hairy margin; usually fused in rows or groups, forming irregular patches and sometimes covering a large area. **UPPER SURFACE** Radially wrinkled, with coarse fibres and fan-shaped outgrowths, and a velvety or hairy texture; shades of brown in concentric zones and with a lighter margin. **UNDERSIDE** Irregularly radially wrinkled, with folds and ridges; light or dark brown. **HABITAT** Occasionally solitary but usually in fused groups on soil or, occasionally, woody debris, in acidic heathland, moorland and open woodland. **STATUS** Widespread and common.

Stinking Earthfan *Thelephora palmata*

Coral-like fungus with a repulsive smell of putrid garlic. **FRUIT BODY** To 7cm high and wide; a rudimentary, short, thick stem divides into flattened palmate branches ending in

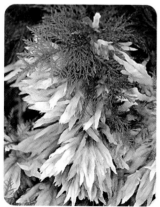

truncated tips; the tips are variable in shape, ranging from flat to spatulate, and are often toothed or fringed; whitish at first but soon turning brown with a purple tint, the tips remaining whitish. Surface smooth, with the flesh tough and fibrous and emitting a powerful fetid odour. **HABITAT** Solitary or in small groups with birches and pines on acid soils. **STATUS** Widespread but uncommon.

Thelephora penicillata (= *T. spiculosa*)

Encrusting tuft of spiky branches. **FRUIT BODY** To 4cm high; comprises a cluster of erect, arching branches that end in flattened, multi-pointed tips; branches arise from a thick, rudimentary stem and are fused radially to form an irregular tuft; tough and fibrous with a downy or felty texture; purplish brown with top part – including tips – white. **HABITAT** Encrusting soil or decayed leaf litter, often in wet areas. **STATUS** Widespread but uncommon.

Thelephora penicillata

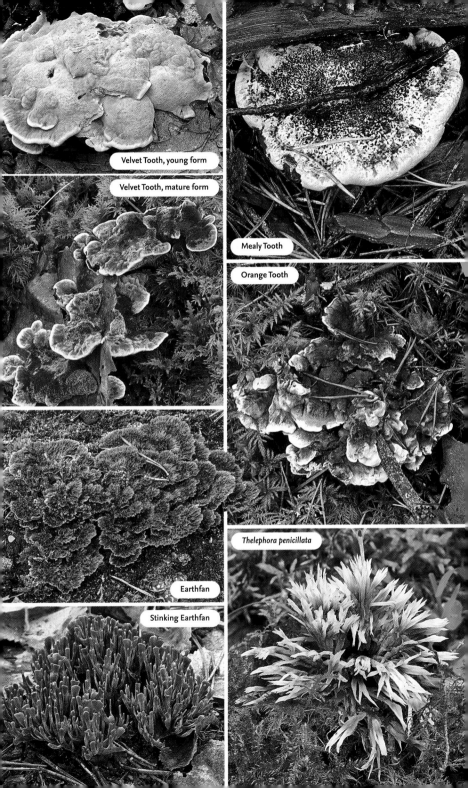

Velvet Tooth, young form

Velvet Tooth, mature form

Mealy Tooth

Orange Tooth

Earthfan

Thelephora penicillata

Stinking Earthfan

Bankeraceae members are toothed fungi similar to *Hydnellum* and *Sarcodon* species (pp. 296–9), but with a distinctive white spore print and, generally, a pungent, spicy smell of fenugreek when dried. The flesh is usually tough and leathery, and is zoned in *Phellodon* species and without zones in *Bankera*. Most have a well-developed stem, which is often off-centre.

Drab Tooth *Bankera fuligineoalba* (Bankeraceae)

Fleshy, drab-coloured toothed fungus, usually heavily encrusted with plant debris, this often growing through the fruit body. **CAP** To 10cm across; flattish convex, becoming slightly centrally depressed with an undulating and blunt margin; surface generally smoothish but developing fine scales; cream or off-white with a paler margin, but becoming yellowish brown with age. **UNDERSIDE** Spines to 0.5cm long and slightly decurrent; white, maturing greyish brown. **STEM** To 5cm long; stout and sometimes eccentrically attached to cap; dull reddish brown with a white annular zone at apex. **HABITAT** On soil amongst needle litter of pines. **STATUS** Widespread but occasional in Scotland. **SIMILAR SPECIES Spruce Tooth** *B. violascens* has violet tints and is extremely rare; the only records are from Scotland, where it is associated with spruce.

Black Tooth *Phellodon niger* (Bankeraceae)

Toothed fungus with a distinctive blue-black cap. **CAP** To 8cm across; circular and irregularly lobed, flattish with a sharp margin but becoming concave; surface uneven, scaly and pitted in centre, and fibrous towards edge; initially blue-black with a whitish margin, but ageing black. **UNDERSIDE** Short, slightly decurrent spines to 0.3cm long; white or blue-grey, maturing greyer. **STEM** To 5cm long; thick and irregular with a velvety texture; black. **HABITAT** Solitary, gregarious or fused on soil in deciduous and coniferous woodland. **STATUS** Widespread but uncommon.

Woolly Tooth *Phellodon tomentosus* (Bankeraceae)

Toothed fungus, typically found in large, irregular patches or overlapping tiers. **FRUIT BODY** Comprises an irregularly flattish, rounded cap to 6cm across, with a depressed centre and short stem; several usually fuse to form large, irregular patches. **UPPER SURFACES** Tough, leathery and wrinkled, with fibrous ridges and a finely velvety texture; initially white, becoming hazel or reddish brown with darker zones, particularly at centre, and a whitish margin. **UNDERSIDE** Spines to 0.3cm long and slightly decurrent; white, maturing grey. **STEM** To 3cm long; thickish and cylindrical, often with several stems arising together and the caps forming a canopy; light or dark brown with a fibrous texture. **HABITAT** Usually with pines in coniferous woodland. **STATUS** Widespread but occasional. **SIMILAR SPECIES Grey Tooth** *P. melaleucus* has a greyer non-zonate cap and flesh that discolours green on application of KOH. It is associated with broadleaved trees and conifers.

Wood Hedgehog *Hydnum repandum* (Hydnaceae)

Soft, fragile, fleshy toothed fungus, similar to some Thelephoraceae species (pp. 296–9), but these usually have a tough leathery texture. Generally considered a good edible species. **CAP** To 15cm across; irregular, often misshapen, flattish convex or cushion-shaped, sometimes with a depressed centre; margin undulating, inrolled and occasionally with lobes; surface matt and smooth or finely felty; cream to bright yellow-ochre. **UNDERSIDE** Spines to 0.6cm long and somewhat decurrent; similar in colour to cap. **STEM** To 6cm high; short and cylindrical or spindle-shaped, and often off-centre; paler than cap. **HABITAT** Solitary or gregarious on soil or leaf litter in deciduous woodland. **STATUS** Widespread but occasional. **SIMILAR SPECIES Terracotta Hedgehog** *H. rufescens* is smaller, with a deeper apricot or orange colour.

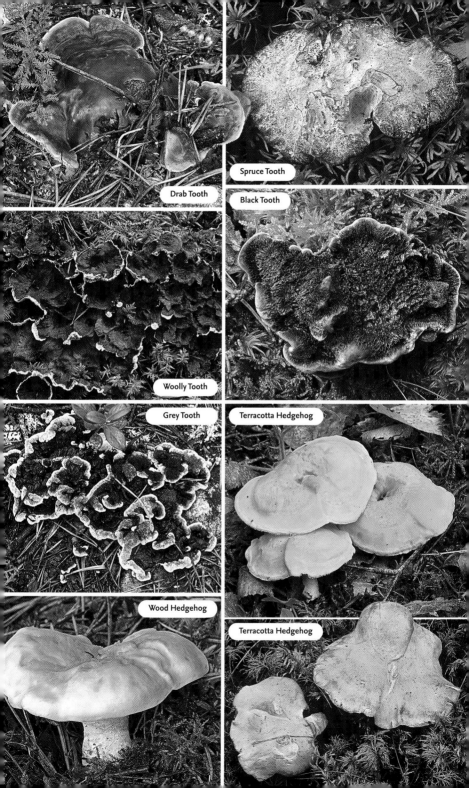

Drab Tooth

Spruce Tooth

Black Tooth

Woolly Tooth

Grey Tooth

Terracotta Hedgehog

Wood Hedgehog

Terracotta Hedgehog

Ergot *Claviceps purpurea* (Clavicipitaceae)
Has a two-stage life cycle: the banana-shaped blackish sclerotium develops in grass flower-heads, including commercial cereals; the mature sclerotium falling in autumn and over-wintering on the ground; it then 'germinates' in spring into several very small fruit bodies. **FRUIT BODY** Drumstick-shaped, with a relatively long, slender stem to 1.5cm high and a rounded head to 0.3cm across; yellowish brown. Ergot is very poisonous, sometimes deadly, and enters the foodchain via cereals. Ergot poisoning is mind-affecting: it has been suggested as a cause of recorded bizarre behaviour of 'witches' in the Middle Ages. **HABITAT** Grasses of all types. **STATUS** Widespread and common; more conspicuous at the sclerotium stage.

Choke *Epichloë typhina* (Clavicipitaceae)
Small, pale ascomycete that clothes the stems of living grasses. **FRUIT BODY** A bulrush-shaped tissue (stroma) envelops the stems of living grasses to a length of 0.5cm, inside which the fruit bodies develop; these are whitish at first but become yellow as the spores mature, their surface initially smooth but becoming dotted with pore openings, creating a rough, granular texture. **HABITAT** Stems of various grasses. **STATUS** Widespread but occasional.

Choke

Snaketongue Truffleclub

Snaketongue Truffleclub *Cordyceps ophioglossoides* (Cordycipitaceae)
Parasitic fungus growing on buried truffle-like species of *Elaphomyces* (*see* below). **FRUIT BODY** To 8cm high; comprises a fertile head and a sterile, slender stalk. **HEAD** To 1cm wide; irregularly club-shaped, dotted with fine pores that create a rough, scurfy texture; initially yellowish but becoming reddish brown or black with age. **STEM** To 6cm high; cylindrical, smooth and dull; concolorous with head but yellowish towards base. **HABITAT** Solitary or in small groups and parasitic on species of *Elaphomyces*, typically in coniferous woodland. **STATUS** Widespread but occasional.

Cordyceps longisegmentis (Cordycipitaceae)
Similar to Snaketongue Truffleclub but with a rounded head. **FRUIT BODY** To 9cm high; fertile head and slender stem. **HEAD** To 1cm in diameter; rounded, dotted with fine pores and slightly shiny; yellowish brown. **STEM** To 8cm tall; cylindrical with longitudinal fibres; yellow. **HABITAT** Solitary or clustered on species of *Elaphomyces*, usually in conifer woodland. **STATUS** Uncommon.

Scarlet Caterpillarclub *Cordyceps militaris* (Cordycipitaceae)
Bright orange-red fungus, parasitic on buried insect larvae. **FRUIT BODY** To 6cm high; comprises a fertile head and sterile stem. **HEAD** Irregularly club-shaped (swollen extension of stem) and dotted with raised pores; orange-red. **STEM** Merging into head, paler in colour and somewhat mottled. **HABITAT** Parasitic on the buried larvae of butterflies and moths in soil. **STATUS** Widespread but occasional; commonest in S.

Scarlet Caterpillarclub

Paecilomyces farinosus (Trichocomaceae)
Tiny fungus, parasitic on buried moth pupae. **FRUIT BODY** To 3cm tall (often less than 10mm visible); comprises a fertile head and sterile stem. **HEAD** Spiky, often curved at tip, sometimes branched; white and 'floury' with spores. **STEM** Merging into head; attached to moth pupa. **HABITAT** Parasitic on buried moth pupae, often on mossy banks. **STATUS** Locally common but easily overlooked.

Paecilomyces farinosus

False Truffle

False Truffle *Elaphomyces granulatus* (Elaphomycetaceae)
Rounded, subterranean tuber, easily confused with truffles; commonly parasitised by *Cordyceps* species (*see* above). **FRUIT BODY** To 4cm across; spherical tuber with a coarse, warty surface and thick brown skin enclosing a purplish-black spore mass. **HABITAT** Usually in small, scattered groups a few centimetres below the soil, generally in conifer woodland. **STATUS** Widespread but uncommon.

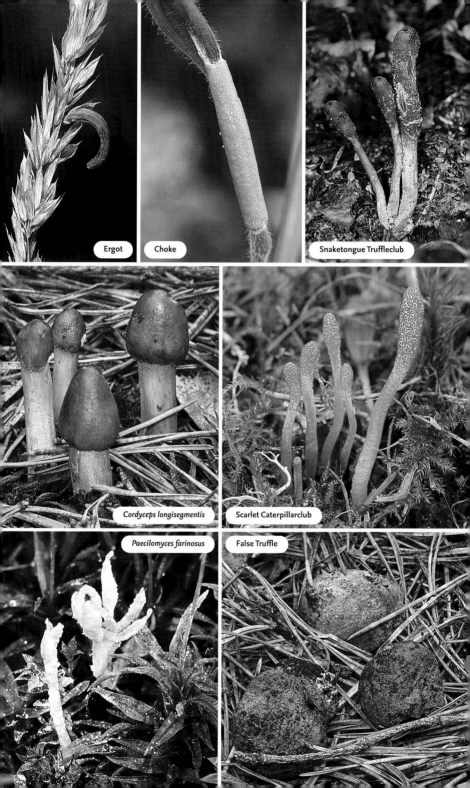

Ergot

Choke

Snaketongue Truffleclub

Cordyceps longisegmentis

Scarlet Caterpillarclub

Paecilomyces farinosus

False Truffle

Hairy Earthtongue, stem

Hairy Earthtongue *Trichoglossum hirsutum* (Geoglossaceae)

Blackish earthtongue with a finely hairy stem. **FRUIT BODY** To 8cm tall; comprises a fertile head tapering into a slender stem. **HEAD** Up to half height of fruit body; flattened and spatulate or club-shaped, with indentations and furrows. **STEM** More slender than head, cylindrical, sometimes grooved, rounded or compressed, with dense velvety hairs (use a hand lens). **HABITAT** Solitary or gregarious in grass and mosses on acid soil. **STATUS** Widespread and locally common.

Geoglossum cookeanum (Geoglossaceae)

Robust earthtongue; recalls Hairy Earthtongue but has a smooth stem. **FRUIT BODY** To 7cm tall; comprises a broad head tapering into a short stem; entire fruit body is blackish brown. **HEAD** Flattened and club-shaped with irregular indentations and furrows. **STEM** Short and smooth. **HABITAT** Solitary or gregarious in grass on sandy soil; often in dunes. **STATUS** Widespread but occasional. **SIMILAR SPECIES** *G. fallax* has finely scaly stem and is brownish.

Green Earthtongue *Microglossum viride* (Leotiaceae)

Greenish earthtongue. **FRUIT BODY** To 3cm tall; flattened head tapers into a short stem. **HEAD** Club-shaped and greenish. **STEM** Short and textured. **HABITAT** Mossy woodland banks. **STATUS** Widespread but scarce and easily overlooked.

Bog Beacon *Mitrula paludosa* (Incertae sedis – Helotiales)

Bright yellowish earthtongue found in wet places, usually during spring or early summer. **FRUIT BODY** To 5cm high; comprises a fertile head up to ⅔ of the overall height, which tapers into a stem. **HEAD** Variable in shape – cylindrical to club-shaped, but sometimes irregularly rounded or oval; smooth and gelatinous, often with longitudinal grooves or furrows; bright orange-yellow. **STEM** Cylindrical, with a clear division between head and stem; whitish. **HABITAT** Gregarious on plant remains, often underwater in streams, ditches and pond margins; sometimes with *Sphagnum* moss. **STATUS** Uncommon.

Cinnamon Jellybaby *Cudonia confusa* (Cudoniaceae)

Gelatinous fungus with a very irregular, distorted cap. **FRUIT BODY** To 3cm high; comprises a fertile head and well-developed stem. **HEAD** To 2cm across; convex at first but becoming flattened, sometimes with a central depression, very irregular and convoluted, with margin inrolled; pale ochre or cinnamon, with a gelatinous texture. **STEM** To 3cm high; similar in texture and colour to head. **HABITAT** Gregarious or clustered in soil, mosses or needle litter in coniferous woodland. **STATUS** Rare. **SIMILAR SPECIES** **Redleg Jellybaby** *C. circinans* has a reddish-brown stem and is confined to Scotland.

Jellybaby *Leotia lubrica* (Leotiaceae)

Similar to Cinnamon Jellybaby but more robust, with olive tints to the head. **FRUIT BODY** To 6cm tall; comprises a fertile head and stem. **HEAD** To 1.2cm across; rounded or flattened, irregularly lobed and undulating, with margin rolled under; texture gelatinous and smooth, clammy or slimy; greenish yellow or olive-ochre. **STEM** Cylindrical or flattened and fairly stout, with tiny granules and occasional furrows; yellow. **HABITAT** Gregarious on soil, mosses and plant debris in damp deciduous woodland. **STATUS** Widespread but occasional.

Yellow Fan *Spathularia flavida* (Cudoniaceae)

Bright yellow earthtongue with a fan-shaped head. **FRUIT BODY** To 5cm high; comprises a fertile head and stem. **HEAD** Irregularly fan-shaped and flattened; often undulating, furrowed and distorted; pale or deep yellow with a dry, smooth surface. **STEM** Clearly demarcated from head, irregular, sometimes flattened and usually tapering to base; paler than head, smooth or finely felty. **HABITAT** On the ground and in needle litter in conifer woods. **STATUS** Widespread but occasional, sometimes locally common.

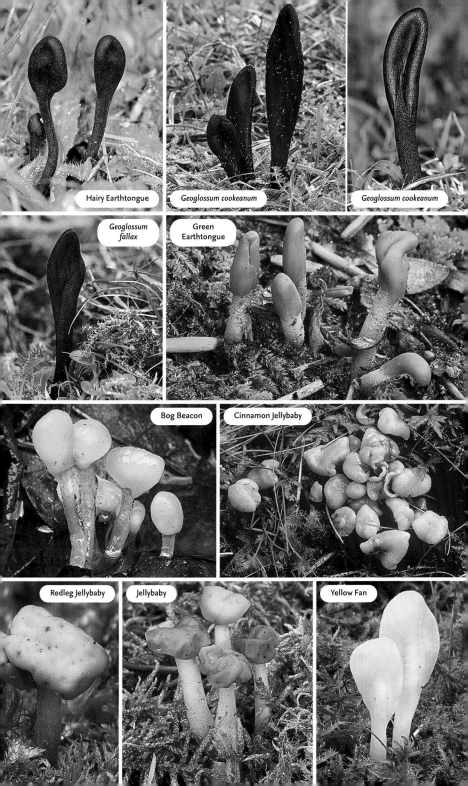

Hairy Earthtongue

Geoglossum cookeanum

Geoglossum cookeanum

Geoglossum fallax

Green Earthtongue

Bog Beacon

Cinnamon Jellybaby

Redleg Jellybaby

Jellybaby

Yellow Fan

Black Bulgar *Bulgaria inquinans* (Bulgariaceae)

Rubbery button-shaped fungus with a blackish spore print that strongly stains the substrate and also fingers when handled. Sometimes confused with the black species of *Exidia* (p. 250), but easily separated as *Exidia* produce a white spore print. **FRUIT BODY** To 4cm high and across; initially globular but later expanding and flattening, often with a raised margin, to form a distinct central disc; usually sessile but sometimes narrowing into a stem-like base; central area black, shiny and smooth, outer surface blackish brown with a felty or scurfy texture. **HABITAT** Gregarious or in dense swarms on dead wood of deciduous trees, usually fallen trunks of oak and Beech. **STATUS** Widespread and common.

Oak Pin *Cudoniella acicularis* (Helotiaceae)

Tiny, lollipop-shaped fungus with a distinctive mottled, pale colour. **HEAD** To 0.3cm across; rounded or cushion-shaped, usually with an inrolled margin; white at first but becoming mottled white and greyish brown with a smooth texture. **STEM** To 1cm high; cylindrical and concolorous with head, and with a similar texture. **HABITAT** In trooping groups on old, rotten wood of deciduous trees, especially oaks. **STATUS** Widespread and common.

Spring Pin *Cudoniella clavus* (Helotiaceae)

Small *Cudoniella* with a pallid head and stem. **HEAD** To 1.2cm across; flattish convex or cushion-shaped and sometimes centrally depressed; greyish white or pale ochre with a smooth texture. **STEM** Variable in length depending on the substrate; cylindrical or widening towards apex; concolorous with head and with a similar texture. **HABITAT** Solitary or gregarious on woody debris from trees and herbaceous plants, frequently in wet places. **STATUS** Uncommon.

Lemon Disco *Bisporella citrina* (Incertae sedis – Helotiales)

Common disco covering the substrate in swarms of bright yellow discs. **FRUIT BODY** To 0.3cm across; saucer- or plate-shaped disc tapering into a small base or, occasionally, with a very short stalk; somewhat rubbery and with a smooth texture; lemon- or bright yellow with a paler outer surface, ageing more orange. **HABITAT** Gregarious or in swarms on dead wood of deciduous trees, frequently covering entire branches. **STATUS** Widespread and very common.

Bisporella subpallida (Incertae sedis – Helotiales)

Similar in form to Lemon Disco but a duller, more subdued colour. **FRUIT BODY** To 0.15cm across; flat or plate-shaped disc, attached to the substrate without a stem; ochre with a smooth surface, sometimes with a paler, slightly scurfy outer surface. **HABITAT** Gregarious or crowded on dead wood of deciduous trees. **STATUS** Occasional. **SIMILAR SPECIES** *B. pallescens* is white or very pale ochre in colour.

Beech Jellydisc *Neobulgaria pura* (Helotiaceae)

Common pale pink jelly fungus, usually found in swarms on Beech. **FRUIT BODY** Initially globular then becoming spinning-top- or cushion-shaped with a flat or concave upper surface and slightly raised margin; frequently distorted as a result of several fruit bodies growing together and being tightly compressed; gelatinous texture with a smooth top and a scurfy or granular margin and outer surface; dull pale pink with a hint of lilac and somewhat opaque, margin and outer surface slightly darker. An uncommon convoluted, brain-like form (var. *foliacea*) is also found. **HABITAT** Grouped or in dense swarms on fallen logs and branches of deciduous trees, especially Beech. **STATUS** Widespread and common.

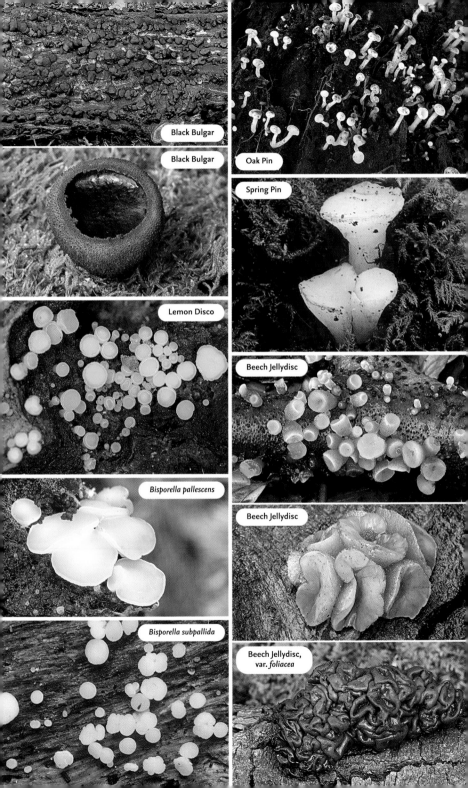

Black Bulgar

Black Bulgar

Oak Pin

Spring Pin

Lemon Disco

Beech Jellydisc

Bisporella pallescens

Beech Jellydisc

Beech Jellydisc,
var. *foliacea*

Bisporella subpallida

Purple Jellydisc *Ascocoryne sarcoides* (Top 100) (*Incertae sedis* – Helotiales)

Similar to Beech Jellydisc (p. 306) and found in the same habitat, but with a much stronger, darker colour. **FRUIT BODY** To 1cm across; spherical at first but soon becoming top- or cushion-shaped, with a flat, cleft or depressed top and somewhat uplifted margin; usually found densely crowded and forming convoluted, sometimes brain-like clusters; generally sessile but occasionally with a short stem; soft and gelatinous with a smooth or finely granular surface; dark reddish purple, with margin sometimes even darker. **HABITAT** Occasionally solitary but typically clustered on fallen and rotting wood of deciduous trees, especially Beech; rarely on conifers. **STATUS** Widespread and common. **SIMILAR SPECIES** *A. cylichnium* is sometimes slightly larger, but microscopic spore examination is needed for certain separation.

Green Elfcup *Chlorociboria aeruginascens*
(= *Chlorosplenium aeruginascens*)
(*Incertae sedis* – Helotiales) (Top 100)
Small cup fungus that strongly stains its wood substrate green; under the name 'Tunbridge ware' this wood has been extensively used as a decorative inlay in the manufacture of furniture. **FRUIT BODY** To 0.5cm across; plate- or cup-shaped with an undulating margin and short, tapering stem; often compressed or distorted as a result of its clustered mode of growth; inner surface smooth, outer surface finely granular; bluish green with the outside slightly paler. **HABITAT** Gregarious on rotten wood of deciduous trees, especially oaks. **STATUS** Widespread and common; the green-stained wood is conspicuous year-round but the fruiting bodies are less frequent.

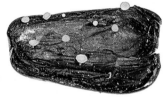

Nut Disco *Hymenoscyphus fructigenus* (Helotiaceae)
Tiny cup fungus with a long stem, found growing on various nuts. **FRUIT BODY** To 0.4cm across; cup- or saucer-shaped, sometimes flatter, with the margin often incurved and tapering to a relatively long, slender stem; white or creamy yellow with a smooth surface. **HABITAT** In small groups on fallen acorns, Beech mast and other nuts. **STATUS** Widespread and common.

Hymenoscyphus herbarum (Helotiaceae)
Small, pale disco, frequently found on rotting Common Nettle stems. **FRUIT BODY** To 0.3cm across; initially cup-shaped but flattening into a disc and attached to the substrate by a short stem; whitish or yellowish ochre with a smooth inner surface and slightly paler felty outer surface. **HABITAT** Gregarious or clustered on dead stems of herbaceous plants, particularly Common Nettle. **STATUS** Widespread and frequent.

Spring Hazelcup *Encoelia furfuracea* (Sclerotiniaceae)
Irregularly star-shaped, sessile cup fungus, found in winter and spring. **FRUIT BODY** To 1.5cm across; initially blister-like, then splitting open from the top and becoming cup- or plate-shaped with a split or ragged margin; usually crowded or tightly clustered on the substrate; inner surface cinnamon or darkish brown with a smooth texture, outer surface paler and distinctly scurfy. **HABITAT** Clustered in small to large groups on dead wood of Hazel and, occasionally, Common Alder. **STATUS** Widespread but uncommon.

Godronia ribis (Helotiaceae)
Spring-fruiting cup fungus with a blackish exterior and contrasting yellowish inner surface. **FRUIT BODY** To 0.25cm across; initially spherical, then splitting open from the top and becoming saucer-shaped with a ragged, toothed, incurved margin; connected to the substrate by a short stem; texture tough and leathery; inner surface yellowish or greyish and smooth, outer surface black or blackish brown and scurfy. **HABITAT** Clustered on dead stems of currant bushes (*Ribes* species). **STATUS** Uncommon.

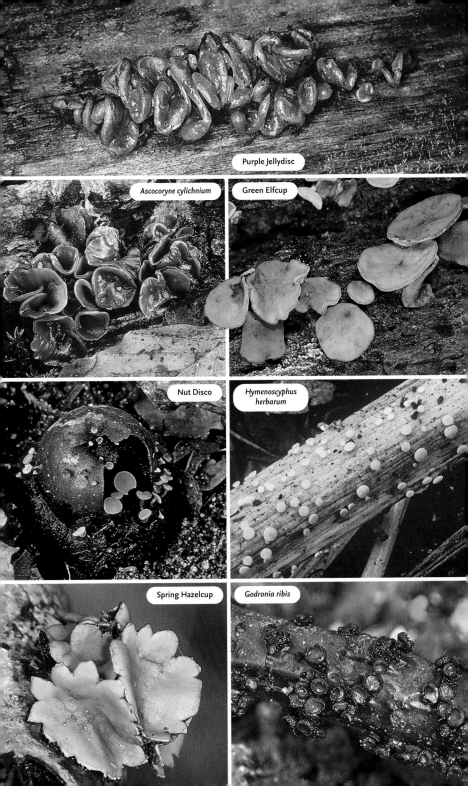

Purple Jellydisc

Ascocoryne cylichnium

Green Elfcup

Nut Disco

Hymenoscyphus herbarum

Spring Hazelcup

Godronia ribis

The genus *Helvella* includes saucer- or saddle-shaped fungi with a simple stem, cup-shaped forms, and some species with irregular and distorted heads and a hollow, ribbed, furrowed stem. Aside from White Saddle, they are generally in subdued, dark shades, and are usually brittle with a smooth spore-bearing surface. Some fruit in spring, others in autumn; most are associated with deciduous trees.

White Saddle *Helvella crispa*

The most conspicuous and common of the saddle-shaped fungi. **FRUIT BODY** Variable in size but typically to 15cm high; comprises an irregular head and thick stem. **HEAD** To 6cm across; contorted saddle-shaped, with 2 or 3 undulating, wrinkled, pendent lobes that are not fused to stem; white or pale ochre. **STEM** To 4cm thick, with deep longitudinal ridges and grooves; hollow interior is a series of longitudinal chambers; whitish. **HABITAT** Soil in damp deciduous woods, often on pathsides. **STATUS** Widespread and common.

Elfin Saddle *Helvella lacunosa*

Similar to White Saddle but darker. **FRUIT BODY** To 15cm high; comprises an irregular head and thick stem. **HEAD** To 5cm across; convoluted saddle-shaped, with the inrolled lobes fused to stem; variable in colour but typically dark shades of grey, brown or even totally black. **STEM** To 3cm across; irregular with deep longitudinal ridges and grooves; interior is a series of hollow chambers; pale brownish grey and smooth. **HABITAT** On soil in deciduous and coniferous woodland. **STATUS** Widespread and common.

Elastic Saddle *Helvella elastica* (= *Leptopodia elastica*)

Simple saddle-shaped *Helvella*. **FRUIT BODY** To 10cm high; comprises an irregular head and slender stem. **HEAD** To 4cm across; irregularly rounded or simple saddle-shaped with the margin rolled under; fawn or pale brown with a smooth surface. **STEM** Slender and finely downy; white or cream. **HABITAT** On damp soil in deciduous and coniferous woodland. **STATUS** Widespread and common.

Vinegar Cup *Helvella acetabulum* (= *Paxina acetabulum*)

Spring-fruiting *Helvella* with a goblet-shaped head and prominently ribbed stem. **HEAD** To 6cm across; cup- or goblet-shaped, becoming expanded with age and with an irregular, undulating margin; interior darkish brown with a smooth surface; exterior paler and finely scurfy. **STEM** To 4cm tall; prominent raised and branching ribs that extend up cup exterior; whitish with a smooth or finely downy surface. **HABITAT** Soil and leaf litter in woodland, usually on calcareous soil. **STATUS** Widespread but occasional.

Sooty Cup *Helvella leucomelaena* (= *Paxina leucomelas*)

Similar to Vinegar Cup but with the stem ribs extending only to the base of the cup. **HEAD** To 4cm across; irregular cup-shaped but becoming flatter and frequently splitting at the margin; interior dark grey-brown or blackish with a smooth surface; exterior greyish and finely scurfy or granular. **STEM** Whitish with short ribs, and often deeply buried and barely visible above ground. **HABITAT** On sandy soil, usually with pines and other conifers; often on stony or gravelly ground. **STATUS** Widespread but occasional in England; rare elsewhere.

Felt Saddle *Helvella macropus*

Autumn-fruiting *Helvella* with a shallow cup-shaped head and long, slender stem. **HEAD** To 3cm across; flat cup-shaped and turning back on itself, becoming more saddle-shaped with age; grey or grey-brown with a smooth interior; outer surface paler, covered in dense tufts of minute hairs and appearing granular. **STEM** To 5cm high; cylindrical and similar in colour and texture to outside of head. **HABITAT** Soil and leaf litter in deciduous woodland; occasionally with conifers. **STATUS** Widespread and common.

Pine Fire Fungus *Rhizina undulata* See p. 346.

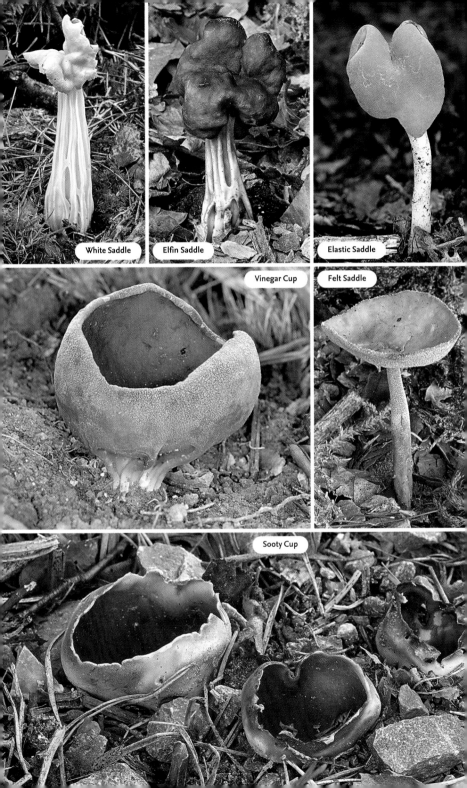

White Saddle

Elfin Saddle

Elastic Saddle

Vinegar Cup

Felt Saddle

Sooty Cup

Helvella corium (Helvellaceae)

Helvella with a cup-shaped cap and relatively short stem. Generally fruits in the spring. **HEAD** To 3cm across; shallow cup-shaped; inner surface dull blackish with a paler margin and smooth texture; outer surface dark brown or black, with dense tufts of minute hairs that give it a distinctly granular appearance. **STEM** To 2cm high; cylindrical but sometimes compressed, with blunt ribs; concolorous with outside of head and with a similar texture. **HABITAT** On sandy calcareous soil, sometimes dunes. **STATUS** Widespread but occasional in England.

Helvella corium

Helvella atra (Helvellaceae)

Dark brown saddle-shaped *Helvella* with a long, slender stem. **HEAD** To 3cm across; saddle-shaped lobe that folds back on itself into an irregular, vertically flattened disc, with margin partially attached to stem; outer surface variable in colour from grey through to brownish black, and with a scurfy texture; interior paler. **STEM** To 7cm high; cylindrical and sometimes twisted or grooved; similar in colour and texture to head. **HABITAT** Solitary or gregarious on soil in deciduous and coniferous woodland. **STATUS** Widespread but uncommon to rare.

Helvella latispora (Helvellaceae)

Very small, saddle-shaped *Helvella* with a slender stem. **HEAD** To 2cm across; saddle-shaped lobe, becoming a vertically flattened disc with an inrolled margin; outer surface pale brown with a smooth texture; inner surface whitish. **STEM** To 2.5cm high; white and downy. **HABITAT** Solitary or gregarious on soil in deciduous woodland. **STATUS** Widespread but uncommon. **SIMILAR SPECIES** *H. ephippium* is larger, with a hairy surface to the head and stem.

False Morel *Gyromitra esculenta* (Discinaceae)

Fragile, morel-like *Helvella* found in spring and early summer. **FRUIT BODY** To 15cm across and 12cm high; comprises a rounded, brain-like head fused to a short, stout stem. **HEAD** Irregularly rounded, with convoluted, flattened lobes that form a brain-like structure; reddish brown or blackish brown with a smooth surface. **STEM** Stout and to ⅓ overall height of fruit body; strongly furrowed, with the hollow interior a series of chambers; whitish with a felty texture. **HABITAT** Solitary or gregarious on sandy soil in coniferous woodland. **STATUS** Widespread but occasional.

Pouched False Morel *Gyromitra infula* (Discinaceae)

Similar to False Morel but less convoluted and fruiting in autumn. **FRUIT BODY** Comprises a mitre- or saddle-shaped head and hollow stem. **HEAD** To 8cm high and across; hollow, with irregular and distorted lobes forming a crumpled bag-like structure, and fused to stem at margins; cinnamon or dark brown with a smooth surface. **STEM** To 8cm high; hollow, furrowed and pitted; whitish or pale ochre with a smooth surface, but felty towards base. **HABITAT** Usually solitary on soil in coniferous and broadleaved woodland. **STATUS** Widespread but rare.

Pig's Ears *Gyromitra ancilis* (= *Discina perlata*) (Discinaceae)

Fleshy, ear-like *Helvella* found in spring and summer. **FRUIT BODY** To 10cm across; initially cup-shaped, then expanding and becoming flat and plate-shaped, irregular and distorted with wrinkles, bumps and ridges; texture cartilaginous; cinnamon or dark brown, with outer surface and margin slightly paler; attached to the substrate by a short whitish stem, which is completely obscured by the wide head. **HABITAT** Solitary or gregarious in needle litter or on rotted wood in coniferous woodland or rarely mixed woodland. **STATUS** Rare; found mainly in Scottish pinewoods.

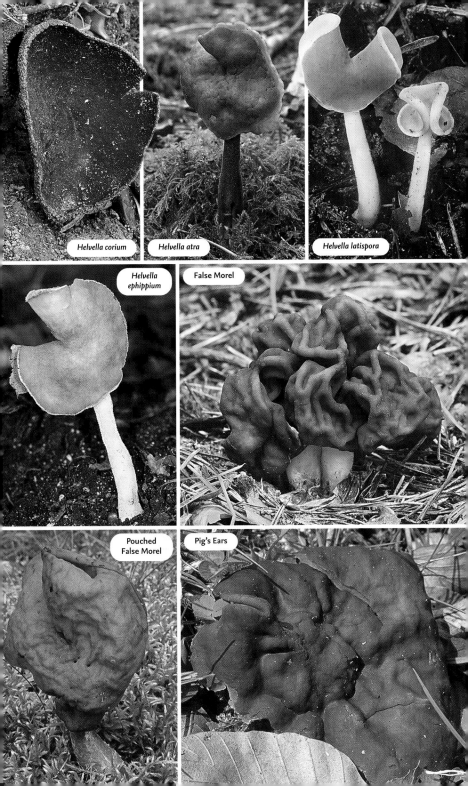

Helvella corium

Helvella atra

Helvella latispora

Helvella ephippium

False Morel

Pouched False Morel

Pig's Ears

Cedar Cup *Geopora sumneriana (= Sepultaria sumneriana)*
Unusual cup fungus, found partially buried in the soil under cedar trees. **FRUIT BODY** Initially bladder-like and developing just under the soil, then partially emerging and expanding into an irregular star-shaped cup to 7cm across, this splitting into short individual lobes; inner surface smooth and undulating; cream or light grey and somewhat opalescent; outer surface reddish brown and covered in coarse brown fibres. **HABITAT** Grouped or clustered in soil under cedar trees, rarely Common Yew, in parks, gardens and church-yards. **STATUS** Widespread but occasional; may be locally abundant in some years.

Glazed Cup *Humaria hemisphaerica*
Small cup fungus with a pale, opalescent interior. **FRUIT BODY** To 3cm across; sessile, deep cup-shaped and retaining its neat shape for a long time before becoming flatter and more irregular; inner surface opalescent whitish grey, sometimes with a bluish glaze, and with a smooth texture; outer surface a contrasting brown and covered with short, pointed, dark brown hairs that are darker and more prominent at margin. **HABITAT** Solitary or, more usually, gregarious on soil or rotted wood in damp, shady places. **STATUS** Widespread but occasional.

Orange Peel Fungus *Aleuria aurantia*
Spectacular cup fungus, resembling orange peel in colour and with thin, fragile flesh. **FRUIT BODY** To 10cm across; sessile, cup- or saucer-shaped, becoming flatter and irregular with a smooth, wavy margin; inner surface bright shades of orange with a smooth texture; outer surface paler and covered in a fine whitish down. **HABITAT** Solitary or gregarious on freshly broken ground, often on paths or roadsides; also in grass. **STATUS** Widespread and occasional to common.

Orange Cup *Melastiza cornubiensis (= M. chateri)*
Small, sessile, bright orange cup fungus with a conspicuous hairy margin. **FRUIT BODY** To 1.5cm across; shallow cup- or disc-shaped, becoming irregular and undulating, and somewhat contorted where several fruit bodies are crowded together; margin prominent and covered in small tufts of brown hairs; dull reddish orange with a smooth inner surface and a slightly paler, sometimes downy exterior. **HABITAT** Solitary or in small groups on sandy or gravelly soils in open places. **STATUS** Widespread but uncommon.

Melastiza scotica
Very similar to Orange Cup but larger and slightly paler. **FRUIT BODY** To 3cm across; shallow cup- or disc-shaped, becoming irregular, undulating and contorted where several fruit bodies are crowded together; narrow margin is covered in small tufts of pale, inconspicuous hairs; pale yellowish orange with a smooth inner surface and paler outside. **HABITAT** Solitary or in small groups on soil or mosses, often in open coniferous woodland. **STATUS** Uncommon, with most records from Scotland.

Octospora rutilans (= Neottiella rutilans)
Similar to some *Melastiza* species but without the hairy margin. **FRUIT BODY** To 1.5cm across; shallow cup- or disc-shaped, becoming undulating, irregular and contorted where fruit bodies are condensed and crowded together; sessile or sometimes attached to the substrate by a short, sometimes deeply buried stem; inner surface bright yellowish orange with a smooth texture; outer surface paler and covered in minute downy white hairs; stem whitish where buried. **HABITAT** Solitary or in small groups in light sandy soil amongst mosses. **STATUS** Widespread but uncommon. **SIMILAR SPECIES** *O. humosa* is slightly smaller and has a finely toothed margin.

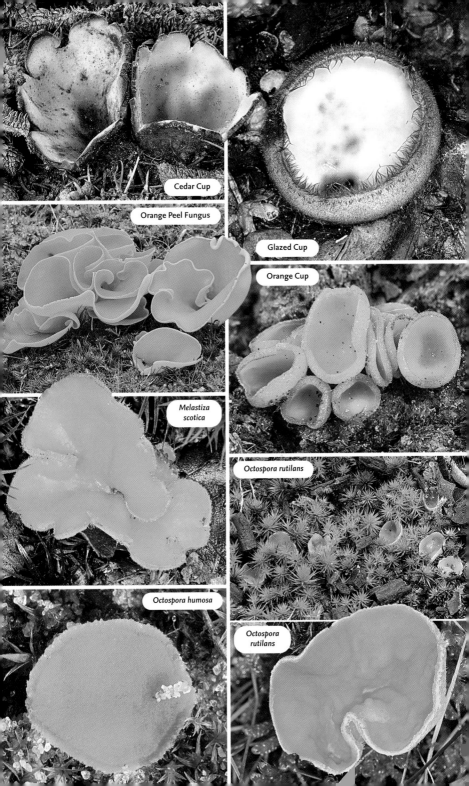

Cedar Cup

Orange Peel Fungus

Glazed Cup

Orange Cup

Melastiza scotica

Octospora rutilans

Octospora humosa

Octospora rutilans

Common Eyelash *Scutellinia scutellata* (Pyronemataceae)

Sessile, bright red disco with conspicuous, long 'eyelashes'. **FRUIT BODY** Initially rounded, but becoming a flat disc to 1cm across with an upturned margin; inner surface bright scarlet and smooth; margin and outer surface brownish orange and covered in long, bristle-like hairs to 0.2cm in length. **HABITAT** Occasionally solitary but usually grouped or clustered on damp, rotting wood, frequently in wet places. **STATUS** Widespread and common.

Scutellinia olivascens (= *S. ampullacea*) (Pyronemataceae)

Similar to Common Eyelash but larger and with shorter 'eyelashes'. **FRUIT BODY** To 2cm across; disc-shaped, with the margin covered in short, bristle-like hairs less than 1mm long; brownish red. **HABITAT** Damp, rotted wood or soil. **STATUS** Widespread but uncommon to rare. **SIMILAR SPECIES** There are several other similar *Scutellinia* species that can only be separated microscopically.

Anthracobia macrocystis *See p. 346.*

Scutellinia olivascens

Cheilymenia granulata (= *Coprobia granulata*) *See p. 344.*

Holly Speckle *Trochila ilicina* (Incertae sedis – Helotiales)

Very common, dark disco found on dead Holly leaves. **FRUIT BODY** To 0.5cm across; irregular discs with a lid-like top that breaks open to expose the spore surface; olive to blackish brown. **HABITAT** Usually in large groups deeply embedded in the leaf tissue on the upper side of fallen Holly leaves. **STATUS** Widespread and very common.

Common Grey Disco *Mollisia cinerea* (Incertae sedis – Helotiales) (Top 100)

Sessile, small grey disco found crowded on wet, rotting wood. **FRUIT BODY** To 0.2cm across; cup-shaped, becoming flatter and undulating with a raised margin; frequently convoluted and distorted as a result of several fruit bodies growing together and being tightly compressed; inner surface pale grey with a smooth texture, but margin often paler; outer surface greyish brown with a smooth or finely downy texture. **HABITAT** Densely clustered on damp, rotting wood of deciduous trees. **STATUS** Widespread and common.

Catinella olivacea (Incertae sedis – Helotiales)

Small, dark disco with a distinctive olive margin. **FRUIT BODY** To 0.8cm across; saucer-shaped but becoming flatter, irregular and undulating, and attached or embedded in the substrate without a stem; blackish brown with an olive-brown margin; interior smooth; exterior scurfy. **HABITAT** Densely crowded on rotting wood of deciduous trees. **STATUS** Uncommon to rare; mainly in scattered localities in England.

Coral Spot *Nectria cinnabarina* (Nectriaceae) (Top 100)

Very common asco found in two distinct stages that produce independent fruit bodies. **FRUIT BODY** Perfect (sexual stage) comprises a dense cluster of brownish-red egg-like spheres to 0.4cm across, each with a nipple-like projection at the top and erupting stemless from the substrate; preceded by the much more familiar, soft coral-pink cushion-like pustules (conidial stage) from which it derives its common name. **HABITAT** In dense groups on dead and dying wood of deciduous trees; rarely on conifers. **STATUS** Widespread and extremely common. **SIMILAR SPECIES** *N. epishaeria* is orange-red and found on old fruit bodies of some ascomycetes.

Snowy Disco *Lachnum virgineum* (= *Dasyscyphus virgineus*) (Hyaloscyphaceae) (Top 100)

Tiny spring- and summer-fruiting disco with a thick hairy margin. **FRUIT BODY** To 1mm across; deep cup-shaped but expanding and becoming more open, with a distinct stalk; inner surface white or cream with a smooth texture; outer surface and margin concolorous and covered in a thick white hairy mat. **HABITAT** Gregarious or trooping on dead Bramble stems and other plant debris, including Beech nuts and pine cones. **STATUS** Widespread and common.

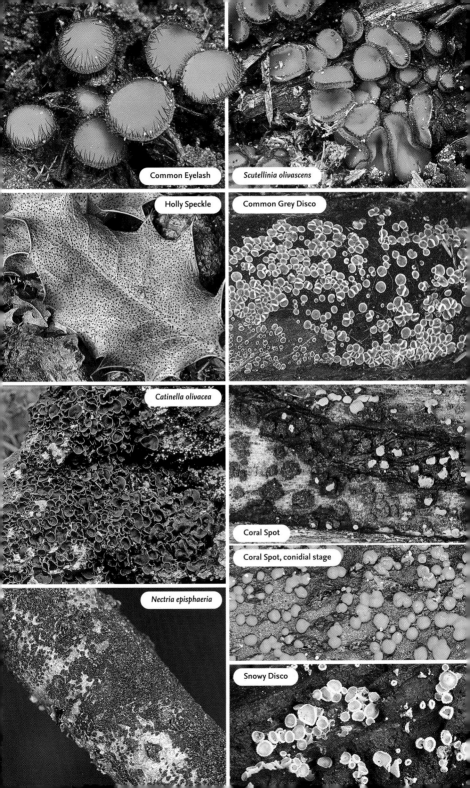

Common Eyelash

Scutellinia olivascens

Holly Speckle

Common Grey Disco

Catinella olivacea

Coral Spot

Coral Spot, conidial stage

Nectria episphaeria

Snowy Disco

Common Morel *Morchella esculenta*

Fruits in spring and is one of the most prized edible fungi. In the past, several different species were recognised, but it is now thought that they do not warrant full species status and are considered to be merely forms of *M. esculenta*; consequently, it is very variable both in shape and colour. **FRUIT BODY** To 20cm high; comprises a head and stem. **HEAD** Round, oval or broadly conical, consisting of a series of irregular pits divided by connected ridges arranged in a honeycomb-like pattern; fused to stem along its entire length and with the margin inrolled; various shades of yellowish brown but becoming darker, particularly the ridges; texture smooth but brittle. **STEM** Short, hollow and irregular, usually broader at base, and with longitudinal furrows; white or pale cream; slightly scurfy and brittle. **HABITAT** Generally solitary but sometimes in groups in scrub, open deciduous woodland and waste ground, often under dead and dying trees, especially on calcareous soils. **STATUS** Widespread but uncommon.

Black Morel *Morchella elata*

Similar to Common Morel but more conical and darker in colour. **FRUIT BODY** To 15cm high; comprises a head and stem. **HEAD** Narrow conical and tapering into stem; comprises a series of pits, with the connecting ridges more or less in parallel lines; brown or blackish; texture smooth and brittle. **STEM** Relatively tall and hollow, cylindrical or broadening downward; white or cream; scurfy, with longitudinal wrinkles. **HABITAT** Solitary or grouped in deciduous and coniferous woodland, sometimes on woodchip mulch. **STATUS** Widespread but uncommon to rare.

Semifree Morel *Morchella semilibera* (= *Mitrophora semilibera*)

Spring-fruiting morel with a disproportionately small head and long, thick stem. **HEAD** To 4cm high; conical, comprising a series of pits with irregular, vertical connecting ridges arranged in a honeycomb-like pattern; joined only at top half, with lower part flared and free of stem, hence the common name; shades of brown with a paler interior, ridges blackening with age. **STEM** To 8cm tall; stout and irregular, sometimes widening at base, often grossly so; longitudinally grooved and finely granular; white or cream. **HABITAT** Solitary or in small groups in damp woodland and meadows. **STATUS** Widespread but uncommon.

M. semilibera and *M. esculenta* showing cap attachment to stem

Thimble Morel *Verpa conica*

Similar to Semifree Morel and with the same fruiting season, but with a plainer head and connected to the stem only at the apex. **HEAD** To 4cm high; thimble-shaped but becoming more bell-shaped; usually wrinkled and occasionally more convoluted; connected to stem only at apex; pale or dark brown with a paler interior. **STEM** Cylindrical or slightly irregular; white or cream; finely granular, in very faint concentric bands. **HABITAT** Solitary or in small groups in scrub and woodland on chalk, usually with Common Hawthorn. **STATUS** Rare, but locally common in some years.

Thimble Morel

Black Cup *Disciotis venosa*

Large, flat, spring-fruiting morel with brittle flesh and a chlorine-like smell. **FRUIT BODY** To 15cm across; initially convoluted and indeterminate in shape, but becoming flattened and irregular plate-shaped, and connected to the ground by a rudimentary, usually buried, stem; inner surface strongly wrinkled, veined and ribbed, usually radiating out from centre; light or dark brown, with the margin paler, inrolled and irregularly wavy; outer surface white or cream and finely granular. **HABITAT** Solitary or in groups in damp woodland, usually on chalk. **STATUS** Widespread but occasional; may be locally common or abundant in some years.

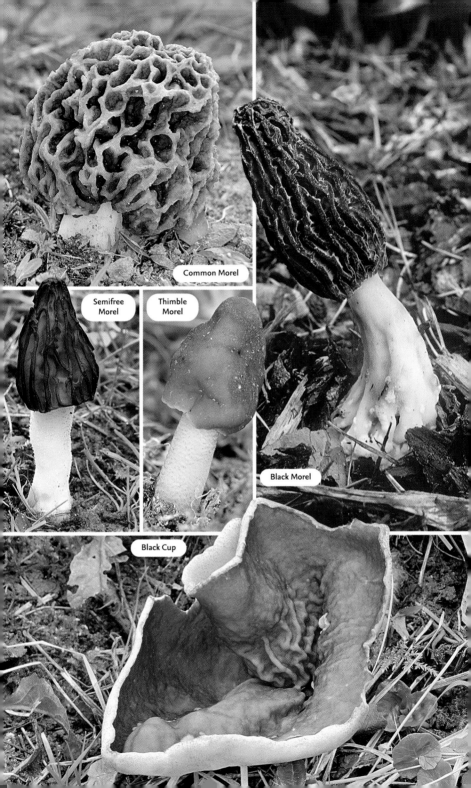

Common Morel

Black Morel

Semifree Morel

Thimble Morel

Black Cup

Peziza species are usually disc- or cup-shaped, and are mostly sessile but occasionally have a short, rudimentary stem. Most are in shades of brown but some have a reddish or purple tint. Most fruit in the autumn in open places but on a wide variety of substrates. Their flesh is mostly thin and fragile with the taste and smell of no significance. Some species exude a clear or coloured juice when damaged and this, together with the fruit-body colour and substrate, are important field characteristics. However, as more than 50 species are found in Britain, a microscopic examination is needed to identify the majority.

Blistered **Cup**

Blistered Cup *Peziza vesiculosa*

Distinguished by its clustered, blister-like growth. Fruits year-round. **FRUIT BODY** To 8cm across; initially deep cup- or goldfish bowl-shaped with a strongly inrolled margin, but expanding to saucer-shaped with the margin splitting and becoming ragged or blistered; inner surface yellowish brown with a smooth texture; outer surface similar in colour and finely granular. **HABITAT** Typically in tight, fused clusters on straw, manure, compost and rich soil, and increasingly on woodchip mulch. **STATUS** Widespread and common.

Palamino Cup *Peziza repanda*

Pale cup, often found in woody debris. **FRUIT BODY** To 12cm across; cup-shaped but expanding and becoming wavy and irregular, with the margin 'toothed' and sometimes split; inner surface pale ochre-brown with a smooth texture; outer surface paler, ochre-cream and slightly scurfy. **HABITAT** Solitary or in small groups on soil, and with woody debris, including sawdust and woodchip mulch. **STATUS** Widespread and common.

Cellar Cup *Peziza cerea*

Pale cup associated with limestone and often found growing out of mortar joints in buildings. **FRUIT BODY** To 5cm across; irregular cup-shaped, with the margin inrolled at first; inner surface pale ochre or yellowish brown with a smooth texture; outer surface concolorous and finely granular. **HABITAT** Solitary or in small groups on woody debris, sandbags, limestone rubble, lime mortar and, sometimes, in damp cellars. **STATUS** Widespread and common.

Cellar
Cup

Bay Cup *Peziza badia*

Distinctive brown cup; the most common dark brown *Peziza* species. **FRUIT BODY** To 8cm across; initially cup-shaped but becoming flatter, very irregular and undulating; inner surface smooth, variable in colour but typically dark reddish brown and developing olive tints with age; outer surface reddish brown and finely granular. **HABITAT** Typically in groups, sometimes clustered, on soil, especially along pathsides and in grass; often on light sandy soils. **STATUS** Widespread and common.

Bonfire Cauliflower *Peziza proteana* var. *sparassoides*

Very atypical *Peziza* with a distinctive cauliflower shape. **FRUIT BODY** To 12cm across; irregularly rounded and very convoluted, comprising a number of tightly packed, brittle lobes arranged in a cauliflower-like shape; inner surface whitish with ochreous tints and a smooth texture; outer surface whitish, flushed pink, and scurfy. **HABITAT** Old fire sites. **STATUS** Widespread but rare.

Yellowing Cup *Peziza succosa*

Common *Peziza* that exudes a yellow juice when damaged. **FRUIT BODY** To 5cm across; initially cup-shaped, but becoming flatter and undulating with age; inner surface dull light brown and somewhat wrinkled towards centre; outer surface paler, finely scurfy and sometimes stained yellow by the exuded juice, particularly towards margin. **HABITAT** Solitary or in small groups in damp woodland. **STATUS** Widespread and occasional to common.

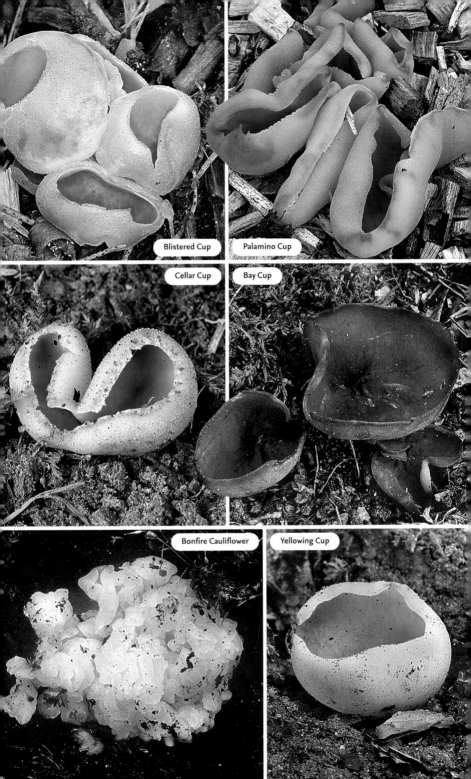

Blistered Cup

Palamino Cup

Cellar Cup

Bay Cup

Bonfire Cauliflower

Yellowing Cup

Charcoal Cup *Peziza echinospora*

The distinctive features of this *Peziza* are the contrast in colour between the outer and inner surfaces and the burnt-ground habitat. **FRUIT BODY** To 8cm across; initially cup-shaped with an inrolled margin, but becoming more expanded with age; inner surface mid- to dark reddish brown with a smooth texture; outer surface paler, sometimes almost white, and distinctly scurfy. **HABITAT** Solitary or in small groups, occasionally clustered, on charcoal, burnt wood and burnt ground. **STATUS** Widespread and common.

Peziza micropus

The most common *Peziza* found on rotten wood. **FRUIT BODY** To 5cm across; cup-shaped, but becoming very irregular and flatter, with the margin somewhat contorted, toothed and split; usually attached to the substrate by a short stem; inner surface ochre or pale brown with a smooth texture; outer surface paler and finely floury. **HABITAT** Solitary or in small fused groups on rotten wood of broadleaved trees, less often with conifers; formerly common on elms but now more often on Beech. **STATUS** Widespread and common.

Peziza ampelina

Distinctive *Peziza* with a violaceous inner surface. **FRUIT BODY** To 5cm across; saucer-shaped, then irregularly expanding and often distorted when growing in tightly compressed clusters; margin frequently split; inner surface dark violet or violet-brown with a smooth texture; outer surface light ochre, sometimes with olive tints and finely floury at margin. **HABITAT** Solitary or in fused groups on soil, sometimes on charred wood on bonfire sites. **STATUS** Uncommon.

Layered Cup

Layered Cup *Peziza varia*

Distinguished from several other similar species of *Peziza* by the layered flesh. **FRUIT BODY** To 5cm across; cup-shaped but expanding irregularly and becoming flatter with an undulating margin; inner surface hazel or light brown with a smooth texture; outer surface paler and finely scurfy. Flesh in distinct layers; in cross-section, the dark lines demarking each layer are visible under a hand lens. **HABITAT** Solitary or in small groups on soil and rotted wood. **STATUS** Widespread but occasional.

Peziza michelii

Reddish *Peziza*, usually found on bare stony ground. **FRUIT BODY** To 5cm across; deep cup- or disc-shaped with the margin inrolled; usually sessile but occasionally attached to the substrate by a rudimentary stem; inner surface reddish brown with a violet tint and smooth; outer surface slightly paler and scurfy. Flesh exudes a watery juice when damaged. **HABITAT** Solitary or in small groups on bare ground on roadsides, and at woodland margins. **STATUS** Rare.

Dune Cup *Peziza ammophila* See p. 340.

Plicaria endocarpoides

Similar to several species of *Peziza* but separated by its different spore shape. Often found in winter. **FRUIT BODY** To 6cm across; initially cup-shaped but expanding and becoming irregular and flattish; inner surface shades of brown, sometimes blackish, with a smooth, shiny but wrinkled texture; outer surface similar in colour but finely granular. Exudes a yellowish juice when damaged. **HABITAT** Solitary or in small fused groups on bonfire sites and burnt ground, particularly when these are on sandy heaths. **STATUS** Widespread but occasional.

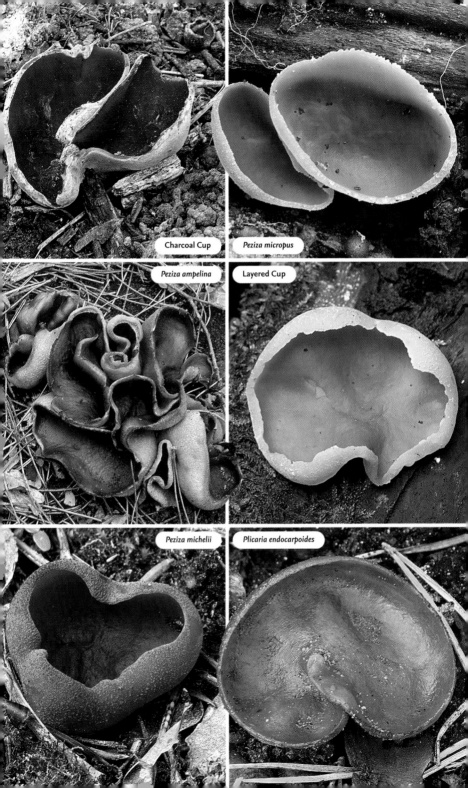

Charcoal Cup

Peziza micropus

Peziza ampelina

Layered Cup

Peziza michelii

Plicaria endocarpoides

Hare's Ear *Otidea onotica*

Members of the genus *Otidea* are similar to some *Peziza* species but are more elongated and have a longitudinal slit down one side. **FRUIT BODY** To 6cm wide and 10cm high; irregular cup-shaped and elongated on one side, resembling a Rabbit's ear, with an inrolled, overlapping slit running down the short side; inner surface yellowish ochre and smooth; outer surface concolorous, finely scurfy and tapering into a short whitish stem. **HABITAT** Solitary or in small groups in deciduous woodland. **STATUS** Widespread but occasional.

Tan Ear *Otidea alutacea*

Similar to Hare's Ear but less ear-shaped and showing a colour contrast between inner and outer surfaces. **FRUIT BODY** To 4cm across and 6cm high; irregular cup-shaped, elongated on one side and with an inrolled, overlapping slit running down the opposite side; inner surface clay-brown with a smooth texture; outer surface paler, buff and finely scurfy; sometimes with a short stem. **HABITAT** Solitary or in small groups, sometimes clustered on soil in deciduous woodland. **STATUS** Widespread but uncommon.

Toad's Ear *Otidea bufonia*

Dark brown *Otidea*. **FRUIT BODY** To 6cm across and 3cm high; irregular cup-shaped, sometimes elongated, with an inrolled, overlapping slit running down one side; inner surface dark brown with a smooth texture; outer surface slightly paler and downy. **HABITAT** Solitary or in small groups, sometimes clustered, on soil along roadsides, tracks and in woodland. **STATUS** Uncommon.

Toad's
Ear

Tazzetta catinus

Similar to several species of *Peziza* but with a finely toothed margin and distinct stem. **FRUIT BODY** To 4cm across; bowl- or deep cup-shaped, but expanding and sometimes splitting into lobes, with a finely serrated margin; inner surface cream-ochre with a smooth texture; outer surface concolorous but downy and widening into a longish stem. **HABITAT** Solitary or sometimes in small groups on bare earth in open places, roadsides, tracks and woodland. **STATUS** Widespread but occasional.

Toothed Cup *Tazzetta scotica* (= *T. cupularis*)

Similar to *T. catinus* but with a shorter stem or even sessile. **FRUIT BODY** To 2cm across; permanently bowl- or deep cup-shaped with a finely serrated margin; sessile or, occasionally, with a short, deeply embedded stem; inner surface greyish ochre and smooth; outer surface concolorous but downy. **HABITAT** Solitary or, sometimes, in small groups on bare earth, occasionally woodchipping in open places and woodland. **STATUS** Widespread but occasional to rare.

Midnight Disco *Pachyella violaceonigra* (Pezizaceae)

Flat reddish-brown *Peziza*. **FRUIT BODY** To 7cm across; initially disc-shaped, then flattening and developing undulating folds; tightly joined to the substrate by a rudimentary stalk-like attachment; inner surface dark reddish brown with a smooth texture; outer surface cream or buff and finely floury. **HABITAT** Damp areas, usually on wet wood. **STATUS** Rare.

Sowerbyella radiculata

Brightly coloured *Peziza*-like cup with a distinct stem. **FRUIT BODY** To 5cm across; shallow cup-shaped, but expanding and becoming irregular and almost flat; inner surface greenish yellow and often wrinkled, particularly towards centre; outside paler and floury, becoming whitish or greyish with age. **STEM** To 4cm long; furrowed and often encrusted with debris. **HABITAT** Solitary or in small groups in coniferous woodland. **STATUS** Rare.

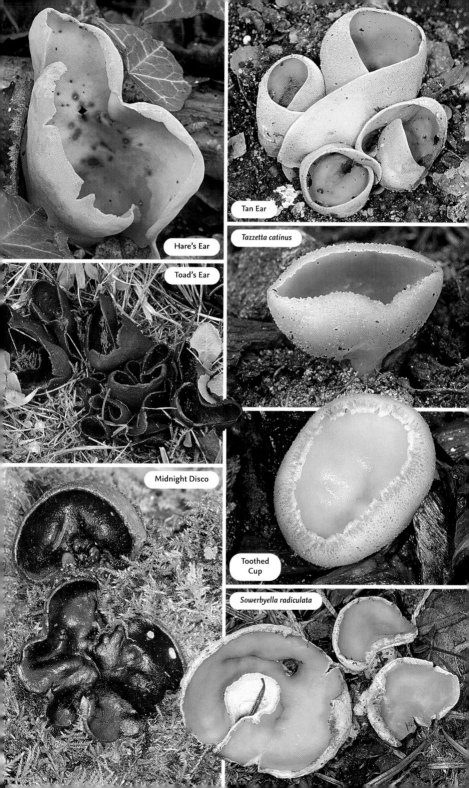

Hare's Ear

Tan Ear

Tazzetta catinus

Toad's Ear

Midnight Disco

Toothed Cup

Sowerbyella radiculata

Scarlet Elf Cup *Sarcoscypha austriaca* (Sarcoscyphaceae)

Brilliantly coloured disc fungus found in winter or early spring. **FRUIT BODY** To 5cm across; circular or oval, sometimes more elongated; initially deep cup-shaped but becoming disc-shaped; usually attached to the substrate by a short stem; flesh fragile and breaking up with age; inner surface scarlet with a smooth texture; outer surface paler and covered in whitish downy hairs. **HABITAT** Solitary or in small groups on dead wood of deciduous trees, often moss-covered logs. **STATUS** Widespread but occasional.

Ciboria batschiana (Sclerotiniaceae)

Ciboria batschiana

Small cup fungus found growing on old acorns. **FRUIT BODY** To 1.5cm across; initially cup-shaped, then flatter and becoming a concave disc; attached to the substrate by a long stem; inner surface reddish brown with a smooth texture; outer surface concolorous and finely downy. **STEM** To 2cm long; slender and usually wavy; dark brown. **HABITAT** Solitary or gregarious on old fallen acorns. **STATUS** Widespread but occasional in England.

Brown Cup *Rutstroemia firma* (Rutstroemiaceae)

Small brown cup fungus attached to the substrate by a shortish stem. **FRUIT BODY** To 1cm across; initially cup-shaped, but becoming flatter, undulating and wrinkled; inner and outer surfaces reddish brown with a smooth texture; margin darker and usually slightly uplifted. **STEM** To 5mm long; slender and pale brown. **HABITAT** Solitary or gregarious on dead branches of deciduous trees, especially oaks and Hazel. **STATUS** Widespread and common.

Rutstroemia echinophila (Rutstroemiaceae)

Instantly recognisable by its growing habitat: old Sweet Chestnut husks. **FRUIT BODY** To 0.7cm across; initially cup-shaped but expanding and becoming shallower; margin finely toothed; inner and outer surfaces reddish brown and smooth; occasionally sessile but usually attached to the substrate by a short, pale brown stem. **HABITAT** Sometimes solitary but typically gregarious on the inside of empty Sweet Chestnut husks. **STATUS** Widespread but uncommon.

Alder Goblet *Ciboria caucus* (= *C. amentacea*) (Sclerotiniaceae)

Spring-fruiting *Ciboria* found on Common Alder or willow catkins. **FRUIT BODY** To 1cm across; initially cup-shaped but becoming flatter, attached to the substrate by a long, slender, wavy stem; inner surface pale brown with a smooth texture; outer surface concolorous and downy. **STEM** To 2.5cm long; pale brown with a slightly downy surface. **HABITAT** Solitary or grouped on fallen male catkins of Common Alder and willows. **STATUS** Widespread and common.

Ochre Cushion *Hypocrea pulvinata* (Hypocreaceae)

Resupinate fungus found on old fruit bodies of Birch Polypore (p. 254). **FRUIT BODY** Fully resupinate, irregularly rounded or cushion-shaped blobs that coalesce to cover the substrate; surface uneven and irregular, covered in bumps or warts, and with small pores; yellowish or ochre with a soft texture when fresh. **HABITAT** Densely covering the pore surface of old fruit bodies of Birch Polypore when these are either lying on the ground or still attached to the substrate. **STATUS** Occasional where Silver Birches are common.

Alder Goblet

Hypocrea gelatinosa (= Creopus gelatinosus) (Hypocreaceae)

Tiny greenish gelatinous blobs found on rotted wood. **FRUIT BODY** Small balls of tissue (stroma), 2mm across, in which the fruit bodies develop; initially almost colourless and somewhat transparent, with the fruit bodies showing through as greenish dots; flesh gelatinous, with the pore openings creating a warty, pitted surface. **HABITAT** Crowded on damp wood of deciduous trees; rarely on conifers. **STATUS** Widespread but occasional.

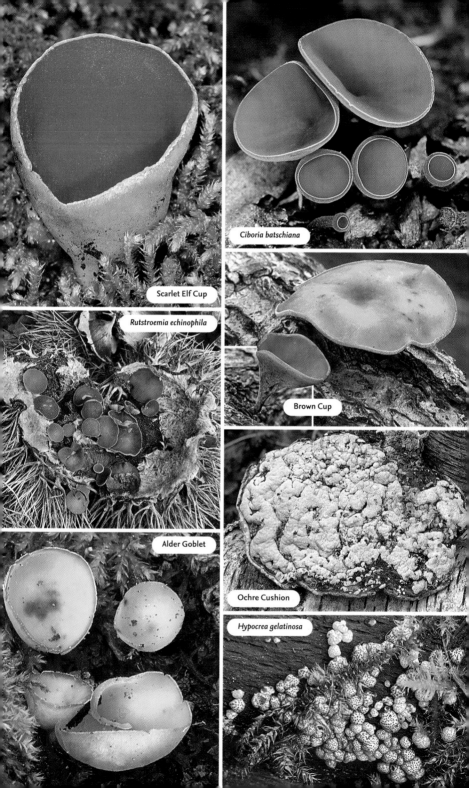

Scarlet Elf Cup

Ciboria batschiana

Rutstroemia echinophila

Brown Cup

Alder Goblet

Ochre Cushion

Hypocrea gelatinosa

Candlesnuff Fungus *Xylaria hypoxylon* (Top 100)

Very common club-like fungus that resembles a burnt candle wick when young. Found year-round. **FRUIT BODY** To 6cm high; irregular, flattish, wick-like stem, sometimes with a simple fork near the top but typically with several branches forming an antler-like head; black and slightly hairy towards base but progressively covered upward in a white powder produced by asexual spores; when mature, more club-like with a granular surface. **HABITAT** Dead wood of broadleaved trees. **STATUS** Widespread and very common.

Dead Man's Fingers *Xylaria polymorpha* (Top 100)

The grisly common name of this fungus is very descriptive. **FRUIT BODY** To 8cm high; plump, irregularly club-shaped fingers, sometimes with flattish lobes and a rounded or truncated top; attached to the substrate by a short, cylindrical stem that snaps when bent (unlike Dead Moll's Fingers, below); grey-brown or light brown, becoming blackish with age; head covered in tiny raised pores, giving it a rough texture. Flesh tough, fibrous and white. **HABITAT** Usually in tight clusters, fused at the base, on dead wood of broadleaved trees, particularly Beech. **STATUS** Widespread and common.

Dead Moll's Fingers

Dead Moll's Fingers *Xylaria longipes*

A more slender version of Dead Man's Fingers, with the same texture and flesh colour. **FRUIT BODY** To 6cm high; slender cylindrical to club-shaped, sometimes bent, with a rounded top and tapering into a long stem; dark brown or black with a rough texture and often cracking into a crazed pattern. **STEM** To 3cm high; cylindrical, slender and generally smoothish, but becoming slightly felty towards base; flexible when bent; brown or black. **HABITAT** Sometimes solitary but usually clustered on fallen branches of broad-leaved trees, especially Sycamore. **STATUS** Widespread and common.

Beechmast Candlesnuff *Xylaria carpophila*

Similar to Candlesnuff Fungus (*see* above) but smaller, more slender and found on Beech mast. **FRUIT BODY** To 1cm high; thread-like and irregularly compressed, with the central part sometimes thickened; generally simple but occasionally forked; brownish black with white tips when young, and covered with tiny raised pores; somewhat felty towards base. **HABITAT** Solitary or clustered on fallen Beech mast. **STATUS** Widespread and common.

Beechmast Candlesnuff

Brittle Cinder *Kretzschmaria deusta* (= *Ustulina deusta*)

Perennial black cinder-like fungus that is preceded by greyish-white infertile stage. **FRUIT BODY** Fully resupinate, crust several centimetres in extent, with an irregular, undulating surface covered in tiny pores; initially greyish white with a floury coating, becoming brown, then finally black and extremely brittle. **HABITAT** Encrusting rotten stumps and roots of broadleaved trees, especially Beech. **STATUS** Widespread and common.

Cramp Balls or King Alfred's Cakes *Daldinia concentrica* (Top 100)

Uneven, rounded fungus that resembles burnt buns. **FRUIT BODY** To 10cm across; irregularly rounded or knob-like, firmly and broadly attached to the substrate without a stem; initially reddish brown but becoming black, with a smooth texture; dusted with fallen spores on maturity, these rubbing off to leave a shiny surface. Flesh tough and leathery when fresh but becoming brittle and charcoal-like with age.

cross section

Cut vertically, fruit body shows distinctive concentric black and whitish bands. **HABITAT** Solitary or in groups on dead wood of deciduous trees, virtually exclusively Ash. **STATUS** Widespread and common. **SIMILAR SPECIES** *D. fissa* (= *D. vernicosa*) is scarcer and smaller, and is frequently found on burnt gorse. *D. loculata* is very rare and extremely shiny, and typically found on burnt Silver Birch.

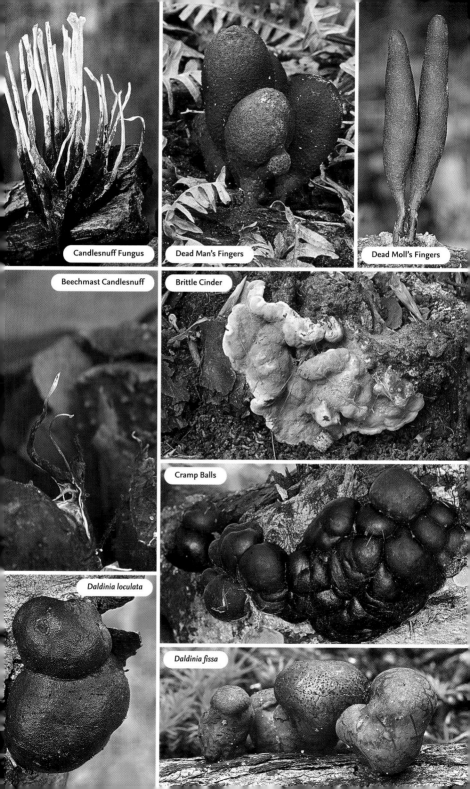

Candlesnuff Fungus

Dead Man's Fingers

Dead Moll's Fingers

Beechmast Candlesnuff

Brittle Cinder

Cramp Balls

Daldinia loculata

Daldinia fissa

Beech Woodwart *Hypoxylon fragiforme* (Xylariaceae) (Top 100)

Very common, round, sessile ascomycete found in dense swarms on the dead trunks and branches of Beech. Hemispherical crusty tissue (stroma) to 1cm across, in which tiny fruit bodies are embedded, invisible externally apart from a pore opening; surface colour initially pinkish, then reddish brown and finally black on maturity, and covered in the small, pointed, pimple-like pore openings; interior brown or black with a hard coke-like texture. **HABITAT** Typically massed on dead trunks and branches of Beech that usually still have the bark attached. **STATUS** Widespread and very common. **SIMILAR SPECIES Hazel Woodwart** *H. fuscum* (Top 100) is browner with less pointed pore openings, and is found on Hazel and Common Alder.

Birch Woodwart *Hypoxylon multiforme* (Xylariaceae) (Top 100)

Similar to Beech Woodwart in structure, and typically associated with birches. Irregular stroma, which house the tiny fruit bodies, vary in shape from round and cushion-shaped to elongated, and generally grow out of fissures in the bark of the substrate, with several coalescing to cover an area a few centimetres in extent; surface initially rust-red then dark brown or black, and dotted with prominent raised pore openings; interior similar in colour, with a coke-like texture. **HABITAT** Usually on dead trunks and branches of birches, occasionally Common Alder or, more rarely, other broadleaved trees. **STATUS** Widespread and common.

Hypoxylon petriniae (Xylariaceae)

Previously confused with, and identified as, *H. rubiginosum* (not described). Very thin, irregular, crusty patch to 10cm across, in which the small black fruit bodies are embedded; surface brown with violaceous tones and a blackish margin, becoming darker with age, smooth and covered in inconspicuous pore openings. **HABITAT** Typically fallen branches of Ash or, rarely, other broadleaved trees. **STATUS** Uncertain owing to the confusion with *H. rubiginosum*, but probably widespread and common.

Hypoxylon petriniae

Beech Tarcrust *Biscogniauxia nummularia*
(= *Hypoxylon nummularium*) (Xylariaceae)

Sheet-forming ascomycete that looks like tar. Irregular crust, forming a thin sheet several centimetres in extent in which the black fruit bodies are embedded; surface black and extensively dotted with small, pointed pore openings. **HABITAT** Thin layers on fallen dead wood of deciduous trees, especially Beech. **STATUS** Widespread and relatively common.

Beech Barkspot *Diatrype disciformis* (Diatrypaceae) (Top 100)

Small, disc-like ascomycete that distinctively erupts from beneath the bark of fallen branches. Circular, cushion-shaped stroma with a flat top in which the tiny fruit bodies are embedded; stroma develop beneath bark and erupt, causing it to peel back; surface black and dotted with small, raised pore openings, producing a slightly rough texture. **HABITAT** Small or large groups on fallen branches of Beech that still have bark attached. **STATUS** Widespread and common. **SIMILAR SPECIES *Diatrypella quercina*** is very similar; it is usually associated with oaks.

Common Tarcrust *Diatrype stigma* (Diatrypaceae) (Top 100)

Similar to Beech Tarcrust (*see* above) but with lighter-coloured spores. Irregular crust several centimetres in extent in which the tiny fruit bodies are embedded; surface black, smooth and sometimes split, and dotted with small, slightly raised pores openings; develops under the bark of the substrate, eventually causing it to roll back and eventually become detached. **HABITAT** In sheets on fallen branches of deciduous trees, especially Beech. **STATUS** Widespread and common.

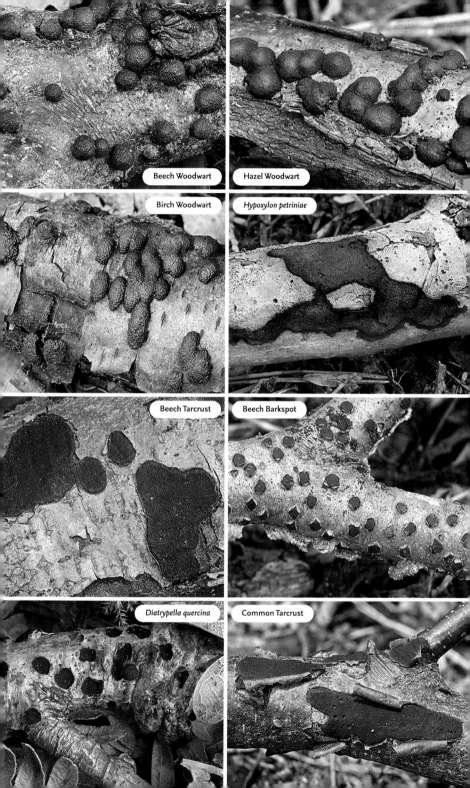

Beech Woodwart

Hazel Woodwart

Birch Woodwart

Hypoxylon petriniae

Beech Tarcrust

Beech Barkspot

Diatrypella quercina

Common Tarcrust

Look closely and you will find that almost every plant you inspect in the natural world is affected to varying degrees by fungal pathogens and parasites. Some take the form of spots and lesions on leaves, while others cause distortions and cankers on stems; a hand lens can reveal great detail in these cases. A few species induce their hosts to produce bizarre and extraordinary galls, which are large enough to be appreciated with the naked eye. Just a small selection of the more obvious species are shown here.

Rusts

Rusts are members of the Basidiomycota (*see* p. 8), whose complex life cycles are beyond the scope of this book; in some species, different host plants are infected by different stages in the life cycle. Rusts affect a wide range of plants, and in many instances the fungus has a specific name that relates to the genus scientific name of its host. **Puccinia** is a particularly diverse genus that affects an extraordinary range of plants; only a handful of examples are illustrated here.

NETTLE RUST *Puccinia urticata* produces rusty-orange spots on the leaves of Common Nettle.

COLTSFOOT RUST *Puccinia poarum* produces rusty-orange spots on the leaves of Coltsfoot.

PELARGONIUM RUST *Puccinia pelargonii-zonalis* produces rusty-orange spots on the leaves of cultivated pelargoniums.

VIOLET BRAMBLE RUST *Phragmidium violaceum* (Top 100) produces reddish-violet spots and patches on the leaves of Bramble.

POPLAR RUST *Melampsora populina* produces orange pustules on the leaves of poplars.

LEFT: *Gymnosporangium clavariiforme* appears in spring as strange antler-like projections from the stems of Juniper; these are bright orange when fresh and damp.

RIGHT: *Uromyces muscari* appears as dark spots on the dying stems of Bluebell.

Smuts

Smuts are internal parasites of plants and are obvious to observers only when they are at the spore-producing stage. They manifest themselves in a variety of different ways according to species, some affecting the reproductive parts of the plant, others appearing as blisters and pustules on leaves. **Microbotryum violaceum** affects members of the pink family Caryophyllaceae, notably Red Campion; it infects and darkens the anthers of male flowers.

Tar-spot fungi

Tar-spot fungi (genus *Rhytisma*) are members of the Ascomycota and appear as dark, tar-like spots on the leaves of trees. **R. acerinum** (Top 100) is a familiar species that affects the leaves of Sycamore.

Mildews

The term 'mildew' is a catch-all phrase that is used in an unscientific way to describe a range of fungal growths on the surface of plants; mildews are members of the Ascomycota. Powdery mildews – a notable group – appear as whitish powdery coatings on leaves; **Oak Mildew** *Microsphaera alphitoides* is a typical example, seen on the young leaves of oaks, in particular Pedunculate Oak.

Gall-inducing *Taphrina*

Taphrina is a genus of parasitic Ascomycota, some of which induce intriguing galls in their host plants. **Witches' Broom** *T. betulina* is the largest and probably most familiar, inducing dense twig-like formations (the size and shape of a squirrel's drey) among the branches of birches; these are most conspicuous on leafless trees in winter. **Pocket Plum** *T. pruni* affects Blackthorn and causes the fruits (normally sloes) to become green and runner bean-like in appearance. **Alder Tongue** *T. alni* produces flaming tongue-like outgrowths from the fresh cones of Common Alder.

Agents of decay

Rhopographus filicinus is a member of the Ascomycota and is almost ubiquitous in autumn. It appears as striking black patches on the dying stems of Bracken.

Blights

Nowadays, blights such as those in the genus *Phytophthora*, although fungus-like, are placed in a separate kingdom – Chromista. But for the purposes of this book they are treated as honorary fungi. These pathogens cause die-back and rots in plants; the most notorious is **Phytophthora infestans**, which causes blight in Potato and Tomato plants.

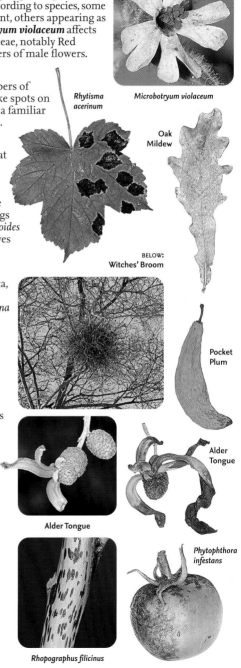

Rhytisma acerinum

Microbotryum violaceum

Oak Mildew

BELOW: Witches' Broom

Pocket Plum

Alder Tongue

Alder Tongue

Phytophthora infestans

Rhopographus filicinus

Once thought of as bizarre fungi, slime moulds are now recognised as being entirely unrelated. Opinions differ as to their precise classification but, using Collins' *New Naturalist Fungi* as a guide, they are placed in the kingdom Protozoa. Slime moulds start life as single-celled amoeboid organisms that are free-living and feed by ingesting mainly bacteria but also fungi. When feeding conditions are good, and they encounter suitable mating partners, these coalesce into a plasmodium stage of interconnecting strands. In larger slime moulds, these masses – slimy, often forming colourful coatings on vegetation and fallen timber – are what observers see, usually in autumn. The plasmodium stage of a slime mould is able to move, the mass oozing over the feeding substrate, albeit at a snail's pace. As the source of food runs out, spore-producing stages appear. The following are some of the most frequently encountered species. Although many species are colourful and striking, they are ephemeral and seldom remain in good condition for more than a day or so.

Fuligo septica var. *flava* – plasmodium stage is a bright yellow spongy mass, usually seen on dead wood.

Fuligo candida – plasmodium stage is a grubby white mass, coating woodland debris and sometimes on woodchip mulch.

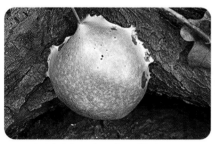

Reticularia lycoperdon – plasmodium stage is a white mass, resembling expanded foam, seen on fallen trunks and dead branches.

Arcyria denudata – fruit bodies are reddish brown and globular, seen in clusters on dead wood.

Arcyria nutans – plasmodium stage comprises tangled masses of yellowish worm-like strands, usually found on dead wood.

Badhamia foliicola – plasmodium stage comprises masses of globular, pustular masses that coat the living stems of grasses.

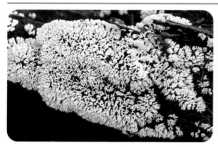

Ceratiomyxa fruticulosa – plasmodium stage comprises white tubes, arranged as flat, clustered rosettes on dead wood.

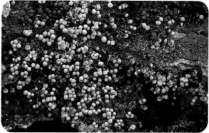

Cribraria persoonii – fruit body comprises a fawn to reddish-brown globular head on a distinct stalk; found on dead wood.

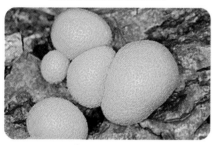

Lycogala terrestre – plasmodium stage is a rather spherical pinkish-buff ball; found on dead wood, usually in clusters.

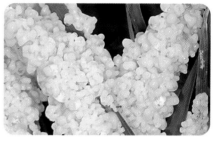

Mucilago crustacea – plasmodium stage is a creamy white mass that spreads over grasses and other meadow vegetation.

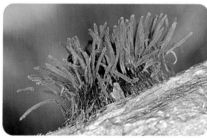

Stemonitis fusca – fruit body comprises dense clusters of thin, dark, hair-like strands bearing sausage-like spore masses; found on dead wood.

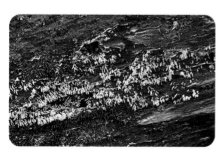

Stemonitopsis typhina – plasmodium stage comprises tufts of white finger-like projections; grows on dead wood.

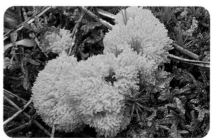

Tubulifera arachnoidea – plasmodium stage comprises orange, rather granular-looking masses, superficially recalling fish roe; found on dead wood and woodland litter.

Dripping Slimecap *Limacella illinita* (Amanitaceae)

Very slimy whitish *Limacella*. **CAP** To 8cm across; hemispherical or oval, becoming flattish bell-shaped, usually with a broad umbo; white or ivory, sometimes with a pale ochre centre and occasionally staining red in small patches; smooth texture and covered in a thick glutinous slime but drying dull. **GILLS** Free; crowded; whitish. **STIPE** To 10cm long; cylindrical and somewhat fragile; concolorous with cap and equally as slimy. **HABITAT** Deciduous and mixed woodland. **STATUS** Rare.

Amanita inopinata (Amanitacaeae)

Distinctive *Amanita* recently found in the British Isles; also known from Holland and New Zealand. **CAP** To 8cm across; convex, then flatter with a slightly depressed centre; greyish sepia with darker, coarse scales. **GILLS** Free; crowded; white, often with a pinkish-apricot tint. **STIPE** To 8cm long; stout with a ragged, pendulous ring; concolorous with cap, with darker scales that form bands below ring. **HABITAT** Generally associated with conifers in man-made environments such as cemeteries, churchyards and gardens, but now also found in the wild. **STATUS** Rare; confined to SE.

Amanita inopinata

Leucocoprinus cretaceus (Agaricaceae)

Uniformly white fungus, completely covered in soft cottony scales. **CAP** To 2.5cm across; initially elongated hemispherical but expanding to almost flat with a shallow umbo; margin grooved and scalloped; pure white and covered in concolorous scales. **GILLS** Free; crowded; white. **STIPE** To 8cm long; widening downward to a broad, bulbous base, and with a short-lived cottony ring; white but discolouring cream, and with same texture as cap. **HABITAT** Usually woodchips, but occasionally on dung or soil. **STATUS** Rare.

Phaeomarasmius erinaceus (Cortinariaceae)

Small and shaggy, with the appearance of a *Pholiota* (*see* p. 202). **CAP** To 1.5cm across; convex, becoming flatter; russet-ochre and densely covered in erect, darker scales; margin incurved and ragged. **GILLS** Adnate; rather distant; beige, maturing reddish brown. **STIPE** To 2cm long; cylindrical and often curved; concolorous with cap and with a similar texture. **HABITAT** Usually dead wood of deciduous trees, usually willows or birches. **STATUS** Widespread but occasional.

Yellow False Truffle *Rhizopogon luteolus* (Rhizopogonaceae)

Small tuber resembling a truffle but not edible. **FRUIT BODY** To 3cm across; irregularly spherical potato-like tuber, either growing on the surface or partially buried; dirty yellowish brown with a roughish texture and covered in a flattened network of brown rootlets; thick skin encloses the spore mass (gleba); white at first, maturing olive-brown. **HABITAT** Always associated with pine on sandy soils. **STATUS** Occasional; common only in Scotland.

Yellow False Truffle

Tiger Sawgill *Lentinus tigrinus* (Lentinaceae)

Distinctive sawgill with a scaly cap, often found around water edges. **CAP** To 5cm across; rounded at first but becoming flatter with a depressed centre; margin initially incurved but later expanded and undulating; cream to ochre and covered in dark brown or blackish scales, which are raised towards the centre. **GILLS** Decurrent with finely toothed edges; cream or yellowish brown. **STIPE** To 5cm long; cylindrical, sometimes eccentric, and occasionally with a faint ring zone; cream or pale brown with small brownish scales towards base. **HABITAT** Usually clustered on living or dead wood, frequently willow or alder, alongside streams, rivers, ponds and wet areas generally. **STATUS** Very uncommon, most frequent in S.

Pink Disco *Aleurodiscus wakefieldiae* (Aleurodiscaceae)

Resupinate fungus with a distinctive pink colour. **FRUIT BODY** Fully resupinate; initially rounded spots that coalesce to form irregular patches several centimetres in extent; surface irregular, very bumpy and undulating; bright pink, with margin paler or white and fringed. **HABITAT** On attached and recently fallen branches of deciduous trees. **STATUS** Rare.

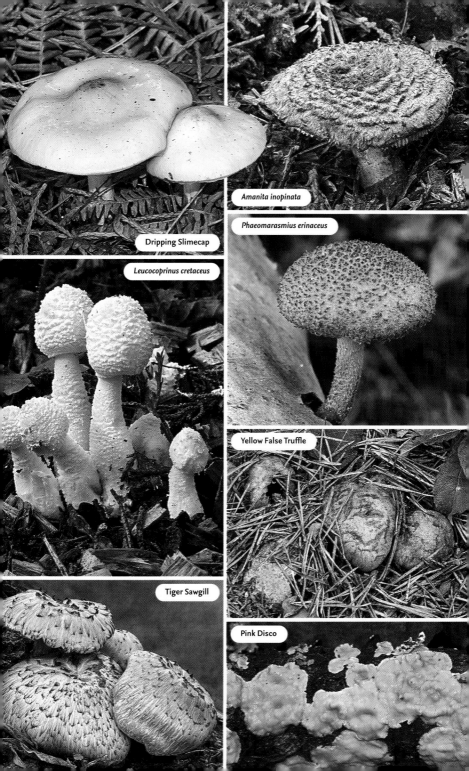

Dripping Slimecap

Amanita inopinata

Phaeomarasmius erinaceus

Leucocoprinus cretaceus

Yellow False Truffle

Tiger Sawgill

Pink Disco

Sandy Stiltball *Battarrea phalloides* (Battarraeaceae)

Rare, prehistoric-looking fungus whose spores develop on the outside of a cap-like structure. **FRUIT BODY** Initially a tough whitish 'egg' that then erupts, allowing a slender stem to emerge, this topped by a rounded spore mass resembling a rudimentary cap; reddish brown with a matt, powdery texture. **STEM** To 2.5cm long; cylindrical and covered in coarse, shaggy fibres; base encased in the bag-like remnants of the 'egg'; concolorous with 'cap' or paler. **HABITAT** Dry sandy soils with both deciduous and coniferous trees. **STATUS** Rare.

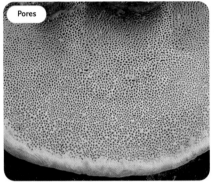

Pores

Pycnoporus cinnabarinus (Coriolaceae)

Bright orange bracket fungus. **FRUIT BODY** To 10cm across; broadly attached bracket projecting up to 6cm, semicircular or fan-shaped with a sharp, irregular margin. Upper surface orange or orange-red, sometimes with the margin paler, becoming duller with age; texture rough, with bumps, undulations and warts. Underside with fine, rounded or angular pores, these sometimes becoming elongated; similar colour to upper surface. **HABITAT** Dead wood of deciduous trees. **STATUS** Extremely rare. Has not been recorded in the British Isles for many years and is possibly now extinct here.

Fenugreek Stalkball *Phleogena faginea* (Phleogenaceae)

Tiny, lollipop-shaped fungus with a strong, spicy smell when dried. **HEAD** Initially rounded but becoming more irregular, elongated or convex, and tapering into a distinct stem; dirty white at first but discolouring greyish fawn, often in a patchy or marbled pattern; surface dull and irregularly pitted. **STEM** Relatively long and somewhat darker in colour. **HABITAT** In troops or swarms on living or dead trunks of deciduous trees. **STATUS** Occasional in S England.

Pepperpot *Myriostoma coliforme* (Geastraceae)

Unmistakable earthstar relative. **RAYS** 7–12cm across when expanded; comprise 10–15 segments, usually arching (never flat) when open, and raising the spore sac off the ground. **SPORE SAC** 3–5cm across; buff-brown, with numerous pores; borne on very short stalks (hard to see except in dry specimens). **HABITAT** On free-draining, often sandy soils. **STATUS** Very locally common on sand dunes in the Channel Islands; formerly considered extinct in Britain but recently rediscovered in Norfolk, growing in a sandy hedgerow.

Dotted Fanvault *Camarophyllopsis atropuncta* (Hygrophoraceae)

Small, pale fungus whose stipe is covered in dark, conspicuous scales. **CAP** To 2cm across; convex at first, then flattening with a depressed centre; dark brown, but hygrophanous and drying pale greyish beige. **GILLS** Decurrent; very distant; greyish beige. **STIPE** To 4cm long; cylindrical or tapering downward; pale reddish brown and speckled with large, prominent blackish scales. **HABITAT** Soil or grassy areas in deciduous woodland, often in dense grass tussocks. **STATUS** Uncommon to rare.

Hebelomina neerlandica (Cortinariaceae)

Extremely rare member of the Cortinariaceae family, resembling a *Hebeloma* with a distinctive antiseptic smell. **CAP** To 5cm across; initially conical or rounded, but becoming flatter and somewhat undulating with a slightly depressed centre; surface smooth with white veil remnants adhering to margin; white or ivory, sometimes with a buff centre. **GILLS** Somewhat distant; concolorous with cap. **STIPE** To 6cm long; cylindrical but occasionally thicker towards base and frequently bent; white or pale buff and longitudinally fibrous. **HABITAT** On soil in deciduous and mixed woodland, usually with pine and birch. **STATUS** Extremely rare; known only from one site in Surrey.

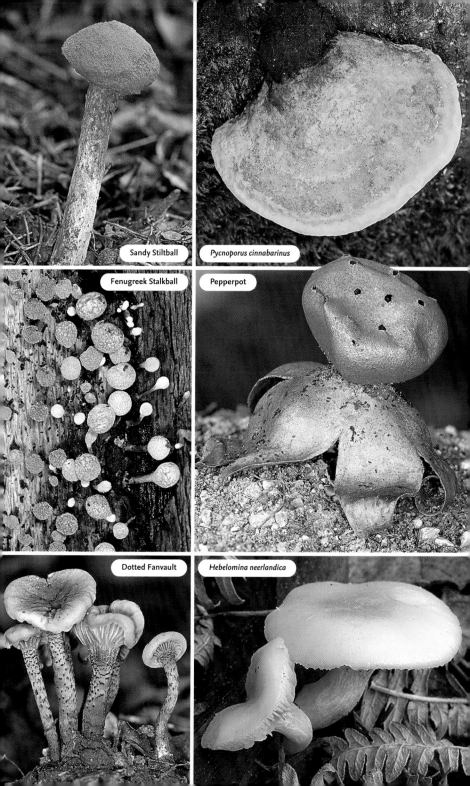

Sandy Stiltball

Pycnoporus cinnabarinus

Fenugreek Stalkball

Pepperpot

Dotted Fanvault

Hebelomina neerlandica

Most species associated with dunes are found in the stable part of the system covered in lowland heath-type vegetation, or in dune slacks with stands of Creeping Willow. They are not solely confined to dunes and can be found elsewhere in similar habitats. The more unstable part of the system, inhabited by Marram Grass, is a more hostile environment with a high calcium content; species found here are adapted to the conditions and are not usually found elsewhere. They are frequently deeply buried and often covered in sand, making them quite inconspicuous.

Agaricus devoniensis (Agaricaceae)
Medium-sized *Agaricus*, partially buried in the sand. **CAP** To 7cm across; convex, then flatter, with the margin often hung with veil remnants; grubby white and often covered with sandy debris; flesh whitish but flushes pink when bruised and has a mushroomy smell. **GILLS** Free; crowded; pale pink, maturing dark brown. **STIPE** To 4cm long; cylindrical and deeply buried, with a fragile, short-lived ring; whitish and slightly scaly. **HABITAT** Dunes and coastal grassland; rarely inland on sandy soil. **STATUS** Widespread but rare.

Dune Waxcap *Hygrocybe conicoides* (Hygrophoraceae)
Virtually identical to red or orange forms of *H. conica* (p. 98) but with minimum or no blackening. Greasy only when young. **CAP** To 4cm across; initially conical, then convex with a sharp umbo; red or orange. **GILLS** Free or adnexed; fairly crowded; yellow, maturing orange or red. **STIPE** To 7cm long; cylindrical and slender; yellowish and somewhat fibrous. **HABITAT** Coastal grassland and dunes. **STATUS** Widespread but occasional.

Dune Waxcap

Inocybe serotina (Cortinariaceae)
Drab-coloured *Inocybe*, usually deeply buried in the substrate. **CAP** To 6cm across; conical, expanding to bell-shaped with a low, broad umbo; yellowish brown with a radially fibrillose surface; usually covered in sand and soil particles. **GILLS** Adnate or adnexed; whitish, maturing buff. **STIPE** To 6cm long; cylindrical and deeply buried; whitish but sometimes yellowing with age. **HABITAT** Sandy soil, usually in sand dunes with willows. **STATUS** Uncommon.

Dune Cup *Peziza ammophila* (Pezizaceae)
Unusual *Peziza* that develops underground. **FRUIT BODY** To 5cm across; deep cup- or urn-shaped, tapering to a long stipe-like attachment that is permanently and deeply buried in the substrate. On maturity, top half of cup is visible, with the margin usually splitting into several irregular rays; cup interior is brown, and exterior is similar colour but obscured by binding sandy debris. **HABITAT** Coastal sand dunes. **STATUS** Widespread but uncommon.

Tiny Earthstar *Geastrum minimum* (Geastraceae)
Easily overlooked, miniature earthstar. **RAYS** 1.5–3cm across; comprise 6–10 segments, fleshy at first but becoming leathery and slightly recurved with age; whitish. Mycelial layer beneath rays is often encrusted with sand particles. **SPORE SAC** 0.8–1cm across; usually grey with a fibrous and rather small pore opening and a short stalk. **HABITAT** Calcareous sand dunes. **STATUS** Rare; restricted to a few areas of dunes on the N Norfolk coast.

Dwarf Earthstar *Geastrum schmidelii* (Geastraceae)
Diminutive earthstar, often tinged rufous buff. **RAYS** 1.5–3.5cm across; comprise 5–8 segments, these split halfway to centre; fleshy at first and usually slightly recurved when mature. **SPORE SAC** 0.5–1cm across; has a pleated pore opening and surround, and a very short stalk. **HABITAT** Among lichens in short dune vegetation. **STATUS** Local in mature dune systems; very occasionally inland on free-draining chalky and sandy soils in England and Wales.

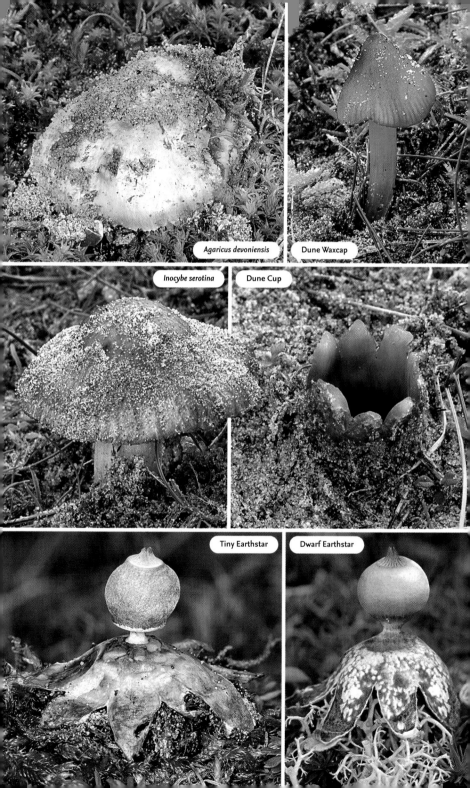

Agaricus devoniensis

Dune Waxcap

Inocybe serotina

Dune Cup

Tiny Earthstar

Dwarf Earthstar

Most typical wood-inhabiting fungi can also be found on woodchip mulch, but the open nature of this substrate and its ability to retain water, combined with the heat that builds up during decomposition, makes for a fertile mix. Consequently, many species grow much larger than normal here – often in spectacular clumps.

Golden Bolete *Buchwaldoboletus sphaerocephalus* (= *B. hemichrysus*) (Boletaceae)

Uniformly bright yellow bolete that discolours reddish brown. **CAP** To 10cm across; convex with an incurved margin; initially slightly greasy but drying dull, with an irregular and pitted surface; golden yellow. **PORES** Small and irregular; concolorous. **STIPE** To 10cm long; stout and somewhat enlarged in the middle; concolorous and with a fibrous texture. **HABITAT** Decayed wood of conifers, as well as sawdust and wood-chippings. **STATUS** Rare.

Warty Knight *Melanoleuca verrucipes* (Tricholomataceae)

Warty Knight

White *Melanoleuca* with a scaly stipe. **CAP** To 11cm across; convex or bell-shaped, becoming flatter and wavy; white or cream with a smooth texture. **GILLS** Often slightly decurrent; crowded; white, maturing cream. **STIPE** To 7cm long; cylindrical or with a wider base; concolorous but covered in small black scales, these often in ridges. **HABITAT** In soil and leaf litter as well as on wood-chippings. **STATUS** First recorded in Britain in 2000 but now increasing.

Gymnopilus dilepis (Cortinariaceae)

Similar in appearance to the white-spored Plums and Custard (p. 116) but distinguished by its brown spore print. **CAP** To 8cm across; convex, becoming flatter with an inrolled margin; variable in colour but typically with a pale ground and densely covered in wine-red or purple scales or fibrils. **GILLS** Adnate or slightly decurrent; crowded; golden yellow. **STIPE** To 8cm long; cylindrical with a small, short-lived ring; similar in colour and texture to cap. **HABITAT** Clustered in large, fused clumps on sawdust or wood-chippings. **STATUS** Rare but spreading in the SE.

Gymnopilus dilepis

Agaricus subrufescens (= *A. rufotegulis*) (Agaricaceae)

First recorded in the British Isles in 2003. **CAP** To 11cm across; hemispherical or convex, becoming flatter; pale ground colour covered in reddish-brown scales or fibrils. **GILLS** Free; crowded; pale pink, maturing dark brown. **STIPE** To 9cm long; broadly cylindrical; white, covered in fine concolorous scales; large, descending white ring with a smooth upperside and the lower side covered in brownish cottony squamules. **HABITAT** Occasionally solitary but usually clustered in large clumps on composted leaf and grass cuttings, as well as on wood-chippings. **STATUS** Very rare.

underside

Agrocybe rivulosa (Bolbitiaceae)

Pale *Agrocybe* with a strongly wrinkled cap. **CAP** To 7cm across; irregularly conical, becoming convex and radially wrinkled; pale buff, drying paler. **GILLS** Free; crowded; whitish, maturing brown. **STIPE** To 14cm long; cylindrical; concolorous with cap and covered in whitish fibres, with a large, easily torn, floppy ring. **HABITAT** Confined to wood-chippings. **STATUS** First identified in the British Isles in 2004 but now found in almost every county.

Agrocybe rivulosa

Agrocybe arvalis (Bolbitiaceae)

Small brownish *Agrocybe* with a sclerotium. **CAP** To 3cm across; convex but becoming flatter and undulating, sometimes with a broad umbo; yellowish brown with a smoothish texture, but hygrophanous and drying paler. **GILLS** Adnate; pale fawn, maturing reddish brown. **STIPE** To 11cm long; cylindrical and slender; whitish or fawn with the entire length white and floury; base rooting and usually connected to a pea-sized black sclerotium. **HABITAT** Found on soil in woodland, as well as on woodchip mulch. **STATUS** Widespread but occasional.

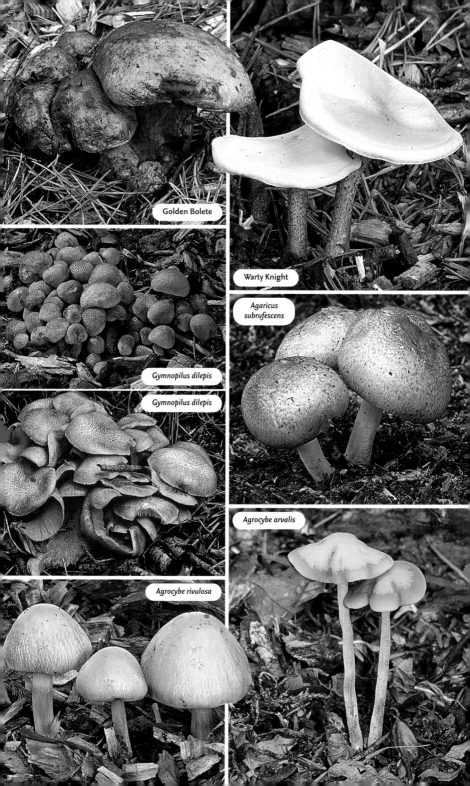

Golden Bolete

Warty Knight

Agaricus subrufescens

Gymnopilus dilepis

Gymnopilus dilepis

Agrocybe arvalis

Agrocybe rivulosa

Dung provides a rich substrate for fungi, with its easily accessible nutrients and high water-retention qualities. As a growing medium, its acid nature and various chemical compounds require a high degree of specialisation, and consequently many dung-inhabiting fungi are not found on any other substrate. The dung of herbivores is host to more species than that of carnivores. The first stage in the life cycle is the ingestion of the spores by the animal in its food, and accordingly these spores are excreted with the dung. The heat generated during the decomposition process aids germination and the first fruit bodies of primitive species start to appear in a few days, with a succession of different species following over a period of time.

Conocybe pubescens (Bolbitiaceae)
Conocybe with a velvety stipe. **CAP** To 1.5cm across; conical or bell-shaped and remaining so throughout its life; striate when moist; orange-brown, but hygrophanous and drying ochre. **GILLS** Adnate; pale ochre, maturing rust-brown. **STIPE** To 8cm long; cylindrical and fragile; concolorous with cap but progressively darker downward and with a white floury coating. **HABITAT** Dung of herbivores, often in woodland. **STATUS** Widespread but occasional.

Nail Fungus *Poronia punctata* (Xylariaceae)
Unique ascomycete in the shape of a nail and with the colouring of a Dalmatian dog. **FRUIT BODY** Comprises a flat, irregularly circular disc to 1.5cm across, with a raised margin on maturity; connected to the substrate by a long black stem. **UPPER SURFACE** Spore-bearing; dull white, covered in black pore openings and becoming grubby with age. **HABITAT** Dung of horses and ponies. **STATUS** Occasional but declining.

Nail
Fungus

Cheilymenia granulata (= *Coprobia granulata*) (Pyronemataceae)
Common, very small yellow ascomycete, often found in swarms on cow-pats. **FRUIT BODY** To 0.2cm across; sessile, saucer-shaped or flatter disc; inner surface yellowish orange when fresh but drying darker, with a smooth texture; outer surface and margin concolorous but distinctly granular. **HABITAT** Typically in groups or swarms on cow dung. **STATUS** Widespread and very common.

Coprinopsis stercorea (= *Coprinus stercoreus*) (Psathyrellaceae)
Small inkcap with a very mealy cap and stipe when young. **CAP** To 1cm across; egg-shaped, with margin clasping stem, but expanding to bell-shaped or flatter; margin rolls up and often splits; white then light grey. **GILLS** Adnate or free; white, then brown and finally black and deliquescing. **STIPE** To 4cm high; cylindrical and fragile; white. **HABITAT** Solitary or grouped on the dung of a variety of herbivores. **STATUS** Widespread and common.

Coprinopsis radiata (= *Coprinus radiatus*) (Psathyrellaceae)
Fragile, very short-lived inkcap that rarely lasts the day. **CAP** To 2cm across; initially oval but flattening to bell-shaped with the margin curling up; translucent-striate almost to centre; grey, sometimes with an ochreous centre and covered with fleecy white scales that flake off in a patchy manner; flesh thin, watery and deliquescing. **GILLS** Adnexed or free; distant; white, maturing black. **STIPE** To 7cm long; cylindrical and somewhat slender; white, covered in fleecy fibrils. **HABITAT** Gregarious on the dung of herbivores, especially horses. **STATUS** Widespread and common.

Ascobolus furfuraceus (= *A. stercorarius*) (Ascobolaceae)
Very small *Peziza*-like ascomycete with a scurfy margin. **FRUIT BODY** To 0.4cm across; initially cup-shaped, becoming disc- or cushion-shaped; inner surface light brown, finely pitted with darker pore openings; outer surface and margin paler and distinctly scurfy. **HABITAT** Cow manure. **STATUS** Occasional.

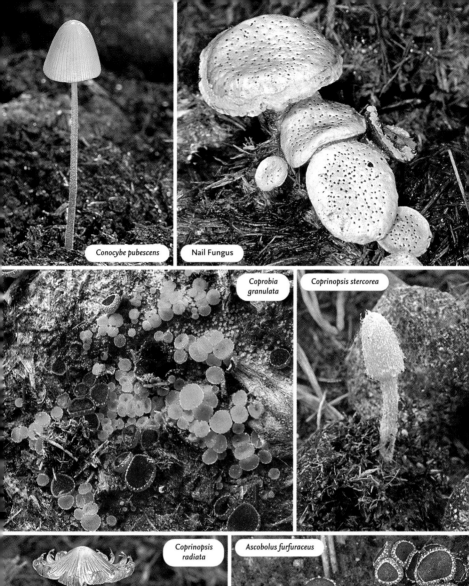

Conocybe pubescens

Nail Fungus

Coprobia granulata

Coprinopsis stercorea

Coprinopsis radiata

Ascobolus furfuraceus

The principal change in soil chemistry following a fire is a noticeable increase in its alkalinity and this, rather than the presence of carbon, satisfies the requirements of phoenicoid fungi. Following a fire there is a clearly defined succession of fungi, with the first species appearing within a few months; this process can continue for several years. As with some flower species, a short exposure to extreme heat is often required for germination.

Anthracobia macrocystis (Pyronemataceae)
Small orange disco, found throughout the year on old bonfire sites. **FRUIT BODY** To 0.3cm across; small, sessile disc with a conspicuous margin dotted with short brown tufts of hair; inner surface yellowish or reddish orange, with a smooth texture; outer surface paler and with scattered tiny tufts of hair. **HABITAT** Occasionally in small groups, but typically in dense swarms on burnt ground, especially old bonfire sites. **STATUS** Widespread but occasional.

Pine Fire Fungus *Rhizina undulata* (Rhizinaceae)
Large, unusual, resupinate *Helvella*. **FRUIT BODY** To 10cm across; flat and cushion-like with irregular, undulating lobes and folds, and with a number of root-like growths on the underside; frequently, several fruit bodies coalesce to form large, irregular patches; chestnut or blackish brown with a paler margin when young and a smooth texture. **HABITAT** Solitary or gregarious on recently burnt ground in coniferous woodland. **STATUS** Widespread but occasional.

Hebeloma anthracophilum (Cortinariaceae)
Viscid *Hebeloma* with a two-tone cap. **CAP** To 6cm across; hemispherical then convex or flatter, sometimes slightly umbonate; viscid or greasy when moist but drying smooth and satiny; brown but paler towards margin. **GILLS** Adnate, with fringed edges; pale buff, maturing light brown. **STIPE** To 5cm long; cylindrical; flexible and can be bent without breaking; whitish or fawn but discolouring brown from base upward. **HABITAT** Usually on old bonfire sites. **STATUS** Widespread but uncommon; mostly found in S England.

Psathyrella pennata (Psathyrellaceae)
Smallish *Psathyrella* with veil remnants on the cap and stipe when young. **CAP** To 3cm across; hemispherical, then convex or flatter and covered in whitish veil remnants, particularly towards margin; reddish brown, but hygrophanous and drying pale buff and smooth. **GILLS** Adnate; crowded, with white cottony edges; light buff, maturing dark brown. **STIPE** To 4cm long; cylindrical and often curved; pale fawn, covered in a white down. **HABITAT** Burnt ground and charred wood, often on heathland. **STATUS** Widespread but occasional.

Bonfire Scalycap *Pholiota highlandensis* (Strophariaceae)
An early coloniser of burnt areas. **CAP** To 5cm across; convex, becoming flatter with an incurved margin, and hung with veil remnants when young; greasy but soon drying silky; colour variable, but typically yellowish brown or reddish brown, drying paler. **GILLS** Adnate; crowded; greyish brown, maturing darker. **STIPE** To 5cm long; cylindrical, sometimes with a ring zone; light yellow, covered in light brown fibrils. **HABITAT** Burnt ground. **STATUS** Widespread and common; the most common phoenicoid species.

Coprinellus angulatus (= *Coprinus angulatus*) (Psathyrellaceae)
Drab inkcap. **CAP** To 3cm across; elongated egg-shaped, and strongly striate or grooved up to the smooth centre; margin undulating and irregular; shades of darkish brown, but slightly hygrophanous and drying paler. **GILLS** Adnexed; greyish, maturing grey-black. **STIPE** To 4cm long; cylindrical; cream or buff, covered in white fibrils when young. **HABITAT** Solitary or in small groups on old burnt ground and charred wood. **STATUS** Widespread but occasional.

Tephrocybe anthracophila (Tricholomataceae)
Drab brown *Tephrocybe* often found in dense swarms. **CAP** To 2.5cm across; initially convex then flat, with a striate margin and the centre usually depressed; surface smooth and dull; dark to very dark brown when moist but hygrophanous and drying paler. **GILLS** Adnate; whitish becoming greyish with age. **STIPE** To 4cm long; cylindrical; concolorous with cap or darker and slightly fibrillose. **HABITAT** Grouped on burnt soil or charcoal. **STATUS** Widespread and occasional.

Anthracobia macrocystis

Pine Fire Fungus

Hebeloma anthracophilum

Psathyrella pennata, young form

Bonfire Scalycap

Psathyrella pennata, mature form

Coprinellus angulatus

Tephrocybe anthracophila

Pinning down a strict definition for lichens has always been difficult. To the novice, they may look like primitive, non-flowering plants. In reality, however, lichens are curious organisms that comprise a partnership between a fungus and either an alga (the commonest form of association) or a cyanobacterium (capable of photosynthesis); in a very few instances, the three organisms work in partnership. In all cases, the lichenised relationship is symbiotic – to the benefit of both or all. Today, in the strict sense, lichens with fungal symbionts are referred to as 'lichenised fungi', since the fungus element of the partnership is dominant and because the term 'lichen' is not scientific: superficially similar they may be, but they are not necessarily closely related. The following are among our most familiar lichenised fungi.

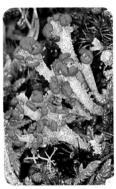

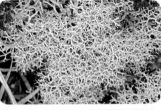
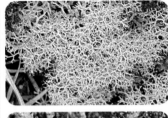

LEFT: *Cladonia portentosa* looks like wire-wool. It is common on moors and heaths, and forms intricate networks of densely packed blue-grey or whitish strands.

BELOW: *Graphis scripta* is a bark-encrusting species, found mainly on Hazel and Ash. It forms rounded blue-grey patches; its spore-producing structures are black lines and scribbles.

ABOVE: *Cladonia floerkeana* is a common red-tipped species of heaths and moors. It forms encrusting patches of greyish-white scales from which granular, scale-encrusted stalks arise, topped with bright red spore-producing bodies.

ABOVE: *Cladonia pyxidata* is greyish green and comprises large, broad, cup-shaped fruit bodies with a granular texture, borne on short stalks. It is found on heaths and rotting wood.

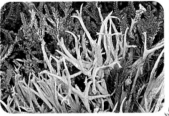

BELOW: *Hypogymnia physodes* grows on branches, rocks and walls, forming encrusting, irregularly rounded patches that are smooth and grey above.

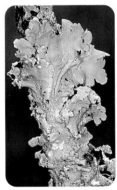

ABOVE: *Parmelia caperata* encrusts deciduous tree bark, forming patches of rounded grey-green, often overlapping, lobes with flat-topped brown spore-producing discs.

RIGHT: *Usnea florida* forms tangled masses of threads, attached to twigs with a holdfast. Hair-fringed cup-shaped spore-producing bodies form at tips.

ABOVE: *Cladonia uncialis* has bluish-green antler-like, branched fruit bodies. It favours heaths and moors, often growing in waterlogged ground.

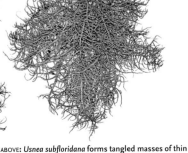

ABOVE: *Usnea subfloridana* forms tangled masses of thin threads; it is attached by a holdfast to twigs, but sometimes grows on rocks. The spore-producing bodies are cup-shaped.

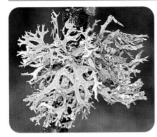

OAK MOSS *Evernia prunastri* comprises divided, flattened but curled branches. It is greenish grey above, white below and grows attached to oak branches.

TREE LUNGWORT *Lobaria pulmonaria* has spreading lobes, pitted and adorned with pale, divided veins. It grows on ancient trees in damp places.

Placynthium nigrum encrusts limestone and weathered concrete, and is black, granular and often faintly cracked. It has a passing resemblance to a splash of black paint.

CRAB'S-EYE LICHEN *Ochrolechia parella* forms encrusting patches on walls and rocks, mainly in western Britain. It is greyish with a pale margin and clusters of raised, flat-topped spore-producing structures.

MAP LICHEN *Rhizocarpon geographicum* is an encrusting upland lichen, yellowish with black spore-producing bodies. Colony boundaries are defined by black margins.

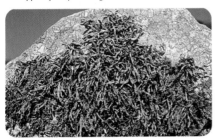

SEA IVORY *Ramalina siliquosa* is a tufted lichen of coastal rocks and stone walls, tolerating salt spray. The flat grey branches bear disc-like spore-producing bodies.

BLACK SHIELDS *Tephromela atra* forms patches on seashore rocks, and sometimes on walls inland. Its knobbly grey surface has grey-margined, black spore-producing structures.

YELLOW SCALES *Xanthoria parietina* is a familiar lichen, spectacular on coasts but also common inland. It forms orange-yellow patches, with leafy scales, on rocks and walls.

Caloplaca marina forms bright orange patches on rocks around the high-water mark on seashores. It tolerates salt spray and brief immersion in sea water.

DOGTOOTH LICHEN *Peltigera canina* forms dense patches on sandy heathland soil. The upper surface bears tooth-like reproductive structures.

Beneath the ground, the mycelia of many fungus species have intimate, often species-specific relationships with the roots of certain trees. So recognising tree species can aid fungal identification. When identifying trees, use leaves (both living and fallen), fallen fruits and tree bark, ideally in combination. The following pages illustrate the essential features of some of the most commonly encountered native and introduced tree and shrub species.

SCOTS PINE *Pinus sylvestris*

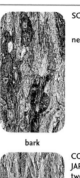

needles

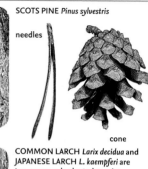

bark cone

CORSICAN PINE *Pinus nigra* ssp. *nigra*

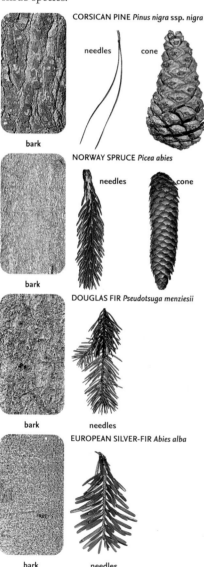

needles cone

bark

COMMON LARCH *Larix decidua* and JAPANESE LARCH *L. kaempferi* are two commonly planted species

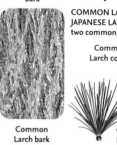

Common Larch cone

Japanese Larch cone

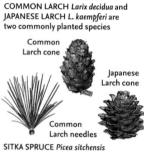

Common Larch bark Common Larch needles

NORWAY SPRUCE *Picea abies*

needles cone

bark

SITKA SPRUCE *Picea sitchensis*

bark needles

DOUGLAS FIR *Pseudotsuga menziesii*

bark needles

WESTERN HEMLOCK-SPRUCE *Tsuga heterophylla* and EASTERN HEMLOCK-SPRUCE *T. canadensis* are two commonly planted species

Western Hemlock-spruce foliage

Eastern Hemlock-spruce foliage

Western Hemlock-spruce bark

EUROPEAN SILVER-FIR *Abies alba*

bark needles

YEW *Taxus baccata*

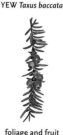

bark foliage and fruit fruit

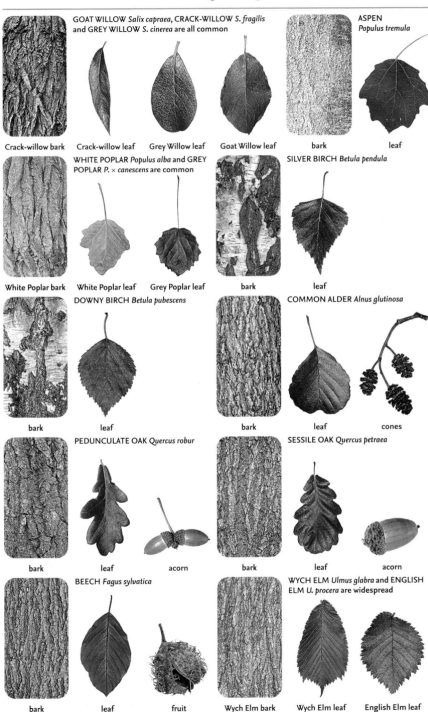

GOAT WILLOW *Salix capraea*, **CRACK-WILLOW** *S. fragilis* and **GREY WILLOW** *S. cinerea* are all common

ASPEN *Populus tremula*

Crack-willow bark Crack-willow leaf Grey Willow leaf Goat Willow leaf bark leaf

WHITE POPLAR *Populus alba* and **GREY POPLAR** *P. × canescens* are common

SILVER BIRCH *Betula pendula*

White Poplar bark White Poplar leaf Grey Poplar leaf bark leaf

DOWNY BIRCH *Betula pubescens*

COMMON ALDER *Alnus glutinosa*

bark leaf bark leaf cones

PEDUNCULATE OAK *Quercus robur*

SESSILE OAK *Quercus petraea*

bark leaf acorn bark leaf acorn

BEECH *Fagus sylvatica*

WYCH ELM *Ulmus glabra* and **ENGLISH ELM** *U. procera* are widespread

bark leaf fruit Wych Elm bark Wych Elm leaf English Elm leaf

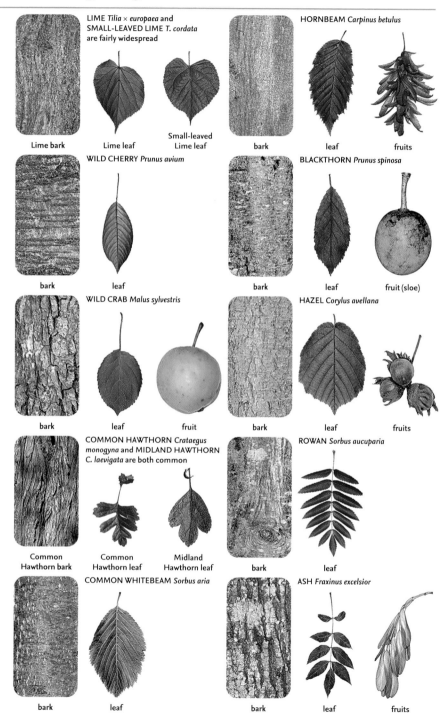

LIME *Tilia × europaea* and SMALL-LEAVED LIME *T. cordata* are fairly widespread

Lime bark

Lime leaf

Small-leaved Lime leaf

HORNBEAM *Carpinus betulus*

bark

leaf

fruits

WILD CHERRY *Prunus avium*

bark

leaf

BLACKTHORN *Prunus spinosa*

bark

leaf

fruit (sloe)

WILD CRAB *Malus sylvestris*

bark

leaf

fruit

HAZEL *Corylus avellana*

bark

leaf

fruits

COMMON HAWTHORN *Crataegus monogyna* and MIDLAND HAWTHORN *C. laevigata* are both common

Common Hawthorn bark

Common Hawthorn leaf

Midland Hawthorn leaf

ROWAN *Sorbus aucuparia*

bark

leaf

COMMON WHITEBEAM *Sorbus aria*

bark

leaf

ASH *Fraxinus excelsior*

bark

leaf

fruits

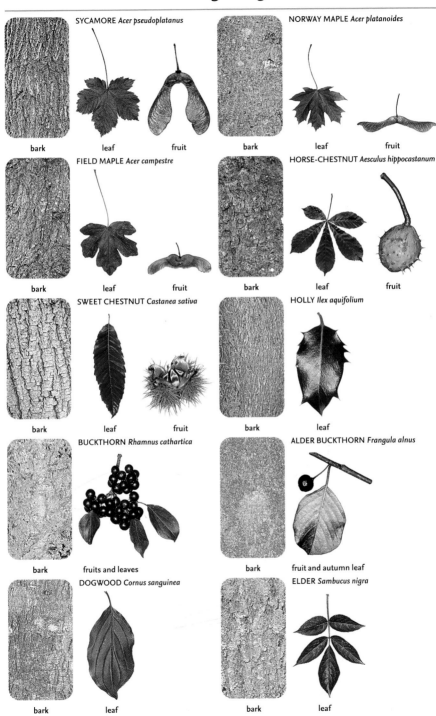

SYCAMORE *Acer pseudoplatanus*

bark leaf fruit

NORWAY MAPLE *Acer platanoides*

bark leaf fruit

FIELD MAPLE *Acer campestre*

bark leaf fruit

HORSE-CHESTNUT *Aesculus hippocastanum*

bark leaf fruit

SWEET CHESTNUT *Castanea sativa*

bark leaf fruit

HOLLY *Ilex aquifolium*

bark leaf

BUCKTHORN *Rhamnus cathartica*

bark fruits and leaves

ALDER BUCKTHORN *Frangula alnus*

bark fruit and autumn leaf

DOGWOOD *Cornus sanguinea*

bark leaf

ELDER *Sambucus nigra*

bark leaf

Oak woodland and associated fungi

Oak woodlands are incredibly important for wildlife in general and harbour a rich diversity of fungi, some with ectomycorrhizal assocations with the tree roots, others feeding saprophytically on dead and decaying timber and leaves. Pedunculate Oak *Quercus robur* is one of the commonest large native tree species in central and southern England. It dominates many woodlands either because soil conditions favour it or because it is encouraged (often having been planted) by man: traditionally, it was always the construction timber of choice. Sessile Oak *Q. petraea* often grows alongside its Pedunculate cousin but it favours subtly different growing conditions, predominating in upland and western areas where rainfall is highest. The fungi found in Sessile Oak woodland are broadly similar to those under Pedunculate Oak. At the detailed level, however, there are subtle differences: in part this may be a reflection of the generally harsher climatic conditions that Sessile Oak favours but the history of land use by man sometimes plays a part too. The fungi shown here are commonly encountered in oak woodland, although some are occasionally found in other wooded areas.

ORANGE OAK BOLETE
Leccinum aurantiacum
(see p. 40)

ROOTING BOLETE
Boletus radicans
(see p. 32)

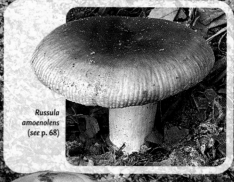

Russula amoenolens
(see p. 68)

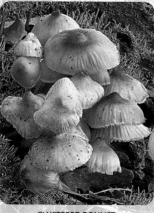

CLUSTERED BONNET
Mycena inclinata
(see p. 146)

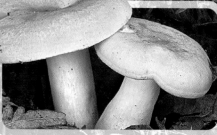

YELLOWDROP MILKCAP
Lactarius chrysorrheus
(see p. 48)

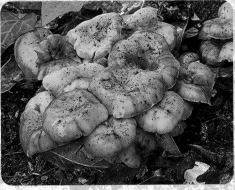

SPINDLESHANK
Collybia fusipes
(see p. 128)

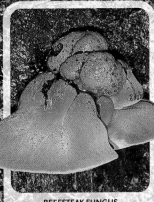

BEEFSTEAK FUNGUS
Fistulina hepatica
(see p. 280)

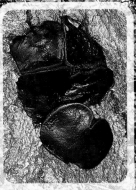

BLACK BULGAR
Bulgaria inqinans
(see p. 306)

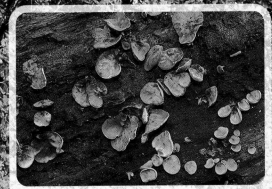

GREEN ELFCUP
Chlorosplenium aeruginascens
(see p. 308)

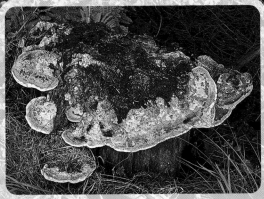

OAK MAZEGILL
Daedalea quercina
(see p. 258)

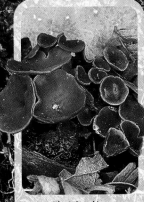

Ciboria batschiana
(see p. 326)

Beech woodland and associated fungi

Few trees are more successful at eliminating competition from rival species than Beech and in mature woodland it often forms such a dense canopy that potential competitors are essentially eliminated. Beech will tolerate a wide range of soil types from fairly acid to calcareous. It is arguably at its finest growing on the latter, especially when covering the slopes of chalk downs. Beech woodlands in such settings have the fitting name of 'hangers'. For many people, Beech woods are at their best in the autumn, not only because of the stunning foliage colours but also because of the intriguing range and abundance, in wet years, of fungi. Many of these are entirely restricted to Beech woodlands and some of the associated *Russula* and *Boletus* species are extremely colourful. The following are among the most commonly encountered.

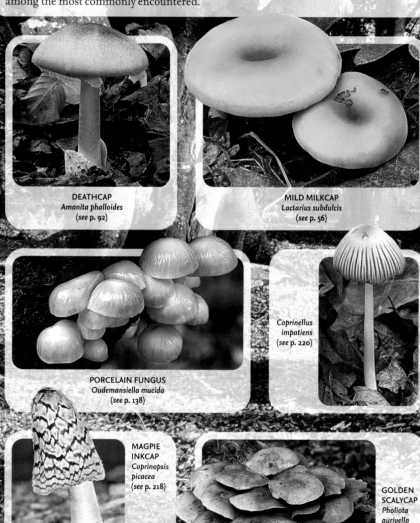

DEATHCAP
Amanita phalloides
(see p. 92)

MILD MILKCAP
Lactarius subdulcis
(see p. 56)

PORCELAIN FUNGUS
Oudemansiella mucida
(see p. 138)

Coprinellus impatiens
(see p. 220)

MAGPIE INKCAP
Coprinopsis picacea
(see p. 218)

GOLDEN SCALYCAP
Pholiota aurivella
(see p. 202)

SAFFRONDROP BONNET
Mycena crocata
(*see* p. 142)

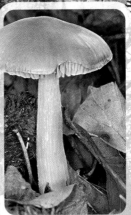

BEECH JELLYDISC
Neobulgaria pura
(*see* p. 306)

LILAC BONNET
Mycena pura
(*see* p. 144)

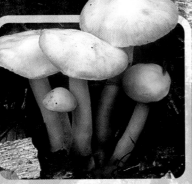

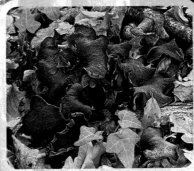

IVORY WOODWAX
Hygrophorus eberneus
(*see* p. 104)

HORN OF PLENTY
Craterellus cornucopioides
(*see* p. 228)

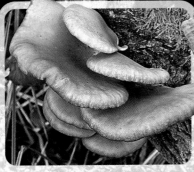

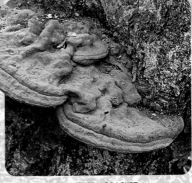

OYSTER MUSHROOM
Pleurotus ostreatus
(*see* p. 222)

SOUTHERN BRACKET
Ganoderma australe
(*see* p. 268)

Birch woodland and associated fungi

MAIN PICTURE: **Silver Birch woodland in autumn.**

Birches are often viewed with disdain and dismissed as being little more than scrub trees. It is certainly true that, in certain circumstances, Silver Birch *Betula pendula* in particular is an aggressively invasive species of heathland and newly cleared woodland on neutral to acid soils. However, in its favour is the fact that it plays host to a wide range of wildlife and its fungal associates are rich and varied. Downy Birch *B. pubescens* often grows alongside Silver Birch but comes to replace it in many western, northern and upland areas. In terms of specifically associated wildlife, it has much in common with Silver Birch, particularly when it comes to fungi. In the autumn, birch leaves usually turn a spectacular golden yellow for a week or two. Around the same time, a varied array of fungi put in an appearance. The following selection is commonly encountered.

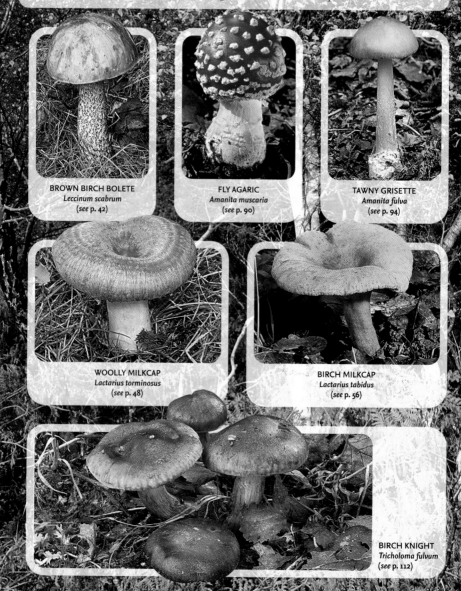

BROWN BIRCH BOLETE
Leccinum scabrum
(see p. 42)

FLY AGARIC
Amanita muscaria
(see p. 90)

TAWNY GRISETTE
Amanita fulva
(see p. 94)

WOOLLY MILKCAP
Lactarius torminosus
(see p. 48)

BIRCH MILKCAP
Lactarius tabidus
(see p. 56)

BIRCH KNIGHT
Tricholoma fulvum
(see p. 112)

YELLOW SWAMP BRITTLEGILL
Russula claroflava
(see p. 64)

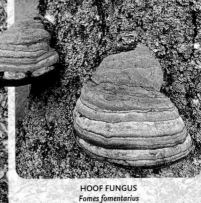

HOOF FUNGUS
Fomes fomentarius
(see p. 256)

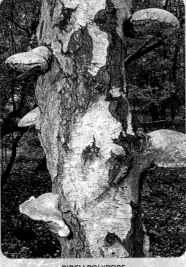

BIRCH POLYPORE
Piptoporus betulinus
(see p. 254)

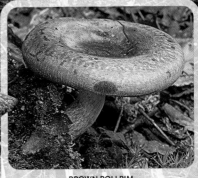

BROWN ROLLRIM
Paxillus involutus
(see p. 184)

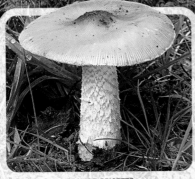

ORANGE GRISETTE
Amanita crocea
(see p. 94)

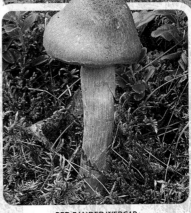

RED BANDED WEBCAP
Cortinarius armillatus
(see p. 168)

Hazel, Ash and associated fungi

MAIN PICTURE: **Hazel woodland in autumn.**

In the past, Hazel was an extremely important species, maintained as a shrub by regular cutting – coppicing – to produce long, straight wands; these are used in hurdle-making in particular. Typically, it was grown as an understorey beneath large trees such as Ash. Although the economic significance of Hazel woodland products has declined, the habitat is often maintained for its intrinsic value to wildlife. Several species of fungi are associated primarily, or exclusively, with Hazel. Ash is an important source of woodland products – firewood and fenceposts, for example – and is often managed by coppicing or pollarding. Its roots do not form extomycorrhizal associations and consequently few typical mushrooms are found under pure stands of Ash.

One of the few fungal species to be associated almost exclusively with Ash, CRAMP BALLS *Daldinia concentrica* (see p. 328), appears on dead and dying branches.

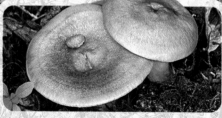

FIERY MILKCAP
Lactarius pyrogalus
(see p. 52)

SPRING HAZELCUP
Encoelia furfuracea
(see p. 308

HAZEL WOODWART
Hypoxylon fuscum
(see p. 330)

CINNAMON PORECRUST
Phellinus ferreus
(see p. 282)

GLUE CRUST
Hymenochaete corrugata
(see p. 288)

Several species of willow are widespread in Britain and Ireland and in suitable habitats they can be locally dominant; familiar species include Goat Willow *Salix capraea*, Grey Willow *S. cinerea* and Crack-willow *S. fragilis*. In ecological terms, willows are colonising species of damp ground and some species are actively cut and managed to produce long, thin wands for weaving. A range of fungal species are associated primarily, or exclusively, with willows; of these, some of the most impressive are found on trunks and dead timber.

Hebeloma leucosarx
(see p. 190)

GIRDLED KNIGHT
Tricholoma cingulatum
(see p. 108)

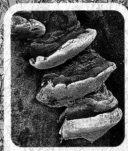

WILLOW BRACKET
Phellinus igniarius
(see p. 282)

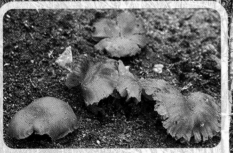

TWISTED DECEIVER
Laccaria tortilis
(see p. 124)

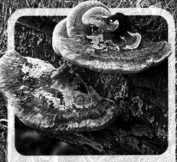

BLUSHING BRACKET
Daedaleopsis confragosa
(see p. 258)

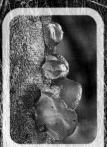

Exidia recisa
(see p. 250)

Hymenochaete tabacina
(also found on Hazel)
(see p. 288)

TIGER SAWGILL
Lentinus tigrinus
(see p. 336)

Conifer woodlands and associated fungi

Visit the Highlands of Scotland and you will discover remnants of native ancient Scots Pine forests that once cloaked the region; this habitat is often referred to as Caledonian Pine Forest. With the exception of Juniper *Juniperus communis* and Yew *Taxus baccata*, conifers seen away from central Scotland will not be naturally occurring. Regimented plantations are easy enough to spot, with their uniform age trees planted a standard distance from one another. But even isolated clumps of Scots Pine, found on a southern heathland, are at best going to be naturalised trees, their seeds having spread from nearby plantations. Alien conifers are often reviled in conservation circles but on the positive side all conifer woodlands, be they native or introduced, support an intriguing range of fungi; many species are extremely species-specific in terms of the trees with which they are associated.

FUNGI ASSOCIATED WITH LARCH SPECIES (including *Larix decidua* and *L. kaempferi*) **AND SPRUCE SPECIES** (including *Picea abies* and *P. sitchensis*)

LARCH ASSOCIATES

CEDAR ASSOCIATES

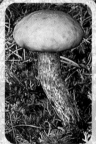

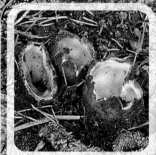

LARCH BOLETE
Suillus grevillei
(see p. 44)

LARCH SPIKE
Gomphidius maculatus
(see p. 226)

CEDAR CUP
Geopora sumneriana
(see p. 314)

SPRUCE ASSOCIATES

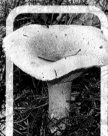

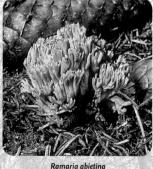

FALSE SAFFRON MILKCAP
Lactarius deterrimus
(see p. 50)

FRUITY BRITTLEGILL
Russula quelettii
(see p. 74)

Ramaria abietina
(see p. 240)

FUNGI ASSOCIATED TYPICALLY WITH SCOTS PINE *PINUS SYLVESTRIS* BUT SOMETIMES ALSO WITH OTHER *PINUS* SPECIES

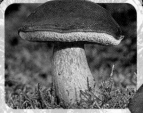

BAY BOLETE
Boletus badius
(see p. 34)

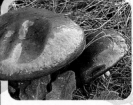

SLIPPERY JACK
Suillus luteus
(see p. 44)

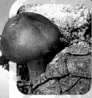

HERALD OF WINTER
Hygrophorus hypothejus
(see p. 104)

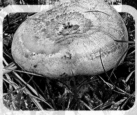

SAFFRON MILKCAP
Lactarius deliciosus
(see p. 50)

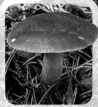

LIVER MILKCAP
Lactarius hepaticus
(see p. 60)

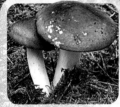

PRIMROSE BRITTLEGILL
Russula sardonia
(see p. 74)

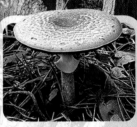

BLUSHING WOOD MUSHROOM
Agaricus silvaticus
(see p. 208)

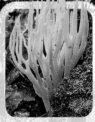

YELLOW STAGSHORN
Calocera viscosa
(see p. 248)

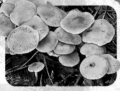

COMMON RUSTGILL
Gymnopilus penetrans
(see p. 186)

BLEEDING CONIFER CRUST
Stereum sanguinolentum
(see p. 232)

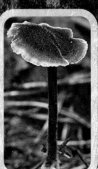

EAR PICK FUNGUS
Auriscalpium vulgare
(see p. 280)

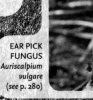

DYER'S MAZEGILL
Phaeolus schweintzii
(see p. 252)

MAIN PICTURE: **Caledonian Pine Forest.**

Ground that is permanently inundated with freshwater is a challenging environment for most organisms. From an ecological perspective, the associated habitats are referred to as 'mires'. Those whose waters are acid are called 'bogs' while those with alkaline waters are referred to as 'fens'. The term 'marsh' is a catchall phrase often applied to wet ground generally. Unsurprisingly, fungal diversity is limited compared to drier habitats but a select band of specialists are worth looking for. Alder *Alnus glutinosa*, a tree that thrives with its feet in water, has its own band of associated fungi. The following species are regularly encountered.

FUNGI ASSOCIATED WITH BOGS AND MARSHES

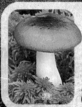

**Russula
aquosa**
(see p. 78)

**SPHAGNUM
GREYLING
*Tephrocybe
palustris***
(see p. 130)

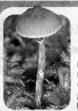

**BOG
BELL
*Galerina
paludosa***
(see p. 188)

**BOG
BEACON
*Mitrula
paludosa***
(see p. 304)

**MIDNIGHT
DISCO
*Pachyella
violaceonigra***
(see p. 324)

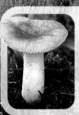

**Russula
robertii**
(see p. 70)

FUNGI ASSOCIATED WITH ALDER CARR

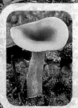

**ALDER
MILKCAP
*Lactarius
obscuratus***
(see p. 58)

**Paxillus
rubicundulus**
(see p. 184)

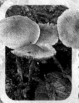

**OCHRE
ALDERCAP
*Naucoria
escharioides***
(see p. 188)

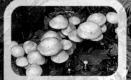

ALDER SCALYCAP
Pholiota alnicola (see p. 202)

**ALDER
BRACKET
*Inonotus
radiatus***
(see p. 286)

**ALDER
TONGUE
*Taphrina
alni***
(see p. 333)

In the context of Britain, most areas of grassland are manmade, the result in the first instance of forest clearance in times past. Regular grazing or cutting for hay prevented colonisation by rank vegetation and eventual habitat succession back to woodland. Continued management by man is essential to maintain grassland habitat. A range of rather specialised fungi are associated with grassland, the precise species present often influenced by the underlying soil type and the following are regularly encountered.

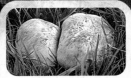

FIELD MUSHROOM
Agaricus campestris
(see p. 208)

FAIRY RING CHAMPIGNON
Marasmius oreades
(see p. 132)

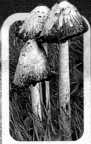

SHAGGY INKCAP
Coprinus comatus
(see p. 218)

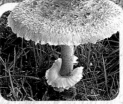

PARASOL
Macrolepiota procera
(see p. 80)

GOLDEN SPINDLES
Clavulinopsis fusiformis
(see p. 236)

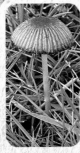

PLEATED INKCAP
Parasola plicatilis
(see p. 220)

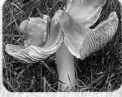

PINK WAXCAP
Hygrocybe calyptriformis
(see p. 100)

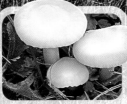

SNOWY WAXCAP
Hygrocybe virginea
(see p. 102)

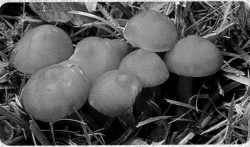

SCARLET WAXCAP
Hygrocybe coccinea
(see p. 96)

FURTHER READING

Breitenbach, J., and/or Kränzlin, F. (1984–2005) *Fungi of Switzerland* (6 volumes), Mykologia Luzern.

Phillips, R. (2006) *Mushrooms,* Macmillan.

Courtecuisse, R., and Duhem, B. (1995) *Mushrooms & Toadstools of Britain & Europe,* HarperCollins (currently out of print but worth looking for a second-hand copy).

Bon, M. (1987) *The Mushrooms and Toadstools of Britain and North-western Europe,* Hodder & Stoughton (currently out of print but worth looking for a second-hand copy).

Legon, N.W., and Henrici, A., with Roberts, P.J., Spooner, B.M., and Watling, R. (2005) *Checklist of the British & Irish Basidiomycota,* Royal Botanic Gardens, Kew.

Field Mycology. Mycological magazine (4 issues per year). email: nlinfo-f@elsevier.com

DVDs of FUNGAL IMAGES

MycoKey 2.1 DVD Thomas Læssøe & Jens H. Petersen. www.mycokey.com

MycoBel DVD: http://www.mycobel.be

USEFUL ADDRESSES

British Mycological Society
Wolfson Wing of the Jodrell Laboratory
Royal Botanic Gardens
Kew
Richmond
Surrey TW9 3AB
www.britmycolsoc.org.uk
(BMS has a number of inexpensive publications and booklets)

Association of British Fungus Groups
Harveys
Alston
Axminster
Devon EX13 7LG
www.abfg.org